Cézanne
The Late Work

Cézanne
The Late Work

Essays by

THEODORE REFF

LAWRENCE GOWING

LILIANE BRION-GUERRY

JOHN REWALD

F. NOVOTNY

GENEVIÈVE MONNIER

DOUGLAS DRUICK

GEORGE HEARD HAMILTON

WILLIAM RUBIN

Edited by William Rubin

THE MUSEUM OF MODERN ART, NEW YORK

Distributed by New York Graphic Society, Boston

CONTENTS

This book and the exhibition
it accompanies have been made possible
through the generous support of
IBM Corporation and the National Endowment
for the Humanities.

FOREWORD

THIS BOOK IS PUBLISHED ON THE OCCASION of the exhibition "Cézanne: The Late Work," organized by The Museum of Modern Art, New York, and the Réunion des Musées Nationaux, France, and shown also at The Museum of Fine Arts, Houston. Although exhibitions covering the whole of Cézanne's career have been held in the past both in this country and abroad, this exhibition is the first to focus on the last decade of the artist's life, from 1895 to 1906, the years in which Cézanne's work underwent a series of transformations that give it a particular character and make it the bridge between the art of the nineteenth century and that of the twentieth.

I first realized the need for such an exhibition in 1952, when I was a member of a doctoral seminar on Cézanne held by Meyer Schapiro at Columbia University (and if exhibitions had dedications, then "Cézanne: The Late Work" would be dedicated to Meyer Schapiro). Not long before that seminar I had seen the last major Cézanne exhibition to have been held in New York, the large retrospective at The Metropolitan Museum in 1952. In studying the work exhibited there and the catalogs from earlier Cézanne exhibitions that I had missed, it became clear to me that the late work was being shown inadequately—in too little depth for the questions of its character, style, and importance to be studied. None of those exhibitions, nor any subsequent one, made sufficiently clear the marked change that took place in Cézanne's work after 1895 and reached its fulfillment in his paintings of the twentieth century. From the time that I was appointed Curator at The Museum of Modern Art, it was my intention to organize such an exhibition. But the immense cost—especially for insurance—entailed by such a project and the difficulty of securing the loans led to a temporary shelving of the project, which I had first proposed in 1970.

We are, therefore, exceedingly grateful to the IBM Corporation and the National Endowment for the Humanities for making it possible for us to undertake the project at this time; without their support the exhibition could not have taken place. In addition to their aid, the Federal Council on the Arts and the Humanities, through the Art and Artifacts Indemnity Act, provided foreign-loan coverage which, if purchased commercially, would certainly have precluded realization of the full scope of the exhibition.

Essential to the mounting of this exhibition has been the cosponsorship of the Réunion des Musées Nationaux. Neither of our collaborating institutions acting alone could have

presented an exhibition of this amplitude, drawing as extensively as it does on collections both in America and Europe. French sponsorship was inspired in the first instance by the enthusiasm for this project on the part of Michel Guy, formerly Secrétaire d'Etat à la Culture. On behalf of The Museum of Modern Art, as well as personally, I should most particularly like to thank him and Hubert Landais, Inspecteur Général, Adjoint au Directeur des Musées de France; Hélène Adhémar, Conservateur en Chef des Galeries Nationales du Jeu de Paume et de l'Orangerie; Maurice Sérullaz, Conservateur en Chef du Cabinet des Dessins, Musée du Louvre; and Geneviève Monnier, Conservateur au Cabinet des Dessins, Musée du Louvre. Their invaluable counsel and aid have been given unstintingly and in a spirit that has made our joint endeavor a true transatlantic *entente.* In the United States, we are pleased to be sharing the exhibition with The Museum of Fine Arts, Houston, and are grateful to its Director, William C. Agee, for his cordial cooperation.

From the beginning I have wanted this exhibition to serve the scholarly community in the fullest possible manner—an aim reflected in the fact that the Museum requested to serve as codirectors two of the world's outstanding Cézanne scholars, Professor John Rewald of the Graduate Center of the City University of New York and Professor Theodore Reff of Columbia University. It has been my pleasure and privilege to work with them. Not only are Professors Rewald and Reff contributors to this book, but they have worked with me virtually from the inception of this project in the selection of the works exhibited, the development of the plan of the present volume, the overall program of the orientation galleries of the exhibition, and the week of Cézanne studies projected for October 1977. In addition, Professor Rewald has generously put at the service of this project his unique and irreplaceable documentary and photographic files.

The success of the exhibition has depended upon the generosity of the owners of key works who have lent their pictures knowing that they would thus be deprived of them for many months. In addition to a number of lenders who wish to remain anonymous, our deepest thanks are due the following owners of works included in the exhibition: Dr. Ruth Bakwin; Mr. and Mrs. Walter Bareiss; Ernst Beyeler; Mr. and Mrs. Adrien Chappuis; Mrs. Allan D. Emil; Stephen Hahn; The Alex Hillman Family Foundation; Riccardo Jucker; Jacques Koerfer; the estate of Jean Matisse; Gianni Mattioli; Mrs. Carleton Mitchell; Dr. and Mrs. Alexander Pearlman; Mrs. Rose Pearlman, on behalf of the estate of Henry Pearlman; Mr. and Mrs. Joseph Pulitzer, Jr.; Mr. and Mrs. Henry Reed; S. Rosengart; Dr. and Mrs. William Rosenthal; Ernest von Simson; Sam Spiegel; John S. Thacher; Mr. and Mrs. Eugene Victor Thaw; H. Thyssen-Bornemisza; Mr. and Mrs. John W. Warrington; Mr. and Mrs. Richard K. Weil; Musée Granet, Aix-en-Provence; Baltimore Museum of Art; Kunstmuseum Basel; Galerie Beyeler, Basel; Museum of Fine Arts, Boston; Kunsthalle Bremen; Albright-Knox Art Gallery, Buffalo; National Museum of Wales, Cardiff; The Cincinnati Museum of Art; The Art Institute of Chicago; The Cleveland Museum of Art; National Gallery of Ireland, Dublin; Folkwang Museum, Essen; Nelson Gallery of Art–Atkins Museum, Kansas City, Missouri; The Hermitage Museum, Leningrad; Courtauld Institute

Galleries, London; The Newark Museum; The Solomon R. Guggenheim Museum, New York; The Metropolitan Museum, New York; Cabinet des Dessins, Musée du Louvre, Paris; Galerie du Jeu de Paume, Musée du Louvre, Paris; Musée du Petit Palais, Paris; Musée du Louvre, Paris; Philadelphia Museum of Art; The Art Museum, Princeton University; The Museum of Art, Rhode Island School of Design, Providence; The City Art Museum, St. Louis; McNay Art Institute, San Antonio; The Fine Arts Museums of San Francisco; Staatsgalerie, Stuttgart; National Gallery of Art, Washington; The Phillips Collection, Washington; Kunsthaus, Zurich.

To the authors of the essays in this volume goes a special tribute for their contribution to our knowledge and understanding of Cézanne and for their patience with editorial details. Aside from the authors, those who went to much trouble to assist the research and documentation of this project and who shared their special knowledge are Daniel-Henry Kahnweiler, Louise Leiris, Maurice Jardot, Pierre Daix, Edward F. Fry, John Richardson, and Christopher Burge.

This undertaking has naturally involved many staff members at both The Museum of Modern Art and the Louvre. My foremost thanks must go to the two Directors, Richard E. Oldenburg of The Museum of Modern Art and Emmanuel de Margérie of the Réunion des Musées Nationaux, who have supported this complex project with enthusiasm and conviction. Waldo Rasmussen, Director, International Program, acted as the Museum's representative during many of our early discussions with the Réunion des Musées Nationaux. Richard Palmer, Coordinator of Exhibitions at The Museum of Modern Art, and Irène Bizot, Secrétaire Générale de la Réunion des Musées Nationaux, have expertly supervised and coordinated the intricate logistics involved in the organization of this project. They have been ably and skillfully supported by Mary Lea Bandy, Associate Coordinator of Exhibitions, Eloise Ricciardelli, Associate Registrar, and Barbara Savinar, Senior Cataloguer, all of the Museum's staff.

The burden placed on my own department in realizing an exhibition and book of this order has been enormous. Monique Beudert, Curatorial Assistant, has been unsparing of her efforts, and her professionalism and expertise have contributed significantly to the accomplishment of this project. My assistant, Sharon McIntosh, has been involved in every phase of the exhibition and book, and her services have, as always, been invaluable. Michael Marrinan of the Institute of Fine Arts, New York University, worked tirelessly against impending deadlines in preparing the brochure on Cézanne for the orientation galleries and organizing the orientation galleries themselves, which were designed by Irving Harper of Harper and George, Inc. John Elderfield, Curator of Painting and Sculpture at the Museum, supervised these sections of the project and was responsible for the detailed organization of the week of Cézanne studies. Judith Cousins, Researcher of the Collection, worked diligently and with her customary thoroughness in gathering documentation for the exhibition and for my essay, and provided as well many excellent suggestions. Carolyn Lanchner, Research Curator, made important contributions to my text and notes. My secretary, Diane Gurien, has handled a considerable portion of the correspondence related to this book and exhibition and typed much of my manuscript. To Emily Walter I am

indebted for her perseverance in obtaining photographs under the pressure of imminent deadlines.

I especially wish to acknowledge, in the Department of Publications, the contribution of Francis Kloeppel, a superb editor with whom it has been my good fortune to work before and who expertly and patiently guided this book through all its phases; his perceptive suggestions were invaluable. Another particular expression of thanks must go to James M. Eng, who most capably designed this book, and to Jack Doenias and Stevan Baron, who ably saw the volume through production.

My appreciation goes also to William Burback, Director's Special Assistant for Education, and Myrna Martin, Administrative Assistant, for organizing the details of our education program as it relates to the Cézanne exhibition. Both John Limpert and James Snyder have worked tirelessly to enlist support for this exhibition and its accompanying book. Other staff members who have made valuable contributions to this project are Jean Volkmer, Chief Conservator; Tosca Zagni, Senior Conservator; Antoinette King, Senior Paper Conservator; Richard Tooke, Supervisor, Department of Rights and Reproductions; Mikki Carpenter, Archival Assistant; and Fred Coxen, Production Supervisor.

We are also indebted to the New York Graphic Society, Boston, for graciously putting at our disposal a number of photographs assembled for the firm's projected publication of the catalogue raisonné of Cézanne's paintings and watercolors being prepared by John Rewald.

It is not possible to list all those who have liberally given of their time and knowledge, but I should like here to register my deep appreciation for all such assistance.

WILLIAM RUBIN, Director
Department of Painting and Sculpture
The Museum of Modern Art

Cézanne
The Late Work

The dimensions of illustrated works are given both in inches
and in centimeters, with height preceding width.
Captions are based on information provided by the owners
of the illustrated works and do not necessarily agree
in every respect with the entries in the catalog.
The Venturi numbers identifying works by Cézanne refer to
Lionello Venturi's catalogue raisonné, *Cézanne: son art — son oeuvre*
(Paris: Paul Rosenberg, 1936).
Where no Venturi number appears in a caption,
the work in question is not listed in Venturi.

Painting and Theory in the Final Decade

Theodore Reff

I

"PAINTERS MUST DEVOTE THEMSELVES entirely to the study of nature and try to produce pictures which will be an education," Cézanne wrote shortly before his death.[1] Yet he could hardly foresee how exemplary his own pictures would become: since then almost every major painter, even if less devoted to nature than he, has found in his work a source of instruction as well as inspiration. For Klee he was "the teacher par excellence," for Matisse "the father of us all," for Picasso "a mother who protects her children."[2] As is evident from their work, each of them responded to another aspect of Cézanne's complex and constantly evolving art, and the same is true of all those modern painters who, from Gauguin in the 1880s to Jasper Johns eighty years later, have taken it as a model or ideal.

If, nevertheless, one period in Cézanne's long development has been of special importance, it is surely the last one, comprehending the extraordinary changes that occurred in his work after 1895 and especially after 1900 and continued without interruption until his death in 1906. It is this phase which, although little understood or appreciated at the time, has so deeply impressed later artists, regardless of their own stylistic tendencies. For the Orphic Cubist Delaunay, there was "in the last watercolors of Cézanne a remarkable limpidity tending to become a supernatural beauty beyond anything previously seen."[3] To the Purist Ozenfant, it was clear that "toward the end of his life [he] conceived painting as approximate to an effort of pure creation."[4] The Surrealist Marcel Jean found "the effect of mirror-light [seen in Mallarmé] reappearing with Cézanne, especially in the [late] watercolors . . . prismatic universes crossed by jagged rainbows."[5] And the Abstract Expressionist Hans Hofmann saw in his last pictures "an enormous sense of volume, breathing, pulsating, expanding, contracting through his use of colors."[6] Thus Cézanne's late work is an essential part of the history of twentieth-century art. But more than that, it constitutes one of the greatest achievements this century's art has known thus far, one so rich and varied that it is still inadequately understood some seventy years later.

It was Roger Fry, the most perceptive writer on Cézanne of his generation, who noted that "for certain intelligences among posterity, the completest revelation of his spirit may be found in these latest creations."[7] Fry added modestly that they "still

outrange our pictorial apprehension," but his was in fact the first comprehensive account of Cézanne's development and the first to appreciate the distinctive character, both stylistic and thematic, of its latest phase. Fry's book was published exactly fifty years ago; and by another coincidence Meyer Schapiro's appeared exactly twenty-five years later. More responsive to the personal content and hidden continuities within Cézanne's art, Schapiro's subtle interpretation of the late portraits, landscapes, and still lifes has influenced most subsequent discussions, including the present one.[8] Yet, like Fry's study, it does not attempt to establish a chronology for Cézanne's late style or to follow its development systematically; nor does it consider the theoretical pronouncements and references to older art that figure so prominently in his letters and reported conversations and their relation to his practice.

When did this later period begin? Not in a single year, obviously, but in the course of several years. It has been argued that features characteristic of the late style already emerged toward the end of the eighties;[9] but as we shall see, they appeared consistently and clearly only after 1895. It was then that Cézanne painted a group of portraits and genre figures—the *Geffroy,* the *Young Italian Girl,* the *Old Woman with a Rosary*—more profound in content, more complex in coloring, more somber and mysterious in tone than anything he had achieved earlier. It was then, too, that he began to work at the Château Noir and the Bibémus quarry, remote or overgrown sites in which he discovered echoes of his own exaltation and despair, and transposed them onto his canvases with an intensity of color and form unprecedented in his art. It was also about 1895 that he undertook a series of grandiose still lifes, containing a floral-patterned pitcher, draperies, and fruit, which are at once more sumptuous materially and more symphonic in color and composition than those of the previous decade. And it was also then that he took up the first of the three *Large Bathers,* a final realization of his lifelong ambition to paint nude figures outdoors on a monumental scale like that of the old masters he admired in the Louvre.

Biographically, too, 1895 marked a turning point in Cézanne's development. Five years earlier, he was so little known to younger artists that Maurice Denis considered him "almost a myth" and "questioned his very existence."[10] With two minor exceptions, his work had not been shown in Paris since the

Notes to this essay begin on page 50.

Impressionist exhibition of 1877, and could be seen only in the collections of a few colleagues and enlightened amateurs and occasionally in the shop of a small color merchant. In the eighties, it had of course exerted a profound influence on Gauguin and Emile Bernard, and the latter had published a biographical sketch of Cézanne in 1891. This was followed by one or two sympathetic articles; yet in one of them the critic Gustave Geffroy was forced to admit that Cézanne was "at once unknown and famous . . . a mystery surrounds his person and his work."[11] In November 1895 this situation changed abruptly, at least as far as the work was concerned: at the urging of Pissarro, Monet, and other Impressionist friends, who had long recognized the importance of Cézanne's achievement, the dealer Ambroise Vollard organized a retrospective exhibition containing some 150 pictures. It resulted in increased sales and critical discussions that firmly established Cézanne's reputation; and it coincided with his painting a major portrait of Geffroy, which occupies the same place in his oeuvre as Manet's portrait of Zola does in 1868 and Degas's of Duranty in 1879, though Cézanne was past sixty by then. The exhibition at Vollard's was followed by an increasing number of others, at the same gallery, at the Salon des Indépendants, and eventually at the Salon d'Automne in 1904–06, where Cézanne's greatness was consecrated and his impact on Matisse, Picasso, and other artists of their generation began to be felt.

It was about 1895 that Cézanne's position in his native Aix-en-Provence also improved considerably. From having been a virtual recluse, he emerged as the cultural hero of a circle of young poets and writers, led by Joachim Gasquet, who met and immediately attached himself to him then. A pupil of the neo-Catholic philosopher Georges Dumesnil and a compatriot of the royalist and reactionary thinker Charles Maurras, Gasquet attempted to promote a revival of Provençal culture based on its native traditions and Mediterranean heritage, and admired in Cézanne both his conservative views and his classical vision of the Provençal landscape.[12] Through him Cézanne met Léo Larguier, Edmond Jaloux, and other writers in that circle, whose memoirs, like Gasquet's own, have to a large extent colored our image of him. A friend of Zola, Paul Alexis, and several others in the Naturalist movement in the seventies and eighties, Cézanne had of course never been entirely isolated or provincial culturally; and his correspondence is filled with perceptive comments on Zola's novels and indications of his reading in the French and Latin classics and in Stendhal, Baudelaire, and Flaubert. Yet it was only in the last decade of his career that he emerged as something of a public figure in the cultural life of both Paris and Aix, the twin centers of his activity.

II

THE PAINTINGS OF CÉZANNE'S last period are probably more difficult to date correctly than those of any other, but unless the more important ones are placed in a coherent chronological order his stylistic development in these years can hardly be understood. Fortunately, there are a number of securely dated portraits and genre figures, to which some of the landscapes and still lifes can be related, enabling us to trace the outlines of that development.[13] In the figure paintings we also see most clearly the new features of Cézanne's art as they emerged about 1895.

To this period belong the portrait of Geffroy (pl. 1), painted during daily sessions at his home between April and June 1895 and taken up again in February–March 1896;[14] the portrait of Joachim Gasquet (pl. 2), begun in May 1896 according to his account or in the previous winter according to his wife's;[15] the portrait of Henri Gasquet (pl. 3), executed immediately before or after the one of Joachim;[16] the *Old Woman with a Rosary* (pl. 7), completed by July 1896 and supposedly worked on during the preceding eighteen months;[17] the *Young Italian Girl* (pl. 9), reportedly painted in the winter of 1896–97;[18] and *The Reader* (pl. 6), later dated 1896 by Vollard.[19]

In all of these there appears, both in the color harmony and the psychological content, a new note of somberness and mystery, a dark, flickering spirituality reminiscent of Baroque art and especially of Rembrandt. Most are images of serious, even sad meditation; the subjects' postures and features, so often said to be inexpressive and masklike, speak eloquently of this mood. The *Old Woman with a Rosary* may not be quite the tragic figure—an aged nun, escaped from her convent, who was found wandering by Cézanne and taken in as a servant—whom Gasquet later described,[20] but her gaunt, intense, deeply shaded face and stooped body emerging from darkness do evoke a tormented existence. The *Young Italian Girl* is, despite her youthful attractiveness, an image of melancholy lassitude, leaning far to one side of her space as she supports her head with one hand and braces her body with the other. The inclined, unstable axis of both figures appears again, more surprisingly, in the portrait of Joachim Gasquet; and combined with the head placed unusually high and the eyes turned to the side, it imparts an air of eccentricity, almost of craftiness. "How strange!" remarked his former teacher Dumesnil; "I thought I had plumbed the soul of my pupil, and yet this portrait shows me a Gasquet I did not know. I see now that the real Gasquet was not the ingenuous creature I took him for."[21] Even the more forthright image of Henri Gasquet, a boyhood friend of Cézanne's and the local baker, conveys a feeling of inwardness through the tilted axes of the head and hat and the unfocused gaze.

Only the critic Geffroy appears in a stable posture, centered in his space. Seated squarely behind his desk, his arms folded on it, he forms a conventional triangle, just as his features form a pleasant mask, one that seems less expressive than the vividly colored, oddly tilted volumes on the bookshelves behind him. This lack of intimacy may reflect the lack of ease Cézanne felt in the presence of the well-known Parisian writer or, as Geffroy himself implies, his ambition to produce an important work that would win him recognition at the Salon.[22] Or, again, he may have had too much in mind such imposing precedents as

Portrait of Geffroy (pl. 1). 1895. Venturi 692
Oil on canvas, 45¾ x 35 in (116.2 x 88.9 cm)
Musée du Louvre, Paris. Life interest gift

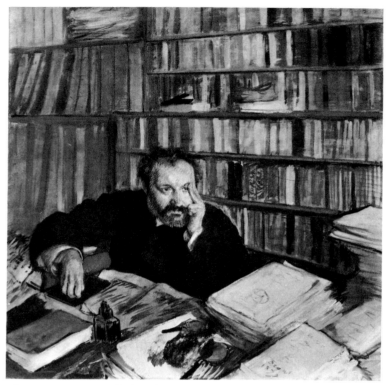

Edgar Degas. *Portrait of Edmond Duranty.* 1879
Distemper, watercolor, and pastel on canvas,
39½ x 39½ in (100 x 100 cm)
Glasgow Art Gallery and Museum

Manet's portrait of Zola and Degas's of Duranty, where the sitter is likewise subordinated to the richly evocative setting, if not quite to this extent.[23] Whatever the reason, the portrait of Geffroy stands apart from the others painted about 1895 in its greater pictorial complexity and psychological aloofness.

In its color harmony, however, it accords very well with the others in this group. Like them, it shows the figure emerging as a dark form against a darker background, whereas in comparable pictures of the early nineties, such as the larger *Cardplayers* (Venturi 559, 560) and the *Smokers* (Venturi 684, 686, 688), it is sharply silhouetted against a light ground. The new relationship is still more evident in *The Reader,* whose purple-brown setting, left unfinished when the picture was abandoned, reinforces the somberness of the young man's costume and the brooding expression of his face. And just as his suit is painted largely in tones of purple, brown, and deep green and blue, with flickering accents of orange and yellow, so the coloring of the other pictures in the group is dominated by such tones or by similarly dark or muted ones. In the portrait of Geffroy, for example, the jacket is black and charcoal gray with deep rose, the fireplace brown and mauve above and blue and mauve below, and even

the face contains touches of blue and gray in addition to rose, pink, and tan. Distinctly different in range and mood are the colors of such characteristic figures of the early nineties as the *Boy with a Red Vest* (Venturi 680–83), whose very costume reveals a taste for warm, bright colors that is unusual later in the decade, and the *Woman with a Coffeepot* (Venturi 574), whose bright blue dress and pale blue cup and coffeepot contrast strongly with the orange-brown tablecloth and the white and rose wallpaper.

In the works of about 1895, we also observe a greater freedom and variety of execution than had prevailed earlier. The brushstroke, very restrained in the portrait of Geffroy, where it is conspicuous only in peripheral forms such as the books and fireplace, is of an unprecedented boldness in *The Reader,* partly no doubt because the canvas was left unfinished. In texture, too, the surface varies greatly now, from heavily impasted in the *Young Italian Girl* and the *Old Woman with a Rosary,* which were supposedly painted over long periods, to thin and half-transparent in the portraits of Joachim and Henri Gasquet, known to have been executed during relatively brief intervals. The younger Gasquet's features are formed by strokes so broad and distinct

Woman with a Coffeepot. c. 1893. Venturi 574
Oil on canvas, 51⅛ x 38⅛ in (130 x 97 cm)
Musée du Louvre, Galerie du Jeu de Paume,
Paris

that they resemble watercolor washes, yet there is nothing casual or sketchlike about them. Their deliberately shaped contours define planes precisely, and their changes from cool to warm color, including surprising notes of crimson, violet, blue, and green in areas of flesh and beard, reinforce the sense of volume.

In other pictures of the same period, it is true, stylistic features characteristic of the early nineties continue to be found; in Cézanne's development such survivals are more the rule than the exception. The *Child with a Straw Hat* (pl. 11), painted in

July 1896,[24] stands forth against a light background in the manner of earlier portraits like that of Mme Cézanne (Venturi 569); its soft, luminous coloring, restricted to warm gray, blue gray, orange-brown, and yellow-tan, likewise contrasts with the somber purple tonality typical of the mid-nineties. Even the closed, sculptural form of the child and its static pose, centered and symmetrical, are closer to those in the earlier portraits; and like them it evokes, and may well be inspired by, the similar conception of form in Italian Renaissance portrait busts. These

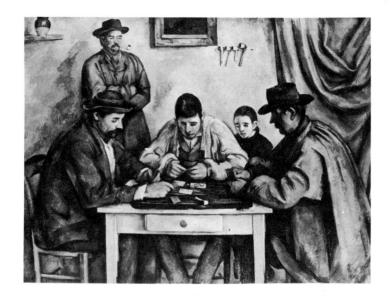

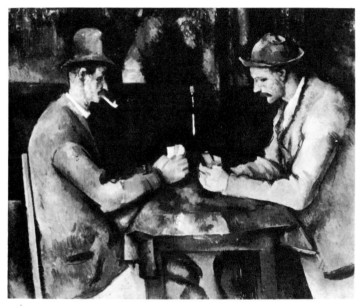

Top: *Cardplayers.* 1890–92. Venturi 560
Oil on canvas, 52¼ x 70½ in (133 x 179 cm)
© The Barnes Foundation, Merion, Pa.

Above: *Cardplayers.* 1893–96. Venturi 558
Oil on canvas, 17¾ x 22½ in (45 x 57 cm)
Musée du Louvre, Paris

were among Cézanne's favorite works of older art, to judge from the number of times he drew after them, and their influence has been seen in his *Man with a Pipe* (Venturi 564) of about 1893 in "the very sculptural pose of the body with parallel folds of drapery, cut sharply below the shoulders."[25] It is also evident in the *Woman with a Coffeepot,* when this similarly frontal, static, and plastic figure is compared with those of Benedetto da Maiano's busts of Filippo Strozzi and Pietro Mellini, both of which Cézanne copied in the Louvre.[26] The *Peasant with a Blue*

Blouse (pl. 10) is another example of this sculptural style, though whether it was painted at the beginning or the end of the decade is uncertain. It is mentioned by Gasquet in 1898 and has therefore been dated about that time;[27] yet its color harmony, dominated by bright blue, yellow-tan, and red, suggests that it is contemporary with the larger *Cardplayers,* and it may even show the same peasant as the one seen standing in them.

The series of *Cardplayer* compositions was begun in 1890, according to the daughter of the peasant depicted in one of them (Venturi 560), and was still in progress the following year, when Alexis visited Cézanne's studio in the Jas de Bouffan;[28] hence the whole series is generally dated 1890–92. But there is disagreement about the order in which they were painted: some writers maintain that the smaller versions with two figures precede the larger ones with four or five, others argue the reverse.[29] The two conceptions of Cézanne's creative process, one stressing his growing confidence and ambition, the other his increasing concentration on essentials, seem equally attractive. In terms of his stylistic development in the first half of the nineties, however, the sequence placing the two-figure versions later is more likely correct, since they are more easily linked with the pictures of 1895–96. Moreover, those versions themselves reveal a development toward the later style when they are placed in the generally accepted order, with the one formerly in the Lecomte Collection (Venturi 556) first, the Courtauld Institute's (Venturi 557) second, and the Louvre's (Venturi 558) third. For the last appears remarkably similar to the portrait of Geffroy and *The Reader* in its figures emerging from a dark background and its harmony of purple, deep blue, black, reddish brown, and yellow-tan, and should therefore be dated about 1894–95. It is in any event unlikely that so long and ambitious a series, involving so strenuous an effort of self-criticism, could have been completed in the two years traditionally given it. Rather, Cézanne's gradual transformation of his conception, moving progressively from the largest to the smallest format and number of figures and from the brightest, most objective representation to the darkest and most mysterious, is one that must have taken several years to unfold. The final version, the small yet infinitely refined and complex version in the Louvre, has rightly been regarded as one of the summits of his achievement.

As genre subjects stripped of their local color and anecdotal content and transformed into images of somber, deeply serious meditation, the *Cardplayers* are not unique in Cézanne's work of the early nineties. The closely related paintings of a peasant seated at a table and smoking are equally monumental and imposing in conception. One version (Venturi 684) was definitely completed by 1892, and the others probably date from the same time.[30] The figure in all three, although seated in a stable, frontal manner, leans to the left, supporting his head with his hand in a sadly contemplative mood. The same gesture occurs in the roughly contemporary *Boy with a Red Vest* (Venturi 681) and *Boy with a Skull* (pl. 8) and in the somewhat later *Young Italian Girl,* but if it clearly had a special attraction for the aging,

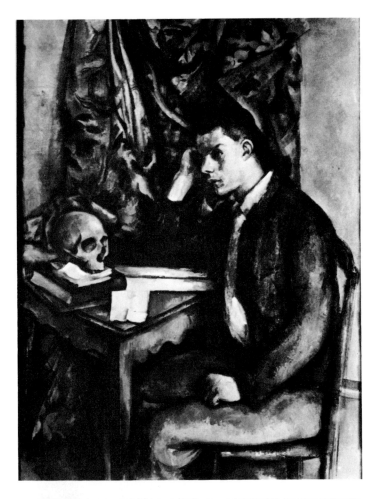

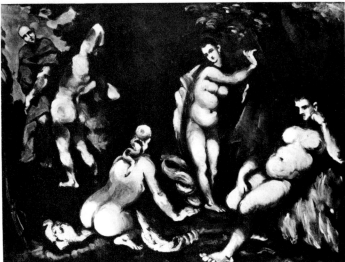

Top: *Boy with a Skull* (pl. 8). 1892–94. Venturi 679
Oil on canvas, 51⅛ x 38⅛ in (130 x 97 cm)
© The Barnes Foundation, Merion, Pa.

Above: *The Temptation of St. Anthony.* c. 1870. Venturi 103
Oil on canvas, 21¼ x 28¾ in (54 x 73 cm)
Private collection, Switzerland

increasingly resigned and melancholy artist, its origins must be sought much earlier in his work. It first appears in the sixties in the morbid image of the repentant Magdalen brooding over a skull (Venturi 86), perhaps inspired by Domenico Feti's picture of the same subject in the Louvre.[31] A few years later it recurs in the gloomy central figure, supposedly Cézanne himself, in *The Idyll* (Venturi 104), whose source was evidently the corresponding figure in Delacroix's *Death of Sardanapalus,* a work Cézanne admired and copied at that time.[32] It occurs again about 1870 in the heavy nude who sits somewhat apart from the principal action in the *Temptation of St. Anthony* (Venturi 103) and seems to brood on its erotic or ascetic meaning; and again it is based on a figure by Delacroix, the imaginary portrait of Michelangelo seated in his studio in a mood of frustration and despair.[33] Thus the posture carries for Cézanne from the beginning a burden of romantic pathos and private guilt that represents an essential side of his artistic personality, one that resurfaces, after the Impressionist and constructive periods of the seventies and eighties, in such deeply melancholy images as the *Young Italian Girl* and the *Boy with a Skull.*

In the latter Cézanne takes up the traditional theme of youth poignantly contemplating death,[34] and though his model is an anonymous peasant, he invests the image with a profoundly personal significance. According to Gasquet, "He loved that canvas, it was one of the rare ones that he spoke about occasionally, after having finished it."[35] There seems little doubt that, like his later still lifes with skulls, the *Boy with a Skull* reflects Cézanne's growing sense of the imminence of death. The thought seems to have haunted him even in his middle years: in 1885 he wrote to Zola, "I shall leave this world before you," and in 1891 he informed Alexis, "I feel that I have only a few days left on earth."[36] Not surprisingly, it was accompanied by a renewed interest in religion; in fact his remark to Alexis occurred in a justification for his return to the Church: "It is fear. . . . I believe I shall survive and do not want to risk roasting *in aeternum.*" An awareness of religious values is also seen a few years later in the *Old Woman with a Rosary* and perhaps still later in the landscapes in which a church or church tower figures prominently (e.g., pl. 112 and Venturi 1531). Yet if Cézanne's conversion and subsequent practice were deeply personal, they also belonged to that pervasive revival of religion, and of mysticism and spirituality in general, which characterized French culture in the late nineteenth century and manifested itself in the conversions, among many others, of Verlaine and Huysmans, writers with whom Cézanne was acquainted.[37]

In the background of two of the *Smokers,* parts of other paintings by Cézanne appear: in the Moscow version (Venturi 688), it is the left side of the slightly earlier portrait of Mme Cézanne (Venturi 528), a human fragment, like that of Michelangelo's *Moses* in Delacroix's imaginary portrait of him; in the Leningrad version (Venturi 686), it is the left side of a still life painted twenty years earlier (Venturi 71), positioned in such a way that the vase and bottle shown in it appear to be resting on

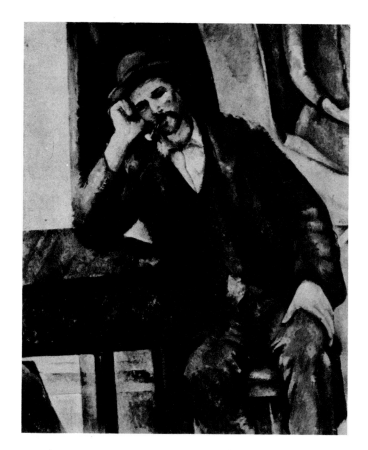

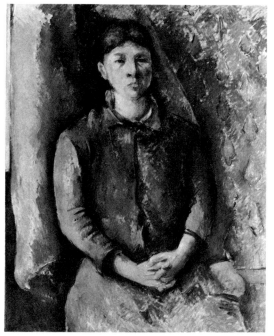

Left: *Smoker.* 1890–92. Venturi 688
Oil on canvas, 36¼ x 28¾ in (92 x 73 cm)
The Hermitage Museum, Leningrad

Above: *Portrait of Mme Cézanne.* c. 1885. Venturi 528
Oil on canvas, 39¾ x 32 in (100.1 x 81.3 cm)
Detroit Institute of Arts, bequest of Robert H. Tannahill

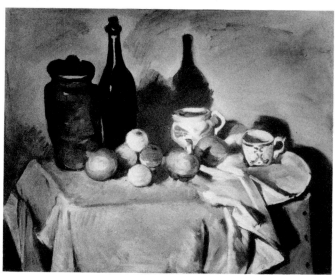

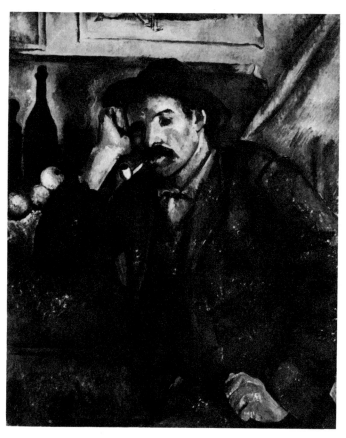

Above: *Still Life with Bottle.* 1869–70. Venturi 71
Oil on canvas, 25¼ x 31½ in (64 x 80 cm)
Nationalgalerie, Berlin

Right: *Smoker.* 1890–92. Venturi 686
Oil on canvas, 36¼ x 28¾ in (92 x 73 cm)
Pushkin Museum of Fine Arts, Moscow

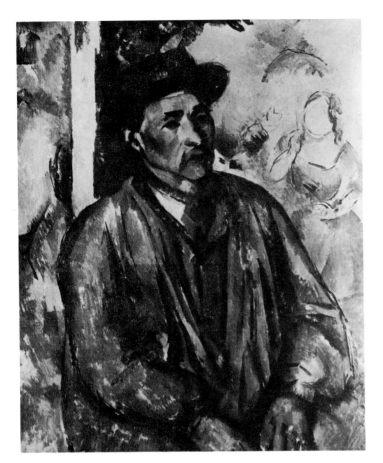

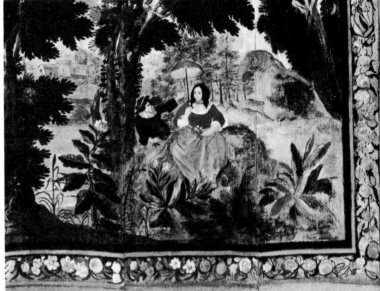

Left: *Peasant with a Blue Blouse* (pl. 10). 1890–92. Venturi 687
Oil on canvas, 31⅞ x 25⅝ in (81 x 65 cm)
Private collection, Detroit

Above: Detail, *The Environs of Aix-en-Provence*. 1858–60. Venturi 3
Painted screen, c. 60 x 80 in (c. 150 x 200 cm)
Wally Findlay Galleries, New York

the "real" table placed before it in the *Smoker*.[38] Almost literally, then, Cézanne incorporates the earlier picture and affirms its continuity with his recent work, despite the great changes his art has undergone in the interim. A motif with a long history in European art, the picture within the picture was especially popular in the late nineteenth century, both as an iconographic and as a structural device. As such it occurred in works that Cézanne certainly knew, such as Pissarro's portrait of him and Manet's of Zola,[39] and also in some of his own works of the mid-seventies, notably a self-portrait (Venturi 288) with a Guillaumin landscape in the background and a still life (Venturi 494) with a Pissarro landscape.[40] But as a pictorial motif extensively and ingeniously employed, it is characteristic of Cézanne's art only in the nineties, and is one measure of its greater complexity in that period. One of the *Cardplayers* (Venturi 560) contains an unidentified painting in the background, and two of the others (Venturi 557, 558) a window view rendered so ambiguously as to be interpretable as a landscape. In the *Peasant with a Blue Blouse,* part of the lower right corner of Cézanne's earliest work, a screen painted about 1858–60 in collaboration with Zola (Venturi 1–3), appears at the right, its image of a woman with a parasol occurring close enough to the peasant to suggest a deliberate juxtaposition of her Rococo elegance and his rustic simplicity; the woman and her lover are in fact based on a Lancret print of couples dallying in the countryside.[41]

Portions of the same screen, which must have occupied a prominent place in Cézanne's studio, also occur in the background of several still lifes in the nineties.

In other still lifes, we shall see, a cast of a statuette plays an important part. A small sculpture, or a cast of one, also figures in the portrait of Geffroy; intercepted by the left edge of the frame, it stands on his desk before him, its bent arms echoing his own. Since Geffroy himself describes it as a plaster by Rodin, it can be identified as his *Pomona,* modeled about 1886.[42] And since Cézanne had met Rodin in the presence of Geffroy in 1894, shortly before undertaking the portrait,[43] its presence can probably be understood as an allusion to the sculptor as a mutual friend.

The tendency toward a somber or muted coloring, seen in the portrait of Geffroy and other works of the mid-nineties, reaches a climax in the portrait of Ambroise Vollard (pl. 4), painted in the fall of 1899.[44] Dominated by browns ranging from near-black to dull orange and by smaller areas of blue, violet, and green, it is a remarkably dark, almost monochromatic harmony, which enhances the effect of solemn introspection conveyed by the figure's rigidly frontal, centralized placement and its static pose with one leg crossed over the other and the hands folded in the lap. Paradoxically, the iridescent bluish-white shirt front, the one area Cézanne considered satisfactory after 115 sittings,[45] and the intriguing shapes in the background, probably representing a

window view but so abstractly as to forecast Motherwell's Spanish Elegies, seem more compelling than the heavily repainted face. Singularly inexpressive, and sharply separated from the hair and beard, it is almost literally a mask and says little about Vollard's colorful and crafty personality—far less than Bonnard's etched portrait, for example, or even Picasso's Analytic Cubist one, though the latter was undoubtedly influenced by Cézanne's.[46] To what extent were the Baroque features of Cézanne's picture, the resonant brown, black, and white tones, the mysterious, glowing light, inspired by works he had studied in the Louvre, such as Rembrandt's *Supper at Emmaus* or those by Velázquez that he maintained he had come to Paris for at just this time?[47] Was it these that he went to the museum daily to examine and copy, even insisting to Vollard that "if the copy I'm making at the Louvre turns out well, perhaps I will be able tomorrow to find the exact tone to cover up those spots [in the portrait]"?[48] Or was it to sharpen his perception of form by "drawing after statues, ancient ones or ones by Puget," that he went there, as Maurice Denis reports?[49] The questions remain unanswered, yet the necessity of posing them is in itself revealing of the dialogue with older art that was an essential part of Cézanne's creative process.

Brown, black, tan, and white, here combined with gray-green, violet, and blue, also constitute the color schemes of both versions of the *Man with Folded Arms* (pls. 12, 13), which have likewise been dated about 1899.[50] Again the figure is posed in a remarkably simple, almost naïve manner, centralized, symmetrical, and frontal, but now the turned head and especially the twisted features and hairline, marked by wavy lines slanting in opposite directions, impart a sense of restlessness and inner tension. They are also more expressive of a kind of peasant cunning, and indeed the subject probably was a farm worker at the Jas de Bouffan, like those who posed for the *Smokers* and *Cardplayers;* there is no evidence that he was a clockmaker, though the pictures sometimes bear that title.[51] Yet this restlessness is contradicted by the immobility and self-constraint implied by the figure's folded arms. Like the head resting on the hand, it is a recurrent motif in Cézanne's work, especially in his last years.

The motif appears in the early nineties in the standing spectator of the larger *Cardplayers* and in a study for the same (Venturi 563), where he is shown half-length, like the so-called *Clockmaker.* It appears again in a more remarkable form in the picture of a peasant standing at such full length, in so austere a setting (pl. 18), that his narrow figure, placed directly on the central axis and extending from the upper edge to the lower, forms a vertical column of architectural severity. Although sometimes linked in older art with idleness or obstinacy, the crossed arms here suggest a melancholy resignation, as they do in images of male saints by painters like Le Sueur and Restout;[52] and as such they already occur in Cézanne's work in the sixties, notably in the portrait of Uncle Dominique as a monk (Venturi 72) and the servant in the background of *Déjeuner sur l'herbe* (Venturi 107). As a gesture of abnegation, they are related in feeling to that of the hand supporting the head; as a posture of self-constraint, to that of the legs crossed with the hands folded over them in the lap. The latter, which we have already seen in the portrait of Vollard, also occurs in two pictures of a seated peasant (Venturi 691, 712), probably painted in 1898–1900, and in three later portraits of Cézanne's gardener Vallier, to which

Far left: Auguste Rodin. *Pomona.* c. 1886
Plaster, 24 in (61 cm) high
Musée Rodin, Paris

Left: Pierre Bonnard
Portrait of Ambroise Vollard. c. 1914
Etching, 14 x 9½ in (35.5 x 24 cm)
The Museum of Modern Art, New York

we shall return. These further resemble the Vollard portrait in their strict frontality and symmetry, their centralized positions, and their imposing, almost iconic presence. Yet if Cézanne can embody in these simple figures the dignity and restraint that are so characteristic of his own behavior, it is because they represent for him, despite their humble social status, an unassuming simplicity and natural nobility which he admires and with which he can identify the finest qualities in himself.[53] They were congenial human types, not merely available models, and he lamented their disappearance from modern society: "Look at the old café proprietor seated before his doorway," he told a visitor in 1902. "What style!"[54]

Yet he was also attracted on occasion by distinctly bourgeois types in rather fancy dress; witness the many portraits of his wife wearing the latest fashion and the two portraits of unidentified women, possibly his sisters, in an elegant costume with wide lapels and puffed sleeves and a blue hat adorned with flowers. The older woman (pl. 20) holds a small, no doubt pious, book and has an earnest, almost dour look; the younger one (pl. 19) rests one arm on a tapestry-covered table and has a tenderly sad and serious expression still more out of keeping with her setting and attire. Ultimately, however, the interest in both portraits resides in the complexity of the color modulations, ranging from black through deep blue to purple and green, that Cézanne can discover in the brilliant blue costume. Characteristically, an object of feminine charm becomes one of artistic delectation. Both portraits were probably painted about 1900–02, yet in one the figure is frontal, strongly outlined, and stands out as a lighter form against a dark background, while in the other it is turned three-quarters into depth and merges with, or seems to emerge mysteriously from, its more shadowy setting. Here, as in many seventeenth-century portraits, the head and hands alone are strongly lit and much of the figure remains in shadow. It is perhaps the most fully Baroque in style of Cézanne's late portraits. Yet such is the complexity of his art that at about the same time or slightly earlier—1898 and 1901 are the dates generally given[55]—he could also paint a self-portrait (pl. 5) reminiscent of the early nineties in its coloring: the deep blue coat and cap silhouetted against the atmospheric blue background, the contrasting red area at the lower right, and the accents of white in the moustache, beard, and collar. But in addition to Cézanne's apparent age, close to that in a lithograph of 1897–98 (Venturi 1158),[56] the intricate play of color planes, including unexpected touches of violet, crimson, and orange in the modeling of the face, confirms the later dating.

The latest and grandest of all Cézanne's portraits are those of his gardener Vallier, one of which he was working on only days before his death in October 1906.[57] The series was begun at least as early as 1902, since the writer Jules Borély saw in Cézanne's studio in July of that year what must be the version now in Washington (pl. 22).[58] It was still in progress in January 1905, when the painters Rivière and Schnerb saw it and noted the "great importance" he attached to it: "If I succeed with this

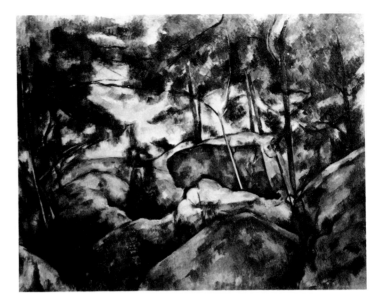

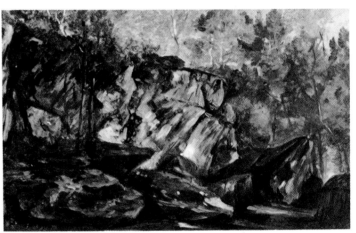

Top: *Rocks in the Forest* (pl. 67). c. 1894. Venturi 673
Oil on canvas, 28¾ x 36¼ in (73 x 92.1 cm)
The Metropolitan Museum of Art, New York,
H. O. Havemeyer Collection

Above: Paul Huet. *Rocks in the Forest of Fontainebleau.* c. 1858
Oil on canvas, 13 x 21⅝ in (32.9 x 50.5 cm)
Whereabouts unknown

fellow," he said, "it will mean that the theory was correct."[59] Its heavily reworked surface, the paint standing out in ridges where revisions were made, is evidence of this long gestation, as is its exceptional darkness and mat texture. The black costume, dark brown wall, and deep green foliage, relieved only by the yellow-brown head and hands, create an airless, almost impenetrable gloom unparalleled in the other late portraits. Beside it, the ultimate version (pl. 26) is a triumph of luminous color, in which the head and hat stand forth in vivid orange and yellow-green against the dark blue, purple, and green background, and the costume and beard are enlivened by paler tints of the same colors, applied with an exuberant sweep that makes even the most neutral passages seem to pulsate. This is still more evident

in the watercolor study (pl. 27), where the large, untouched areas of white in the figure flash against the densely overlapping planes of blue and crimson behind it and, at their edges, gradually absorb their chromatic energy. Yet, despite the agitated execution and ceaseless color modulations, there is in this quietly seated figure an imposing dignity, like that in Renaissance portraits, but without reference to the subject's social status or personal achievements. This inherent nobility is felt not only in his serene expression, but in his monumental proportions, which allow him to fill his space impressively.[60] In other portraits contemporary with these, Vallier's figure is smaller in relation to its setting, and the latter is described more explicitly as a garden with a house and trees some distance away (pls. 25, 28). In these he is still shown seated, but full-length and frontal, with his legs crossed in the familiar manner and his features rendered still more summarily. No longer portraits in the traditional sense, they are images of a man wholly absorbed into his natural environment and entirely at peace with it, and as such they express more eloquently than any other late works the profoundly spiritual vision of Cézanne's last years.

III

IT HAS GENERALLY BEEN ASSUMED that Cézanne's style developed uniformly in all the types of subject matter he treated.[61] Yet it is unlikely that an artist as subtly responsive as he would paint in the same manner whether he was working from a single figure or a panoramic landscape, observing a still life or inventing a composition of bathers. Thus the development of his landscapes cannot be made to coincide with that of his portraits and figures, though there are points at which the two converge.

One of these occurs at the very beginning of the late period, in the *Rocks in the Forest* (pl. 67), probably painted at Fontainebleau in 1894, when Cézanne spent the summer there.[62] Both in its coloring, dominated by purple, deep green and blue, with smaller notes of orange-brown and yellow, and in its fine, densely woven, parallel brushstrokes, it resembles closely the portrait of Geffroy (Venturi 692) and others of that period. If anything, its mood is still more somber and hermetic, owing to the pervasive gray and purple tonality, the subdued light, muted even in the sky, and above all the oppressive site, with its foreground blocked by large boulders and its distance by trees so closely overlapping as to exclude almost all space and air. The interior of the Fontainebleau forest, enclosed by rocks and tall trees as it is here, had often been represented by Corot, Rousseau, and other Barbizon painters, but in a more human or bucolic vein, with shepherds, grazing flocks, easily traversed spaces, and areas of luminous sky.[63] Even a view largely filled with boulders, cliffs, and trees, such as Paul Huet's, is warmer in coloring than Cézanne's and allows easier access into its depths, thus humanizing its effect; for all their steepness, Huet's rocks lack the massive, brooding character of Cézanne's and their intimations of violence and despair.[64] This taste for remote,

inhospitable corners of nature, in which his deepest, most troubling feelings could be projected, is as typical of Cézanne's last years as the taste for open and attractive ones is earlier. In *Mountains in Provence* (Venturi 491) of about 1887, for example, the foreground is likewise closed entirely by tiers of heavy rocks, but they are made less oppressive by their smaller scale and warm gray and rose coloring, and above them the trees, houses, and distant fields, bathed in the same roseate light, lead calmly to the

Below: *Large Pine.* c. 1885. Venturi 459
Oil on canvas, 31⅞ x 39⅜ in (81 x 100 cm)
Private collection, Paris

Bottom: *Large Pine.* 1895–97. Venturi 458
Oil on canvas, 28¾ x 36¼ in (73 x 92 cm)
Pushkin Museum of Fine Arts, Moscow

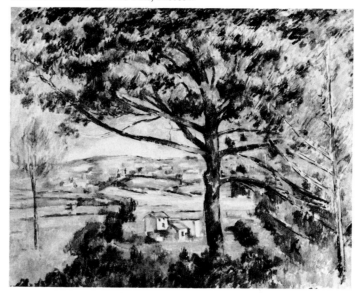

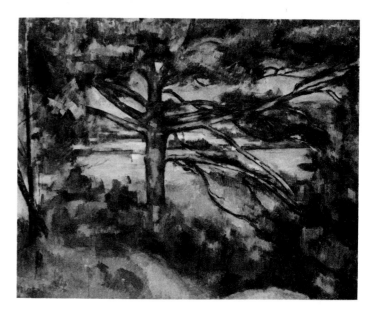

open sky. The change in vision becomes still more apparent in comparing two views of the same motif, a tall pine with spreading branches that Cézanne painted in the mid-eighties and again in the late nineties. In both works, the heavy foliage largely fills the surface, but in the earlier one (Venturi 459) it is more attenuated and opens up at the left to allow a view of the distant valley and sky, while in the later one (Venturi 458) its masses of deep green, blue-black, and purple, together with the dark red earth, close off the views into depth on all four sides.[65]

In the abandoned quarry called Bibémus, east of Aix, Cézanne found a landscape of colossal, jagged forms and overgrown spaces, still more solitary and inhospitable than that of Fontainebleau. Most of his pictures of this site can be dated between November 1895 and September 1899, the period in which he rented a hut there to store his painting materials.[66] They, too, are composed of steeply vertical forms piled on each other so oppressively that they provide little room for the sky above or for the spectator to gain access below; on the contrary, his vision is blocked by the massive stone walls and frustrated by their crowded and confused shapes (pls. 31, 35, 38). Clearly the unused quarry, remote and overgrown with vegetation, yet displaying in places the geometric forms of blocks and steps once cut by man, held a great appeal for the aged Cézanne, who could rediscover there in the long silence both the constructive and the violent in his own nature. He need not, of course, have been conscious of this, but that he was sensitive to the human aspects of landscape is evident from his comment on one of Zola's novels: ". . . the places, through their descriptions, are impregnated with the passion that moves the characters. . . . They seem to become animated, to participate as it were in the sufferings of the living beings."[67] In the burning heat and brilliant light of the Bibémus quarry, he must indeed have felt nature participate in his own sufferings, and Venturi is right in comparing his views of it to Dante's vision of the Inferno[68]—a tormented landscape supposedly inspired by the fantastic rock formations at Les Baux, not far from Aix.

For Bibémus, unlike Fontainebleau, is a Provençal motif, and Cézanne renders it with a coloristic intensity unknown in his Northern landscapes. Even in their natural state the rocks are a reddish orange, the foliage a vivid yellow-green, the sky a deep blue, and the "violent contrast" between them has struck one observer as giving the site a "fantastic aspect."[69] Yet Cézanne heightens these already intense hues, so that the cliff in the *Red Rock* (pl. 33) becomes an unbroken expanse of orange and yellow ocher, jutting out against the brilliant blue sky, and the vegetation becomes, by contrast, a vibrating field of emerald and yellow-green, with surprising touches of red, purple, and black. Here, as in other views of the quarry (e.g., Venturi 781), the paint is applied in thin, parallel strokes, increasing the effect of optical vibration and of dry, hot air reverberating from the stone surface. The technique as such is not new in Cézanne's work, but its use as a vehicle of pulsating color is. In fact, so consistent a juxtaposition of saturated, complementary colors is unparal-

leled in his earlier landscapes, even those painted in Provence. Similar changes in color and execution occur in the work of other French artists at this time or slightly earlier, and are related to the general shift from Impressionism to Post-Impressionism in French painting in the late eighties and nineties. They are already evident, though, in the more subdued form characteristic of Cézanne's style about 1895, in one of the earliest Bibémus pictures (pl. 35), where orange, reddish brown, and purple in the rocks contrast with deep blue, green, and yellow-green in the vegetation. Here the expressively distorted space of the later versions is also adumbrated in the tree that seems to be growing laterally, causing the design to appear unstable or even inverted.

The appeal for Cézanne of the abandoned quarry, a site once diligently worked by man and now reclaimed by irresistible natural forces, reflects a taste already found a few years earlier in the *House with Cracked Walls* (Venturi 657). It is an image of imminent destruction unimaginable in his classical landscapes of the eighties, although it might have appeared in the romantic ones of the sixties. The theme is in fact a romantic one and as such occurs in a text that Cézanne may well have read, since it was translated by Baudelaire, one of his favorite authors. This is Edgar Allan Poe's tale "The Fall of the House of Usher," where

House with Cracked Walls. 1892–94. Venturi 657
Oil on canvas, 31⅞ x 25⅝ in (81 x 65.1 cm)
Collection Mrs. Enid A. Haupt, New York

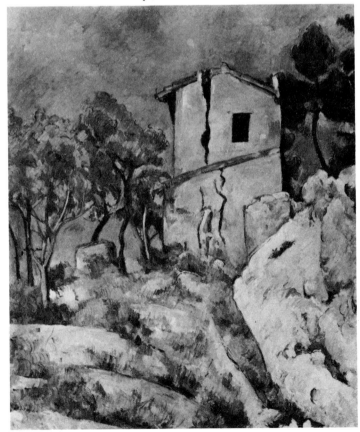

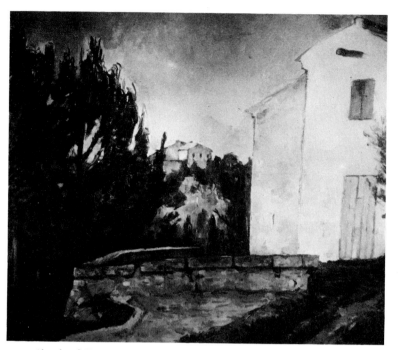

Abandoned House. 1877–80. Venturi 659
Oil on canvas, 19¾ x 24 in (50.2 x 61 cm)
Private collection, Boston

in the climactic scene "that once barely-discernible fissure . . .
extending from the roof of the building, in a zigzag direction,
to the base . . . rapidly widened . . . and the mighty walls came
rushing asunder."[70] Much the same haunted atmosphere per-
vades the somewhat earlier *Abandoned House* (Venturi 659),
where the blank walls and shuttered openings, even the awk-
ward placement and odd slant of the building, create disturbing
effects that, in André Breton's view, make it the scene of a
potential crime. It is for him another of those morbid "subjects
with halos" that he finds in Cézanne's work, one distinctly
reminiscent of the still earlier *House of the Hanged Man* (Venturi
133).[71] The latter, although painted in 1872–73, was still in
Cézanne's mind much later, as is apparent from his decision to
exhibit it at the Exposition Universelle in 1889. On that occa-
sion, it is true, he implied that the rather romantic title was not
his own.[72] Yet he had employed that title in showing the
picture in the Impressionist exhibition of 1874, and his willing-
ness to use an image of a hanged man as a personal emblem on
an etching of that period (Venturi 1159), in effect identifying
himself as the Master of the House of the Hanged Man, shows
his awareness of its morbid connotation.[73] And just as that
landscape, painted at the beginning of his Impressionist period,
reveals the survival of his still earlier, romantic obsession with
themes of violence and death, so the *Abandoned House* and *House
with Cracked Walls* hint at the reemergence of such feelings in
the old Cézanne, after being banished from his more objective
and impersonal art in the intervening years.

Another such "subject with a halo" is the so-called Château

Noir, a mid-nineteenth-century country house near the Bibémus
quarry, which Cézanne painted often from about 1895 on.[74] The
subject of many local legends, it had once been known as the
Château du Diable, presumably because its former owner's al-
chemical demonstrations had frightened his provincial neighbors
into imagining it was inhabited by the devil. (The name seems
to have been popular, for it was also given to another house
outside Aix.)[75] Visually, too, the Château Noir must have had a
romantic appeal for Cézanne, not for its color, which was the
yellow-orange of the Bibémus stone rather than black, but for its
tall pointed windows of Gothic inspiration and its unfinished
portions, which gave it the look of an abandoned ruin. In some
of his views (pls. 54, 57), it is seen through the densely overlap-
ping branches of surrounding trees, their dark green and black
enhancing its glowing orange tones, their complex, tangled
shapes adding a note of agitated movement; in the deep orange
facade, outlined in deep blue, the lighter blue windows shine
mysteriously, and the Indian red door sounds a single note of
passionateness. This restless, dramatic treatment of the sur-
rounding trees is altogether different from their use as a struc-
tural device, a screen framing a distant view, in landscapes of the
mid-eighties (Venturi 425, 479, 480), though it is foreshadowed
in one version of Mont Sainte-Victoire with a pine tree (Venturi
454). By the late nineties, when these views of the Château Noir
were painted, the interaction of branches and building has
become so intricate that the whole surface is crisscrossed by
brushstrokes moving in conflicting directions. The same taste
for tangles of spiky lines appears in the drawing of the trees in a

House of the Hanged Man. c. 1873. Venturi 133
Oil on canvas, 21⅞ x 26¼ in (55.5 x 66.5 cm)
Musée du Louvre, Galerie du Jeu de Paume, Paris

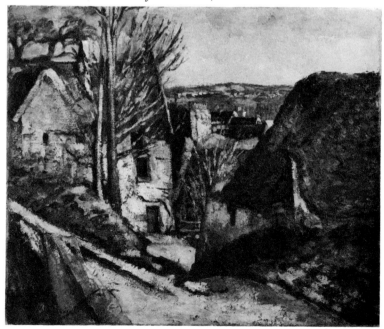

late picture of Mont Sainte-Victoire (pl. 115) and in that of the onion stems in a contemporary still life (pl. 148).

Unlike the motifs Cézanne had painted in previous decades west and south of Aix—at the Jas de Bouffan and Gardanne, and still farther south at L'Estaque—the Château Noir, the Bibémus quarry, and most of those he chose in the last decade were in a region east of the city, halfway toward the village of Le Tholonet.[76] It was a more remote and rugged terrain, nearer the base of Mont Sainte-Victoire, with fewer dwellings and wilder vegetation, one which he must have felt mirrored his own austere condition. It is indeed remarkable how often he returned to the same few sites; unlike Monet and Renoir, who traveled widely in search of the picturesque, he was deeply aware of "the links which bind me to this old native soil" and once admitted, "Were it not that I am deeply in love with the landscape of my country, I should not be here."[77]

In addition to the house, the large estate of the Château Noir, solitary and overgrown with heavy foliage, strewn with cut stones never used to complete its creator's grandiose scheme, offered Cézanne many congenial subjects in the late nineties. Pictorially, the circular form of an abandoned grinding wheel, the cylindrical form of a wall, the long rectangular forms of masonry blocks provided an interesting foil to the roughness and irregularity of the rocks, trees, and foliage (pls. 47, 48, 53). With great subtlety he distinguishes their different shapes and textures, arranging them, as it were, on a continuous scale from the geometric to the organic and forcing us to recognize their similarities as well as their differences. Thus the tree trunk begins to look as cylindrical as the well, and the cut stone block as angular and roughhewn as the boulder; and all are painted with the same flickering brushstroke and pervaded with the same brown and gray, orange and green tones. But the appeal of such a motif was more than purely pictorial: in the shadowy forest interior Cézanne found an intimate, solitary world for meditation, and in the almost chaotic profusion of forms, from which an order half natural and half human gradually emerges, a metaphor of his own mental process.

The rocky ridges and boulders in the forest of the Château Noir may have seemed human in another sense as well. It has long been recognized that they form "bizarre groups, profound grottoes, strange profiles,"[78] but not that Cézanne enhanced these physiognomic suggestions in representing them. We cannot help sensing, especially in the watercolors of rock cliffs (pls. 42, 43, 45), the semblance of a human form, a female body half-hidden in shadow, yet emerging into light in voluptuously rounded shapes. Nor can we forget, in observing this metamorphosis, that Cézanne admired in the Louvre Poussin's poetic rendering of the myth of Echo and Narcissus, in which the unhappy nymph is shown merging with the rock behind her. In the same way, the rocks in the lowest zone of the Fontainebleau forest interior "have a strange organic quality—a visceral effect—in their curved and congested forms," and we perceive "a vague human profile in the lower right and physiognomic

intimations—a reclining head—in the brighter central rock with scalloped edge."[79] A similarly heightened vision of the rocks at Fontainebleau occurs in the Goncourts' novel of artistic life, *Manette Salomon,* which Cézanne is reported to have admired; the protagonist Coriolis, wandering through the forest, comes upon "enormous sandstones, which have taken on the profiles of imagined animals, the silhouettes of Assyrian lions, the stretchings of manatees on a promontory . . . the skulls of mammoths with their immense eye sockets . . ."[80] But here the organic analogies are consciously contrived to hint at evolution, whereas in Cézanne they are unconscious projections of an emotionally charged vision, like the faces that appear so mysteriously in the clouds and earth around some of his earlier bathers.[81]

The somber and fantastic aspects of Cézanne's late landscapes are not, however, the only ones, or even the most important as far as he was concerned. It was the serene and luminous side, "the vibrating sensations reflected by this good soil of Provence," that he stressed in his letters, though partly because he was responding in each instance to Gasquet's lyrical exaltation of their native land.[82] Opposite the oppressive forest interiors discussed previously may be set the *Brook in a Forest* (pl. 70) of 1898–1900, an image of calm and radiant joy in the contemplation of nature, evoked here by the freshness of coloring, the deep blue and emerald juxtaposed to orange, pale ocher, and touches of crimson, and above all by the brilliant, flickering movements of Cézanne's brush. Opposite the haunting visions of the Château Noir may be placed the *Colline des Pauvres* (Venturi 660) of 1890–94,[83] where the small buildings, a Jesuit estate, are likewise surrounded by trees, but of a tender green and gently rounded form, echoing the curved hills beyond, and the paint-handling, far from suggesting conflict or struggle, seems effortless and half-transparent, as in a watercolor. Perhaps the outstanding example of this lyrical tendency is *Lake Annecy* (pl. 68), painted during a sojourn at Talloires in the summer of 1896.[84] If the composition, with its massive tree closing one side and its horizon bisecting the surface, is remarkably simple, the coloring is of an enchanting complexity, modulated through infinite variations of green and blue in the foliage and water and contrasted with equally rich tones of yellow, orange, and pink in the mountainside, the château, and their reflections. Here, too, the execution is fluent and confident, and the water is painted in broad, brushy strokes with many areas left untouched, adding their note of spontaneity.

The use of a large tree as a means of framing a scene at one side recurs in two views of Mont Sainte-Victoire: one (Venturi 763) was traditionally dated 1897 in Cézanne's family,[85] and the other (pl. 115) is closely related to it in design. In their measured progression into depth, culminating in the imposing, centered form of the distant peak, they recapitulate the classical vision of this motif in Cézanne's landscapes of the later eighties (Venturi 457, 488), though their coloring is more intense and their handling freer. That it is a truly classical conception is clear from its resemblance to that of Titian, Poussin, and other

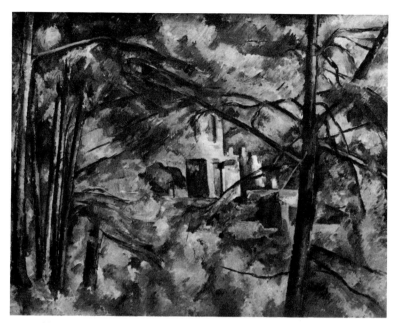

Château Noir (pl. 54). c. 1895. Venturi 667
Oil on canvas, 28¾ x 36¼ in (73 x 92 cm)
Oskar Reinhart Foundation, Winterthur

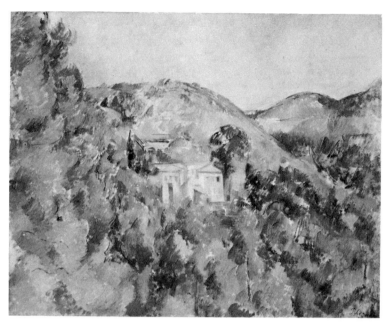

La Colline des Pauvres. 1890–94. Venturi 660
Oil on canvas, 32 x 25⅝ in (81.3 x 65.2 cm)
The Metropolitan Museum of Art, New York, Wolfe Fund

masters in whose landscapes a majestic mountain is likewise silhouetted against the sky and compared to a single, equally isolated tree in the foreground—the one remote, unchanging, and divine in connotation, the other accessible, ever-changing, and humanized.[86] By the end of the nineties, however, this serenely balanced view was replaced by one more romantic in feeling, in which the peak is seen from a closer, lower vantage point that excludes the intervening trees and hills and causes it to loom larger against the sky (pl. 114 and Venturi 664). It becomes a solitary, aspiring form, still heroic but less poised; and appropriately, its crest is now nearer the top edge of the canvas and its silhouette has a more distinct physiognomy, straight on one side and irregularly curved on the other. Intermediate between the two conceptions are several versions in which the traditional dialogue of mountain and tree, of far and near, is still heard, but in a distorted manner, with the tree crowded to one edge, sometimes even the top edge, from which its foliage seems mysteriously suspended (pls. 58, 119).

In the most powerful of these variants (pl. 37), painted about 1898–99, before Cézanne ceased working at the Bibémus quarry, the tree's sinuous trunk is barely visible at the right edge, while the mountain's colossal form fills most of the sky. As a photograph of the site makes clear,[87] Mont Sainte-Victoire appears here much larger than it should, and its silhouette and coloring, far from being blurred and gray, are strongly characterized. Rising in its iridescent pink and blue whiteness above the smaller, more deeply cleft, red and orange cliffs and the still smaller and more numerous trees of vibrant yellow-green, it hovers like a mysterious, divine presence, at once near and unapproachable. Yet it is linked to these intensely colored, up-

ward-striving forms through the repetition of its pale pink and violet tones along the crest of the cliffs and amidst the foliage below, and to the sky behind it through their shared blueness.

In the last landscapes of Mont Sainte-Victoire, painted between 1902 and 1906 from positions near Cézanne's studio on the Chemin des Lauves outside Aix, it is once again a distant form, seen beyond a tree-covered hillside and a broad valley dotted with houses and trees and seeming to rest majestically on the horizon marking their farthest limit. Eight times or more the same simple image recurs, stripped of the compositional complexities of the previous decades, reduced to the elemental earth, mountain, and sky (pls. 120–25, 128–29). And as the variants succeed each other, they become more passionate in execution and more spiritual in content, the peak seeming to embody that striving upward from the darkness of the valley toward the luminous sky in which Cézanne's own religious aspiration can be felt, yet at the same time dissolving in the torrent of energetic brushstrokes, fusing with the air filled with similar strokes all around it.[88] How deeply personal this conception was, despite its seeming simplicity, becomes clearer when it is compared with the many views of the same subject painted by Provençal artists throughout the nineteenth century. For Mont Sainte-Victoire, the most conspicuous landmark of the region, was also a site famous in local history and legend from Roman times on, and inevitably was a popular motif.[89] Most of these earlier views are forgotten today, except perhaps for those by François-Marius Granet, an artist Cézanne is reported to have admired; in Granet's wash drawings we find the same familiar form as in Cézanne's (pl. 138 and Venturi 1018), but not its transcendent power—it appears instead veiled in an atmospheric

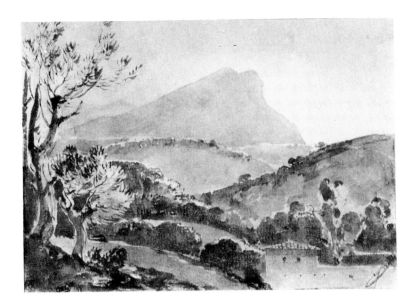

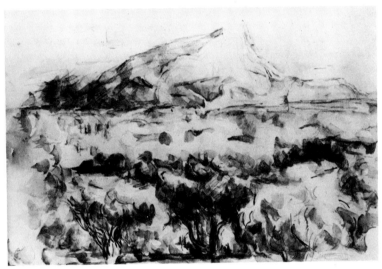

Top: François-Marius Granet. *Mont Sainte-Victoire near Aix.* 1848–49
Pencil and bister wash, 5⅞ x 5½ in (10.5 x 14 cm)
Musée du Louvre, Paris

Above: *Mont Sainte-Victoire Seen from Les Lauves* (pl. 138). 1902–06
Venturi 1030. Pencil and watercolor, 14⅛ x 21⅝ in (36 x 55 cm)
The Tate Gallery, London

vertical strokes. At times, as in a Swiss collector's version of Mont Sainte-Victoire (pl. 123), they are densely woven like the threads in a tapestry; at others, more varied and agitated, as in the Philadelphia version (pl. 122). Given their rudimentary designs, such pictures depend largely on their animated execution and complex color modulations for structural coherence and expressive force. In the Philadelphia picture, for example, long vertical patches of deep green, dark blue, and black in the foreground contrast with smaller, more varied units of bright green, ocher, tan, and rose-orange in the valley, and these in turn are juxtaposed to impetuous, swirling strokes of blue, green, and lavender in the mountain and sky; the whole thus rises in a powerful crescendo, culminating in the mysteriously blue peak. The same style appears in the latest versions of the Château Noir, probably painted about 1904,[93] but, as always in Cézanne, with interesting variations. In the Picasso Estate's version (pl. 59), the heavy foreground foliage is formed of roughly square patches of vertical strokes, the sky of larger blocks with a diagonal drift, and the château of smaller, crisscrossed marks. In a less finished version privately owned (pl. 55), the rhythmic effect of repeated squarish strokes, often diagonally aligned like those in Cézanne's pictures of about 1880, is still more evident and gives the whole a pronounced unity of surface, like the weave in a fabric.[94] The analogy with woven materials, a familiar theme in the literature on Cézanne, was already drawn by his contemporaries: Geffroy was reminded of "the muted beauty of tapestry," Osthaus of wall hangings in the Cathedral of Aix, and Denis of Persian carpets.[95]

The origin of this distinctive handling is seen in certain works of the late nineties, such as the *Turning Road at Montgeroult* (pl. 69), where, in contrast to the smooth, firmly outlined forms of the road and buildings, the shapeless masses of foliage are painted in large patches of roughly textured strokes. Within a few years such patches became the characteristic units of Cézanne's structure, turning the surfaces of pictures like the *Park of the Château Noir* (pl. 50) and the *Curving Road in the Woods* (pl. 75) into tapestries of shimmering colors, precisely adjusted in tone and mysteriously resonant, or building up heavily textured areas in contrast to thinly washed or partly unpainted ones, with each stroke remaining perfectly legible, as in the *Forest Interior in Provence* (pl. 73) and the *Houses on a Hill* (Venturi 1528). In some of the latest works, such as the *Garden at Les Lauves* (pl. 79) of 1906, this painterly application of color so completely determines the pictorial structure that composition in the traditional sense is reduced to an elementary schema of horizontal lines, which divide the surface into three zones—the hillside, terminating in a low wall; the valley beyond, broken by houses and clumps of trees; and the sky above, with a mass of foliage descending from a tree outside the visual field. Definition of form and space is achieved almost entirely by the small patches of color, which shift from yellow-green and reddish purple, through orange and green, to violet, blue, and rose, becoming increasingly cool in successive layers of depth. In their

blue or bister, and nestled amid rolling hills, Provençal villas, and gardens.[90] Yet the visionary intensity of Cézanne's conception has nothing to do with religion as such: he ignores the monumental iron cross erected on the summit after the Franco-Prussian War;[91] and unlike his watercolors showing the tower of the Aix cathedral in the distance (pls. 98–100), these contain no signs of conventional belief;[92] their spirituality is inherent in their pictorial vision and means.

It is remarkable how radically those means are transformed in Cézanne's last years. The single fine brushstroke, long the basic unit in his creation of form, becomes a mass of closely packed

energetic rhythms, predominantly vertical, but more irregular and curved in the sky, they animate the surface with a passionate intensity, a visible equivalent of the artist's exaltation. It is also felt in the latest of the Mont Sainte-Victoire series and in the *Cabanon de Jourdan* (pl. 83), where strokes of pulsing color, applied with extraordinary freedom and conviction, build up an image of the world in continual flux, the land merging with the trees, the trees with the sky; even the solid mass of the building is inundated by their dynamic rhythms. Yet out of the welter of vivid, throbbing colors there emerges a clear contrast between the architectural and the natural, the stable and the shifting, in which an imposing sense of order reigns.

In Cézanne's late watercolors we discover other aspects of his achievement as a landscape painter. Many represent the same subjects as the oils and are conceived as pictures rather than studies, even if not entirely filled out to the edges; yet their partly uncovered surfaces affect us differently than the unfinished oils and convey a different feeling for nature. Since their color washes remain transparent no matter how often they overlap, allowing the paper to shine through, its whiteness enhances the luminosity of the already high-keyed greens, blues, crimsons, and yellows so characteristic of the late landscape watercolors, imbuing them with a joyful radiance unmatched in the corresponding oils. Rendered in transparent wash, the Mont Sainte-Victoire becomes a weightless, hovering form, suffused with light like the sky (Venturi 1018), and even a somber forest interior is crisscrossed with flashes of dazzling color (pl. 94). In the lighter, more easily and swiftly handled medium, Cézanne can also study natural phenomena that would hardly constitute motifs of sufficient importance for the more ambitious medium of oils—small, almost insignificant phenomena that appeal to the tender and lyrical sides of his personality.[96] In watercolor he is content to focus on a single branch extending over a brook (Venturi 1065), on a rose emerging from a profusion of foliage (pl. 169), or a pattern of tendrils and leaves so delicately silhouetted that it suggests the stillness of Oriental art (pl. 168). Moreover, the transparent, liquid color allows him to explore the immaterial and evanescent in nature, the stirring of branches in a breeze (Venturi 1553), the reflections of foliage in a lake (pl. 87)[97]—qualities that he rarely tries to capture in the more robust medium and that we do not normally associate with his art.

IV

IN GENERAL, THE LATE STILL LIFES of Cézanne are more difficult to date, and thus to place in a meaningful sequence, than the landscapes and portraits. Painted in the studio, independently of natural sites and human models, they can rarely be correlated with his known movements and contacts. And if the recurrence of certain objects enables us at times to form groups of related works, it soon becomes evident for other reasons that they were painted over a period of many years, both in Paris and Aix. For contrary to what is sometimes assumed, certain objects traveled back and forth with the artist, and the same floral drapery or Oriental carpet can be found in still lifes painted in both cities.[98] Other objects, such as tables and a painted screen, were of course less portable and can be assumed to have remained in Aix, where they can still be seen in Cézanne's studio.[99] These enable us to localize, if not date precisely, some groups of still lifes, but on the whole their compositions and coloring provide surer guides.

In the *Still Life with Apples and Oranges* (pl. 139), we find the same vivid tones of purple, yellow, red, and green, contrasted in the same manner with a purple-brown background and a white cloth vibrant with many tints, as in the *Young Italian Girl* (pl. 9) painted in 1896–97. In both works, moreover, the table is covered with an Oriental rug and tilted upward steeply, and the principal elements slant from lower left to upper right. There are also spatial and coloristic affinities between the still life and the portraits of Geffroy and Gasquet (pls. 1, 2), which confirm its dating to about 1896. It is the first of six pictures in which the same white pitcher with floral decoration and the same floral drapery (at the right side—the rug is at the left) occur together with apples and other fruit; some also have other objects in common; all were most likely painted between 1896 and 1899, when Cézanne settled definitively in Aix and took up new still-life themes.[100] Their thematic unity is indeed striking: all are more sumptuous in feeling and more symphonic in design than the still lifes painted earlier and later. They mark a material and sensual culmination, followed by the simpler, often stark and tragic works of the last years.

Through close comparisons, it is possible to determine the probable order in which the six variants were painted. If the Louvre version (pl. 139) was first, the more finished of the two in the Barnes Foundation (pl. 141) was very likely second: in it the pitcher and compotier still occupy the same positions, the table is still slanted, though in the opposite direction, and the floral drapery still appears at the right, though a different one replaces the Oriental rug at the left. Next come the magnificent version in the Hermitage (pl. 140) and the partly unfinished one in the Barnes Foundation (pl. 142), where the pitcher remains in its position but the compotier is replaced by a plate of apples and the floral drapery is moved to the left side; in addition, the table is set parallel to the rear wall, creating a calmer, more stable design. In the Reinhart Foundation's version (pl. 143), which is probably fifth in the series, the plate of apples is still at the left but tilted up, the floral drapery is still behind it but extended onto the table, and for the first time the pitcher is moved to the center. In the last version, in Washington (pl. 144),[101] it is at the left, with the floral drapery still behind it, and its place at the right is occupied by a flower holder whose finely scalloped edge echoes those of the pitcher and the table's apron. Regardless of its position, the pitcher is seen in all six works in a profile view with the handle at the right. It is a naïve or archaic view that older artists such as Chardin, whose still

lifes Cézanne studied in the Louvre,[102] carefully avoided; yet it serves not only to strengthen the pitcher's silhouette against the dark background, but to show its floral decoration to fullest advantage. With these painted flowers, Cézanne draws analogies of shape and color to the "real" fruit placed directly below the pitcher, just as he compares and connects the "real" fruit and the painted leaves behind them in other late still lifes (pls. 149, 152).

When the six variations are seen in this order, a characteristic development in Cézanne's conception of color in the late nineties becomes evident. The splendid, vibrant tones of the Louvre version are gradually replaced by deeper, more inwardly glowing ones, whose effect is more spiritual than material. The change begins to be felt in the subtler play of the orange and yellow fruit against the yellow-tan and blue drapery and the smoky blue wall in the Hermitage version. It is more apparent in the Reinhart version, where the fruit are, if anything, more intensely red and yellow, yet are surrounded by deeply resonant shades of dark brown, mauve, green, and tan in the drapery, table, and wall, so that the contrasts are not so much dramatic as solemn and mysterious. The development reaches a climax in the Washington version, whose warm, deeply glowing tones, harmonized with few strong contrasts—even the nominally white cloth consists largely of rose, mauve, tan, and yellow-green tints— suggest a kind of autumnal or late-afternoon light reminiscent of that in Bellini and Mantegna and a mood of rapt, silent contemplation.

Three still lifes containing a milk pitcher with floral decoration, painted at intervals throughout the nineties, enable us to

Still Life with Pitcher. c. 1890. Venturi 593
Oil on canvas, 29⅞ x 38¼ in (75.9 x 97.2 cm)
Nasjonalgalleriet, Oslo

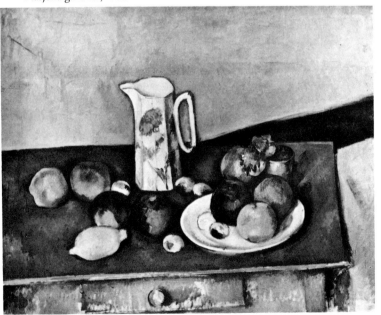

recapitulate and extend earlier the development just traced. In the Oslo version (Venturi 593) of about 1890, the background wall, whose flickering, bluish tone is like the sky in Cézanne's landscapes of this period, provides a foil for the white pitcher silhouetted against it; and the vividly colored apples, oranges, and lemons, clearly conceived as notes on a chromatic scale from blue to red, are no less sharply outlined against the dark blue and brown table. Throughout we encounter a brightness and clarity that are truly classical. In the New York version (pl. 147) of five or six years later, that radiant objectivity yields to a darker, more moody effect: the objects, though still vivid, are more heavily shaded and tend to merge with the shadows behind or beneath them; the background, too, is darker, especially in the center, where brown, purple, and black predominate, and it is more ambiguous spatially, in part because the drapery at the left is somewhat unfinished. In the Washington version (pl. 146) of about 1900, the design is simpler than in either of the others, so simple as to be almost artless: the relatively few objects are aligned laterally and close to the picture plane, and the background is closed by a wall and dark draperies; yet the warm tones of tan, yellow, orange, and red suffused throughout create the kind of mellow, autumnal glow and serenely meditative mood that we have come to associate with such late works.

One of the most complex and intriguing of the later still lifes, the one with a plaster cast of a cupid (pl. 145), is usually dated about 1895; yet it can hardly be contemporary with the Louvre still life and the portraits discussed earlier.[103] Its generally light tonality, dominated by bright blue, red, and white, with larger areas of yellow, tan, gray-green, and gray-blue in attenuated, atmospheric states, is similar to that in the Oslo still life and such genre pictures of the early nineties as the four-figure *Cardplayers* (Venturi 559). Moreover, its spatial design is closely related to that of the *Still Life with Basket* (Venturi 594), which probably dates from about 1890 and in any event cannot be later than 1891–92, when Alexis acquired it.[104] In both works Cézanne experiments with extending his field of vision to include much of the studio in which the still life proper is set, and in the later one he is clearly more successful. Here he integrates foreground and background not only through similar color modulations and the repetition of similar objects—the smaller, nearly monochromatic apple and the painted copy of a cast, a *Flayed Man* attributed to Michelangelo, echo the larger, more vividly colored apples and the "real" cast, of a *Cupid* attributed to Duquesnoy[105]—but through an intricate fitting together of their elements. At the lower left, the onion stem merges with the table leg beneath the blue drapery, though the leg and drapery belong to another picture, the *Still Life with Peppermint Bottle* (Venturi 625), shown leaning against the wall; and the painted drapery in turn merges with the "real" drapery on the table in front of it.[106] Through another visual paradox, the cupid, whose round base harmonizes with the plate and fruit in the extreme foreground, appears to be framed by the vertical

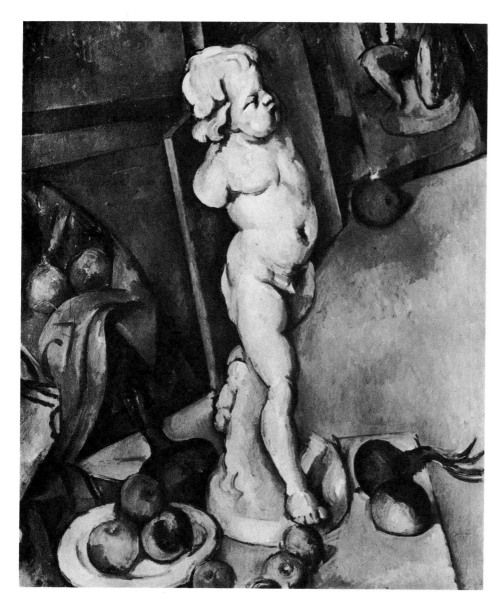

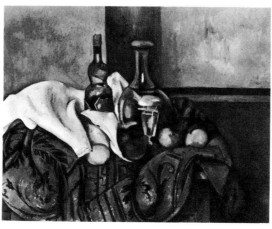

Above: *Still Life with Plaster Cupid*
(pl. 145). c. 1892. Venturi 706
Oil on paper mounted on panel,
27½ x 22½ in (70 x 57 cm)
Courtauld Institute, London

Right: *Still Life with
Peppermint Bottle.* 1890–92
Venturi 625. Oil on canvas,
25⅝ x 31⅞ in (65 x 81 cm)
National Gallery of Art,
Washington

Top: Attributed to François Duquesnoy
Cupid. 1630–40
Plaster cast, 17¾ in (45 cm) high
Collection Lawrence Gowing, London

Above: Copy after Poussin's *Concert*
c. 1890. Chappuis 1012
Pencil, 8⅝ x 4¾ in (20.9 x 12.2 cm)
Kunstmuseum, Basel

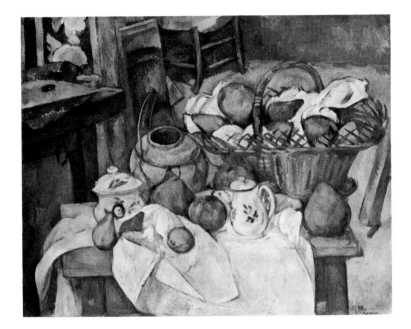

Left: *Still Life with Basket.* c. 1890. Venturi 594. Oil on canvas, 25⅝ x 31⅞ in (65 x 81 cm). Musée du Louvre, Paris

Above: Detail, *The Environs of Aix-en-Provence.* 1858–60. Venturi 3 Painted screen, c. 60 x 80 in (c. 150 x 200 cm) Wally Findlay Galleries, New York

edges of a second canvas, placed behind it in the middle distance. Here Cézanne seems to have been inspired by still another work of art. At about the time he painted the *Still Life with Plaster Cupid,* he copied part of Poussin's *Concert* in the Louvre, just that part in which a *putto,* Baroque in style like the one in his work, and like it partly turned to the right, is framed at the sides by adjacent elements, lying in different spatial planes.[107] It was possibly with his own picture in mind that Cézanne isolated so unusual and inorganic a motif from Poussin's in the first place. Thus his still life, which appears at first a simple studio scene, emerges as a highly contrived composition, in which a plaster cast of a Baroque statuette, a painted copy of a cast of a Renaissance statuette, a partial copy of one of his own paintings, and a motif based on his copy of an older painting all coexist with "real" apples and onions, themselves subjected to an unnatural coexistence.

The number of works, both painted and sculpted, that Cézanne quotes in the *Still Life with Plaster Cupid* is unparalleled in his art, but the use of such quotations is not. They occur throughout his career and especially in the nineties, a period of great pictorial inventiveness. We have already seen examples in the *Smokers* (Venturi 686, 688), the portrait of Geffroy (pl. 1), and the *Peasant with a Blue Blouse* (pl. 10); and the painted screen (Venturi 1–3) that appears in the latter also figures in a number of still lifes. It must have remained at the Jas de Bouffan from the time Cézanne and Zola decorated it in the late 1850s, for it occurs in the background of the *Still Life with Basket,* painted in his attic studio there about 1890.[108] Here the function of the screen is purely compositional—to close the design at the left side by blocking the view into depth beyond the high table—and only a small section of its floral border can be recognized. But in two still lifes of about a decade later, both in the Barnes Foundation, larger portions of it are shown, includ-

ing plants and figures, and these play a thematic role as well.

In one of these pictures (pl. 149), the lower right corner of the screen fills the background completely. The orange and white blossoms in its border repeat at the far right the rounded red and orange forms of the fruit placed on the table, and the green and black leaves of the plant in its first panel seem initially to be those of the fruit themselves. In the other picture (pl. 152), parts of the next two panels, without the border, form the background, with the leaves shown in them once again seeming to grow around the apples and pears on the table directly before them; but here Cézanne also includes portions of the figures seen above the plants. They are the same amorous couple that he represents in the background of the *Peasant with a Blue Blouse,* though now only the lady's orange skirt is recognizable, and she is contrasted—or must have been, when Cézanne set up the still life and saw her whole form—with an inanimate object, the skull placed so ominously amid the fruit, its stark whiteness and their robust colors providing still another contrast. *Memento mori,* a reminder of the imminence of death in the very midst of fruit, flowers, and a female figure connoting sensual pleasure, was a theme never far from Cézanne's thoughts in these years. It is already implicit in his juxtaposition of the *Flayed Man* and the *Cupid* in the still life discussed previously, and is seen more overtly in his later drawings and watercolors of the same *Cupid* and of a skull—obvious enough symbols for the artist who wrote: "I have sworn to die painting, rather than go under in the debasing paralysis which threaten old men who allow themselves to be dominated by passions which coarsen their senses."[109]

The Barnes Foundation still life of about 1900 is probably the earliest of a series in which a skull occurs. The *Three Skulls* (pl. 153) must date from about 1902: when Borély visited Cézanne in that year, he saw the polished skulls themselves still

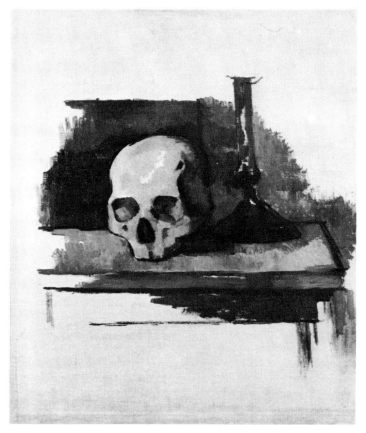

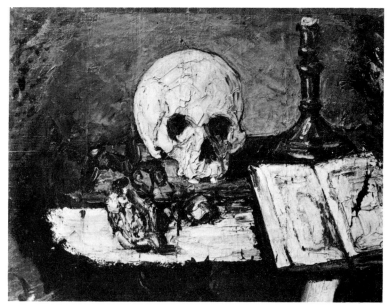

Left: *Skull and Candlestick* (pl. 154). 1900–04
Oil on canvas, 23⅝ x 19⅝ in (61 x 50 cm)
Staatsgalerie, Stuttgart

Above: *Still Life with Skull*. c. 1865. Venturi 61
Oil on canvas, 18½ x 24⅝ in (47.5 x 62.5 cm)
Private collection, Zurich

set up on a plain wooden table, as in the picture.[110] The effect they produce, lined up almost brutally on that bare surface in a room shrouded in darkness, is of a stark, unflinching meditation on death. It is the vision of an ascetic hermit—St. Jerome in his cell, St. Anthony in the desert—and we recall that in the early seventies Cézanne had depicted the Temptation of St. Anthony (Venturi 240, 241) and in the early nineties had represented a young man seated beside a skull and books like a modern St. Jerome (pl. 8). The still life with a single skull and candlestick on the same wooden table (pl. 154)[111] also recalls a traditional theme, the *memento mori,* where these objects symbolize the transience of life and the inevitability of death. Cézanne had paired them once before, in a still life of the mid-sixties (Venturi 61), together with an open book and a fading rose, equally familiar emblems of mortality. The later picture, although more a vignette with large areas unpainted, is more effectively composed, the contours of the candlestick and skull forming fascinating rhythms, and is infinitely more subtle in color and execution—so much so that the morbid subject becomes an object of aesthetic refinement. In some of the watercolors (pls. 156, 159), skulls resplendent with rainbowlike hues can even provide aesthetic delight. "A skull is a beautiful thing to paint," Cézanne told Vollard in 1905.[112] They were discussing the *Three Skulls on an Oriental Rug* (pl. 155), which Bernard, too, saw in his studio in this year, after having watched him work on it intensively the year before.[113] Heavily revised, somber in tonal-

ity, the oil painting is perhaps a less effective statement than the related watercolor (pl. 156), where the white skulls form a striking contrast to the vivid red and green flowers of the Oriental rug, yet are united with them through the repetition of similar shapes and wavy contours. Here the morbid and the sensual, the poles of Cézanne's art in his last years, are brought together in the very choice of the objects—an unusual choice for which it would be difficult to find a precedent or parallel.

The lyrical tendency is expressed more directly in these years in several still lifes of flowers, but even here the opposite tendency is never entirely absent. Cézanne, for all his fascination with color and light, his ecstatic descriptions for his friends of sunlight falling on the fruit served at dessert,[114] could never abandon himself to that intoxication the way Renoir could. In the *Vase of Flowers* (pl. 162) of 1901–03, we find the same Oriental rug covering the table, but on it a tall vase with a colorful bouquet instead of the skulls, and behind it a drapery with other flowers. Yet the symmetrical arrangement, the drapery hanging ceremonially on the same axis as the stately vase, suggests a solemn ritual; and the muted, almost phosphorescent yellow, white, and blue flowers, glowing against the deeper yellow-brown drapery and gray-blue wall, convey a mystical mood like that in Redon's late pastels. Again this is partly a result of extensive reworking, especially in the vase and flowers, whose contours are marked by thick accumulations of pigment. From his letters to Vollard, it is clear that Cézanne labored on the

picture for over a year, hoping to exhibit it at the Salon.[115] From the same correspondence, we learn of a watercolor of flowers by Delacroix that Vollard gave him in 1902 and that he copied in oil soon after (pl. 163).[116] Here the composition is simpler and without tension, the blossoms forming a roughly circular design that fills the surface; yet in simplifying and clarifying their forms and in intensifying their colors and contrasts, Cézanne distills from Delacroix's minutely objective study a picture of greater resonance and mystery. Again we are reminded of Redon, of whom Cézanne wrote: "I like his talent enormously, and from my heart I agree with his feeling for and admiration of Delacroix."[117]

A flower piece by Delacroix may also have inspired one of the most unusual of Cézanne's late works, the *Vase in a Garden* (pl. 164): like that master's pictures of a basket of flowers in a park, Cézanne's depicts blossoms that have been cut and placed in a vase, brought outdoors, and juxtaposed to living plants and trees.[118] But his more immediate model was an ornamental print, presumably of the Second Empire, which he had already copied in the mid-seventies (Venturi 222). Although the later version is much more freely executed, it clearly depicts the same ornate Rococo vase and lush, overflowing bouquet. Now, however, it is placed before a curving garden wall surmounted by statues and is flanked at the bottom by smaller masses of foliage and at the top by trees curving inward, reinforcing the closed,

Top left: Eugène Delacroix. *Roses and Hortensias.* 1848–50
Watercolor, 24¾ x 23⅝ in (63 x 60 cm)
Musée du Louvre, Paris

Bottom left: Copy after Delacroix's *Roses and Hortensias* (pl. 163)
1902–04. Venturi 754. Oil on canvas, 30¼ x 25¼ in (77 x 64 cm)
The Pushkin Museum of Fine Arts, Moscow

Below: *Preparations for a Banquet.* 1890–95. Venturi 586
Oil on canvas, 17¾ x 21 in (45.1 x 53.3 cm)
Collection Mrs. Irene Mayer Selznick

Far left: Copy after Desjardin's
Bust of Pierre Mignard. 1892–95
Chappuis 1027. Pencil,
8 x 4⅞ in (20.5 x 12.4 cm)
Kunstmuseum, Basel

Left: Copy after Donatello's
St. John the Baptist. 1895–98
Chappuis 1126. Pencil,
8½ x 5⅜ in (21.6 x 13.7 cm)
Musée du Louvre, Paris

circular nature of the design. This conception, too, is reminiscent of late-seventeenth- and eighteenth-century art in Italy and Flanders,[119] and like the slightly earlier *Preparations for a Banquet* (Venturi 586) shows in its most overt form that aspiration toward Baroque richness and grandeur which is implicit in much of Cézanne's late work. Yet, despite their beautiful color modulations and execution, both pictures testify more to the force of the aspiration than to its realization.

If the style of Cézanne's last works can be described as Baroque—and beginning with Roger Fry, it has often been described as such—it is not on the basis of a few self-consciously Baroque pictures like the *Vase in a Garden.* Nor can his late style be classified as Baroque in the same sense as seventeenth-century art, by using the well-known criteria of Heinrich Wölfflin.[120] Thus it is the exceptional landscape (Venturi 656, 728) or still life (pls. 139, 167) that is built on a diagonal receding into depth. The majority are composed of forms parallel to the picture plane, as in Renaissance art and Cézanne's own art of the eighties. And it is only in the very last works, the portraits of Vallier and the views of Mont Sainte-Victoire, that a truly pictorial unity, based on the subordination of the parts to the whole, can be seen. In most of the others, the effect is of multiplicity, of the balancing of relatively discrete masses, as in Cézanne's earlier work. Moreover, his very method of painting, alternating between drawing and coloring in the gradual definition of a form, results in its being both open and closed, its color planes fusing with those of adjacent forms at certain points

and its dark contour sharply separating it from them at others. If his late style is Baroque, then, it is in a restricted, personal sense, one not defined by the traditional polarity.[121] In choosing older works to copy in these years he was equally attracted to Baroque and Classic styles: among his models we find richly contoured portrait busts by Girardon and Desjardins, but also severely planar ones by Donatello and Desiderio da Settignano; serenely classical statues such as the *Borghese Mars* and the *Discophoros,* but also dynamic and dramatic ones such as Puget's *Milo of Croton* and *Caryatids.*[122] In his studio there were reproductions of pictures by Poussin as well as Rubens, of Couture as well as Delacroix; and in his letters, expressions of admiration for Veronese as well as Michelangelo.[123]

We have already observed some of the features that can truly be called Baroque in Cézanne's late works. The objects emerge as unevenly lit forms from their dark, shadowy setting, rather than standing forth sharply as dark forms against a light, atmospheric background, as is generally the case in the eighties and early nineties. At times they seem to merge with their setting, creating a kind of restless movement in and out of depth and a mood of mystery and spirituality not found earlier. The portraits of Vollard and Vallier (pls. 4, 26) and the still lifes with three skulls and with a vase of flowers are good examples. In addition, the contours become continuous, wavy lines, unifying the surface through their repeated rhythms, rather than straight lines and simple arcs as they had been previously. Already observable in certain still lifes of the early and mid-nineties (pls. 145, 148,

and Venturi 625), as well as in landscapes of that period (pls. 52, 67), this tendency becomes increasingly pronounced, and probably also accounts for the appearance in the later still lifes of objects with complex, irregular shapes, such as onions (pls. 145, 148), pomegranates (pl. 152 and Venturi 733), and skulls (pls. 152, 155, 157), alongside the simpler, more spherical apples and oranges. This taste also finds expression in the Gothic windows of the Château Noir (pls. 55, 57, 59, 60) and above all in the very late watercolors, whose surfaces seem entirely consumed by the flickering, flamelike shapes produced by the overlapping of countless agitated strokes of color.

It is in fact in watercolor that Cézanne's ultimate conception of still life is seen, since his last oil paintings are of other subjects. In them the objects he had once shown as almost heavier and more solid than they were in reality are dissolved into weightless, floating shapes, half material, half transparent, their forms blurred by ceaselessly repeated strokes along their contours, their colors alone defining or implying their presence. It is a remarkably spiritualized vision that informs these last still lifes in watercolor (pls. 181, 184, and Venturi 1144), one whose potential for a radical transformation of the familiar world would be realized a few years later by Delaunay and other abstract artists. As Delaunay himself observed, "The late watercolors of Cézanne foretell Cubism; the colored, or rather, luminous planes destroy the object."[124]

For Cézanne himself, who wished ultimately to preserve the object, such an effect was conceivable only in watercolor, where planes of transparent wash are illuminated by white paper shining through them with something of the radiance of stained glass, and where moreover forms are not fully defined but allowed to dissolve into, or emerge from, the large unpainted areas around them. This failure to cover the surface completely has a different effect than in the unfinished paintings: since the color washes are from the beginning related to the white rectangular sheet, the untouched areas do not appear as gaps in their structure; in the oils this is true only when the canvas is toned or stained with liquid color in advance and the background tints can approximate the missing ones, or when the white canvas itself is sufficiently close to them in tone. In the watercolor *Study of a Skull* (pl. 159), for example, the whiteness of the unpainted areas toward the edges is felt beneath the painted ones, which merge imperceptibly with them, and recurs at the center in the dazzling skull itself. In the *Skull and Candlestick* discussed earlier, on the other hand, the objects and parts of the table and wall around them are completely covered, and stand out as an irregularly silhouetted vignette against the rest of the canvas, which is completely blank. In one of the still lifes with a milk pitcher belonging to the series analyzed earlier (Venturi 750), the relatively finished objects in the center are likewise dissociated from the entirely unpainted areas surrounding them; whereas another one in the same series (pl. 147), which is admittedly more advanced, succeeds pictorially because the rectangular format as a whole has been considered. The untouched parts of the white

Still Life. 1895–1900. Venturi 750
Oil on canvas, dimensions unknown
Formerly collection Dr. Werner Reinhart, Winterthur

drape at the bottom merge with the light tones adjacent to them, and even those of the floral drape at the left are integrated through the pattern sketched over them.

Thus it is essential to distinguish the kinds and degrees of incompleteness in Cézanne's pictures. Yet from the beginning the sheer number of unfinished canvases has provoked sweeping, polemical statements, both negative and positive. During his lifetime the existence of such works, to which he himself drew exaggerated attention, was seen as a confirmation of his inability to "realize."[125] Only a rare, tolerant viewer like Pissarro could recognize that in the 1895 exhibition "there were exquisite things, still lifes of an irreproachable completeness, others much worked on and yet left unfinished, even more beautiful than the others. . . ."[126] Within a year of Cézanne's death, Denis was complaining that the current "mystique of the unfinished" caused people to admire only the rough studies and to look suspiciously at the completed pictures;[127] and soon after, painters like Picasso and Derain, charmed by the freshness and force of the effects thus obtained, were deliberately imitating them. Twenty years later, Roger Fry was convinced that in the unfinished late works Cézanne achieved a new economy of expression; "for he is able to leave large parts of the white canvas preparation intact. . . . And yet if we view the canvas from the proper distance the effect of plastic continuity is complete."[128] And thirty years after that, another critic insisted that the unfinished areas are the essence of Cézanne's achievement, "an especially clear expression of what is fundamentally new in his representational means and pictorial structure."[129] As long as the discussion remains on this level of generality, however, we cannot understand his complex, sometimes contradictory intentions.

About these we learn not only from his works themselves, but from his letters and reported conversations. They reveal that he considered many paintings merely a means of investigating a pictorial problem. The painter Albert Silvestre, who visited him at Fontainebleau in 1894, recalled that "he never ceased declaring that he was not making pictures, but that he was searching for a technique. Of that technique, each picture contained a portion successfully applied, like a correct phrase of a new language to be created."[130] Yet Cézanne clearly thought of other paintings as definitive statements, which he was willing to spend a great deal of time on and planned to exhibit. The *Vase of Flowers* discussed previously, a picture he worked on for over a year and intended to show at the Salon of 1902, is a case in point; so are the portrait of Geffroy (pl. 1), for which he hoped to win a medal at the Salon, and the *Large Bathers* (pl. 187), on which he labored intermittently for ten years. In fact, every painting he considered sufficiently finished to sign—and from the late seventies, when the issue first emerges, there are only thirteen—reveals a completely covered surface.[131] And if, as Pissarro's letter indicates, this was not true of some of the still lifes that Cézanne allowed Vollard to exhibit in 1895, he must have had reservations about them nevertheless, for in discussing these very works with Silvestre the year before, "he outlined with his finger the portion that seemed viable to him and regretted that the whole canvas was not as advanced."[132] One reason for this, at least in his last years, was Cézanne's inability to distinguish the exact tones where forms intersected; in a letter of 1905, he complained of the "sensations of color, which . . . do not allow me to cover my canvas entirely, nor to pursue the delimitation of the objects where their points of contact are fine and delicate; from which it results that my image or picture is incomplete."[133] Thus it is evident that he considered a painting finished only when its surface was completely covered.

Yet even in those that are not, it is important to distinguish the degrees of finish, which reflect different circumstances and ambitions. It is often said that Cézanne began with the pictorial structure, the essential lines and planes of his subject, and proceeded toward the representation, the web of color planes that defined it more fully, and that in doing so he "advanced all of his canvas at one time," as he supposedly told Gasquet.[134] In fact, only some of his unfinished pictures, such as the *Still Life* in the Tate Gallery (pl. 151), where no form is fully realized at the expense of the others, and a balance of painted and unpainted, of colored and white areas is maintained throughout, support this contention. In others, including one of the still lifes with a floral-patterned pitcher (pl. 142) discussed earlier, the contrast between the two is absolute and causes a disjunction in the pictorial harmony as well as the spatial illusion. The untouched portions read only as blank canvas, forcing our eye to return abruptly from the world of rounded, colored objects to the abstractness of the picture surface. The first still life is complete, though unfinished; the second is neither complete nor finished. It is true, of course, that such works are often aesthetically

satisfying and, as Pissarro said, "even more beautiful than the others. . . ."[135] For as Renoir never ceased to marvel, Cézanne "could not put two touches of color on a canvas without its already being very good."[136] And as later artists, followed by critics and collectors, soon perceived, it is precisely in such works that we seem to be most intimately in contact with the genius of Cézanne's vision and the most advanced aspect of his art. Yet this does not alter the fact that, judged by his own, clearly more conservative standards, these works were bound to seem incompletely realized.

Below: *Still Life with Water Jug* (pl. 151). c. 1893. Venturi 749
Oil on canvas, 20⅛ x 26¾ in (51 x 68 cm)
The Tate Gallery, London

Bottom: *Still Life* (pl. 142). 1897–98. Venturi 745
Oil on canvas, 25⅝ x 31⅞ in (65 x 81 cm)
© The Barnes Foundation, Merion, Pa.

V

ALTHOUGH CÉZANNE'S GREATNESS seems today to depend chiefly on his portraits, landscapes, and still lifes, his own ambition, especially in his last years, was to create monumental compositions of nude figures like those he admired in older art. Among his Impressionist colleagues, only Renoir shared this ideal; the others either avoided the human figure or represented it in modern urban or rural settings. And like Renoir he envisaged the nude in an occasional mythological subject but primarily in those scenes of passive, outdoor activity, almost devoid of content, that nominally depict bathing. Beginning in the mid-seventies with small studies of single bathers, Cézanne gradually increased both the number of figures and the size and complexity of his designs. These he developed in two parallel series, corresponding to their twin sources of inspiration. The female bathers emerged from the early romantic pictures of erotic pleasure or tension, such as the *Temptation of St. Anthony* (Venturi 103), from which some of their poses and groupings actually derived; and they continued to express a sensual ideal, despite their greater formal structure and aloofness.[137] The male bathers embodied memories of youthful excursions with Zola and Baptistin Baille in the countryside around Aix and of summer days spent swimming in the Arc River. Zola, too, cherished these memories and in *L'Oeuvre* recalled how they would "spend whole days there, stark naked, drying themselves on the burning sand, and then replunging into the river, living there as it were. . . ."[138] Compositionally, the female figures form a roughly triangular group, framed at the sides by inward-slanting trees—a closed, compact design that may reflect the inhibition Cézanne felt in dealing with this subject and his need to impose a constraining form on it. In contrast, the male figures form a friezelike pattern of alternately low and high elements, open at the ends and at times extending farther into depth; and the greater openness, like the more vigorous poses, expresses the sense of freedom and energetic activity Cézanne associated with this subject from the beginning. In *L'Oeuvre* Zola indicates one of the reasons why the bather compositions would later be segregated by sex and take different forms: "They had even planned an encampment on the banks of the Viorne, where they were to live like savages, happy with constant bathing. . . . Even womankind was to be strictly banished from that camp."[139]

Despite this long preparation, it was only in the last decade of his life that Cézanne attempted to realize his ambition in three large compositions of female bathers. Although much discussed, their dates and the order in which they were painted have never been established convincingly, partly because all the relevant visual and documentary evidence has never been assembled. Once it is, and the three are placed in chronological sequence, other late bather pictures can be dated in relation to them and the evolution of Cézanne's vision of the subject can be followed.

The literary evidence is not quite conclusive about all three, but much can be deduced from it. According to Vollard, one version was begun about 1895 and was still in progress when he posed for his portrait, i.e., in October 1899.[140] It must be the same one that Rivière and Schnerb saw, still in progress, when they visited Aix in January 1905, for they were told it was begun a decade earlier; and since they specify "eight figures almost life-size," it can be identified as the Barnes version (pl. 187).[141] That Cézanne was working on it at that time is confirmed by Bernard, who saw and photographed it when he visited Aix in February–March 1904, and found it considerably revised when he returned in April 1905.[142] Much less is known about the London version (pl. 188), but it was probably this one that Borély saw when he was in Aix in July 1902; his description of "white bodies against lunar blues" fits it better than any of the others.[143] It may have been begun about 1898–99, for Vollard, the painter Louis Le Bail, and the critic Georges Rivière all report that, contrary to his normal practice, Cézanne posed a nude model repeatedly in his Paris studio at that time.[144] Curiously, however, no one mentions seeing two of these pictures, which were much too large to be overlooked, together in his studio. As for the Philadelphia version (pl. 189), art historian Karl Ernst Osthaus saw it in a rather early stage, its trees beginning to form an arch, on his visit in April 1906.[145] Its thinly applied paint and many unfinished areas also suggest that it was begun very late and brought to its present state rather quickly. Moreover, although it is the largest of the three, Denis does not mention seeing it in Aix in January 1906; he refers instead to a version that Cézanne began before settling definitively there and took up again many years later, which could be either of the other two.[146] Gasquet, it is true, claims to have seen a replica of the Philadelphia picture at the Jas de Bouffan, i.e., before the end of 1899, but the latter is too large to have been painted in Cézanne's attic studio there, and since it is unfinished, the replica can hardly have been "almost finished."[147] If Gasquet's account is authentic—and he is often an unreliable witness—it probably refers to the London version, many of whose figures resemble those in the Philadelphia one.

The most likely conclusions, then, are that the Barnes version was begun in 1895 and the London version several years later, that they were worked on intermittently until 1906, and that the Philadelphia version was painted in that year. There are indeed signs of extensive revision in the earlier two and especially in the first, just as there are indications of rapid progress in the third. Moreover, when the three are placed in this order, several compositional progressions emerge: the number of figures increases from eight to eleven to fourteen; they form increasingly distinct groups, moving from a nearly friezelike arrangement in the first version to a division into two pyramidal clusters in the third; some of the poses in the second version repeat those in the first, and others anticipate those in the third; and the figures decrease in size relative to the landscape, reflecting a development that is evident in all the late bather pictures, especially when

Eight Bathers. 1892–94. Venturi 540
Oil on canvas, 11 x 17⅜ in (28 x 44 cm)
Private collection, Paris

they are compared with those of the eighties and nineties.[148]

These slight compositional changes ultimately have a far-reaching effect, as the corporeality of the first version is gradually transformed into the spirituality of the third. The larger, more expansive figures of the first, some of them overtly sensual in posture, give way to the smaller, emotionally neutral figures of the third, whose poses are calmer and clearly constrained by the pyramidal groupings. In the same way, the congested, agitated landscape of the first, with its dramatic contrasts of trees, clouds, and sky, is replaced by the serenely spacious setting of the third, whose soaring trees form an arch reminiscent of Gothic vaulting. Even in execution the opaque, heavily encrusted texture of the first seems coarse in contrast to the half-transparent, thinly painted surface of the third, whose untouched areas and incisive lines create a flickering, delicate effect. But it is above all in its coloring that the latter achieves its dreamlike otherworldliness: the same pale tones of tan, gray, green, and blue, above all of blue, pervade the sky, water, and foliage, suffusing them with a common cool atmosphere, without the dramatic tension of the earlier versions.

For all its emotional aloofness, however, the Philadelphia *Bathers* is a highly personal image, whose sources lie deep within Cézanne's art and experience. Its roughly triangular design, the inward-slanting trees enclosing the bathers in a compact grouping that contrasts with and seems to inhibit their sensuality, first appears in small, three-figure compositions almost thirty years earlier (Venturi 270, 381). The trees themselves are less like those Cézanne saw on the banks of the Arc in 1906, while working on the *Bathers,* than the ones he had seen throughout his life much closer to home: the avenue of tall, arching chestnut trees at the Jas de Bouffan, a motif he had often painted in the eighties (e.g., Venturi 649, 942).[149] The fisherman on the distant shore facing toward the nude woman in the foreground first occurs, in a more obviously erotic guise, in a small canvas of

about 1870 (Venturi 1520A).[150] Even the still life with remnants of a picnic, which would surely have been shown, as it is in the other *Large Bathers,* if the Philadelphia one had been completed, links these compositions thematically with picnic scenes of the early seventies (Venturi 234, 238), just as the black dog lying next to the still life as another sign of animality recalls the one shown earlier in erotic subjects like *The Struggles of Love* (Venturi 379, 380). These are, it is true, merely hints of the personal sources and significance of the *Large Bathers,* hints of a lifelong dream of sensual fulfillment which, in this final realization, is sublimated into an ambivalent, curiously impersonal statement with a vaguely spiritual resonance. Yet they allow us at least to define the terms in which its content can be sought—terms more appropriate, surely, than the literal ones proposed by those historians who would see in the distant, featureless fisherman a likeness of Cézanne himself and in the large void between the trees an unconscious portrait of his wife.[151]

With the sequence of the three *Large Bathers* established, some of the earlier compositions leading up to them can be redated. A group of eight figures, as found in the Barnes version, first occurs in two smaller pictures (Venturi 539, 540), which are generally dated 1883–87, but are probably of 1892–94, since they lead directly to the larger work, begun in 1895, both in their designs and in the poses of some of their figures. Moreover, Cézanne gave one of the two to Marie Gasquet in 1896, and it was more likely a recent work than one a decade old.[152] The bather pictures definitely painted in the mid-eighties are not of eight, but of four or five figures (e.g., Venturi 542, 547), and are based on earlier versions of the same number (Venturi 382–86); they prepare the way for the later ones with eight, and eventually with eleven and fourteen, figures. So consistent a development would be inconceivable in the more complex and varied works painted directly from nature or life, but it is plausible in those created entirely from imagination.

Of the life studies of models in various poses reportedly painted in 1898–99, only two are now known. The others were presumably destroyed, together with many other sketches and unfinished works, when Cézanne was forced to leave the Jas de Bouffan.[153] Both the oil (pl. 190) and the closely related watercolor (Venturi 1091) are painted in warm, somber tones of yellow-brown, reddish brown, purple, and black, with small touches of green in the modeling, and are thus very similar in coloring to the portrait of Vollard (pl. 4), also of 1899. In addition, the oil shares with it a distinctive kind of outlining in broken, repeated, heavy black strokes. In both versions, the model faces to the left, arching her body and raising both arms around her head in a voluptuous manner, but this effect is contradicted by her heavy proportions and sad expression and above all by Cézanne's laborious execution. Although the pose is reminiscent of those he had admired and copied in Rubens' and Delacroix's nudes, he was incapable of achieving a comparable sensuality.[154] Yet this was clearly his ambition, and the same

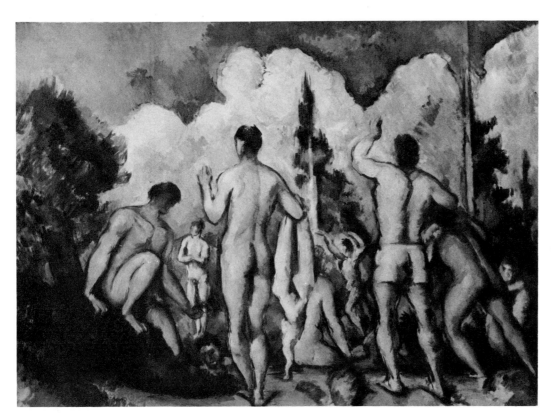

Ten Bathers. c. 1894
Venturi 580. Oil on canvas,
23⅝ x 31⅞ in (60 x 81 cm)
Musée du Louvre,
Galerie du Jeu de Paume, Paris

pose recurs at the right side of the Barnes Foundation's *Large Bathers* and, in a still more assertive, frontal position, in the center of the *Four Bathers* in Copenhagen (pl. 191). The seated figure at the left in the latter is also like those in similar positions in the Barnes and London versions of the *Large Bathers,* and the standing figure at the right is like the reclining one in the London picture turned upright. Thus it is likely that the *Four Bathers,* too, dates from about 1900. However, its expressive effect is quite different from that in the other pictures: the figures are enclosed in an unusually dark, oppressive landscape, and seem to challenge or recoil from one another, their forceful yet ambivalent postures and gestures conveying a tense, repressed eroticism. As we shall see, this veiled sensuality was, on the one hand, rooted in a picture of explicitly erotic content painted much earlier by Cézanne and, on the other, partly responsible for pictures of a similar content painted some years later by Picasso and Matisse.

In the early 1900s, while continuing to revise the Barnes and London versions of the *Large Bathers,* Cézanne painted a number of smaller compositions, experimenting with figures in different poses and groupings and with landscapes of a different scale. In two of them (pls. 192, 193), the figures are clearly reminiscent of those in the larger pictures in their leaning, crouching, or reclining poses, but in their division into two distinct groups and their small size relative to the landscape they anticipate the later version in Philadelphia. Moreover, the smaller compositions differ considerably from each other, one

containing thirteen figures, the other only seven—or so it seems, for they are defined so summarily that it is hard to be certain. Painted with a boldness and exuberance not found in the larger versions, and with a coloristic intensity that makes the warm flesh tones flash out against the deep greens and blues of the landscape, they express a radiant, lyrical vision of humanity in harmony with nature that is lacking in the large, laboriously revised compositions. Appropriately, nature tends now to dominate, the tall trees at the sides rising against the luminous sky and dwarfing the figures below them. In another of these sketches (pl. 186), probably later than the other two, the bathers are still more thoroughly incorporated into the landscape, whose flickering strokes and modulations of green, blue, violet, and tan are repeated in the modeling of their nude bodies. Here Cézanne experiments with still another design, in which the bathers, standing apart from the framing trees rather than clustered around them, form a group in the center as well as at each side. And in an equally late watercolor (pl. 197), he arranges them in an open, unstructured manner on the banks of a river spanned by a bridge—the Arc River, no doubt, and the Pont des Trois Sautets, the subject of a landscape of 1906 (pl. 113), incorporated here into an imaginative composition, its solid, angular form providing a foil for the remarkably fluid, intertwining forms of the figures.

Until about 1900, the design of the male bather pictures remains relatively constant, much more so than that of the female bathers. Already established in the late seventies, it con-

sists of two standing figures, seen largely or entirely from behind, alternating with three seated or bending figures, the central one in the water behind the others (Venturi 268, 388–90). The same design occurs in the eighties, though now the middle figure is on the opposite shore, thus deepening the apparent space (Venturi 541, 582, 590).[155] In the early nineties this schema is developed further by the gradual addition of smaller figures in the intervals between the larger ones (Venturi 588, 581); and by about 1894 it has become a complex grouping of nine, or possibly ten, bathers of varied postures and sizes, hence at different distances from us, fitted into an intricate surface pattern (Venturi 580). Larger than any of the others, this version is also more robust in coloring, the warm yellow and tan tones of the bathers vibrating against the yellow-green foliage and orange-red earth, just as the luminous white cloud behind them, enlivened with touches of the other colors used, shimmers against the deep blue sky. It thus embodies in an impressive form the image of an unconstrained, vigorous existence that seems to have inspired the male bathers from the beginning.

After that culminating statement, the design appears only rarely: in a color lithograph of six figures (Venturi 1156) executed in 1896–97, and in a painting of seven figures (pl. 202) that is closely related to the print and probably dates from the same period or slightly later, rather than 1879–82 as is generally stated.[156] Stylistically, too, the heavy, repeated contours, the broad brushstrokes, and the thinly applied paint support the later date. Contrary to Cézanne's usual practice, in both compositions two of the male bathers appear in poses originally invented for female bathers.[157] On one level they function as inward-turning figures to close the design at the sides; but on another, they raise interesting questions about the mingling of the sexes in pictures thought to be clearly differentiated and, with other figures of hermaphroditic character (e.g., in Venturi 589, 590), about their sexual identity altogether. Still more directly dependent on an earlier composition are the other lithographs of bathers—one in monochrome, the other in color (Venturi 1157, 1158)—that Cézanne executed in 1896–98; for both reproduce the painting *Bathers at Rest* (Venturi 276), which he had exhibited twenty years earlier. Reprises such as this of much older pictures or pictorial problems are not unusual in his art, but in this case he may have had another, more specific reason: the *Bathers at Rest,* which had been lavishly praised by one critic, though condemned by others, when it was shown in 1877, was probably his most famous work, and as such a natural enough subject for a print that would make it visible to a larger audience.[158]

The latest pictures of male bathers (pl. 201 and Venturi 727, 729) were probably painted in the early 1900s, to judge from their stylistic similarity to the female bathers of those years (pls. 192, 193). Breaking with the pattern of regularly alternating forms, they depict eight or nine figures spread irregularly across the surface in a more dynamic rhythm, no longer stabilized by the tall, columnar forms of the two figures seen from behind.

There is a corresponding movement and variety in their postures: although some are based on earlier types, they are reversed or rearranged to create different intervals between them; and others, such as the wrestling figures and those approaching each other as if to wrestle, are new. Yet these pictures remain modest in scale and sketchlike in execution. There are no ambitious, culminating works among them, comparable to the large female bather compositions.

In the bathers, more than in any other subject he treated, the problem of Cézanne's pictorial sources looms large. It is clear that he was never able to realize his lifelong ambition of posing nude figures outdoors; both his own inhibitions and the provincial mores of his native town prevented it. If he did occasionally sketch soldiers bathing in the Arc, as Gasquet reports, these studies are no longer known; and even his modest plan to pose a single figure on its banks, mentioned in a letter of 1906, seems to have remained unfulfilled.[159] At most he was able to paint from a nude model in his Paris studio on occasion, and we have seen the few results, dating from 1898–99; a pencil drawing of a model, related to the standing figure at the left in the Philadelphia *Large Bathers,* is also extant.[160] It was possibly drawn from the old invalid whom, according to both Bernard and Osthaus, Cézanne sometimes had pose for him at Aix in his last years.[161] But there are no other drawings of this kind, and few of the other figures in that picture appear to have been painted from life. And as for the early academic drawings that Bernard and the painter Francis Jourdain maintain he relied on, not many more of these are known, and none resembles a later bather closely enough to be considered its source.[162] In these circumstances, given his lack of facility in inventing anatomically and expressively convincing poses, Cézanne was forced to depend on other art, his own and that of older masters.

This is why, having found a few suitable poses, Cézanne used them repeatedly, only changing their positions, combining them differently, or reversing them for greater variety. But had they become, as a result, "almost geometric abstractions with which he sought desperately to establish significant combinations"?[163] Such a conclusion ignores both the expressive content of the poses Cézanne chose to repeat and the hidden continuities these reveal between works of different subjects and dates. The earliest compositions of female bathers, painted in the mid-seventies, are direct transpositions into this more idyllic, emotionally neutral realm of figural types and groupings devised in the previous decade for pictures of a strange, nightmarish eroticism. Thus, the triangular design of the *Three Bathers* (Venturi 266) repeats that of the three principal nudes in the early *Temptation of St. Anthony* (Venturi 103), and two of their sensual poses repeat those of the nudes themselves. The fourth one, shown confronting the saint, likewise recurs in a picture of bathers (Venturi 265), still arching her body provocatively, but now without apparent cause: the dramatic context is gone, and the landscape she inhabits is as bright and spacious as the earlier one had been dark and oppressive.[164] More surprisingly, the same figure appears twenty-five

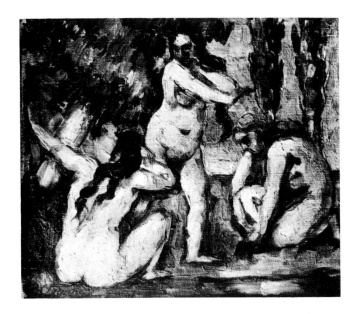

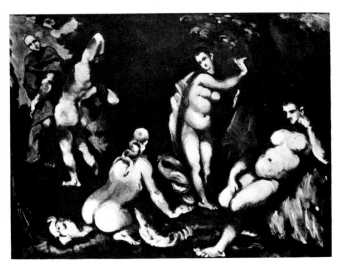

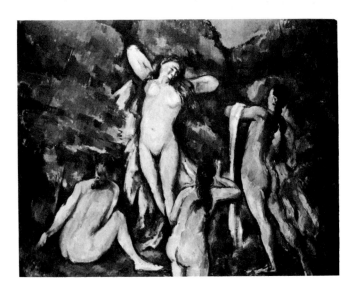

years later, together with the somber setting and other figures reminiscent of the *Temptation of St. Anthony,* in the *Four Bathers* (pl. 191) discussed previously; and this derivation may explain why they project, despite their supposedly idyllic content, an air of tense, repressed sexuality. A similar transformation can be followed in the reclining nude seen from behind, who first appears beside a fully clothed man in the eerie *Idyll* (Venturi 104) of 1870, then with other nude women in a composition of *Five Bathers* (Venturi 264) some seven years later, and finally in the London and Philadelphia versions of the *Large Bathers* painted after 1900, where she still projects something of her initial sensuality.

In addition to his own art, Cézanne drew heavily on older art as models for his figures, using illustrated books and reproductions or copies he had made in museums as his guides. Many examples of such derivation have been shown in his works of the seventies and eighties, but very few in his later ones. In the Philadelphia *Bathers,* the crouching nude at the left is taken directly from a Hellenistic *Crouching Venus* that Cézanne copied repeatedly in the Louvre; and the nude standing against a tree at the right may be based on the *Venus of Milo,* which he had also drawn many times.[165] In addition, the symmetrical disposition of the figures is very much like that in Veronese's *Supper at Emmaus,* reportedly one of Cézanne's favorites in the Louvre.[166] In both works, the figures form pyramidal masses at the sides, the inner ones looking and gesturing inward and down, the outer ones standing against trees or fluted columns and turning inward. In both, the space between the figures is filled with a horizontal form—the far shore and water, the draped table—though in one there is a void above it and in the other the principal figure, Christ. It is even possible that, given his great admiration for Veronese, especially in his last years, Cézanne had drawn a diagram of the *Supper at Emmaus,* just as he is reported to have done of the *Marriage at Cana* in the Louvre.[167] That he could compare pictures of altogether different subject matter in such abstract terms is evident from Denis's account of his finding the tonal structure of the *Marriage at Cana* repeated in the Delacroix *Bouquet* that he owned.[168]

Similar examples of borrowing can be found in the male bathers. In several compositions of the early nineties (e.g., Venturi 582, 585), the standing figure with his arms around his head is based on Michelangelo's *Dying Slave* in the Louvre; the other, with his back to us, on a Signorelli drawing of which

Top: *Three Bathers.* c. 1876. Venturi 266
Oil on canvas, 8⅝ x 7½ in (22 x 19 cm)
Private collection, Paris

Center: *The Temptation of St. Anthony.* c. 1870. Venturi 103
Oil on canvas, 21¼ x 28¾ in (54 x 73 cm)
Private collection, Switzerland

Bottom: *Four Bathers* (pl. 191). c. 1900. Venturi 726
Oil on canvas, 28¾ x 36¼ in (73 x 92 cm)
Ny Carlsberg Glyptotek, Copenhagen

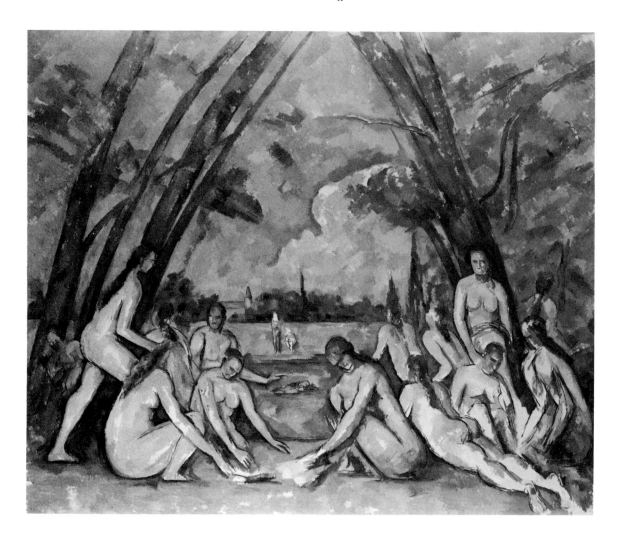

Top: *Large Bathers* (pl. 189). c. 1906. Venturi 719
Oil on canvas, 81⅞ x 98 in (208 x 249 cm)
The Philadelphia Museum of Art, W. P. Wilstach Collection

Left: Copy after antique *Crouching Venus*. 1892–96. Chappuis 1097
Pencil, 7⅛ x 4⅝ in (18.2 x 11.6 cm)
Collection Mrs. Enid Haupt, New York

Above: Paolo Veronese. *Supper at Emmaus.* c. 1560
Oil on canvas, 9 ft 6 in x 14 ft 8 in (290 x 448 cm)
Musée du Louvre, Paris

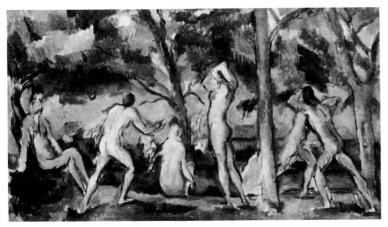

Bathers (pl. 201). 1898–1900. Venturi 724
Oil on canvas, $10\frac{5}{8}$ x $18\frac{1}{8}$ in (27 x 46.4 cm)
The Baltimore Museum of Art, Cone Collection

Right: Eugène Delacroix. *Spartan Women Practicing for War.* 1845–47
Pencil, $8\frac{5}{8}$ x $10\frac{1}{4}$ in (22 x 26 cm)
Musée du Louvre, Paris

Cézanne owned a reproduction. Both appear repeatedly among his copies.[169] In other versions of the same design (e.g., Venturi 580, 581), a Signorelli drawing of a man with raised arms seen from behind is the model for one of the standing figures.[170] And in some of the latest compositions (pl. 201 and Venturi 727, 729), the Michelangelesque bather appears alongside two who approach each other as if to wrestle, inspired by Delacroix's drawings of Spartan girls wrestling, one of which Cézanne had copied earlier.[171] That Michelangelo, Signorelli, and Delacroix, artists whose invention of powerful, expressive forms he admired, should have provided inspiration for these late works is not surprising.

Compared with his sources, Cézanne's figures appear all the more awkward and inhibited, lacking in precisely that correct proportioning and convincing representation of movement that he admired in older art. Roger Fry thought them "calculated to outrage our notions of feminine beauty."[172] Compared with the image of the human form in more recent art, however, they appear singularly personal and expressive in their very distortions and ambiguities. They anticipated by a few years the assertively sensual nudes in the early work of Picasso and Matisse, and sometimes directly influenced them. The relevance of the *Four Bathers* to both the *Demoiselles d'Avignon* and the *Joy of Life* has been noted more than once.[173] Yet it remains true that in the late bathers in particular the stiff, often featureless figures seem less eloquent than the landscape surrounding them, which, as we have seen, plays an increasingly large role. And more important than either in conveying feeling is the painted surface itself—the lively, flickering brushstroke, the fine, incisive drawing, and above all the infinitely variable color, vibrant and virile in the largest of the male bathers, subtle and atmospheric in the last of the large female bathers. In effect, then, the locus of meaning shifts in them from the mimetic aspects characteristic of older art to the pictorially expressive ones dominant in modern art. Like the great figure compositions of Matisse and Picasso of about 1907–09, which they sometimes inspired, they are eloquent yet uninterpretable. But even more than this progeny, Cézanne's late bathers stand at a crucial junction in European art and look back nostalgically at the older tradition while foretelling the newer one.

VI

THE EXTRAORDINARY ACHIEVEMENTS of Cézanne's last decade were the result of long observation and meditation on nature, on the old masters, and above all on the workings of his own mind. His novel methods of painting and drawing were products of a keen intelligence acutely aware of its own processes. "One must reflect," he told Rivière and Schnerb; "the eye is not enough, reflection is needed."[174] Almost inevitably, this prolonged self-scrutiny resulted in a number of statements, made largely in the last few years of his life, that could be said to constitute his art theory. They were by no means formulated reluctantly, in response to persistent questioning by younger artists such as Bernard, as is sometimes maintained. In declining to exhibit in 1889, Cézanne explained, "I had resolved to work in silence until the day when I should feel myself able to defend theoretically the result of my attempts."[175] As late as 1906 he was still planning to "write out his ideas on painting."[176] Therefore an analysis of his methods cannot be divorced from an exposition of his theories. These in turn were often influenced by his reading of writers such as Stendhal, Balzac, and Baudelaire and of artists such as Thomas Couture and Jean-Désiré Regnier, but since his debts to them have been discussed elsewhere, in greater detail than would be possible here,[177] we shall concentrate on the statements themselves and their relation

to his practice. Of particular importance for the subsequent history of modern art are Cézanne's ideas on the choice of the subject and motif, the creation of form and space, and the relation of color and line.

About the subjects of his pictures, Cézanne said relatively little, at least little that can be considered authentic. There are many eloquent avowals in Gasquet's memoir, but their very eloquence—so different from the simplicity of Cézanne's letters, so similar to Gasquet's own poetic flights—renders them suspect. There are, however, some revealing remarks in the letters, and these confirm what the pictures tell us of Cézanne's deep feeling for nature and especially for his native Provence. Thus he writes to Gasquet of "this old native soil, so vibrant, so austere, reflecting the light . . . and filling with magic the receptacle of our sensations," and again, to Gasquet's father, of "these horizons, these landscapes, these unbelievable lines which leave in us so many deep impressions."[178] The letters also express his impatience with tame, conventional views of nature "as we have learned to see it in the travel sketchbooks of young ladies" or as his former teacher in the Municipal Drawing School saw it. "These people perceive correctly," he remarked, "but they have the eyes of professors."[179]

Yet Cézanne is aware that even the most stirring spectacle is not equivalent to a pictorial subject, and he writes from L'Estaque that in looking across the bay he has "some beautiful views, but they do not quite make motifs."[180] What then does? The clearest indication is in one of his last letters: "Here on the bank of the [Arc] river the motifs multiply, the same subject seen from a different angle offers subject for study of the most powerful interest and so varied that I think I could occupy myself for months without changing place, by turning now more to the right, now more to the left."[181] Thus the motif is a configuration of lines or planes discovered when the natural subject is seen from a specific viewpoint; a different one would yield a different configuration. The watercolor *Pont des Trois Sautets* (pl. 113), painted in the very months when the letter was written, reveals one such pattern in the trees and the bridge behind them. But broad as it is, even this definition of "motif" is too narrow: it accords with our tendency to equate the structural in Cézanne's art with the linear and planar aspects, perhaps because these anticipate most clearly certain geometric and abstract tendencies in subsequent art. Those who spoke to him about the matter in his last years also emphasize other aspects.

According to Rivière and Schnerb, he sought to transform a subject into a motif by achieving "a perfectly balanced whole . . . by the logic of the reproductive process, by working out the balance of the luminous and shaded parts."[182] Denis reports that the motif was for Cézanne "a delicate symphony of juxtaposed tones . . . attached to the logical support of a composition, a plane, an architecture."[183] This emphasis on tonal and coloristic qualities, although less relevant to the classically constructed works of the eighties and early nineties, seems particu-

larly appropriate to those of the last decade. In unfinished paintings like *Houses on a Hill* (Venturi 1528) and *The Garden at Les Lauves* (pl. 79), the planar structure is reduced to a simple scaffolding, to which the brilliant color modulations are attached. In many late watercolors, too, the pictorial interest resides entirely in the sequences of color washes, whose progressions and spacings reveal an exquisite sensibility; the shimmering, opalescent *Trees Reflected in the Water* (pl. 87) is a beautiful example.[184]

So refined had Cézanne's responsiveness to this aspect of his art become by the end of his life that he could create different pictorial structures while depicting the same subject from the same viewpoint. In two watercolors of a cliff in the park of the Château Noir, one in St. Louis (pl. 43), the other in London (pl. 42), he achieves strikingly different effects—or rather, discovers them in responding simultaneously to the light and color of the scene and to the possibilities of the medium.[185] In the more airy and delicate St. Louis version, he superimposes on a rough pencil sketch thin washes of blue, green, and reddish brown that are sufficiently transparent for the lines to remain visible. Shapeless, isolated spots of color, the washes are generally diagonal like the pencil shading and evenly distributed, though there is some concentration at the contours of major forms. In the more earthy and solid London version, he works directly with the brush, allowing the touches of saturated color to define forms through their shapes and contrasts of tone. Here the stroke is much more varied and represents texture as well as mass: broad, diluted washes are reserved for rock surfaces, heavier ones for shadows and dark crevices, and fine curling marks for outgrowths of foliage. Appropriately, too, the surface of the more descriptive London watercolor is filled to the edges, while the peripheral areas of the more abstract St. Louis version are untouched, creating an elliptical field like that in Analytic Cubist paintings.

Thus the broadest definition of the concept of the motif, such as the one given by Rivière and Schnerb, is probably the best: "a section of nature encompassed by [the artist's] view and for that very reason isolating itself, making a whole of what is a fragment."[186] In the late works Cézanne often achieves that unity through the subtle manipulation of color and texture rather than form. The *Park of the Château Noir* (pl. 49), for example, is constructed on the framing of a view by trees, like many earlier landscapes, yet it lacks their strong centrality and seems at first diffuse. Only gradually do clear distinctions between the center and the periphery emerge: the greatest contrasts, especially between the deep orange earth and the bluish-white cliffs and trees, and the richest, most heavily applied paint are in the center, while in the periphery the colors are more muted and the surface more thinly covered. In *Mont Sainte-Victoire Seen from Bibémus* (pl. 37), the central cliff, the cleft beside it, and the tree below it form by their greater brilliance of color and density of pigment a hidden center of interest, ultimately more compelling than the mountain itself. These complex and varied means of unifying

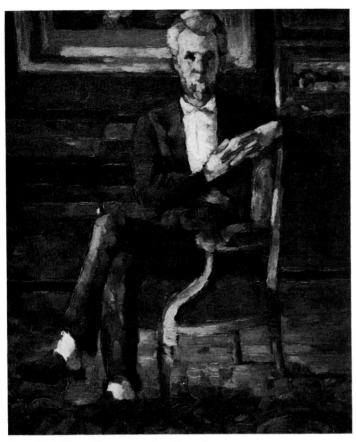

Portrait of Victor Chocquet. c. 1877. Venturi 373
Oil on canvas, 18⅛ x 15 in (46 x 38 cm)
Columbus Gallery of Fine Arts, Ohio

the visual field are also implicit in Cézanne's often-quoted explanation to Gasquet of what constitutes a motif: bringing his hands slowly together and interlacing his fingers, he says, "there mustn't be a single link too loose, not a crevice through which may escape the emotion, the light, the truth."[187] It is the very gesture that he had represented about 1877 in his portrait of Victor Chocquet (Venturi 373), and appropriately that work is also among the earliest examples of his search for a cohesive, highly integrated surface, one, in other words, in which the subject is transformed into a motif.[188]

From the time his work was first discussed in the 1890s down to the present, Cézanne's treatment of pictorial space has been recognized as one of his most striking innovations. That "nature is in depth" was a favorite axiom of his; that "nature for us men is more depth than surface" occurs again in introducing his most important statement on perspective, in a letter to Bernard of April 15, 1904.[189] It is all the more disappointing, then, to find in that pronouncement an altogether conventional idea, based on a method of linear construction which originated in the Renaissance: "Treat nature by means of the cylinder, the sphere, the cone, everything brought into proper perspective so that each side of an object or a plane is directed towards a central point." And as if to remove any doubt, he writes again to Bernard a few months later: "The edges of the objects flee towards a center on our horizon."[190] Clearly Cézanne has in mind traditional perspective, as it was taught in art schools and popularized in manuals like Jean-Pierre Thénot's *Principes de perspective pratique,* which he reportedly owned.[191] Yet in practice he avoids such effects by eliminating orthogonal lines or modifying their angle of convergence, by tilting up receding horizontal planes to reconcile them with the picture surface, by bringing distant forms into closer relation with those in the foreground; and he does so even when the subject contains strongly convergent elements, such as an alley of trees or a receding road.[192] Does this mean that we cannot "interpret Cézanne's statement as anything but a contradiction of his work"?[193] Only if his subject is assumed to be the representation of space, whereas he is actually concerned with the depiction of objects. As we shall see, he recommends the use of receding planes of graded tonality in order to enhance the effect of roundness while modeling a form. He says nothing about the use of converging lines to create an illusion of deep space, and thus does not contradict his practice.

On the contrary, Cézanne goes on in the same letter to advocate a means of suggesting depth that is perfectly consistent with his practice: "Lines parallel to the horizon give breadth. . . . Lines perpendicular to this horizon give depth." This sounds at first like another echo of conventional theory, but only if the "lines perpendicular to the horizon" are mistaken for orthogonals (these would be truly perpendicular, not converging). Instead they should be understood as verticals both in depth and on the picture surface; and this reading is confirmed by a remark of Cézanne's reported by the poet Jean Royère: "At the Ecole des Beaux-Arts one indeed learns the rules of perspective, but one has never understood that depth is achieved by a juxtaposition of vertical and horizontal planes, and that in fact is perspective."[194] How is depth thus achieved? Presumably by placing vertical planes, or lines marking their edges, at diminishing intervals in space and linking them with horizontal planes or lines at similar intervals, thus producing an effect of recession without convergence. Cézanne's use of this method is most evident in just those views of receding alleys and roads where strict convergence is eliminated and the distances between trees, and those between their shadows on the ground, progressively diminish (e.g., Venturi 628, 649).[195] It is also evident in certain landscapes after 1900, despite their lack of a firm linear structure, in the gradual diminution in the scale and spacing of the color patches (e.g., pls. 72, 75)—a method that Mondrian, too, was later to adopt in a more schematic form in his Pier and Ocean pictures.

In landscapes of the later nineties, however, Cézanne employs the more familiar device of overlapping planes, clearly outlined and graded in color intensity, to create an illusion of space. He told Osthaus that "the main thing in a picture is the effect of distance; the colors must reveal every interval in depth," and

went on to "trace with his fingers the boundaries of the planes in his pictures, explaining precisely how far they succeeded in suggesting depth and where they failed."[196] They were discussing a Bibémus landscape, no doubt the one Osthaus acquired for the Folkwang Museum (pl. 31), and when it is compared to a photograph of the motif, its overlapping planes do appear more strongly marked and more clearly organized.[197] To distinguish them while working in the blinding light, Cézanne often shaded his eyes, a trick he had learned from Chardin. "What a rascal that Chardin was with his visor," he remarked to Bernard, and putting his index finger between his eyes he added, "Yes, that way I have a clear view of the planes."[198] Cézanne's source was not a text, but one of the older master's self-portraits in the Louvre: in writing to Bernard about "the fine pastel by Chardin, equipped with a pair of spectacles and a visor," he asked whether he had noticed that "by letting a light plate ride across the bridge of the nose the tone values present themselves better to the eye."[199]

In the letter of April 15, 1904, Cézanne also speaks of atmospheric perspective, of "the need to introduce into our light

Alley at Chantilly. c. 1888. Venturi 628
Oil on canvas, 31⅞ x 25½ in (81 x 65 cm)
Private collection

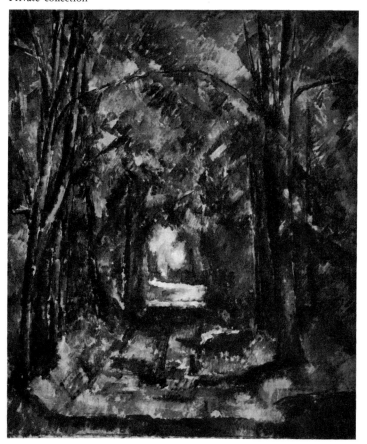

vibrations, represented by the reds and yellows, a sufficient amount of blueness to give the feel of air." The theme recurs in one of his last letters, where, in speaking of his "ideas and sensations," he exclaims, "long live the Goncourts, Pissarro and all those who have the impulse towards color, representing light and air."[200] But nowhere else does he mention his use of blue, which plays so prominent a part in suggesting mood as well as atmosphere in his landscapes of these years. In the *Pines and Rocks* (pl. 52), for example, a bright blue vibrates in the intervals between the reddish-brown trunks and branches, pulses amidst the equally vibrant green and yellow foliage, and merges imperceptibly with the pale gray sky, vividly conveying the circulation of air. In one version of the *Château Noir* (pl. 57), the strokes of deep blue and green in and around the trees also create a sensation of air, yet they are applied so thickly that they become an integral part of the paint fabric, blurring the distinction between solid and void. And in the so-called *Blue Landscape* (pl. 71), heavy veils of somber blue and green, pervading the sky and earth as well as the masses of foliage, evoke not only an atmosphere, but a mood of profound stillness and sadness, like that in Picasso's virtually contemporary Blue Period pictures.[201]

It is unfortunate that Cézanne's remark on "treating nature by means of the cylinder, the sphere, the cone," made merely to introduce the one on perspective, was soon separated from it and has remained so ever since. This has made it impossible to understand what he meant by either statement or to reconcile it with his practice. In itself, the idea of reducing nature's diversity to simple geometric solids is as conventional as that of rendering its depth in perspective, and like that idea has provided a basis for much academic instruction. Asked by Jourdain for guidance, Cézanne advised him to follow that very method—to paint his cylindrical stove pipe by distinguishing the light, shade, and half-tones.[202] And he in turn was undoubtedly recalling advice he had received many years earlier in the Municipal Drawing School of Aix or had read in one of the manuals of self-instruction popular in the first half of the century. Thus Pierre-Henri de Valenciennes and Jean-Philippe Voiart recommend that the student begin by learning to draw fundamental forms—cubes, cylinders, spheres—rather than by copying engravings, as had been the practice earlier; and Thénot, already noted as a source for Cézanne's ideas on perspective, specifically mentions the cylinder, the cone, and the sphere.[203] Charles Blanc's *Grammaire des arts du dessin,* a standard summary of academic thought, discusses only the cube and the sphere, but in idealistic terms which show how much the Platonic notion of geometric forms as the origin and essence of natural ones persists in the nineteenth century.[204] In fact a Greek inscription, found among the ruins at Pergamon and published in 1809, states explicitly that "the cone, the sphere, and the cylinder are divine things and provide pleasing forms."[205]

More important, this Platonic interpretation was imposed on Cézanne's purely practical advice from the beginning. When he offers it, in a conversation reported by Bernard, the latter's

idealistic aesthetic leads him to reply that geometric forms are "contained in everything we see, they are its invisible scaffolding."[206] In the Cubist studios, where such ideas were common, Cézanne's statement, divorced from its context and enhanced by his prestige, quickly gained currency. An article on Picasso of 1910 already refers to Cézanne as a master "for whom nature was sphere, cone, and cylinder," and in a later treatise Gleizes maintains that "he spoke of the cylinder, cube, and sphere, thinking that their purity could unify everything."[207] And when, as happens here, the cube is added to the other solids, the distortion of Cézanne's meaning becomes complete. For he chose them only as forms whose curving surfaces recede from the eye, and in another letter to Bernard he says as much: "[The eye] becomes concentric through looking and working. . . . In an orange, an apple, a ball, a head, there is a culminating point; and this point is always—in spite of the tremendous effect, light and shade, color sensations—the closest to our eye."[208] Eventually he was able to see such convexity everywhere: one of the axioms recorded by his son was that "bodies seen in space are all convex"; and according to Rivière and Schnerb, he applied it equally to "a definitely spherical or cylindrical object and to a flat surface like a wall or floor."[209] This would explain those constant modulations from light to dark and from warm to cool in the coloring of bare surfaces such as tabletops and walls in his late still lifes (e.g., pls. 148, 149). In the one with pomegranates and pears (Venturi 733), for example, the color shifts perceptibly from orange to violet to blue to green not only on the ginger jar, the floral drapery, and the white cloth, but on the blank wall in the center that is so curiously framed and made conspicuous by the other elements.

Such effects were products not only of theory, but of Cézanne's habitual method of applying color in sequences of small, graded units, which he called "modulating." Having discovered, as he told Denis, that sunlight "could not be reproduced, but had to be represented by something else . . . by color," he was forced to transpose the immense scale of natural color into the more limited one at his disposal.[210] This in turn obliged him to determine the precise chromatic equivalents of tones normally perceived as dark and light, "to do with color what used to be done with black and white shading."[211] Thus he had to find equivalents within his own chromatic scale of the light and shade he observed on objects of various local colors. To do so, he prepared his palette with as many as eighteen pigments, arranged in series like musical scales, as Delacroix's were (his *Journal,* published in 1893, was undoubtedly familiar to Cézanne), and applied them systematically, working up the scale from dark, cool, relatively neutral tones to light, warm, relatively vivid ones and at the same time moving from the shaded edges of a form to its illuminated or salient center.[212] This can be seen most easily in the late watercolors, where washes of Prussian blue mark the areas of shadow and provide a foundation for those of progressively warmer tone superimposed on them.[213] As a result, the coloring in Cézanne's late pictures, like the form it

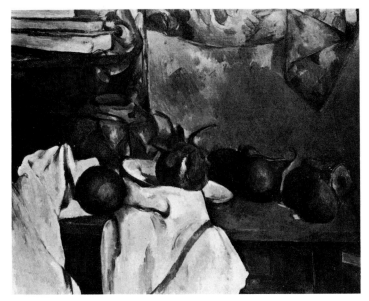

Still Life with Pomegranates. 1895–98. Venturi 733
Oil on canvas, 18¼ x 21⅝ in (46 x 55 cm)
The Phillips Collection, Washington

defines, has a musical or geometric character, though in contrast to certain twentieth-century styles built on it, it does not depart radically from familiar local color. Those who visited him in his last years, particularly the artists—Bernard, Denis, Rivière and Schnerb—dwell on the novelty of this procedure.[214] But in those very years he often abandoned this patient, disciplined method and applied color in large patches, marking the major planes of forms rather than their modulations; this is especially evident in the unfinished landscapes (e.g., pl. 115 and Venturi 1528) and still lifes (e.g., pls. 142, 147).

As a system of coloring built on the layering of semitransparent warm and cool tones, Cézanne's modulations can be understood as a modern equivalent of the Venetian Renaissance masters' underpainting and glazing.[215] Preoccupied with their methods in his last years, he continued to confront the works of Titian, Tintoretto, and Veronese in the Louvre as he had when still a student, determined to wrest from them their technical secrets. For he was convinced that those methods, once a source of ease in execution, had been lost, and he told the poet St-Georges de Bouhélier in 1899: "Today we understand nothing at all about the important matters. The masters of the past knew how to work. We possess only bits and scraps of their secrets."[216] According to Gasquet, it was especially their methods for preparing and underpainting the canvas that he sought to understand, and the frequent references to Venetian art in his last letters and reported conversations confirm this interest.[217] So, too, does his extensive use in the nineties of underpainting and toned grounds, which enabled him to build up a complex color structure from thinly applied layers of paint, rather than working directly with opaque pigments on a white canvas, as he

had done in the previous decade and as the Impressionists continued to do. His shift in the later period to underpainting in washes of variously cool and warm tone, over which complementary ones were applied more heavily, may well reflect his closer study of Venetian practice in those years. This approach is particularly apparent in one of the *Smokers* (Venturi 564), whose richness of color results from the scumbling of opposed and nearly complementary tones—reddish brown and reddish green—over each other, and in the *Park of the Château Noir* (pl. 51), whose canvas was first stained in bright red and green, then reworked in heavier, more subdued tints that allow the previous ones to shine through. Once again, however, the very late works are an exception, for they are often painted directly on a primed canvas (e.g., pls. 85, 124), despite Cézanne's earlier objection to this procedure.

For all its constructive and expressive power, color alone was not sufficient; line was also needed, and some of Cézanne's most familiar statements concern the relation of the two. They are often cited in debates on the relative importance of color and drawing in his art. Some historians maintain that he "removed all linear contours . . . [and] positively constructed the whole picture with tones," or that the lines, which after all do occur, merely define the edges of receding color planes, which constitute the "real supports of the pictorial structure."[218] But others insist that "the fundamental spatial relations remain clear when . . . the basic planes are established only with outlines," or even that, given his way of applying color to a linear framework, proceeding from the contour into the mass, "drawing is perhaps the key factor" in his art.[219] In fact, the two elements are equally essential and ultimately inseparable, as Cézanne was perfectly aware.

If he opposed the purely decorative use of a black contour line by Gauguin and his followers as "a fault which must be fought at all costs,"[220] Cézanne favored the constructive use of it in defining form and space. For if lines do not exist in nature, as he never tired of observing,[221] they do exist in pictures. According to Rivière and Schnerb, outlining in black was a practical necessity; it enabled Cézanne to "correct the proportion of a form by beginning with the contour, before modeling it in color."[222] But he also thought of it in a larger, more synthetic sense, as a device for locating and arranging the elements of a composition, and in advising the painter Charles Camoin to "strive to achieve a good method of construction," he added, "Drawing is only the outline of what you see."[223] Thus it played as central a role in the creation of form and space as coloring did, and the two were in fact developed simultaneously. "Drawing and color are not at all separate," he explained to Bernard; "while one paints, one draws; the more the color harmonizes, the more the drawing becomes precise. When the color is at its richest, the form is at its fullest. Contrasts and relations of tone, that is the secret of drawing and modeling."[224] The same ideas, repeated almost verbatim, appear among the aphorisms recorded by Cézanne's son.[225] And it is

clear from the *pentimenti* in his paintings that he altered forms, sometimes drastically, as he harmonized their colors: many of the figures in the Barnes version of the *Large Bathers* (pl. 187) fluctuated in size, and Denis confirms this;[226] a strip of several inches was added at the bottom of one of the portraits of Vallier (pl. 22); several such strips at the right side of a *Mont Sainte-Victoire* (pl. 125), at the bottom and left side of a *Château Noir* (pl. 55), and so forth. In fact, line had by now been so completely absorbed into Cézanne's painting that he felt little need to employ it independently of color. For the last decade, only about seventy-five pencil drawings, or seven percent of the total, are known, and they are largely copies after older art, made in small portable notebooks.[227] Individually, many of them are superb examples of his incisive and rhythmic handling of line, but collectively they do not form a significant part of his late work.

Thus the much-debated opposition of drawing and color, a continuation in effect of a controversy begun in the seventeenth century between followers of Poussin and Rubens and pursued in the nineteenth between partisans of Ingres and Delacroix, is largely irrelevant to Cézanne's practice as well as his theory. At a given moment in his last years, his style may be incisively linear, as in the Philadelphia *Large Bathers* (pl. 189), and almost abstractly coloristic, as in the *Bank of a River* (pl. 78); and within a given picture it may oscillate between the two poles, as in the still lifes with richly colored, strongly outlined forms (pls. 146, 166). Moreover, even when a line appears most precise it is never a continuous contour, but consists of short, thin strokes, like those of the color planes, and is drawn with the same rhythmic movements; together, they define relations between forms and also affirm the constructed character of the surface.[228] Often the lines are not uniformly dark blue, but vary in color in response to those of the objects they bound: in the *Park of the Château Noir* (pl. 47), for example, they are brown, gray, and black, as well as blue. Often, too, their breaks and repetitions enable a form to fuse momentarily with those adjacent to it, increasing the integration of color and drawing, as well as of surface and depth. These so-called "passages," which were soon to be employed more systematically in Analytic Cubism, were probably not conceived as such, but resulted from Cézanne's habit of alternating between color and line in the slow, cumulative shaping of a form.[229] It is never entirely closed by its contour, never entirely open to adjacent forms, but oscillates between the two. In one late *Mont Sainte-Victoire* (pl. 119), almost identical tones of gray, green, ocher, and rose occur in the trees, the mountain, and the sky, and only their sharply drawn outlines separate them. In another version (pl. 37), the contours of the foreground trees, half-obliterated by extensive repainting, are redefined in some places but remain so open in others that the trees seem to dissolve into the rock cliffs behind them. In this, as in so many other aspects of his late work, Cézanne makes the very process by which he transforms nature into art the very substance of his art.[230]

NOTES

1. Paul Cézanne, *Letters,* ed. John Rewald, 4th ed. (New York: Hacker Art Books, 1976), p. 303, to Emile Bernard, May 26, 1904.
2. Paul Klee, *Diaries,* ed. Felix Klee (Berkeley: University of California Press, 1964), p. 237. Alfred H. Barr, Jr., *Matisse: His Art and His Public* (New York: Museum of Modern Art, 1951), p. 87. Daniel Henry Kahnweiler, *My Galleries and My Painters,* trans. Helen Weaver (New York: Viking Press, 1971), p. 55.
3. Robert Delaunay, *Du cubisme à l'art abstrait,* ed. Pierre Francastel (Paris: S.E.V.P.E.N., 1957), p. 58.
4. [Amédée] Ozenfant, *Foundations of Modern Art,* trans. John Rodker (New York: Dover Publications, 1952), p. 68.
5. Marcel Jean, *The History of Surrealist Painting,* trans. Simon Taylor (New York: Grove Press, 1960), p. 12.
6. Hans Hofmann, "The Search for the Real in the Visual Arts," in Sam Hunter, *Hans Hofmann* (New York: Abrams, 1964), p. 41.
7. Roger Fry, *Cézanne: A Study of His Development* (New York: Macmillan, 1927), p. 79. See *Cézanne in Perspective,* ed. Judith Wechsler (Englewood Cliffs: Prentice-Hall, 1975), pp. 9-12.
8. Meyer Schapiro, *Paul Cézanne* (New York: Abrams, 1952), especially pp. 27-30, 94-126. The content of the late work is also discussed perceptively in Lionello Venturi, *Cézanne: son art—son oeuvre* (Paris: Paul Rosenberg, 1936), 1: 61-65; and in Kurt Badt, *Das Spätwerk Cézannes* (Constance: Universitäts Verlag, 1971).
9. Venturi, *Cézanne,* 1: 61.
10. Maurice Denis, "Cézanne," *Théories, 1890-1910,* 4th ed. (Paris: Rouart et Watelin, 1920), p. 246; from *L'Occident,* September 1907.
11. Gustave Geffroy, "Cézanne," *La Vie artistique,* 3e série (Paris: Dentu, 1894), pp. 249-50.
12. See Theodore Reff, "Cézanne and Poussin," *Journal of the Warburg and Courtauld Institutes* 23 (1960): 150-74; and John Rewald, *Cézanne, Geffroy et Gasquet* (Paris: Quatre Chemins, 1960), pp. 19-55.
13. The documentary evidence is collected with exemplary thoroughness in Robert Ratcliffe, "Cézanne's Working Methods and Their Theoretical Background" (Ph.D. dissertation: University of London, 1960), pp. 21-32, on which I have relied heavily.
14. See Cézanne, *Letters,* pp. 239-40, to Geffroy, April 4 and June 12, 1895; and Camille Pissarro, *Lettres à son fils Lucien,* ed. John Rewald (Paris: Albin Michel, 1950), pp. 398-99, to Lucien Pissarro, February 6, 1896. The portrait was abandoned definitively in April 1896; see Gustave Geffroy, *Claude Monet* (Paris: Crès, 1922), p. 197.
15. Joachim Gasquet, *Cézanne,* 2nd ed. (Paris: Bernheim-Jeune, 1926), pp. 91-92. Marie Gasquet, untitled memoir, in *Tombeau de Cézanne* (Paris: Société Paul Cézanne, 1956), pp. 32-33.
16. See the previous note.
17. See Gasquet, *Cézanne,* p. 111; and Rewald, *Cézanne, Geffroy et Gasquet,* p. 29.
18. See Georges Rivière, *Le Maître Paul Cézanne* (Paris: Floury, 1923), p. 221; and Cézanne, *Letters,* p. 253, to Joachim Gasquet, September 29, 1896.
19. Ambroise Vollard, *Paul Cézanne* (Paris: Galerie A. Vollard, 1914), p. 149, note 1.
20. Gasquet, *Cézanne,* p. 112. See Martin Davies, *National Gallery Catalogues: French School, Early 19th Century . . .* (London: National Gallery, 1970), pp. 19-21.
21. Ambroise Vollard, *Recollections of a Picture Dealer,* trans. Violette Macdonald (Boston: Little, Brown, 1936), p. 185.
22. Geffroy, *Claude Monet,* p. 197.
23. Paul-André Lemoisne, *Degas et son oeuvre* (Paris: Brame et de Hauke, 1946-49), vol. 2, no. 517; and note 39, below. See also *Cézanne dans les Musées Nationaux* (Paris: Musées Nationaux, 1974), no. 45.
24. A watercolor study for it (Venturi 1096) is on the verso of one painted at Talloires (Venturi 965). For Cézanne's presence there, see his *Letters,* pp. 250-51, to Joachim Gasquet, July 21, 1896.

25. Lawrence Gowing, in *An Exhibition of Paintings by Cézanne* (London: Tate Gallery, 1954), no. 51.
26. Gertrude Berthold, *Cézanne und die alten Meister* (Stuttgart: Kohlhammer, 1958), nos. 83-87.
27. Rewald, *Cézanne, Geffroy, et Gasquet,* p. 34 and fig. 9.
28. Interview with Léontine Paulet, July 1955, in Marcel Provence Archives, Atelier Paul Cézanne; cited in Ratcliffe, "Cézanne's Working Methods," pp. 19-20. Alexis, letter to Zola, February 13, 1891; cited in John Rewald, *Cézanne: sa vie, son oeuvre, son amitié pour Zola* (Paris: Albin Michel, 1939), p. 336, cf. p. 237.
29. See, among others, Douglas Cooper, "Two Cézanne Exhibitions," *Burlington Magazine* 96 (1954): 380; Lawrence Gowing, "Notes on the Development of Cézanne," *Burlington Magazine* 98 (1956): 191; and Kurt Badt, *The Art of Cézanne,* trans. Sheila Ogilvie (Berkeley: University of California Press, 1965), pp. 88-89.
30. Venturi 684, given to Alexis before he returned to Paris in April 1892, is described as in his collection in Geffroy, "Cézanne," p. 259.
31. See Germain Bazin, *French Impressionist Paintings in the Louvre,* trans. S. Cunliffe-Owen (New York: Abrams, n.d.), p. 114.
32. See Theodore Reff, "Cézanne and Hercules," *Art Bulletin* 48 (1966): 40.
33. Ibid. See also Theodore Reff, "Cézanne, Flaubert, St. Anthony, and the Queen of Sheba," *Art Bulletin* 44 (1962): 117-18.
34. See, for example, the painting by Bernardino Licinio (Ashmolean Museum, Oxford) and the engraving by Giulio Campagnola (Hind 20). The pose has also been related to Delacroix's *Tasso in the Madhouse;* see Sara Lichtenstein, "Cézanne and Delacroix," *Art Bulletin* 46 (1964): 60.
35. Gasquet, *Cézanne,* pp. 30-31.
36. Cézanne, *Letters,* p. 215, to Emile Zola, May 14, 1885. Alexis, letter to Zola, February 13, 1891; cited in Rewald, *Cézanne: sa vie, son oeuvre,* pp. 239-40.
37. See Elizabeth Fraser, *Le Renouveau religieux d'après le roman français de 1886 à 1914* (Paris: Belles Lettres, 1934); and, on Cézanne's practice, M.C., "Quelques souvenirs sur Paul Cézanne," *Gazette des beaux-arts* 56 (1960): 299-302.
38. On the latter, see *Impressionist and Post-Impressionist Paintings from the U.S.S.R.* (Washington: National Gallery of Art, 1973), no. 4; also note 155, below.
39. See Theodore Reff, "Pissarro's Portrait of Cézanne," *Burlington Magazine* 109 (1967): 627-33; and idem, "Manet's Portrait of Zola," *Burlington Magazine* 117 (1975): 35-44.
40. See Ludovic Pissarro and Lionello Venturi, *Camille Pissarro: son art, son oeuvre* (Paris: Paul Rosenberg, 1939), vol. 1, no. 206. I plan to discuss the self-portrait and related works in the near future.
41. See Edgar Munhall, in *"Les Environs d'Aix-en-Provence" by Paul Cézanne* (New York: Wally Findlay Galleries, 1974), for the Lancret source; and Ratcliffe, "Cézanne's Working Methods," pp. 50-51 and note 128 on the *Peasant with a Blue Blouse.*
42. See Geffroy, *Claude Monet,* p. 197; and Georges Grappe, *Catalogue du Musée Rodin, I. Hôtel Biron* (Paris: Musée Rodin, 1927), no. 90.
43. Geffroy, *Claude Monet,* p. 196.
44. See Maurice Denis, *Journal* (Paris: La Colombe, 1957-59), 1: 157, dated October 21, 1899. Cézanne's letter to Marthe Conil, May 16, 1899 (*Letters,* p. 268), may also refer to this portrait.
45. Ambroise Vollard, *Paul Cézanne: His Life and Art,* trans. Harold Van Doren (New York: N. L. Brown, 1923), p. 138.
46. See Edward Fry, *Cubism* (New York: McGraw-Hill, 1966), p. 20 and figs. 20-21, though here the differences are stressed.
47. Reported in St-Georges de Bouhélier, "Simplicité de Cézanne," *L'Echo de Paris,* June 15, 1936. For the works, mainly copies, that Cézanne would have seen, see José Lopez-Rey, *Velázquez* (London: Faber and Faber, 1963), nos. 135, 251, 285, 389, 398; particularly interesting in relation to the Vollard portrait is no. 285.
48. Vollard, *Paul Cézanne,* 1923 ed., pp. 123, 126.
49. Denis, *Journal,* 1: 157, dated October 21, 1899.
50. Angelica Rudenstine, *The Guggenheim Museum Collection: Paintings 1880-*

1945 (New York: Guggenheim Museum, 1976), 1: 52–53, citing John Rewald's opinion.

51. Ibid., p. 53.

52. See Robert Herbert, in *Jean-François Millet* (Paris: Musées Nationaux, 1976), p. 82; and, for other meanings of the gesture, Susan Koslow, "Frans Hals's *Fisherboys:* Exemplars of Idleness," *Art Bulletin* 57 (1975): 421, note 24.

53. See Venturi, *Cézanne,* 1: 60; and Schapiro, *Paul Cézanne,* p. 126.

54. Jules Borély, "Cézanne à Aix," *L'Art Vivant* 2 (1926): 493; based on a visit to Aix in July 1902.

55. See Ratcliffe, "Cézanne's Working Methods," p. 24; Gowing, in *Exhibition of Paintings by Cézanne,* no. 61; and Cooper, "Two Cézanne Exhibitions," p. 380.

56. See also the photographs taken in 1902–06 (Venturi 1603–05) and the self-portrait drawing dated 1896–1900 in Wayne Andersen, *Cézanne's Portrait Drawings* (Cambridge: M.I.T. Press, 1970), pp. 39–40, 68.

57. Cézanne, *Letters,* p. 337, from Marie Cézanne to Paul Cézanne *fils,* October 20, 1906.

58. Borély, "Cézanne à Aix," p. 491.

59. R. P. Rivière and J. F. Schnerb, "L'Atelier de Cézanne," *Grande Revue* 46 (1907): 817. It was probably this portrait that Charles Camoin and Francis Jourdain saw in 1904; see the latter's *Cézanne* (Paris: Braun, 1950), p. 9.

60. See Schapiro, *Paul Cézanne,* p. 126.

61. See, among others, Cooper, "Two Cézanne Exhibitions," pp. 344–49, 378–83; and Gowing, "Notes on the Development of Cézanne," pp. 185–92. For a critique of this assumption, see Theodore Reff, "Cézanne's Constructive Stroke," *Art Quarterly* 25 (1962): 215–19.

62. See the memoir of Albert Silvestre, "Un Peintre genevois a rencontré Cézanne," *Vie, art, et cité,* December 1939, pp. 319–20. The identification of the site has, however, been questioned; see Charles Sterling and Margaretta Salinger, *French Paintings . . . Metropolitan Museum of Art* (New York: Metropolitan Museum, 1967), 3: 117.

63. See, among others, Robert Herbert, *Barbizon Revisited* (Boston: Museum of Fine Arts, 1963), nos. 10, 41, 89, 98.

64. See Pierre Miquel, *Le Paysage français du xixᵉ siècle* (Maurs-la-Jolie: Editions de la Martinelle, 1975), 2: 230.

65. The later version, dated 1885–87 by Venturi, is convincingly redated 1897–98 in *The Hermitage: Western European Paintings of the Nineteenth and Twentieth Centuries* (Leningrad: Aurora Art, 1976), no. 72.

66. Erle Johnson, "Cézanne's Country," *The Arts* 16 (1930): 532.

67. Cézanne, *Letters,* pp. 156–57, to Zola, 1878, apropos *Une Page d'amour.*

68. Venturi, *Cézanne,* 1: 64.

69. Johnson, "Cézanne's Country," p. 530.

70. Edgar Allan Poe, *Complete Works,* ed. James Harrison (New York: Putnam, 1902), 3: 297. Baudelaire's translations of Poe's *Tales* appeared in 1856–57.

71. André Breton, *L'Amour fou* (Paris: Gallimard, 1937), pp. 155–57.

72. See Cézanne, *Letters,* p. 229, to Armand Doria, June 20, 1889.

73. Jean Cherpin, "L'Oeuvre gravé de Cézanne," *Arts et livres de Provence,* Bulletin 82 (1972), p. 34.

74. John Rewald and Léo Marschutz, "Cézanne au Château Noir," *L'Amour de l'art* 16 (1935): 15–21. Although Cézanne rented a room there from 1887 to 1902, most of his views of the château were painted between 1895 and 1906.

75. Achille Makaire, *Excursions aux environs d'Aix* (Aix: La Tour-Keyrié, 1894), p. 141.

76. John Rewald and Léo Marschutz, "Cézanne et la Provence," *Le Point* 1 (August 1936): 27. See Emile Solari's notes on excursions with Cézanne in this region in 1895, in Gerstle Mack, *Paul Cézanne* (New York: Knopf, 1935), pp. 327–29.

77. Cézanne, *Letters,* pp. 250, 245, to Joachim Gasquet, July 21 and April 30, 1896, respectively.

78. Rewald and Marschutz, "Cézanne et la Provence," p. 31. See also the photographs reproduced in Erle Loran, *Cézanne's Composition,* 3rd ed. (Berkeley: University of California Press, 1963), pp. 72, 117, 118.

79. Schapiro, *Paul Cézanne,* p. 118.

80. Edmond and Jules de Goncourt, *Manette Salomon,* 2nd ed. (Paris: Char-

pentier, 1894), pp. 244–45. On Cézanne's admiration for the novel, see Vollard, *Paul Cézanne,* 1923 ed., p. 169.

81. See Theodore Reff, "Cézanne's Bather with Outstretched Arms," *Gazette des beaux-arts* 59 (1962): 177–78; and Diane Lesko, "Cézanne's 'Bather' and a Found Self-Portrait," *Artforum* 15 (December 1976): 52–57.

82. Cézanne, *Letters,* p. 250, to Joachim Gasquet, July 21, 1896; see also pp. 270–71, to Henri Gasquet, June 3, 1899.

83. It has also been dated as early as c. 1887 and as late as 1895–97; see Sterling and Salinger, *French Paintings,* 3: 116.

84. See note 24, above.

85. Venturi, *Cézanne,* 1: 229.

86. See Germain Bazin, "Cézanne et la Montagne Sainte-Victoire," *L'Amour de l'art* 19 (1938): 377–83.

87. Reproduced in Loran, *Cézanne's Composition,* p. 60.

88. See Venturi, *Cézanne,* 1: 64–65; and Schapiro, *Paul Cézanne,* pp. 30, 124.

89. See Makaire, *Excursions aux environs d'Aix,* pp. 77–91; and the paintings by François-Marius Granet, Joseph Villevieille, and Marius Engalière in the Musée Granet, Aix-en-Provence.

90. See also the watercolor illustrated in Miquel, *Paysage français,* 1: 62. On Cézanne's admiration for Granet, see Emile Bernard, *Souvenirs sur Paul Cézanne* (Paris: Michel, 1926), p. 55; and Gasquet, *Cézanne,* p. 26.

91. Makaire, *Excursions aux environs d'Aix,* pp. 78, 84–85.

92. Pls. 98, 99 are not listed in Venturi; for the former, see John Coplans, *Cézanne Watercolors* (Los Angeles: Ward Ritchie, 1967), no. 36. On Cézanne's admiration for the cathedral, see Denis, *Journal,* 2: 28, dated January 26, 1906.

93. See Bernard, *Souvenirs,* pp. 47–48, 55; based on a visit to Aix in February–March 1904, when Cézanne was working on Château Noir motifs. On the rooms he rented there, see Léo Larguier, "Souvenirs sur Cézanne," *Journal des Débats,* March 13, 1926.

94. On the origin of the earlier technique, see Reff, "Cézanne's Constructive Stroke," pp. 215–25; on the history of this analogy, Joseph Masheck, "The Carpet Paradigm: Critical Prolegomena to a Theory of Flatness," *Arts Magazine* 51 (September 1976): 82–109.

95. Geffroy, "Cézanne," p. 259. Karl Ernst Osthaus, "Cézanne," *Feuer; Monatsschrift für Kunst und Künstlerische Kultur* 2 (1920–21): 83. Denis, "Cézanne," p. 252.

96. See Meyer Schapiro, "Cézanne as a Watercolorist," in *Cézanne Watercolors* (New York: M. Knoedler, 1963), pp. 11–13.

97. Not listed in Venturi; see *Exposition Cézanne* (Tokyo: Musée National d'Art Occidental, 1974), no. 79.

98. Thus, the Oriental rug appears both in the *Young Italian Girl* (Venturi 701), painted in Paris (see note 18, above), and in the *Three Skulls on an Oriental Rug* (Venturi 757), painted in Aix (see note 113, below).

99. See the photographs of the studio reproduced in Johnson, "Cézanne's Country," p. 539, and in Loran, *Cézanne's Composition,* p. 13.

100. According to Gasquet, *Cézanne,* p. 102, he spent the winter of 1898–99 in Paris, painting "his large still lifes," among them no doubt some in this series. But since Venturi 732 first belonged to Geffroy, it was probably given to him by Cézanne before their relationship changed in 1896; see Ratcliffe, "Cézanne's Working Methods," p. 21.

101. Not listed in Venturi; see *Exposition Cézanne* (Tokyo), no. 52.

102. See John McCoubrey, "The Revival of Chardin in French Still-Life Painting, 1850–1870," *Art Bulletin* 46 (1964): 52–53.

103. This is also the opinion of Gowing, "Notes on the Development of Cézanne," p. 191.

104. It was one of two still lifes that, as Signac recalled, Alexis brought back from Aix in 1892; see Rewald, *Cézanne: sa vie, son oeuvre,* p. 336.

105. It is now attributed to Duquesnoy or Veyrier; see Robert Ratcliffe, in *Watercolour and Pencil Drawings by Cézanne* (London: Hayward Gallery, 1973), no. 59. On the *Flayed Man,* see ibid., no. 76; and Venturi 709.

106. See Gowing, in *Exhibition of Paintings by Cézanne,* no. 50; and Schapiro, *Paul Cézanne,* p. 98.

107. See Theodore Reff, "Cézanne et Poussin," *Art de France* 3 (1963): 304–5.

108. See Ratcliffe, "Cézanne's Working Methods," pp. 50–51 and note 128; he

also identifies it in the still lifes discussed below and in several other still lifes (Venturi 207, 503, 1134). Bernard, *Souvenirs,* p. 14, recalls seeing the screen in Cézanne's studio in 1904.

109. Cézanne, *Letters,* p. 330, to Bernard, September 21, 1906. Watercolors of the *Cupid* datable 1900–04 are Venturi 1081–83; of a skull, Venturi 1030–31.

110. Borély, "Cézanne à Aix," p. 493.

111. Not listed in Venturi. See *Katalog der Staatsgalerie Stuttgart* (Stuttgart: Stuttgarter Galerieverein, 1957), p. 63; and, for iconographic precedents, Ingvar Bergström, *Dutch Still-Life Painting in the Seventeenth Century,* trans. Christina Hedström and Gerald Taylor (London: Faber and Faber, 1956), pp. 171, 175.

112. Vollard, *Paul Cézanne,* 1923 ed., p. 181.

113. Bernard, *Souvenirs,* pp. 20, 63.

114. See, among others, Edmond Jaloux, "Souvenirs sur Paul Cézanne," *L'Amour de l'art,* 1 (1920): 285.

115. Cézanne, *Letters,* pp. 279, 288, 293, to Vollard, January 23, 1902, April 2, 1902, and January 9, 1903, respectively.

116. Ibid., pp. 279–80, to Vollard, January 23, 1902. See John Rewald, "Chocquet et Cézanne," *Gazette des beaux-arts* 74 (1969): 88–89.

117. Cézanne, *Letters,* p. 302, to Bernard, May 12, 1904. See John Rewald, "Quelques Notes et documents sur Odilon Redon," *Gazette des beaux-arts* 49 (1956): 96–100.

118. See, among others, Alfred Robaut, *L'Oeuvre complet d'Eugène Delacroix* (Paris: Charavay Frères, 1885), nos. 1041, 1072.

119. For Italian examples, see Giuseppe de Logu, *Natura morta italiana* (Bergamo: Istituto Italiano d'Arti Grafiche, 1962), pp. 132, 147; for a Flemish example, Peter Mitchell, *Great Flower Painters* (Woodstock: Overlook Press, 1973), p. 249.

120. *Principles of Art History,* trans. M. D. Hottinger (New York: Dover Publications, 1950), especially pp. 14–16.

121. See Schapiro, *Paul Cézanne,* p. 28.

122. See Berthold, *Cézanne,* nos. 183–86 (Desjardins, Girardon), 90–92 (Donatello, Desiderio), 1–9 (*Mars*), 37 (*Discophoros*), 96–107 (*Milo*), and 127–30 (*Caryatids*).

123. Cézanne, *Letters,* pp. 282, 309, to Camoin, February 3, 1902, and December 9, 1904, respectively. Theodore Reff, "Reproductions and Books in Cézanne's Studio," *Gazette des beaux-arts* 56 (1960): 303–9.

124. Delaunay, *Du cubisme à l'art abstrait,* p. 72.

125. See, for example, the comments of Thiébault-Sisson, a sympathetic critic, quoted in Rivière, *Maître Paul Cézanne,* pp. 112–14.

126. Pissarro, *Lettres,* p. 388, to Lucien Pissarro, November 21, 1895.

127. Denis, "Cézanne," p. 255.

128. Fry, *Cézanne,* p. 77. For D. H. Lawrence's reaction to this view, see his "Introduction to These Paintings," 1929, reprinted in *Cézanne in Perspective,* pp. 92–93.

129. Fritz Novotny, "Der Reiz des Unvollendeten bei Cézanne," *Du; Europäische Kunstzeitschrift* no. 218 (April 1959): 46–49, 66–67.

130. Silvestre, "Un Peintre genevois," p. 319.

131. These are Venturi 323, 325, 334, 336, 454, 459, 464, 465, 478, 489, 594, 600, 660, of which the last one has some uncovered areas.

132. Silvestre, "Un Peintre genevois," p. 319; he specifically mentions the many still lifes in Cézanne's studio. See also Rivière and Schnerb, "L'Atelier de Cézanne," p. 816.

133. Cézanne, *Letters,* pp. 316–17, to Bernard, October 23, 1905.

134. Gasquet, *Cézanne,* p. 130. See Fry, *Cézanne,* pp. 64–65; and Loran, *Cézanne's Composition,* pp. 15, 127.

135. See note 126, above.

136. Quoted in Denis, "Cézanne," p. 252. Picasso later expressed the same idea; see Hélène Parmelin, *Picasso: The Artist and His Model* (New York: Abrams, 1965), p. 150.

137. See Alfred Neumeyer, *Paul Cézanne: Die Badenden* (Stuttgart: Philipp Reclam, 1959), pp. 3–10.

138. Emile Zola, *L'Oeuvre,* ed. Maurice Le Blond (Paris: Bernouard, 1928), pp. 37–38; published in 1886.

139. Ibid., pp. 39–40. On its autobiographical origin, see Rewald, *Cézanne: sa vie, son oeuvre,* pp. 18–23.

140. Vollard, *Paul Cézanne,* 1923 ed., p. 126. See note 44, above.

141. Rivière and Schnerb, "L'Atelier de Cézanne," p. 817.

142. Bernard, *Souvenirs,* pp. 22, 63. See also Bernard's letter to his mother, February 5, 1904, in *Art-Documents* no. 50 (November 1954): 4. One of his photographs, incorrectly dated 1905, is reproduced in Loran, *Cézanne's Composition,* p. 9.

143. Borély, "Cézanne à Aix," p. 491.

144. Vollard, *Paul Cézanne,* 1923 ed., p. 127. Le Bail's memoir, in Rewald, *Cézanne: sa vie, son oeuvre,* p. 388. Rivière, *Maître Paul Cézanne,* pp. 222–23.

145. Osthaus, "Cézanne," p. 84. See Davies, *National Gallery Catalogues,* pp. 22–23.

146. Denis, *Journal,* 2: 29, dated January 26, 1906.

147. Gasquet, *Cézanne,* pp. 54–55. His detailed description, ibid., pp. 56–57, is clearly based on a reproduction.

148. This is also the sequence proposed, on the basis of visual evidence alone, in Melvin Waldfogel, "A Problem in Cézanne's *Grandes Baigneuses,*" *Burlington Magazine* 104 (1962): 203–4. A different sequence, with Venturi 721 before Venturi 720, has been suggested in Davies, *National Gallery Catalogues,* pp. 22–23.

149. See Neumeyer, *Paul Cézanne,* p. 14.

150. Sidney Geist, "The Secret Life of Paul Cézanne," *Art International* 19 (November 1975): 8–9.

151. Ibid., pp. 10–16; and Badt, *Spätwerk Cézannes,* p. 53.

152. Venturi 540 is inscribed "5 mai 1896." Waldfogel, "Cézanne's *Grandes Baigneuses,*" p. 203, likewise dates it 1890–95, though he dates Venturi 539 c. 1888.

153. See the memoir of Rougier, in Georges Charensol, "La Vie de Cézanne à Aix-en-Provence," *L'Intransigeant,* January 31, 1939; and that of Edouard Aude, dated 1907, in *Tombeau de Cézanne,* p. 7.

154. See Berthold, *Cézanne,* nos. 204–13; and Lichtenstein, "Cézanne and Delacroix," p. 56, note 6, nos. 14–17.

155. Venturi 582 was painted before 1890–91, since its lower edge is visible in the background of the *Smoker* (Venturi 686) of that date.

156. Douglas Druick, "Cézanne, Vollard, and Lithography: The Ottawa Maquette for the 'Large Bathers' Colour Lithograph," *National Gallery of Canada Bulletin* 19 (1972): 11–12.

157. For the seated figure at the right, cf. the one in Venturi 383, 386; for the seated figure at the left, the one in Venturi 720, 721.

158. See Druick, "Cézanne," p. 20; and, for another explanation, Melvin Waldfogel, "Caillebotte, Vollard, and Cézanne's *Baigneurs au Repos,*" *Gazette des beaux-arts* 65 (1965): 114–17.

159. Gasquet, *Cézanne,* p. 55. Cézanne, *Letters,* p. 322, to his son, August 12, 1906.

160. Not listed in Venturi; illustrated in Jiri Siblik, *Paul Cézanne: Zeichnungen und Aquarelle* (Hannover: Fackelträger, 1971), pl. 37.

161. Bernard, *Souvenirs,* p. 76. Osthaus, "Cézanne," p. 84.

162. Bernard, *Souvenirs,* p. 22. Francis Jourdain, "A propos d'un peintre difficile: Cézanne," *Arts de France,* no. 5, 1946: 7. On his plan to use photographs of models, see Jean de Beucken, *Un Portrait de Cézanne* (Paris: Gallimard, 1955), pp. 259–60.

163. Fry, *Cézanne,* p. 82.

164. See Schapiro, *Paul Cézanne,* p. 116; and Theodore Reff, "Cézanne: The Enigma of the Nude," *Art News* 58 (November 1959): 29.

165. Neumeyer, *Paul Cézanne,* p. 16. For the copies, see Berthold, *Cézanne,* nos. 19–23, 10–18.

166. Rivière and Schnerb, "L'Atelier de Cézanne," p. 815. On his admiration for Veronese, see ibid., p. 817; and Cézanne, *Letters,* p. 282, to Camoin, February 3, 1902.

167. Denis, *Journal,* 2: 29, dated January 26, 1906.

168. Ibid. On the Delacroix, and Cézanne's copy of it, see note 116, above.

169. Berthold, *Cézanne,* nos. 61–64, 248–51.

170. For copies of it, see ibid., nos. 279–81; and Theodore Reff, review of

ibid., in *Art Bulletin* 42 (1960): 148, where the source is identified.

171. Sara Lichtenstein, "A Sheet of Cézanne's Copies after Delacroix," *Master Drawings* 5 (1967): 182–87.

172. Fry, *Cézanne,* p. 82. See also Loran, *Cézanne's Composition,* pp. 94–95.

173. See Carla Gottlieb, "The *Joy of Life:* Matisse, Picasso, and Cézanne," *College Art Journal* 18 (1958): 110; and John Golding, *Cubism: A History and an Analysis, 1907–1914,* 2nd ed. (New York: Harper & Row, 1968), pp. 49–51.

174. Rivière and Schnerb, "L'Atelier de Cézanne," p. 815.

175. Cézanne, *Letters,* p. 231, to Octave Maus, November 27, 1889.

176. Rivière and Schnerb, "L'Atelier de Cézanne," p. 811. See also Camoin's letter to Matisse, December 2, 1905, in Daniel Giraudy, "Correspondance Henri Matisse–Charles Camoin," *Revue de l'art* 12 (1971): 9–10.

177. Ratcliffe, "Cézanne's Working Methods," pp. 309–76. Rewald, *Cézanne: sa vie, son oeuvre,* pp. 397–410.

178. Cézanne, *Letters,* pp. 250, 271, dated July 21, 1896, and June 3, 1899, respectively. See also the memoir of Jean Royère, "Un Aixois: Joachim Gasquet," *Le Mémorial d'Aix,* December 15, 1929, quoting Cézanne on the Provençal landscape.

179. Cézanne, *Letters,* pp. 250, 158–59, to Joachim Gasquet, July 21, 1906, and Zola, April 14, 1878, respectively.

180. Ibid., p. 209, to Zola, May 24, 1883.

181. Ibid., p. 327, to his son, September 8, 1906.

182. Rivière and Schnerb, "L'Atelier de Cézanne," p. 816.

183. Denis, "Cézanne," p. 251.

184. Not listed in Venturi; see *Exposition Cézanne* (Tokyo), no. 79.

185. See Theodore Reff, "Cézanne: The Logical Mystery," *Art News* 62 (April 1963): 29–30, where a third version (Venturi 1043) is also discussed.

186. Rivière and Schnerb, "L'Atelier de Cézanne," p. 816.

187. Gasquet, *Cézanne,* p. 130. See Loran, *Cézanne's Composition,* p. 15.

188. See Schapiro, *Paul Cézanne,* p. 50; and, on the connection between this picture and Cézanne's remark, Gowing, in *Exhibition of Paintings by Cézanne,* p. 10.

189. Cézanne, *Letters,* p. 301. Cézanne's axiom, along with many others reported by his son, is in Léo Larguier, *Le Dimanche avec Paul Cézanne* (Paris: L'Edition, 1925), p. 136.

190. Cézanne, *Letters,* p. 306, to Bernard, July 25, 1904.

191. De Beucken, *Portrait de Cézanne,* p. 304. Jean-Pierre Thénot, *Principes de perspective pratique . . . ,* 2nd ed. (Paris: L'Auteur, 1837), pp. 14–18.

192. See Loran, *Cézanne's Composition,* pp. 47–55; and Fritz Novotny, *Cézanne und das Ende der wissenschaftlichen Perspektive* (Vienna: Schroll, 1938), pp. 32–47.

193. Loran, *Cézanne's Composition,* p. 8.

194. Jean Royère, "Paul Cézanne, Erinnerungen," *Kunst und Künstler* 10 (1912): 485. He met Cézanne about 1896 through Gasquet.

195. For a later example, see the drawing *Study of Trees* of 1896–99; Adrien Chappuis, *The Drawings of Paul Cézanne* (Greenwich, Conn.: New York Graphic Society, 1973), no. 1180. See in addition the watercolors Venturi 845, 942.

196. Osthaus, "Cézanne," p. 82.

197. See Loran, *Cézanne's Composition,* p. 70; also the comparison in ibid., pp. 114–15.

198. Bernard, *Souvenirs,* p. 36; see also ibid., p. 71, and Gasquet, *Cézanne,* p. 123.

199. Cézanne, *Letters,* p. 305, dated June 27, 1904. See McCoubrey, "Revival of Chardin," p. 52; and Georges Wildenstein, *Chardin* (Greenwich: New York Graphic Society, 1969), no. 372, for the self-portrait.

200. Cézanne, *Letters,* p. 320, to his son, August 3, 1906. *Idées et sensations* was the title of a book published by the Goncourts in 1866.

201. On the meaning of blue for Cézanne, see Badt, *Art of Cézanne,* pp. 56–58, 79–82.

202. Jourdain, "A propos d'un peintre difficile," pp. 4–5. See also the remark reported by Denis, *Journal,* 2: 29, dated January 26, 1906: "I am searching for light—the cylinder and the sphere; I want to be able to produce black and white with color."

203. Jean-Pierre Thénot, *Morphographie; ou l'art de représenter . . . des corps solides* (Paris: L'Auteur, 1838), pp. 50–56. On Valenciennes and Voiart, see Georg Kempter, *Dokumente zur französischen Malerei in der ersten Hälfte des 19. Jahrhunderts* (Munich: Ludwig-Maximilians-Universität, 1968), pp. 342, 368.

204. Charles Blanc, *Grammaire des arts du dessin,* 2nd ed. (Paris: Renouard, 1870), pp. 572–76. Proposed as Cézanne's source in Christopher Gray, *Cubist Aesthetic Theories* (Baltimore: Johns Hopkins Press, 1953), p. 49.

205. Marie Florent, Comte de Choiseul-Gouffier, *Voyage pittoresque de la Grèce* (Paris: Barbié du Bocage et Letronne, 1809), 2: 171–72.

206. Bernard, *Souvenirs,* p. 94. On Bernard's Platonism, see Reff, "Cézanne and Poussin," pp. 151–52.

207. Léon Werth, "Exposition Picasso," *La Phalange,* June 1910; trans. in E. Fry, *Cubism,* p. 57. Albert Gleizes, *Peinture et perspective descriptive* (Sablons: Moly-Sabata, 1927), p. 9.

208. Cézanne, *Letters,* p. 306, dated July 25, 1904. See also Gottlieb, *"Joy of Life,"* pp. 110–11.

209. Rivière and Schnerb, "L'Atelier de Cézanne," pp. 813–14. For the axiom, see Larguier, *Dimanche avec Paul Cézanne,* p. 136.

210. Denis, "Cézanne," p. 253.

211. Ibid., p. 258, and Rivière and Schnerb, "L'Atelier de Cézanne," p. 814.

212. See Bernard, *Souvenirs,* pp. 23–24, 29, 49–51.

213. See Badt, *Art of Cézanne,* pp. 47–56; and idem, "Cézanne's Watercolour Technique," *Burlington Magazine* 82–83 (1943): 246–48.

214. Bernard, *Souvenirs,* p. 51. Denis, "Cézanne," pp. 258–59. Rivière and Schnerb, "L'Atelier de Cézanne," pp. 814–15.

215. Ratcliffe, "Cézanne's Working Methods," pp. 61–112, discusses this thoroughly. See also Loran, *Cézanne's Composition,* pp. 26, 30.

216. Bouhélier, "Simplicité de Cézanne."

217. Gasquet, *Cézanne,* pp. 166–68. See, among others, Cézanne, *Letters,* pp. 305, 309–10, to Bernard, July 25 and December 23, 1904, respectively.

218. See, respectively, Julius Meier-Graefe, *Cézanne,* trans. J. Holroyd-Reece (New York: Scribner's, 1927), p. 55; and Fritz Novotny, *Cézanne* (Vienna: Phaidon Press, 1937), pp. 11–13; also idem, "Cézanne als Zeichner," *Wiener Jahrbuch für Kunstgeschichte* 14 (1950): 225–40.

219. See, respectively, Loran, *Cézanne's Composition,* p. 10; and John Elderfield, "Drawing in Cézanne," *Artforum* 9 (June 1971): 52; also Chappuis, *Drawings of Paul Cézanne,* 1: 12–14.

220. Cézanne, *Letters,* p. 317, to Bernard, October 23, 1905.

221. Larguier, *Dimanche avec Paul Cézanne,* p. 135. Rivière and Schnerb, "L'Atelier de Cézanne," p. 813.

222. Ibid. See also Novotny, "Cézanne als Zeichner," pp. 232–33, 238.

223. Cézanne, *Letters,* p. 309, dated December 9, 1904. He goes on to distinguish between Michelangelo, "a constructor," and Raphael, "an artist who . . . is always tied to the model.—When he tries to become a thinker he sinks below his great rival."

224. Bernard, *Souvenirs,* p. 32.

225. Larguier, *Dimanche avec Paul Cézanne,* pp. 135–36.

226. Denis, "Cézanne," p. 256.

227. Chappuis, *Drawings of Paul Cézanne,* 1: 239–44, 251–61, 265–75, passim. Of the one hundred drawings listed, one-quarter should probably be redated before 1895.

228. Novotny, "Cézanne als Zeichner," pp. 236–38. See also John Rewald, in Paul Cézanne, *Carnets de dessins* (Paris: Quatre Chemins, 1951), 1: 9–11.

229. See Loran, *Cézanne's Composition,* pp. 26, 102–3; and André Lhote, *Traité du paysage* (Paris: Floury, 1939), p. 34.

230. I am indebted to Elizabeth Streicher for assistance in gathering material for this essay and to Patricia Ciaffa, Barbara Coffey, Fereshteh Daftari, Valerie Fletcher, Piri Halasz, Michael Marrinan, Marjorie Munsterberg, and Lucy Oakley, students in my Cézanne seminar at Columbia University in the spring of 1976, for many observations and suggestions.

The Logic of
Organized Sensations

Lawrence Gowing

ONE MIGHT WRITE the history of that order of originality which this century identifies as the essence of art—and eventually it must be written—as a history of inveterate misunderstanding. We cannot claim that the view of Delacroix that inspired Cézanne represented a true evaluation of him. The guiding star that Cézanne followed shone far more steadily than the flawed jewel of Romanticism ever did. And Delacroix himself, how shallow his interpretation of Rubens! Then Rubens—was not his merely sensuous appreciation of physical rhythms as the basis of style a gross misconstruction of the philosophical meaning that the human body held for Michelangelo? And so on . . . Yet this succession of creative misunderstandings was as nothing by comparison with the way that the twentieth century used Cézanne. The interpretations to which his example was subjected in the years after 1906 converted art into something new, something he would certainly have accepted even less than he accepted Gauguin, an order of image and a function of style neither of which had ever existed before.

The fact that Cézanne was open to such a radical interpretation, embracing the whole foundation of art, is enough to show that something quite extraordinary and unparalleled happened in the work of the old solitary in the years after 1900. Yet if we interpret this happening simply as a hermetic style—a novel kind of fragmentation, the development of discontinuity into pattern, or the elevation of concords of color and line into harmonies that were sufficient in themselves—then we are certainly missing something that shines out of both Cézanne's late oil paintings and his watercolors, different as they are in other respects. Cézanne's undiminished concern with the existent world is equally evident in his own commentary on his art in his last years. But we are in a difficulty; we do not have the critical equipment to evaluate the existential tenor of a formal style. If we seek to understand the development after 1900 as part and parcel of the evolution that we can trace in the four previous decades, we remain at a loss. From the 1860s onward Cézanne was a painter of objects. While his contemporaries painted effects, Cézanne painted things. In 1896 Gustave Geffroy described "the ardor of his curiosity and his desire to possess the things that he sees and admires."[1] For the great part of his achievement he remained rooted, as none of his contemporaries were, in direct and daily contact with a native countryside.

But after 1900 separable physical objects in Cézanne's work increasingly merge into the flux of color. The subject of the late landscapes becomes, as it never was before, chiefly the breadth and depth of nature—"or, if you prefer, of the spectacle that the Pater Omnipotens Aeterne Deus spreads out before our eyes."[2] Modern opinion has sometimes regarded the allover weave of color in these pictures as akin to Impressionism—a throwback and thus a retreat from the compositions of 1890 and the classicism of modern art. I was once advised by a good artist that Cézanne had begun as a progressive and ended as a reactionary. There are indeed signs of a reminiscent mood in the work of Cézanne's last years. Some of his last watercolors had more in common with the kind of subject that he had dealt with at Auvers more than thirty years earlier than with anything in his art since. Thinking of Pissarro and Impressionism in 1906, "How far away it all seems," he wrote, "and yet how near."[3]

Nevertheless, Cézanne's work from 1900 onward is radically different from the object-based structures of earlier years. Few now find the visual language of the late work obscure in any ordinary sense, but some certainly impute by association qualities that would have astonished Cézanne. I remember a collector's resentful glare, not much more than a decade ago, as she showed me an earlier flowerpiece and remarked, "That was before Cézanne went modern!" It would have been no defense to point out that in his last years Cézanne was reaching out for a kind of modernity that did not exist, and still does not. He was very aware, in one mood at least, of the sacrifices entailed in the seeming discontinuity and fragmentation of the style to which, as if involuntarily, he was led. These were the very characteristics that suggested ways of perception and patterns which the twentieth century has cherished most. The styles that Cézanne has inspired are hardly the promised land that he foresaw. In 1904 he resigned himself to being "the primitive of the way that I discovered,"[4] but if he had in mind, as is likely, a way that kept close to the naturalness of the real world, even this claim remains to be verified.

The vexed critical history of the late pictures in the seventy years since Cézanne's death, comparable to the fortunes of Beethoven's posthumous quartets, is significant. Comparing Cézanne's art of his thirties and of his sixties, we are in fact comparing two quite different kinds of rationale. The distinction was already clear to Maurice Denis when he wrote about Cézanne in 1907.[5] We turn from the logical mimetic theory of

Notes to this essay begin on page 70.

painting to another, one that is based on inherent meanings, for which, despite all that has happened, our critical framework is by comparison intuitive, based on a way of thought rather akin to free association. It yields the rich and satisfying returns that we find in modern art. A doubt remains; is this what Cézanne's powerful mind intended? Is this all that the fiercely prehensile eye was grasping at in the last years? If it was, we might think that the intense intellectual effort, with which the last utterances and the pictures too were stamped, was in a sense misdirected—even that some of Cézanne's remarks about his art contained an element of equivocation. It is not easy to think of Cézanne as the inventor of the kind of aesthetic double-talk that has been prevalent since. We recognize form that is voluminous without being solid, color that is luminous without light, representation that is apparently specific yet specifies nothing. We recognize, in fact, the contradictory kinds of reference that the paradoxes of our own art are built upon. In Cézanne, however, there is no paradox, but an order of pictorial statement full of an earnestness and a conviction that possess the single-minded moral dignity of tradition.

Cézanne himself was well aware how problematic his standpoint would be found. He developed an uncharacteristic longing for exegesis and explanation. A preoccupation with theory and with the status of theory filled his letters and his conversation. Posterity might have made better use of the lavish clues he offered. They are certainly needed. Contemplating the seminal works on which the twentieth century has depended so greatly, we are examining what aesthetic comprehension consists of in our age. We are considering what kind of sense we can claim to make of our own culture.

The move toward a disintegration of the object in some of the most memorable works of a painter so passionately attached to objects is the attraction and the riddle of Cézanne's last phase. The element that usurped its place, the patch of color in itself, had a history of its own in his art, one that is worth tracing. In the middle 1860s, when Cézanne for a time built pictures out of paint that was applied with a knife, in patches shaped by the knife-edge, his handling had an originality which has not always been understood. Among the Aix painters it is said to have caught on like an epidemic, and Pissarro appreciated it immediately; pictures like his still life at Toledo, Ohio, painted with the knife in the following year, show how well he understood its meaning. Earlier in the century knife-painting had been the mark of an attachment to what was actual and physical in a subject. It was so for Goya and for Constable and, in particular, for Courbet, who was Cézanne's inspiration. But only Cézanne realized that in the new context a picture that was touched with the knife should be painted with the knife throughout. He instinctively understood that in the new age the handling *was* the picture. The consistency of facture that Cézanne achieved makes a new kind of intrinsic material unity, which links the picture not only with the material significance of objects, but

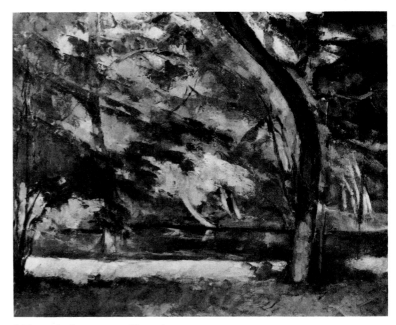

L'Etang des Soeurs. 1877. Venturi 174
Oil on canvas, 24 x 29¼ in (60.5 x 74 cm)
Courtauld Institute Galleries, London

with the common consistency of the material world.

The innovation of 1866 had also a wider significance. It was the sign of a new aesthetic, the aesthetic of extreme standpoints and total solutions—the most indubitable of all the many intimations of it in the 1860s—which effectively and finally isolated the avant-garde. The steps in the development of the Impressionist style and its sequels marked, fundamentally, the progress of just this aesthetic. The longest and most plainly irreversible of them all was the extreme and elusive standpoint that Cézanne took up in his last years. It is interesting that it was the palette-knife style of 1866 that Cézanne remarked on as virile in later years, not the curling, snakelike brushstrokes of the paintings before and after it. Impressionism involved a dissolution of the paint patch. But patches of color with straight edges applied with the knife reappeared at the next crucial stage in the emergence of Cézanne's originality eleven years later, when he painted *L'Etang des Soeurs* (Venturi 174) in the Courtauld Gallery. It was in 1877 that color differentiation took its place as a chief medium of definition in Cézanne's art, and no picture has a more crucial place in his development.

Although the color patches applied with the knife in *L'Etang des Soeurs* may be regarded as a last reminiscence of Courbet, who had lately died, and of the style that Cézanne had based on him, the parallel alignments of color patches propound the kind of structure that his work came to depend on twenty years later. Color patches like those in *L'Etang des Soeurs* appeared again, in watercolor first, around 1890. In the nineties the watercolor style eliminated the material substance that remained the subject of the oil pictures. The objects and space that they represented were now translated into apparently immaterial relationships of color.

The possibilities that emerged in the watercolors opened to oil painting in the late nineties. After 1895 groups of vertical brushstrokes formed into areas, at first irregular in shape, then more clearly and squarely bounded, at first delicately graded in color, then more and more widely differentiated—patches like detached facets, which drifted down and settled one against another between the points of precise figurative reference. But the increasing detachment and the relaxation of the need to describe and circumscribe the particular units of a design may conceal from us the fact that color patches still had a figurative function.

In one of the aphoristic "opinions" that Emile Bernard transcribed and published, with Cézanne's approval, in 1904, the figurative significance of the *tache* in the late style is described precisely.[6] "To read nature is to see it, as if through a veil, in terms of an interpretation in patches of color following one another according to a law of harmony. These major hues are thus analyzed through modulations. Painting is classifying one's sensations of color." Cézanne was a precise user of words. In his youth they had fascinated him, not only in his poetry but in his jokes, like the *Dictionnaire du langage Gautique* that he mailed to Zola when he was twenty. None of the painters of his time is likely to have been better educated—surely no other translated an idyll of Theocritus for pleasure. He certainly did not use the words "law," "harmony," "modulation" at all casually. He appears to have had in mind a system as reasoned as the descriptive method of earlier styles. The figurative reference is characterized quite poetically in the aphorism. There are other signs that his conversation was sometimes more literary and fanciful than his mature letters. Is it possible that he thought momentarily of comparing the color patches that portrayed the face of nature to the graded tones seen through the interstices of a lady's veil in the *grande époque*?

The appearance of a tonal homogeneity that recalls Impressionism in the years after 1900 is deceptive. The arrangement of color patches in the later pictures is certainly structured, but it never molds the form as color did in the eighties and early nineties. From the middle sixties, for more than thirty years, Cézanne's art had a solid physique, one that was remarkably constant, irrespective of subject. A grooved surface of rock or drapery is crowned by a dominating central block in the *Black Marble Clock* (Venturi 69) and the Baltimore *Mont Sainte-Victoire* (pl. 37) alike, painted thirty years apart. The same formation was echoed for a little longer, with the grooved cliff at the Bibémus quarry, now capped with the domed top of a tree. The last paintings do not have this physical shape. The structure is no longer one that we can imagine built. It is a property of the juxtaposition of colors on the flat surface. During the same years Cézanne's own remarks about the solidity of three-dimensional form were quite positive. In one of his letters to Emile Bernard he described how the eye ranges over the shape that is seen. "The eye becomes concentric by looking and working. I mean to say that in an orange, an apple, a *boule*

or a head, there is a culminating point and this point is always—in spite of the formidable effect of the light and shadow and the sensations of color—the point that is nearest the eye."[7]

In another letter he enunciated the traditional yet much debated principle that nature modeled itself on the sphere, the cylinder, and the cone.[8] With Cézanne this principle took on a special significance. Visitors to his studio in 1905 who found him, as he said, "applying himself to rendering the cylindrical aspect of things," reported that enunciating the formula he "would indicate indiscriminately an apple or another object that was actually spherical or cylindrical, or a flat surface such as a wall or floor."[9] This habit seems to have reflected an awareness of the fact that the line of vision from the eye meets a flat surface at every point at a different angle. At the right of a surface it is obviously seen more from the left; on the left the line of vision strikes it more from the right. The variation in the angles at which a flat surface presents itself to the eye is thus different only in degree from the angles at which the line of vision strikes a rounded surface. In this view flat planes share with forms of circular section a common property in the geometry of vision. Cézanne had a maxim to this effect, which his son reported to Léo Larguier: "Bodies seen in space are all convexes."[10] The varying angles of incidence of the lines of sight transmit to the eye light reflected from different sources—light necessarily of different colors. Cézanne's habit of pointing at a flat surface when he spoke of nature modeling itself on forms of circular section expressed, as his visitors concluded, a conviction that, notwithstanding the objective flatness of a plane, "if the painter spreads a single color over his canvas to represent it, he will reproduce it without truth." Cézanne's practice throughout his mature work conformed to the doctrine. Painting in the grounds of the Jas de Bouffan, for example, he often modulated the farmhouse wall as roundly as the tree trunks.

This application of Cézanne's principle illuminates another aspect of his thought. If, as it seems, he was exceptionally aware of the changing angle of incidence of the line of sight to lines that in actuality were straight, this explains a growing tendency to compensate for it. It accounts, for example, for the way horizontals in a landscape like the Zurich *Mont Sainte-Victoire* (pl. 124) fall into increasingly deep parabolas the farther below the horizon they are placed. Compensations of this kind represent an abandonment of the prime hypothesis of plane perspective. We have here the best evidence of Cézanne's own attitude to a part of his practice that has been much discussed on little documentary foundation. Moreover, it informs us about an aspect of his art so obvious that it usually escapes discussion altogether. It seems that a hypersensitive alertness to the varying angles at which the cone of sight meets a surface stimulated him to imagine the corresponding varieties of light and color that were reflected. He was well aware that his mutations of color originated as much in theory as in observation. When one of his visitors was puzzled to find him painting a gray wall green, he explained that a sense of color was developed not only by work

but by reasoning. In fact the need was both emotional and intellectual. The mutations of color with which he modulated surfaces that would have seemed to a less logical mind to require no modeling whatever were a necessity to him. It was this that Gauguin had failed to understand. Cézanne told Bernard, "I never wanted and will never accept a lack of modeling or gradation. *C'est un non-sens!*"[11] For him color modulation was the sense of painting.

We think of the significance of the affinities and contrasts as abstract. Cézanne himself referred to the color patches that he was using in 1905 as abstractions, and felt them to be in need of explanation. But he made it clear that they possessed a systematic figurative function, a function which though not descriptive was expository. The history of these expository systems of color, which appeared in the watercolors and ultimately permeated Cézanne's whole art, seems to begin soon after 1885—another of the points at which the direction of his work shifted, and evidently the time of an emotional reverse as well. It was a stage in Cézanne's progressive process of sublimation. The perceptual and material character of representation in the years before was eroded, so that the new images had an ascetic, almost impoverished look. It was subordinated to designs that were by contrast structural and bare of sensuous enrichment. The picture form was recognizably akin to the buildings which were among the first subjects of the phase at Gardanne. It was from this beginning that the architectural grandeur of the second half of Cézanne's work sprang. (It reminds one of an academic contemporary's comment on El Greco: "I call this laboring to be

The Green Pitcher. 1885–87. Venturi 1138
Pencil and watercolor, 8⅝ x 9¾ in (22 x 24.7 cm)
Cabinet des Dessins, Musée du Louvre, Paris

poor.") It was apparently at about this time that Cézanne made a watercolor exceptional in his work, *The Green Pitcher* (Venturi 1138) in the Louvre. While modeling the pot in rather listless pencil hatching, he suddenly abandoned the tonal method and stated the round shape in an arrangement of colors that was schematic rather than perceived. On either side of the *point culminant,* left blank on the paper—at first sight one could mistake it for the highlight on the pot, but it was nothing of the kind—the colors were arranged in order, first blue, then emerald green (to specify the material color of the pot), then yellow ocher. At this stage one hardly notices that a deliberate system is being employed, but close inspection leaves no doubt of it. No pot ever produced this logical sequence arranged like the blue, green, and yellow bands of the spectrum and spread out on paper in its natural order. On the contrary, the color sequence in the Louvre drawing produced the likeness of the pot, while a spot of complementary red at the base gave it its stance and the asymmetrical outline its pictorial poise, as if breasting a gentle current of space flowing away to the right into the distance.

In all these respects a work like *The Green Pitcher* propounded in elementary form the method and the way of thought that were to be developed and elaborated in the complex richness of Cézanne's later work. In oil paintings of the later eighties it appears that the color sequences in which form was modeled were increasingly independent of direct transcription of sense data. Across Mme Cézanne's cheek in the little portrait (Venturi 521) from the White Collection at Philadelphia, for example, the sequence is, first, green-blue, then carnation pink and a residue of almost bare canvas for the *point culminant,* then orange-pink and blue-green. The clear colors are abruptly stated so that they cannot be read as continuous modeling in light and dark. They convey the rounded surface metaphorically.

The watercolors of about the same time moved further in the same direction. Color patches spell out the form not tangibly but imaginatively, not forcefully but with a uniform and deliberate restraint. In drawings like the *Mont Sainte-Victoire* (Venturi 1023) in the Courtauld collection, diluted tints are placed in a wide-spaced series—yellow-green, emerald, and blue-gray. It is an emergent logic in the order, rather than anything one can imagine observing on the spot, that reconstructs the mass of the trees and links it with the mountain behind. In the oil landscapes of the later eighties variations of color, playing over large areas that were at first sight amorphous, emerged as a vehicle of expression. Related color mutations were noted in groups of brushstrokes in contrasting directions, beginning to form into discrete patches, with no reference to separable objects, amounting sometimes to a whirling blizzard of color changes, which left an even deposit of apparently random color differentiation.

The method that developed in the next decade was both more systematic and more detached. It was in watercolor rather than in oil paint, with its implications of material substance, that

Cézanne pursued his discovery that colors placed in order one against another carried an inherent suggestion of changes of plane. The series of colors, always in the order of the spectrum and always placed at regular intervals along it, mounted toward a culminating point; beyond that point, where it was repeated in the opposite order in the watercolors of the nineties, it gave a sense both of melodic response and of the continuous curvature of the surface. Cézanne was quite explicit about this; "the contrast and connection of colors," he told Bernard, "—there you have the secret of drawing and modeling." There was clearly a special value to him in the idea that nature was modeled on forms with a rounded section. The color series continually evoke the efflorescence of rounded surfaces. The system was sometimes complicated by the superimpositions with which he orchestrated his theme. At other times watercolor was used for fragmentary rehearsals of the way that sequences of color might re-create the form along a crucial contour. But the principle remained essentially the same. In place of the observed data of light and shadow, even replacing the dynamic thrusts which had been the core of natural structures, watercolor evoked changes of surface and the ideal roundness of mass as if in a code, but one that was not merely symbolic. It capitalized natural, almost physical reactions to the relationships and the contrasts inherent in intervals of color.

Emile Bernard, who watched Cézanne at work on a watercolor of Mont Sainte-Victoire in 1904, described the way in which color patches were used, essentially, throughout the late work: "His method was remarkable, absolutely different from the usual way and extremely complicated. He began on the shadow with a single patch, which he then overlapped with a second, and a third, until these patches, hinging one to another like screens (*faisant écrans*), not only colored the object but molded its form. I realized then that it was a law of harmony that directed his work, and that the course these modulations took was fixed beforehand in his mind . . . He deduced general laws, then drew from them principles which he applied by a kind of convention, so that he interpreted rather than copied what he saw. His vision was much more in his brain than in his eye."[12]

Even works of the later 1890s, in which the color elements were still shaped by the motif rather than formed into sequences of separate and consistent patches, were basically organized in the same way. In one of the watercolors of rocks at the Château Noir (pl. 42), which has affinities with the sandy-yellow and blue-violet polarity of color to which Cézanne tended around 1900, there is a spot of red exactly at the visual center, which marks the nearest point in the noble front of rock as the *point culminant* of the whole picture. Receding from it the colors compose a brilliant descant on the local hue, ending in violet blue. A related, simpler sheet in the Pulitzer Collection (pl. 43) offers deepening echoes of a single progression; in both it is the color, not the description, that makes the form. The mass of trees in the watercolor (pl. 90) of a Provençal farmhouse at The

Museum of Modern Art, which seems to date from the late 1890s, is rendered by a constellation of four colors, blue over green, then, to the right of them, yellow over a very pale wash of red. The tensions between them portray the shifting axis of the volumes.

The "opinions" recorded by Bernard included the maxim "One should not say modeling, one should say modulation." It is difficult to know how many of the associations of the word *moduler* were intended. Perhaps all of them. The meaning of tempering, the employing of a standard measure, and the musical analogy itself may all have played some part. As a young man Cézanne had painted his sister playing the overture to *Tannhäuser;* in later years he named Weber as his favorite composer and liked to hear *Oberon* or *Euryanthe* in the evening. (Elaborate parallels between his method and music are apt to provoke *un soupir étouffé* more like a yawn than Baudelaire's romantic sigh.) Modulation implies a transition through clearly perceptible stages. Smooth monochromatic modeling always seemed to Cézanne a falsification. But it is possible that in later years he may have thought of shifts in the range of colors in his code, which sometimes seem to evoke changes in the direction of the curvature that is evoked, as comparable to changes of key. In the watercolor of the farm at The Museum of Modern Art, blue is nearly everywhere coupled with green. Where it gives place to the juxtaposition of yellow and red and the alignment of the form appears to change, it may be that Cézanne thought of himself as passing to the next scale. In any case the possibility is enough to show that this is a procedure in which reason and calculation are inseparable from the poetics. Similarly, the occurrence of a pale but definite pink near the middle of a form that is ostensibly green indicates how far these progressions are from any direct reliance on empirical data. Cézanne regarded everything, "art in particular"—but apparently everything else as well, as if he had some Neo-Platonic doctrine at the back of his mind—as "theory developed and applied in contact with nature."[13]

Sheets like the *Bridge under Trees* (pl. 95) in the Steinberg Collection show the sphere and cylinder in their ideal perfection. Specific local color virtually vanished. A single color series based on green and blue is consistently deployed as an equivalent to the great blossoming of form. *Bridge under Trees* must have been painted at about the time in 1897 when Cézanne sent Gasquet his definition of art as "a harmony parallel with nature." Here the musical reference was at least balanced by a more general sense of the word. The idea of color as harmony in Neo-Classical thought and perhaps in Cézanne's own goes back to antiquity. Pliny, writing of the beginnings of painting among the Greeks, drew exactly Cézanne's distinction: ". . . the range between light and shade they called *tonos*—strength; the relationships and transitions between colors they called harmony."[14]

At the end of the 1890s there were, in fact, two distinct systems of color in use in Cézanne's work. In the oil paintings color brought together (in general) the observations of na-

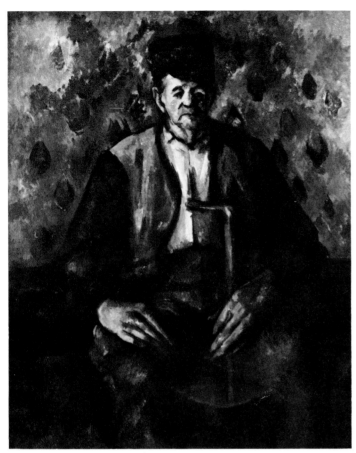

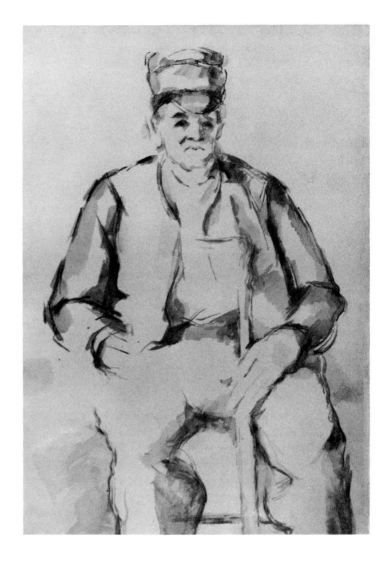

Above: *Seated Peasant with a Stick* (pl. 14). c. 1900. Venturi 713
Oil on canvas, 28⅜ x 23 in (72 x 58.5 cm)
Collection Christian de Galea, Paris

Right: *Seated Peasant* (pl. 15). 1900–04. Venturi 1089
Watercolor, 18½ x 12⅝ in (47 x 32 cm). Kunsthaus, Zurich

ture—local hues, their mutual reflections, the atmosphere and light surrounding them—and presented their combinations and interpenetration in heightened form. The watercolors, on the other hand, translated form into metaphoric sequences of color, which operated through the gradations of color interval rather than identifying any local hue or effect of light that could be observed and transcribed from a subject. The distinction is clear in the difference between the watercolor (pl. 15) and the oil painting (pl. 14) of the *Seated Peasant with a Stick.* In the watercolor the key of blue modulating into yellow and pink formed a conventional system for the notation of the actual bulk. When the lumpy shapes of the model had been elucidated on paper Cézanne could proceed to the pyramidal formulations from which he built the structure on canvas—forms that taper upward from the elbows toward the head and downward to the hands, making a diamond shape, which was painted in the specific earthy colors of the subject (colors of which there is no sign in the watercolor) and reinforced by the pattern of the wallpaper behind. The painting, which appears more "real,"

with a more objective and material reference, is in fact more schematic. The drawing is straighter; the planes are flatter. It seems that the conventional coloration of the watercolor served a functional purpose. It was needed to grasp the actual volumes; it was a digestive system. Only when the complex solidity had been grasped were the schematic structure and indeed the naturalness within reach. In this case the imposing simplicity of the painting was evidently arrived at in two stages. In other pictures the two processes, analytic and synthetic, were combined in a single operation. The pictures show complex permutations of metaphoric color with the hues that were specific to the subject. The combination of two quite different methods is enough to account for the immense labor, indeed the eventual impossibility, of completing a picture like the *Portrait of Vollard* (pl. 4). The labor was shared by the sitter, and Vollard's famous record of it has led some to think that Cézanne was always a laborious painter. The size of his output is enough to show that his procedures were in essence far from labored. But the method in his last years was an increasingly deliberate one,

as he brought together and coordinated the two processes.

Vollard's account of the sittings in 1899 provide incidentally the best evidence we have that Cézanne thought of relationships of color as actual conjunctions of form. Vollard ventured to mention two patches of bare canvas in the hands of his portrait—and received an answer that astonished and intimidated him. "If my study in the Louvre presently goes well, perhaps tomorrow I shall find the right color to fill the white spaces. Just understand, if I put something there at random, I should have to go over the whole picture again starting from that spot."[15] It is understandable that the gaps were not mentioned again, and the canvas remains bare at these points to this day. The studies that Cézanne made in the museum were pencil drawings, particularly from Baroque sculpture, which emphasized its rhythmic sequences—studies, in fact, of a style that would seem to have no point of contact with the rectilinear severity of Vollard's portrait. But for Cézanne the relationships of color—and color existed only in relationships; the story makes clear that he was unable to apply it in any other connection—were evidently akin to the physical articulation of forms that he drew in line in the museum. The linear sequences of the Baroque exercised the very

Portrait of Vollard (pl. 4). 1899. Venturi 696
Oil on canvas, 39½ x 32 in (100.3 x 81.3 cm)
Musée du Petit Palais, Paris

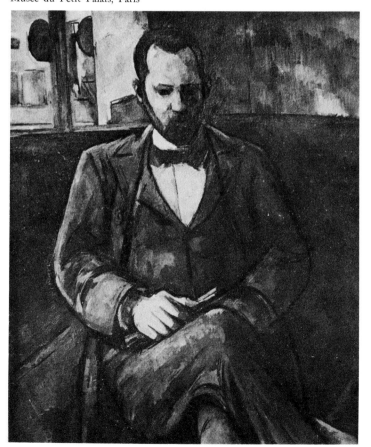

faculty that was employed in his procedure of placing color patches side by side.

After 1900 Cézanne's figurative method married the material equation with the metaphoric system. But to regard these complex systems as entirely figurative hardly accounts for the independence of their parallel with nature. Repeatedly in art, before and since, an artist has found his figurative instrument so magical that he has come to glory in it as an order of reality in itself. As his style developed, Cézanne seems to become concerned not only with form but with the fabric of color differentiation as such. He had always been interested in the segmented surfaces of foliage. It had often become the obsessive essence of a landscape. But by 1900 it seems quite uncertain whether the tilt of individual leaves was meant to be legible in a drawing like the study of foliage (pl. 168) in The Museum of Modern Art. It seems rather that the brilliant vibration of red, emerald, and violet, repeating in every combination across the great sheet, reflects an absolute intoxication with color contrast as an order of reality in itself, a complete world. He finds in it a morphology of its own, endowing the stems that pass through it with a sexual thrust. Color contrasts become the internal life of art. He found that painting could make nothing else and needed nothing. "There is no such thing as line or modeling," he told Emile Bernard; "there are only contrasts." He lived by them. We can imagine him living among them. He saw the same fabric of color outside his window and painted it percolating through the iron tracery of the balcony in his watercolor.

This self-sufficient fabric of color contrast, which is hardly legible as form in any specific or detailed sense, was occasionally the sufficient theme of watercolors in particular in the years around 1900. But side by side with this there is another use of color, forming sequences that we read, however metaphorically, quite naturally as volume. In one group of oil pictures, a little later, the colors fan out as if around the circumference of disks, which take on a general but indubitable volumetric meaning, making spherical segments that succeed one another diagonally across the canvas. In the *House on the Hill* (pl. 62) from the Loeser Collection in Washington, it seems that one can locate precisely the successive *points culminants*. Some of these points are gray-blue; others are ocher-pink. Around these the sequences arrange themselves in spectrum order—one repeated progression is through emerald, cobalt, the blue-gray culmination, and violet; in another, crimson is succeeded by Venetian red, the pink apex, and golden ocher. In another picture, formerly in the Clark Collection, he used a similar formulation in another key for the trees mounting the hillside to the Château Noir. A related system remains perceptible in the *Blue Landscape* (pl. 71), which seems to have been painted at Fontainebleau in 1905.

Our understanding of Cézanne's purpose is evidently incomplete if we do not follow the determination, of which he spoke so often, to read nature. It was one of his favorite phrases. It recurs in the letters; it was his constant objective. "Reading the

model (*la lecture du modèle*) and realizing it are sometimes very slow in coming for the artist."[16] The word echoes through the "opinions" transcribed by Bernard. He begins with a couple of remarks differentiating the "'pernicious classicists' who deny nature or copy it with their minds made up" from Gothic art, which "belongs to the same family as we do." Then he begins his exhortation: "Let us read nature, let us realize our sensations in an aesthetic that is at once personal and traditional." So Bernard made him say, at all events, without provoking any complaint. Indeed, the record was approved "on the whole."[17] The observation ends: "The strongest will be the one who sees most deeply and realizes fully, like the great Venetians." Two observations later, he gives the definition that I have quoted: "To read nature is to see it . . . in terms of an interpretation in patches of color," and the fifteenth observation (which forms a conclusion, though Bernard added conversational remarks and paragraphs out of recent letters) notes that the doctrine "is all summed up in this: to possess sensations and to read nature."

To follow Cézanne's thought we have to feel the force of his terminology. Here too he seems to have been well aware of the situation. Over and over again the crux of his art theory was a definition of the terms that he was using or a meditation on the validity of definitions. Theory was indispensable to him, though from another standpoint it was obviously superfluous—totally useless. He told Bernard, who was the recipient not only of the largest part of his theoretical teaching but of his warnings against art talk, that he did not want to be right in theory but in nature.[18] In a jocular mood at a café, he announced to Aurenche that it was not his business to have ideas and to develop them.[19] But it was his business, and he remained haunted by the two parallel necessities. For painting one had to have both a way of seeing and a system of thought—both *une optique* and *une logique*.[20] Devoting oneself entirely to a study of nature, one tried "to produce pictures that are an instruction."[21] Fifteen years earlier, he had already explained his isolation: "I must tell you . . . that I had resolved to work in silence until the day when I should feel myself able to defend in theory the results of my attempts."[22] His regret in the last months of his life was that he could not "make plenty of specimens of my ideas and sensations." The two aspects of painting were inseparably coupled. They occupied him equally. "There are two things in the painter," he announced in the fifth of the "opinions" that Bernard recorded, "the eye and the mind; each of them should aid the other. It is necessary to work at their mutual development, in the eye by looking at nature, in the mind by the logic of organized sensations, which provides the means of expression."

Has any painter explained his artistic constitution more intelligently and exactly? Cézanne's terminology was precise; yet it is enigmatic in just the same way as the visual propositions in the late pictures. What did he mean by "sensations"? What did "realization" in fact involve? The late works are his own meditations on just these questions. Sensations were the root of everything for Cézanne. From the beginning to the end of his career,

they were his pride and justification. In 1870, when he was interviewed for the *Album Stock* on submitting his entries for the Salon, the sensations of which he boasted seem to have comprised not only the data of sight but feelings also. "I paint as I see, as I feel—and I have very strong sensations. The others, too, feel and see as I do, but they don't dare . . . they produce Salon pictures . . ."[23] In his last years, they were sometimes still described in the same terms, as "the strong sensation of nature—and certainly I have that vividly."[24] The pride and the assurance that sensations gave him remained unaltered; they served him as a defense. "As sensations form the foundation of my business, I believe myself invulnerable."[25] Yet at the same time they were also being defined rather differently. The fifth "opinion" in 1904 established them as something organized by logic in the mind. So far from regarding them simply as sense data (as is often thought), he more than once implicitly distinguished them from perceptions.[26] The sensations for which he continued to seek an expression to the end of his life, as he explained to Henri Gasquet, the friend of his youth, were "the confused sensations which we bring with us when we are born."[27] The word had, in fact, a double meaning—contact with nature "revived within us the instincts, the artistic sensations (*sensations d'art*) that reside within us." The double meaning of the word corresponds to the dual significance attaching to the paint marks themselves in the late work. It is in the last two years of Cézanne's life that the sensations are identified precisely as color sensations,[28] the sensations of color that give light.[29] It was in view of these that he most regretted his age, as he told his son two months before he died.[30]

At this final stage sensations were thus senses of color which were as much innate as experienced. They were the chief object of the painter's efforts; they influenced all the "opinions" published by Bernard. Painting was first and foremost a matter of "realizing" them.

The idea of realization was central to Cézanne's purpose; his use of the word has a history in itself. One can trace the steps by which it took on a meaning rather beyond the general usage, and quite distinct from the common meaning of completion. In his vocabulary it first appeared to mean simply the satisfaction of natural wishes. It was used in this sense in the letter to Chocquet, which propounded a touching landscape metaphor for the reverse that he had suffered in 1885 and his failure to secure "the realization of wishes for the simplest things which should really come about of their own accord . . ."[31] He used the same word in wishing Solari fulfillment of his "legitimate hopes" in his marriage.[32] The aspirations that fulfilled themselves naturally for others seemed doomed to difficulty and frustration for Cézanne. The erotic drive was sublimated in the pursuit of a consummation in art, which was eventually described as "to realize." It inherited the same emotional impetus and labored under a similar difficulty. The unsatisfied longings for either companionship or realization were indeed linked together in his

thought. In his pathetic explanation to Gasquet of his self-inflicted isolation in his fifties, he wrote: ". . . the pleasure must be found in work. If it had been given to me to realize, I should have been one to relax in my corner with the few studio companions that I used to have a drink with . . ."[33] Eight years later, he had to explain to a correspondent, whose solicitude touched him deeply, that he did not have the "freedom of spirit" to write a letter "after a whole day working to overcome the difficulties of realizing from nature."[34] Cézanne's phrase was *réalisation sur nature*. The realization was *on* nature, like a variation or a descant. What was real in art was essentially separate and different from the actuality of nature. "What is one to think of those fools who tell one that the artist is subordinate to nature?" Cézanne had demanded of Gasquet nine years before. "Art is a harmony parallel to nature."[35] The faith shared by the Impressionists and the Realists before them, a belief that a condition of rightness in an image would transfer some virtue in the subject directly into art, was entirely opposed to his. Only the basis in observation remained, and the love of "this beautiful nature" which embraced everything visible, "man, woman, still life," so long as the light was right.[36] It was coupled not only with "a mistrust of the photographic eye, the automatic accuracy of drawing taught in the Ecole des Beaux-Arts," as visitors to his studio in 1905 reported, but a more sweeping disbelief in the whole conception of representation as a reflex action, isolated from intellectual interference and pursued as if stupidly, on which enlightened studio practice in the nineteenth century was supposed to have been based. It was "a mistrust of any movement in which the eye would direct the hand without reason intervening."[37] Again, it emerges that Cézanne's faith was not only in nature but in logic.

Cézanne was equally careful in speaking of representation. In his logical way he distinguished between representing and reproducing. The sun, for example, was something that one could only represent, not reproduce.[38] In general he preferred the idea of interpreting to that of representing, in its usual sense. To read nature was "to see it . . . in terms of an interpretation," as he told Bernard, and one of Gasquet's reports that ring truest recorded how Cézanne, casting about for a word to express just this distinction, lighted on it at last with relief: "I have it! It is an interpretation." His position was complicated by the fact that he remained equally aware of the opposite, traditional way in which an image worked, and this must have formed part—the intellectual ingredient—of his difficulty. In the same year, most likely, that he put to Bernard his basic definition of painting from nature, he also mentioned to him a need that seemed to contradict it. "Some imitation is necessary, and even a little deception of the eye. That does no harm if the art is there."[39]

For Cézanne, alert from youth to the derivations and overtones of words, it is evident that to realize, beyond its meaning of fulfillment, held its primary sense of making real. By 1904 no other sense of the word fits Cézanne's use of it. There were two stages in the operation. It was, first, "the reading of the model" and, second, "its realization" that were "sometimes very slow in coming for the artist."[40] First, tracing and construing form, then making it real. The reality of the subject itself, the actual motif, could not be transferred to art by imitation. It could only be made real through whatever was intrinsically real in painting, and the "opinions" are quite clear on what that was. It was the "logic of organizing," the "classifying" of the sensations that were as much inborn as perceived, the sensations of color. This personal understanding of what it meant to realize was more and more in the forefront of Cézanne's mind in his last years. It was the basis of the antithesis between "copying the object" and "realizing one's sensations." The antithesis itself had a history of its own. It has been noticed that its currency was due to critics of the older generation like Castagnary, who wrote in 1857 that "a realized work" was "not a copy and also not a partial imitation."[41] Castagnary, like Duranty and Champfleury, thought much about Constable and wrote about him. The remarks on art quoted in Leslie's *Memoirs,* a book that Castagnary read closely, contributed to the rationale of Naturalism in the 1860s. Cézanne's antithesis—even the lurking contradiction of which both painters were aware—descended from the definition that was found among Constable's papers: "What is painting but an imitative art? An art that is to *realise* and not to *feign*."[42] The "opinion" that was dictated to Bernard was a close and appropriate echo of Constable's words: "Painting from nature is not copying the object, it is realizing one's sensations."

For Constable, most probably, the making real consisted in an image that was visibly made up of self-evidently real oil paint. For Cézanne the intrinsic reality of painting was not only the sense of color that was inborn and confirmed from nature; it resided in the logic, the organization, and the classification, which the sense of color was subjected to. The sixth "opinion," about interpretation in patches of color, makes it clear that the organization consisted in the order in which the patches "follow one another," which was to conform to "a law of harmony." In fact, in each sequence of colors that interprets the roundness of a volume in the late work, the patches almost invariably follow one another in the order of the spectrum, and consist in hues spaced quite evenly along it. It may be that the "law of harmony," as Cézanne finally regarded it, was simply the sequence of the spectrum, and the approximately equidistant placing in it of the notes which in a given key formed his scale. He spoke of it as if it constituted an inborn visual syntax.

The agony deepened in the last years with the sense that "my age and my health will never allow me to realize the dream of art that I have pursued all my life."[43] But now it was circumstances, not fate, that prevented it; a philosophic note is detectable. The fulfillment was slow, but the destination, whether or not there was time to reach it, was ordained. The Moses syndrome was forming, which was itself a feat of insight and a consolation.[44] The difficulties that were inevitable, for some artists at least, were the pains of a natural process like a birth; if one could not avoid them, one could at least become more lucid

and believe that one improved a little every day, however painfully. Indeed, the eventual diagnosis of the pain was a part of the triumph. Picasso, thirty years later, went so far as to say: "It's not what the artist does that counts, but what he *is* . . . What forces our interest is Cézanne's anxiety—that's Cézanne's lesson . . ." Cézanne's letter to his son six weeks before his death continued: "With me, the realization of my sensations is always painful. I cannot attain the intensity that unfolds itself before my senses. I do not have the magnificent richness of coloring that animates nature." And nine days before the end: "I simply must realize after nature. My sketches, my pictures, if I were to do any, would be *constructions d'après* . . ."[45]

It is almost the last letter, and it completes the picture. Painting had to be a making-real that would parallel nature in its harmony and follow it in structure. To make something as real as Cézanne needed he would have had to possess color that was as "magnificent," as great-making, as the color of nature, because that was what animated nature—what gave it life. So Cézanne had to have the life of nature inside him in order to construct and harmonize as nature did. His explicit aesthetic was also an imperative emotional need to the end.

In form the pictures done just before 1900 descend directly from the works of the previous ten years. It is the color that first shows the special character of the late works and the quality that remains characteristic of Cézanne until his death. The "great still lifes" which are said to have been painted in 1899 must be among the group of pictures that show a rounded ewer with a wide opening and Cézanne's tapestry curtain with the pattern of large yellow leaves against dark blue, or his other cloth with a red flower-pattern in square brown compartments, and occasion-

Still Life with Apples and Peaches (pl. 144). c. 1905
Oil on canvas, 32 x 39⅝ in (81.3 x 100.7 cm)
National Gallery of Art, Washington, gift of Eugene and Agnes Meyer

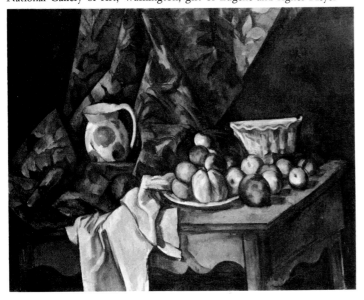

ally both. They are grander, more deliberately arranged, with the draperies falling in cataracts of pattern down the designs, and sometimes larger than the earlier still lifes, but their design is not essentially different in kind. The color, however, is deep and intense, based on somber resonances that reecho through the canvas. Usually there is a polarity of ginger and violet or orange and blue-green. The color is embedded in schemes with an almost congested material richness. In two or three of these pictures the crockery is exchanged—for the familiar ginger jar and sugarbowl in the Museum of Modern Art canvas (pl. 165) and for a teapot in the example at Cardiff (pl. 166)—and when it is, the mood alters too, and the still life takes on the character of an indoor landscape. The heaped-up cloth at Cardiff is as mountainous as the Sainte-Victoire massif. The portrait of Vollard on which Cézanne worked so long in 1899 has the same intense polarity of ginger and violet, but there it generates its own kind of design, aligned along rigid axes. The form grows ridged and furrowed in the labor of its consolidation out of color. Color of this kind is almost unparalleled in Cézanne's art before. Even the somber pictures of 1896, the *Old Woman with a Rosary* (pl. 7) and *Lake Annecy* (pl. 68), which is more schematic than any landscape painted solely from nature, are still dominated by deep blue with an atmospheric connotation. After 1899 the consistency is not primarily atmospheric. It is generated by a specifically pictorial pressure between complementary colors. In the characteristically rich still life (pl. 144) from the Meyer Collection in Washington, for example, a greenish blue presses against orange-pink to model the flower holder; the orange-pink deepens across the canvas into a vibrant putty-color. The image is molded out of the progression from orange through green-blue into violet. Even the white, which is still clear in the torrent of drapery in the Louvre picture, has a liver-color in it.

Two little portraits of a lady in a tailored blue jacket with black lapels and a flowered black hat are like pendants to the "great" still lifes; they may have been among the pictures painted in the rue Boulegon at Aix before the studio on the Chemin des Lauves was finished in 1902. The first (pl. 20) in the Phillips Collection at Washington, is massively modeled in light and dark and sharply characterized. (The curving folds are deeply creased, as in the portrait of Vollard.) In the second (pl. 19), although the chiaroscuro remains as deep, modulations of color take over the rendering of volume. The summits of the relief have patches of pink. From pink the progression passes to yellow-buff and emerald on the way to the local hue of cobalt blue, and thence to the surrounding black, loosely following the recession, but less as an exposition than as a descant. Far from systematic though the color is, its primacy and its codification involve a change in the role of the human subject. The lady's face appears transfixed, emptied of personal or expressive character. The features themselves and the red triangle of the cheek are isolated in the mask, like a pattern, as remote from any function or purpose as the red bouquet on the tablecloth. Neither character nor the human role as such greatly concerns Cézanne in his

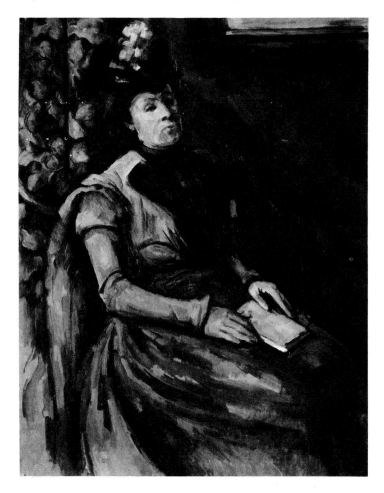

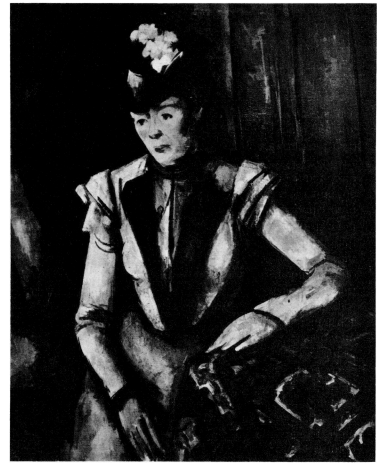

figure pictures after this, although there are echoes of past themes, a portrait in the style of about 1900 of a stolid young man in a violet-gray jacket with a book (pl. 6), who as a youth a few years before had posed with a skull—far from eloquent by comparison with his previous role as a personification of melancholia—and, from two or three years later, a charming, indeed touchingly blank *Girl with a Doll* (Venturi 699), which took up again a theme exhibited in 1895.

Not long after the "great" still lifes, one would guess, the creation of form out of color modulations took a new turn in an exceptional watercolor (pl. 178) now in the Louvre, a row of pears and apples with an enamel saucepan on a shelf; it has an astonishing brightness. The simplest progressions of primary colors are arranged in order: from red through yellow, then from yellow into green and from green to blue. The culminating point, "which is always nearest to the eye," is the violet-blue handle of the saucepan, projecting where the color scales converge. The *Pears* watercolor is striking, not only in its brightness, but because the formal content is so physical and sensual; it recalls the crouching Venus that Cézanne had drawn. The successors to such biomorphic modeling were as much among the rocks at the Château Noir, where his chief landscape motifs were found for two or three years after 1900, as in the bathers.

Top left: *Seated Woman in Blue* (pl. 20). 1902–06. Venturi 703
Oil on canvas, 26 x 19⅝ in (66 x 49.8 cm)
The Phillips Collection, Washington

Top right: *Woman in Blue* (pl. 19). 1892–96. Venturi 705. Oil on canvas, 34⅞ x 27⅝ in (88 x 71 cm). The Hermitage Museum, Leningrad

Above: *Still Life: Apples, Pears, and Pot (The Kitchen Table)* (pl. 178). 1900–04. Venturi 1540
Pencil and watercolor, 11 x 18¾ in (28.1 x 47.8 cm)
Cabinet des Dessins, Musée du Louvre, Paris

There was a last crisis after 1900, when Cézanne established himself in Aix, painfully aware of failing health and isolation. The letters express a sense of self-immolation and mortification, but they also record the heroic determination (he called it obstinacy) which he summoned to work through the dark mood by painting from nature, as he had before. Cézanne's last phase was the ultimate sublimation. How much sensuality there still was in the balance of his art is seen not only in the *Pears* but in a watercolor (pl. 45) at The Museum of Modern Art, painted at the Château Noir a little farther along the rocky bluff that had provided his majestic upright motifs before. The rounded lumps into which the sandstone is weathered cluster over a slanting cleft; it is the kind of place where one may feel that the *genius loci* has disturbingly developed a real physique, and Cézanne painted it like a body. The sandy yellow is present or latent everywhere. It is the top of one color-scale, which descends through green to violet; it is the middle of another, a deeper one, between red and blue-green; and it combines in a vibrant chord with a very pale, clear blue, which Cézanne raised to the same value by adding (a rare expedient) white body-color to the ultramarine—as if the form was physically to palpitate with the meeting of hues. The contour adds roundness like a fierce caress; one finds oneself crediting an extraordinary, bodily bulk to the modulations from scale to scale, and sharing a sensual mood that has an undertone of violence.

In these years the tangle of rocks and undergrowth in the woods around the Château Noir seems to have provided motifs for Cézanne's meditations on the diversity and complication of nature. Landscape in itself, as he told Gasquet, was chaotic, transient, muddled, and quite outside the life of reason.[46] Yet the confusion of sensation that made progress so slow was as much within him as in nature. The real and immense study, which had to be undertaken, was the manifold image of nature.[47] The deep-toned oil paintings of *sous-bois* at the Château Noir, which succeeded the clear, bright differentiation in orange, emerald, and blue at Bibémus, show compound interpenetrations of umber and violet. A way out, again, seems first to appear in watercolors, like the great sheet at Newark (Venturi 1056), in which one can imagine that memories of the rhythmic sequences of Baroque sculpture sustained him once again. Branches like great sculptured locks of hair spring outward with centrifugal energy. The color creates the drawing, finding the edge and finding it differently, more exactly yet with more convulsive feeling, as each color in the progression is added to the last.

Again, a dichotomy of style emerges, reflecting the emotional issue that Cézanne had been facing since his twenties. There was an opposition between the bulging, biomorphic rhythms, which are half-destructive, and the light, yet calculated precision with which color patches are built along parallel lines into rectilinear structures. These structures sublimated the physical and sensual content of form into the successions of chromatic intervals. Cézanne's doctrine that "there is no such thing as line or

modeling; there are only contrasts of color" was indispensable to his own beleaguered peace of mind.

Eventually success in realizing his sensations in relationships of color was identified as nothing less than the prerequisite of his own sense of identity. If he failed, a real annihilation lay in wait. He not only felt himself stronger than those around him, "presumed to dominate every situation," with a strength and a presumption that were built into the parameters of his style, but also, in another mood, the helpless victim of himself, as he had been since boyhood, appealing pathetically for the support of the friends who knew the contradictions of his nature. His friends did support him; their companionship was the greatest boon of his life. Yet there was an instability in it; few friends could carry such a burden. Indeed, he was their helpless victim, too. Any of them might enter his room without knocking, arrive by the wrong train or travel in the wrong class, be too reserved or too talkative, and the good would turn bad in a moment; the annihilation would face him again. "Do you not see to what a sad state I am reduced?" he had written when the black mood threatened to engulf a precious friendship with the son of a companion of his youth. "Not master of myself, *a man who does not exist . . .*"[48]

The condition of self-mastery was "command of one's subject and one's means of expression."[49] Confidence and "getting the upper hand" depended in their turn on "attaining a good method of construction." The stylistic issue on which his whole art had turned had a deeply personal content. "As long as we are forced to proceed from black to white . . ." (model, that is to say, in chiaroscuro as Cézanne himself had done in his twenties) "we do not succeed in mastering ourselves or being in possession of ourselves."[50] More and more the logical reading of nature in terms of "patches of color following one another according to a law of harmony" was identified not only with mastery and self-mastery, but with survival itself. Lacking it, he feared for his reason.

The structured sequences of color patches, which became a confident basis for representation in the last three or four years of his life, seemed to provide the answer. We are still not altogether accustomed to this kind of representation. It is easy to mistake it for the styles that have grown out of it, in which color is either literal or independent. Cézanne's patches do not represent materials or facets or variations of tint. In themselves they do not represent anything. It is the relationships between them—relationships of affinity and contrast, the progressions from tone to tone in a color scale, and the modulations from scale to scale—that parallel the apprehension of the world. The sense of these color patches rests on their juxtapositions and their alignments one with another, so that they imply not only volumes but axes, armatures at right angles to the chromatic progressions which state the rounded surfaces of forms. Characteristically, in such works as the versions in watercolor (pl. 30) and oil (pl. 25) of the full-face pose of Vallier, the gardener who was like a projection of himself, they create an invisible upright

scaffolding around which the hues fan out like a peacock's tail.

The pictures (e.g., pls. 105, 110) in which trees meet overhead to form a vault (as Cézanne himself described them) have wedge-shaped color patches, like segments of a cone, which register at the same time both the actual directions of foliage and the imagined structures implied by the echoing incidence of each color. Much of the content of this style rests on implications of gradient that are as naturally inherent in color intervals as in musical intervals. The fact remains that a code of representation based on reactions to color that are inherent in the psychology of vision, rather than on denotative or descriptive reference, pays a price. There is an optimum size for the units that touch off the sense of color interval. The patches must be large enough to remain perceptible in their own right—which prevents them from particularizing specific objects. There was of course an alternative to the bare notation of color; Cézanne had reverted to it repeatedly since his youth. It was the linear flourish that marked the passion of the figurative act, and dramatized in exigent and repeated contours the old pursuit of descriptive rightness in an image, a quality by no means symbolic or abstracted but one that might prejudice the artist's detachment—perhaps even threaten the sublimation on which the creative balance rested. The ultimate figurative effectiveness of the interpretation in patches of color following one another solely according to a law of harmony was in doubt; if it failed, the autonomy of a reaction to nature as a creative method and the assumption on which the art of Cézanne's whole generation rested were in question. The "opinions" dictated to Bernard in 1904 had revolved around a central proposition. When the relationships of tones "are harmonious and complete . . . the picture develops modeling of its own accord." The idea descended from the Impressionist idea, as Pissarro expressed it, that "brushstrokes of the right value and color should produce the drawing" of *their* own accord.[51] It was the idea, which had preoccupied Delacroix in 1852, of an image as the product not of an act of will, but of a process that was analogous to the automatism of nature.

The issue was of crucial significance and, in other forms, it remains so; it concerns the status of the will in the making of art. The antithesis was mediated and resolved, as always by Cézanne, in front of nature, in the series of pictures which are in one aspect the most modest in his art, representing repeatedly the most obvious motif from a position at his own garden gate. Yet in analyzing his problem into terms in which it could be solved, if solution was possible, the series of pictures of Mont Sainte-Victoire from the Chemin des Lauves was as ambitious as anything in Cézanne's work, and it has proved to possess as deep a significance. It will be well to follow the story in detail.

The series seems to begin with the version (pl. 120) at Kansas City. The foreground is a sloping field in which the dry grass and the ocher earth are specified with their local colors. Rising from the field are a number of trees, the largest casting a pool of shadow. The lighted plains of foliage and vegetation are noted

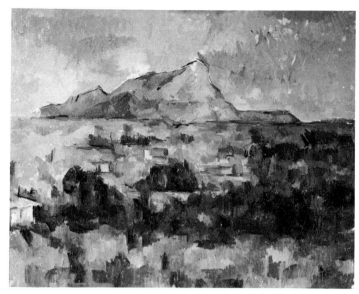

Mont Sainte-Victoire (pl. 123). 1902–06. Venturi 802
Oil on canvas, 25⅝ x 31⅞ in (65 x 81 cm)
Private collection, Switzerland

in subtly modeled ocher-green, graduated into dark blue shadows. The modeling is almost tangible, and in the distance the mountain is sculptured in abrupt angular strokes, quite close to the style in which the other side of the massif was painted from the Route du Tholonet before 1900. The version shown in Venturi 802 (our pl. 123) is much gentler. The differentiation is as much in light and dark as in color, and there is a good deal of highly specific drawing of contours. The mountain has its indented saddle, drawn in more detail than in any other picture—indeed a little exaggerated—and in the middle distance, to the left and in the center, the overhanging eaves of houses are precisely defined. The sky is sky-color, a hazy blue-gray without any sudden accent. The sky in the Kansas picture by contrast has modeled clouds, still very unobtrusive but clearly linked in shape and color—a polarity of blue-green and ocher—with the trees in front. The Venturi 802 picture is quiet in mood, but the accents out of which the image is built are arranged as much on the surface as in depth, and in the foreground an essential step is taken: the broad cylindrical volumes which make up the trees are stated in a chromatic code, a continuous band of color modulation between yellow-green and violet stretching from side to side of the painting.

The color patches in Venturi 802 coalesce out of parallel vertical brushstrokes that unite the canvas. The patches themselves are ranged along the horizontal lines of the panorama. The value which the new style gave to the conjunction of the two axes of a picture was entirely deliberate. Cézanne wrote of it in the letter to Emile Bernard about picture structure in April 1904—and this may be quite close to the date of Venturi 802. "Lines parallel to the horizon give breadth, whether it is a

section of nature or, if you prefer, of the spectacle which the Pater Omnipotens Aeterne Deus spreads out before our eyes. The lines perpendicular to this horizon give depth but nature for us men is more depth than surface, whence the need to introduce into our vibrations of light, represented by the reds and yellows, a sufficient amount of blueness to give the feeling of air." It is likely that the alignments of form along the axes of a picture always carry a specific content which is at the heart of pictorial meaning in the tradition that extends from Giotto to Mondrian. Cézanne is no exception, but his contribution in this respect, as in most others, was the crucial one. It is significant that he associated the vertical alignment with the significance of the natural scene to man. Thanks to his example, in which his philosophy was conceivably perceptible, the Cubists and Mondrian in the next generation built the human role vertically into the conception of an image as a conjunction of alignments.

But, quite apart from this comprehensive and philosophic structure, the surface homogeneity which the vertical brushstrokes enforced was indispensable to the development of the new kind of picture. One would guess that it was the lack of it in the *balayé* brushstrokes with which rather solid masses were brushed onto an incomplete canvas of this phase (pl. 127) that caused it to be abandoned. In the pictures that followed, the vertical handling generated a new cast of form. The detail of the landscape was reimagined in bands of color modulation, with sharp contrasts that gave an effect of pleated surfaces like folding screens arrayed across the plain, or upright prisms capped with pointed roofs, each refracting a segment of the spectrum. The most sparkling yet the most serene of them is the broad canvas (pl. 125) in the Annenberg Collection. In this the buildings in the middle of the plain still show some of the material realism of the previous decade and the light and shadow which delicately mark the receding surfaces of the mountain are also legible as solid form. The sky is now rendered in delicate mutations between jade green and violet-gray. It had become apparent that in the new kind of unity the sky must be landscape-color. The cloud shadows must be as green as the trees. But the material differentiation of one substance from another—sandy earth from angular rock and both of them from the impalpable sky—is still complete. The developed form of this style in the two Philadelphia versions (pls. 121, 122) is far more abstracted and abrupt. The whole scene was now rendered in an almost consistent range of color. The dark blue-green is not only the shadow on foliage; it is the basic color of definition throughout. But the linear marks no longer precisely define anything. They are detached accents—isolated deposits rather than the outlines of anything. The version in the Philadelphia Museum (pl. 122) retains a little modeling in the sky. After that, in the version in a private collection (pl. 121), the clouds break up into a notation of dots and dashes, the same kind of accent that builds up the crystalline forms of the landscape. The scattering of green in the sky is characteristic of these pictures. We become aware that affinity and correspondence in themselves

were now Cézanne's conscious concern, the concern that apparently intensified during his time at Fontainebleau in 1905; it was described in a letter in August of the following year. The color modulation from golden ocher through intense emerald and blue into violet-gray has a strongly atmospheric implication which, as the values lighten into the distance, gives a sense of air and space, but the planes that are folded into facets to evoke the solidity of the foreground forms have a quality of agitation that disturbs the surface.

The version in Zurich (pl. 124), which may represent the next development, translates the spatial illusion into a juxtaposition of color patches. The epigrammatic crystal shapes disappear; all the form and recession are embodied in the system of color. The progressions converge somberly in the center of the plain; the part played by the vivid emerald is reduced; it is the lower end of the scale, where touches of crimson lead to a dark violet-gray approaching black, that dominates the picture. The wide parabolas along which the series is ranged and repeated, then stated again, concentrate a sense of the real—lumpy, almost congested in the middle—yet the flatness of the surface remains unbroken. The formulation is all-embracing, yet its generality (and its very abstraction) is in a sense inconclusive. Works like the Zurich Mont Sainte-Victoire are based on a kind of ambivalence that forbade any precise description of separate things. Cézanne was acutely aware of the dilemma. He described it to Bernard in October 1905. "Now being old, nearly seventy years, the sensations of color, which give light, are for me the reason for the abstractions that do not allow me to cover my canvas entirely or to pursue the delimitation of objects where their points of contact are fine and delicate; from which it results that my image or picture is incomplete." But the alternative was still more unsatisfactory. "Otherwise the planes fall on top of one another," as they did in the styles which Cézanne described as Neo-Impressionism, though it seems that he had in mind rather the varieties of Synthetism, "which circumscribe the contours with a black line, a fault that must be fought at all costs. But nature, if consulted, gives us the means of attaining this end."

The consultation of nature that Cézanne carried out in the final years of his life engaged the whole force of his character. Tired and ill, he had to gather his strength for it with an immense effort. It appears that his time at Fontainebleau in the summer of 1905 had a special importance. The North had associations with a closer and more analytical reading of the whole compound experience of light, atmosphere, and natural shape. It must have reminded him afresh of the part that submission to nature had played at the turning point of his development more than thirty years before. It was probably in 1905 rather than 1904 that the *Blue Landscape* (pl. 71) in Leningrad, surely a Northern scene, was painted. An energetic picture called *Beside the River* (pl. 85), painted in the North in 1904 or 1905, pointed in the same direction. The intense blue of the river in the middle distance diffuses in choppy diamond patches across the land-

scape. The mood of Cézanne's work at Fontainebleau in 1905, to which he looked back in the following months, is typified by the watercolor of the Château in a Paris collection (pl. 107). There was a new restlessness in the pursuit of linear definition. A tree trunk moved step by step back across the sheet through successive positions, until the relationships were adjusted to frame the distant view (which vibrated in sympathy) and accommodate the rhythm of a hanging branch. The serpentine line and the picturesque pattern of the near and the distant have a deceptively traditional look. We might expect a style as descriptive as that in which Mont Sainte-Victoire was framed in pine branches eighteen years before. Looking closer into the Fontainebleau drawing, we find an advanced and complex abstraction of the information in overlapping codes, which include, as well as the color sequence, a graphic system too—a linear code for the passion of apprehending and grasping.

In the *Blue Landscape* the curving lines of hanging branches have again a muscular vigor that galvanizes the design. It is almost the largest pure landscape Cézanne painted in maturity, and the detached and fragmentary color patches that vexed him in the inconclusive pictures of 1905 are drawn together into a coherent whole, while the blue-black accents of shadow again mold rounded volumes. The *Blue Landscape,* though not noticeably incomplete by the standards of other paintings in the last years, must have exasperated the painter. Like other canvases it has been slashed in a mood of impatience. Cézanne was getting his fierce linear grappling hooks onto nature once more, for the last time. Cursive line, even a manual flourish, suddenly recovered its place in this style. The passion and richness of the result in the paintings and watercolors of 1906 mark them as a crowning achievement.

The visit of Maurice Denis and his friends to Cézanne at Aix in January 1906, which has often been misdated in the literature, produced a photograph and a painting that document the date of the version of Mont Sainte-Victoire from the Chemin des Lauves (pl. 116) now in Leningrad, and thus the watercolor connected with it (pl. 138) in the Tate Gallery.[52] The version of the subject at Basel (pl. 128) must be close in date to the Leningrad picture, and it is likely that the version (pl. 117) in the Pearlman Collection—another upright picture, like the *Blue Landscape* and similarly asymmetrical, with a lateral movement in its design—belongs to the same phase. The Leningrad picture is quite different from any other version. It was worked on until the patches took on the granular richness of repeated superimpositions of pigment. The light areas have mutations of red and ocher. From them the sequence passes through sparing touches of emerald fiercely punctuated with crimson, violet, violet-gray, and black. The handling is sharp and wiry. The painter's claws are out; repeated contours assert the tree trunks and branches. The mountain heaves its hump restlessly once again.

The watercolor in the Tate, where the S curves are more Baroque than ever, and the related drawing in Philadelphia for the Pearlman version show that originally, before the pigment

became so loaded as to fix everything in the Leningrad picture in a state of still incandescence, the fan-shaped foreground tree was like a converse echo of the distant mountain. Cézanne had used this device before. In a drawing of the eighties (Venturi 1547), the distant mountain glimpsed between trees was echoed by the same shape inverted in the shadow of a forking trunk in the foreground cast on the garden wall at the Jas de Bouffan. In the Tate watercolor a progression of golden yellow, green, and violet creates space, which radiates from the lively tree; it is gathered in again toward the peak at the top of the picture. In the painting this movement consolidates in a symmetrical array of color areas, but the echo between the near and the distant remains. In the Basel picture, too, the golden light is concentrated in the middle and the same dark coulisse on the left frames the view, but the path and the foothill extending to the right give the landscape a directional aspect, which is more subtly unfolded in the expanding space at the right of the Pearlman picture. The Pearlman version, with its flat ocher foreground, in some ways echoes the beginning of the series, but now everything is different. The vertical prisms of earlier formulations have split into little splinters—the same fragmentary intimations of color correspondence, with no three-dimensional connotation, that make light—and the lively likeness of a real place—in Cézanne's last landscape, *Le Cabanon de Jourdan* (pl. 83). The graphic rhythm here is more convulsive and vivid than ever, but it is still surpassed by the wiry line out of which the contour is woven in the profile portrait of the gardener, Vallier, on which Cézanne was working a few days before his death. In the last months of his life Cézanne was still finding new motifs, yet they summed up all his work. The watercolor *Houses in the Valley* (pl. 112) shows all the power of Cézanne's last style in the convulsively twisted line

Pont des Trois Sautets (pl. 113). c. 1906. Venturi 1076
Pencil and watercolor, 16⅛ x 21⅜ in (40.8 x 54.3 cm) irregular
Cincinnati Art Museum, gift of John J. Emery

that harnesses bold modulations of ocher, yellow-green, and bright red-violet, yet that style is also capable of giving an enchanting naturalness to the shaded bank beside the little road.

The last watercolors have a gentler unity than those before. The correspondences of color melt together. The contained shadows in the tower of Saint-Sauveur dissolve into the purple of the distance. The foliage and fruit of Cézanne's apple tree form a festive garland across the view over the town from his studio garden. The line is more tense and muscular than ever, but there is nevertheless a dissolution of the separateness of things and a total reconciliation of differences which often marks a great artist's last works. At the bridge of Trois Sautets (pl. 113) in the ferocious August heat, where the air was a little fresher down by the river, the splendid linear structure of his watercolor was linked with a pervading, mild luminosity, which reflected his own pleasure in the solution that he had reached. "I felt very well there yesterday. I started a watercolor in the style of those I did at Fontainebleau. It seems more harmonious to me. It is all a question of establishing as much interrelation as possible."[53] His words may stand as the motto of the last pictures. The gardener in profile has not only a look of Cézanne himself but the look of a Michelangelesque Moses—another of Cézanne's self-projections, and one without anything immodest in it. The prophetic grandeur was his own.

The epoch that Cézanne certainly began is marked most clearly by the fact that each artist, each originator, institutes a new dimension of understanding. The apparent arbitrariness of a continuous and unending process of redefinition, on the basis of a past which is itself in a perpetual state of rediscovery and revaluation, places some values in doubt. Cézanne demonstrated, as he intended, that the process is rational and sensible nevertheless. The means of expression continually concerned him in his last years.[54] His ultimate conception of painting was of an art of rational intelligibility. The ideal is not the least of our debts to him. He recognized the means of art as "simply the means of making the public feel what we feel ourselves."

NOTES

1. Gustave Geffroy, "Cézanne," *La Vie artistique,* 3ᵉ série (Paris: Dentu, 1894), p. 253. I am indebted for this and other references to Michael Doran.
2. *Paul Cézanne, Letters,* ed. John Rewald, 4th ed. (New York: Hacker Art Books, 1976), April 15, 1904. The chief sources for the original texts of the letters, from which the present quotations are translated, are *Correspondance,* ed. John Rewald (Paris: Grasset, 1937), and John Rewald, *Cézanne, Geffroy, et Gasquet* (Paris: Quatre Chemins, 1960).
3. *Letters,* July 18, 1906.
4. Emile Bernard, *Souvenirs sur Paul Cézanne et lettres* (Paris: La Rénovation Esthétique, 1921), p. 65.
5. Maurice Denis, "Cézanne," *Théories, 1890-1910,* 4th ed. (Paris: Rouart et Watelin, 1920), p. 245; from *L'Occident,* September 1907.
6. Emile Bernard, "Paul Cézanne," *L'Occident,* July 1904, pp. 23-25.
7. *Letters,* July 25, 1904.
8. Ibid., May 15, 1904.
9. R. P. Rivière and J. F. Schnerb, "L'Atelier de Paul Cézanne," *La Grande Revue,* December 25, 1907, p. 313.
10. Léo Larguier, *Le Dimanche avec Paul Cézanne* (Paris: L'Edition, 1925), p. 136.
11. Bernard, *Souvenirs,* p. 39.
12. Ibid., pp. 29-30.
13. *Letters,* February 22, 1903.
14. K. Jex-Blake and Eugenie Sellers, *The Elder Pliny's Chapters on the History of Art* (Chicago: Ares, 1968), p. 97. (1st ed., London, 1896.)
15. Ambroise Vollard, *Paul Cézanne* (Paris, 1919), p. 129. (1st ed., 1914.)
16. *Letters,* December 9, 1904.
17. Ibid., May 26, 1904.
18. Ibid.
19. Larguier, *Le Dimanche,* p. 277.
20. Bernard, *Souvenirs,* p. 27.
21. *Letters,* May 26, 1904.
22. Ibid., November 27, 1889.
23. John Rewald, "Un Article inédit sur Paul Cézanne en 1870," *Arts* (Paris), July 21-27, 1954; cited in Rewald, *The History of Impressionism,* 4th ed. (New York: Museum of Modern Art, 1973), p. 246.
24. *Letters,* January 25, 1904.
25. Ibid., October 15, 1906.
26. Ibid., May 26, 1904.
27. Ibid., June 3, 1899.
28. Ibid., July 25 and December 23, 1904.
29. Ibid., October 23, 1905.
30. Ibid., August 23, 1906.
31. Ibid., May 11, 1886.
32. Ibid., November 2, 1897.
33. Ibid., April 30, 1896.
34. Ibid., January 29, 1904.
35. Ibid., September 26, 1897.
36. Ibid., January 17, 1905.
37. Rivière and Schnerb, loc. cit.
38. Maurice Denis, *Journal* (Paris: La Colombe, 1957-59), 2: 48.
39. Bernard, *Souvenirs,* p. 92.
40. *Letters,* December 9, 1904.
41. Jules Castagnary, *Philosophie du Salon de 1857* (Paris, 1858), pp. 8-9; quoted by Kurt Badt, *The Art of Cézanne* (Berkeley and Los Angeles: University of California Press, 1965), p. 200.
42. C. R. Leslie, *Memoirs of the Life of John Constable,* ed. J. Mayne (London: Phaidon, 1951), p. 275.
43. *Letters,* January 23, 1905.
44. Ibid., January 9, 1903. Cf. the lines from de Vigny's *Moïse* that Cézanne produced when asked for a quotation with which he agreed:

Seigneur, vous m'aviez fait puissant et solitaire,
Laissez-moi m'endormir du sommeil de la terre.

Cited in "Mes Confidences," an album with questions answered by Cézanne, which probably dates from the artist's last years. See Adrien Chappuis, *The Drawings of Paul Cézanne* (Greenwich, Conn.: New York Graphic Society, 1973), 1:49 ff.

45. *Letters,* October 13, 1906.

46. Joachim Gasquet, *Cézanne,* 2nd ed. (Paris: Bernheim-Jeune, 1926), p. 132.

47. *Letters,* May 12, 1904.

48. Ibid., April 30, 1896.

49. Ibid., May 26, 1904.

50. Ibid., December 23, 1904.

51. Rewald, *History of Impressionism,* p. 456.

52. The evidence is summarized by Robert Ratcliffe, to whom the present writer is indebted throughout, in the catalog *Watercolours and Pencil Drawings by Cézanne* (London: Arts Council, 1973), p. 170, note 99. This appears strong enough to outweigh the information in A. Barskaya, *Paul Cézanne* (Leningrad: Aurora Art Publishers, 1975), pp. 190–91: "On the back of the subframe of the canvas was a label with the words 'Exposition 1905' and underneath on the right 'Vollard, 6 rue Laffitte' had been added with blue pencil . . ." If correctly recorded, the label might have indicated only that when with Vollard the canvas had been placed on a used stretcher.

53. *Letters,* August 14, 1906.

54. E.g., in the letters of January 23, 1905, and September 21, 1906.

The Elusive Goal

Liliane Brion-Guerry

"TO PRODUCE THE IMAGE of what we see while forgetting everything that has appeared before our day"[1]—these words sum up the search of a lifetime. With Cézanne everything is called once again into question; with him a new vision of the world comes into being—and this is doubtless the reason why his contemporaries showed such a fundamental lack of understanding of his art. "The impression that nature makes on us is not the one felt by the artist," one art critic[2] wrote in all seriousness; "this is an art at odds with sincerity," another[3] was to say.

If in the history of spatial composition, in the continuity of its expression, Cézanne constitutes "the great divide," if he can be said to stand at the beginning of all modern painting—Cubism, Expressionism, abstraction—it is because he "dismantled space,"[4] overturning an order that had lasted for four centuries of Western painting. Cézannian space is no longer a cube of air inside which volumes are laid out in accordance with a pre-established arrangement, where it is possible within a given structure to alter the position and form of a figurative object so long as it is rationally integrated with a traditional system of representation. In Cézanne's composition, unlike that which obeys the laws and methods of Alberti's perspective (classical perspective, which, despite all the transfigurations of the Baroque, prevailed in Western painting until Impressionism), the spatial container (Panofsky's *Raumkasten*)[5] does not exist prior to its contents and is not distinct from them; it is on the very existence of the latter that the whole figurative construction depends. It is the object (whatever it may be, an element of landscape or still life, the human figure) that by expanding in the third dimension gives rise by itself to the proper structure that will bestow on it its identity. This object thus finds itself, by its very nature, indissolubly bound to the space it engenders and from which it will never be able to dissociate itself.

One can see that each element of this type of composition is absolutely determined by the whole and finds its justification only as a consequence thereof. The depicted universe becomes a single object perfectly homogeneous in its parts, an object whose existence is linked to the complete elimination of any autonomous particularity.

Cézannian space is no longer space indifferent to its contents (as could be said of Plato's ὑποδοχή[6] in relation to the elements that penetrated it), existing before the creation of the object and therefore distinct from it: it is a world in itself where objects and their interstices are immediate data, and it is from them that the artist will proceed to set up the problems of the imaginary in accordance with the conceptual structures of a new world.

A few days before his death Cézanne wrote to Emile Bernard: "Will I reach the goal I've sought so long and hard? . . . so I go on with my studies . . . I'm still studying from nature and it seems to me that I'm making slow progress."[7] Cézanne's struggle "to realize" (as he expressed it), the struggle to which he applied himself with all his strength, consisted precisely in the effort to achieve equilibrium amid the violence of the sensation—to which perhaps no painter was ever more sensitive—the re-creation of a "harmony parallel to nature" (these are his own words), and finally the surrender by the creator to this re-creation that has now become autonomous. "With him the two processes, that of visual perception, so unerring, and that of the appropriation, the personal utilization of what is perceived, counteract each other so that neither is too conscious," wrote the poet Rainer Maria Rilke with remarkable intuition as early as 1907.[8]

As for the stages in this struggle, each is marked by masterpieces that Cézanne himself could not have considered as achievements but rather as stepping-stones in a continuing search.

In the works of the period he later described as *couillarde*—we might say those works that preceded his stay at Auvers with Pissarro—the structure obeys the promptings of an inspiration more literary than plastic, one that must forge for itself the conditions for its own stability. It tries at that time all sorts of structural combinations: a lighted area in the center of the picture that seems to thrust the middle part forward in order to throw the contours of shadow into depth (*A Modern Olympia,* Venturi 106; *Melting Snow at L'Estaque,* Venturi 51); inversely, a hole of shadow sinking into the center of the composition to bring the peripheral areas back toward the light (*The Ravine* in the Pinakothek of Munich, Venturi 50); or concentric orbs successively widening to produce a whirling space (*Don Quixote on the Shores of Barbary,* Venturi 104; *The Orgy,* Venturi 92). The mobility is superficial, caused by the liveliness of the touch (agitated brushstrokes furrowing the canvas with great streams of paint or slashes of the palette knife) more than by an inner pulsation that would unify the spatial container and its contents in a single rhythm. Deliberately more concerned with the psy-

Notes to this essay appear on page 82.

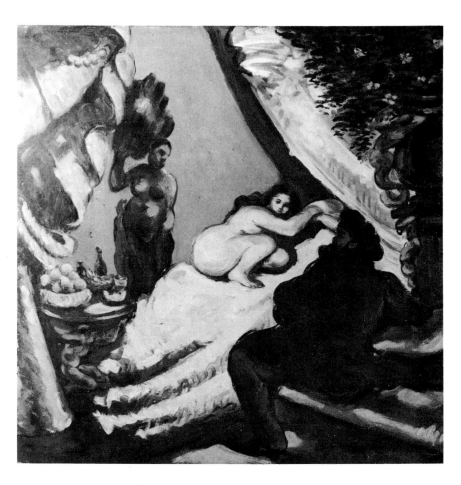

A Modern Olympia. c. 1870. Venturi 106
Oil on canvas, 22 x 21⅞ in (56 x 55 cm)
Private collection, Paris

chological overtones of the object represented than with the plastic values of this object itself (which from this fact he experiences some difficulty in grasping and immobilizing), Cézanne finds himself faced with the conflict between an atmospheric envelope that aspires to order itself according to natural laws of rhythm, and a "denatured" object—denatured because it is not of the same nature as the space that surrounds it and therefore cannot be integrated with it. For this very reason rendered more unstable, the object must have recourse to various artifices to recover the conditions of an equilibrium that would allow two worlds of different essence, its own and that of its spatial envelope, to breathe together in rhythmic unison.

This conflict, which seems apparently overcome as early as the works of the artist's so-called Impressionist period, continues to exist however, and for the same reason: spatial container and contents remain heterogeneous. But this time the terms of the proportion are reversed. While the contents—the house by the side of the road, the vase of flowers, the human figure—are faithfully transcribed from reality, indeed so faithfully that they take on the uncertainty of its color harmonies and the mobility of its light variations, the atmospheric container is henceforth willed by Cézanne to play the role of a stabilizing constant. Because Cézanne cannot content himself, like Pissarro or Monet, with the mere exact representation of one of these variations of

the ever-changing, of this fleeting equilibrium that time destroys, because he aspires to an art "as lasting as that of the museums," he must fix that which by nature cannot be grasped, immobilize that which slips away; he must reconstruct, he must abstract.

The problem—transposed—was the same one that troubled Degas when he studied the gallop of a horse or the steps of a dancer: the overall view of a race or a ballet is false because it immobilizes what is continuity and isolates one instant in a series that is both spatial and temporal. This is why a snapshot of this race or ballet would seem to us completely arbitrary and contrary to reality, giving us only a fraction of the movement instead of restoring its progressive development, something that pictorial re-creation paradoxically gives us the illusion of, because of the fact that it is a deliberately false image of reality that transgresses the exactitude of the particular moment to express in an intellectual reconstruction the synthesis of all these moments.

In the same way, Cézanne tries to synthesize in a single vision—not, like Degas, the various intervals of a movement, but what comes to the same thing—the successive moments of a temporal continuity, namely the different harmonies of color that the sun's progress gives rise to with the passage of the hours. From an analysis of all these variations he will *abstract* a

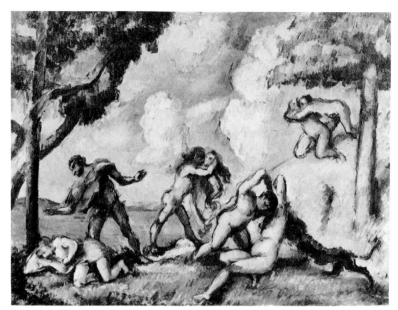

The Struggle of Love. c. 1879. Venturi 379
Oil on canvas, 16½ x 21¾ in (42 x 55 cm)
Private collection, Paris.

Portrait of Victor Chocquet. 1876–77. Venturi 283
Oil on canvas, 18⅛ x 14⅛ in (46 x 35.9 cm)
Collection The Right Honorable Lord Rothschild, Cambridge

supreme harmony that will not be the image of any one of them but will utilize them all.

What element will serve to control these mobile variations, these fluctuations of light, these changes in color? The spatial container, but only if it itself renounces all mobility, resists the transmission of whatever fluctuation there may be, and denies change, transition, impermanence, and hence life. In the midst of all that moves it henceforth appears as an arbitrary reconstruction, an "insulating sheet," which threatens to bring about the breakup of the composition by the separation of its constituent elements. The stability of the subject is achieved ("the art of the museums"), but the space depicted tends to divide on the one hand into an inner moving mass (fluctuations of light playing over the elements of landscape, fleeting differences enlivening the expression of a human face) and on the other into the presence of a controlling "envelope" (broad patches of sky, hard wall partitions, etc.) that acts to break the flow and can lead in extreme cases to a fragmentation of the various parts (*The Struggle of Love,* Venturi 379; *Harvesters Resting,* Venturi 249).

In just the opposite way, Cézanne runs the risk of finding himself faced with the same conflict as in his dark period: the spatial container and its contents split up and resist each other because their natures are different. A double peril lies in wait for the painter: the breakup of inner form under the play of light,

or inversely the fragmentation of the space as the result of an overemphasis on volumes. The picture then becomes a juxtaposition of autonomous elements and not a unified organic system.[9] This in no way hinders the obvious success of any number of works from these years, works that seem very close to the Impressionist aesthetic while in reality they are quite far from it. It happens that the human form succeeds in synthesizing, in an infinitely complex way, the many expressions that can successively enliven a face, and this countenance agitated by different emotions remains in perfect accord with the vibrations of light that make the surrounding space palpitate (such is the case, among others, of the admirable *Portrait of Chocquet,* Venturi 283, and the pink-splotched *Portrait of the Artist,* Venturi 286). It likewise happens that the various elements that go to make up a still life are sufficiently linked organically for the shifting harmonies created by variations in the light to remain always in accord, transposing themselves as the illumination progresses, but not affected by the interference of outside reflections (*Still Life with Apples and Biscuits,* Venturi 212; *The Fruit Dish,* Venturi 214).

But this subtle equilibrium of container and contents, this difficult harmony between essentially differentiated elements, can only be precarious. To Cézanne it appears as a compromise solution, and once again he raises the whole problem of

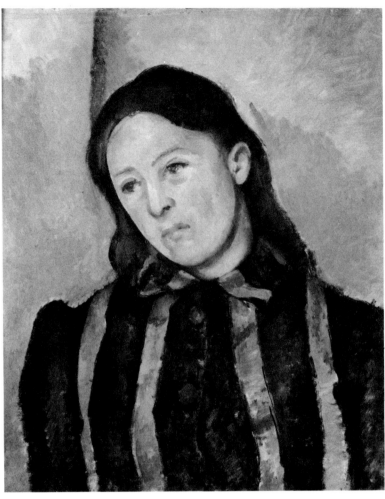

Mme Cézanne with Hair Let Down. 1890–92. Venturi 527
Oil on canvas, 24½ x 20⅛ in (62.3 x 51.1 cm)
Collection Henry P. McIlhenny, Philadelphia

spatial unification by going at it in a completely different way.

This will lead to the great achievements of the years 1878–95, among others the superb *L'Estaque* and *Sainte-Victoire* series, those of *Gardanne* and the *Cengle,* the *Cardplayers* and *Harlequins,* and some of the *Large Bathers.*

Instead of using artifices, which could only be arbitrary and impermanent, to re-create an equilibrium between constituents of a heterogeneous nature, he strives to reduce them as much as possible to a common essence. He merges solid and void into a single structure, and in order to make sure that the elements will not run the risk of splitting up again by being differentiated, he deliberately transposes them into abstraction. This synthesis will have all the more chance of lasting the more advanced the abstraction, that is to say the further the image departs from its model.

It is henceforth only the plastic value of the object that will govern its position in space and will be the very condition of its equilibrium. But there too lies a possibility of rupture: the image, being a transposition into the abstract, necessarily behaves like a systematization of reality. It cannot reproduce the complex details of that reality, its supple inflections; it must necessarily represent a choice among the data of nature, a choice that implies simplification. If this reconstruction remains constantly parallel to the repertoire of forms suggested by the concrete world—"a harmony parallel to nature," as Cézanne hoped—the work of art arrives at a state of equilibrium as stable, perhaps even more stable, than the natural harmony of which it is a transposition. It is no longer subject to uncertainties of light; it is fixed in a state that the passage of time denies to any actual combination. There are no atmospheric variations that could alter the facial features in the admirable portrait of *Mme Cézanne with Hair Let Down* (Venturi 527), modify the plastic stability of the *Landscape at L'Estaque* in the Metropolitan Museum in New York (Venturi 429), or threaten the integrity of the tulips, onions, and apples in the great still lifes of this period (*Still Life with Tulips,* Venturi 618; *Still Life with Medlars,* Venturi 603; *Still Life with Large Apples,* Venturi 621).

The structural unification of the composition is here fully achieved. No longer do we find heterogeneous elements trying to become united in a dynamic outburst (as in works of the *couillarde* period), or struggling against the threat of fragmentation (as in certain Auvers landscapes)—from now on solids and voids, indissolubly united, have become a homogeneous, inseparable plastic mass. This is why the slightest detail in the composition must be treated simultaneously as part of a whole and as a whole in itself. All it takes is for the contour of a form at a single point in the canvas to be exaggerated or insufficiently rendered, a tone to be too weak in value or too saturated, for the whole picture to be thrown out of harmony and the volumetric equilibrium broken. "The slightest faltering of the eye messes everything up (*fiche tout à bas*)."[10]

Indeed, how precarious is this reunification in and by abstraction! The painter can only "walk a tightrope" between the

stimulations of the concrete and the promptings of the imaginary. An overly insistent suggestion by reality, or on the other hand too much reliance on independent speculation—no more than that is needed to rupture the parallelism between the world of the concrete and its re-creation in the world of the image. The simplification of form, an operation here indispensable and the prelude to any figurative transposition—the cylinder, sphere, and cone of the famous letter to Emile Bernard[11]—this is what stimulates and induces the autonomy of the reconstruction! Once the object behind the figure it begets is transformed, the latter has become an end in itself: it then imposes on the painter, by aesthetic necessity or even simply by structural convention, a whole set of abstract combinations that behave as an independent system of construction. From the concrete object the image has received its original impulse, but now it can only ignore it or be disturbed by a memory that hinders the free blossoming of its own structural design. The subject of the painting is transformed into a complex combination of volumes whose arrangement is subject only to the arbitrary will of the artist.

Arbitrary, and therein lies the difficulty: for this world of the image tempted by autonomy must also rediscover a stasis. It must invent for itself the conditions of its own equilibrium, and these conditions vary with the *données* of each spatial combination. The results are the anomalies of construction, that sophisticated play of compensated disequilibriums to which the painter will have to take recourse in order to ensure the stability of his creation: the walls that are not perpendicular to the ground in the *Maison Maria* (Venturi 761), the unbalanced obliques in the *Portrait of Mme Cézanne in a Yellow Armchair* (Venturi 570), the double rebound of the line of sight in the *Still Life with Plaster Cupid* (pl. 145). These fascinating but vulnerable structures lie halfway between memory and freedom, refusing to break with the stimulating powers of the real world—that will be reserved for Braque or Juan Gris[12]—and both enjoying and fearing the glimpsed intoxication of independent speculation.

Recalling the concrete world, whose repertoire of forms still continues to find support, figurative reconstruction cannot enjoy all the possibilities of freedom that a deliberate transgression would bestow on it. At the end of this period of very difficult research, Cézanne, who seemed to have achieved in a rigorous fashion the unification of the air container and its contents, and to have transcended the solid-void antinomy, escapes the threat of a new schism of the spatial components only by a severe exercise of privation. The picture tends to harden in a defensive immobility that makes the image lose the suppleness, the softness of inflection, the suggestion of motion in space that were the very goals of Cézanne's research.

Here then the problem is raised again, and it will require no less than a renewal of technique, the tangible sign of a profound aesthetic reversal, to resolve it fully. A foreseeable reversal and completely within the logic of the Cézannian problem: indeed, what path, when he has just painted the *Woman with Coffeepot*

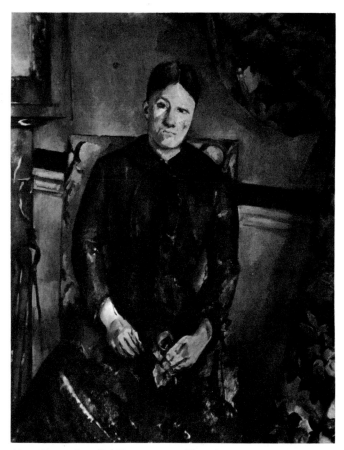

Mme Cézanne in a Red Dress. c. 1890. Venturi 570
Oil on canvas, $45\frac{3}{4}$ x 35 in (116 x 89 cm)
The Metropolitan Museum of Art, New York,
Mr. and Mrs. Henry Ittleson, Jr., Fund

Georges Braque, *Maisons à L'Estaque*. 1908
Oil on canvas, $28\frac{3}{4}$ x $23\frac{1}{2}$ in (73 x 59.5 cm)
Hermann and Margrit Rupf Foundation,
Museum of Fine Arts, Bern

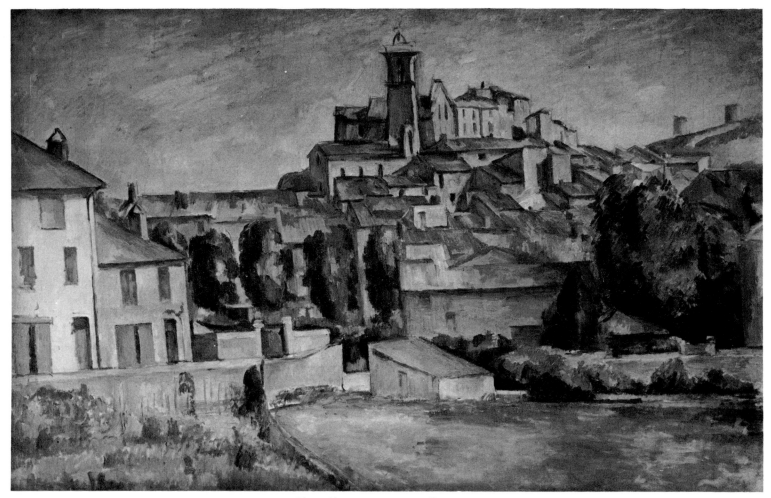

The Village of Gardanne. 1885. Venturi 430. Oil on canvas, 25⅝ x 39⅜ in (65 x 100 cm). © The Barnes Foundation, Merion, Pa.

(Venturi 574), *The Village of Gardanne* (Venturi 430), or *Still Life with Pitcher* (Venturi 509), lies open to the painter?

One that emerges naturally from the one he has been following: the recourse to planimetry, the only possibility of absolute control over a composition in which spatial unification is sought by reducing the components to a structure tending toward abstraction, deliberately autonomous but nevertheless still borrowing its outlines from the repertoire of the concrete world.

This is the path that the Cubists were to adopt. But unless it is to become deadly immobilization, it implies a subterfuge of spatialization, the "circuit around the object" accomplished by the gaze of the spectator—who is no longer the onlooker riveted to a fixed point as in classical perspective, perceiving the various parts of the picture from the same visual angle, but a mobile reference modifying at each instant, by a constantly oscillating effort of the imagination, the data of the figurative representation. Thus the planimetric image rediscovers an absent third dimension, a spatiality, thanks to the supposed mobility of the onlooker, and also to a continual mental transfer that leads the latter to take possession (successively or simultaneously) of all the object's surfaces. All its surfaces: that is to say the one the eye perceives in a natural way, but also the invisible one recreated by the imagination, and this leads inevitably to the denaturalization of the object. Unfolded and spread out on the plane, its reflections themselves becoming solids, it is simultaneously perceived from a frontal or oblique or downward view, taken in all at once from front or side, fore and aft, and as a result rendered unrecognizable.

This is what Cézanne cannot bring himself to do. The *Woman with Coffeepot,* immobilized in abstract space, immune to the injuries of Time, the *Houses at Gardanne,* which have become unalterable cubes and prisms—each figure or object is a *terminus ad quem.*

He refuses to undertake the next step, which will lead to Picasso's *Seated Nude* (Tate Gallery) or Braque's *Quarries of Saint-Denis* (private collection, New York). The "playing-card" landscape[13]—in other words, reduced to a flat plane—the figure resembling a "Chinese image"[14]—that is to say renouncing tridimensionality—Cézanne rejects them almost with horror: "I will never accept the lack of modeling or gradation. It's non-

sense."[15] And elsewhere: "Nature . . . lies more in depth than in surface."[16]

Oddly enough—for of course he never had the slightest awareness of the thinking that, in Germany in these same years of transition, was once more calling into question the whole aesthetic of Western painting—if we were to extrapolate Worringer's statement that "space is the greatest enemy of any effort at abstraction,"[17] Cézanne would seem to be in agreement with him in believing that any attempt at abstraction could only begin with a rejection of tridimensionality.

So since abstraction, the quality of abstraction that for him means the reduction of forms, is non-space, and since this non-space is precisely what he cannot accept and the opposite of the "goal sought so long and hard," he must inevitably confront problems of composition in a quite different way, no longer by reducing the forms of nature to their most simple volumes—sphere, cube, prism, etc.—but on the contrary by re-creating these forms in their essential freedom, the freedom that gives rise to movement, inflection, uncertainty, extension, in short to life. The depicted object, which up until then was accentuated in the rigor of its outlines and acquired its stability only from the precision of its volumetric autonomy, opens itself to the vibrations of the atmosphere.

One can see that Cézanne was tempted by the technique of watercolor at this period of his life more than at any other. And it is certain that the aesthetic values of watercolor in their turn influenced the technique of his last oil paintings, brushed as with great transparent washes and letting parts of the canvas show through (*Mont Sainte-Victoire Seen from Les Lauves,* Zurich Kunsthaus, pl. 124; *Bathers,* Chicago Art Institute, pl. 193; etc.). The air vibrates through these quivering touches of paint, it circulates outside the picture, better still it is simply one with that of the real world.

The rigorous fitting together of volumes, hitherto done so to speak "without mortar," and giving rise to various structural artifices to ensure the stability of a spatial architecture that was freeing itself from the laws of statics of the natural world, tended toward the certainty of immobilization. On the other hand, this hesitant breathing, which in Cézanne's last compositions brings about the progressive disappearance of the outlines of form, suggests the greatest mobility of the inner volumes, and consequently an increased possibility for structural variations. The object is no longer encased exactly within its limits; it may recede or overflow its own volume depending on whether the play of light gives rise to contraction or expansion, this alternation becoming a kind of pulsation that softly enlivens the surrounding layers of air. The image "breathes" like a living being.

It is obviously in still life that this search for the expression of *passage*—the transition between pure volume and the air that surrounds it—presents the most difficulties. This is why Cézanne tries to soften the harsh edges of objects that are too pronounced in contour (round fruits, earthenware jugs, etc.) by the apparently disordered, but actually cleverly arranged, folds of the

Pablo Picasso. *Seated Nude.* 1909–10
Oil on canvas, 36¼ x 28¾ in (92 x 73 cm)
The Tate Gallery, London

strange brownish drapery with a scarcely discernible pattern of red and green flowers that very often appears in the works of this period (*Still Life* in the Bernheim Collection, pl. 167; *Still Life* in the New York Museum of Modern Art, pl. 147; etc.).

This expression of *passage* is still more subtle in portraits, for then the image is no longer situated only in space but in time as well. It is a question of harmonizing two mobile elements of different essence: one, that of the enveloping air, which is, if one may say so, indifferent to the progress of time, the words "before" and "after" having no meaning for it; the other, that of the living being, in some way a positive mobile element, in which there exists a development, an evolution—but an unforeseeable evolution, one merely oriented by the gesture that precedes it and not determined by it. Its very freedom endows it with a margin of countless possibilities, and the role of the artist is precisely to suggest them to us. To express the harmony of these two mobile elements implies a subtle equilibrium, difficult to maintain.

The harmony suggested by the *Old Woman with a Rosary* (London National Gallery, pl. 7) is a fine example of one such success: the figure has been harmonized with the rhythms of the concrete world, it has been adapted to its inflections and pulsations (the rosary inching through the fingers in some way materializes this flight of time). Like the Rembrandt characters whom she evokes, the old woman with the rosary is simply one with the space that surrounds her; she has accepted this space as the abode for her aging life, has *consented* to it—unlike other Cézannian figures painted earlier, *Vollard, The Cardplayers, Mme Cézanne in a Yellow Armchair,* the *Woman with Coffeepot,* who stiffen and isolate themselves from the living world, refusing to adapt themselves to Time, and as a result are condemned to immobility.

Old Vallier (pl. 26), the sublime testament of Cézanne,[18] has also consented to be integrated with the rhythm of the universe, to live and grow old there, but it is by accepting the fact of his aging that he transcends the moment and becomes the very expression of an imperishable "essentiality." Technically this integration of the living being with the surrounding space is suggested by the disappearance of the outline that marked the separation of two worlds hitherto of irreducible essence. The figure is drowned in darkness, the hands lose the contours of their form, the clothing takes its indecision from the flesh it covers. Sleeve and collar are hatched with lines and aftertouches that pierce through them, the straw hat is frayed at the edges: all matter is penetrated by air and vibrations of light.

It would not, however, be entirely exact to say that the solids unite with the voids by consistently giving up the protection of their visible contours—a renunciation that could (as was the case with certain works of the first months of the artist's stay at Auvers) lead to a fragmentation of the object devoured by reflections of the light. In his last works, Cézanne achieves the miracle of a representation, at first sight exact but actually unreal, of the original model. The figures of the concrete world (persons, elements of landscape or still life) are no longer evoked in an imitation of form, which would only be a transcription of their volumetric materiality. Rather they are re-created beyond an external appearance, in the extensions of the latter, in its essentiality, its *manifestation* (the word being taken in the sense in which Goethe said that the work of art "manifests" certain hidden laws of nature that would not be able to express themselves without it). It is probably in this sense that Cézanne's remark to Larguier should be understood: "To paint is not to copy the object slavishly, it is to grasp a harmony among many relationships."[19]

Between the actual limit of the objectified volume and its "adjustment" to the surrounding space, there exists henceforth an area that remains poorly defined because ceaselessly moving, an area whose mobility has become the very condition of its existence. What the touch emphasizes, the atmospheric modulation effaces. It is this imprecise area, situated between the ideal contour of the solid contents and their representation, that bestows on the composition its equilibrium of a moment, more precious than all stability. It no longer threatens to break down, as would a volumetric system too tightly integrated; it always allows the hope of a more subtle variation, a new equilibrium rarer than the previous one, an equilibrium that fulfills not only the creative will of the artist, but the free development of expression acquired by the work of art and the imaginative contribution of the spectator as well. What the painter tries to suggest, the image expresses (this image of the object that is no longer imitation but a double in the act of becoming), and the spectator completes.

This completion offers a multitude of possibilities, each of which is valid only for a vanishing moment: successive qualities whose value lies in their uncertainty since the aim is always toward a final harmony as yet unachieved but constantly hoped for. So it is no longer a question of the onlooker choosing among these possibilities—that would only mean immobilizing a flow, setting limits to an evolution—but quite the contrary of accepting in their potentiality all the suggestions of the image, as one receives, without constraining or directing them, the many proposals of form from life, the very conditions of its mobility.

The image's field of depth thus finds itself enlarged by all that is suggested without being specifically expressed, it becomes immense by an extension in untold directions. "It cannot be contained in a frame, it has no limits, it expands in all imaginable directions, to infinity," the Hungarian philosopher Lajos Fülep had already observed, having been one of the first to write in aesthetic terms on Cézanne's oeuvre during the painter's lifetime.[20]

This "multiple" space (Bazaine)[21] becomes enlarged all the more as the object is no longer presented for its autonomous, immediately apparent, accidental, delimited value, but is re-created in the infinitude of its extensions, in other words as it *manifests* itself in its original significance. This is no longer Mont

Wassily Kandinsky. *Romantic Landscape.* 1911
Oil on canvas, 37 x 50¾ in (94.3 x 129 cm). Städtischen Galerie, Munich

Sainte-Victoire, isolated in its specified, volumetric autonomy, but the mountain *in itself* placed again in its cosmic perfection, the mountain that has become—to borrow another expression from Rilke—the "freedom to be," both a subject transcending the visible face of the natural world and a projection of the inner space of the one who re-creates it: a *Weltinnenraum.*[22]

One cannot help observing that at the very moment when this Cézannian spatial universe is being elaborated, containing in itself the promise of all the renewals to which contemporary painting under various aspects has aspired, the universe of music also experienced an essential overturning of structure.

Pictorial perspective in the classical West up until Cézanne had laid stress on the object, the object being in some way the stabilizing element of the space within which it found itself; likewise musical architecture had built its own structures on the unifying element constituted by perfect accord over the tonic, the fundamental of the key. Just at the moment when painting was to tend toward the expression of something beyond the figure, since it is with this possible infinite extension of reality that the artist is concerned, music likewise evolved toward the rejection of the particularizing function of a given tone.

Whether in the case of the object of pictorial representation extended outside its own figuration or in that of harmonic aggregations that transcend tonal particularism, a new awareness of spatial structure is being elaborated. It would be tempting to compare these two simultaneous (but of course completely independent) developments in the pictorial and musical worlds: with Cézanne the outline confining the object to itself is progressively effaced; in a similar way, *perpetual variation* of the Schoenbergian type permits the utilization of all chromatic possibilities and embraces in homogeneity all the constituent elements of musical discourse.[23]

This search for a unified space in which all things are open to each other, without either limits or bonds, this approach to a beyond that might be without restrictions, glimpsed by Cézanne as a *promised land*[24] that "like the great leader of the Hebrews" he was not certain of entering, this conception is quite different from the glorification of form for its own sake that characterizes the Cubist aesthetic. It foreshadows much more Klee's aspirations to depict "a world that might be without restrictions," or Kandinsky's search for the expression of "unmoored space," both symptomatic of the same desire to extend reality beyond its

figurative appearance: there color was to cease to characterize the object and become a value in itself; better still, this color, detaching itself from the object, was to combine with other portions of color likewise rendered autonomous, and then form a new and completely independent association with no longer any reference to the object. A new reality, conceived by the painter, was to emerge. Space, which had been the place for the localization of the object, was to be entirely transformed with the abolition of that object, and this new space was to correspond to a new and autonomous pictorial reality. (One could pursue this same development in contemporaneous poetry, where the line would cease to hold a precise meaning in any exact and restrictive way: the line evolves toward autonomy, escaping the meaning that it holds; with Mallarmé and Valéry, it becomes reality in itself.)

Let us not push anticipation too far. It is not Cézanne who was to take up this essential mutation of the pictorial values of Western painting. Moreover, he would not have agreed with it. But it is undeniable that he made it possible. One must give full weight to the avowal he made one day to Chocquet: "I am attracted by the boundless things of nature."[25] A highly exceptional grasp of these "things of nature," in their perceptible reality—but also in that which is not—allowed him to transcend all distinction of species, all differentiation of spaces.

Translated from the French by John Shepley

NOTES

1. Letter to Emile Bernard of October 23, 1905, quoted in E. Bernard, *Souvenirs sur Paul Cézanne et lettres* (Paris: Société des Trente, 1912).

2. *Le Petit Parisien,* April 7, 1877. Lionello Venturi, who quotes the remark, rightly adds, "It took at least thirty years for Cézanne's way of feeling to become that of the public." See Venturi's *Cézanne: son art—son oeuvre,* 2 vols. (Paris: Paul Rosenberg, 1936), 1:30.

3. *La Fédération artistique belge,* January 26, 1890.

4. The phrase is by the painter Jean Bazaine; see *L'Oeil,* January 1957.

5. "Box of air." See Panofsky's well-known essay *Die Perspektive als Symbolische Form* (Hamburg: Vorträge d. Bibl. Warburg, 1924), p. 258 ff.

6. The "container" of material forces considered as an irreducible and eternal entity perfectly distinct from its contents. See the *Timaeus.* The conception was to remain a current one in the Italian Renaissance, typical in this respect being the formulation of Pomponius Gauricus: "natura ante omnia corpora et citra omnia corpora consistens, indifferenter omnia recipiens." See Robert Klein, "Pomponius Gauricus on Perspective," *Art Bulletin* (September 1961), 43:211-30.

7. Paul Cézanne, *Correspondance,* ed. John Rewald (Paris: Grasset, 1937), p. 291, letter of September 21, 1906.

8. After a visit to the Salon d'Automne. Letter to his wife, October 9, 1907. See *Correspondance,* ed. Philippe Jaccottet (Paris: Le Seuil, 1976), p. 103.

9. Panofsky would say an *Aggregatraum* instead of a *Systemraum.* See *Die Perspektive . . . ,* p. 269 (the expression is there used to describe Italo-Hellenistic painting).

10. Quoted by Joachim Gasquet, *Cézanne,* 2nd ed. (Paris: Bernheim-Jeune, 1926), p. 152. (1st ed., 1921.)

11. *Souvenirs et lettres;* see letter of April 15, 1904: ". . . to treat nature by the cylinder, the sphere, the cone, everything in proper perspective so that each side of an object or a plane is directed toward a central point."

12. Typical in this respect is the remark by Robert Delaunay in his notebooks: "Cézanne's fruit dish, already given a powerful jolt by him, has been conclusively shattered by us, the first Cubists." See *Du cubisme à l'art abstrait,* documents, ed. Pierre Francastel (Paris: S.E.V.P.E.N., 1957), p. 79.

13. Letter to Pissarro of July 2, 1876; *Correspondance,* ed. Rewald, p. 127.

14. See Emile Bernard, *Souvenirs et lettres,* p. 39.

15. Ibid.

16. Letter to E. Bernard of April 15, 1904; *Correspondance,* ed. Rewald, p. 259.

17. "So ist der Raum also der grösste Feind alles abstrahierenden Bemühens . . ." See *Abstraktion und Einfühlung,* 4th ed. (Munich: Piper, 1948), p. 50. (1st ed., Bern, 1907.)

18. The portrait of Vallier in the Leigh B. Block Collection is, one may recall, the last portrait painted by Cézanne. There exist other portraits of the gardener Vallier from shortly before this one (in particular the example in the Tate Gallery, Venturi 715; in the Lecomte Collection, Venturi 716; and in the Müller Collection in Soleure, Venturi 717), as well as several watercolors, including the admirable Venturi 1102 in the Hanley Collection, preparatory to the Block painting.

19. Quoted in Venturi, *Cézanne: son art—son oeuvre,* p. 60. Compare Cézanne's letter to his son of August 14, 1906, one of the last before his death: ". . . it [a watercolor] seemed to me more harmonious, the main thing is to put as much rapport into it as possible." His remark invites comparison with Novalis' "the greater the love, the vaster and more diverse the universe of similarities," Delacroix's "genius is the art of coordinating relations," Braque's "I don't paint things but their relations," and Matisse's "I don't paint things but the differences between things."

20. Fülep adds: "I truly felt, in this humane work, the tangible and measurable presence of those two unknowns, infinity and eternity." The article appeared a few days after Cézanne's death, in *Szerda* of October 31, 1906, pp. 214-19, included by Charles de Tolnay, "Les Ecrits de Lajos Fülep sur Cézanne," in *Acta Historiae Artium Academiae Hungaricae* 20 (Budapest, 1974): 108.

21. See the article cited above, *L'Oeil,* January 1957.

22. See in particular these characteristic lines taken from the *Posthumous Poems:*
> Raum greift aus uns und übersetzt die Dinge:
> Dass dir das Desein eines Baumes gelinge
> Wirf Innenraum um ihn aus jenem Raum
> Der in dir West.

23. Only a brief span separates Cézanne's death from the first works of Schoenberg in which tonality is consciously suspended: Quartet op. 10, 1908.

24. Letter to Ambroise Vollard of January 9, 1903: "I work steadily, I glimpse the Promised Land. Will I be like the great leader of the Hebrews or will I be able to enter it?" *Correspondance,* ed. Rewald, p. 252.

25. Letter of May 11, 1886; *Correspondance,* ed. Rewald, p. 209.

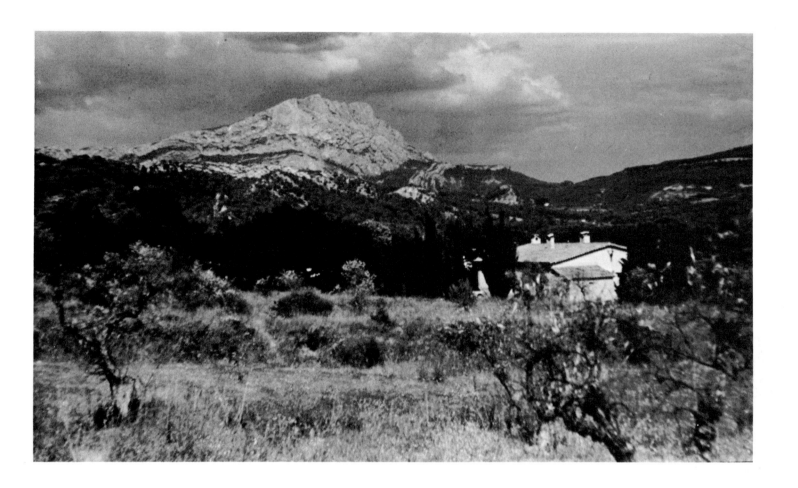

The Last Motifs at Aix

John Rewald

As Cézanne grew old his world became ever more restricted. He was not yet fifty when, at his father's death, he inherited substantial wealth and could at last have undertaken trips abroad, to Italy and Spain for example, which he had never visited and whose museums contained treasures that meant a great deal to him. Yet he did nothing to change the rhythm of his simple life and, rather than venture farther away from Aix, actually confined himself still more to its immediate surroundings. These never lost their attraction for him. Aix itself, a pleasant town almost asleep in the shade of its tree-lined avenues, lulled by the bubbling of its numerous fountains, comfortably huddled round the steeples of its many churches, held scant fascination for him—and its provincial inhabitants even

less. He remained a loner in the midst of a region where every stone, every tree, every brook was familiar to him since his youth. He never grew tired of its colors and harmonious shapes, its light and distant vistas dominated by Mont Sainte-Victoire. "For me," he wrote to a friend, "what is there left to do . . . only to sing small; and were it not that I am deeply in love with the *configuration* of my country, I should not be here."

Little by little Cézanne had renounced L'Estaque, once a favorite haunt of his on the shores of the Mediterranean, because its increasing industrialization distressed him; he also abandoned picturesque Gardanne and, eventually, even the Jas de Bouffan, which had for so long offered him a rich harvest of motifs.

While he continued his periodic stays in Paris and its vicinity,

The pond at the Jas de Bouffan

Vineyards beyond the Jas de Bouffan

The alley of chestnut trees at the Jas de Bouffan

Cézanne's only other trips were dictated by his health when diabetes prompted him to go to Vichy. In 1890 he spent several months in Switzerland at his wife's behest, and in 1896 he sojourned on Lake Annecy, possibly because his wife, in compensation for the boring cures at Vichy, exacted this concession from him.

At the same time Cézanne began to look for new places around Aix. He worked at the Bibémus quarry and in the area of Le Tholonet, where he felt drawn to Château Noir and its wooded slope, which afforded a close view of Sainte-Victoire. After his mother's death in 1897 the Jas de Bouffan had to be disposed of in order to divide the proceeds among the painter and his two sisters. At the end of 1899 it was sold for 75,000 francs. Nothing is known of the reasons that induced Cézanne to agree to this sale, which remains so puzzling since it was perfectly within his means to buy up the shares of the two others. Perhaps he felt that he had fully explored all the possibilities of the beautiful estate. It seems more likely, however, that he wished to escape the many memories—both happy and unhappy—attached to the place; also, he may have considered it much too big for his modest life-style, especially since his wife and son usually resided in Paris and he found himself alone most of the time. It is probable that his wife detested the Jas, from which she had been "banned" for many years, and where she was not welcome even after she and the painter had been married in 1886.

Still, leaving the Jas forever must have been a traumatic experience for Cézanne, since the place had meant home to him. There was the vast salon which, in his exuberant youth, he had decorated with large wall-paintings (all left behind), and, more important, there was the garden with its alley of magnificent old chestnut trees reflected in the limpid pool. There were the

greenhouse and the low wall beyond which, on clear days, Sainte-Victoire was visible; there were vineyards with their neat rows stretching to distant hills, one of these, on the other side of town, called Les Lauves; there was the elongated farm-complex where he had watched the laborers play cards. There was also that priceless seclusion so essential to him, and the recollection of seasonal changes—the bare branches forming elaborate designs against the windswept sky in winter; the trees decked out in tender green gauze in spring; the stillness of the trembling heat accented by the incessant singing of the cicadas in the summer; the vineyards turned purple and dead leaves rustling on the ground in the fall. Never one to adapt easily to new environments, Cézanne had found in the familiarity of the many aspects of the Jas both reassurance and isolation, the perfect ingredients for his work. Their loss was great. (It is said that before leaving, he made a bonfire of many of his belongings, among them quite a few of his works.)

For living quarters Cézanne rented a small apartment in a narrow street in Aix, 23 rue Boulegon, not far from the splendid town hall and its beautiful square. He had a good-sized window installed in one of the rooms on the fourth floor beneath the roof, but clearly this was—though fairly spacious—no more than a makeshift studio. It was less easy to find a place where he could work undisturbed out of doors, for it seems that most owners of large estates hesitated to grant him permission. It was at this time that he approached the owner of Château Noir, which stood uninhabited most of the year, with an offer to buy the property, a proposal that was turned down (the place still belongs to the owner's direct descendants). He was, however, able to rent a small room off an inner court of the main building where he could store his paraphernalia and fresh canvases, and was allowed to paint wherever he wished. A hired carriage would take him to Château Noir and call for him at the end of his day.

What was then the "Petite Route du Tholonet" leads from Aix eastward in the direction of Sainte-Victoire. The road bends frequently, rises and falls, until, after about a mile, at a sharp turn, the view is suddenly free over an undulating landscape that reaches the foot of the commanding gray rock. After one more gentle curve a small, slowly mounting path to the left of the road disappears into the forest. From a slight elevation near the path, one can look down over the road and see the two umbrella pines that cast their shadows on it, with Mont Sainte-Victoire looming over the whole scene. From here Cézanne painted two views of the mountain, of those pines, and of the road that loses itself in the distance (pls. 116, 119).

The path, strewn with pine needles, leads through the woods toward the so-called Maison Maria. On the way, where the trees are less densely clustered, there are glimpses of Château Noir, with Sainte-Victoire beyond. Yet it was from the broadening path in front of Maison Maria, where the ground sloped down on one side and rose on the other, that Cézanne had a better view of the building, or rather of its west wing, which he

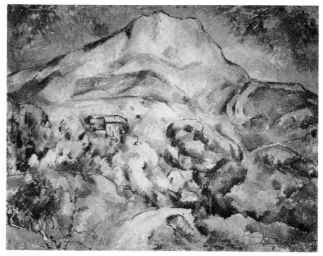

The Route du Tholonet with Parasol Pines (pl. 116). 1896–98

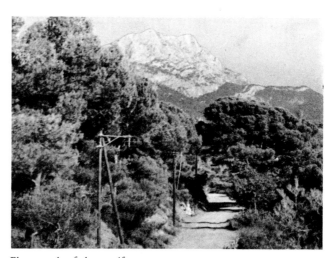

Photograph of the motif

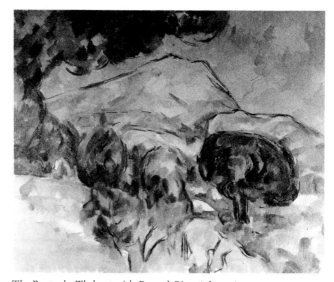

The Route du Tholonet with Parasol Pines (pl. 119). c. 1904

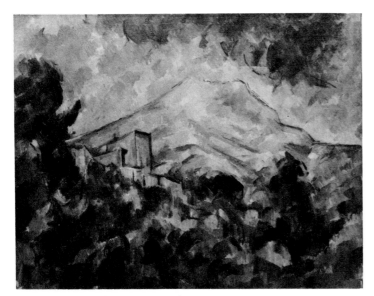

Château Noir with Sainte-Victoire (pl. 58)

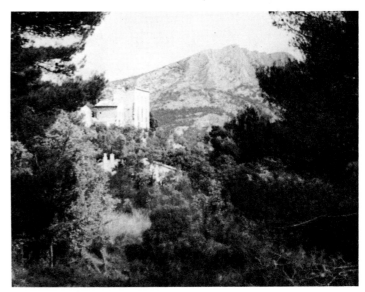

Photograph of the motif

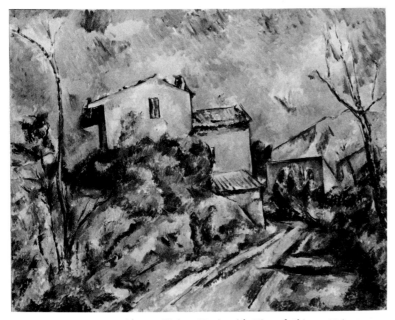

Above: *Maison Maria with View of Château Noir.* c. 1895
Private collection, Lausanne

Center right: Photograph of the motif

Bottom right: Cézanne's room on the courtyard of Château Noir

painted repeatedly from that vantage point (pls. 55, 57, 59–61).
Situated halfway between Aix and the village of Le Tholonet,
Château Noir had been built in the second half of the nine-
teenth century somewhat above the road near the bottom of the
wooded hill that rises behind it. It consists of two separate
buildings, set at a right angle to each other; the higher, main

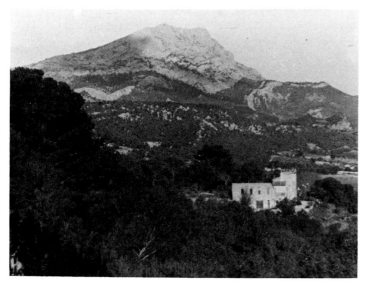

View of Château Noir from a neighboring hill

Top: *Pistachio Tree in the Courtyard of Château Noir* (pl. 66)
Bottom: Photograph of the motif

building looks south, down on the road and into the valley that leads to the distant village of Palette on the highway to Nice. A series of pillars extends from this main building to the west wing. They were to be part of an orangerie, which was never finished. They rise into the sky, supporting nothing, and lend the complex an incongruous aspect of ruins. Incongruous, too, is the style of the buildings, with their narrow Gothic windows and steep roofs. Between them lies the court that Cézanne's room overlooks; at its center there is still a gnarled pistachio tree surrounded by stones, and a heavy stone lid—probably for a well—that had been abandoned there, which Cézanne represented in a watercolor (pl. 66).

Legend has it that the complex, which was planned to be twice as large as it is, was built by a coal merchant who had it painted black. Other tales assert that he was an alchemist who had intimate commerce with the devil—hence the designation "Château du Diable," by which the strange structure was also known. But even the less forbidding name of "Château Noir" is a misnomer, for there is nothing black about it, nor is it a château; it is built of the beautiful yellow stone from the nearby Bibémus quarry, which also furnished the material for most of the patrician houses and the churches of Aix. In Cézanne's paintings it is always the glow of the orange-gold facade of the west wing, livened by the large red barn-door (now faded), as seen from the Maison Maria, that dominates the unruly blue-green vegetation.

The path from the Maison Maria, now wider and more level, continues straight to another bend where a number of stone blocks lie helter-skelter, a stone wheel standing erect among them. At this site an oil mill was to be erected, yet the blocks are still waiting to be set into place. Like so many other projects, this too was abandoned, and trees and bushes have grown freely among the blocks. Some of the trees have died, choked by the surrounding forest, and their trunks litter the ground. Next to

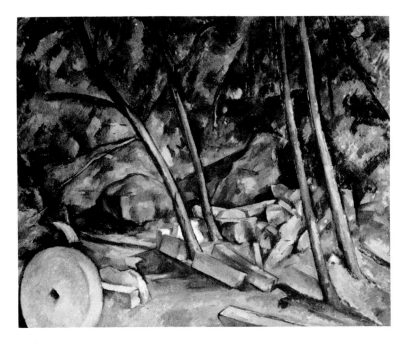

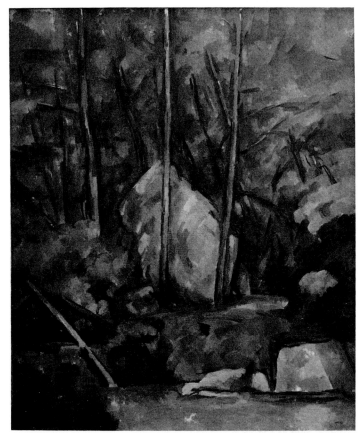

Top left: *Millstone in the Park at Château Noir* (pl. 47)

Lower left: Photograph of the motif

Top right: *Cistern in the Park at Château Noir* (pl. 92)

Bottom right: Photograph of the motif

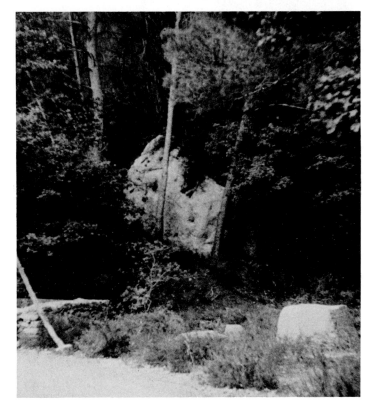

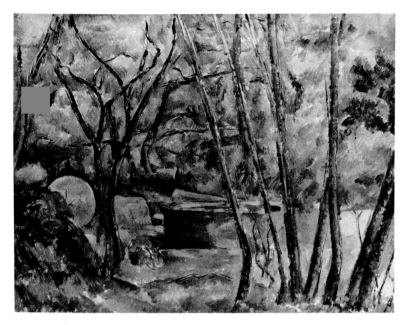

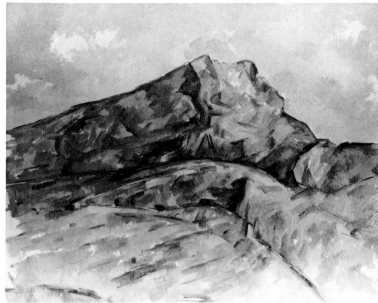

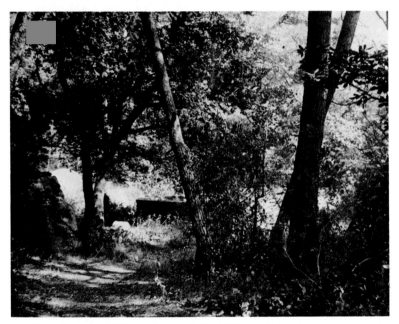

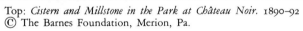

Top: *Cistern and Millstone in the Park at Château Noir.* 1890–92
© The Barnes Foundation, Merion, Pa.

Above: Photograph of the motif

Top: *Mont Sainte-Victoire Seen from a Grove near Terrace of Château Noir*
(pl. 114). c. 1904

Above: Photograph of the motif

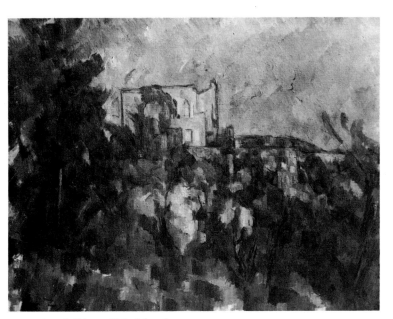

View of Château Noir (pl. 59)

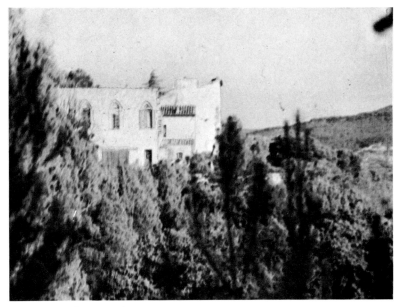

Photograph of the motif

Photograph of the small well on the path to Château Noir (see pl. 63)

this spot is an ancient cistern, for there was a spring below, as attested by an irregular row of oak trees; from three wooden poles joined together above it, a chain used to dangle with a bucket that could be lowered into the cool depth. Cézanne liked to put up his easel here to paint the cistern, the abandoned mill, the rocks and the trees behind them (pls. 53, 92).

Beyond this spot the path narrows again and, passing a small well, soon reaches the broad, sun-drenched terrace that surrounds Château Noir on three sides. To the left of the west wing Cézanne could ascend to his room on the inner court, for—because of the rising ground—that court is level with the second floors of the two buildings. When he followed the terrace to the east, he reached a shady grove where the view toward Sainte-Victoire was unhampered, with not a house in sight, nothing but vineyards, fields dotted with dark cypresses, woods, and hills behind which rises the mountain, its massive, chopped-off cone barring the horizon.

Cézanne painted Château Noir only from a distance, as it emerges above the treetops. He usually preferred to work in the forest, climbing up the fairly steep hill through the thickets, skirting large boulders that seem to have been stopped by a mysterious force as they tumbled down the slope. Here the sky is hidden by the branches and the air is fresh and fragrant, enlivened by the tireless song of the cicadas. As he reached the top, Cézanne came to a spot where a chain of huge rocks is strung along the ridge of the hill. Crushing and surmounting each other, they form caves half-hidden by vegetation. It was not an easily accessible place, and he was certain not to be disturbed.

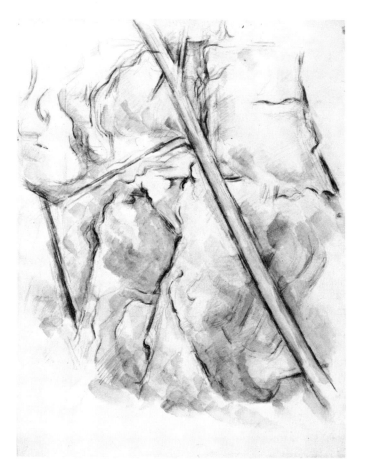

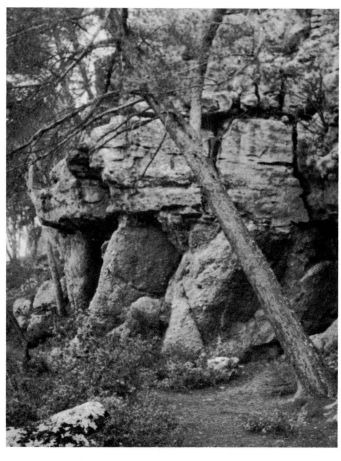

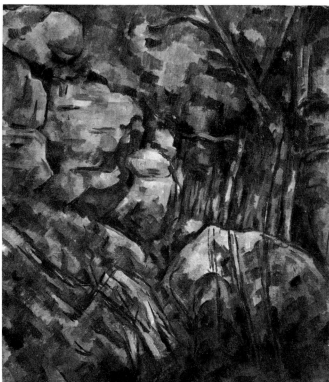

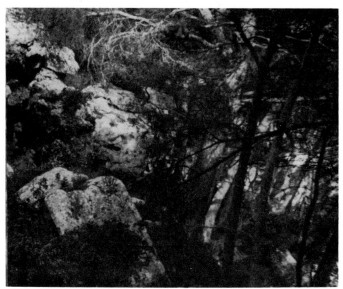

Top left: *Pine Tree in Front of the Caves above Château Noir* (pl. 65)

Top right: Photograph of the motif

Bottom left: *The Rocky Ridge above Château Noir* (pl. 38)

Bottom right: Photograph of the motif

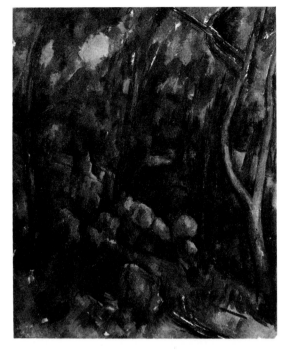

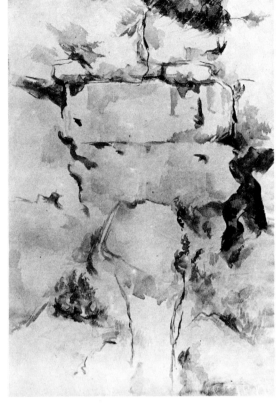

Top: *Forked Tree near the Caves above Château Noir* (pl. 50)
Bottom: Photograph of the motif

Top: *Rocks near the Caves above Château Noir* (pl. 42)
Bottom: Photograph of the motif

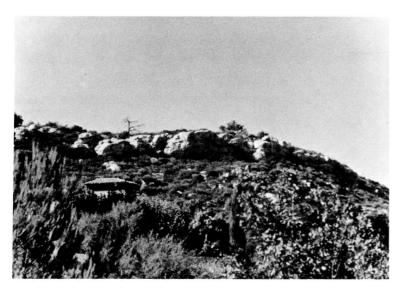

The rocky ridge above Château Noir after a recent forest fire

After the more or less well-kept grounds of the Jas, here Cézanne discovered nature untouched by human hand, yet with an almost intimate atmosphere: a sequestered spot where, amid the jumble of stones, the shrubs had gained a precarious foothold in the wilderness. The light filtered gently through the branches of the pines (pls. 49, 50).

The bizarre forms of the rocks are sometimes difficult to "read," and many of the watercolors that Cézanne painted at the caves have been hung upside down. Yet he faithfully traced their irregular shapes, the surfaces full of crevices, grooves, and hollows, the nooks invaded by shadows (pls. 40, 43, 45, 65). A recent forest fire has denuded the upper part of the hill, and the rocks are now bare, exposed to the sun; all the wild vegetation is gone, and so is the secluded beauty of the spot.

Behind the rocky ridge, which continues to the east well beyond the Château Noir property, lies a high plateau taken over by brambles because the packed ground and the mistral discourage most other growth. To the northwest, the distant Tour de César points its slim needle into the sky. This plateau—as well as the ridge itself—extends in the direction of Sainte-Victoire to the nearby Bibémus quarry.

Moderate slopes lead up to the plateau for much of its length, but at this point it is edged with cliffs that overlook the valley. After the winter rains the soaked soil turns orange, and the evergreen laurels, thyme, and rosemary glisten with moisture. From far below, vapor rises like smoke behind every swelling, every undulation of the ground, while Mont Sainte-Victoire disappears under low-hanging clouds. In the distance, to the left, the ocher chapel of the Domaine Saint-Joseph stands out against the dark firs of the slope. Farther away, the straight rows of sycamores that lead from the Château du Tholonet toward Palette cut across the plain, which is dotted with isolated farms, rain-drenched vineyards, and olive or almond groves. According to local legend, the reddish earth takes its color—which is

particularly vivid after rainfall—from the blood with which it was drenched when Marius defeated the Teutons at the foot of Sainte-Victoire, a hundred years before Christ.

Provence is rich with ancient quarries, some of them going back to Roman times. Though quite a few are being reexploited now, many have lain unused for centuries. Their intricate cubic forms, the strange shapes of their weathered stones—usually the result of man's intervention—offer striking and picturesque effects under cloudless blue skies. Stone from these quarries is usually distinctive, and the real lover of Provence can distinguish the porous gray product of Rognes from the discreetly veined slabs of Tavel or the white blocks of Lacoste, rich in fossilized creatures of the sea. But the stone from Bibémus is still different: it has a soft ocher color, as though the rays of the sun had been captured in it. This is why so many stately residences on the Cours Mirabeau of Aix, their facades withering under the persistent mistral, maintain the rich yellow that forms such a warm contrast to the cold splendors of marble.

At Bibémus, as in most Provençal quarries, the stone is excavated without the aid of superstructures, and there is nothing to signal these extensive work sites to the passerby. Even those who explore the country into its farthest, most secret

Photograph of rocks at the Bibémus quarry

Left: Photograph of
Cézanne's *cabanon*
at the Bibémus quarry

Below: Photograph of the terrace
and the linden tree in front of
Cézanne's studio at Les Lauves

corners can easily pass them without noticing, or suspecting, the presence of their fascinating, sunken architectures.

Bibémus is reached by a once-much-traveled road over which the stone from the quarry was carried to Aix. This road crosses the high plateau to the north of Château Noir. The quarry itself is an immense complex of large holes cut into the ground, often in layers that form strange steps. Beyond and below Bibémus (and north of Le Tholonet) lie the Gorges des Infernets, where Emile Zola's father had designed the dam that provides Aix with water. In their youth, Zola and Cézanne used to come here to hunt, or to swim in the dammed-up waters, but it was not until almost forty years later—in the middle nineties—that the painter returned to the area to work at Bibémus. He rented a small, completely isolated one-room shack (a *cabanon*) and began to look for motifs.

The quarry had been abandoned for some time, and trees and bushes had taken root among the ocher rocks. In the distance, the ever-present Mont Sainte-Victoire rises into the sky (pl. 37). The scenery is quite different from that of the caves near Château Noir, for the space is wide open, exposed to the sun and winds, and the shapes of the rocks were not formed by nature but bear the marks of human industry. Yet it appears as though no plan presided over the exploitation of the quarry, where the stone has been extracted here and left untouched there. Between deep cavities and shallow furrows, solitary blocks remain standing, scarcely tampered with. It is a vast field of seemingly accidental forms, as if some prehistoric giant, constructing a fantastic playground, had piled up cubes and dug

holes and then abandoned them without leaving a hint of his intricate plan. And nature has since spread a carpet of plants over the turrets, the square blocks, the sharp edges, the clefts, the caves, the tunnels and arches, thus reclaiming the site that had been wrested from her.

Wherever he turned, Cézanne found enticing aspects whose basic elements were always ocher rocks and more or less timid vegetation. He made numerous paintings at Bibémus, but few watercolors, which he executed mostly in the more protected

plain, two-story structure he built there—it was ready in September 1902—contains small rooms on the ground floor, while the second floor is taken up almost entirely by a large studio, more than twenty-three by twenty-five feet and a little over thirteen feet high, its north wall made up of a huge window next to which there is a long, narrow slit through which big canvases can be moved. On the opposite wall are two tall windows (the third lights the stairwell) that afford a magnificent view of Aix and, in the far distance, the misty blue mountain range, the Chaîne de l'Etoile, with its protruding, square Pilon du Roi.

There is a twenty-foot-wide terrace in front of the studio, bordered by a low wall, separating it from a small garden that descends toward a narrow canal. An old gardener, Vallier, took care of the grounds. Behind the studio a wooded plot, belonging to a neighbor, provided a green curtain for the large window.

It must have been while the studio was being constructed that Cézanne, inspecting the progress of the work, began to venture farther up the still unsettled hill. Climbing the fairly steep road beyond the studio to the crest of Les Lauves, he found a new, exhilarating panorama stretching away to his right. From here Sainte-Victoire, remote but imposing, no longer appeared as the chopped-off cone that he had contemplated from Château Noir or Bibémus, but as an irregular triangle, its long back gently rising to the abrupt, clifflike front that tapered off to the horizontal extension of the Mont du Cengle (pls. 117, 118, 120–22, 124, 127–29, 134–36). At his feet extended a vast, undulating plain with a quilted pattern of fields and clusters of

setting of the not-too-distant caves just above Château Noir.

Eventually, however, Cézanne felt the need for a place of his own. It may have been a desire not so much for a change of scenery as for a studio where he could work on his large compositions of bathers, one of the major concerns of his last years. As it turned out, he was to find both: a house where he was at ease and new landscape subjects. In November 1901, Cézanne acquired a property of modest size halfway up the hill of Les Lauves, to the north of Aix and overlooking the town. The

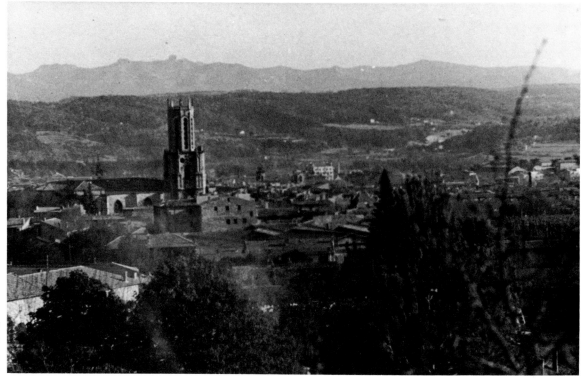

Top: Early photograph of Cézanne's Lauves studio

Right: View of Aix from Cézanne's studio (see pl. 100)

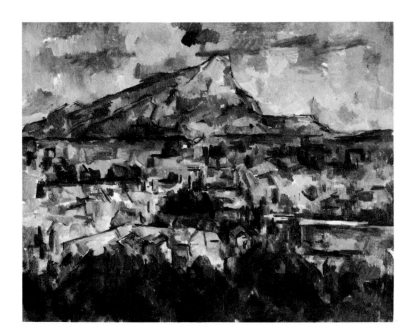

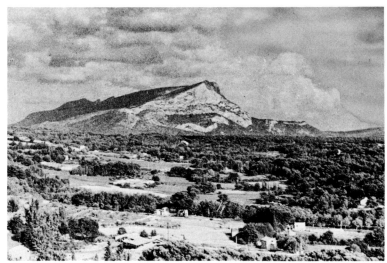

Left: *Mont Sainte-Victoire
Seen from Les Lauves* (pl. 122)

Above: Photograph of the motif

trees, interrupted by occasional farm buildings. It was a welter of horizontals and verticals, a dense conglomerate of color patches over which his eyes could roam at will and which was so wide that he had to turn his head to the right and left to take all of it in. Sometimes he even had to add strips of linen to his canvas—or paper to his sheet—when he tried to encompass the whole breadth of the view in a painting or a watercolor (pls. 125, 126).

Above this immense stretch, Sainte-Victoire seemed to float ethereally in the southern light, hanging there like a glorious symbol of Provence. Cézanne's almost obsessive fascination with the mountain drew him again and again to this spot, where

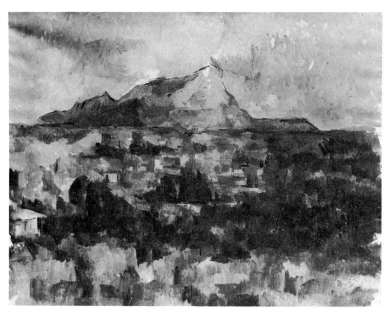

Mont Sainte-Victoire Seen from Les Lauves (pl. 123)

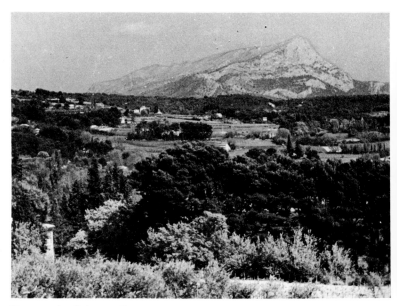

Photograph of the motif

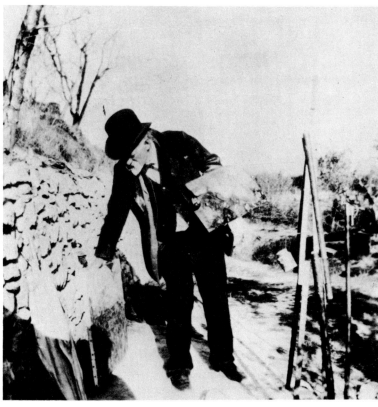

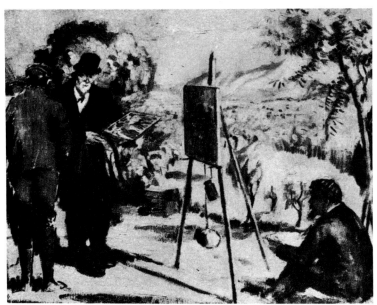

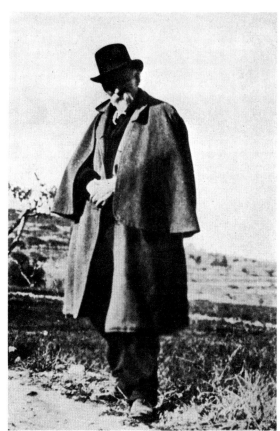

Top left and right: Cézanne working on a view of
Mont Sainte-Victoire at Les Lauves in 1906

Bottom left: Maurice Denis's *Cézanne "on the Motif"*
[with K.-X. Roussel at left and M. Denis at right]. 1906
Private collection, France

Bottom right: Cézanne in 1905

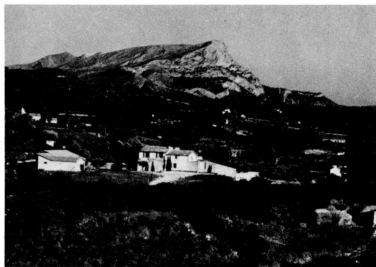

Left: *Farm in Front of Mont Sainte-Victoire.* 1902–04
Watercolor. Private collection, Paris

Above: Photograph of the motif

many of his last landscapes were painted. Here he paid ultimate homage to the mountain which, no longer squatting beneath the infinity of the skies, appears pointed toward heaven, in as solitary splendor as ever, though possibly still more majestic.

The artist was sixty-three years old when at last he could move for the first time into a studio built to his specifications. He furnished it sparsely but brought along many of the objects

(quite a few are still there) that he liked to use for still-life compositions. Among them were four or five skulls, a blue ginger pot, old bottles, green olive jars, various containers and crockery, as well as a rather ugly rug or table cover made of some kind of heavy felt. It had rusty brown and deep green and red tints, its geometric design set in squares, the whole surrounded by a lighter, flower-patterned border. Cézanne used it

Mont Sainte-Victoire Seen from the Community of Saint-Marc (pl. 130)

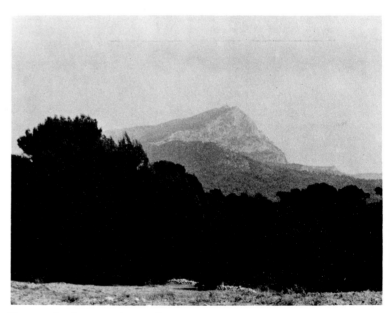

Photograph taken near the motif

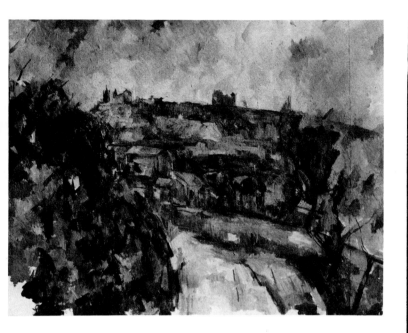

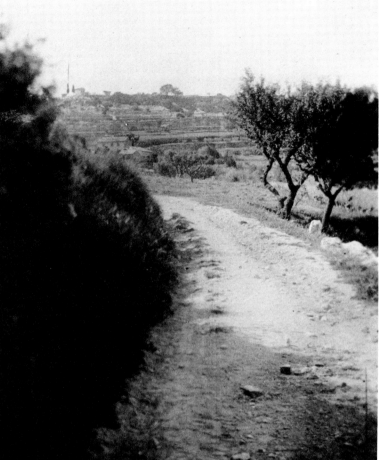

Top left: *Bend in Road on the Crest of Les Lauves.* 1904–06
Present whereabouts unknown

Lower left: Watercolor of the same subject (pl. 112)

Top right: Photograph of the motif found in Cézanne's studio,
probably taken by Emile Bernard in 1904

Bottom right: Still-life objects in Cézanne's studio

also for a backdrop, like a curtain, and it provided a lively prop for portraits (pls. 9, 19) as well as for many still lifes, among them those with several skulls (pls. 155, 156, 158). Though dirty and faded, this rug was still in the studio a few years before the war; souvenir hunters and moths have since got the better of it.

While little attached to possessions, Cézanne seems to have cared for these rather common objects, which he kept for many years and on which he could always rely. He also took to the studio a small wooden table with scalloped apron that he had already used for over a decade and on which he liked to assemble still lifes. It is still there. Preserved also are the white plaster putto, *L'Amour,* attributed to Puget, and a—now decapitated—plaster of a *Flayed Man,* both frequently represented by the artist. On the walls hung assorted lithos or photographs of works by Signorelli, Rubens, Delacroix, and Forain; others were kept in large folders. In a corner, leaning against the wall, still stands an immense ladder that Cézanne needed for work on the large bathers, for which a special extensible easel also still exists. Among the few pieces of furniture was a small chest that served for paints, brushes, and similar paraphernalia.

Two young painters, R. P. Rivière and J. F. Schnerb, visited Cézanne in Aix in January 1905 and found him much less misanthropic than his reputation made him out to be. They were admitted to his studios and noticed that "in the corners canvases were lying about, still on their stretchers or rolled up. The rolls had been left on chairs and had been crushed. His studios, the one in the rue Boulegon and the one . . . in the country, were in great disarray, in an unstudied disorder. The walls were bare, the light was crude. Half-empty paint tubes, silk brushes stiff with colors long since dried, remnants of meals that had become subjects of still lifes covered the tables. In a corner stood a collection of parasols such as landscape painters use, their coarse armatures doubtless provided by some local merchant and their pikes shod by some neighborhood blacksmith; next to them were game bags to take victuals out into the fields."

Cézanne never really lived at the studio but continued to reside in Aix. He went up to start work very early in the morning, sometimes rising at five o'clock to escape the heat. While the studio was not too far from his home, the walk was uphill and there was no shade on the Chemin des Lauves. The painter generally left again by eleven, but occasionally he had food sent up so as not to interrupt his work. Around four in the afternoon, once the hot weather had subsided, he might have a carriage take him to outlying motifs. Cézanne loved that time of day for painting *sur le motif;* then the heat no longer vibrates over the fields, the shadows grow longer, the air becomes limpid and crystalline, the distance takes on a peculiar sharpness, and the foreground glows under the rays of a leisurely disappearing sun. It is an unforgettable hour of harmony and peace. Those who have wandered over the countryside of Aix in the footsteps of the artist call it "the hour of Cézanne."

When he drove or walked back from his studio, Cézanne skirted the massive Hôpital Saint-Jacques at the foot of Les

Above: Still-life objects in Cézanne's studio, among them the rust-brown, red, and green carpet no longer in existence

Below: A corner of Cézanne's studio

Top left: Photograph of
a still life "re-created"
in Cézanne's studio
(see pl. 148)

Above: Photograph of
Cézanne's studio

Far left: Drawing after
L'Amour en plâtre. c. 1890
British Museum, London

Left: Photograph of
the plaster cast
in Cézanne's studio

Top: *Pont des Trois Sautets* (pl. 113)
Above: Photograph of the Pont des Trois Sautets

out the elegant silhouette of the tower of Saint-Sauveur. On the low parapet of the terrace rows of potted plants were assembled (pl. 104); there, in the dappled shade, he not only painted watercolors of the splendid panorama of the town (pl. 100), but also repeatedly had his gardener Vallier—and sometimes other willing peasants—sit for him (pls. 16, 17, 22–24, 26, 27, 29).

During the summer of 1906, when the heat became particularly unbearable (perhaps his diabetes caused him to suffer more acutely from it), Cézanne looked for shade elsewhere. He went to a secluded spot on the Route des Milles, where the Arc River flows not very far from the Jas de Bouffan, and near the property of Montbriant, once owned by his brother-in-law. But soon he preferred to have his coachman take him to another familiar place in the Arc valley, scene of many of his youthful escapades. His carriage followed narrow, cobbled streets, crossed the Place des Prêcheurs to the Route de Nice; before reaching the village of Palette, the coachman would turn right and drive over the old, strangely pointed, single-lane bridge of Les Trois Sautets. On the far side, on the bank of the river and beneath large trees that formed a vault over the quiet waters—sometimes rippled, ever so slightly, by a dragonfly—Cézanne found coolness and isolation; close by he also found a place to leave his painter's gear.

"I must tell you," he wrote his son on September 8, "that as a painter I am becoming more clear-sighted before nature, but with me the realization of my sensations is always painful. I cannot attain the intensity that is unfolded before my senses. I do not have the magnificent richness of coloring that animates nature. Here on the bank of the river the motifs multiply, the same subject seen from a different angle offers subject for study of the most powerful interest and so varied that I think I could occupy myself for months without changing place, by turning now more to the right, now more to the left."

But four weeks later, as he informed his son, Cézanne had a falling-out with the coachman, who had "raised the price of the carriage to three francs return, when I used to go to Château Noir [which is farther away] for five francs. I fired him." Fortunately, by then the terrific heat had lessened, and he could return to Les Lauves.

"As the banks of the river are now a bit cool," he wrote on October 13, "I have left them and climb up to the Quartier de Beauregard where the path is steep, very picturesque but rather exposed to the mistral. At the moment I go up on foot with only my bag of watercolors, postponing oil painting until I have found a place to put my baggage; in former times one could get that for thirty francs a year. I can feel exploitation everywhere."

To reach the Quartier de Beauregard, Cézanne took the Route de Vauvenargues that runs along the bottom of a shady vale northeast of Aix, in the direction of the Tour de César. To the right rises the high plateau with the Bibémus quarry; to the left the ground mounts toward the Beauregard section. The artist would climb a winding lane at left, up to the top where the tall pines and thickets of short cork-oaks of the protected slope give way to fields and meadows with sparse trees and a few isolated

Lauves, then went through the most ancient sector of the town, passing the cathedral of Saint-Sauveur (where a new "idiot of an abbé, who works the organ and plays wrong," prevented him from attending mass) and the imposing old Law Faculty (where he had once studied) before reaching the square in front of the town hall; turning left at the quaint clock tower, he found himself in the rue Paul Bert, which leads to the rue Boulegon.

When it was too hot or when the Lauves crest was swept by the mistral, Cézanne could work under a linden tree on the terrace in front of his studio. The vegetation of his garden did not yet block the view of the Aix rooftops, against which stood

The Tour de César photographed from near the Bibémus quarry

What may have been the Cabanon de Jourdan (see pls. 83, 84), in the Beauregard section. The house has apparently been altered since the early years of this century.

houses. It is almost an hour's walk from Aix. When the mistral blows here, it sweeps over the flat lands and sways the trees. From some spots, vegetation permitting, Mont Sainte-Victoire can be glimpsed beyond the village of Saint-Marc. (In earlier years Cézanne had done a watercolor from there, pl. 130.)

The landscape has not changed much since the artist's day, the sprawling town not yet having reached these peaceful outskirts. It is said that an Aix merchant, Jourdan, owned a good deal of land here. Although it is not known exactly where Cézanne painted *Le Cabanon de Jourdan* (pl. 83), on which he had already worked in July, and the corresponding watercolor

(pl. 84), it is more than likely that they were done here. They are reputed to have been his last landscapes.

Meanwhile the rainy fall season had set in. On October 15—two days after he had informed his son of his excursions to the Quartier de Beauregard—Cézanne was overtaken by a violent thunderstorm while painting. He remained exposed to the rain for several hours until he was brought back to the rue Boulegon in a laundry cart; two men had to carry him up to his bed. But the next day he went to his garden to work under the linden tree on a portrait of Vallier. He reached his home in a state of collapse and died on October 22, 1906.

I FIRST CAME TO AIX in the late spring of 1933 and there met the painter Léo Marchutz, who for several years had been living at Château Noir. He owned a copy of the April 1930 issue of *The Arts* with an article by Erle Loran [Johnson] on "Cézanne's Country," where the first photographs of the artist's motifs had appeared. On his own, Marchutz had located a series of further motifs, especially at Château Noir and around Le Tholonet. He asked me to take photographs of these with my newly acquired Leica; it wasn't long until I moved into the main building of Château Noir and we set out on a systematic hunt for Cézanne's motifs throughout the region of Aix, L'Estaque, Gardanne, usually on bicycles, which we often had to push uphill in the stifling heat, for Cézanne liked to work from elevated positions. In those days telephoto lenses were not yet very powerful and color film was not commercially available. In many of my pictures the bulk of Mont Sainte-Victoire appears much too small in relation to the foreground and the middle ground. We

met with particular difficulties at the Bibémus quarry, where some work seemed to have been carried out after Cézanne had painted there. While certain of his motifs could still be readily recognized, we found it impossible to stand on the exact spots from which Cézanne had represented them. (We resolved, however, not to retouch our photographs, as Erle Loran had done occasionally in an attempt to match his more closely with Cézanne's landscapes.) Since World War II the quarry has been reactivated and Cézanne's motifs have been literally demolished.

Until 1939 I spent several months in Aix every year, staying at Château Noir and roaming the countryside with Léo Marchutz. I went there not only in the summer but also in the spring, before the leaves of the chestnut trees at the Jas de Bouffan could hide a number of the vistas Cézanne had painted. With evergreen pines or cypresses, unfortunately, there were no such seasonal aids. Sometimes we had to get up at dawn and, with Marchutz standing watch and checking the results, I

climbed the trees to cut a few branches in the forest of Château Noir—something strictly forbidden by the owner—to disengage some overgrown sites or "liberate" views of the buildings which they obstructed (nature has since reclaimed its prerogatives).

In the north I extended my search to Auvers, Montgeroult, La Roche-Guyon, and other places where Cézanne was known to have worked. Lionello Venturi, who was then preparing his oeuvre catalog of Cézanne—which appeared in 1936—lent us photographs of little-known or unpublished works so that we could try to identify them. In exchange we communicated to him exact geographical titles wherever possible (though he never managed to make a distinction between the Bibémus quarry and the caves above Château Noir). In 1937 we provided our friend Fritz Novotny with a list of all identified motifs which he published in his book *Cézanne und das Ende der wissenschaftlichen Perspective* (Vienna: Scholl, 1938).

After the war, from 1947 on, I returned every year to Aix. Marchutz meanwhile had moved into the Maison Maria, but our pursuit of more motifs had to be abandoned. Things were changing rapidly; forest fires ruined some sites, new constructions others. Eventually, Marchutz refused to leave his studio. He could not bear, for instance, to see the Jas de Bouffan shorn of its vineyards, reduced to an island wedged in by superhighways. (By now it is, in addition, surrounded by hideous prefabricated housing developments, painted in dreadful colors.)

The entire hill of Les Lauves is today cluttered with enormous, monotonous, barrackslike buildings between which Mont Sainte-Victoire can no longer be seen anywhere. In 1953, Cézanne's studio—which I had visited many times—was threatened by real-estate developers; alerted by James Lord, I was able to form an American committee of Cézanne admirers who raised the relatively modest amount necessary for its acquisition. The very day in 1954 that our purchase was concluded, we turned over the studio to Aix officials to preserve it for all time. It is now open to the public. Periodically, however, there are still attempts to encroach on its grounds for a projected widening of the Chemin des Lauves, now piously called Avenue Paul Cézanne. Had it been necessary to rescue Moses from the waters of the Nile as often as it has been necessary to save the integrity of Cézanne's studio, the prophet would surely have drowned.

On various occasions, Marchutz helped organize Cézanne exhibitions in Aix, notably in 1956 at the exquisite Pavillon Vendôme, to celebrate the fiftieth anniversary of the artist's death. In that show Cézanne's works could be seen at last in the same mellow light in which they had been painted, and as the visitors glanced through the windows of the Pavillon, they perceived the tiled roofs of Aix, the spires of its churches, and the tops of its plane trees that had been part of Cézanne's small but intensely loved world.

Léo Marchutz died in January 1976 at the age of seventythree. We buried him in the rural cemetery of Le Tholonet, in sight of Mont Sainte-Victoire. I owe him my fervor for Cézanne.

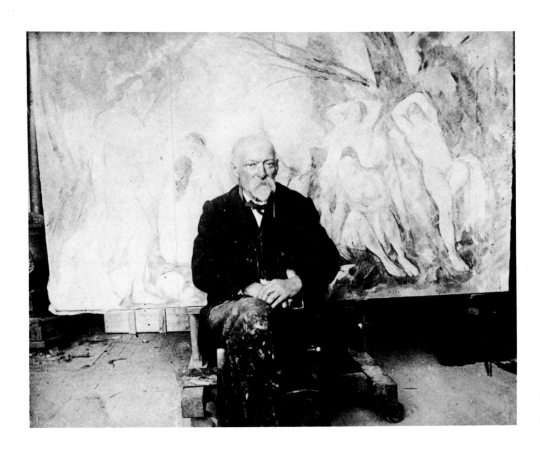

Cézanne in front of his *Large Bathers* (see pl. 187); photograph taken in the Lauves studio by Emile Bernard in 1904

The Railroad Cut. c. 1870. Venturi 50. Oil on canvas, 31½ x 50¾ in (80 x 129 cm). Neue Staates-Galerie, Munich

The Late Landscape Paintings

F. Novotny

THE PARTICULAR QUALITY that distinguishes Cézanne's late from his earlier landscapes becomes immediately apparent when one compares the two groups of paintings. Its source is easy to identify, for in these works there emerges with surprising force a fundamental aspect of the artist's personality: his temperament. Even at the very beginning of his career, in the early figure paintings, it made itself felt in an intense, often consciously "contrary" fashion.

In the paintings that date from the intervening decades, this force of temperament is conspicuously repressed. In the late works, which are the ones that come to mind when Cézanne's name is mentioned, the interpretation of reality and the novelty of his approach reveal the culmination of his art. Intimations of

his final style emerge for the first time in the landscape *The Railroad Cut* (Venturi 50), c. 1870, perhaps the most significant work of Cézanne's early period. The painting appears like an erratic boulder within its milieu. The few, utterly economical blocklike forms of this segment of the real world are built up into structural unity by a correspondingly limited number of colors: the radiant, pulsating blue of the sky; the deep India red of the scar in the hill; the vermilion roof of the cottage; and the long, slow streak of brown that marks the garden wall—scarcely recognizable for what it is—with a soft stain of light green in the left foreground. In the long series of landscapes that followed, the compelling simplicity and bulky weight of *The Railroad Cut* were replaced, persistently through the years, by a

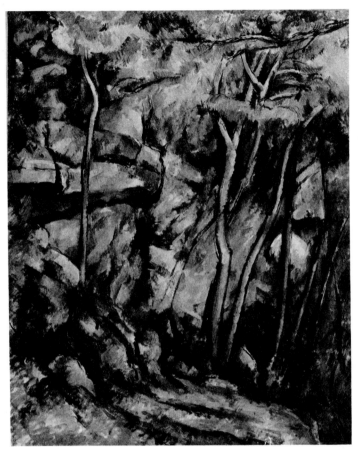

In the Park at Château Noir (pl. 49). 1898–1900. Venturi 779
Oil on canvas, 36¼ x 28¾ in (92 x 73 cm)
Musée du Louvre, Paris

far greater diversity of color, evoked by the myriad configurations of nature. For Cézanne, the multitude of nature's phenomena with all their forms and differentiations became as much a commitment as it had ever been for any realist painter of landscape. Given these parameters, he had to keep his pictures in continual, penetrating focus, and to the last they remained indeed color configurations of a kind never seen before.

But the role of color in these paintings, a central and unusual feature, cannot occupy us here; our concern instead is the total effect of the fully developed particularity of Cézanne's art, and this in two respects: first, the unusual nature of his transcription of reality as an objective concern and, second, the change that took place in the works of the last period—that is, what is unique about the works that are the subject of this exhibition.

Cézanne's depiction of reality is especially striking in one fundamental characteristic: it is perceived as distant from humanity—in acuter form, as distant from life—and, as such, seems something negative. But the powerful aggregate effect of his pictures demands that we recognize a positive aspect as well. The distance from men and life as a whole can be sensed from the very beginning; only after close inspection, however, does one discern a peculiar reduction of detail in these scrupulously rendered views of reality. In particular, this simplification is noticeable in the representation of light, which very seldom includes explicitly distinct shadows, and of the texture of objects, which always in this style of painting is barely indicated. A third characteristic of this style, apparent after a measure of intimacy with the picture has been attained, is that the total spatial effect of the landscape seems singularly subdued. Together, these features produce the image of an actual scene from nature, an image whose intensity is clearly sensed as having a strangely positive force.

The meticulous rendering of the segments of space that are the subject of each of these landscape paintings—with their more or less hazy manner of representation, and the renunciations mentioned—produces in every instance the impression of an unusual power; thus, finally the mysterious effect of these pictures is perceived more clearly as a peculiarity of their total configuration. It is based upon the unique compound effect of an unusual way of painting in which the picture plane acts in a new fashion as a covert force. The result is a representation of the conscientiously and intensively examined reality of nature, so to speak in the state of becoming, in *status nascendi*. Furthermore, the pictorial structure underlying the whole representation reduces the illusionistic effect. This characteristic of Cézanne's style is especially noticeable in his drawings and watercolors, with their expanses of open surface on which his lines or touches of wash are placed. But, though less obvious in his oils, it is no less a factor there, having a fundamental determining effect on the whole and thereby strengthening that paramount peculiarity—the distance from humanity.

Occasionally something of this kind can be found earlier in the history of art, in great painting, but the new form Cézanne

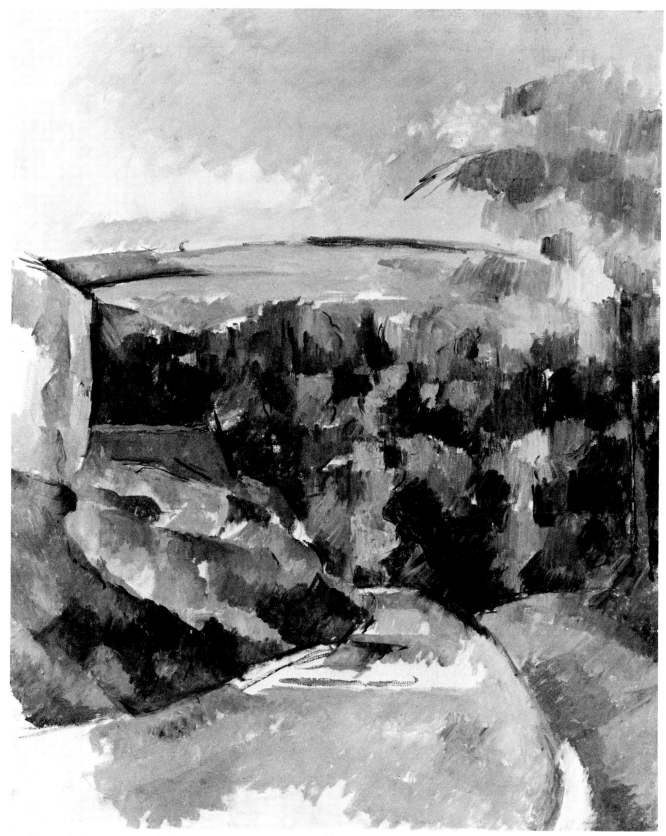

Bend in Road (pl. 80). 1900–06. Venturi 790. Oil on canvas, 32 x 25½ in (81.3 x 64.8 cm). Private collection

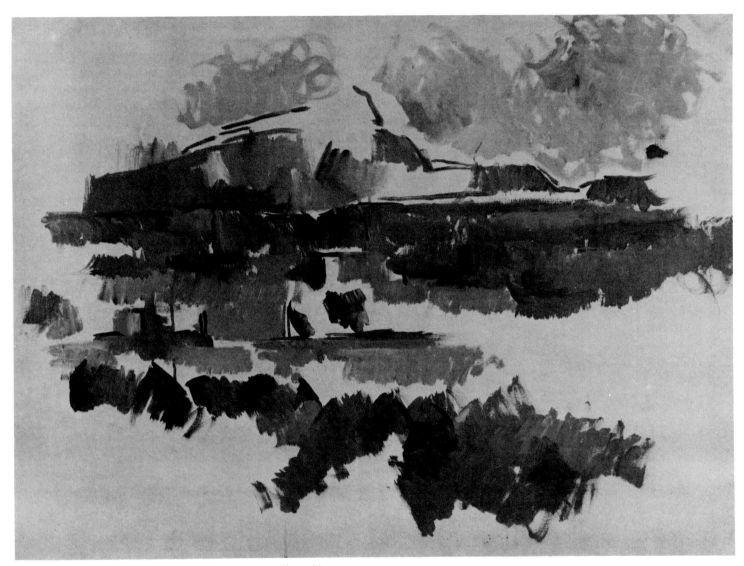

Mont Sainte-Victoire (pl. 127). 1904–06. Oil on canvas, 21¼ x 28¾ in (54 x 73 cm). Galerie Beyeler, Basel

succeeded in giving to it possesses a truly revolutionary power.

If we now examine Cézanne's late landscapes with these observations in mind, an important difference appears. It is particularly evident in the last views of Mont Sainte-Victoire. What strikes one first is the excitement of Cézanne's mode of representation in these pictures, an excitement already discernible in the angle of view, which is considerably narrower than in most of his many earlier paintings with the mountain as dominant motif. The agitated movement of the late renderings is produced by the brushstrokes, which at the same time summarily abbreviate details: the mountain peak, scattered buildings, and the areas, now scarcely decipherable in their particulars, of the middle distance and foreground. This approach goes beyond the earlier suggestive, cautious construction of the outline of single objects, and the rich variations of colors are replaced by a dominant coloration, in this case an intense blue.

The turbulent execution of these late landscapes gives off a restless, overpowering emotion, which was characterized at the beginning of this short essay as symptomatic of the emergence of an unusual temperament. Despite the fact that Cézanne's late rendering of landscape is thus clearly distinguishable from his earlier manner, with its comparatively restrained expression, one essential characteristic of his representation of reality nevertheless informs the work of both periods: distance from humanity. It finds expression as calm and silence in the conscious discipline of the earlier works, and as overt agitation, passionate restlessness, in the final phase. Both styles are based on a perception of nature, of landscape, as a phenomenon that exists essentially apart from mankind.

It is important to bear in mind precisely how the agitated landscapes of Cézanne's last years, violent and deep-plunging in their structure, differ from those that preceded them in the

1890s. The latter display a notable density of the represented section, which is most pronounced in the forest scenes. Predominant are views into the thick foliage of the woods around Château Noir, where from the thicket of branches and leaves, large and small boulders frequently emerge. In one of these paintings Château Noir itself appears; in another notable example an ancient cistern can be seen near great fragments of fallen rock. But in this group of late landscapes, with their usually very dense structure, the pronounced restlessness is absent. Here, too, is a preponderance of blue tones, but they are significantly reduced in intensity compared with those in the turbulent last pictures of Mont Sainte-Victoire.

Cross-directional accents of tree trunks and branches, as well as the contours of the rocks, are held closely together in parallel brushstrokes of a characteristic kind. Yet the blue tonality of these landscapes (earlier, one would have spoken of a blue "palette") lends itself to a sensitive fidelity to nature, reflected in the rendering of individual objects—trunks, branches, and leaves, as well as the shapes of rocks. Here Cézanne's unusual care in the depiction of nature is fully displayed, as it is for example in a painting from his last years, *Bend in Road* (pl. 80); the overall rendering is summary, but the curves in the road are painted with accuracy, whereas in the numerous other paintings that show winding roads the curves are simplified—heavy and clumsy.

A concluding note: it is obvious that truth to nature is given up in Cézanne's series of *Bathers,* with their freely invented landscape elements that look like stage sets. Whatever significance these pictures have in the history of painting, they are not the works that represent the consummation of Cézanne's career. For that we must turn to the turbulent, ecstatic last views of Mont Sainte-Victoire in the distance—the stirring climax of Cézanne's art, together with the late forest landscapes of timeless peace and breathless quiet.

Translated from the German by Ellyn Childs Allison

The Late Watercolors

Geneviève Monnier

A CONSTANT CHARACTERISTIC of Cézanne is his objective, scrupulous vision of nature. We can appreciate this objectivity, and also the sharpness of his eye, if we compare photographs of sites with his representations of them. In a late example such as *Pistachio Tree in the Courtyard of Château Noir* (pl. 66), there persists the same close relationship between photograph and watercolor.

During the last two years of his life Cézanne tirelessly pursued his research in painting from nature. In a letter of January 29, 1904, he wrote of ". . . a whole day working to overcome the difficulties of producing after nature,"[1] and in a letter of September 21, 1906, a month before his death, he said, "I am always studying after nature and it seems to me that I am progressing slowly."[2]

It was not a matter of a traditional representation of nature, but rather of a study distanced to some extent from reality. Cézanne was trying, above all, to give an idea of the internal construction of the spaces before him. In the watercolors of his last period there seems to be a dual development, in the method of composition and in the layout of the subject.

The composition of his previous watercolors was strictly regulated by linear rhythms. This organization of space according to a geometrical plan answered to Cézanne's determination to affirm the objectivity of his perception in contrast to the subjective vision of the Impressionists. Linear structure is the basis of most of his works, including those after the "constructive" period, where it is less evident. In such late watercolors as *Pine and Rocks near the Caves above Château Noir* (pl. 65), *House among Trees* (pl. 90), or *Pistachio Tree in the Courtyard of Château Noir,* the association of verticals and diagonals and their opposition to one another accentuate the dynamism and movement.

In the *Sheet of Water at Edge of Woods* (pl. 91), composition remains predominant, even if the layout is less linear and the horizontals are less evident, for the structure is determined by the succession of planes.

An example of perfectly regulated composition appears in the *House beside the Water* (pl. 106), where there is a harmonious balance between the network of vertical lines of the trees and the diagonals of the rooftops and river banks. This watercolor is another proof of the importance, in Cézanne's late work, of architectonic elements. We have, from April 15, 1904, one of his most famous statements: "Treat nature by the cylinder, the sphere, the cone, everything in proper perspective so that each side of an object or a plane is directed towards a central point . . . Nature for us men is more depth than surface, whence the need of introducing into our light vibrations, represented by reds and yellows, a certain amount of blue to give the impression of air."[3]

In the early watercolors, such as *The Bridge at Gardanne* (Venturi 912), the subject occupies the entire sheet, and the distribution of the various components is effected by the tier arrangement of the planes. Here shadows are stressed across the entire expanse of the paper, whereas in certain later works, such as *Rocks near the Caves above Château Noir* (pl. 45), the subject is restricted to the center and lower right corner, leaving the three other corners empty. The subject seems to be out of balance, dissociated from the idea of a third dimension and from any impression of weight. Cézanne was bent on defining the directions of the various components and the shadings of color rather than on conveying the illusion of space. In this way he broke with the traditional system of linear perspective. Among other watercolors with three blank corners we may mention *Bibémus* (Venturi 1045), *Trees among the Rocks at Château Noir* (pl. 64),

Bridge at Gardanne. 1885–86. Venturi 912
Watercolor, 8⅛ x 12¼ in (20.6 x 31.1 cm)
The Museum of Modern Art, New York, Lillie P. Bliss Collection

Notes to this essay appear on page 118.

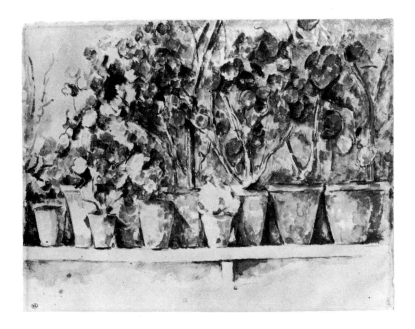

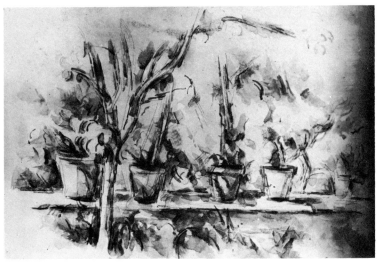

Top: *Pots of Flowers.* c. 1885. Venturi 952
Watercolor and gouache, 9¼ x 12⅛ in (23.6 x 30.8 cm)
Musée du Louvre, Paris

Above: *Pots of Flowers on the Studio Terrace.* 1902–06. Venturi 951
Watercolor, 12¼ x 18½ in (31 x 47 cm)
Private collection, Paris

and *Grotto, Château Noir* (pl. 43), all three 1895–1900. When the subject seems to float, as here, in the middle of the paper, it presents a certain difficulty for deciphering, and the viewer may turn the sheet around to look at it first from one side and then another. But the subject, although isolated from its context and resistant to a traditional reading, forces itself upon the eye because of a structure skillfully re-created by contrasting lights and shadows. Moreover, through this melting of the motif into the surrounding space, Cézanne seems to go a step further toward the abstraction later formulated by Tatlin and Kandinsky, by Malevich and the Constructivists. When Cézanne writes, on September 8, 1906, "Here on the edge of the river the motifs are very plentiful; the same subject seen from a different angle gives a subject for study of the highest interest and so varied that I think I could be occupied for months without changing my place, simply bending a little more to the right or left,"[4] he seems to be striving to achieve a double purpose: the isolation of certain planes observed in detail and also the representation of a nature constantly moving in accord with the vibrations of light and its reflections, in a new vision that might be called "kaleidoscopic."

If we compare an earlier watercolor like *Pots of Flowers* (Venturi 952), c. 1883–87, where there is a study of reflections among leaves, terra-cotta pots, and a background animated by moving shadows, in an almost Impressionistic style, with a much later watercolor of the same subject (Venturi 951), we find that the reflections have been enriched by a play of transparencies and vibrations due to a more elliptical and more fragmented vision.

The effects of transparency develop in the later watercolors to the point where they are like the reflections playing on a stained-glass surface. This tendency is common to the numerous woodland studies (e.g., pls. 105, 110). In these works the composition created by the vertical lines of the trees makes a sort of web on which triangular touches of watercolor are superimposed, along with broad black stripes formed by multiple pencil strokes. There is the same fluidity in *The Bibémus Quarry* (Venturi 1548), which is bathed in an iridescent light like that of shot silk, and in *Forest Road* (Pearlman Collection), where the entire surface is covered by broad triangular and rectangular flat tints, with a lightly traced foreground of pale colors (those which were to inspire Jacques Villon).

"Draw; but it is the reflection which *envelops;* light, through the general reflection, is the envelope," Cézanne wrote to Emile Bernard in 1905.[5] And it seems as if the structure of certain watercolors were based essentially on the play of reflections, for instance, *The Garden Terrace at Les Lauves* (pl. 104) or the *Pont des Trois Sautets* (pl. 113). About this last subject, the Trois Sautets bridge over the Arc River, Cézanne wrote on August 14, 1906, "I started a watercolor in the style of those I did at Fontainebleau; it seems more harmonious to me; it is all a question of getting as much affinity as possible."[6]

The late group of studies of skulls placed on draperies exem-

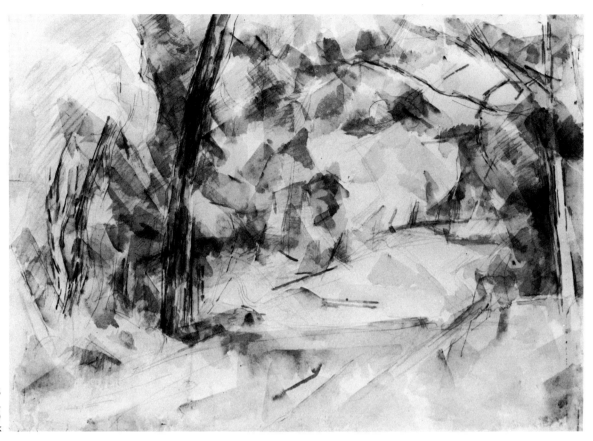

Forest Road (pl. 110). c. 1906
Watercolor,
$17\frac{1}{2}$ x $24\frac{1}{2}$ in (44.5 x 62.2 cm)
Estate of Henry Pearlman, New York

plifies one aspect of this effort. In the examples *Three Skulls* (pl. 156), *Skull on a Drapery* (pl. 158), and *Study of Skull* (pl. 159), we must observe, among other things, how the reflections of the bright colors of the cloth play simultaneously on the shiny skulls, whose deep eye-sockets are made into receptacles of color, and on the background, which is enlivened by light, moving *"informel"* spots.

Until the years 1890–95 the objects of Cézanne's still lifes were situated in a well-defined space, generally on tables with precisely indicated edges. The backgrounds, too, were clearly defined. After 1895 support and framework are often less important, and stress is laid on the objects themselves, as in *Apples, Bottle, and Glass* (pl. 172), or in *Apples, Pears, and Pot* (pl. 178), both enriched by lively coloring. Cézanne uses colors to express the variations of values, thus devising one of the keys to the liberation of painting. In a late watercolor such as *Still Life* (Venturi 1145), the setting is indicated less precisely and the space is more distorted. Indeed, some of the objects seem to be hanging in space, with no support at all. In the Louvre watercolor *The Kitchen Table* (pl. 183), the pots and bottles seem to float over the surface of the table, whose contours are invisible. The color is laid on with rapid, superimposed brushstrokes that do not follow the preliminary sketch. However, we must emphasize the alternation and diversity of Cézanne's experiments with still lifes, and the consequent diffi-

culty in dating them and retracing their chronological evolution.

In the earlier watercolors, like *The Struggle of Love* (Venturi 897), 1875–76, the numerous, swirling, Baroque pencil strokes are closely mingled with the watercolor. In *Large Tree and Undergrowth* (Metropolitan Museum) and the *Landscape at Médan* (Venturi 847), 1879–80, the texture is built up with parallel brushstrokes, diagonal like the shadows. Later there evolves a more elliptic style, with the choice of certain details emphasized in a calligraphic manner.

Eventually the texture is diversified and enriched. Often the color is laid directly on the paper—without trace of any previous penciling—in the form of either large spots with "frayed" edges or else parallel stripes painted with fine strokes of the brush. Additions, with brush and watercolor (usually blue), bring out the occasionally broken but essentially flexible and curving contours. Such markings, also made with brush and blue watercolor, and in the same rapid style, recur in Kandinsky's abstract watercolors of around 1912.

Often the black pencil mark appears only as a second thought on the watercolor. And sometimes it is shifted out of position, parallel to the outline of the spot which it completes. In this way it forms a second surface that serves as a double texture in which there is a magnificent play of movement and reflection. These textural diversions involve either a network of penciling

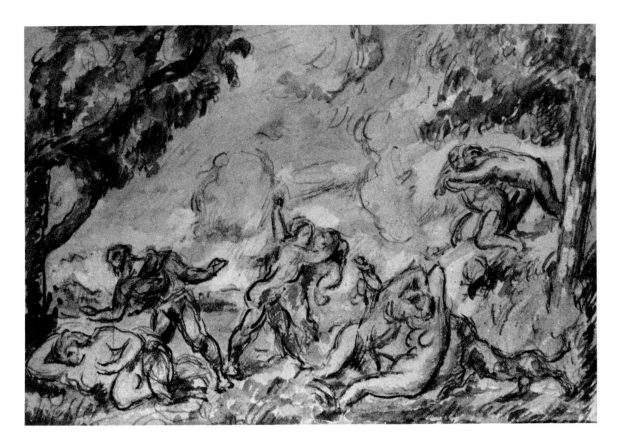

The Struggle of Love
1875–76. Venturi 897
Pencil, watercolor, and gouache,
5⅞ x 8⅝ in (15 x 22 cm)
Private collection, Switzerland

mingled with brushstrokes, as in *Carafe, Bottle, Grapes, Apples* (pl. 185), or else multiple superpositions that create a much richer impression of space than any system of linear perspective. This is the case with *Pine and Rocks near the Caves above Château Noir* (pl. 65). Here trees and rocks are delineated with a brush dipped in blue watercolor. Next there are overlapping patches of color, blue and green above and the lighter beige and pink below. Finally the black pencil sets to work hatchmarking certain spaces that correspond to shadows, while pale colors suggest areas of light. The free and mobile texture breathes in a light, musical rhythm. The hatched shadows, in the shape of triangles of different sizes, make up a sort of patchwork that had previously appeared in the drawing *Study of Trees* (Chappuis 914), 1884–87. These geometrical layouts, modulating certain elements and facets of volumes, pave the way to Cubism.

More and more frequently, the washes of color leave a blank area of paper "in reserve," creating an impression of breadth, space, and luminosity. Thanks to spots of watercolor overlaid on finely traced penciling that was not subsequently modified, *The Tall Trees* (pl. 82) has a light texture suggestive of the air circulating among the leaves.

In the late works the two specific qualities of watercolor—lightness and transparency—progressively develop until they reach their highest level with the *Mont Sainte-Victoire* series. These variations, studied like successive geological strata, grew out of Cézanne's ceaseless experimentation with the theme. They

stem also from the different centering of the subject, which Cézanne insisted upon considering from every possible angle (left, right, forward, backward, high, low), according to the position in which he placed himself. The theme became a pretext for variations whose multiplicity distanced him from the concrete object. As to the planar structure, it always relates to the simplification and synthesis sought by Cézanne, who was then discovering the basis for Cubism.

The watercolors where the area left blank, "in reserve," predominates have often been considered—like the paintings of the same period—unfinished. Some of the paintings, the *Winding Road* (pl. 72), the *Mont Sainte-Victoire* series (e.g., pls. 124, 125, 127), and *Le Cabanon de Jourdan* (pl. 83), are painted in oil abundantly diluted with turpentine. As was observed first by Roger Fry[7] and then by Lionello Venturi,[8] Cézanne's experiments with watercolor influenced the technique of his oils. They led him to the flowering, the liberation, evident in his last works, to the more rapid, lighter touch and greater fluidity. Cézanne expressed himself in the following words on the inadequacies and incompleteness of his pictures: "The sensations of color, which give light, are the reason for the abstractions which prevent me from either covering my canvas or continuing the delimitation of the objects when their points of contact are fine and delicate; from which it results that my image or picture is incomplete."[9] This was another way in which Cézanne broke with the old tradition of complete, finished painting. In his time

there was no recognized art other than that of the complete. But the elusive Cézanne foresaw a new interest in the art of the unfinished and in a certain form of "tachism." Among the numerous twentieth-century artists for whom the blank areas of the canvas have been all-important, we may quote Sam Francis: "I have the feeling that white is like the space existing between objects."

Perhaps the refusal to "outline the contours with a black stroke"[10] in the Neo-Impressionist manner led Cézanne to an aspect of tachism bound up with the idea of destruction of the object, of the motif. The jars and bottles of the *Kitchen Table* (pl. 183) are evoked by masses of light coloring and indefinite cylindrical shapes that seem stripped of all density. This watercolor is in evident contrast to the still lifes of the years 1885–87, such as *The Green Pitcher* (Venturi 1138), in which shape, weight, and substance are brilliantly stated. The close connection between shape and color has been broken for the benefit of a new dissolution of forms common to several watercolors of Cézanne's last period. In this group of more *informel* works we find *Foliage* (pl. 168), made up of touches of watercolor laid in

Foliage (pl. 168). 1895–1900. Venturi 1128. Watercolor and pencil, $17\frac{5}{8}$ x $22\frac{3}{8}$ in (44.7 x 56.9 cm)
The Museum of Modern Art, New York, Lillie P. Bliss Collection

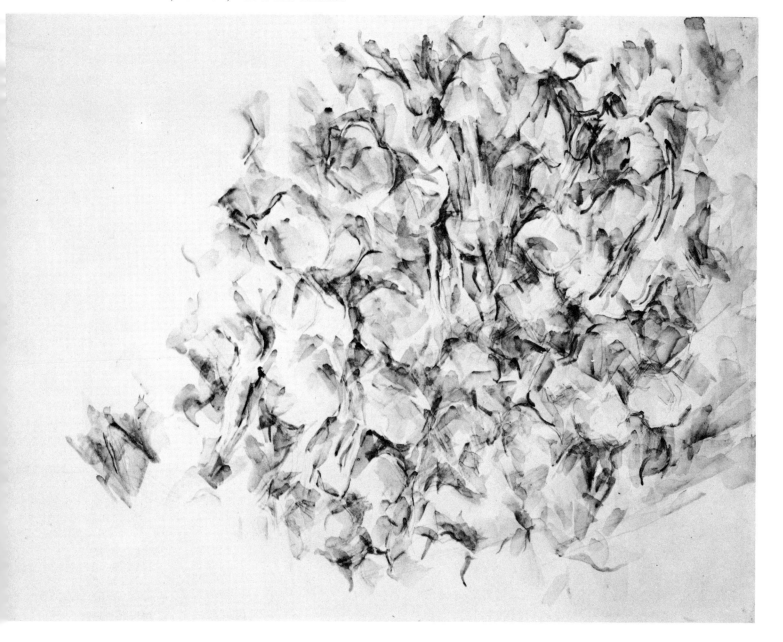

flat tints on light pencil strokes. Second thoughts, executed in black pencil, appear as stripes and scratches that have no relation to shapes and outlines but correspond, rather, to the directions of branches and shadows. The mass of leaves is painted as if it were an endless moving fabric, with no definite boundaries. Tachism is to be found also in the *Rocks near the Caves above Château Noir* (pl. 40), where the shadowy hollows of the rocks contrast with the light animating the scarcely defined surface of these masses.

In the watercolors of Cézanne's last period his analysis is based on contrasts, oppositions, and even contradictions. Contrast between sun and shadows is the theme common to all the *Vaults of Trees;* contrast between the bulk and stability of rocks and the flexibility of leaves and branches bathed in moving light is essential in the views of Château Noir and the quarry at Bibémus. Finally, let us call attention to the total contrast between two series which he painted at the same time: the versions of *Mont Sainte-Victoire,* where the watercolor is greatly diluted and laid out in broad, flat, pale tints, and the various portraits of Vallier, where the subject is sketched expressively

and shaped by numerous fine, curving, calligraphic brushstrokes, charged with strong color—two series that reflect the poles of Cézanne's work: the constructive synthesis and the expressionist ardor.

Translated from the French by Frances Frenaye

NOTES

1. *Paul Cézanne: Letters,* ed. John Rewald, trans. Marguerite Kay (London: Cassirer, 1941), letter to Louis Aurenche, p. 233.
2. Ibid., to Emile Bernard, p. 266.
3. Ibid., to Emile Bernard, p. 234.
4. Ibid., to his son Paul, pp. 262–63.
5. Ibid., to Emile Bernard, p. 251.
6. Ibid., to his son Paul, p. 259.
7. Roger Fry, *Cézanne: A Study of His Development* (New York: Macmillan, 1927).
8. Lionello Venturi, *Paul Cézanne: Water Colours* (Oxford: Cassirer, 1944).
9. *Letters,* to Emile Bernard, pp. 251–52.
10. Ibid., to Emile Bernard, p. 252.

Cézanne's Lithographs

Douglas Druick

IN THE LATTER HALF OF THE 1890s, Cézanne made three lithographs: the *Large Bathers* (Venturi 1157), the *Portrait of Cézanne* (Venturi 1158), and the *Small Bathers* (Venturi 1156).[1] In addition to being the only prints of his later years, they are of particular interest since they represent the only works within Cézanne's oeuvre that were both commissioned and intended for a large audience.

While there have been several studies devoted to those prints,[2] none has dealt with the complexity of what at first glance appears to be a fairly straightforward problem. For while the prints are three in number, the number of works to be considered is greater. In addition to the printings in black (figs. 3, 4, 5), both bather compositions were printed with color stones (figs. 6, 7). In preparation for the color printings, Cézanne heightened a number of the black-and-white impressions with watercolor (figs. 8, 9, 10, 11, 12). These were intended as maquettes, or models, to serve as guides in the execution of the color stones. Accordingly, an understanding of both Cézanne's activity in lithography and the place of his lithographs within the context of his late work involves the analysis of the maquettes, the lithographs in black from which they were prepared, and the color prints for which they served as models. This, in turn, raises the questions of why Cézanne involved himself in lithography and how he decided upon the subject matter of his prints.

Cézanne was not, it seems, very much interested in printmaking. Five etchings[3] and the three mentioned lithographs constitute his entire output of prints. None of these can be said to reflect a desire to explore the possibilities of an unfamiliar medium. Rather, both the etchings and the lithographs were in large part the result of special conditions under which they were executed. The artist's production of etchings, all of which were done at Auvers during the summer and autumn of 1873, can be directly related to the preoccupations of the company in which he found himself.[4] Surrounded as he was by three print enthusiasts—Pissarro, Dr. Gachet, and Armand Guillaumin—Cézanne was coaxed into making prints. As soon as he left that environment he abandoned the medium.[5]

Almost twenty-five years later, when Cézanne again made prints, the motivation was similarly related to a particular set of circumstances: his association with Ambroise Vollard and the latter's role in the print revival of the nineties. It is Cézanne's relationship with his dealer that explains why he again became involved in printmaking. Moreover, the peculiar nature of Vollard's activity within the revival explains both the medium of these later prints and the particular significance of the lithograph and watercolor maquettes in the context of printmaking during the last decade of the nineteenth century. A study of Cézanne's prints from the 1890s must, therefore, begin with a review of the developments in the print revival and the role played by Vollard.

Shortly after having opened his gallery in the rue Laffitte in 1894, Vollard became interested in the idea of commissioning and publishing original prints by contemporary artists.[6] The generative force in the popularizing of original graphics had been the periodical *L'Estampe originale,*[7] which had disseminated prints by contemporary artists representative of a variety of stylistic trends. Published and directed by André Marty, *L'Estampe originale* had appeared as a series of nine *fascicules,* or installments, issued quarterly beginning in March 1893. While the publication included prints in various media, it had been particularly effective in gaining popularity for lithography, and more specifically, lithography in colors. This was a significant development within the history of nineteenth-century printmaking. At the time Marty began his venture, etching generally overshadowed lithography as an artist's medium, and color lithography, in particular, continued to suffer the stigma of its use in commercial printing. The bias of the publication in favor of lithography, however, is reflected in its contents: of the ninety-five prints included, sixty were lithographs, twenty-seven of which were in color.

Marty's venture was greeted with considerable interest in a number of journals[8] and soon became a landmark in the print revival. Thus in the first issue of *L'Estampe et l'affiche,* which appeared in March 1897, André Mellerio, a leading critic and spokesman of the revival, was able to refer to the "unexpected success"[9] of *L'Estampe originale.* Evidently this success was commercial as well as artistic, and the termination of the publication after nine issues was preconceived rather than the result of financial difficulties. Indeed, encouraged by the reception of *L'Estampe originale,* Marty gave up the management of the *Journal des artistes* in 1894 in order to devote all his energies to new publishing ventures.

Notes to this essay begin on page 134.

Because of its success, *L'Estampe originale* became the prototype for a series of publications, the most important of which were to be *L'Epreuve,* the Vollard albums, and *L'Estampe moderne.* In the case of *L'Epreuve,* founded by Maurice Dumont in 1894, the attempt to produce a larger number of prints at a lower annual price[10] resulted in works inferior in quality to those published by Marty.[11] *L'Estampe moderne,* a decidedly commercialized venture, did not appear until the spring of 1897. Thus, with the demise of *L'Estampe originale* early in 1895, there was no publication of comparable content and quality on the market. Vollard's decision of the same year to issue albums of miscellaneous prints by contemporary artists of different schools, in addition to publishing portfolios by individual artists, reflects his intention to take up where Marty left off.

The first of these albums, published under the title *Les Peintres-Graveurs,* appeared in June 1896.[12] The influence of *L'Estampe originale* is evident in several important aspects of this publication. Of the twenty-two artists who each contributed a single print to the album, twelve had worked for Marty.[13] Vollard also seems to have had *L'Estampe originale* in mind both in establishing the price of his publication[14] and in fixing the edition at one hundred signed and numbered impressions. Here too, lithography was the featured medium. Significantly, however, color lithography now played a more dominant role than in the earlier publication: ten of the thirteen lithographs were in color. The important departure from both *L'Estampe originale* and *L'Epreuve* was the manner in which the prints were marketed. They were issued as a complete *recueil* rather than serially in *fascicules.* Moreover, the official publication of the album was signaled by a five-week-long exhibition at Vollard's gallery, which was announced in a poster commissioned from Bonnard (Johnson 12).[15]

This show, which has not, to my knowledge, been discussed in subsequent literature, was undoubtedly calculated to establish Vollard's position as a print dealer and publisher. Accordingly, it was ambitious. In addition to the twenty-two prints comprising the album, the exhibition included another 180 objects.[16] Among these were a number of drawings by artists also represented by prints—a fact indicating that Vollard was taking as model, for both his exhibition and its title, the annual group exhibitions that had been held at Durand-Ruel's from 1889 to 1894.[17] Some of the prints, notably eight lithographs from Redon's *La Tentation de Saint Antoine* (Johnson 195), represented concurrent Vollard publications.[18] Yet the majority of the graphics shown represented the work of rival publishers, including a lithograph by Carrière issued by Marty[19] as well as Toulouse-Lautrec's portfolio *Elles,* recently published by Pellet. Since both Carrière and Toulouse-Lautrec were to publish with Vollard in the near future, it is reasonable to assume that the dealer wished to represent both the work of the artists he had published and the work of artists he was interested in publishing.[20] This undoubtedly prompted Vollard to include eight works by Cézanne in the exhibition, despite the latter's failure

really to rank as a contemporary *peintre-graveur.* The Cézanne entries included six watercolors, one drawing, and one of the etchings of 1873, most probably the *Entrée de ferme, rue Rémy*[21] (Cherpin 5, Venturi 1161).

Vollard's exhibition was greeted with mixed reviews. In his account of the show in *Le Journal des artistes,* the influential print critic Loys Delteil had much to criticize. While he held up as models the work of Fantin-Latour, Besnard, and Blanche, he found that of Valadon (Johnson 144) and Guillaumin (Johnson 61) weak, and frankly deplored the "excessive eccentricity" in the prints of Pitcairn-Knowles (Johnson 97), Toorop (Johnson 142), Rippl-Ronai (Johnson 119), and Denis (Johnson 30).[22] Though less conservative than Delteil, Arsène Alexandre similarly found the quality of the exhibition to be uneven, remarking that one found truly remarkable and original works as well as others that were "insufficient and bizarre."[23] Yet he concluded that Vollard's exhibition, both curious and varied, was certainly of interest. Less qualified praise came from the reviewer for the Belgian publication *L'Art moderne.* Disregarding the established and the mediocre, he focused his attention on the "enigmatic" work of Redon, the "savage" woodcuts of Gauguin, the "decorative flourishes" of Toorop, as well as "the crude, rudimentary, and very striking vision of Césanne [*sic*]."[24]

The interest which the exhibition generated is attested to by Pissarro, who on two occasions wrote to his son Lucien, telling him of the success Vollard's show was enjoying.[25] In spite of the interest, Vollard's album was a commercial failure,[26] perhaps because of the way in which it was marketed. Lost in the context of a much larger exhibition, *Les Peintres-Graveurs* failed to attract attention as a unified publication, and was never considered as such in reviews of the show.[27] While prints were indeed enjoying unprecedented popularity, they were also flooding the market, and collectors were becoming increasingly selective. Distracted by the number of prints not included in the album, potential buyers may have been reluctant to purchase twenty-two prints of uneven quality in order to obtain among them the ones they desired.[28] Moreover, since the album was not a serial publication, it received no further publicity once the exhibition was over.[29] The poor reception of *Les Peintres-Graveurs,* plus the dealer's grandiose ambitions—noted by Pissarro[30]—to distinguish himself as a publisher, probably accounts for the significant differences found in the second album of miscellaneous prints. Announced in October 1897[31] and exhibited at Vollard's gallery in December under the title *L'Album d'estampes originales de la galerie Vollard,* this second venture was considerably more ambitious than its predecessor. Larger in size, it drew even more heavily on the artists who had worked for Marty.[32] Moreover, the album now included a two-page *couverture* lithograph[33] in the tradition of those done by Toulouse-Lautrec for Marty's publication. The most striking feature of the second album, however, was the number of color lithographs included: thirty of the thirty-two prints were lithographs, and twenty-four of these were in color. The remarkable preponderance of this

medium made Vollard's second publication considerably more spectacular than Marty's *L'Estampe originale* and immediately earned it the reputation of an encyclopedia of color lithography as practiced by contemporary artists.[34]

The predominance of color lithography in the second album reflects the will of the publisher rather than the desire of the artists involved to express themselves in this medium. Vollard's particular interest in a single medium undoubtedly derived from two closely related considerations. As an entrepreneur, Vollard was, Pissarro informs us, one who "is only interested in what sells."[35] His conception of the market seems to have developed from an analysis of the print revival similar to that by Mellerio. In an article that appeared early in 1897, Mellerio stated that the current revival had been caused by the "democratization"[36] of the taste for art, a phenomenon fostered by an increasing number of exhibitions, newspaper reviews, and popular books on the subject of art. Vollard appears to have shared Mellerio's view that for the newly created audience of collectors and speculators, original prints represented "the same amount of pure art"[37] as works in other media and were thus purchased instead of the paintings, pastels, and watercolors that were beyond its means. However, while Mellerio did not emphasize the role that color played in the psychology of print-collecting, Vollard apparently did. It seems he believed that the buyer regarded color prints as substitutes for works in the other color media. Such thinking was, no doubt, partially a product of his own interests. Primarily a dealer in paintings, Vollard himself undoubtedly preferred prints that could rival the "presence" of works in the major media, and so was particularly attracted to color prints. Thus, of Pissarro's numerous etchings, apparently only the few printed in color stirred the dealer's interest.[38] But as *estampes murales,*[39] etchings are handicapped by their restricted scale. Vollard's realization that color lithographs are better able than etchings to "hold the wall"[40] explains his career-long interest in the medium.

Pissarro described Vollard's position incisively in a letter to Lucien written in September 1896: "Poor Vollard!" wrote the artist. "I told him he was launching out on an enterprise that called for experience and that prints didn't sell, that the dealers didn't know much about them and were only managing to get by with gimmicks like posters, impressions in color, etc."[41] Vollard, however, did not listen; he knew whom and what he wanted. His attitude as a publisher differed from that of Marty. Whereas the latter recruited talent for his publication, Vollard virtually pressed artists into service. Pissarro was undoubtedly not the only artist who was "tormented"[42] by the dealer's persistent negotiations for prints. We can also assume that the requests Vollard made of the artist were typical. In July 1896, Pissarro wrote that "Vollard has asked me to do a color lithograph—a large composition."[43] In a subsequent letter Pissarro (who finally never did lithographs for Vollard at all) wrote of the dealer's proposal: "I would have preferred to do it in black, but it seems that color is fashionable."[44] Further knowledge of

Vollard's approach is revealed in his own account that he went to "beg"[45] Sisley to provide him with a color lithograph for his second album.

This insistence on a particular medium is very significant. Working in color lithography can be both complex and time-consuming. For each color that is printed a separate stone must be prepared. Furthermore, in order to avoid unwanted over-lappings of color areas, great care must be taken in the successive printings of the color stones. The demands of the procedure are, therefore, directly related to the number of color stones used. Thus for artists like Pissarro, the medium may have been unattractive from both the technical and the aesthetic point of view. It is clear, however, that the dealer's interests took precedence over considerations of the artist's ability or desire to work in a complicated medium.

Vollard's attitude toward the artist and his work thus led naturally to a philosophy of printmaking essentially different from Marty's. The latter had generally been guided by a concept of the original print which, as enunciated by Roger Marx in his preface to *L'Estampe originale,* emphasized that the autographic nature of the artist's print distinguishes it from the reproductive print wherein the "skill of the interpreter replaces invention."[46] Unlike Marty, Vollard made it a practice to act on the principle that the end product justified the means of execution. If an artist was interested and capable, then he might actively participate in the preparation of his color lithographs.[47] However, in cases in which the artist was unable or disinclined to become involved with the medium, Vollard did not hesitate to request maquettes which his printer, Auguste Clot, whose particular skill was color lithography, could translate into prints. Thus, while Redon had himself worked on a portfolio of black-and-white lithographs of Vollard in 1896,[48] he refused to become involved in the dealer's projects for color prints. Accordingly, his best-known color lithograph, *Béatrice* (Johnson 103), which appeared in the 1897 album, was prepared by Clot after a pastel.[49]

In some instances the maquette which the artist prepared for the printer was simply a work executed in a nonprint medium. The pastel by Sisley followed by Clot in making the color lithograph *Les Oies* (Johnson 141)—which appeared in the second album—represents this type of maquette. It was often the case, however, that the artist wished to retain greater control over the execution of the print but did not want to deal with the problems of color lithography. In such instances it became customary to follow a procedure which forced the artist to work toward his final conception by thinking of drawing and color as distinct and successive elements in the creative process. The artist first executed a lithograph in black which served as the skeletal or keystone drawing for the composition. He then hand-colored an impression for the printer to follow in preparing the color stones. The Cézanne *Large Bathers* (fig. 10), in the collection of the National Gallery of Canada, is an example of this second type of color maquette. Since both the black and the color stones were used in the execution of the final print, the

finished work was in part an original and in part a translation.

As both the Sisley and the Cézanne maquettes suggest, however, in neither procedure was it generally the practice of Vollard's artists to make concessions to the medium into which the work was to be translated. Style and complexity of execution reflected attention to the medium in which the color maquette was prepared. The printer was therefore faced with the job of duplicating the effects of other media.

These practices were responsible for the emergence of a new element within the print revival of the nineties: the facsimile and partial-facsimile print. In the album of 1897, these developments were firmly established. The new technical emphasis did not go unnoticed. On December 6 the critic Arsène Alexandre, in his column in *Le Figaro,* noted that "as for avant-garde exhibitions, one should note the showing at the Vollard gallery of a group of original prints, all remarkable at least for their execution."[50] Mellerio, more closely involved with contemporary printmaking, was able to foresee the direction in which such innovations pointed. He was aware that Vollard's passion for color lithography was compromising the purity of the original print. Although the critic wrote that he found the album interesting and worthy of examination, he was distressed by the "behind-the-scenes personality in the album: Clot, the printer."[51] While he praised the printer's extraordinary technical ability in executing color lithographs, Mellerio cautioned that the artist must "absolutely refuse the ready-made tours de force with which the skillful printer seduces you easily—but insidiously."[52] Echoing Roger Marx, he added that the artist must "learn the craft himself, put his own hand to the stone . . . in other words his personal stamp should mark the technique of his prints as much as their inspiration."[53] It is possible that the collectors, by then very wary of deceptions within the print market,[54] shared Mellerio's hesitation and so "continued to fight shy."[55] The quadrupled price of the second album may have been an additional deterrent.[56] In any case, it seems that Pissarro had been right: Vollard had misjudged the market and had mistakenly relied on the "tricks" of color lithography as a guarantee of success. The second album, like the first, was a commercial failure.[57] For the moment Vollard was not daunted. Clearly he intended to make his offerings an annual event, and by July had contacted Clot regarding prints destined "for the *third year* of my album."[58] At some time shortly thereafter, however, Vollard thought better of continuing with the project, and the incomplete third portfolio was abandoned.[59]

Fig. 1. *Bathers at Rest.* 1875–76. Venturi 276
Oil on canvas, 31¼ x 38¾ in (80 x 99.2 cm). © The Barnes Foundation, Merion, Pa.

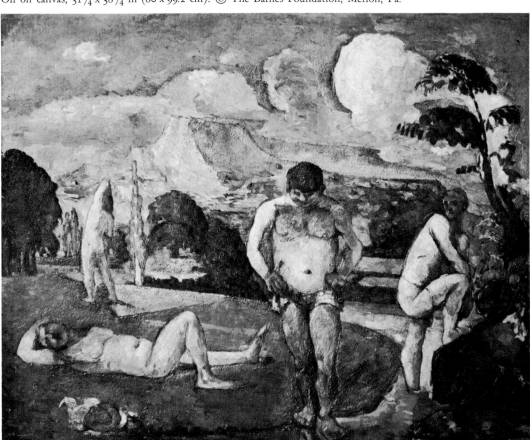

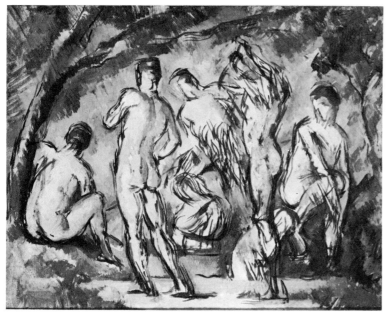

Fig. 2. *Seven Bathers* (pl. 202). c. 1897. Venturi 387
Oil on canvas, 14⅝ x 17¾ in (37.5 x 45.5 cm)
Galerie Beyeler, Basel

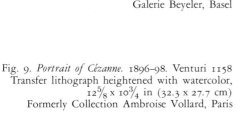

Fig. 9. *Portrait of Cézanne*. 1896–98. Venturi 1158
Transfer lithograph heightened with watercolor,
12⅝ x 10¾ in (32.3 x 27.7 cm)
Formerly Collection Ambroise Vollard, Paris

Cézanne's color lithograph *Small Bathers,* the only one of the three lithographs prepared for Vollard that was published, appeared in the dealer's second album of 1897 under the title *Le Bain*.[60] The two other prints—the *Portrait of Cézanne* and the *Large Bathers* color lithograph, a work based on the impressive composition of four bathers set in an open landscape dominated by Mont Sainte-Victoire, the *Bathers at Rest* of 1875-76 (Venturi 276, fig. 1)—were seemingly among those which Vollard intended to include in his third album of 1898.[61] Since there has been no attempt to relate the lithographs in black and in color to the circumstances of their execution, they have hitherto been misdated.[62]

It is most doubtful that the artist was attracted to the medium of lithography or that, like Pissarro, who had begun to make lithographs in 1895, he would have involved himself in the medium of his own accord. Rather the impetus behind his lithographic production was unquestionably Vollard, who even at the time of his 1896 print exhibition was determined to make a *peintre-graveur* of Cézanne. The artist may well have been grateful to Vollard for having given him his first one-man show

in 1895. Furthermore, he was apparently flattered that the dealer accepted all his canvases.[63] Indeed, the relationship between artist and dealer seems to have been remarkably consistent. Vollard recalled that it was because of the great consideration which Cézanne showed him that he dared to ask him to paint his portrait.[64] Moreover, the artist's letters of the period 1902-03 attest to the affection, respect, and loyalty he felt for Vollard.[65] Clearly, then, even if Cézanne was uninterested in making prints, he would, unlike Pissarro, have complied with the dealer's insistent requests for lithographs.

Since all the lithographs were done for Vollard, none of them could have been done before 1895, the year in which the dealer first contacted the artist. Moreover, it is highly unlikely that Vollard pressed Cézanne for prints either prior to making his acquaintance or even during their first meeting in Aix early in 1896.[66] Had Vollard obtained a lithograph by the artist prior to his print exhibition of the summer of 1896, it certainly would have appeared in that show. Most likely Vollard waited for the artist to visit Paris before presenting his proposition. Cézanne apparently did not come to the city until the fall of 1896. He

Fig. 3. *Large Bathers.* 1896–97. Venturi 1157
Transfer lithograph in black on laid paper,
16 x 19⅞ in (41 x 51 cm)
The National Gallery of Canada, Ottawa

Fig. 4. *Portrait of Cézanne.* 1896–97. Venturi 1158
Transfer lithograph in black on laid paper, 12⅝ x 10¾ in
(32.3 x 27.7 cm). The Museum of Modern Art, New York,
gift of Abby Aldrich Rockefeller

Fig. 5. *Small Bathers.* 1896–97. Venturi 1156
Lithograph in black on *chine volant,* 9 x 11¼ in (23.2 x 28.8 cm)
The National Gallery of Canada, Ottawa

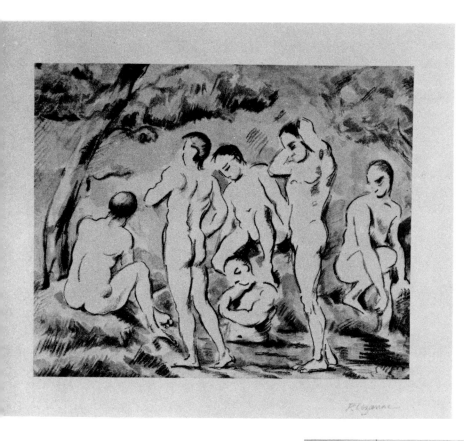

Fig. 6. *Small Bathers.* 1896–97. Venturi 1156
Color lithograph on *chine collé,*
8½ x 10⅜ in (21.8 x 26.6 cm)
The Art Institute of Chicago,
Albert H. Wolf Memorial Collection

Fig. 7. *Large Bathers.* 1896–98. Venturi 1157
Color lithograph on laid paper, 16 x 19⅞ in (41 x 51 cm)
The Metropolitan Museum of Art,
New York, Rogers Fund

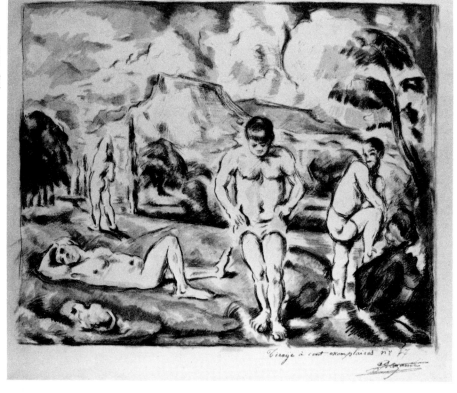

remained there until April of the following year.[67] After his departure, he does not seem to have returned to Paris until the summer of 1898.[68]

The tendency to date the *Small Bathers* earlier than the two other lithographs reflects the assumption that since it alone appeared in the 1897 album, the others must have been done later. Thus, in the only article devoted solely to the *Large Bathers* lithograph, Melvin Waldfogel maintains the commonly held belief that the *Large Bathers* was "commissioned by Vollard specifically for *L'Album des peintres-graveurs* of 1898."[69] To construct a chronology on the basis of publication dates is hazardous, however. As has been pointed out (note 59), while Vollard planned an album for 1898, there is no evidence that he commissioned works specifically for it. Full of schemes and ideas for publications and prone to changing his mind, he evidently obtained works from artists whenever he could and kept them until the opportunity to publish arose. In the matter of approach, it is by means of a review of the technical differences between the keystone lithographs in black, of the stylistic differences between both the maquettes and the color prints to which they are related, and of the considerations which would have motivated Vollard in commissioning the works from Cézanne that one can plausibly establish the chronology for the execution of the lithographs in black, the maquettes, and the color prints, and appreciate their different qualities.

In dealing with Cézanne's prints, it is first necessary to put to rest the problem of their disputed "originality." Although Mellerio's review of the second album touched on the problem of the facsimile print, the critic did not at that time question the authenticity of any of the works included. However, in his book on color lithography which appeared in the following year, Mellerio stated that the work of Rodin (Johnson 120) and Sisley (Johnson 141) represented the triumph of the facsimile print.[70] While he dealt with the Cézanne *Small Bathers* somewhat differently, he nevertheless concluded by grouping the lithographs of the three artists together, regarding them as works not entirely original and yet, because of their technical excellence, not commercial in the sense of the chromolithograph.[71] The implication that all three artists were equally uninvolved in the production of their prints has persisted in the literature.[72] It is, however, incorrect.[73] Indeed, Atherton Curtis, the American print collector and author, noted in the manuscript catalog of his collection that Clot had informed him that Cézanne executed the color stones as well as the keystones for both the bather lithographs.[74] Yet, given the extraordinary fidelity of the color prints to the maquettes and the technical virtuosity involved in this achievement, it is impossible to believe that Cézanne himself prepared the color stones for his lithographs. Rather, the artist undoubtedly executed the lithographs in black, prepared the maquettes, and then, like Redon (see note 49), worked closely with Clot as the latter prepared and printed the color stones. Since apparently neither Clot nor Vollard demanded this participation, it must be assumed that while Cézanne may not have had a strong interest in printmaking, he was sufficiently concerned with the results to oversee the execution of the prints.

In the literature on the Cézanne prints, the lithographs in black have not been considered apart from those in color. As the basic elements in the maquettes and subsequent color prints, the lithographs in black deserve special consideration, particularly because of the significant technical differences involved in their execution. Unlike the keystone for the *Small Bathers* (fig. 5), those used in printing the *Large Bathers* (fig. 3) and the *Portrait of Cézanne* (fig. 4) were prepared by Clot from drawings on lithographic transfer paper that he received from the artist. This difference in the medium of execution permits one to understand certain stylistic differences between the lithographs and, more important, to establish their chronology. The latter is, in turn, a key factor in establishing the sequence in which the maquettes were executed, in clarifying the different problems involved in their execution, and in assessing the degree to which the artist's intentions were realized.

Given the importance of the technical differences involved in the preparation of the keystone lithographs in black, it is necessary first to consider both the persistent assertion that the *Small Bathers* was prepared from a transfer drawing[75] and the possibility that the drawings for the other lithographs were executed directly on the stone. In the *Portrait of Cézanne,* the grain of the image indicates that the drawing was done on transfer paper.[76] Moreover, the fact that in the majority of the nonfrontal self-portraits the head is inclined to the right rather than the left, and that this is the case in the closely related oil *Self-Portrait with a Beret* (pl. 5) of the same period, favors the assumption that the lithographic image is printed in the same direction that it was drawn, and so could not have been prepared directly on the stone. While in the case of the *Large Bathers* the nature of the drawing surface is not as readily apparent, certain areas do exhibit a texture characteristic of transfer lithographs. Furthermore, the fact that the lithograph so closely follows a much earlier work in another medium (fig. 1) argues in favor of preparation by means of a transfer drawing. Had he worked directly on the stone, Cézanne would have had to execute the composition in reverse. This approach was foreign to his working habits; unaccustomed to academic practices such as squaring works for transfer, the artist undoubtedly would have found the task troublesome. It is unlikely that he would have had either the inclination or the patience to involve himself in a procedure of this nature, when instead he could use transfer paper, which eliminates the need to reverse the composition.

In contrast to the *Portrait of Cézanne* and the *Large Bathers,* the keystone lithograph for the *Small Bathers* does appear to have been drawn directly on the stone. It does not exhibit a transfer grain. Moreover, although a multifigured composition like the *Large Bathers,* it does not stand in a comparable relation to an earlier work, and so did not present comparable problems of image reversal. The *Seven Bathers* (pl. 202; fig. 2), to which Venturi relates the *Small Bathers,* is compositionally very similar

but includes an additional figure. Furthermore, the date of 1879–82 which Venturi assigns to the painting is untenable: the repeated contours of the figures, the length and width of the brushstroke, and the thin application of the paint indicate that the painting and the lithograph are undoubtedly contemporary.[77]

Indeed, the *Seven Bathers* may have been executed after the *Small Bathers* lithograph. Even if the lithograph followed the painting, the fact that the painting was both less realized and considerably less well known than the *Bathers at Rest* would have made it a less exacting prototype than the latter. Certainly, however, the *Small Bathers* does represent a type of bather composition that the artist employed several times during the late eighties and early nineties;[78] figures related to those in the lithograph recur in drawings and watercolors from the late eighties onward.[79] Thus Cézanne was still faced with a problem of image reversal, yet one considerably less complex than the *Large Bathers* composition would have posed.

A comparison of the drawing style of both bather lithographs reflects the difference in the medium of execution. In the *Large Bathers* lithograph (fig. 3) the disposition of forms in the painting (fig. 1) is faithfully preserved, but the graphic vocabulary is that of the nineties. The contours of forms have become discontinuous; they move with the curving rhythms that characterize the artist's drawings and paintings of this time. Comparison with other drawings of the same period, however, reveals a certain restraint in the execution of both this and the *Portrait of Cézanne*. Since transfer paper imposes no restrictions upon the artist, this slightly stiff quality can probably be accounted for by the fact that Cézanne was inhibited by the thought of having to produce "finished" work for publication. Since "finish" is a quality that few of his paintings and watercolors and virtually none of his drawings possess, he must have approached the task with an unaccustomed degree of caution. In order to impart a sense of completion to the drawings, he has suppressed the repeated contours one associates with his late drawing style. The vibrancy that characterizes his finest drawings is thereby diminished.

In the drawing of the *Small Bathers* (fig. 5) these uncharacteristic qualities are even more pronounced. The execution was so cautiously controlled that the work appears rather dull. The logical explanation for the pedantic draftsmanship is that Cézanne was drawing directly on the stone. To an artist unaccustomed to working in this manner there are several factors that can combine to inhibit the expression of his customary graphic style. Cézanne undoubtedly felt hesitant working in a medium that had unfamiliar physical properties and that had to be handled with some care. In addition, since the figure and compositional types did derive from an established repertoire, the artist had to think in terms of reversed images, a situation that undoubtedly inhibited spontaneous execution. Both these constraints must be seen as having contributed to the partial paralysis of the artist's usual graphic style.

It is logical to assume that the black keystone for the *Small Bathers* was executed after he did the transfer drawings for the *Large Bathers* and the *Portrait of Cézanne*. For it is likely that the artist would first approach the medium using the materials which best allowed him to work in his accustomed drawing manner. This meant the use of transfer paper, which was the material recommended by the Société des Peintres-Lithographes to painters who wished to try their hand in the fashionable medium.[80] Seemingly the artist would be most inclined to work directly on the stone only after he had become familiar with the medium and had gained assurance. In the case of Cézanne, this hypothesis is supported by the fact that Clot apparently encouraged or persuaded artists who had worked on transfer paper to try drawing directly on the surface of the stone.[81]

Since the drawing of the *Small Bathers* was done on the stone, it must have been executed while Cézanne was in Paris. In view of its publication in December 1897, one can assume that it dates before the preceding April, when Cézanne left the capital. Accordingly, the two transfer lithographs, the *Portrait of Cézanne* and the *Large Bathers,* were produced some time after the artist's arrival in Paris in the fall of 1896, but prior to his beginning work on the stone, which was completed by April 1897. A study of the maquettes bears this out.

The addition of color to the impressions in black and the color printings apparently followed a different sequence. While all the lithographs in black (figs. 3, 4, 5) appear to be self-sufficient works of art, there is nevertheless a noticeable difference between the *Small Bathers* (fig. 5) and the two transfer lithographs (figs. 3, 4). The *Small Bathers* lithograph in black is considerably more simplified in execution than the other two. Furthermore, comparison of color-stone (fig. 6) with keystone (fig. 5) impressions reveals that the color stones "complete" the tree forms, which are only suggested in the lithograph in black. On the other hand, comparison of black and color impressions (figs. 3, 7) of the *Large Bathers* fails to reveal a similar reliance on the color stones. These differences point to a basic difference in intention.

Judging from Pissarro's experience, Vollard was actively soliciting color lithographs in the summer of 1896. During the subsequent fall and winter, while Vollard was planning the album of 1897, Cézanne too was undoubtedly pressed to provide the dealer with a lithograph for color printing. Unwilling to become involved in the tedious and complex aspects of color lithography, Cézanne preferred to follow the procedure wherein he had only to execute the black keystone and subsequently hand-color an impression. Of the three lithographs in black, the *Small Bathers* alone appears to have been executed with the intention of serving as the keystone in a color print. Its more abbreviated nature reflects the artist's awareness that he had to leave room for the addition of color.

Though preferable in one sense, the demands of the procedure followed in preparing the maquette do not appear to have been congenial to the artist. In the nineties, Cézanne had two ap-

proaches to watercolors. He either worked completely in watercolor or built up watercolor washes over a light sketch in pencil or black chalk. When he combined pencil or chalk with watercolor, each medium participated in the creation of the final image. Rather than being strictly tied to the drawn forms, the color areas follow their own logic. In this way the color is integrated with, rather than merely added to, the line drawing. Though abbreviated, the *Small Bathers* keystone print is nevertheless an assertive image and as such posed difficulty for the artist when it came to adding color. The only known maquette for the color lithograph[82] (fig. 8) is "colored in" in a rather pedantic manner that is somewhat uncharacteristic of Cézanne. Compelled to use an artistic procedure foreign to him, the artist was apparently unable to establish the proper accord between watercolor and drawing. Thus, despite the provisions in the drawing for further development, the watercolor tightly hugs the contours of the figures and so has the appearance of an afterthought.

In the two transfer lithographs by the artist, the forms and the value relationships are more fully spelled out than in the *Small Bathers*. Indeed, the *Portrait of Cézanne* (fig. 4) is so totally conceived in terms of black and white that, as the color maquette[83] (fig. 9) makes apparent, there is little room for the addition of watercolor; the color medium is used primarily to reiterate the black-and-white statement and develops the image only in the area of the mouth.[84] This could be a reason why the maquette was never translated into a color lithograph. Certainly it is another reason for maintaining a chronology which places the *Portrait of Cézanne* (fig. 4) and the *Large Bathers* (fig. 3) before the *Small Bathers* (fig. 5). Clearly, any lithographs executed after the *Small Bathers* would have been commissioned for color printing. It is inconceivable that with his knowledge of the problems involved in preparing a color maquette, Cézanne would have executed, at a later date, transfer drawings for keystones which would pose problems of a similar but more acute nature.

It would seem then that when Vollard first asked Cézanne for lithographs, he contented himself with black-and-white prints. But as the dealer's plans for the 1897 album developed and the predominance of color lithography became uppermost in his mind, he again approached the artist, this time requesting a color print. Comparison of the bather maquettes suggests the sequence of events.

Since the *Large Bathers* (fig. 3) is developed further in black than is the *Small Bathers* (fig. 5), it is surprising to find that when adding color, the artist was appreciably more successful in breaking away from the strictures of the drawing. Both hand-colored (figs. 10, 11, 12) and color-printed (fig. 7) versions come closer in style to the watercolors of the nineties. It seems reasonable, therefore, to conclude that the *Large Bathers* maquettes were done sometime after that for the *Small Bathers,* and that having already once worked with the intransigent medium, the artist was better able to overcome the restrictions inherent in the

coloring of a black-and-white impression. The rationale for this sequence of execution is undoubtedly explained by the interests of Vollard and the rather surprising attention paid to the *Small Bathers* at the 1897 exhibition. In the reviews of the exhibition which appeared in the *Mercure de France* and in *L'Estampe et l'affiche,* special attention was accorded to this image of six bathers grouped closely together in a secluded outdoor setting. In *L'Estampe et l'affiche,* the *Small Bathers* was reproduced along with monochrome lithographs of the more established graphic artists Whistler (Johnson 160) and Forain (Johnson 46). Mellerio regarded the work as characteristic of the artist's production: "From Cézanne we have a few figures that are curiously constructed but have a certain energy and rude grandeur characteristic of almost all his work."[85] André Fontainas, of the *Mercure de France,* was more unqualifiedly positive. He described the work as "some nudes in the open air, upon whom the light acts and plays marvelously."[86] Such praise undoubtedly pleased Vollard and gave him the idea of publishing more color lithographs by the artist. In order to secure maquettes for future color printings, he asked Cézanne to color impressions of the earlier transfer lithographs which had not been conceived of as keystones for color prints. The preparation of the maquettes for the *Portrait of Cézanne* and the *Large Bathers,* as well as the first color printing of the latter,[87] was most likely done during the summer of 1898, when Cézanne was in Paris and Vollard was working with Clot on the preparation of the album projected for 1898.

In addition to technical and stylistic considerations, a review of Vollard's tastes and publishing practices leaves little doubt that the *Large Bathers* was the first print commissioned from Cézanne, and the one regarded as the most important. While the dealer later recalled that it had been his practice to collaborate with an artist on the decision regarding the subject matter of the commissioned prints,[88] the example of Puvis de Chavannes suggests that in certain cases Vollard specifically asked that artists do lithographs after their most celebrated works. Puvis generally based the prints he made on recently completed paintings;[89] for example, *La Normandie,* his contribution to Marty's *L'Estampe originale* in 1893, followed an easel picture of the same year. Thus, in providing Vollard with a transfer lithograph after *Le Pauvre Pêcheur,* Puvis's controversial entry at the Salon of 1881 and his most famous easel painting, the artist was undoubtedly acting on the dealer's wishes. Having been successful in this first endeavor, Vollard subsequently entertained the idea of having Puvis execute a color lithograph[90]—a course of action comparable to the one he followed with Cézanne.

The *Bathers at Rest* was undoubtedly Cézanne's most famous work. It had first attracted attention in the third Impressionist exhibition of 1877, which represented the artist with sixteen works. In his review of the exhibition in *L'Impressioniste,* critic Georges Rivière had used this painting as the basis for his lavish praise of the artist.[91] In the nineties the work again received publicity as one of the group of sixty-five paintings which Caillebotte bequeathed to the state upon his death in 1893. In

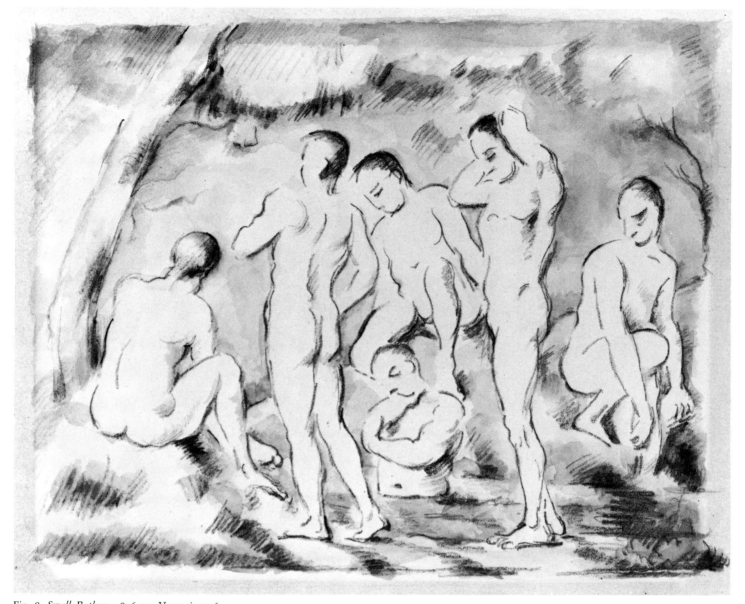

Fig. 8. *Small Bathers*. 1896–97. Venturi 1156
Lithograph in black with additions in pencil, heightened with watercolor on wove paper, 9 x 11¼ in (23.2 x 28.8 cm)
Collection Dr. Martin L. Gecht, Chicago

an article devoted to Cézanne which appeared early in the following year, Gustave Geffroy used the painting as an example of Cézanne's particular strengths; he spoke highly of its brilliance and luminosity, and praised its "ingenuous grandeur," pointing out the Michelangelesque quality of the slightly awkward figures.[92]

Vollard was, by virtue of his personal taste, particularly drawn to Cézanne's early figure compositions. His interest in publicizing these works is reflected in the choice of reproductions for his 1914 monograph on the artist as well as in the invitation which he had printed for the Cézanne exhibition of 1898 and in the one facsimile color lithograph that he commissioned from

Clot after Cézanne's death. This invitation reproduced a drawing of female bathers (Chappuis 514) dating from the period 1879–82, and the composition followed in the facsimile lithograph was the figure painting *Luncheon on the Grass* (Venturi 377) of c. 1878. Naturally attracted to the *Bathers at Rest*, Vollard would also have appreciated the critical attention it had received.[93] Probably for both reasons, the dealer featured the painting in the window of his gallery during the important 1895 exhibition. Later he took great delight in recounting how the work had offended both amateurs and established painters alike.[94] In short, it was to be expected that Vollard would first ask Cézanne to do a lithograph based on the *Bathers at Rest*.

While bather compositions interested Cézanne throughout his career, there is no evidence that he was involved with the particular composition of the *Bathers at Rest* during the nineties.[95] Waldfogel has, however, reasoned that the choice of the *Bathers at Rest* as the subject for the lithograph was Cézanne's and that it was related to the fact that it was among the group of paintings that the State refused to accept from the Caillebotte bequest. The public exhibition of the accepted works took place early in 1897. Waldfogel implies that Cézanne was prompted by this exhibition "to settle some old scores."[96] He regards the *Large Bathers* lithograph as both a statement of defiance and an expression of gratitude to Caillebotte "executed in a medium which he [Cézanne] believed would give him access to a large audience."[97] While there may be some truth to this argument, it is weakened by the fact that the transfer drawing for the lithograph was probably executed before the opening of the Caillebotte exhibition. Furthermore, even if the transfer drawing was executed after the opening of the new wing of the Musée du Luxembourg which housed the collection, Waldfogel's argument would fail to explain why the *Large Bathers* was not included in the album published ten months later, in 1897. If the print was, in fact, primarily motivated by the reasons Waldfogel suggests, then certainly both artist and dealer would have wished to publish it while the issue was still a current one.

Yet, while it is doubtful that Cézanne himself selected the subject matter for his first lithograph, there were obvious and logical reasons why he would not be averse to Vollard's choice of the *Bathers at Rest*.

Little accustomed to recognition, the artist was probably pleased by the elaborate compliments of both Rivière and Geffroy, and may well have had particular confidence in this painting.[98] Moreover, the work was special in two other respects which may have led the artist to find it particularly suitable for reproduction in a print medium. The heavily reworked canvas was seemingly one of the few paintings which the artist believed he had satisfactorily "realized" or developed to a state fulfilling his intentions.[99] It therefore required no further reworkings in order to make it eligible for representation in another medium. The painting was unique, too, in offering the artist the opportunity to express in one work the two preoccupations of his later paintings: bathers in a landscape setting and the view of Mont Sainte-Victoire.

The choice of the subject matter for the two subsequent lithographs may have been less exclusively that of the publisher. Certainly both the *Portrait of Cézanne* and the *Small Bathers* do reflect, to a greater extent than does the *Large Bathers,* the artist's contemporary concerns in drawings and paintings. Yet it must also be noted that Vollard later recalled that even to an interested audience Cézanne's portraits, and particularly the bather compositions Vollard so admired, were less accessible than were his landscapes and still lifes.[100] Moreover, if we are to trust Georges Lecomte's review of the 1895 exhibition, despite the critical attention previously paid to the *Bathers at Rest,* it was the figure paintings that were the revelation of that show.[101]

Quite possibly, then, part of Vollard's concern in publishing prints by Cézanne would have been to promote a greater appreciation of the artist as a figure painter and portraitist. It is reasonable to assume that Vollard would have asked for a portrait directly after having commissioned the *Large Bathers.* Later on, when the dealer decided that for his 1897 album Cézanne should be represented with a color print, he would undoubtedly have wanted a figure composition, since neither the *Large Bathers* nor the *Portrait of Cézanne* had been published.

The lithographs, then, reflect the desires of the publisher, the technical demands exerted by the medium and the printer, and the willing cooperation of the artist. Greater insight into the collaboration of publisher, printer, and artist is provided by the lithograph and watercolor maquettes, particularly those for the *Large Bathers.* For while in the case of both the *Small Bathers* and the *Portrait of Cézanne* there is only one impression known to have been colored by the artist (figs. 8, 9), there are five known impressions of the *Large Bathers* heightened with watercolor. Three of these works can be attributed to Cézanne (figs. 10, 11, 12).[102]

Although the number of maquettes seems initially puzzling, there is no reason to question their authenticity. The only example known to Venturi was that formerly in the collection of Alphonse Kann (fig. 12).[103] Although the present whereabouts of this work is unknown, it is known through reproduction.[104] Judging from the photograph alone, we have no reason to doubt the attribution, which is, moreover, reinforced by a comparison with the two other colored versions. In the case of these examples not cited by Venturi—one in the collection of Mrs. Florence Weil, St. Louis (fig. 11), and the other in the National Gallery of Canada (fig. 10)—considerations of provenance and style leave no doubt concerning their authorship. Both works come from the Vollard collection.[105] Furthermore, the same palette appears in each; dominated by variations of blue, green, and yellow, it is the palette most often found in Cézanne's bather watercolors of the nineties.[106]

One naturally asks why the artist hand-colored several impressions when apparently the printer required only one maquette. Since we have little information about Clot's workshop, it is difficult to determine the usual procedure followed in executing color maquettes for the printer. The example of Renoir suggests, however, that the practice of coloring several impressions-in-black may not have been uncommon in the case of artists involved in Vollard's publishing activities. With regard to *Le Chapeau épinglé* (Johnson 108), Renoir's large color lithograph of 1898, Roger-Marx mentions an impression in black heightened with pastel and watercolor which was used in the preparation of the color print.[107] Another state of this print, not cited by either Johnson or Roger-Marx, closely followed an impression heightened with pastel alone,[108] now in the collection of M. A. C. Mazo, Paris.[109]

Several factors could have accounted for the number of maquettes prepared for the *Large Bathers.* Clot may have wanted several versions in order to choose the one he felt he could translate most successfully. Since Vollard retained at least two of the hand-colored impressions of the *Large Bathers,* it can be inferred that he regarded them as works of art with a potential market value in addition to being working tools for his printer.[110] The dealer may even have requested several colored impressions simply in order to obtain a number of these rare works from the artist. Also because of his temperament and his involvement in the project, Cézanne might well have prepared several maquettes of his own accord.

Certainly, given the high quality of the Ottawa and Weil maquettes, it would be incorrect to hypothesize that the existence of a number of heightened impressions suggests that the artist was not entirely satisfied with his first attempt and so continued to work on the problem. Rather it is most plausible that Cézanne, for whom the repetition and reworking of ideas was customary artistic practice, would naturally have colored several impressions.[111] At a time when the artist was again thinking of large-scale bather canvases, he may have found it particularly interesting to review his monumental composition of the seventies using a medium which by virtue of its transparency and fluidity corresponded to his contemporary oil technique. Indeed, at approximately the same period that Cézanne was preparing these maquettes, Pissarro, referring specifically to Cézanne's bather compositions, remarked to Matisse: "Cézanne is not an Impressionist because all his life he has been painting the same picture."[112] Since the watercolor medium did not permit reworking, the artist may have come to enjoy working on a number of black-and-white impressions in which the composition was given and the artist was free to vary his touch on a stationary motif. Thus, paradoxically, the more fully developed drawing of the *Large Bathers* allowed Cézanne greater freedom to experiment than did the more skeletal *Small Bathers,* in which the artist was obliged to complete some of the major compositional elements with color.

One might expect, then, that more than one maquette would have been executed for both the *Portrait of Cézanne* and the *Small Bathers.* Certainly this seems to have been the case with regard to the latter. The color print exists in two states which differ in the disposition of the color areas.[113] In view of the fact that Clot usually followed the artists' maquettes with great care, it is highly probable that each state of the *Small Bathers* followed a different maquette. Furthermore, as neither state is closely related to the one known impression heightened with watercolor (fig. 8), one can reasonably assume that Cézanne colored at least three of the keystone impressions. Comparison of the Ottawa maquette (fig. 10) with the first color printing of the *Large Bathers* (fig. 7) bears this out, and brings to light another facet of Cézanne's complex involvement with Vollard's project.

Since the *Large Bathers* maquettes are equally successful

works, it is impossible to determine the factors that were operative in choosing the Ottawa version as the definitive model for the color print. Such factors might indeed have included the personal preferences of the artist or the publisher, or technical considerations on the part of the printer. What is remarkable is that the chosen maquette should have been on one hand so respected and on the other so disregarded in the preparation of the color lithograph. The extraordinary fidelity with which the printer has rendered the form and character of the brushwork is both a tribute to his technical skill and testimony to the desire to reproduce the artist's work faithfully. This almost slavish attention to detail makes the color discrepancy between the maquette and the color print all the more surprising. Many areas that are blue in the maquette are ocher in the print. This alteration is disconcerting, particularly in the sky, which in both the Ottawa and Weil maquettes is colored with the rich blues so characteristic of Cézanne's palette. The motivation behind this substitution—retained in the second color printing—is an enigma. This is particularly so in view of the fact that in both color printings of the *Small Bathers* blue is predominant, as it is in the Gecht maquette (fig. 8) and undoubtedly was in the others now lost.

Since Cézanne was closely involved with the preparation of the color print, he must have authorized this change. One can only assume that the substitution was made in the interests of achieving a more successful print, and was thus part of an ongoing experiment to translate Cézanne's watercolor adequately. Indeed, the determination to produce an attractive facsimile is even reflected in the choice of paper used for the printing. Whereas the *Small Bathers* had been printed on the smooth-surfaced *chine collé* commonly used in lithographic printing, the *Large Bathers* was printed on a rather heavy laid-paper.[114] The selection of a paper normally associated with drawings was undoubtedly made with a view to giving the print the aura of a unique work of art; for the pronounced surface texture of the paper increased the difficulty of printing the color successfully. At the time, the inability of color lithography to replicate the limpid tones of watercolor, particularly in color areas produced by the superimposed printings of two or more color stones, was generally considered to be one of its major drawbacks.[115] The fact that in many impressions of the first edition the color is opaque and muddy indicates that, despite his remarkable technical expertise, Clot experienced difficulty in the printing. Yet the fact that in no two impressions of this printing are the colors identical attests to the persistent efforts made to correct this deficiency. In the search for optimum transparency and freshness, Clot seemingly changed the printing inks and chemically experimented with the ink-receiving properties of the color stones during the printing of the edition. The edition was not, then, definitive in the normal sense; it records the search for, rather than the duplication of, the successful image. This exposure of the working process reflects a relatively bold decision on the part of printer, publisher, and artist.

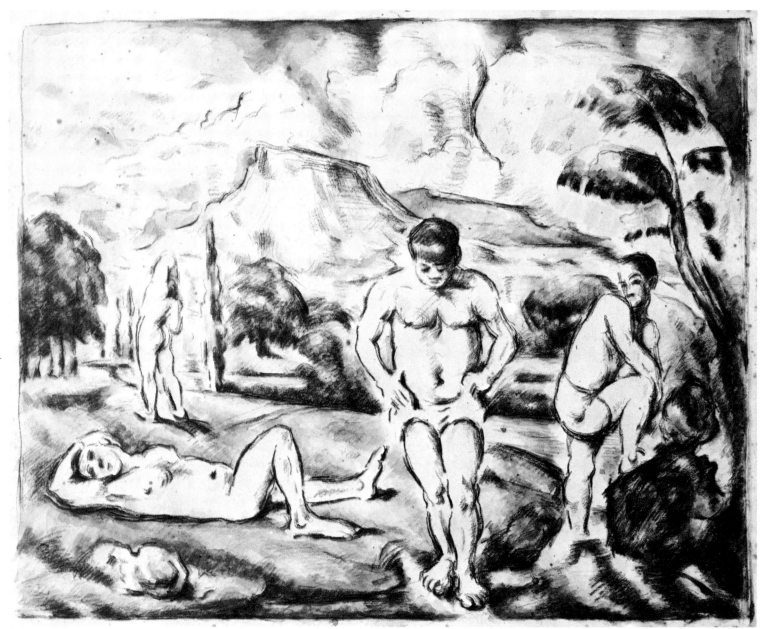

Fig. 10. *Large Bathers.* 1896–98
Transfer lithograph in black heightened with watercolor on laid paper,
16 x 19⅞ in (41 x 51 cm)
The National Gallery of Canada, Ottawa

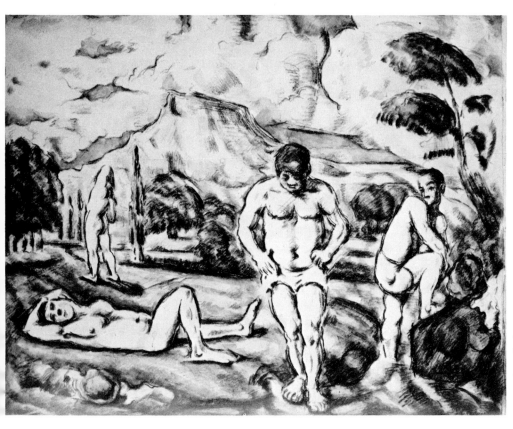

Fig. 11. *Large Bathers.* 1896–98
Transfer lithograph in black heightened with
watercolor on laid paper,
16 x 19⅞ in (41 x 51 cm)
Collection Mrs. Florence Weil, St. Louis

Fig. 12. *Large Bathers.* 1896–98
Transfer lithograph heightened with watercolor,
16 x 19⅞ in (41 x 51 cm)
Formerly Collection Alphonse Kann,
Saint-Germain-en-Laye

Vollard's interest in Cézanne's lithographs was not lessened by the fact that there was no immediate market for them. Even after the artist's death the dealer continued having his work printed. In 1914 he commissioned Clot to do a color lithograph after the *Luncheon on the Grass* (Venturi 377) and had him pull an edition of the *Portrait of Cézanne* in gray.[116] It may well have been at this time that he also had Clot print a second color edition of both bather lithographs, using different sets of color stones. Some six years later yet another edition of the *Portrait of Cézanne* was printed—this time in black.[117] The majority of these prints remained in the possession of either the publisher or his printer, and were dispersed only after World War II.

Thus while Pissarro may have been correct in stating that Vollard geared his publishing projects to the market, it seems that over time the dealer's attitude changed. While it is possible that the later editions of the prints were the result of publishing projects never realized, it is more probable that they were quite simply the result of the dealer's ultimate belief in the importance of the lithographs. Certainly these prints and the related maquettes do hold a special position within Cézanne's work. The etchings of the seventies had been essentially private works; in their preparation Cézanne proceeded with a boldness and lack of inhibition permitted by the knowledge that they would be studied only by a few close friends. Prepared for publication at a time when the artist had begun to attract attention, the lithographs are works of a very different kind. They are more serious, more considered. They reflect not only the artist's approach to a new medium, but also his approach to an unfamiliar, public situation. Furthermore, essentially a collaborative effort, the lithographs are a fascinating document of the relationship between Vollard and Cézanne, giving us greater knowledge of the personality and practices of the highly influential dealer and publisher, and revealing a surprising flexibility on the part of the great, solitary artist.

NOTES

1. The following essay grows out of a study devoted to the lithograph and watercolor maquette in the National Gallery of Canada, Ottawa; see Douglas W. Druick, "Cézanne, Vollard, and Lithography: The Ottawa Maquette for the *Large Bathers* Colour Lithograph," *National Gallery of Canada Bulletin* 19 (1972; published August 1974), pp. 1–36. In the present study the emphasis has been changed to a broader study of Cézanne's lithographic output, and new material has been incorporated.

The problems involved in the study of Cézanne's prints have necessitated visiting numerous collections, both public and private, and requesting information from a number of sources. In addition to those whose assistance I acknowledged in my earlier article, I would like to thank the following, whose help has contributed significantly in the preparation of this study: M. Jean Adhémar, Chief Curator, Cabinet des Estampes, Bibliothèque Nationale, Paris; Mr. Eric G. Carlson, Swarthmore College; Dr. Martin L. Gecht, Chicago; Mr. John W. Ittmann, Curator of Prints and Drawings, The Minneapolis Institute of Arts; M. A. C. Mazo, Paris; Ms. Suzanne Folds McCullagh, Curatorial Assistant, Department of Prints and Drawings, The Art Institute of Chicago; M. Pierre Michel, Paris; M. Hubert Prouté, Paris; Mr. John Rewald, New York;

Mr. Richard J. Wattenmaker, Chief Curator, Art Gallery of Ontario, Toronto; Mrs. Florence Weil, St. Louis.
2. Most notably, Jean Goriany, "Notes on Prints: Cézanne's Lithograph *The Bathers*," *Gazette des beaux-arts* 23 (1943):123–24; Melvin Waldfogel, "Caillebotte, Vollard, and Cézanne's *Baigneurs au repos*," *Gazette des beaux-arts* 65 (1965):113–20; Jean Cherpin, *L'Oeuvre gravé de Cézanne* (Marseilles: Arts et Livres de Provence, 1972), Bulletin no. 82.
3. See Cherpin, nos. 1–5, pp. 64–67. Venturi was aware of only three etchings: 1159, 1160, and 1161.
4. See Paul Gachet, *Cézanne à Auvers: Cézanne graveur* (Paris: Les Beaux-Arts, 1952).
5. Gachet (ibid., n.p. [p. 13]) argues that Cézanne would have continued etching had circumstances permitted. This is doubtful. Despite his continued friendship with Pissarro, and the latter's serious involvement with etching, Cézanne was never again tempted to take up the medium.
6. Ambroise Vollard, *Souvenirs d'un marchand de tableaux* (Paris: Albin Michel, 1937), p. 298.
7. André Mellerio, "La Rénovation de l'estampe: l'estampe en 1896," *L'Estampe et l'affiche* 1 (1897):5.
8. See, for example, Arsène Alexandre, "L'Art à Paris: les peintres-graveurs," *Paris,* April 9, 1893, p. 2. Articles also appeared in *Le Gaulois* (April 1, 1893, p. 2), *Le Matin* (March 30, 1893, p. 2), and *Le Courrier français* (April 30, 1893, pp. 6–7).
9. Mellerio, "La Rénovation de l'estampe: l'estampe en 1896," p. 5.
10. For 150 francs, yearly subscribers to *L'Estampe originale* received forty prints, for which the nonsubscriber had to pay 200 francs. Every print was limited to an edition of 100, each numbered and signed by the artist. *L'Epreuve* issued ten prints monthly in an edition of 205 impressions. The yearly subscription rate was 100 francs for the regular (unsigned) and 250 for the deluxe editions. Therefore even in the deluxe edition the average price per print was just slightly more than half that of a print from *L'Estampe originale.*
11. They were smaller in format and printed on poorer quality papers. Also, photomechanical processes were sometimes used.
12. All the Vollard publications are cataloged in Una E. Johnson, *Ambroise Vollard, Editeur: 1867–1939* (New York: Wittenborn, 1944; rev. ed., New York: Museum of Modern Art, 1977). Subsequent references in text to a work listed in the Johnson catalog will be indicated by the catalog number in the revised edition.
13. These included: Georges Auriol, Albert Besnard, Pierre Bonnard, Henri Fantin-Latour, Alexandre Lunois, Charles Maurin, Maurice Denis, Odilon Redon, Auguste Renoir, Theo van Rysselberghe, Félix Vallotton, and Edouard Vuillard.
14. By Vollard's account, the twenty-two prints sold for 100 francs (see *Souvenirs d'un marchand de tableaux,* p. 299), or half the annual nonsubscription price for the forty prints in *L'Estampe originale.* The January 1898 issue of *L'Estampe et l'affiche* advertised this album at a price of 150 francs (p. 20). This could represent an increase in price, in spite of no increased market demand, or merely Vollard's faulty memory (see below, note 56).
15. The poster announced the dates of the show as June 15 to July 20; it made no specific reference to the album.
16. The catalog of the exhibition was reproduced in *L'Estampe,* no. 20, June 21, 1896, pp. 2–3.
17. The Société des Peintres-Graveurs was founded in 1889. The exhibitions at Durand-Ruel's gallery had included paintings, drawings, and prints. A number of the artists Vollard included in his exhibition had participated in these earlier shows (for example, Fantin-Latour, Pissarro, Redon, and Sisley).
18. Exhibition catalog nos. 147–54. Bonnard's entry no. 22—"lithographies"—may have included prints from his portfolio of twelve lithographs *Quelques Aspects de la vie de Paris* (Johnson 10), said to have been executed in 1895 (Johnson, p. 128), but shown for the first time at Vollard's in 1899. See Claude Roger-Marx, *Bonnard lithographe* (Monte Carlo: André Sauret, 1952), p. 105.
19. Exhibition catalog no. 37, *Portrait de Verlaine* (Delteil 26). Among Fantin's entries was the *Venus et l'amour* (Johnson 39, Hédiard 131) from

Vollard's album, as well as *La Tentation de Saint Antoine* (Hédiard 110) from *L'Estampe originale* (3ᵉ livraison, July–September 1893).

20. Among those included in the exhibition who were never to produce prints for Vollard was Pissarro, from whom, we know, Vollard tried in vain to obtain lithographs.

21. The Cézanne entries were: no. 41, *Paysage,* eau-forte; no. 42, *Maisons sur un coteau,* aquarelle; no. 43, *Bords de rivière,* aquarelle; no. 44, *Fleur dans un vase,* aquarelle; no. 45, *Paysage,* aquarelle; no. 46, *Pêches dans une assiette,* aquarelle; no. 47, *Le Jardin,* aquarelle; no. 48, *Femmes au bain,* dessin.

22. This and subsequent translations from French texts are the author's. Loys Delteil, "Les Peintres graveurs (chez Vollard, 6 rue Laffitte)," *Journal des artistes,* no. 28, July 12, 1896, pp. 1516–17.

23. Arsène Alexandre, "La Vie artistique, peintres-graveurs," *Le Figaro,* June 25, 1896, p. 5.

24. Anon., "Notes d'art parisiennes," *L'Art moderne,* no. 26, June 28, 1896, p. 203.

25. Pissarro comments upon the success of the show in letters to Lucien of June 22 and July 1, 1896. See John Rewald (ed.), *Camille Pissarro: lettres à son fils Lucien* (Paris: Albin Michel, 1950), pp. 409–10.

26. Vollard, *Souvenirs d'un marchand de tableaux,* p. 300. Vollard notes that even twenty years later the edition was not sold out.

27. The reviewer for *L'Art moderne* mentioned in passing that some of the prints "are included in the album of peintres-graveurs M. Vollard is publishing." See "Notes d'art parisiennes," *L'Art moderne,* no. 26, June 28, 1896, p. 203.

28. It is interesting that despite his previous success, Marty's publication of 1896, the *Etudes de femmes,* failed to attract attention. Only four of the projected six fascicules appeared.

29. A number of periodicals, such as the *Mercure de France* and the *Chronique des arts et de la curiosité,* often listed and commented upon the recent fascicules of the serial publications.

30. Letter to Lucien, Paris, July 2, 1896 (Rewald, p. 436). Pissarro also noted that "All the dealers, Sagot, Dumont, etc. . . . are fighting him fiercely for he's come in and upset their modest trade."

31. Gabriel Mourey, "Studio Talk," *The Studio,* no. 55 (October 1897), p. 126.

32. Of the thirty-one artists represented, nineteen had contributed to *L'Estampe originale.* These included: Georges Auriol, Pierre Bonnard, Eugène Carrière, Maurice Denis, Henri Fantin-Latour, Georges de Feure, Eugène Grasset, Alexandre Lunois, Charles Maurin, Lucien Pissarro, Puvis de Chavannes, Odilon Redon, Auguste Rodin, Ker-Xavier Roussel, Charles Shannon, Henri de Toulouse-Lautrec, Edouard Vuillard, T. P. Wagner, and James McNeill Whistler.

33. Executed by Bonnard (Johnson 14).

34. André Mellerio, "Exposition de la deuxième année de *L'Album d'estampes originales;* galerie Vollard, 6, rue Laffitte," *L'Estampe et l'affiche* 2 (1898):10.

35. Letter to Lucien, Paris, April 28, 1896 (Rewald, p. 407).

36. André Mellerio, "La Rénovation de l'estampe: causes du renouveau—conditions de son progrès," *L'Estampe et l'affiche* 1 (1897):45.

37. Ibid.

38. Letters to Lucien, Paris, April 26, 1896, and Eragny, June 22, 1896 (Rewald, pp. 407, 409).

39. The term *estampe murale,* current in the second half of the nineties, specifically referred to the color print executed on a large scale and meant to be framed. For a discussion of the aesthetics of this class of print, see Raymond Bouyer, "L'Estampe murale," *Art et decoration* 4 (1898):185–91. Bouyer defined the *estampe murale* as "the intermediary between the print and the poster" to be used to "decorate walls." He specified color lithography as the true medium for this genre. Unlike Vollard, however, Bouyer believed that the intrinsic qualities of the medium should be developed, that color lithography should not "strain for the enticing virtuosity of the facsimile" (p. 191) and thereby compete with works in other media.

40. See Claude Roger-Marx, *Les Lithographies de Renoir* (Monte Carlo: André Sauret, 1951), p. 18.

41. Letter to Lucien, Paris, September 4, 1896 (Rewald, pp. 414–15).

42. Ibid., p. 415.

43. Letter to Lucien, Paris, July 3, 1896 (Rewald, p. 411).

44. Letter to Lucien, Paris, July 12, 1896 (Rewald, p. 412).

45. Vollard, *Souvenirs d'un marchand de tableaux,* p. 192.

46. Roger Marx, "Preface to *L'Estampe originale,*" *L'Estampe originale,* Album VI (1894). Trans. by Judith Colton in Donna Stein, *L'Estampe originale: A Catalogue Raisonné* (New York: Museum of Graphic Art, 1970), p. 15. On one occasion Marty did introduce a photomechanical reproduction into his publication. This was Puvis de Chavannes's *Le Jeu,* which appeared in the final fascicule of March 1895. See Stein, no. 58, and *Puvis de Chavannes,* English ed. (Ottawa: National Gallery of Canada, 1977), cat. no. 71.

47. Bonnard himself printed the portfolio *Quelques Aspects de la vie de Paris* (Johnson 10, p. 128).

48. *La Tentation de Saint Antoine* (Johnson 195).

49. In a letter Redon wrote to Clot on April 13, 1897, he stated: "I think it will be best for me to be present for the printing of the trial proofs of the pastel M. Vollard is reproducing; no doubt there will be some color to change or modify." I am indebted to M. Jean Adhémar, Chief Curator, Cabinet des Estampes, Bibliothèque Nationale, Paris, for having kindly made this and other letters from the Clot correspondence available to me.

50. Arsène Alexandre, "La Vie artistique, petites expositions," *Le Figaro,* December 6, 1897, p. 5.

51. Mellerio, "Exposition de la deuxième année de *L'Album d'estampes originales;* galerie Vollard, 6, rue Laffitte," p. 11.

52. Ibid.

53. Ibid.

54. Mellerio, "La Rénovation de l'estampe: causes du renouveau—conditions de son progrès," p. 47.

55. Vollard, *Souvenirs d'un marchand de tableaux,* p. 300.

56. While Vollard recalled that the price had been 150 francs (ibid., p. 299), the January 1898 issue of *L'Estampe et l'affiche* listed the price as 400 francs. See "Les Estampes et les affiches du mois," *L'Estampe et l'affiche* 3 (1898):19. High prices alone would not, however, have discouraged buyers. By 1898 the edition of *L'Estampe originale* had been exhausted; the going price was 600 francs, and a set complete with trial proofs had sold for 1,500 francs. See André Mellerio, *La Lithographie originale en couleurs* (Paris: Publication de *L'Estampe et l'affiche,* 1898), p. 27, note.

57. Vollard, *Souvenirs d'un marchand de tableaux,* p. 299.

58. In a letter Vollard wrote to Clot on July 3, 1897, he stated: "You must print the edition of Blanche's plate for the *third year* of my album as soon as you receive the *bon à tirer* impression."

59. Vollard, *Souvenirs d'un marchand de tableaux,* p. 299. Johnson describes eleven prints as having been executed for the third projected album (Johnson 15, 23, 24, 47, 74, 75, 109, 110, 138, 146, 156). One must note, however, that it was obviously Vollard's habit to commission works and then find a place for them. Renoir, for example, executed both the *Mère et enfant* (Johnson 106) and the *Baigneuse debout* (Johnson 109) in 1896. The former was used in the album of the same year, whereas the latter was to be included in the third album (Johnson, p. 145). It is doubtful that Vollard was commissioning works in 1896 directly for a publication scheduled for 1898.

60. Title page, *La Deuxième Année de l'Album d'estampes originales de la galerie Vollard.* Private collection, Chicago.

61. Johnson 23 and 24. See above, note 59.

62. Venturi assigned a date of 1890–1900 to both bather lithographs (Venturi 1156, 1157) but dated the *Portrait of Cézanne* (Venturi 1158) to 1898–1900. See Lionello Venturi, *Cézanne: son art—son oeuvre,* 2 vols. (Paris: Paul Rosenberg, 1936). Cherpin dates the *Small Bathers* to 1897, the *Portrait of Cézanne* to 1898–1900, and assigns no date to the *Large Bathers.* See Cherpin, nos. 6, 7, 8.

63. John Rewald, *Paul Cézanne: A Biography* (New York: Schocken Books, 1968), pp. 172–73.

64. Ambroise Vollard, *Paul Cézanne* (Paris: Galerie A. Vollard, 1914), p. 91.

65. John Rewald (ed.), *Paul Cézanne: Letters,* trans. Marguerite Kay (London: Bruno Cassirer, 1941), pp. 217, 220, 221, 227.

66. Vollard, *Paul Cézanne,* p. 74. Vollard does not specify the time of year, but

it was probably between January and June, since in June Cézanne left Aix. See Rewald, *Paul Cézanne: A Biography,* p. 220.

67. Rewald, *Paul Cézanne: A Biography,* p. 220.

68. Ibid.

69. Waldfogel, p. 114.

70. Mellerio, *La Lithographie originale en couleurs,* pp. 18–19. Rodin's contribution to the second album was a drawing of which Clot had made a facsimile (Johnson 120).

71. Mellerio, *La Lithographie originale en couleurs,* p. 22.

72. For example, Claude Roger-Marx, *French Original Engraving from Manet to the Present Time* (New York: Hyperion Press, 1939), p. 45.

73. Though well informed, Mellerio did on occasion publish incorrect information.

74. Catalogue de la collection A. Curtis, vol. 8, no. 5883, Paris, Bibliothèque Nationale, Cabinet des Estampes, Réserve.

75. See, for example, Claude Roger-Marx, "Les Peintres-Graveurs français à la Bibliothèque nationale," *Beaux-Arts,* March 21, 1933, p. 1.

76. This is particularly evident in an impression on *simili japon* (Bibliothèque Nationale, Cabinet des Estampes, Paris, fol. Dc461).

77. I am indebted to Richard Schiff, University of Chicago, and to John Rewald, New York, for assistance in dating this painting.

78. See, for example, Venturi 582, 589, 590, 591.

79. The figure going down into the water is found in drawings of the late eighties (Venturi 1421, 1411, Chappuis 962, 1066) as well as in a drawing dating close in time to the lithograph (Venturi 1413, Chappuis 1218, 1897–1900). The same figure also appears in the watercolor entitled *Study for "Les Baigneuses"* (Metropolitan Museum of Art, not listed in Venturi), for which a date of c. 1895 seems appropriate.

80. See Henry Hamel, "Chronique," *Revue des beaux-arts,* July 1, 1897, p. 1030. In his important treatise on lithography the printer Duchatel wrote that the artist unaccustomed to working on the stone can proceed with greater "vigor" on transfer paper. See E. Duchatel, *Traité de lithographie artistique* (Paris: Chez l'Auteur, 1893), p. 33.

81. Fantin-Latour, who had for years used transfer paper, worked directly on the stone when collaborating with Clot in the mid-nineties.

82. The maquette was formerly in the collection of Gaston Bernheim de Villers, Paris. It was reproduced in the *Album Cézanne* (Paris: Bernheim-Jeune, 1914), pl. 50.

83. The maquette was formerly in the collection of Ambroise Vollard. It was reproduced in his book *Paul Cézanne* (p. 90). In the index, the work is described as follows: "*Portrait of Cézanne,* watercolor maquette for a color lithograph" (p. 179). Its present whereabouts is unknown.

84. The delineation of the mouth is characteristic of Cézanne's self-portrait drawings of the period (see Venturi 1476, Chappuis 1125, 1897–1900). Thus the abbreviation of the drawing in the area of the mouth does not imply that Cézanne anticipated subsequent reworking with watercolor.

85. Mellerio, "Exposition de la deuxième année de L'*Album d'estampes originales;* galerie Vollard, 6, rue Laffitte," p. 10.

86. André Fontainas, "Memento," *Mercure de France* 25 (1898):506.

87. The entry for no. 5883 of the Curtis catalog indicates two color printings of the *Large Bathers,* the first bearing the inscription in the stone lower right. The sale of the Clot estate confirms this (see *Collection de M. A.C.,* June 13, 1919, Hôtel Drouot: Lithographies no. 36, repr. opp. p. 6).

88. Vollard, *Souvenirs d'un marchand de tableaux,* p. 79.

89. See *Puvis de Chavannes,* cat. nos. 21, 33, 198, 201.

90. Vollard, *Souvenirs d'un marchand de tableaux,* p. 78.

91. Georges Rivière, "L'Exposition des impressionistes," *L'Impressioniste,* April 14, 1877, no. 12.

92. Gustave Geffroy, "L'Art d'aujourd'hui: Paul Cézanne," *Le Journal,* no. 544, March 25, 1894, p. 1.

93. Gertrude Stein pointed out that Vollard was very much influenced by the opinions of others. See Gertrude Stein, *The Autobiography of Alice B. Toklas* (New York: Vintage Books, 1960), p. 39.

94. Vollard, *Souvenirs d'un marchand de tableaux,* pp. 78–79; *Paul Cézanne,* pp. 59 ff.

95. In at least two instances, however, Cézanne was involved with figures related to those in this composition. The center figure of the *Bathers at Rest* is the subject of the single *Bather* (Venturi 548, 1885–90, Museum of Modern Art, N.Y.). The figure on the left of the *Study for "Les Baigneuses"* (Metropolitan Museum of Art) is related to the figure at the far left of the painting.

96. Waldfogel, pp. 114 ff.

97. Ibid., p. 117.

98. Vollard states that when Cézanne learned that the *Bathers at Rest* had been bequeathed to the Luxembourg he said, "Now I'm giving Bouguereau a hard time" (Vollard, *Paul Cézanne,* p. 55). The accuracy of Vollard's accounts of artists' conversations is highly questionable. However, even if Vollard fabricated this quotation, it is significant in thus reflecting the opinion of Vollard himself.

99. Cézanne's letter to Pissarro of July 2, 1876 (see Rewald, *Paul Cézanne: Letters,* p. 104), indicates that he sent to the Impressionist exhibition only those works he believed to be his best. According to Vollard, Renoir recalled that on chancing to meet Cézanne carrying the *Bathers at Rest* to its first owner, the musician Cabaner, the artist expressed his satisfaction that the work was a "rather well-realized study." See Ambroise Vollard, *La Vie et l'oeuvre de Pierre Auguste Renoir* (Paris: Chez l'Auteur, 1919), p. 31.

100. Vollard, *Paul Cézanne,* pp. 58 ff. Gertrude Stein attests to the fact that the nudes were generally thought more difficult to comprehend than the landscapes (Gertrude Stein, *The Autobiography of Alice B. Toklas,* pp. 30–32).

101. Georges Lecomte, "Chronique de la littérature et des arts: les expositions," *La Société nouvelle* 23 (1895):815.

102. Of the impressions that were heightened by someone other than Cézanne, one is in the collection of The Art Institute of Chicago and the other in a Minneapolis private collection. The Chicago impression is incompletely printed, and the coloring follows the Ottawa maquette. The application of color in the Minneapolis impression is based on either the Ottawa maquette or the first state of the color lithograph.

103. It should be noted that in Venturi's catalogue raisonné the photographs corresponding to nos. 1156, 1157, 1158 do not reproduce the lithographs described, but rather the hand-colored impressions mentioned in the course of the catalog entries (that is, figs. 8, 12, 9 of the present text).

104. See Fritz Burger, *Cézanne und Hodler* (Munich: Delphin Verlag, 1920), vol. 2, pl. 49. This is the same work reproduced in Venturi under no. 1157.

105. The Ottawa maquette entered the National Gallery of Canada in May 1940 with many other works from Vollard's collection. There it was housed until its purchase by the Gallery in 1970. The Weil maquette passed from the Vollard estate into the collection of M. Edouard Jonas. The work was acquired by M. Marcel Guiot, Paris, then reacquired by M. Jonas in 1953 and sold to Mrs. Marc Steinberg, St. Louis, in 1954. It has since passed into the collection of Mrs. Steinberg's daughter, Mrs. Florence Weil.

106. The *Baigneurs et baigneuses* (Venturi 1110, c. 1895) and the *Study for "Les Baigneuses"* (Metropolitan Museum of Art, c. 1895) are good examples for comparison with the Ottawa and Weil maquettes. In each, the overall effect is achieved through the orchestration of purplish blue, blue, greenish yellow, yellowish green, and bluish green. Comparison of the watercolors with the Ottawa maquette reveals similarities in the details of color application: the pale red which appears in the cheeks of the bathers in Venturi 1110 and in the *Study* also appears in the face of the center bather in the Ottawa maquette. The comparable figures of the bather, far left, of the Ottawa version and the bather at left in the *Study* have both been given a touch of pink in the left heel. Furthermore, in both, pale red washes are similarly applied over areas of blue and green. The use of ochers is comparable in Venturi 1110 and in the Ottawa maquette.

107. Roger-Marx, *Les Lithographies de Renoir,* under cat. no. 5.

108. An example of this state is in the collection of the Brooklyn Museum, inv. no. 41, 1091.

109. This maquette was purchased by M. Mazo from Clot's son.

110. Vollard's inclination to utilize all possible marketable resources is underscored by the fact that in the early 1900s he purchased from Mary Cassatt some pastels from which he then had Clot execute counterproofs. See Adelyn Breeskin, *Mary Cassatt: A Catalogue Raisonné of the Oils, Pastels, Watercolors, and Drawings* (Washington: Smithsonian Institution Press, 1970), pp. 18–19.

111. The valuation of the Clot estate uncovered an interesting testimony to the artist's approach to the project in the form of a small sheet of transfer paper (Collection Hubert Prouté, Paris) on which is twice written the inscription and signature found in the lower right margin of impressions of the first color printing (fig. 7). Comparison reveals that neither inscription is the one transferred to the stone. Given the transfer paper, the artist covered it with several inscriptions although one would have been sufficient.

112. Alfred H. Barr, Jr., *Matisse: His Art and His Public* (New York: Museum of Modern Art, 1951), p. 38. I am indebted to Richard J. Wattenmaker, Chief Curator, Art Gallery of Ontario, for his provocative observations on the relationship between the maquettes and the painting of 1876.

113. See appendix, below.

114. MBM Arches, "Ingres" variety.

115. See Henri Bouchot, *La Lithographie* (Paris: Librairies-Imprimeries Réunies, 1895), p. 290.

116. Cherpin, cat. no. 8, p. 69.

117. Ibid.

APPENDIX

Recent studies devoted to Cézanne's prints have not adequately considered the problems of dating, states, and edition sizes. It is therefore helpful to catalog the three lithographs by the artist.

I. *The Large Bathers.* (Venturi 1157.) Fall 1896–spring 1897/summer 1898. Composition: 16 x 19⅞ in. (41 x 51 cm), all states. Signed in stone, lower right, all states: *P. Cézanne.*

1st state: Transfer lithograph in black. Edition (possibly 1898): at least 100 impressions on laid paper (watermark: MBM). (Fig. 3.)

2nd state: With the addition of color stones (ocher, blue, green, yellow, red, orange) based on the Ottawa maquette and prepared with brush and tusche. With the exception of a few trial proofs (e.g., Museum of Modern Art, N.Y.), this state bears the inscription in the stone, below the composition, lower right: *Tirage à cent exemplaires N°/P. Cézanne.* Edition (probably 1898): at least 100 impressions on laid paper (watermark: MBM). Color variations between impressions. (Fig. 7.)

3rd state: With a new set of color stones (ocher, blue, green, yellow, red) based on the Ottawa maquette and prepared with brush and tusche and crayon. The character of the brushwork is more generalized and the colors are generally lighter and more translucent than in the second state. The inscription in the stone below the composition has been removed. Edition (probably posthumous, possibly 1914): at least 100 impressions on laid paper (watermark: MBM). Color variations between impressions.

II. *Portrait of Cézanne.* (Venturi 1158.) Fall 1896–spring 1897. Composition: 12⅝ x 10¾ in. (32.3 x 27.7 cm).

Only state. Transfer lithograph. Edition (1914): at least 100 impressions in gray on laid paper (watermark: MBM). The suggestion has been made (see Jean Cherpin, *L'Oeuvre gravé de Cézanne,* Marseilles, 1972, cat. no. 8, p. 69) that the edition may have been intended to serve for a color printing. This is doubtful, as it is customary to print the keystone last, and not first, in executing a color lithograph.

Second edition (1920): at least 100 impressions in black on laid paper (watermark: MBM). (Fig. 4.)

III. *The Small Bathers.* (Venturi 1156.) Fall 1896–spring 1897.

1st state: Lithograph in black. Edition: at least 10 impressions on *chine volant.* Composition: 9 x 11¼ in. (23.2 x 28.8 cm). (Fig. 5.)

2nd state: With additional drawing in the upper left of the composition to indicate branches of the tree. Edition: none. One known trial proof on wove paper, collection A. C. Mazo, Paris (formerly collection Auguste Clot). Composition: 9 x 11¼ in. (23.2 x 28.8 cm).

3rd state: With the addition of color stones (green, yellow, blue, red) based on a lost maquette and prepared with brush and tusche. Most impressions are signed in the stone, below the composition, lower right: *P. Cézanne.* Edition of 1897: at least 100 impressions on *chine collé.* Before the gluing of the *chine* onto its support the composition was cropped, and now measures: 8½ x 10⅜ in. (21.8 x 26.6 cm). Color variations between impressions. (Fig. 6.)

4th state: With a new set of color stones (green, yellow, blue, red) based on a second maquette, now lost, and prepared with brush and tusche and crayon. As in the second color printing of *The Large Bathers,* the character of the brushwork is more generalized and the colors are generally lighter and more translucent than in the first color printing. The inscription in the stone below the composition has been removed. Edition (probably posthumous, possibly 1914): at least 100 impressions on *chine volant.* Composition: 9 x 11¼ in. (23.2 x 28.8 cm). Color variations between impressions.

Cézanne and His Critics

George Heard Hamilton

DURING THE SEVEN DECADES that have elapsed since Paul Cézanne's death on October 22, 1906, the criticism of his art has changed from the first reactions of bewilderment or grudging curiosity to the present recognition of his achievement. This achievement now is not only seen as one of the crucial developments in the history of Western painting, but is also appreciated for what it has done to extend, as the greatest art always does, the capacities of human experience, and so enlarge our knowledge of who, and even why, we are. It may be that the critical attacks to which Cézanne's art was subjected when it was first seen were the result of his discovery and presentation, in form and color, of the fundamental realities of nature and of human nature as they would be understood in the twentieth century.

This preliminary examination of the criticism of Cézanne's art in his own lifetime has, however, a more modest intention than to justify the philosophical implications suggested above. It seeks to identify and isolate the words that were first used to describe or characterize his unfamiliar art, and it seeks to trace the transformations that these terms underwent in the writings of those critics who discussed him in his lifetime and immediately after his death. His work came to public attention scandalously at the first and third Impressionist exhibitions of 1874 and 1877, more seriously in a few remarks by Joris-Karl Huysmans in the 1880s, and then in a torrent of abuse and praise in the decade between his first retrospective exhibition at Ambroise Vollard's gallery in 1895 and his death eleven years later. During this span of some thirty years, several of the basic postulates for Cézannian criticism were established. Since his death certain verbal constructions have become such common conventions of criticism that the difficulties which had to be surmounted before the right words and phrases were found have been all but forgotten.

The handful of English terms most frequently used in the middle years of this century—"architectonic," "plasticity," "significant form," "spatial tension," and the like—were actually introduced only after the artist's death. The most familiar phrase, "significant form," was not coined by Clive Bell until 1913, and Roger Fry rang his changes on Cézanne's "plasticity" somewhat later.[1] These and similar terms were derived from the criticism of Cubist and abstract art, and thus appeared not only posthumously, but after subsequent pictorial developments had capitalized on Cézanne's painting. To criticize an artist in language invented after his lifetime is an inevitable and proper

practice, because the purpose of criticism is to make the masters of the past intelligible to successive generations of their artistic future.[2] But the process distorts, however so slightly, the character of an artist's work as it appeared to his contemporaries, and thus something of the original reaction to Cézanne's work within his lifetime is lost. Although this paper is concerned with only a fraction of such criticism, it is an attempt to recover something of the freshness as well as bitterness of those early critical encounters, wherein friend and foe alike had to refine old words or discover new ones with which to communicate their reaction to this strange and unfamiliar art. Even if we believe, as we have a right to do, that our criticism is more searching and subtle than theirs, we may still learn something from his first observers, both the intelligent and the obtuse, about an important moment in the history and language of modern critical theory and practice.

Cézanne's first critics had to find verbal equivalents for what seemed to them unorthodox pictorial situations for which few of the customary words were adequate or relevant.[3] Until new terms could be found the old ones necessarily imparted a negative, derogatory tone to such criticism. Since a critic could more easily explain what he saw in terms of what it was not than of what it was, one who disliked the new art occupied a stronger verbal position than the sympathetic observer who had not yet hit upon the right words with which to set forth his feelings. This situation prevailed in much French criticism of modern painting during the latter half of the nineteenth century. The difficulty arose from the attempt to evaluate nonnaturalistic techniques and intentions with a phraseology devised for the criticism of academic-naturalistic art. In this way we can account for what seems to us the failure at first of such perceptive writers as Théophile Thoré (Thoré-Bürger) and Jules Castagnary to understand or even adequately to explain the aims and achievements of Manet or Whistler in the 1860s.[4] Their vocabularies were sufficient for the criticism of Courbet or Cabanel, since both painters expressed their very different ideas and intentions with traditional techniques and concepts of visual form. But the same words were quite inadequate for a discussion of Manet's emotional detachment from his subject matter or Whistler's attenuated aestheticism.[5]

In the light of our hard-won admiration for Cézanne we may

Notes to this essay begin on page 147.

sometimes think that he has been properly understood only in the twentieth century, but any extensive reading of contemporaneous criticism alters the shape of this concept. It is true that throughout his lifetime his paintings were ridiculed more often than not, but the source and purpose of such remarks must be kept in mind. From the first caricature of the artist and his work in 1870[6] to the offhand and unsympathetic opinions published at the time of his death, the most abusive criticism usually appeared in the popular press as a reflection of the general public response to his art. Such criticism, if indeed it can be called that, frequently repeats the casual exclamations of bewildered spectators to whom Cézanne's pictorial hypotheses were unintelligible principally because they were unfamiliar. No more than the remarks which may be heard today at an exhibition of advanced art need they be taken as serious evaluations of Cézanne's work. Wound him they might and did, but they were powerless to stay the increasingly discriminating understanding of his work. Even if such journalistic scorn outweighed in quantity the more reflective criticism, the latter through its inherent qualities proved in the long run not only superior but decisive.

It is also well to remember that if it was difficult during Cézanne's lifetime to appreciate his work, it was equally difficult to see it. The occasions upon which it was shown to the public were infrequent and usually unpropitious. Until Vollard's three exhibitions in 1895, 1898, and 1899 only twenty-three paintings had been publicly shown, and of those sixteen had been included long before in the third Impressionist exhibition of 1877. From then until 1895 only two works had been seen in Paris, one at the Salon of 1882 and another at the Exposition Universelle of 1889, where they seem to have attracted no attention. Only those few who knew the artist himself, or were aware of the stack of paintings in Père Tanguy's obscure little color shop, could have had any real familiarity with his work. The wonder is less that the first critics were bewildered by Cézanne's innovations than that a few of them were able so early and so sensitively to put into words certain aspects of his work which we still find of lasting value.

The bulk of contemporary criticism, after the first flurries of dismay in 1874 and 1877, occurs only in the decade after 1895, in conjunction with Vollard's exhibitions and the artist's contribution of a total of fifty-three works to the Salons d'Automne of 1904, 1905, and 1906. To these occasions we may add the important posthumous retrospectives in 1907 of seventy-nine watercolors at Bernheim-Jeune's in June and then of fifty-six oils and watercolors at the Salon d'Automne. By 1910, when Bernheim-Jeune held the most ambitious exhibition of all, which contained sixty-eight oils and watercolors, Cézanne was established as a painter whose work could not be ignored, least of all because it had by then been plundered by the Cubists. The first great age of Cézannian criticism was over.

Yet the fact that significant and useful comments were published at all during the barren years between 1877 and 1895 is proof of Cézanne's slow but certain emergence as a painter whose works, difficult to see, and difficult to understand, were of increasing interest to the younger generation of painters as well as to his older companions among the Impressionists. It is true that during the later 1870s he was recognized as a member of the Impressionist group, even by those who objected to his painting. Duret in 1878, Huysmans in 1879 and 1881, and Zola in 1880 mentioned him in connection with the group as a whole, although Zola, who by then had publicly renounced his faith in the new painting, qualified his description of Cézanne as having "the temperament of a great painter" with the remarks that he was "still floundering in his technical research" and "remains closer to Courbet and Delacroix."[7] The conjunction of the last two names with Cézanne's suggests that Zola was indeed out of touch with his friend's most recent work.

More dubious attention was directed to the artist with the publication of two books, Edmond Duranty's collection of short stories *Le Pays des arts* (1881), with its unflattering description in "Le Peintre Louis Martin" of the studio of the painter Maillobert, who was taken to be Cézanne, and Zola's novel *L'Oeuvre* (1886), in which the personality and productions of the tragically unsuccessful hero, Claude Lantier, were believed to combine aspects of the life and work of Cézanne and Manet.[8]

Not until 1877, and then not again until 1888, by which time Cézanne had been painting professionally for twenty-three years, did he receive cordial and considered appraisal. During the course of the third Impressionist exhibition in 1877 a young critic, Georges Rivière, published five issues of a review, *L'Impressionniste*. In the second issue he hailed Cézanne as "a great painter" and declared that "in his works he is a Greek of the great period; his canvases have the calm and heroic serenity of the paintings and terra-cottas of antiquity, and the ignorant who laugh at the *Bathers,* for example, seem to me like barbarians criticizing the Parthenon." This was the first time that Cézanne's "classicism" had been mentioned, in the double sense of monumentality and qualitative distinction.[9] In the same issue Frédéric Cordey, a young painter who was also exhibiting with the Impressionists, commented on Cézanne's *Bathers* in similarly generous terms and declared that "the painter belongs to the race of giants." Such praise, for the time seemingly so extravagant, and, we may think, even so premature, may have hurt the painter quite as much as helped him. In a later *compte rendu,* for the November 1 issue of *L'Artiste* that year, Rivière was requested by the editor not to mention Cézanne.

The second occasion occurred on August 4, 1888, when Huysmans included five paragraphs on Cézanne in an essay, "Trois Peintres: Cézanne, Tissot, Wagner" (reprinted in *Certains,* 1889). Huysmans had been urged to this by Camille Pissarro, who had written in 1883 complaining that in his new collection of essays, *L'Art moderne,* Huysmans had conspicuously neglected Cézanne, "whom all of us recognize as one of the most astounding and curious temperaments of our time and who has had a very great influence on modern art."[10] Huysmans replied that he knew of Cézanne through Zola, agreed that he had a tempera-

ment and was an artist, but felt that his work, "with the exception of some still lifes, . . . [was] not likely to live." And he added that he believed Cézanne suffered from defective eyesight. In 1888 Huysmans repeated the charge that the painter's vision was faulty (*un artiste aux rétines maladives*),[11] but on the whole his few paragraphs were unexpectedly sympathetic, considering that it must have been difficult to locate examples of the artist's work. Yet his verbal equivalents for his experience of the pictures were far more sensitive and contemplative than Rivière's had been eleven years before.

Huysmans began by analyzing a still life with "crude (*brutales*) and worn (*frustes*) pears and apples, roughed in with a trowel and reworked with his thumb," and "angry, rough plastering of vermilion and yellow, green and blue." But in spite of the aggressive technique Huysmans found that in the painting "truths until then overlooked [were] perceived," "the colors [were] strange and real," and in the folds of the white tablecloth he caught a glimpse of those bluish shadows with which Cézanne created the depth and movement of his forms. Huysmans's description of what he thought he saw is almost untranslatable: "variations in the drapery, bound to the shadows spreading from the contours of the fruit and sprinkled with charming bits of blue which make these canvases innovative works" (in comparison with traditional still lifes against dark and unintelligible backgrounds).

The critic found the landscapes and figure studies less to his taste. The former were too tentative, their freshness spoiled by retouching, merely childish (*enfantines*) and barbarous sketches marred by an appalling lack of perspective. The studies of nude bathers were surrounded by tight but illogical (*insanes*) lines, the colors applied with the fury of a Delacroix but with no refinement or technical finesse. Still and all he thought Cézanne was a revealing colorist "who contributed more than Manet to the Impressionist movement," and that "through his exceptionally intense visual perception he had discovered the premonitory symptoms of a new art." In short, the sixteen canvases which Cézanne had exhibited in 1877 may have dismayed the public, but they had also demonstrated the complete integrity of his art. The tone of this brief review was not unreservedly favorable, but at least the negative comments were matched by discriminating references to Cézanne's color, to the rich materiality of his paint surfaces, and to his position as an artist who was leading Impressionism in a new direction.

If artists for their sustenance need art, so it may be true that critics feed best on criticism. Huysmans's account, for all its brevity, contained words and phrases that soon became commonplace in discussions of Cézanne's work, and upon their shifting meanings the future critical structure of his art was to be built. Consider, for instance, the adjectives *brutal* and *fruste* which Huysmans used to describe the apples and pears in the still life. For the first, "coarse" and "rough" must be thought of as well as the literal translation "brutal," but in French the word also conveys some of the animal sense of "brutish," as in the English "brute force." Both words were eventually applied to Cézanne's appearance and personality. In 1894, when the painter was fifty-five, a journalist wrote that he had "an extremely mobile physiognomy [and] a coarse look, almost like a peasant" (Royère, 1906). And only three weeks after the painter's death, an anonymous writer in the *Revue des beaux-arts* "would venture to say that Cézanne had the genius of a brute."

Since *fruste* also means "worn," "rough," "unpolished" (as of old coins), Huysmans's use of the adjectives together seems to mean that although he found Cézanne's fruits vigorously brushed, they were nonetheless crude and coarse, quite different from those in the "usual still lifes" mentioned in his next paragraph.

"Brutal" and the substantive "brutality" were to have long lives as terms of reproach. Cézanne's enemies used the words frequently: his colors were "brutal and discordant" (Mauclair, 1904); his "characteristics of brutality" were to be found among the younger painters (Mauclair, from 1905); the technique of his still lifes was brutal (Marcel Fouquier, 1904); his whole work was "false, brutal, mad" (Le Say, 1904). Even Louis Vauxcelles, who admired him more than others did, could admit that his work contained "inconceivable" (1895) and "incomprehensible brutalities" (1906).

It might seem that such a word admits of no exceptions, or at least that usually it is derogatory, but strangely enough such was not the case. Often, although not always, a word or phrase originally intended as destructive acquires a quite different value once the formal innovation to which it has been applied has been accepted as a necessary component of a new style.[12] Imperceptibly, and usually in association with commendatory adjectives, "brutal" became almost the equivalent of "powerful" or "strong." In 1895 Thadée Natanson thought that an ill-prepared spectator might be tempted to describe Cézanne's "freedom" as brutal, were it not that, because of this very freedom, his images were handsome in the best sense of the word. To describe Cézanne's colors Natanson found such words as "red, green, or blue" too spare; such terms as "muted violet, strident red, and brutal blue" were more helpful in savoring such harmonies. André Fontainas wrote that the Vollard exhibition of 1898 contained a series of oil paintings that were "noble, brutal, and simultaneously delicate." The next year Félicien Fagus wrote of the "impulsive, brutal charm" of the works at Vollard's. In 1905 Antoine de La Rochefoucauld, in his contribution to Charles Morice's "Enquête sur les tendances actuelles des arts plastiques" in the *Mercure de France,*[13] yielded to none in his admiration of Cézanne as "a very great master" and "a painter of pure genius," and remarked that there must be many who could not understand this artist who was "so splendid even in his harshest (*plus âpres*) brutalities." By this time "brutality," through association with the concepts of freedom, unusual color, nobility, delicacy, and innocence, had lost most of its negative force.

This tendency to convert a term of reproach into one of approval is part of the history of Huysmans's second adjective,

"rough" (*fruste*). Although Mauclair found Cézanne's figures "almost shapeless, rough and naïve" (1896), for Natanson the courage to be "rough and, as it were, savage" was an essential quality testifying to his mastery (1895). In 1899 both André Fontainas the Symbolist poet and Georges Lecomte described his portraits as "sober and a bit rough" and "so rough, so severe." With Guérin's statement that his portraits, still lifes, and figure compositions, "of admirable style and solidity," were "always constructed as if by the hands of a rough and conscientious carpenter" (1904) the word had taken on the significance of "simple," "untutored," or "naïve," favorite words which other critics used at first to describe what they disliked and then what they had grown to admire.

In 1891, three years after Huysmans's brief mention, a lengthier and more circumstantial account of Cézanne's art was published by a young painter who was to become for a short while one of the artist's principal protagonists and later, after Cézanne's death, one of his chief detractors. When Emile Bernard wrote his essay on Cézanne for the weekly biographical leaflet *Les Hommes d'aujourd'hui,* he had not yet met him, but through Paul Gauguin he had heard of his character and accomplishments and on his own initiative had seen more actual paintings than had Huysmans. For the first time three distinct stages in the artist's evolution were established: the early Paris period; the *époque claire,* when Cézanne worked within the strict Impressionist formula; and the *époque grave,* which Bernard described as "scarcely more than a return to the first manner, but in terms of developing theories of color and very personal and unexpected insights into the matter of style." For Bernard the second period was unfortunate; Cézanne had been too much influenced by Monet. But the works of the later period justified the painter's search for an art which, new, strange, and unknown as it was, elicited Bernard's most subtle critical response: "balanced highlights pass mysteriously into transparently solid shadows; an architectural gravity presides over the arrangement of lines, sometimes the impastos suggest a sculptural effect." If there is some reminiscence of Huysmans's attempt to verbalize his reaction to Cézanne's subtle interplay of light and color, Bernard's vocabulary nevertheless was that of a painter, not a man of letters. It may occur to us that Gauguin perhaps showed Bernard what to look for in the master's work, since we know how profoundly Gauguin admired Cézanne at the time. Indeed, so long as Gauguin was alive, even though absent from France, Bernard did not waver in his admiration for Cézanne, but after Gauguin's death in 1903 a reaction set in, perceptible in Bernard's long article of 1904, explicit in his review of the Salon d'Automne of 1907, and confirmed by the later articles attacking Cézanne's palette (1920) and philosophy of art (1921). Because Bernard's criticism of Cézanne shows a progressive inability to understand this art, even as it became more comprehensible to his contemporaries, we are perhaps justified in reading Bernard's earliest essay as a reasonably accurate account of Gauguin's

opinion, or at least of the way Cézanne appeared to the members of Gauguin's circle at Pont-Aven with whom Bernard had been in close touch for three years before he published his first article.

Yet Bernard even then had reservations. For him as for Huysmans the paintings were "strange" and the perspective sometimes "askew"; some canvases disturbed the spectator, they were so "harsh, crude, and dry." But the virtues outweighed such faults. The nude figures had the decorative elegance of the sixteenth-century School of Fontainebleau, there was a new strength in this southern landscape, and a serious quality to the still lifes (the words *grave* and *gravité* recur). Certain sketches, the color scheme of one painting, and the artist's originality were characterized as "powerful." These and similar words were on the whole capable of communicating little more than a general admiration for "power," "solidity," and "seriousness." But interspersed among these comments were two conceptions which were close to the aesthetic of Gauguin and Bernard at this period, and which were to have considerable effect upon subsequent criticism. Huysmans before this had mentioned Cézanne's "childish and barbarous sketches" (1888). Since for Bernard Cézanne's sketches were "powerful," the word *enfantin* when applied to Cézanne's landscapes must be read as other than "childish." For Bernard it was just these "childlike landscapes" (*paysages enfantins*) which evoked the idea of "an inspired young shepherd (*un génial enfant pasteur*)—like Giotto." The works which for Huysmans were spoiled by childish incompetence were seen by Bernard as the instinctive response of an innocent, unspoiled artistic disposition. One word served both conceptions, and, with associated words, recurs in much subsequent criticism. For Mauclair (1906) Cézanne's works shared with Redon's the same charms and the same faults: "a childish symbolism and a disarming ingenuousness." Even as late as 1907 André Pératé, while admiring much about Cézanne, thought that his sketches, those remarkable clues to the last great works, were merely "childish." Others wrote that his drawing was like that of a "clumsy child" (Georges Lanoë, 1905), and that the style of his work was "puerile and childish" (Lestrange, 1905). In 1907 one of the characters in a satirical dialogue by Remy de Gourmont described Cézanne as not so much a great painter as an overgrown child, for all that he was "industrious, inquiring, stubborn, and sufficiently intelligent to understand his weaknesses." But these words, too, tended to reverse their implications, and against the readings of "child" and "childish" we may set several of an opposite tenor. In 1899 Fagus asserted that Cézanne was "a child in the presence of nature," that the "impulsive, childish element" in his work was that very "naïveté, that innocence [which is] the supreme effort of learning in perpetual devotion to nature." For the same writer, studying Cézanne's works at the Salon d'Automne of 1905, even his "childish awkwardnesses (*gaucheries*) were fundamentally skillful." Charles Morice, a minor Symbolist writer, disciple of Mallarmé, and a friend of Gauguin, the first edition of whose *Noa-Noa* he edited and amplified for publication in *La Revue*

blanche in 1897, felt that sometimes Cézanne expressed himself with the "simplicity of an inspired and ingenuous child" (1905), and possibly he supplied Mauclair with the combination of two words, *enfant* and *ingénu,* which the latter manipulated in another way the next year in the remark cited above.

Toward the end of his article Bernard discussed in some detail his opinion of a painting he had seen at Dr. Gachet's in Auvers, the *Temptation of St. Anthony,* which he described as having "the most powerful color," adding that "it goes without saying that the drawing is as naïve as possible; only an example of old folk art (*une ancestrale image populaire*) could convey an idea of it." Here in one sentence are two important concepts of later criticism. Bernard was the first, but by no means the last, to insist that Cézanne's art was naïve; indeed the word occurs eighteen times at the least within the next seventeen years. It was used in the most pejorative sense by Mauclair, for whom Cézanne's figures were "rough and naïve" (1896); his "lifeless, gauche, and ugly" works were also "naïve and sincere as usual" (1905); and the painter, even after his death, was neither a genius nor even a great artist, but only "naïve" (1907). On the other hand, this naïveté was seen by others as a virtue. For Alexandre Milnard, Cézanne was a "sensitive painter, quite French in the naïve and sincere way he translates nature" (1895), and Lecomte believed that his nudes had been studied with "such naïve sincerity" (1899). At the retrospective exhibition of 1907 Morice thought the nude subjects "lyrical in their solidity, truth, and naïveté" (1907). Mellerio found in Cézanne a combination of naïveté and refinement (1896). Although in the summer of 1905 François Monod had thought Cézanne's work "completely incomprehensible," he seems to have had a change of heart when he visited the Salon d'Automne a few weeks later: he felt that through his "naïve contemplation" of colors Cézanne awoke "an inexpressible grandeur of construction heretofore slumbering within them." And in the same year Antoine de La Rochefoucauld, whose admiration for Cézanne has already been noticed, felt that no one else possessed the same combination of naïveté and power. But by the end of Cézanne's life, when his naïveté was reckoned one of the sources of his strength, Bernard had come to doubt the very quality he had been the first to name.[14] At the retrospective exhibition of 1907 his suspicions were confirmed, and in his review of the Salon d'Automne he expressed his hesitations concerning the later paintings. In the colors he detected "a note more decorative than true," and in the stylized outlines "a willfully simple and often naïve form." The distortions he had admired in the *Temptation of St. Anthony* were now seen as involuntary deformities; Cézanne had "exalted intentions" but he failed naïvely. He had no knowledge of anatomy, "working naïvely and inserting illogical elements in the texture of his patient and logical brushwork." Although the word does not occur in Bernard's later "Conversation avec Cézanne" (1921), the patronizing tone with which he parried the master's remarks by his own insistence on the validity of an idealist attitude toward nature leaves no doubt that the errors into which he believed Cézanne had led modern painting were due to the fundamental naïveté of his personality.

Bernard's statement that "only an example of old folk art" could suggest the "naïveté" of Cézanne's drawing introduced another important and difficult concept, that of the artist's supposedly "primitive" qualities. In Bernard's article the word appears twice, to describe the hedges in his "childlike" landscapes, and again in connection with a portrait of Mme Cézanne in a green and black striped dress, which Bernard admired as "essentially hieratic, and of a linear purity like that of the pure primitive masters." Perhaps again Gauguin was guiding the younger painter's eye, for Gauguin himself admired the Breton landscape and way of life and by 1891 had already incorporated in his own work aspects of "primitive" and "old folk art." Bernard may also have been thinking of the earlier European pictorial tradition, of the masters of the thirteenth and fourteenth centuries so often referred to at this time as "primitives."[15] Only a few paragraphs earlier, in his reference to the "charming childishness" of certain works, he had characterized Cézanne as an "inspired young shepherd—like Giotto." In this sense the word was taken over by Gustave Geffroy, who described Cézanne's frequent inability to "overcome his difficulties" as somewhat resembling, but without any method, the "pathetic (*touchant*) research of the primitives" (1894), and he characterized Cézanne as "a scrupulous observer, as anxious for the truth as a primitive" (1895). This idea was enlarged by Lecomte, who insisted that none of Cézanne's awkwardnesses was deliberate: "as an instinctive [painter] who depends entirely on himself he encounters the same difficulties as the primitives" and has "the clumsiness and faults of a true primitive" (1899). In 1905 Lanoë felt that Cézanne had scarcely any talent yet deserved to be studied more than any other Impressionist "because he is a kind of primitive of a new art, not a Giotto but a Cimabue." For Monod, who found much to admire although he could not approve of the work as a whole, Cézanne was "a belated primitive" (1905); for Charles Camoin, who had come to know him while doing his military service at Aix in 1904, Cézanne was "the primitive of open-air painting" (1905); and Morice found the watercolors in an exhibition at Vollard's in 1905 "stamped with that primitive, new quality" of personal vision. A more specifically primitive quality had been suggested earlier by Milnard, who stated that although Cézanne had not yet achieved proper recognition, he had already produced several masterpieces, and that in his opinion the painter was "the most direct and only pupil of the Gothic masters" (1895). The same concept appears in the contention that Cézanne's vision "is uncomplicated like that of the early sculptors" (Solrac, 1904). In 1904 Bernard returned to the comparison with Giotto: "the very nature of Cézanne's style" was distinguished by "a quality of candor and a quite Giottesque grace."

So far we have considered only the favorable uses of the word "primitive" and its various interpretations, but it too could be used in a derogatory sense. Mauclair could always twist any

expression to belittle Cézanne, as he did when he insisted that the landscapes were at the least to be valued for "the sturdy simplicity of vision," that they were "almost painting in the primitive manner," and that they were admired by the younger Impressionists because of the absence in them of any skill (1904). Indeed, Mauclair concluded, Cézanne reminded him more of "an old Gothic craftsman" than of a "modern [artist]." On the whole, however, Cézanne's "primitive" qualities were usually counted to his credit. In 1895 Geffroy, in an enthusiastic review of Vollard's first exhibition, described him as "a scrupulous observer, like a primitive, apprehensive of the truth." Twelve years later Charles Morice, in his memorial tribute, wrote that he "was aware of everything, and he was innocently aware because he had the soul of a primitive, because he had gone to nature as one goes to the universal principle of life" (1907). But Bernard was to have the last of the word. In his disillusioned examination of the paintings at the Salon d'Automne, published late in 1907, he accused Cézanne of having, through his analysis of color, come to a kind of abstraction from which he could not emerge "because he destroyed planes and only with great difficulty achieved the contours of objects. Thus he ended, without so wishing, in the effects of the primitives who no more than he knew how to distribute gradations from dark to light."

Earlier, in 1891, Bernard had introduced a concept which above all others was to prove helpful for the ultimate resolution of the critical difficulties presented by this new mode of painting. Here again one senses the influence of Gauguin, especially with reference to a kind of painting in which pictorial rather than literary or anecdotal qualities would be paramount. To define Cézanne's style or tone Bernard proposed the following formula: "As a painter, before everything else he is a thinker, and a serious one at that; he opens for art this astonishing portal: painting for itself alone." In those four words, *la peinture pour elle-même*, Bernard stated a point identical with that pronounced by Maurice Denis only the year before when he defined a painting as "essentially a flat surface covered with colors arranged in a certain order" (1890). Although this concept of "pure painting" would eventually be used to justify abstract experimentation in the twentieth century, it was of help through the 1890s for the analysis of Cézanne's innovations. If the critic could convince the spectator that the purely pictorial values were of primary importance, the latter's attention might then be diverted from the distortions, the exaggerated perspective, or the artist's disregard for subject matter.

After Bernard's statement of the essentially pictorial character of Cézanne's art, no other critic referred to the matter until 1895, when Thadée Natanson invoked the concept twice. In comparing Cézanne's still lifes with the customary academic article designed to whet the appetite of the gourmand and sensualist, he remarked that what academic painting lacked was "the essential, impenetrable, and most precious [element] . . . everything left over, which is nothing but painting." And he described Cézanne's work as "nothing but painting . . . which

can only please those who love painting." The next year Cézanne and van Gogh were both described as "primarily *painters* in the full sense of the word" (Mellerio).

In his review of the Salon des Indépendants of 1899, to which Cézanne had been persuaded to send three paintings, Fagus returned to the theme. He characterized Cézanne as a painter's painter (the still life as a subject was both "a nightmare and delight to the *painter as painter*"), and he insisted that in contrast to literary or narrative painting it was "necessary to *paint*" (1899). Bernard in 1904 was more specific about the method by which Cézanne arrived at "pure painting." After describing the artist's slow and meticulous study of the motif he concluded: "thus the artist works; the more his work becomes distinguished from the motif, the more he withdraws from the density of the model which serves him as a point of departure, the more he approaches pure painting (*la peinture nue*), with no other end than itself." The same thought was echoed by other critics: "the objects in a painting acquire significance only through the exaltation of pure painting which has no other end than itself" (Solrac, 1904). For those who have no feeling for color or composition, considered apart from the subject, Cézanne's "pure painting" will have no attraction (Pierre Hepp, 1905). In 1905 Morice twice described Cézanne as "exclusively a painter, admirable and uneven," and later enlarged upon this aspect; for Cézanne "painting existed in and for itself, [it was] painting uninterested in and unacquainted with poetry or music, even with sculpture and architecture, painting alien to the movements of life, painting as an end in itself, constrained to tell us how the two clearest eyes in the world perceived relations between colored objects" (1907).

Soon after the publication of Bernard's article of 1891 two other critics emerged who were to have much to say about Cézanne and who also added significant terms to the growing body of critical opinion. In 1892 Georges Lecomte devoted a paragraph to the artist in his study of Paul Durand-Ruel's private collection of Impressionist paintings. Cézanne was not well represented in this group, but Lecomte, in a few lines, communicated his own enthusiasm for the painter. He found him noble, even in the treatment of the most banal subjects, mentioned the beauty of his color, and praised the truth of his still lifes and the logic and order of the landscapes. More than that, he was the first to mention Cézanne's "sincerity," which he admired even in certain landscape studies which he considered inferior to the artist's best work. "Sincere" may seem too simple a term with which to characterize Cézanne's deliberate performance, but it was helpful to many critics anxious to combat the popular assumption that Cézanne was a charlatan painting with tongue in cheek. We read elsewhere that Cézanne is "entirely French in the naïve and sincere way he translates nature" (Milnard, 1895) and that his painting is "absolute and sincere" (Fontainas, 1898). For Lecomte somewhat later, "the awkwardnesses demonstrate the splendid sincerity of the painter," "no other is more

redolent of sincerity, freedom, and passion," and "the nudes are studied with such naïve sincerity" (1899). Even those who disliked his work acknowledged this quality. Mauclair at the Salon d'Automne of 1905 found his contributions gauche and ugly but as "naïve and sincere as usual," and felt that the younger painters were imitating his characteristics but without "the sufficiently solid qualities and unmistakable sincerity of this artist who has no gifts." Two contributors to Morice's "Enquête" of 1905 mentioned this aspect. Henri Hamm was struck by Cézanne's "unmistakable sincerity" but astonished by his clumsiness (*gaucherie*). Gaston Prunier felt that Cézanne was a splendid example of "the return to inward sincerity" (a quality he remarked in Whistler, Gauguin, and Fantin-Latour), and "imposed upon his contemporaries a concern for his own ideal solely by the expansive power of his inward sincerity. He proves what an artist can do who is truly inspired by love of art."

Lecomte, in his paragraph of 1892, referred to Cézanne as "wonderfully instinctive." The phrase must have meant much to him, for in his lengthy article of 1899 in the *Revue d'art,* which was twice reprinted and thus must have reached as considerable a public, both in France and Belgium, as any previous criticism of Cézanne, he referred in the first sentence to "this enigmatic, solitary, nomadic painter, so superbly instinctive." And he used the word four times in all in the same essay. But the term did not gain general currency and appeared again only in 1905, when two contributors to Morice's "Enquête" wrote of Cézanne as "marvelously instinctive" (Alcide Le Beau) and "admirably instinctive" (Pierre Girieud), while another mentioned his "instinctive synthesis" (René Prinet). Although rarely used, it is an important term when taken in relation to others. Gustave Geffroy, also in 1905, coupled it with "ingenuous" when he declared that Cézanne, "who is so tormented and restless, so ingenuous in the presence of nature and art, is at one and the same time instinctive and meditative." A decade earlier, in 1895, Geffroy had described Cézanne's work as "harsh but charming, erudite yet ingenuous." In 1896 Mellerio mentioned the combination of eagerness "with ingenuousness carried to the point of awkwardness" with which Cézanne approached the study of nature. In his review of the Salon d'Automne of 1905, Morice wrote that Cézanne was "an admirable [but] unequal painter . . . at times confined by a difficult cryptic technique (*dans une cryptographie d'une technique difficile*), at others expressing himself with the simplicity of an inspired, ingenuous child." The "ingenuous art of a Cézanne" was a term of contempt for Lestrange (1905), and the phrase "naïve ingenuousness" was used to describe Cézanne's early wall paintings at the Jas de Bouffan which he had signed "Ingres" (Pératé, 1907).

"Instinctive," "ingenuous," "naïve," "sincere," and "childlike" taken together are words which characterize the "primitive" artist, and in such terms Cézanne was interpreted by those who were favorably disposed to his art. But primitivism has negative implications. It could also mean "incomplete," "unfinished," "awkward," or even "impotent" in the sense of being artistically incapable of "realizing" (a favorite word of Cézanne's) one's artistic intentions. Gustave Geffroy, who was always favorably disposed toward Cézanne, even after the painter abruptly terminated the sittings for his portrait, published his lengthiest criticism on him in 1894 in a chapter of his *Histoire de l'impressionnisme,* the first extensive study of the theories and events of Impressionism within an historical context. Geffroy's description of the painter as obstinate, eager, driven by a furious need to work, laboring for long periods of time to possess the motif by visual means and to record as completely as possible his "sensation" of nature, was based upon personal acquaintance with the artist as well as upon conversations with his friends. (It endures substantially to the present as our conception of Cézanne as man and painter.) Although he admired Cézanne's work as much as had any previous critic, Geffroy was not blind to the occasions when the artist "had not realized with the power he wished" the conception of nature that obsessed him. In analyzing such occasional departures from the finest work Geffroy introduced words that were soon adopted by those less persuaded of Cézanne's greatness. One of these words was "incomplete," which Geffroy used in the sense that Cézanne had not always been able to overcome the obstacles to realization. And he found that sometimes the "forms were clumsy." "Incomplete" quickly became a favorite term of rebuke; the next year Natanson remarked that although Cézanne had important friends and was admired by masters, "even the best among his supporters never conclude a panegyric without reservations. Almost everyone settles on the word 'incomplete.'" Natanson himself rejected the accusation as hypocritical; for him "complete" was synonymous with "profitable" as a word with which to whet the curiosity of dealers and speculative collectors. But the damage had been done, and the word appeared frequently thereafter. It was given currency by Thiébault-Sisson, a friend of Zola, who wrote that Cézanne was "too incomplete . . . to realize what he had been the first to see" (1895). For the same critic Cézanne in 1904 was still "quite an incomplete [painter] who had for a long time been rendered incapable by a visual infirmity of seeing straight lines other than askew." And in 1906 the accusation was repeated in reviews of the Salon d'Automne.

Cézanne was more often charged with being "clumsy" or "awkward" (*gauche*). Even those who admired him could not deny this aspect of his work. Geffroy urged his readers to seek out Cézanne's beauty and grace and not be put off by "any clumsiness, by any fault in perspective or proportion, or any unfinished part [of the work]" (1895). Lecomte, although acknowledging that there had been awkwardnesses and naïveté in the earlier work, felt that "even these awkwardnesses have their flavor," and that "certainly none of this clumsiness was willful" (1899). Louis Vauxcelles, in a highly laudatory review, pointed out as many faults as any of the derogatory critics, including "inconceivable brutality and clumsiness," yet he inquired, "Are not some failures as heroic, as worthy of pride, as [some] victories?" (1905). But the word had arrived and was not to be

dislodged; for every critic who declared that awkwardness did not spoil the quality of Cézanne's painting there was one who condemned the work because of it.

Nor were these the only accusations. Thiébault-Sisson in 1895 had written that Cézanne was not only incomplete but "impotent" (*impuissant*) as a critic of his own work, and Lecomte felt that his "spontaneous art was often impotent" (1899). Mauclair added to the "total lack of imagination and taste, the inability to create a figure or a composition" (1907); Rouart deplored the fact that "invaluable qualities were combined with an unhealthy impotence [and] childish clumsiness (*maladresse*)" (1907). Bernard in 1907 felt that in attempting to translate gradations of value into transitions of color Cézanne had created that very impotence "from which he suffered"; "the impotence of his planes" resulted from his color theories.

If Cézanne was to be considered a primitive, then logically he had to be thought of as preceding some later development, as one, so to speak, who initiates a movement. Huysmans had sensed this as early as 1881 when he mentioned "this courageous artist who has been one of the originators (*promoteurs*)" of Impressionism. In 1888 he described the unexpected color developments of Cézanne's still lifes as "initiatory." Both Huysmans and Bernard included references to a new art, but the final discovery of a word to confirm this aspect of Cézanne's work was Geffroy's. In 1893, in a general discussion of Impressionism, he referred briefly to Cézanne as "a sort of precursor of another [kind] of art." In 1894 he described Cézanne as "an original nature" distinct from the other Impressionists, stated that he had set out on "a new path," and that whatever might happen "Cézanne will have been a guide (*indicateur*)." In the same article he declared that Cézanne "had become a kind of precursor claimed by the Symbolists." After that scarcely a year passed without some reference to the prophetic or preliminary character of Cézanne's work. He was "the initiator of the whole revolutionary school" (Anonymous, 1895); for Natanson a precursor as well as initiator (1895); and the younger generation was said to consider Cézanne and van Gogh as "precursors in spite of all their incompleteness" (Mellerio, 1896). By 1904 Thiébault-Sisson came to believe that in spite of all his "incompleteness" Cézanne was "a great artist and the precursor who has revealed to many the way to understand a landscape, the means . . . by which to establish form through the relation of volumes." In 1905 he was "a master because he is a beginning" (Hepp), and, with van Gogh and Gauguin, one of the "three great precursors" (Ouvré). In this sequence we can see how, at the end of his life, Cézanne's "primitive" qualities had gradually been integrated into the concept of an original genius who announces the art of the future. In this sense Morice, in 1905, writing of his watercolors, could couple the adjectives "primitive" and "new" to describe the particular quality of "those admirable designs."

If "simplicity," "naïveté," and "ingenuousness" are related to primitivism, and so to those aspects of late nineteenth-century painting most fully exemplified in the work of Gauguin, whose opinions, as we have seen, may have helped Bernard to formulate his first and most influential comments, Cézanne's work must then have been seen by these critics in terms of the Symbolist art and aesthetic of the 1890s. Although the words "Symbolism" and "symbolic" do not occur often, they are nevertheless important. Albert Aurier, the poet and editor, was the first to specify this relationship. In 1892, in his study of the Symbolist painters, he felt obliged to include some mention of the Impressionists and Neo-Impressionists, of Manet, Degas, Cézanne, and others, because of "their attempts at an expressive synthesis." In 1894 Geffroy described Cézanne as "a sort of precursor whom the Symbolists have claimed, and it is quite certain, to stick to the facts, that there is a direct relation, a clearly established sequence, between Cézanne's painting and that of Gauguin, Emile Bernard, etc." He added that "Cézanne has had the same theoretical and synthetic preoccupations as the Symbolist artists." In 1899 Lecomte pointed out that the apparent lack of depth in Cézanne's landscapes had been admired in "the great days of mystic Symbolism" (which he believed were now over). Maurice Denis, in 1907, was still more specific about the Symbolist element. He quoted Cézanne's statement that the sun could not be "*reproduced* but only *represented* by something else . . . by color," and added that such was the "definition of Symbolism as we understood it about 1890." The same year Morice stated that no one had suggested more clearly than Cézanne "the absolute necessity at the present time for a new Symbolism. He indicated where this Symbolism must be sought, and that it was not in science but in the interpretation of nature according to its own laws" (1907). Morice was mistaken, for although modern painting found a new system of symbolic values, it was almost completely to reject the claims of visible nature as a source of such symbolism. But Morice, as a member of the generation of Symbolist poets and painters, could scarcely fail to read Cézanne's work as a symbolic system in itself.

This contemporary interest in Cézanne's work as a Symbolist expression accounts for another word, "synthesis" (and "synthetic"), with its obvious overtones recalling Gauguin's brief participation in the exhibition of the "Impressionist and Synthetist Group" at the Exposition Universelle of 1889. Three years later Georges Lecomte wrote of Cézanne's "synthesis and simplifications of color, so surprising in a painter particularly concerned with reality and analysis." Others mentioned "this painting which is so free as a synthesis of colors and forms in their intrinsic beauty" (Mellerio, 1896); his "impressive and vital synthesis" (Bernard, 1904); the Provençal landscapes, "so synthetic and so true" (Guérin, 1904); and "the broad synthesis [of his work]" (Solrac, 1904). Finally, in 1907, Morice described in more specific terms his understanding of this aspect. Cézanne, he said, "went to nature, but in order to conquer it he was not content with an analytical procedure which separated him from it; he wanted the synthesis which would allow him *to add* the pleasures of the imagination to those of vision; to the splendors,

of which the least corner of nature is an infinite reservoir, the decorative sense whose secret is in a man's thought. This synthesis, Cézanne *literally adds* to the analysis. He wants to possess nature first of all, just as it is, as he sees it, to set it down with scrupulous fidelity upon his canvas, with reverent obedience." And he concluded, as we have seen, that Cézanne had been the first to call for a new symbolism.

Morice's mention of Cézanne's "decorative sense" is also of interest in the context of Symbolist criticism. The word decorative makes a late appearance. In 1904 Bernard wrote that Cézanne's "absolute submission to nature" was followed by "the elevation of form toward a decorative conception." Solrac, also in 1904, described the "essentially pictorial qualities enriched not only by the discoveries of Impressionism but also by a marvelous understanding of decorative style," and twice mentioned his "decorative ideal." In the same year Thiébault-Sisson called attention to "the superb decorative feeling" of a large still life at the Salon d'Automne. Although by 1907 the term had come to imply an element of weakness in composition or color (Bernard thought Cézanne's colors struck "a note more decorative than true"), its use with reference to Symbolist and Synthetist concepts suggests that the critics who studied Cézanne's works in the later years of his life saw elements different from those which seven decades of Cubist and nonobjective criticism have accustomed us to see. Indeed, our preoccupations with the "architectonic" aspects of Cézanne's art find only infrequent precedents in this contemporary criticism. Bernard had mentioned "architectural gravity" (1891); much later a reviewer thought his portraits "structural (*construits*) and authoritative in the simplicity of their presentation" (François Charles, 1902); the still lifes were described as "constructed by the hands of a carpenter" (Guérin, 1904); and there are references to the "grandeur of construction" slumbering beneath a "horrible rusticity" (Monod, 1905) and to the "qualities both architectural and pictorial [with which] Cézanne's brushstroke constructs landscapes and still lifes like buildings" (Francis Lepesueur, 1906).

We may consider such observations prophetic, but their rarity alone should persuade us that Cézanne's paintings were not usually seen in architectural terms by his contemporaries. If we would understand his works as they appeared at that time we must not read into them what Picasso made out of them, but rather what such a painter as Matisse found there. We know that as early as 1899 he had purchased a small composition of *Bathers* from Vollard, that he kept the painting for thirty-seven years, and that when he presented it to the city of Paris he wrote the authorities that it had never ceased to fascinate him, and that he felt he had not yet seen in it all that was there.[16] The testimony of an artist so dedicated to the "decorative ideal" should convince us that in the later 1890s and first years of this century the decorative rather than the architectural aspects of Cézanne's work were considered paramount and new. To these observations we might add the evidence of decorative vision in the lithograph, after a still life by Cézanne, which Matisse contrib-

uted to the volume of essays, by Octave Mirbeau and others, with reproductions after Cézanne's work, published by Bernheim-Jeune in 1914. Not only is Matisse's print an evocative instance of his ability to see within Cézanne's fundamentally descriptive composition of leaves and apples a decorative design of great linear subtlety, but the impression of a specifically Symbolist interpretation of Cézanne is reinforced by the fact that the other original graphic works in this volume were lithographs after Cézanne by artists more closely related to the Symbolist movement, such as Denis and K.-X. Roussel. Only a few years would elapse before it might seem more appropriate to have such a volume illustrated by Picasso, Braque, and Léger.

NOTES

1. Clive Bell's famous statement, fundamental for the next half-century of formalist criticism, occurs early in his first book, *Art* (London: Chatto & Windus, 1914; the preface is dated November 1913), p. 8: "What quality is common to Sta. Sophia and the windows at Chartres, Mexican sculpture, a Persian bowl, Chinese carpets, Giotto's frescoes at Padua, and the masterpieces of Poussin, Piero della Francesca, and Cézanne? Only one answer seems possible—significant form." Bell's list of intrinsically aesthetic works of art is as interesting for its omissions as it is symptomatic of early twentieth-century taste in its inclusions.

Fry's concern with "plasticity," by which he seems to have meant the intellectual "organization of forms and the ordering of the volumes" (*Cézanne*, 1927, p. 47), first appeared in a brief statement on "Plastic Design," published in *The Nation* 9 (London, 1911): 396. Six years before, in his contribution to Charles Morice's "Enquête" in the *Mercure de France* 57 (1905): 544 (see Bibliography, below, under Morice for the complete reference), Paul Sérusier had written that Cézanne used "purely plastic means" (*moyens purement plastiques*) to create, or rather rediscover, a universal language. In 1917, in his review of Ambroise Vollard's *Cézanne* (Paris: Galerie A. Vollard, 1914), which appeared in *Burlington Magazine* 31 (1917): 52-60, reprinted in *Vision and Design* (London: Chatto & Windus, 1920), Fry wrote that Cézanne was "always plastic before he was linear," of a painting of bathers that it was "rather by the exact placing of plastic units than by continuous silhouette that the design holds," and of the portrait of Mme Cézanne in a conservatory that "the plasticity is all-important . . . all is reduced to the purest terms of structural design." Fry's ideas were expanded in the essay "Plastic Colour," undated but either written or revised in 1926 and published that year in *Transformations: Critical and Speculative Essays on Art* (London: Chatto & Windus, 1926), pp. 213-24. The words "plastic" and "plasticity" occur nineteen times, at least, in his influential *Cézanne: A Study of His Development* (London: L. & V. Woolf, 1927), originally published in a shorter version in *L'Amour de l'art* (Paris, December 1926) as a commentary on the Pellerin collection. Despite Fry's formalistic bias ("Cézanne was always more plastic than psychological"), his analyses of the Pellerin masterpieces are still important critical statements.

2. Fry's formalist aesthetics, which dominated discussion of Cézanne between the wars, culminated in a close examination of the structural organization of his paintings, bolstered by comparisons of photographs of the landscape sites, by Erle Loran in *Cézanne's Composition* (Berkeley and Los Angeles: University of California Press, 1943). By then the revision of formalist criticism, in the direction of more searching studies of the perceptual-psychological and psychic-psychoanalytical bases of Cézanne's method, had begun with the publication of Fritz Novotny's dense *Cézanne und das Ende der wissenschaftliche Perspektive* (Vienna: Anton Schroll, 1938), which demonstrated that Cézanne's

"distorted" perspective was perceptually plausible. Subsequently the superficiality of purely formalistic criticism was exposed by Meyer Schapiro in *Cézanne* (New York: Abrams, 1952), where he indicated the psychoanalytical content of the artist's subjects, a theme further developed in his essay "The Apples of Cézanne: An Essay on the Meaning of Still Life," *The Avant-Garde,* Art News Annual 34 (1968): 34-53. Theodore Reff has identified the psychic tensions in additional subjects in his articles "Cézanne, Flaubert, St. Anthony, and the Queen of Sheba," *Art Bulletin* 44 (1962): 113-25, and "Cézanne's Bather with Outstretched Arms," *Gazette des beaux-arts* 59 (1962): 173-90. Finally, the philosophical implications of Cézanne's work have been interpreted in terms of Existentialist and Gestalt theories by Maurice Merleau-Ponty in the chapter "Le Doute de Cézanne," *Sens et non-sens* (Paris, 1948; English translation by H. L. and P. A. Dreyfus in *Sense and Non-sense* [Evanston, Ill.: Northwestern University Press, 1964]). On a more modest scale the present writer undertook to trace the possible parallels between Cézanne's paintings as images of nature seen through the course of time and Bergson's contemporary conception of reality as durational consciousness in "Cézanne, Bergson, and the Image of Time," *College Art Journal* 16 (Fall 1956): 2-12.

3. The selection of critical excerpts in this essay, although incomplete, is not random. Aware that little is less interesting than criticism grown stale, I have tried to balance the thoughtless journalists against the thoughtful men of letters, most of whom belonged to the Symbolist generation of the 1890s, in order to isolate the key words and phrases in early criticism and thus trace their often curious metamorphosis from blame to praise within Cézanne's lifetime.

4. For both writers see G. H. Hamilton, *Manet and His Critics* (New Haven: Yale University Press, 1954).

5. In this connection see also the interesting example of Philippe Burty, "Exposition des impressionnistes," *La République française,* April 25, 1877, quoted in Lionello Venturi, *Les Archives de l'impressionnisme* (Paris: Durand-Ruel, 1939), 2:292.

6. Stock's caricature, showing Cézanne carrying away his portrait of Achille Emperaire (Paris, Musée de l'Impressionnisme) and a large, apparently lost nude vaguely parodying Manet's *Olympia.* Long forgotten, it was republished by John Rewald in *Arts* (Paris, July 21-7, 1954) and is reproduced in the same author's *History of Impressionism* (New York: Museum of Modern Art, 4th ed., 1973), p. 246.

7. To avoid peppering the pages with footnotes, the sources for the quotations are given in the Bibliography (below) arranged alphabetically by author, and chronologically under the author's entry if there is more than one publication by the same person.

8. The relevant passages in Duranty's *Le Pays des arts* have been reprinted in English translation by John Rewald in *Paul Cézanne: A Biography* (New York: Simon & Schuster, 1948), pp. 127-29. For the controversial identification of Cézanne with Claude Lantier, see R. J. Niess, *Zola, Cézanne, and Manet: A Study of "L'Oeuvre"* (Ann Arbor: University of Michigan Press, 1968), chaps. 4-5. Zola's wavering allegiance to the Impressionists and his disappointment in Cézanne's work are documented in F. W. J. Hemmings and R. J. Niess, *Emile Zola: Salons* (Geneva: Droz; Paris: Minard; 1959). Regardless of the distortions of Cézanne's personality in the character of Claude Lantier, Zola introduced two words in his description of Lantier's work which soon entered Cézannian criticism: *brutal* and *impuissant.* In chapter 9, for instance, Lantier's two years of heroic work on his large painting destined for the Salon have ended only in "a masterly" but chaotic sketch, because of his "helplessness" (*impuissance*). Six pages later Lantier's mistress Christine is described as loathing "this free, superb, and brutal art" (*L'Oeuvre,* Paris: Charpentier, 1886, pp. 311, 317).

9. For excerpts from *L'Impressionniste,* see Venturi, *Les Archives de l'impressionnisme* 2: 305-29. Classic art was somewhat of a touchstone for the qualitative evaluation of nonacademic painting in the later nineteenth century. Théodore Duret in his *Courbet* (Paris: Bernheim-Jeune, 1918), p. 32, describes meeting Mary Cassatt in the Louvre in front of *L'Enterrement à Ornans.* Miss Cassatt exclaimed, "C'est grec!" while Duret was reminded of the late fourth-century B.C. sarcophagus of the Weeping Women in Constantinople. In 1888 Georges Seurat told Gustave Kahn that in *Un Dimanche d'été à l'île de la Grande Jatte*

(Art Institute of Chicago) he had wanted to show modern figures moving as in the Panathenaic frieze (John Rewald, *Post-Impressionism: From Van Gogh to Gauguin,* New York: Museum of Modern Art, 1956, p. 141).

10. Although Huysmans's syntax is somewhat ambiguous, he does seem to have referred to Cézanne in his review of the Impressionist exhibition of 1881 as *ce courageux artiste qui aura été l'un des promoteurs de cette formule* [Impressionism] (*L'Art moderne,* Paris: Plon-Nourrit, 1883, p. 235). For the exchange of letters between Huysmans and Pissarro see Rewald, *History of Impressionism,* pp. 474-75.

11. Huysmans wrote to Pissarro (May 1883) that Cézanne "is certainly an eye case, which I understand he himself realizes." The recurrent belief that the Impressionists in general and Cézanne in particular, because of his radical restructuring of conventional perspectival perception, suffered from optical ailments may perhaps be traced to Huysmans's extended and ill-tempered attack in his review of the Impressionist exhibition in 1880, reprinted in *L'Art moderne,* pp. 89-90.

12. I am indebted to the late Professor Alexander Witherspoon of Yale University for having shown me, many years ago, how this process works in English. To take a commonplace example, the colloquial expression "to die with one's boots on" originally had no heroic connotations. It meant that, rather than falling on the field of battle, one had been caught cheating at cards and summarily shot by another player. One had died, consequently, in disgrace, fully clothed, without having had time to expire decently in bed.

13. This "investigation" of contemporary opinion on the state of the arts in 1905 was elicited by Morice's questionnaire, completed by forty-eight artists, critics, and men of letters whose replies were published in the *Mercure de France* 56-57 (August 1–September 15, 1905). The quotations in this essay are from the replies to Question 4: *Quel état faites-vous de Cézanne?* The answers ranged from Kees van Dongen's "Cézanne is the finest painter of his period" to Fernand Piet's "Cézanne? Why Cézanne?"

14. Bernard's misgivings had been expressed as early as 1905, when he remarked in a journal unlikely to be seen by Cézanne: "Were I to be taken for a fossil, nonetheless I would dare declare that in my eyes Cézanne's *Bathers,* where there is neither idea, nor drawing, nor color, does not constitute the last word in painting." (*Le Dauphinois,* October 25, 1905. Quoted by Vollard, *Cézanne,* p. 168.)

15. "Primitive" as a definition of early, principally thirteenth- and fourteenth-century Italian painting seems to have been more current in the English-speaking world than in France. As late as 1875 Larousse's *Grand Dictionnaire universel du XIXᵉ siècle* listed no definition of *primitif, -ive,* applicable to painting or any other art; yet in 1892, according to the *Oxford English Dictionary* (corrected reissue, 8, 1933), the following exclamation appeared in the London *Spectator* on January 30: "O impressionist, do I find you among the primitives?" In more general terms G.-Albert Aurier, in his essay of 1892 on the Symbolist painters, referring to the isolated efforts of Gustave Moreau, Puvis de Chavannes, and the English Pre-Raphaelites to "revindicate the right to dream," wrote of "the excellence of the good and true tradition: that of the Primitives . . . of all schools, master of every epoch where truly traditional art was not yet soiled by the sacrilegious desires of realism or of illusionism" (1893).

16. Alfred H. Barr, Jr., *Matisse: His Art and His Public* (New York: Museum of Modern Art, 1951), p. 40.

BIBLIOGRAPHY

ANON. "Oeuvres de M. Césanne [*sic*]." *L'Art français,* November 23, 1895.

AURIER, G.-Albert. "Les Peintres symbolistes." *Revue encyclopédique,* April 1, 1892. Reprinted in Aurier, *Oeuvres posthumes* (Paris: Mercure de France, 1893), pp. 293-309.

BERNARD, Emile. "Paul Cézanne." *Les Hommes d'aujourd'hui* 8 (1891), no. 387.

———. "Paul Cézanne." *L'Occident* 6 (July 1904): 17-30.

———. "Réflexions à propos d'un Salon d'Automne." *La Rénovation esthétique* 6 (December 1907): 57-68.

———. "La Méthode de Paul Cézanne." *Mercure de France* 138 (March 1, 1920): 289-318.

———. "Une Conversation avec Cézanne." *Mercure de France* 148 (June 1, 1921): 372-97.

CAMOIN, Charles. "Enquête . . ." *Mercure de France* 56 (August 1, 1905): 353. For complete entry see below, Morice.

CHARLES, François. "L'Exposition des Artistes Indépendants." *L'Ermitage* (May, 1902), pp. 397-400.

DENIS, Maurice. "Définition du néo-traditionnisme." *Art et critique* (August 23, 1890). Reprinted in *Théories, 1890-1910* (Paris: Rouart & Watelin, 1920), pp. 1-13.

———. "Cézanne." *L'Occident* 12 (September 1907): 118-33. Reprinted in *Théories* (1920), pp. 245-61.

DURET, Théodore. *Les Peintres impressionnistes.* Paris: Heymann & Perios, 1878. Reprinted in *Critique d'avant-garde* (Paris: Charpentier, 1885).

FAGUS, Félicien. "XVe Exposition des Artistes Indépendants." *La Revue blanche* 20 (September-November 1899): 387-88.

———. "Au Salon d'Automne." *L'Occident* 8 (November 1905): 250-59.

FONTAINAS, André. "Art moderne." *Mercure de France* 26 (June 1898): 890.

———. "Art moderne." *Mercure de France* 32 (December 1899): 816.

FOUQUIER, Marcel. In *Le Journal,* October 14, 1904. Quoted in Ambroise Vollard, *Paul Cézanne* (Paris: Galerie A. Vollard, 1914), p. 159.

GEFFROY, Gustave. "L'Impressionnisme." *La Revue encyclopédique* 3 (December 15, 1893): 1223.

———. "Histoire de l'impressionnisme." *La Vie artistique,* 3rd ser. (1894): 249-60.

———. In *Le Journal,* November 16, 1895. Reprinted in *La Vie artistique,* 6th ser. (1900): 214-20.

———. "Le Salon d'Automne." *Le Journal,* October 17, 1905.

GIRIEUD, Pierre. "Enquête . . ." *Mercure de France* 56 (August 15, 1905): 551.

GOURMONT, Remy de. "Dialogues des amateurs." *Mercure de France* 70 (November 1, 1907): 110-13.

GUÉRIN, Joseph. "Le Salon d'Automne." *L'Ermitage* 3 (December 1904): 309-14.

HAMM, Henri. "Enquête . . ." *Mercure de France* 56 (August 15, 1905): 552.

HEPP, Pierre. "Sur le choix des maîtres." *L'Occident* 8 (December 1905): 263-65.

HUYSMANS, Joris-Karl. "Le Salon de 1879." *L'Art moderne,* (Paris: Plon-Nourrit, 1883), pp. 3-81.

———. "L'Exposition des Indépendants en 1880." *L'Art moderne,* pp. 85-123.

———. "Trois Peintres: Cézanne, Tissot, Wagner." *La Cravache,* August 4, 1888. Reprinted in *Certains* (Paris: Tresse & Stock, 1889), pp. 38-43.

LANOË, Georges. *Histoire de l'école française du paysage depuis Chintreuil jusqu'à 1900.* Nantes: Société Nantaise, 1905, pp. 266-72.

LA ROCHEFOUCAULD, Antoine de. "Enquête . . ." *Mercure de France* 56 (August 15, 1905): 542.

LE BEAU, Alcide. "Enquête . . ." *Mercure de France* 56 (August 1, 1905): 354.

LECOMTE, Georges. *L'Art impressionniste d'après la collection privée de M. Durand-Ruel.* Paris: Typographie Chamerot & Renouard, 1892, pp. 30-31.

———. "Paul Cézanne." *La Revue de l'art,* December 9, 1899: 81-87.

LEPESUEUR, Francis. "De Michel-Ange à Paul Cézanne." *La Rénovation esthétique* 2 (November 1906): 254-60.

———. "Le Salon d'Automne." *La Rénovation esthétique* 4 (1906): 28.

LE SAY. In *L'Univers,* November 14, 1904. Quoted in Ambroise Vollard, *Paul Cézanne,* p. 164.

LESTRANGE. In *Le Tintamarre,* November 5, 1905.

MAUCLAIR, Camille. "Choses d'art." *Mercure de France* 17 (January 1896): 130.

———. *L'Impressionnisme, son histoire, son esthétique, ses maîtres.* Paris: Librairie de l'Art Ancien et Moderne, 1904.

———. "La Crise de la laideur en peinture." *La Revue,* December 15, 1905. Reprinted in *Trois Crises de l'art actuel* (Paris: Fasquelle, 1906).

———. "Le Salon d'Automne." *La Revue bleue* 4 (October 21, 1905): 521-25.

———. "Le Salon d'Automne." *Art et décoration* 20 (November 1906): 141-52.

———. "Le Salon d'Automne." *La Revue bleue* 8 (October 12, 1907): 463-66.

MELLERIO, André. *Le Mouvement idéaliste en peinture.* Paris: Floury, 1896.

———. "L'Art moderne, exposition de Paul Cézanne." *La Revue artistique* (1896).

MILNARD, Alexandre. "L'Art français." *La Rénovation esthétique* 3 (1906). The article is dated 1895.

MIRBEAU, Octave, et al. *Cézanne.* Paris: Bernheim-Jeune, 1914.

MONOD, François. "Enquête," *Mercure de France* 67 (September 1, 1905): 76.

———. "Le Salon d'Automne." *Art et décoration* 18 (December 1905): 198-210.

MORICE, Charles. "Aquarelles de Cézanne." *Mercure de France* 56 (July 1, 1905): 133-34.

———, ed. "Enquête sur les tendances actuelles des arts plastiques." *Mercure de France* 56 (August 1, 1905): 346-59; (August 15, 1905): 538-55; 57 (September 1, 1905): 61-85.

———. "Paul Cézanne." *Mercure de France* 65 (February 15, 1907): 577-79. Reprinted in *Quelques Maîtres modernes* (Paris, 1914), pp. 94-122.

NATANSON, Thadée. "Paul Cézanne." *La Revue blanche* 9 (1895): 496-500. Reprinted in *Claude Monet et Paul Cézanne* (Paris, 1900).

OUVRÉ, A. "Enquête . . ." *Mercure de France* 56 (August 15, 1905): 553.

PÉRATÉ, André. "Le Salon d'Automne." *Gazette des beaux-arts* 38 (1907): 387-90.

PRINET, René-X. "Enquête . . ." *Mercure de France* 57 (1905): 66-67.

PRUNIER, Gaston. "Enquête . . ." *Mercure de France* 56 (August 15, 1905): 351-52.

ROUART, Louis. "Réflexions sur le Salon d'Automne, suivies d'une courte promenade au dit Salon." *L'Occident* 12 (November 1907): 230-41.

ROYÈRE, Jean. "Sur Paul Cézanne." *La Phalange,* November 15, 1906.

SOLRAC. "Réflexions sur le Salon d'Automne." *L'Occident* 6 (December 1904): 303-11.

THIÉBAULT-SISSON, François. In *Le Temps,* December 22, 1895.

———. "Le Salon d'Automne." *Le Petit Temps,* October 14, 1904.

VAUXCELLES, Louis. "Cézanne." *Le Gil Blas,* March 18, 1895.

———. "Le Salon d'Automne." *Le Gil Blas,* October 15, 1906.

ZOLA, Emile. "Le Naturalisme au Salon." *Le Voltaire,* June 18-22, 1880. The reference to Cézanne is reprinted in F. W. J. Hemmings and R. J. Niess, *Emile Zola, Salons* (Geneva: Droz; Paris: Minard; 1959), p. 242.

Cézannisme and
the Beginnings of Cubism

William Rubin

CÉZANNE'S PAINTING WAS INFLUENTIAL only within a very limited circle in the later years of the nineteenth century. His characteristic work was largely unknown; only two Cézannes had been publicly exhibited in Paris during the eighteen years between the third Impressionist exhibition of 1877—roughly the onset of the artist's mature style—and his first one-man show (at Vollard's) in 1895.[1] The latter exhibition, and others at Vollard's in 1898 and 1899, began to establish Cézanne as a painter with whom young artists had to contend; it was around the time of the last of these shows that Matisse bought his *Three Bathers*.[2] By 1900 Cézanne had begun showing a few pictures a year in group exhibitions such as the Salon des Indépendants, where he first showed in 1899 and then again in 1901 and 1902, and the Paris Centennial Exposition of 1900. But widespread knowledge of his work—even in the restricted world of vanguard artists and collectors—came only with the exhibition of larger groups of pictures at the Salon d'Automne of 1904 (thirty paintings, two drawings, plus photographs of at least twenty-seven other works), of 1905 (ten paintings), of 1906 (ten paintings), and of course in the memorial exhibition of fifty-six works at the same Salon in 1907.

Judging by painters' responses to Cézanne's art, the time frame of its greatest direct influence can, I think, be defined as beginning roughly in 1900 with Matisse's great *Male Nude* and ending in 1909 with Léger's earliest Cubist paintings, such as *The Bridge*. Painters who developed their mature styles in this decade—pioneer Fauvists and Cubists such as Matisse, Derain, Picasso, and Braque—experienced Cézanne largely in Cézanne's own terms. Thereafter, Cézanne's influence did not so much wane as become fused with that of artists already deeply affected by him. Thus in viewing the art of Cézanne, Delaunay in 1910–12,[3] Mondrian in 1911–12, and Duchamp in 1911–12 were responding to language already indelibly inflected by its adaptations in the work of Braque and Picasso of the just-preceding years. An instance of what might be called a third wave in this development is provided by Klee insofar as the Cézannism of his pictures of the teens was based upon a reading of the master of Aix conditioned by the experience of Delaunay as well as of Picasso and Braque.

It would take more than an essay to detail the role of Cézanne's painting in the work of all the significant young artists who emerged in the first decade of the century. My aim

here is to focus on the most consequential aspect of that influence—the beginnings of the Cubist style in the crucial sixteen-month period between Picasso's last work on the *Demoiselles d'Avignon* (summer 1907) and the exhibition (in November 1908) of Braque's first full-fledged Cubist pictures. Given the advanced state of art-historical literature and the immense

Henri Matisse. *Male Nude.* 1900. Oil on canvas, 39⅛ x 28⅝ in (99.3 x 72.7 cm). The Museum of Modern Art, New York

Notes to this essay begin on page 195.

(though infrequently particularized) authority already attributed to Cézanne in the unfolding of twentieth-century painting, it may seem almost preposterous to argue that his role at the very inception of Cubism has not yet been sufficiently clarified, or even fully appreciated. Nevertheless, I shall try to show that in this seminal period Cézanne's influence was even more extensive and consequential than has been realized, and that—fleetingly through Derain and, more crucially, through Braque—it led directly along a path as yet inadequately charted to the earliest form of Cubism.

Concentrating on this short but critical segment of the history of modern art from this particular point of view will, I believe, force us to revise some sacrosanct conceptions about the beginnings of Cubism. We shall discover that the sudden reversal of direction popularly supposed to have taken place between Braque's late Fauve pictures and his earliest Cubist efforts is a myth; that Braque had already evolved significantly in the direction of Cubism *before* he met Picasso and that his progression from Fauvist to Cubist owes far less to Picasso—to the *Demoiselles* in particular—than has been supposed. Indeed, we shall be forced to conclude that the *earliest* form of Cubism was less a "joint creation"[4] of Picasso and Braque than an invention of Braque alone, extrapolated from possibilities proposed by Cézanne. The place of Picasso (and thus, necessarily, of primitive art) in this specific development (up to the fall of 1908) will be reexamined, and he will be seen less as a contributor to the formal language of early Cubism than as a model of daring whose radical departures probably inspired the basically conservative Braque to take uncharacteristic chances.

Consistent with this, I shall argue, most of the thrust of Picasso's extraordinary inventiveness from the spring of 1907 until the end of 1908 lay in areas that were not at the center of the formulation of Analytic Cubism or its subsequent elaboration (even as Picasso himself would share in that elaboration). Indeed, it seems to me probable that one of the most crucial steps in the development of Picasso's Cubist style—the full assumption of the modernist possibilities of Cézannian *passage*—came to him only after seeing Braque's L'Estaque paintings of the spring and summer of 1908. This revelation, I believe, influenced him to repaint the famous *Three Women* in the Hermitage. I shall demonstrate that this picture, as we know it today, is a revised version of the original composition.

If there is any validity in applying to art history measuring criteria borrowed from the calendar, then nineteenth-century painting ends and that of the twentieth century begins in the months which separate the early summer of 1907 from that of 1908. In this short period fall the completion of the *Demoiselles,* the confirmation of Matisse's personal, post-Fauve style, and Braque's fashioning of the earliest form of Cubism.[5]

Much of what seems to me distorted in the received history of the inception of Cubism revolves around the role attributed to the *Demoiselles,* a role generalized as primal and pivotal, largely on the basis of the picture's astonishing inventiveness and radicality, but never much spelled out in relation to a definition of Cubism. The earliest references to the *Demoiselles* did not, to be sure, characterize it as a specifically Cubist work. André Salmon, for example, writing five years after the completion of the painting, at the height of the Cubist style, saw the *Demoiselles* as the "first application of [Picasso's] researches" which would "provoke" Cubism[6] (a movement he subsequently identified as having begun about a year later).[7] The first identification of the *Demoiselles* as "the beginning of Cubism" is to be found in Daniel-Henry Kahnweiler's classic *Weg zum Kubismus,* written in 1914 and 1915 but not published until 1920.[8] In 1933 Kahnweiler identified "the birth of Cubism" specifically with Picasso's second period of work on the *Demoiselles,*[9] and subsequently, in 1946, he singled out the "right-hand part" of the picture as the section that "constitutes the beginning of Cubism."[10] The nomination of the *Demoiselles* as the starting point of Cubism was further reinforced by Alfred Barr, who wrote in *Picasso: 40 Years of His Art* (1939) that the *Demoiselles* "may be called the first Cubist picture"—a passage repeated in *Picasso: 50 Years of His Art,* published in 1946.[11] In 1954, Barr set the *Demoiselles* into a symmetrical relationship with the *Three Musicians* in which Cubism was conceived as having begun with the former and culminated with the latter.[12]

The combined authority of Kahnweiler and Barr sufficed to assure that the *Demoiselles* would dominate the history of early Cubism, and indeed almost all popular and scholarly accounts published following World War II identify it as the first Cubist picture. Typical of what was to become a tradition on both sides of the Atlantic are Jean Cassou's characterization in 1960 of the *Demoiselles,* in *Les Sources du XX*e *siècle*—"the first manifestation of Cubism in its first phase"[13]—and Herschel B. Chipp's eight years later, in *Theories of Modern Art:* "marks the beginning of Cubism."[14]

To my knowledge, the first questioning of the position traditionally ascribed to the *Demoiselles* was a passing remark by Victor Crastre in *La Naissance du cubisme,* published in 1948. Crastre, who considered Picasso's Cubism as beginning only with the paintings executed at Horta in 1909, did "not believe" that the *Demoiselles*—which he wrongly dated 1908—"can be called Cubist."[15] By 1960, a number of historians of Cubism had become more circumspect about the *Demoiselles.* During the late fifties, two splendid and very different histories of Cubism were being written by John Golding and Robert Rosenblum. In the latter's incisive *Cubism and 20th Century Art,* which appeared, after publishing delays, in 1960, the *Demoiselles* is described as "crucial for the still more radical liberties of the *mature* years of Cubism,"[16] but the picture is disengaged from the more specific identification that had been favored by Kahnweiler and Barr. Meanwhile Golding's *Cubism*—still unsurpassed as a detailed, scholarly analysis of the movement—had appeared in England. While Golding saw the *Demoiselles* as the "logical point to begin the history of Cubism," he considered it "not strictly speaking, a

Pablo Picasso. *Les Demoiselles d'Avignon.* May–July 1907. Oil on canvas, 8 ft x 7 ft 8 in (243.9 x 233.7 cm)
The Museum of Modern Art, New York, acquired through the Lillie P. Bliss Bequest

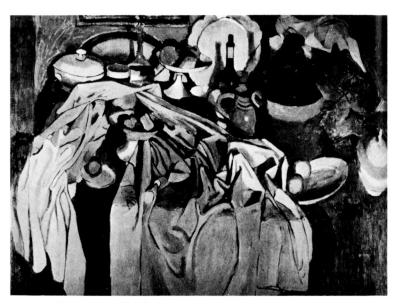

André Derain. *Still Life.* 1904. Oil on canvas,
45¼ x 64½ in (115 x 164 cm). Private collection, Paris

Cubist painting."[17] This more cautious view was summarized by Cooper in *The Cubist Epoch* (1971), where he spoke of the *Demoiselles* as "the logical picture to take as the starting point for Cubism," but characterized it, at the same time, as "not yet Cubist."[18]

One of the results of the tendency to disengage the *Demoiselles* somewhat from its traditional place in the teleology of Cubism has been the encouragement of fresh research, both in relation to the picture's place in Picasso's individual development and in regard to its sources in other art. Thus the last few years have seen important new approaches to the painting by Leo Steinberg and Robert Rosenblum. The former[19] showed how our tendency to view the *Demoiselles* from the Cubist perspective has blinded us to many aspects of the picture's meaning and has significantly deformed our image of Picasso's aims and interests in 1907. Steinberg found that the most important consideration suppressed in prevailing views of the *Demoiselles* is the picture's specific sexual content; Rosenblum's text[20] built upon this aspect of the work and unlocked hitherto unexplored sources of it in Goya, Ingres, Delacroix, and Manet. Now that the new, non-Cubist perspectives on the *Demoiselles* have permitted us to see the picture as a richer, more complex work in itself, they must also, I believe, open the way for us to reevaluate the picture's place in the early history of Cubism.

Most writers who concede that the *Demoiselles* is something less—or, more precisely, something *other*—than "the first Cubist picture" tend to agree that Braque's paintings at L'Estaque in the spring and summer of 1908 are, as Cooper says, the first examples of "Cubism proper."[21] Golding, for instance, characterizes these Braques as "the first group of truly Cubist paintings."[22] Indeed, nothing accomplished by Picasso either in the

Demoiselles itself or in the work of the year following it can lay a claim to being Cubist in the manner of the L'Estaque Braques which, in the fall of 1908, were to be the inspiration for the term Cubism. Cooper is quite right in pointing out that Picasso would only "catch up" with this stage of Braque's accomplishment in the summer of 1909.[23]

Where the accounts of Golding, Cooper, Leymarie, and others who hold this view become vague is in the area of the precise relationship between Braque's "Cubism proper" and the work of Picasso up to that time (the summer of 1908), though all attribute—and here I believe them wrong—a determining role in Braque's development to his having seen the *Demoiselles*. This vagueness is perhaps not surprising insofar as the development of Braque's work from the early autumn of 1907 to the summer of 1908 has remained in many important respects unknown or unpublished.[24] Moreover, the absolute conviction that the *Demoiselles* was the starting point for Cubism has discouraged the exploration of alternative paths of development. Regrettably I can fill only a few of the gaps existing in our knowledge of Braque's work of this period, but sufficient evidence will emerge, I think, to show that, far from finding his way by means of the *Demoiselles,* Braque progressed—following the fixed star of Cézanne—in a determined, independent, and original manner. Precisely by *not* beginning my account of the inception of Cubism with the *Demoiselles,* it will be possible—especially with reference to little-known and unpublished work—to demonstrate a crucial continuity from Cézanne to Cubism via Braque that is presently obscured.

The received history of the early Picasso-Braque relationship characterizes Braque as "a minor Fauve" painter who is dramatically "converted" by his contact with Picasso: In the late autumn of 1907, Braque is taken by Guillaume Apollinaire to Picasso's studio, where he sees the *Demoiselles*. Not surprisingly, he is staggered. ". . . it made [me] feel as if someone were drinking gasoline and spitting fire," Braque is reported as saying.[25] Braque forthwith abandons his Fauve style and, under the influence of the *Demoiselles,* makes the large *Nude* ("a complete about-face," says Leymarie),[26] which starts him along the path to Cubism. "The effect on Braque" of the *Demoiselles,* writes Cooper, "was to make him follow Picasso's lead, from which time the early phase of Cubism became the joint creation of these two artists." Since, moreover, Cooper considers that *Demoiselles* is "not yet Cubist," and the Braques painted roughly six months after the visit to Picasso's studio constitute "Cubism proper," there is an implication that Braque's Cubism was a response to and elaboration of something found in Picasso.[27]

The traditional view regarding the initial results of Braque's contact with Picasso took hold in the *entre deux guerres*. By that time, Picasso had been widely confirmed as a greater and more seminal painter than Braque, a factor that not surprisingly had a retroactive influence on the accounts of their relations. Indeed, Picasso's position became so commanding that Braque's role in Cubism in general might have been largely forgotten but for

Kahnweiler's account of him in *Der Weg zum Kubismus* and the impact of the Kahnweiler and Uhde auction sales of the early twenties, which provided the first opportunity to see prewar Cubism in large quantities.[28] The works in these sales did not, however, throw any light on the specific roles of the two artists in the first years of the movement.[29]

The assumption has therefore remained unaltered that Braque's *Nude* (reproduced below) started him along the new path. I shall try to demonstrate, on the contrary, that Braque's *Nude* was something of a "sport" in the unfolding of his art during this period; that, rather than building upon it, he ultimately set it aside to pursue what had already been established as his personal line of exploration; and that his stylistic development both before and during the work on this picture—right into "Cubism proper"—in no way predicates the intervention of Picasso. Indeed, much that we identify as Cubist (and thus, by extension, Picassoesque) in the *Nude*—the *passage* of planes and the faceted brushstrokes—was taken by Braque from Cézanne, not Picasso, who was not to paint in *that* Cubist manner until more than a year later. To understand all this, however, it is necessary to look back to the winter of 1907–08 and to situate the development of both Braque and Picasso in the context of a conflation of tendencies that came to be called *Cézannisme*.

The year following Cézanne's death on October 22, 1906, saw the two most important exhibitions of his work up to that time: a show of seventy-nine watercolors at the Bernheim-Jeune Gallery from June 17 to 29, 1907, and, more important, the retrospective held as part of the fifth Salon d'Automne, which opened October 1 and closed one year to the day after Cézanne's death. Its catalog listed fifty-six works, most of them oil paintings. (These two exhibitions often are cited incorrectly in the literature[30] as having occurred consecutively—if not simultaneously—possibly because of a confusion with the group show that took place at Bernheim-Jeune from November 14 to 30, entitled "Fleurs et natures mortes," which included six works by Cézanne.) Almost simultaneously, the *Mercure de France* published Cézanne's letters to Emile Bernard, one of which contained the celebrated passage about treating nature "in terms of the cylinder, the sphere, the cone . . . ,"[31] to which curious words we shall return later.

The immense excitement unquestionably generated by the Cézanne retrospective, together with the fact that it took place roughly midway between the painting of the *Demoiselles* and the formulation of the first full-blown Cubist style, has led, I believe, to a tendency to overstress the immediate influence of this particular exhibition. Not that Picasso or Braque—or the other important young vanguardists—failed to learn from or be stimulated by it. But they had known the work of Cézanne quite well before, and the first year of Cubist art was hardly dependent on this exhibition. What was peculiar to the memorial retrospective—apart from its size—was its public presentation, for the first time, of a group of Cézanne's very late works including

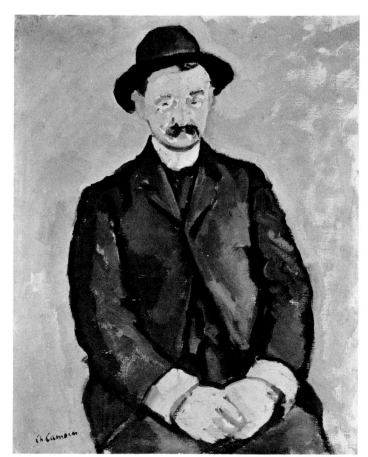

Charles Camoin. *Portrait of Marquet*. 1904. Oil on canvas, 36¼ x 28⅞ in (92.4 x 73.3 cm). Centre National d'Art et de Culture Georges Pompidou, Musée National d'Art Moderne, Paris, gift of Mme Albert Marquet

some highly faceted, very abstract landscapes, and a few nominally unfinished oils, such as the *Still Life with Apples* (pl. 147; Museum of Modern Art), in which Cézanne had left parts of the canvas unpainted.[32] But interest in Cézanne's "non-finito" would not affect the history of Cubism, as we shall see, until about a year later (early 1909), and the full weight of the faceting of Cézanne's late landscapes would not be felt until Cubism entered its "painterly" phase in 1910.

The two most important Fauvist painters, Matisse and Derain, had both demonstrated a significant involvement with Cézanne before the formulation of Fauvism itself. Indeed, the period spanning Matisse's *Male Nude* of 1900 and Derain's *Still Life* of 1904 may be considered the first phase of Cézannism—the more "private" phase, coinciding roughly with the years immediately previous to the first Cézanne exhibition at the Salon d'Automne.[33] While both Matisse and Derain experimented with a variety of contradictory sources during that period, Camoin—whose personal contacts with Cézanne provided a living link between the Fauve group and the master of Aix[34]—was typical of the more imitative young artists who worked consistently and directly from Cézanne's style (as instanced by his *Portrait of Marquet,* 1904). And subsequently,

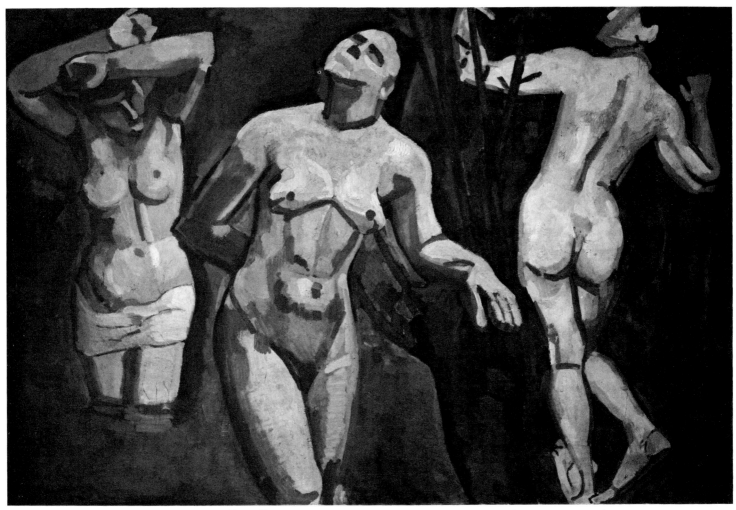

André Derain. *Bathers.* 1907. Oil on canvas, 51¼ x 75¾ in (130.2 x 192.2 cm). Private collection, Switzerland

despite Camoin's nominal identification as a Fauve,[35] he remained apart from his colleagues precisely in maintaining his Cézannesque style during 1905 and 1906, when the others moved into an art more influenced by Neo-Impressionism and Gauguin.

The second phase of Cézannism, which was to prove the springboard for Cubism, began in the winter of 1906–07 (almost a year, it should be noted, before the memorial show), and it was signaled by a profound change in the work of Derain—the painter who "more than any other," Kahnweiler recalled, "communicated to his colleagues, through his paintings and in his words, the lessons of Cézanne."[36] Turning away from the assumptions of Fauvism in the direction of more "sculptural" painting, Derain committed himself to Cézanne more resolutely than he had in the pre-Fauve years. Shortly afterward, Matisse came to grips with sculptural painting once again in his Cézanne-influenced *Blue Nude,* completed early in 1907. It is not by accident that both Matisse's and Derain's major canvases of this period were directly related to the making of sculpture in the round.[37]

Derain's immense importance in 1907 as a bridge between Cézanne and the vanguard painters—a role so central that Apollinaire would five years later (mistakenly, to be sure) identify him as coinventor (with Picasso) of Cubism[38]—has been obscured by a variety of factors, not the least of which is the weakness of his late work, which tended retroactively to diminish interest in all his post-Fauve painting. More critical, however, was Derain's burning in 1908 of almost all his work of the period from autumn 1906 through spring 1907. Not even photographs of these works exist.[39] And the sole survivor of the immolation, the monumental *Bathers* exhibited in the Indépendants of 1907 (saved only because it had been sold), has been buried for over half a century in one of the most private of Swiss private collections.[40] Not publicly exhibited between the Indépendants of 1907 and The Museum of Modern Art's Fauve show of 1976, the *Bathers* was seen privately by few art historians and was, to my knowledge, reproduced only three times, in black and white, during the fifty-nine years in question.[41]

The prestige of Derain was at its height in the spring of 1907, and it takes some effort to remind ourselves that he was then

considered in vanguard circles as more important and more radical an artist than Picasso. The latter was just beginning to paint the *Demoiselles* (on which he would cease work in early summer), but nothing he had done until then could match in daring the Fauve works of Derain. Now, with his *Bathers* at the Indépendants—a picture that for the first time combined a suggestion of primitive art with the influence of Cézanne—Derain seemed to be pointing to a bold new sculptural painting as a resolution to the equivocations of Fauvist style.

It was at the time of the opening of the 1907 Indépendants that Braque—who had been working in a Fauve manner for over a year—met Derain and Matisse. Derain's *Bathers* must have looked very tectonic to Braque next to his own pictures. And, indeed, the Cézannist message of Derain's painting was to make itself progressively felt in Braque's work at La Ciotat, where he went in May, following the Indépendants, and at L'Estaque, where he spent the end of the summer. From spring 1907 until he became very friendly with Picasso in early 1909,[42] he remained in constant touch with Derain, visiting with him frequently even in the Midi. The mistaken accounts of Apollinaire and others, which attribute to Derain a primary role in the creation of Cubism, are partly a matter of confusing Derain's and Braque's Cézannism during those years.

Though the twin interests Derain was "pushing" among his friends in the winter of 1906–07 were Cézanne and African sculpture (which he was among the first to collect), it was the former which clearly dominated the big, bluish *Bathers;* African influences were limited almost entirely to the stylized face of the central figure.[43] For Derain, however, the two, as experience, were linked: what he read as reductive and sculptural in Cézanne unlocked in him, as it were, a new awareness of "volumetric" primitive art.[44] It was Derain who in the spring of 1907 convinced Picasso to visit the Trocadero museum in what Picasso recalled (incorrectly) as his first confrontation with African sculpture. This visit has always figured importantly in the various scenarios offered for the working-up of the *Demoiselles*. But Derain's influence on that picture had also to do with its Cézannist side, inasmuch as one of its sources is certainly the large framed photographic reproduction of Cézanne's *Five Bathers* (Venturi 542) which Picasso saw frequently, since it was prominently displayed on Derain's wall.[45] This work—along with the *Bathers* (Venturi 381) in Matisse's collection and probably the *Bathers* (pl. 191) in Copenhagen—provided a base for what was ultimately the very diffused influence of Cézanne Bather pictures on the formulation of the *Demoiselles*.[46]

I suspect, nevertheless, that the Derain *Bathers*—exhibited as it was just before Picasso began painting his large canvas[47]—had itself a role in the history of the *Demoiselles,* if not as a prototype of a monumental composition of female nudes then as a spur. As Barr suggests,[48] Picasso's "concentration of his resources" in the *Demoiselles* was in "emulation" of Matisse—a response to the *Bonheur de vivre,* Matisse's great idyll of the winter of 1905–06, which had been shown at the Indépendants the year before. It is

André Derain in his studio, c. 1908
Architectural Record (New York), May 1910

hard for me not to believe that Picasso's sense of rivalry was not also piqued—even more immediately—by the Derain *Bathers,* which is closer in many respects to what Picasso worked out in the *Demoiselles* than is the *Bonheur de vivre*. According to Kahnweiler,[49] who had just come to Paris, the Derain was much talked about, and the critic Louis Vauxcelles, who had given the Fauves their name—and who eighteen months later would do the same for Cubism—had attacked the Derain's "barbaric simplifications," which he regarded as "revolutionary."[50] Competition was, in any case, in the air around the *Bathers,* and Picasso may very well have heard the story that this picture and Matisse's *Blue Nude,* shown in the same Salon, were the results of a contest between Derain and Matisse as to who could paint the better "blue nude."[51]

The late spring and summer of 1907 saw most of the Fauve painters in the Midi—Derain at Cassis and Braque together with Friesz at nearby La Ciotat. Braque visited frequently with Derain and kept up with the latter's new work. But the landscapes Derain was painting in Cassis, less manifestly Cézannist than the

Georges Braque. *Still Life with Pitchers.* 1906–07. Oil on canvas, 20¾ x 25⅛ in (52.7 x 63.8 cm). Private collection, Switzerland

Bathers and other works of the winter of 1906–07 (which Braque continued to see since Derain had them with him in the South),[52] were not to have an impact on Braque until the end of the summer. Derain was, in fact, having problems with his painting in the Midi. "Je traverse une crise," he wrote Vlaminck. "Impossible de faire quelque chose de propre."[53] Derain did not seem to have the inspiration or conviction required to press the structural interests announced in the *Bathers* further in the direction of sculptural painting. On the contrary, the Cassis landscapes of that summer take a step backward to a compromise between Cézanne and the Fauvism of 1905–06. The tectonic interests of the *Bathers* are renounced, as is most of its modeled relief, which is "primitivized" into a form of heavy black contouring binding a sober palette of dark ochers, rusts, greens, and blues.

For his part, Braque was increasingly emphasizing the Cézannian component (already evident in his pictures of L'Estaque from the fall of 1906) within what remained a Fauve style. This Cézannism has caused Braque's Fauve pictures to be unfavorably compared with those of Matisse and Derain. But the dismissal of Braque as a "minor Fauve"[54] automatically contributes to a misunderstanding of his subsequent development, as it posits a more radical change in the value of his work than was in fact the case. The sheer quality of Braque's *Still Life with Pitchers* and *Landscape at La Ciotat* raises him far above the level of the minor Fauves, including Dufy, to rival Vlaminck at his best. And though they are less flat and bright than paintings by the two remaining masters of the movement, such Braques should no more be interpreted as failed Matisses or Derains than the

Cézannes of 1872–75 should be seen as failed Impressionist pictures.

What distinguishes these Braques is the presence of a kind of concealed modeling accomplished by lining up unexpected, decorative hues according to their values—an extension, based on substitution, of Cézanne's modeling through color. Braque's tendency to align his own gamut of Fauve colors—founded on secondary and tertiary hues, frequently pastel—in value relationships that imply sculptural relief, an interest utterly alien to the more purely decorative concerns of Matisse and Derain in 1905–06, was no failing on his part, but an anticipation of his own Cubist future. As was the case with Cézanne's conservative version of Impressionism in the early 1870s, Braque was simply loath to give up the particular plasticity of modeled forms—with its attendant emotional and ethical implications. That *gravitas* and sobriety, secured by the illusion of relief, which links the beginnings of the Renaissance and modern traditions in the persons of Giotto and Cézanne, accorded well with Braque's personality (as his subsequent history in Cubism bore out). Hence, Braque's conservative Fauvism must be understood as a deliberate and personal variant of the style—a "withholding of complete assent, and a restoration of that connecting tonal tissue that Matisse had abruptly terminated."[55]

This "restoration" is the basic measure of Braque's commitment to Cézanne, whose painting he had seen as early as 1902 and who was a factor in his development as early as 1904. But by the summer of 1907, Braque's Cézannism had become more than a question of implied modeling. In *Landscape at La Ciotat,* for example, he adapts from Cézanne the entire configuration of his picture, a configuration that he would subsequently make paradigmatic for Cubism. Braque takes Cézanne's high horizon, a perspective that lays out the picture more in height than in

André Derain. *Mountain Road, Cassis.* Summer 1907. Oil on canvas, 31½ x 39 in (80 x 99 cm). The Hermitage Museum, Leningrad

Georges Braque
Landscape at La Ciotat. Summer 1907
Oil on canvas, 28¼ x 23⅜ in (71.7 x 59.4 cm)
The Museum of Modern Art, New York

depth, and treats it in such a way that the forms seem to spill downward and outward toward the spectator from the hill at the top. In addition, Braque extensively uses his own rude adaptation of Cézanne's "constructive stroke" and, like the master of Aix, outlines his forms in Prussian blue. While profoundly Cézannesque, *Landscape at La Ciotat* nevertheless also contains, in the decorativism of the foliage, vestiges of an interest in Gauguin,[56] whose art had earlier been at the center of Fauvism. However, the very Gauguins echoed here—such Brittany pictures as *Boy with a Goose* (1889)—were painted at a moment when Gauguin himself was deeply influenced by Cézanne.[57]

Braque's Cézannism becomes considerably more marked in a small number of canvases executed or set under way in September 1907, when the painter stopped for a few weeks at L'Estaque en route to Paris in the company of his friend Othon Friesz. The very choice of L'Estaque, where Braque had also worked the year before, reflects a tendency on his part to visit places in which Cézanne himself had painted,[58] and is symptomatic of a profound psychological identification with the master of Aix that

characterizes Braque's thinking beginning in 1907. A *View of L'Estaque* showing the bay beyond groups of houses and trees is closest to the La Ciotat pictures in style and is probably the first of Braque's 1907 L'Estaque pictures, possibly the only one completed during his short stay;[59] the pervasive blue of the sea, mountains, and sky in the background—interrupted only by the yellow aureole of the horizon—immediately recalls Cézanne's views of the same bay. In this picture, Braque betrays more overt concern for relief—especially in the large green tree in the center and the predominantly yellow one in the lower right—than heretofore, and opts for a somewhat darker tonality than in previous Fauve works. Despite the diagonal thrust of the foreground landscape—an undeniably *non*-Cézannesque aspect of the motif—the general simplification and firming up of the forms and the somewhat stiff, more tectonic contouring testify to a new interest in structure. One need only compare this picture with Friesz's *Terrace of the Hotel Mistral*—both characterized by pronounced outlines probably adopted from the Cassis Derains of the preceding months—to see how Braque has put a brake on the freewheeling, curvilinear language of Fauvist drawing.

The few other pictures we can associate with Braque's brief 1907 stay at L'Estaque were certainly completed in Paris after his return. One of these, *Viaduct,* which shows the motif framed by trees with houses in the background, is difficult to place in chronological order because the painting has been lost and we possess only a black-and-white photo of it. *Viaduct* is in many respects more architectonic than *View of L'Estaque,* and we should therefore perhaps accept Braque's assertion, made late in life, that the picture was completed even after the *Terrace of the Hotel Mistral,*[60] which is known to have been begun at L'Estaque and worked on extensively in Braque's Paris studio following his return. If, indeed, Braque's recollection is correct, the coloring of the picture would have been less Fauvist than Kahnweiler remembers—admittedly at a distance of many years.[61] In any event, *Viaduct* is an unabashedly Cézannian conception from the compositional point of view, and it is clear from the photograph that the facture—particularly the execution of the foreground trees—marks Braque's further metamorphosis of Cézanne's "constructive" stroke into the broad diagonal notation that was to characterize his painting in 1908.

A juxtaposition of *Viaduct* with the painting of the same motif made early the following summer—a picture already markedly Cubist in character—provides an emphatic measure of the continuity in Braque's development from September 1907 to

Georges Braque. *View of L'Estaque.* September 1907. Oil on canvas, 21⅝ x 18⅛ in (55 x 46 cm). Private collection, Switzerland

Othon Friesz. *Terrace of the Hotel Mistral.* September 1907
Present whereabouts unknown

the summer of 1908. To juxtapose these two paintings is automatically to raise the question of the importance usually attributed to Braque's exposure in the interim to the work of Picasso (and thus also to the place normally accorded in Braque's oeuvre to the large *Nude*). In the 1908 *Viaduct,* Braque closes in on the motif, eliminating the framing device of the trees. By moving from a position directly opposite the viaduct to one in which it is seen from below, he effectively compresses the space and renders much more explicitly that Cézannian-Cubist conception of a composition which unfolds downward and outward toward the spectator rather than retreating from the picture plane. These differences, and others in the figuration and execution of the two pictures—e.g., the broader brushwork of the later one—are part, however, of a logical progression, and the overall continuity remains striking.

The painting, however, on which Braque's new and more intense Cézannism has always turned in the literature is the *Terrace of the Hotel Mistral,* for which such Cézannes as *Cistern in the Park of the Château Noir* (pl. 53) suggest themselves as influences.[62] The general structure at least of Braque's composition dates from the stay at L'Estaque and thus relates to a direct

Georges Braque. *Terrace of the Hotel Mistral.* September–October 1907
Oil on canvas, 31⅞ x 23⅝ in (81 x 60 cm). Private collection, New York

confrontation of the motif. A comparison of the painting to Friesz's version of the same motif painted during the same sojourn measures Braque's abandonment of Fauvism. Friesz's buildings are atilt, the contours of his landscape are sinuous, and his terrace balustrade is at a slight angle. Braque's terrace is horizontal and his trees are more straight-edged and vertical; he cuts off the tops of the foreground trees so as to emphasize the structural quality of their *charpente* (while Friesz retains the *chapeaux* of the trees, handling them with dark Derainesque outlines in a galvanic, almost expressionist manner). Though Braque, unlike Friesz, retains a number of bushes and small trees in his more detached and classical version of the motif, he draws them in a stiff, angular manner—as if their contours were magnetized by the gridlike structure established by the horizontals of the terrace balcony and background architecture and the verticals of the three trees.

As it dates from the weeks at L'Estaque, the overall configuration of the *Hotel Mistral* antedates Braque's renewed exposure to Cézanne in the form of the memorial exhibition, which he saw shortly after his return to Paris. But the darkish, anti-Fauve tonality of the picture—centered on green, ocher, sienna, and

blue, a palette not untypical of Cézanne—must be associated with important changes that took place in the paintings Braque finished or wholly executed from memory at his studio in Paris. Here, for the first time, Braque was not working before the motif, and this freedom from visual data engendered a rapid movement toward abstraction. The shift from the perceptual to the conceptual led not only to a simpler, more schematic kind of contouring, but to a marked reduction in the number of colors and in their fragmentation. Thus while the tonality of the *Hotel Mistral* is broadly Cézannesque, its reductiveness—clearly heading toward monochromy—might well be called proto-Cubist.

Braque said that some works executed in the autumn of 1907 after his return to Paris were entirely developed in the studio—a conceptual approach on which Braque himself set great store.

Paul Cézanne. *Cistern in the Park of the Château Noir* (pl. 63). c. 1900
Oil on canvas, 28¾ x 23⅝ in (73 x 60 cm)
Estate of Henry Pearlman

He spoke of "fighting against the habit of painting before the motif—which makes detachment more difficult." "I had learned to paint from nature," Braque told Dora Vallier, "and so when I came to the conclusion that I had to be free to work without a model, I did not find it at all easy. But I struggled on, following my intuitions, and gradually found that I had become more and more detached from motifs. At such a time, one has to follow

Georges Braque. *Viaduct*. September–October 1907. Oil on canvas, 25⅝ x 31⅞ in (65 x 81 cm). Present whereabouts unknown

dictates which are almost unconscious, since there is no know-ing what will happen."[63] If Cubism is to be distinguished from the work of Cézanne in part through its more conceptual char-acter, Braque's shift in method on his return to Paris before his introduction to Picasso testifies to the independence of his enterprise. "This dismissal of a visual model," as Golding ob-serves, "marked a decisive break with Fauve procedure and an important step towards a new, more rational and intellectual kind of painting."[64] Picasso, needless to say, had arrived at a more radical, more wholly conceptual form of painting some months earlier in the *Demoiselles*.

It should be noted, however, that the distinction traditionally drawn between the Cubists and Cézanne on the basis of the conceptual versus the perceptual character of their respective approaches has often been exaggerated. Despite the tremendous emphasis Cézanne placed on his sensations—they "form the foundation of my enterprise"—and on "the reading of the model" before nature, there is much in his art that is clearly conceptual in character. The Bathers, for example, were all

conceived in the studio, and this probably has much to do with their frequent near monochromy. Indeed, when one considers the antinaturalist overall blueness of these and other late Cé-zannes—which almost have the *stimmung* quality of Symbolist paintings (and thus also betray an affinity with the contempora-neous pictures of the young Picasso)—one wonders if the popu-lar distinction between Cubism and Cézanne does not get some-what overdrawn from taking the master of Aix too much at his own word. Although he occasionally used live models for his Bathers, the figures were for the most part extrapolated from earlier works or photographs, and they were situated in land-scapes devised in the studio. Moreover, the very setting-up of the still lifes in the studio prior to painting them must be consid-ered a form of conceptualizing the motif. But most important, it should be observed that the majority of the so-called "distor-tions" in Cézanne's paintings—ranging from the discontinuities of tabletops and wainscoting to the flattening of many ellipses and the opening of objects' contours—have no connection with perception (unless we accept Huysmans's conclusion that there

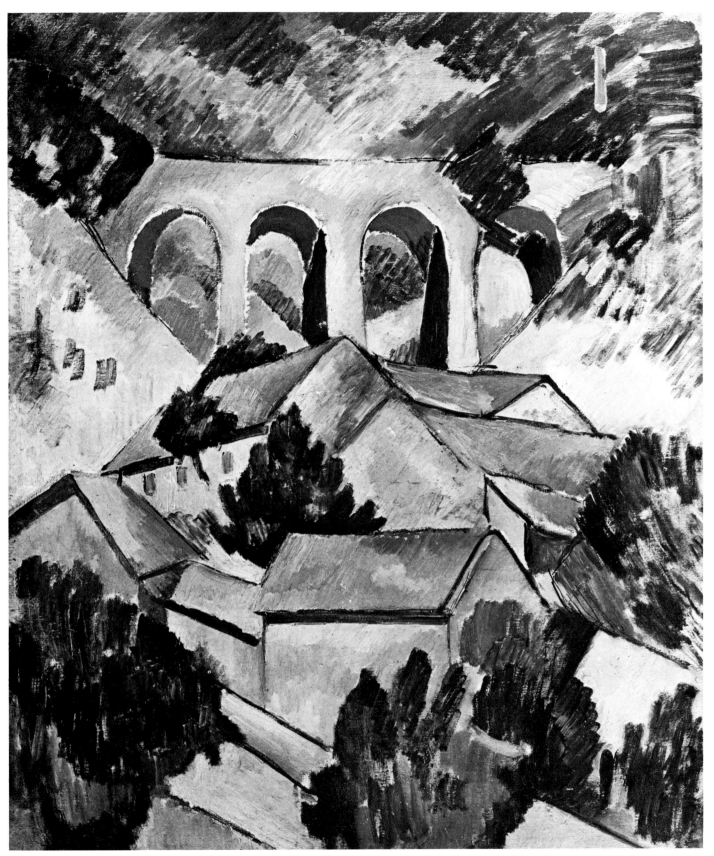

Georges Braque. *Viaduct*. June–July 1908. Oil on canvas, 28½ x 23¼ in (72.5 x 59 cm). Collection M. and Mme Claude Laurens, Paris

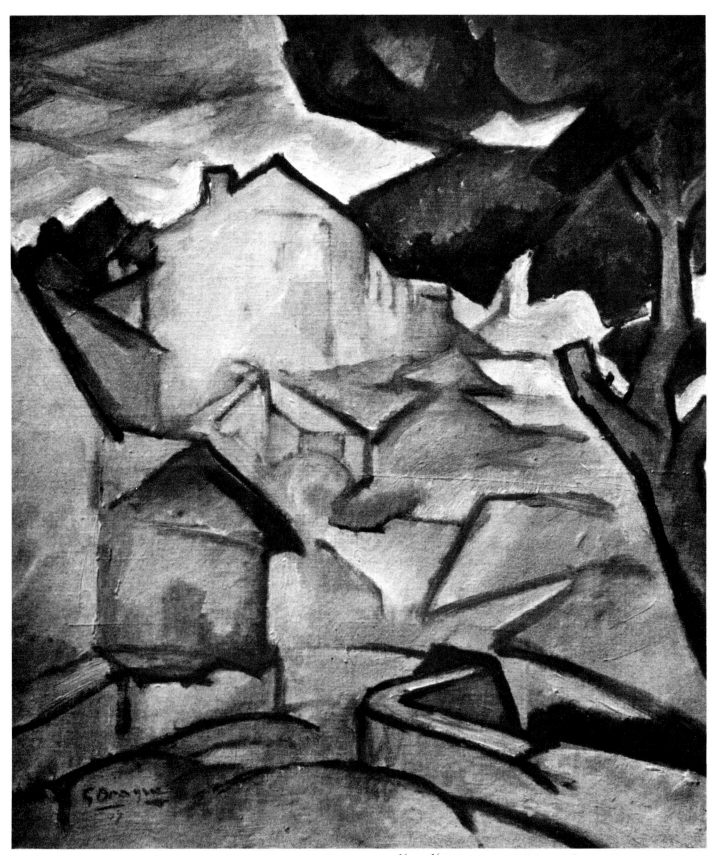

Georges Braque. *Landscape with Houses*. October–November 1907. Oil on canvas, 21¼ x 18⅛ in (54 x 46 cm). Private collection, France

was something wrong with Cézanne's eyes).[65] These *alterations* of nature (I prefer this to "distortions")[66] in favor of the picture's compositional structure constitute collectively a sophisticated form of conceptualizing that challenges many of Cézanne's own dicta and suggests that the difference in method between him and the Cubists was as much one of degree as of kind. Indeed, this conclusion is supported by certain of Cézanne's observations that stress the function of the artist's mind, such as his insistence that painting was as much *une logique* as *une optique*.[67] Bernard went so far as to conclude that Cézanne's vision "was much more in his brain than in his eye."[68]

By far the most significant among the landscapes Braque developed in the studio after his return from L'Estaque in the autumn of 1907 is an unpublished painting that surfaced momentarily eight years ago in a minor auction.[69] This *Landscape with Houses,* probably a recollection of L'Estaque,[70] pushes Braque's Cézannism far beyond the point of the *Hotel Mistral* into a veritable proto-Cubism—which, nevertheless, reflects no influence of Picasso. Indeed, *Landscape with Houses* was almost certainly painted prior to Braque's visit to Picasso, the reaction to which is marked by his *Nude,* begun in December 1907.[71] While the *Hotel Mistral* is organized in planes parallel to the picture plane and tends toward a kind of architectural scaffolding generally reminiscent of the master of Aix, *Landscape with Houses* builds upon a more specific and more pivotal Cézannian conception, already broached in Braque's still-Fauvist *Landscape at La Ciotat*—the composition conceived spatially as a simulacrum of bas-relief, which moves downward and outward toward the spectator from a back plane that closes the space.

The immense advance made here by Braque in the rendering of Cézanne abstractly has to do essentially with his grasp of Cézanne's *passage* of planes, precisely the means which—extrapolated to meet new needs—would henceforth characterize Braque's Cubism and set it in advance of Picasso's during the following eighteen months. Unlike the *Hotel Mistral,* in which emphatic Derainesque outlines enclose the trees and buildings, the contours of most forms in *Landscape with Houses* are broken at some point to allow the planes they define to spill or "bleed" into adjacent ones. Only the top of the house in the center of the landscape and its adjacent foliage are allowed to interrupt this continuity. In certain respects, *Landscape with Houses* is so reminiscent of Cézanne that it may be considered a proto-Cubist paraphrase of such pictures as the *Montgeroult* (pl. 69; 1898).

In further pressing Cézanne's type of composition toward abstraction, Braque is primarily concerned with the grouping of the larger forms and their relation to one another; in concentrating on this component of the work, he has momentarily relinquished much of the painterliness of the previous works. While the *passage*-linked planes of *Landscape with Houses* are shaded, they are unbroken by anything comparable to the myriad *petites sensations* that vibrate in a Cézanne, and the relatively continuous tone intensifies the feeling of geometricity and ab-

André Derain. *Provençal Landscape.* 1908? Oil on canvas, 15 x 18⅛ in (38 x 46 cm). Collection Professor W. Hadorn, Bern

stractness in Braque's composition. Carrying Cézanne's elimination of detail in the rendering of doors and windows even further, Braque treats the buildings as quasi-geometric entities and, through a process of analogy, assimilates the terraced forms of the landscape to those of the rooftops. Braque has also begun in a tentative way to shape the cloud formations geometrically in order to analogize them, in their turn, to the forms of the architecture and to the right foreground of the landscape. The large tree at the right is handled so as to allow the eye to pass uninterruptedly through the foreground space from the top center of the picture down to the bottom right, while the continuous line formed by its angularly shaped boughs and the roof of the principal house locks foreground and background together.

At the latter passage, i.e., the horizon line, there is in *Landscape with Houses* a more marked break between the houses and the sky than was to be characteristic of Braque's Cubist painting. Later he would either choose a position in which the sky was virtually eliminated—as in *Houses and Trees* of the following summer—or carefully open up the planes on the horizon line so as to allow the eye to pass downward. Picasso would resolve this same problem only in the summer of 1909 at Horta, where he began to endow the sky of his landscapes with geometrical cloud formations. Braque's model for this unification of earth and sky was certainly Cézanne—notably the late views of Mont Sainte-Victoire—and commentators also traditionally refer to these Cézannes in discussing Picasso's Horta landscapes. But there is no question in my mind that Picasso's solution to this problem derived as much from the 1908–09 Braques as from the example of Cézanne.[72]

Paul Cézanne. *Bend in Road at Montgeroult* (pl. 69). 1898. Oil on canvas, 32 x 25⅝ in (81.2 x 65.1 cm). Private collection

The coloring of *Landscape with Houses* is very subdued—ochers, greens, pale blue with a touch of rose here and there—thus permitting the picture to project primarily in terms of its light-dark relationships. Consequently, though it is less centered on the browns, siennas, and dark greens that give the *Hotel Mistral* a specifically proto-Cubist coloring, it is structurally much closer to the work that Braque would execute at L'Estaque in 1908. Indeed, it constitutes the real "missing link" in the understanding of his development. As a work that stands midway between Cézanne and Cubism, *Landscape with Houses* is of extraordinary historical importance, for it demonstrates that Braque arrived at Cubism by a direct extrapolation of the means of Cézanne, by accepting Cézanne's conceptions integrally and expanding their limits (as contrasted to Picasso, who took Cézanne in bits and pieces in combination with many other sources). The degree, however, to which Braque advanced beyond simple Cézannism in this picture is evident if we compare it with one of Derain's Cézannian landscapes of the following year.[73] In *Provençal Landscape,* we see Derain having sacrificed the vestiges of Fauvism that marked both his *Bathers* and the

Cassis picture of 1907. The Provençal colors of this canvas (ocher, green, gray, and blue), its simplified house and upward-tilted road all speak of the master of Aix. But the picture represents a "primitivization" of Cézanne that misses the essential point of his structure.

The date of Braque's return to Paris in the fall of 1907 is usually placed in October, but inasmuch as the Salon d'Automne—at which his painting *Red Rocks* was shown[74]—opened October 1, it is probable that Braque returned to the capital between September 20 and 25. Presentations to the jury of the Salon took place very shortly before its opening—usually no more than a week and often just three or four days. As Braque did not yet have a dealer, it is likely he took care of sending his entries himself. Kahnweiler had seen Braque's work at the Indépendants the previous spring, but had not bought any (although he had purchased works by Derain, Vlaminck, and others). Sometime in October, however, during the course of the Salon, he acquired from Braque a group of works that included the *Terrace of the Hotel Mistral* and the *Viaduct.* As *Landscape with Houses* never passed through Kahnweiler's hands—the primary reason it had gone unrecorded—it was probably painted after this purchase, in late October or November.[75] Braque was still in possession of the picture when it was purchased by the father of the present owner around the time of World War I.

The story of how Kahnweiler introduced Braque to Apollinaire and how Apollinaire took Braque on a visit to Picasso's studio has been told many times, although always very sketchily. The celebrated visit is placed variously in October or November, though the latter month seems much more probable. According to Kahnweiler, Braque was not only taken aback by the *Demoiselles,* but disliked it intensely and argued vehemently about it with Picasso.[76] Yet Braque could evidently not dismiss it from his mind and was forced to come to terms with it in his work.

In the first instance, then, Braque's *Nude* represents a reaction to Picasso. The very choice of subject—so uncharacteristic for Braque—signals this engagement. But the picture also constitutes Braque's attempt to submit some of the data of Picasso's experiments to the rigors of Cézannian structure. We know that Braque worked on the *Nude* almost exclusively for six months.[77] That knowledge together with the visible evidence of the picture's myriad *pentimenti* forces us to imagine Braque working and reworking the picture constantly. It is therefore, I think, no exaggeration to see this canvas as a kind of battlefield on which is recorded Braque's struggle to assimilate the opposed influences of Cézanne and Picasso.

In order to appreciate fully the conditions of the struggle, we must return momentarily to the question of Braque's relation to Cézanne, a matter thus far discussed only in terms of paintings. It is in the intensity of Braque's commitment to Cézanne—the man as well as the artist—that we find the spiritual and artistic reserves which enabled him eventually to overcome the chal-

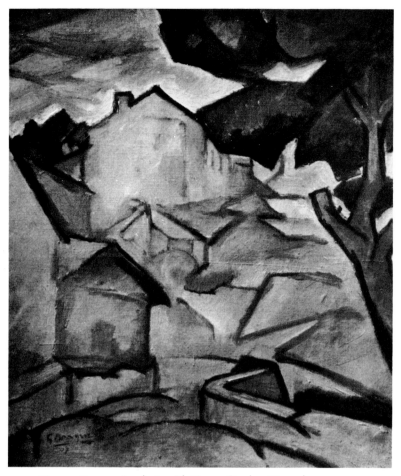

Georges Braque. *Landscape with Houses*. October–November 1907
Oil on canvas, 21¼ x 18⅛ in (54 x 46 cm)
Private collection, France

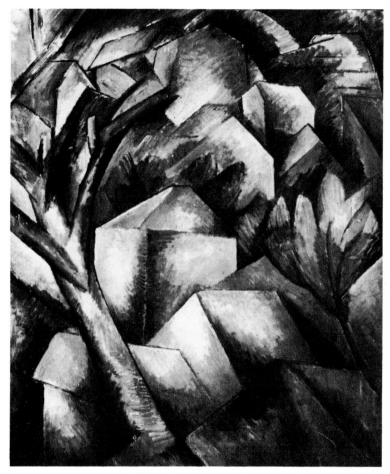

Georges Braque. *Houses and Trees*. August–September 1908. Oil on canvas,
28¾ x 23⅜ in (73 x 59.5 cm). Kunstmuseum, Bern, Hermann and Margrit
Rupf Foundation. © ADAGP

lenge of the *Demoiselles*. That he did so we may gauge by the degree to which Picassoid constituents of the *Nude* are submitted—though with mixed success—to what is structurally a Cézannian conception. Nor is it accidental that Braque terminated work on this infelicitous picture only *after* he had reinforced his ties to Cézanne in the form of landscape painting. I can assert this because, as we shall see, it is now possible to demonstrate that the *Nude* was not completed in Paris before Braque's return to L'Estaque in 1908, as is presumed throughout the literature, but in the month following his arrival there. This means that the last changes in the *Nude* followed—or were, at the very least, contemporaneous with—the markedly Cézannian L'Estaque landscapes of May and June 1908.

Although Braque's descriptions of his early attachment to Cézanne date for the most part from after World War II, they are entirely consistent with the attitude to which his Cubist pictures bear witness. Braque's image of Cézanne, like all the "mythologies" of earlier masters, is incomplete, though it is far less fragmentary than that of Picasso. "Everything about [Cézanne] was sympathetic to me," Braque proclaimed,[78] "the

man, his character, everything . . ." Although Maurice Gieure no doubt exaggerates when he describes Braque as "obsessed by Cézanne to the point of hallucination,"[79] it is certain that Braque identified with Cézanne—and with Cézanne alone—to a degree unmatched in intensity by any other major twentieth-century painter (whether the identification be with Cézanne or another precursor).

At the center of Braque's image of Cézanne is a certain awkwardness that Braque identified with his own lack of versatility. "Cézanne is as great," he insisted, "for his clumsiness as for his genius."[80] Braque associated this *maladresse* with the earnestness, seriousness, and effortfulness of the Italian primitives. He loved Giotto and Uccello but was suspicious of the Venetians, despite Cézanne's own preference for them. Braque's Cézanne was therefore more a Giotto than a Titian. Braque despised the High Renaissance's "art of eloquence": "When Veronese paints two apples, it's beautiful, very beautiful if you wish. But for me, it's theater, it's pompous . . . It took many years, even centuries, for this theatrical spirit to be eliminated. Cézanne gave it the *coup de grâce*. He swept painting clear of the idea of mastery."[81]

Georges Braque. *Nude*. December 1907–June 1908. Oil on canvas, 55¾ x 40 in (141.5 x 101.5 cm)
Collection Alex Maguy, Paris

What even today has an appearance, albeit deceptive, of clumsiness in Cézanne's work—especially prior to 1875—must have looked still more awkward when Braque was young. Indeed, Cézanne was not, in the traditional sense, a very talented painter. He was thus forced to rely on his genius—which endowed each of his pictures with an individual ethical and pictorial drama frequently lacking in the art of, say, Picasso, whose incredible talent acted against the interests of his genius by permitting him to "coast." "Cézanne," as Braque observed, "worked away from all the *facilités* that talent gives." "The recourse to talent," he continued, "shows a defect in the imagination."[82] Cézanne's quality, then, lay in the mind—in conception rather than in execution. "One has often heard speak of Manet's talent," Braque used to say, "never of Cézanne's."[83] Braque's view of Cézanne's art is epitomized in a remark to Jean Leymarie. Braque was showing him a Cézanne from his own collection, *Bouquet of Flowers* (pl. 160). "With a sweep of his hand, Braque silently indicated the immense space separating the flowers from the vase in which they sink their roots. We looked at the picture a long while. Then he said: 'In Matisse and Manet you get only the flower; in Cézanne you get the flower and the root as well. And what counts is the way in which he goes from the root to the flower; there a whole life is summed up.'"[84]

As Braque was meditative and slow-working—wary of those gifted with great ease either in talking or in painting—he felt very comfortable with Cézanne. Indeed it was, as John Russell wrote, "*because* Braque was not a 'brilliant student' and could not have carried off the effects of virtuosity with which many young painters burst upon the world" that he approached the situation analytically, and focused on Cézanne. "Able to proceed only to a limited degree with the traditional reconstitution of Nature for pictorial ends," Russell continues, "[Braque] went in search of new centers of resistance."[85] That this conforms to Braque's image of himself is certain, for Braque significantly described his Cubism as "a means I created for my own use, whose primary aim was *to put painting within the reach of my own gifts.*"[86] "Progress in art," as he observed in one of his notebooks, "consists not in extending one's limits, but in knowing them better."[87]

The life styles, personalities, and political views of both Cézanne and Braque were notably conservative. But it was fundamentally a conservatism of a pictorial order that they shared. Both approached maturity at a time when painting was tending toward greater flatness—in Cézanne's case the flatness of Manet, in Braque's that of Fauvism. Both wanted to preserve the expressive qualities associated with relief. Cézanne accomplished this with color, whereas Braque found his method through economy—by reducing his picture to a value situation. Braque's interest in Cézanne was addressed to the landscapes and still lifes. This contrasted with Picasso's, which was largely focused on the figure pictures—a reflection of his sculptural interests. Indeed, Picasso's predominantly volumetric painting of the year following the *Demoiselles* has far more affinity to sculpture in the

Henri Matisse. *Blue Nude.* Early 1907. Oil on canvas, 36¼ x 55¾ in (92.4 x 140.6 cm). The Baltimore Museum of Art, Cone Collection

round—especially African carving—than to the bas-relief notion underlying Cézanne's mediation between old-master illusionism and the veritable flatness of the picture surface.

Despite the radical changes Braque wrought in Cézanne's landscape conception as he progressed into Cubism, he nevertheless accepted it integrally as a starting point. Braque concentrated on the problem of painting what he called the "visual space" that "separates objects from each other."[88] This is precisely the space bridged by Cézanne's *passage.* Thus what Braque described as a "materialization of a new space"—making space as actual, as concrete and perceivable pictorially as the objects themselves—was, in effect, the explicit articulation and radicalization of a Cézannian idea. From autumn 1907 until autumn 1908 Braque's "visual space" was explored primarily in landscapes; after his one-man exhibition at Kahnweiler's in November his focus shifted to still life, and Braque began to regard interstitial space as virtually "tactile."

Braque's decision in December 1907 to undertake a large painting of a nude (it was labeled "Bather" in Isarlov's catalog)[89] was certainly in part a response to the challenge of the *Demoiselles,* and to that extent it went against the grain of his previous development. "Materialization" of the space that "separates objects" is obviously far better served by landscape or still life painting than by the representation of the single human figure. Landscape in particular provides a visual field made up of a multiplicity of components, many of them small and unidentifiable, that yield easily to the process of abstraction and the rendering of *passage.* More integral as a motif, the figure resists disintegration or "analysis." In addition, both artist and viewer are inevitably involved in a degree of empathic identification, and it is this fact that accounts for the centrality of the figure in Picasso's oeuvre and its infrequency in the work of the more detached, more dispassionate Braque.

Georges Braque. *Standing Nude.* Late 1907
Etching, 10⅞ x 7¾ in (27.5 x 19.5 cm). Private collection

just over fifty percent of his production during the years of High Analytic Cubism.) But even during this period, the figure remained important to Picasso, accounting for almost forty percent of his output as opposed to ten percent for Braque.

The literature has never situated Braque's *Nude* with any precision in relation to his other paintings. Accounts of his work trail off after a discussion of the *Terrace of the Hotel Mistral* and resume with the *Nude;* after this, the scene shifts to L'Estaque, where Braque's work takes yet another turn. My concern here is to clarify the relationship of the *Nude* not only to the landscapes that have wrongly been presumed to follow it at some distance, but to two graphic works that must certainly have been executed in Paris between the Estaque visits of 1907 and 1908. These are the lost drawing *Three Nudes,* which Braque gave to Gelett Burgess, who reproduced it in a 1910 article,[91] and *Standing Nude,* an etching dated 1908 by Cooper and others[92] but given 1907 in the Maeght catalog of Braque's prints.[93]

In its final state—as we see it today—the large *Nude* doubtless looks very different from the way it appeared at its beginnings in the winter of 1907–08 and probably tells us more about Braque's painting at the outset of the crucial third visit to L'Estaque than it reveals about his first reactions to Picasso. The inability to determine the chronology of its various stages with any certainty complicates the problem of relating the *Nude* to the drawing and etching, and it is therefore best to start by comparing the latter two.

I do not see how it is possible to date the drawing, *Three Nudes,* prior to the etching, as has been done.[94] The latter, *Standing Nude,* seems to me obviously identified with the proto-Cubist period of late November 1907 characterized by *Landscape with Houses.* If Braque was, in fact, inspired to return to the figure as a result of his contact with Picasso, this rather timid work—which makes as yet no attempt to assimilate the Spanish artist's style—may be the first stage of that effort. Whereas the degree of abstractness is roughly comparable to that of *Landscape with Houses,* the *passage* of planes is less developed, because the human figure does not lend itself to being broken up in a proto-Cubist manner.

Three Nudes seems to me infinitely more assured, much smoother in its understanding of how Cézannist principles might be extrapolated in regard to the human figure. Indeed, the woman on the left, closely related in pose to the one in the large *Nude,* is in some respects more satisfactorily realized than her counterpart in the painting. In the drawing, for example, the pose makes sense. Both feet are planted on the ground, and the definition of the back is consistent with the gesture of the arms. In the painting, the distortion of the figure's back (obviously so rendered to make its depth more assimilable to the picture plane) is stylistically at odds with the rest of the figuration and anatomically incongruous. Braque intensifies this incongruity by bending the left arm behind the head at the elbow. The other arm hardly reads more naturally; the flaccid and unsure curve of

Prior to the *Nude,* Braque had painted only two figure pictures—half-draped women seen from behind in *profil perdu.* These two versions of the same pose are among his least successful Fauve paintings. The large *Nude* was the only figure picture Braque completed in 1908, and he executed only one in 1909. During the period 1906–09, Braque's four figure paintings represent less than six percent of his work, while landscapes make up more than three-fourths of it. By contrast, Picasso's figure pictures in the same years amount to almost three-quarters of his output, of which landscapes constituted less than eight percent.[90] During the years of High Analytic Cubism (1910–12), still life dominated Braque's oeuvre, representing somewhat over eighty percent of his painting. That fact notwithstanding, the more marked abstraction practiced in those years permitted Braque to manage the figure with more success than before, and he painted twice the number of figure pictures. By 1910, Picasso had also become primarily a painter of still life, though he concentrated on that subject less than Braque. (It represented

Georges Braque. *Three Nudes.* Early 1908. Ink on paper
Present whereabouts unknown

Georges Braque. *Nude.* December 1907–June 1908. Oil on canvas,
55¾ x 40 in (141.5 x 101.5 cm). Collection Alex Maguy, Paris

the forearm fosters, in combination with the tilt of the head and the posture of the other arm, an impression that the figure is resting on a pillow. Since the figure's left leg does not rest on the ground but is bent up as in a posture of sleep and since the drapery spreads behind her like bedsheets, a question arises as to whether the pose was not originally prone rather than standing—which would bring it closer to Matisse's *Blue Nude,* one of its important sources.[94a]

In view of the sophistication of the drawing in comparison with the *Nude* and its greater clarity and consistency of planar structure and light-dark patterning, I find it impossible to situate it as early as 1907, where Fry, in his often brilliant exegesis of the Burgess article, places it.[95] It seems to me more likely associated with work done on the *Nude* during February and March, if not later.[96] In Fry's effort to relate *Three Nudes* directly to the *Demoiselles* and thus, by extension, relate the *Demoiselles* to the *Nude,* he exaggerates the similarities between the drawing and Picasso's large canvas. He speaks, for example, of both the seated central figure and the standing figure on the

right of the drawing as derived from the *Demoiselles.* Certainly persuasive as regards the seated figure, Fry is less convincing with respect to the standing one. The left-hand figure of Derain's *Bathers* is a closer model for the latter, if one must be found. Indeed, the affinity of *Three Nudes* to Derain is much more marked than any debt to Picasso; not only in the overall articulation of the figures but in the hatching itself *Three Nudes* strongly suggests Derain's sculpture of 1907.

If Fry's emphasis on the link between the *Nude* and the *Demoiselles* is exaggerated, it is nevertheless shared by most commentators.[97] Golding, for example, mentions as part of Braque's "debt to Picasso" in the *Nude* the treatment of the background in terms of large, angular planes and the picture's "muted pinks, buffs and greys," which he identifies as "the predominant colors in the *Demoiselles.*"[98] Cooper, on the contrary, while speaking of Braque's indebtedness to Picasso, pointedly dissociates the large *Nude* from the *Demoiselles.* "There is little in it," he asserts, "which looks as if it had been directly inspired by the handling of the figures in the *Demoiselles;* even

Georges Braque. *Bay of L'Estaque.* May–June 1908. Oil on canvas, 13 x 16⅛ in (33 x 41 cm). Collection Jean Masurel, Paris

the subdued color scheme of pink, beige and grey is unlike the sharp color contrasts in Picasso's picture." "Nevertheless," Cooper argues, "Braque's indebtedness to Picasso is explicit, though it seems to derive more from earlier pictures such as the *Woman with a Comb* and *Two Nudes* (both of 1906)."[99] It seems to me possible to go a step further and argue that not only is the *Nude*'s color different from that of the *Demoiselles* (and from the Picassos of the six months following), but that its very buffs, pinks, and grays *are* in fact to be found in Braque's own *Terrace of the Hotel Mistral* and *Landscape with Houses,* both executed before his contact with Picasso. At the same time, the schematic drawing of the face of the *Nude* is perfectly consistent with that of Braque's etching, *Standing Nude,* also of late 1907, and has no more to do with the stylization of faces in the *Demoiselles* than it has to do with African sculpture.

If the role of Picasso in Braque's 1907–08 development tends to be overdrawn, that of Matisse tends to be overlooked. What Braque was aiming at in the draftsmanship of *Nude* has less to do with anything in Picasso than with the schematic figuration exemplified by Matisse's *Blue Nude,* whose inexpressive face Cooper emphasizes as one of its sources.[100] Braque's heavy black outline drawing, however, is at once more angular than Matisse's and far less successful in suggesting the turning of modeled forms in space. The failure of such contouring in the *Nude* must have played a central role in Braque's shift to a more discontinuous, fragmentary manner of describing the edges of planes in his subsequent paintings, all of which were landscapes. Cooper also points out that the *Nude* and *Blue Nude* have in common the "broad, sweeping, parallel brushstrokes which emphasize modelling."[101] But for Braque this represented simply

a continuity of the Cézanne-inspired notation already visible in his later Fauve pictures.

Even as he was putting the finishing touches on the *Nude,* Braque was resuming in his landscapes the wholly personal line of development that had been deflected by his confrontation with Picasso near the end of 1907. In the earliest landscapes painted at L'Estaque, pictures such as *Bay of L'Estaque,* the vestiges of Picasso still evident in *Nude* have disappeared, and Braque's preoccupation with Cézannian structure is reasserted. As Fry well put it, the final effect of Braque's 1907 encounter with Picasso was "more to accelerate and intensify Braque's exploration of Cézanne's ideas" than to "divert his thinking in any essential way."[102]

Braque's critical third stay at L'Estaque is assigned by Cooper, Golding, Fry, and most other commentators to the summer of 1908; Hope and Leymarie are among the few who indicate a longer sojourn, placing Braque in the Midi already in the spring.[103] The question is of considerable importance inasmuch as the brevity implied by a simple summer stay has contributed to the universal treatment of Braque's L'Estaque production as a unit. The standard treatment ignores what was in fact an extraordinary *evolution* from the Cézannist proto-Cubism of the *Balustrade, Hotel Mistral* and *Bay of L'Estaque* to the fully achieved early Cubism of *Houses and Trees.* In the absence of any attempt in the literature to distinguish among Braque's various 1908 paintings at L'Estaque or to put them in chronological order, even such scholars as Golding and Leymarie have misunderstood the period. When the former takes *Houses and Trees* as "representative of the whole series of 1908 landscapes"[104] and the latter characterizes the same picture as the "most representative of this new group of works,"[105] it becomes apparent that Braque's painting in the Midi that spring and summer constitutes virtually a lost chapter in the history of art. *Houses and Trees* is, to the contrary, *unrepresentative* of Braque's 1908 landscapes, coming as it does at the end of a long development.

As the date of Braque's arrival at L'Estaque is an issue, it is fortunate that we have a document which permits its resolution. A postcard thus far overlooked in the miscellany of the Kahnweiler archives fixes Braque in the Midi about mid-May. Sent to Kahnweiler from L'Estaque in the last days of May, the card is stamped as having arrived in Paris on June 1. In this card, Braque writes of being already "well begun with his work." Kahnweiler recalls that Braque went south that summer by bicycle, sending his belongings, canvases, and other materials by post. As it is likely that Braque remained in Paris until the closing of the Indépendants on May 2, an allowance of roughly ten days for his bicycle trip places him in L'Estaque by May 15. This date would accord with his reference to being well into his work by the end of the month. No comparable document has been found to determine the date of Braque's return to Paris. Kahnweiler recalls that he normally remained away as long as possible, arriving only when it was necessary to present works to

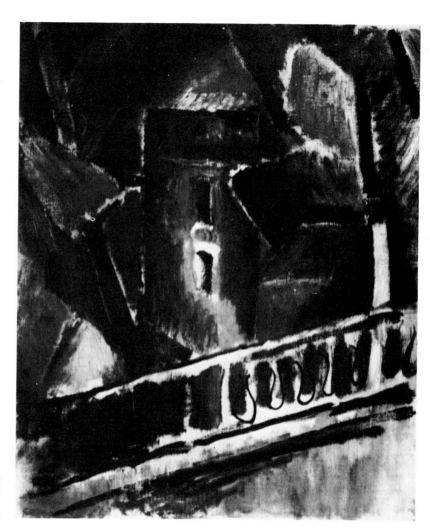

Georges Braque
Balustrade, Hotel Mistral. May–June 1908
Oil on canvas, 16⅛ x 13 in (41 x 33 cm)
Collection D.-H. Kahnweiler

the Salon d'Automne. As the Salon opened that year on October 2, we may conjecture that Braque returned to Paris by about September 25, in order to send his L'Estaque works to the jury. The jury (which included Matisse) rejected all six of the works he presented (though two were subsequently admitted),[106] and Braque withdrew all his entries, showing them with other pictures at Kahnweiler's in November.[107]

Braque's sojourn in the Midi thus lasted a full four months, a period that allows for both the large number of pictures we know he painted there and, above all, for the magnitude of the transformation his style underwent from the first to the last of them. I cannot here undertake a full chronology of these paintings. Nevertheless, I shall attempt a beginning by outlining and illustrating what I take to be the major phases of Braque's stylistic progression from May through September, a progression which is at the heart of the creation of Cubism.

I have assigned to the first month of Braque's stay the *Bay of L'Estaque* and *Balustrade, Hotel Mistral* because they are, relatively speaking, the most Cézannist and most tentative of the Midi paintings. The former could almost be taken for a painting by Cézanne—except for the somewhat jumbled geometry of the

foreground houses and the reduction of the palette to buff, green, gray, and blue. The curious treatment of the planes in *Balustrade*—flat and parallel to the picture plane—suggests that Braque was influenced in this tiny work by recollections of the version of the same motif he had executed the previous autumn. Indeed, to the extent that *Balustrade* sets itself apart stylistically from the other 1908 landscapes, it seems a bridge between the 1907 and 1908 groups of L'Estaque paintings, and may well have been the very first work undertaken in May 1908.[108] It is also unique among these landscapes for the line drawing etched on the forms of the balusters. This sort of drawing, in which line constitutes a decorative superimposition on a plane rather than a definition of its edge, suggests the drawing of the facial features in the *Nude*.

As the *Nude* is dated "June 1908" on the reverse of the canvas, it seems clear that Braque sent it south with the rest of his material and finished it some weeks after his arrival.[109] How much he worked on it in L'Estaque is impossible to say, for when Braque writes Kahnweiler at the end of May that he is "well begun with his work" we do not know to which paintings he refers. It is quite possible, however, that Braque worked on

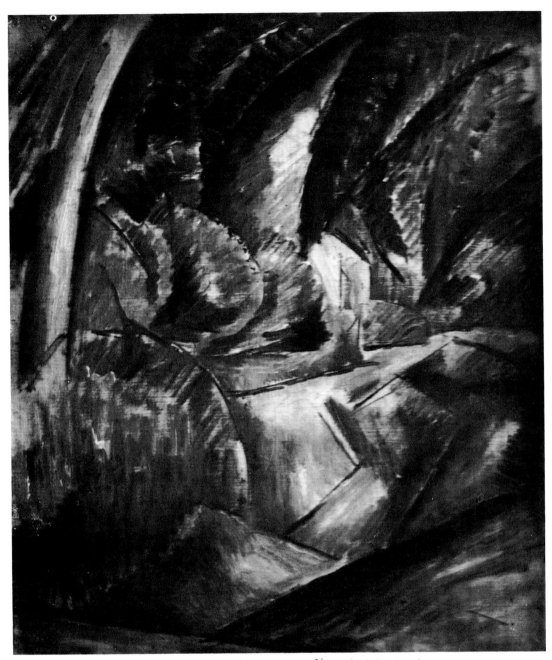

Georges Braque. *Road at L'Estaque.* June 1908. Oil on canvas, 18⅛ x 15 in (46 x 38 cm)
Centre National d'Art et de Culture Georges Pompidou, Musée National d'Art Moderne, Paris

the *Nude* extensively at L'Estaque. This would explain the similarity of its surface articulation—especially the long parallel diagonal brushstrokes—with the notation of *Road at L'Estaque* in the Purris Collection and the somewhat more developed *Road at L'Estaque* now at the Centre Pompidou (which I place in June, slightly after *Bay at L'Estaque* but prior to the Laurens *Viaduct*). If Braque put only finishing touches on the *Nude* after his arrival, they would likely have been the contours of the facial features—an unsatisfying solution to a passage that probably gave Braque a lot of trouble. That type of drawing is close, in

any event, to the ornamental linear passage of the *Balustrade,* suggesting a contemporaneity of the two passages.

In the Centre Pompidou *Road at L'Estaque,* the angular lines of the house and road are set against summary arabesques indicating tree trunks and foliage, in a manner producing effects akin to the *Nude* but also related—though at a greater distance—to *Landscape with Houses* of autumn 1907. The planes of *Road at L'Estaque,* like those of other pictures of May and June, have a tendency to line up relatively parallel to the picture plane as compared with subsequent paintings, and the objects repre-

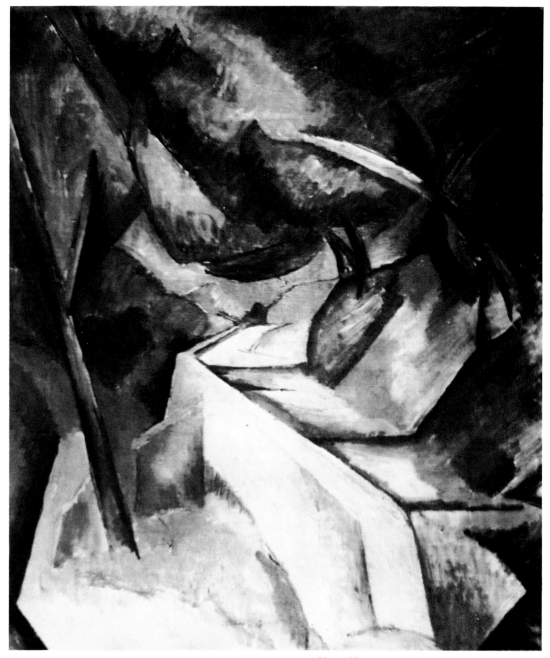

Georges Braque. *Road near L'Estaque.* July 1908. Oil on canvas, 23¾ x 19¾ in (60.3 x 50.2 cm)
The Museum of Modern Art, New York

sented are more shaded than modeled. Nevertheless, the light and shadow are now wholly autonomous and follow the logic of the pictorial structure rather than that of nature, and the style in general has advanced to a new degree of abstraction.

The Laurens *Viaduct* may be taken as the measure of Braque's style after he had been in L'Estaque for at least a month. Though still realized primarily with long, coarse diagonal strokes, it is somewhat less painterly (in the Wölfflinian sense) than either version of *Road at L'Estaque*. Particularly in those passages describing architecture, the brushwork patterns help advance the cause of relief rather than hanging flat upon the plane as in the just previous pictures. Even the relatively loosely painted trees imply more density and relief than those, for example, of the Centre Pompidou *Road at L'Estaque*. The controlled reduction of painterliness in *Viaduct* and, even more, the ordering of the remaining painterly effects in the service of modeling set a pattern for the summer. We can gauge the next step in this progression by comparing the trees in *Viaduct* with those in *Road near L'Estaque* (Museum of Modern Art), the execution of

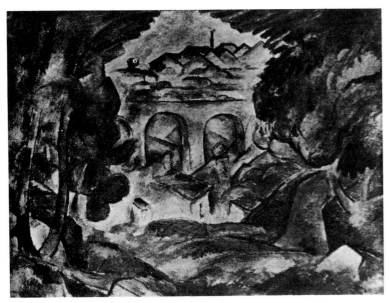

Georges Braque. *Viaduct.* September–October 1907. Oil on canvas, 25⅝ x 31⅞ in (65 x 81 cm). Present whereabouts unknown

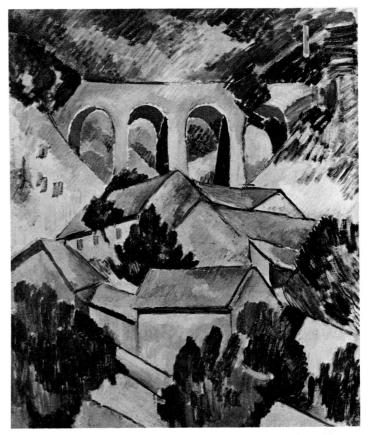

Georges Braque. *Viaduct.* June–July 1908. Oil on canvas, 28½ x 23¼ in (72.5 x 59 cm). Collection M. and Mme Claude Laurens, Paris

which probably followed *Viaduct* by a few weeks. In *Road near L'Estaque,* the brushwork is tighter and less coarse and is so arranged as to reinforce the illusion of relief prompted by the gradations from light to dark, with the result that the forms are firmer and more compact.

In *Viaduct,* Braque has rendered fully explicit the Cézannian compositional type taken up in 1907 in *Landscape at La Ciotat* and *Landscape with Houses.* Its prototypes in Cézanne are to be found less in works representing this particular motif (which appears usually at a distance in paintings of Sainte-Victoire) than in compositions such as the *Montgeroult* and the views of Gardanne. In *Viaduct,* Braque has intensified the possibilities of this compositional structure by closing in on the motif in such a way that the forms of the houses spill almost vertiginously out and down toward the viewer from the middle-ground viaduct, to whose stable architecture they are nevertheless visually anchored.[110] While the architecture imaged in *Viaduct* is somewhat more simplified and in that sense more "abstract" than in Cézanne, the difference is one of degree. The windows, for example, of Braque's houses are more often suppressed than are Cézanne's. But the overhang of the eaves, suggested by blue shadows, is still retained. This detailing was to be eliminated by Braque at the end of the summer in the more "cubic" houses of the Rupf picture. Some of the roof and wall contours in *Viaduct* have almost been dissolved in the interest of *passage,* but the effect remains more naturalistic than abstract. Perspective, moreover, is still handled relatively consistently. Reference to the 1907 *Viaduct* reproduced earlier shows that Braque has moved down the hill to a position among the houses that had appeared in the middle ground of that work. From there, he looks up at the viaduct, taking a position more to the left than previously.

As a result, the town in the distance of the 1907 view has disappeared behind the viaduct.

While the shadows in *Viaduct* are independent of a specific light source, the overall light-dark patterning of the picture has nothing of the autonomy that characterizes *Trees and Viaduct,* the more abstract version of the same motif painted about a month later. In the latter, Braque combined elements of his two earlier treatments in a composition whose compactness depends upon a conceptual rearrangement of the motif. The viaduct itself is represented, as in the 1907 version, with the eye on a level with its top. But had Braque consistently represented it again from the hill, the houses in the near ground of *Trees and Viaduct* would have had to appear much smaller than they do, and the viaduct would have been farther in the distance. At the same time, such a perspective—if handled consistently—would not have permitted the architecture of the town to appear just above the viaduct, as we see it in *Trees and Viaduct.*

Braque obviously achieved these highly ordered symmetrical and geometrical effects by creating a composition not *d'après nature* but in the studio, where the components of earlier paintings and perhaps sketches were combined imaginatively with recollections of the motif. The ogival branches and foliage

Georges Braque. *Trees and Viaduct.* August 1908
Oil on canvas, 28¾ x 23⅝ in (73 x 60 cm). Private collection, London

which frame the motif in *Trees and Viaduct* have nothing of the picturesqueness of the naturalistic framing foliage in the 1907 version and were conceived by Braque both to echo the forms of the distant roofs and provide the image with a binding geometry; this aspect of the composition may well reflect the influence of the large Philadelphia *Bathers* (pl. 189), one of Cézanne's most conceptually ordered works, which Braque would have seen in the memorial retrospective. The linkage of the distant roofs and the sky in *Trees and Viaduct* (a continuity enhanced by the diagonal brushwork patterns common to both) and the passage of the foreground foliage into the houses, and of the latter into the viaduct, have the effect of fusing the picture's structure into an indivisible unity such as is found in no earlier painting by Braque. The antinaturalistic manipulation of the composition—e.g., its enforced centrality, even to the centering of the smokestack—and the abstract rendering of its individual

Photo by D.-H. Kahnweiler of the motif of Braque's *Houses and Trees*
Courtesy Galerie Louise Leiris, Paris

Georges Braque. *Houses and Tree.* August–September 1908. Oil on canvas, 16⅛ x 13 in (41 x 33 cm). Collection Jean Masurel, Paris

components combine to produce a composition well beyond the level of abstraction of the Cézannian prototypes. Braque seems to have arrived at this type of painting—Cubist in the full sense of the word—around midsummer.

Houses and Trees, the only painting of the series I know for which an oil study exists, represents from a purely structural point of view the culmination of Braque's progress at L'Estaque. Late in life, Braque told Nicole Mangin that the study or small version, *Houses and Tree* (16⅛ x 13 in.; Masurel Collection), which shows only part of the motif, was the first picture he executed following his arrival at L'Estaque. But like many other indications he gave at that time, this must be dismissed. It is not possible that *Houses and Tree* precedes the paintings I assigned above to May and June. Slightly more painterly than its famous counterpart in the Rupf Collection, the Masurel picture, like most of the work of the Estaque sojourn, was probably begun in front of the motif and finished in the studio. The larger Rupf picture may have been entirely developed in the studio. It is, in any case, less controlled by nature, as we can see by comparing the two with the photograph Kahnweiler took of the motif, which demonstrates that Braque accepted the actual form of the tree in the small composition. In the larger of the two versions, however, he felt a greater necessity to alter nature, and there his

tree has been imaginatively rearranged.

The green area to the right of the tree in both versions—which represents, as the photograph shows, the forward part of the knoll on which Braque stood (and its foliage)—is already somewhat geometricized in the Masurel study; two lines, one extending the diagonal of a roof and the other echoing a nearby horizontal rooftop, have been superimposed on the green plane to link it geometrically to the rest of the picture. This somewhat tentative arrangement is superseded in the Rupf picture by a pattern that wholly assimilates the knoll to the rooftops, thus rendering its green color ambiguous. Indeed, one of the important characteristics of the later L'Estaque pictures is the increasingly "arbitrary" use of the buff, green, and gray which had previously described buildings, foliage, and rock. Blue was largely eliminated as Braque increasingly contrived compositions in which the sky was not shown. This new autonomy in the handling of color represented an extension of the kind of Cubist thinking that had earlier led to the disengagement from naturalistic light and shadow and from the obligations of perspective.

Houses and Trees is a paradigm of the composition that moves outward toward the spectator instead of receding from him, a structure Kahnweiler identified as early as in *Der Weg zum Kubismus* as an essential aspect of the Cubist style.[111] Braque was

Georges Braque. *Houses and Trees*. August–September 1908. Oil on canvas, 28¾ x 23⅜ in (73 x 59.5 cm)
Kunstmuseum, Bern, Hermann and Margrit Rupf Foundation. © ADAGP

Georges Braque. *The Forest, L'Estaque.* July–August 1908
Oil on canvas, 28¾ x 23⅝ in (73 x 60 cm)
Statens Museum for Kunst, Copenhagen, Collection J. Rumps

Raoul Dufy. *Landscape at L'Estaque.* Summer 1908. Oil on canvas,
22 x 18⅛ in (56 x 46 cm). Private collection

quite conscious of what he was doing, as is indicated by his recapitulation of this forward movement in the very execution of the painting itself. Whereas he had previously started a picture by painting the planes nearest to the picture plane, he began his pictures that summer in L'Estaque with the background plane, "advancing the picture toward myself bit by bit."[112] At the same time, he stopped using frames that slope inward, frames that set the paintings in depth and enhance illusion; he turned instead to what he called *cadres en fuite,* which advance the image toward the viewer.

It was Raoul Dufy's good fortune to spend part of the summer of 1908 with Braque at L'Estaque. An adept and extremely talented painter, Dufy appeared to assimilate much of what Braque was doing. But a comparison of their work shows that, despite their common love of Cézanne, Dufy missed the essence of Braque's *démarche.* His version of it—like his Fauvist version of Matisse—was ultimately decorative and conventional. As Oppler says of these pictures, "spatial relationships are illegible, not because they are complex and inventively rearranged, as in Braque's use of *passage,* but because Dufy had not quite mastered the new technique."[113] Nevertheless, Dufy's L'Estaque pictures are further into Cézannist-Cubist syntax than any work being done elsewhere at the time, including that of Picasso.

Had Braque never painted *Houses and Trees,* he would no less have invented Cubism at L'Estaque. But the movement would probably have had another name. Matisse's and Vauxcelles's references the following autumn to *petits cubes* actually are wholly appropriate only to this picture and its study; indeed, we know that in Matisse's case *Houses and Trees* was precisely the picture he had in mind.[114] By now only Sunday Supplement writers think Cubism contains cubes—or any other illusions of closed three-dimensional geometric forms. Nevertheless, while geometric simplification is certainly an attribute of the Cubist style, the chance name with which the movement was saddled because of a very particular picture has tended to direct thinking toward this attribute and away from the handling of space, of light, and the linkage of planes—all of which are finally more central to a definition of Cubism than any particular aspect of its variable morphology.

There is no record of Picasso's reactions to Braque's L'Estaque pictures. We do not even know when he first saw them, though almost certainly it was prior to their showing at Kahnweiler's in November, which "in retrospect," as Leymarie writes, "has become perhaps the exhibition of the century."[115] Picasso must have been impressed, however, and he was probably also surprised to see that Braque had advanced very far along a path

influences of Cézanne's female Bathers, whose contouring accounts in part for the chunky forms of *Two Nudes* (a picture primarily involved, nevertheless, in Picasso's "Iberianism").[118] As was observed earlier, the female Bathers had a certain influence on the *Demoiselles*, particularly on the studies leading up to it. But, as Golding observes, "any influence of Cézanne that there may be in the *Demoiselles* as it now appears is of the most general kind."[119] Suggestions of Cézanne are almost entirely absent in Picasso's style from autumn 1907 to summer 1908. While paintings of those months contain some rudimentary *passage*, they are stylistically inspired primarily by African art. Even in *Woman with a Fan*, where the figure is free of African

Pablo Picasso. *Boy Leading a Horse.* 1905–06. Oil on canvas, 86¾ x 51½ in (220.3 x 130.6 cm). The Museum of Modern Art, New York, gift of William S. Paley (the donor retaining a life interest)

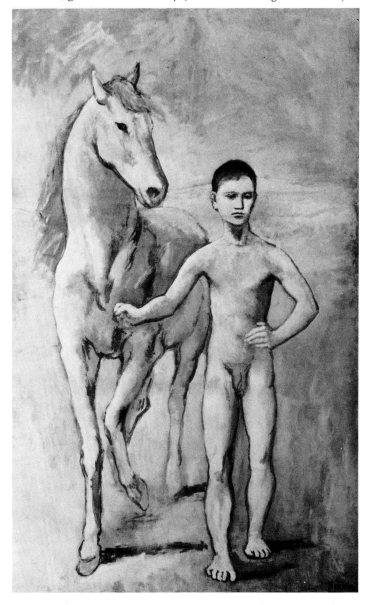

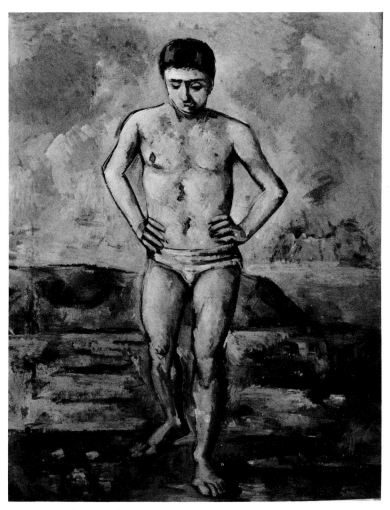

Paul Cézanne. *The Bather.* c. 1885. Venturi 548. Oil on canvas, 50 x 38⅛ in (127 x 96.8 cm). The Museum of Modern Art, New York, Lillie P. Bliss Collection

onto which he himself had ventured somewhat casually (and wholly independently) that same summer, when during his August stay at La Rue des Bois he had executed a group of Cézanne-influenced landscapes that stand entirely apart from his production of the previous year.

Picasso's interest in Cézanne was awakened in 1901 when, at the time of his first one-man show at Vollard's, he saw a number of Cézanne's pictures. If one sets aside as ultimately fortuitous and different in purpose the blueness common to both oeuvres in the early years of the century,[116] the first significant influences of Cézanne to appear in Picasso's style are not to be found until 1905–06, in paintings such as *Boy Leading a Horse*. Here the overlapping, multiaccented contouring, the monumentality of the boy as well as his masklike features and determined stride all speak of Cézanne—in particular of The Museum of Modern Art's *Bather* (Venturi 548), which Picasso probably saw at Vollard's.[117]

During the fall of 1906, Picasso's work reflects the first

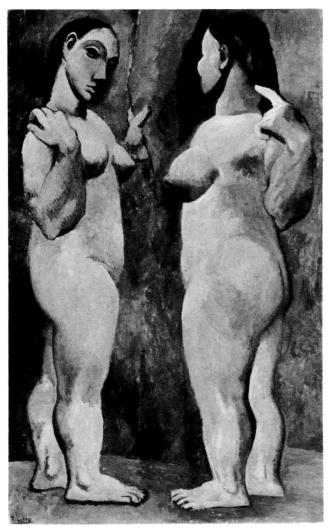

Pablo Picasso. *Two Nudes.* 1906. Oil on canvas, 59⅝ x 36⅝ in (151.3 x 93 cm). The Museum of Modern Art, New York, gift of G. David Thompson in honor of Alfred H. Barr, Jr.

Bois reflect the influence of the Douanier, who is likewise the inspiration of the toylike, geometrical houses that appear in some of them (though such reductionism may also reflect not Cézanne's painting but his recommendation to paint nature "in terms of the cylinder, the sphere, the cone . . .").[120] In the Meyer *Landscape,* however, the Rousseau influence is combined with a rudimentary linkage of planes attributable to the painting of Cézanne. The earth "passes" into the tree trunks, and some of the foliage melds into the sky. The individual planes are relatively large and flat (shaded rather than modeled) and are very tentative in definition. In terms of Cubist syntax, such Picassos of August 1908 are not vastly advanced beyond the level of Braque's *Balustrade, Hotel Mistral,* executed three months earlier, prior to Braque's decisive evolution. Nevertheless, *Landscape* bristles with an extraordinary plastic energy peculiar to Picasso—a quality wholly independent of where this or any other work may stand in the evolution of style. Indeed, a comparison of the Picassos and Braques painted in the summer of 1908 requires that we examine what has become virtually a reflex action in the criticism of modern art, that is, the equation of precocity—in terms of the evolution of a style—and quality.

Pablo Picasso, *Peasant Woman.* La Rue des Bois, August-September 1908. Oil on canvas, 32 x 25⅝ in (81 x 65 cm) The Hermitage Museum, Leningrad

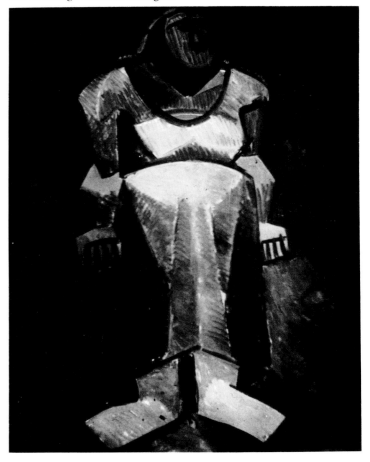

attributes, there is a tendency to treat the forms as a simulacrum more of sculpture in the round than of low relief.

It is significant that the reawakening of Picasso's interest in Cézanne should be associated with a brief excursion into landscape painting. The figure pictures executed at La Rue des Bois, the *Peasant Woman* for example, are sculptural in the manner of his works of the early summer. But landscapes such as the one illustrated here (from the Meyer Collection) are decidedly less sculptural and tend—unlike the figures—to engage the whole of the pictorial field in the fabric of the composition. This is only partly explained by the inherent differences between landscapes and single figures. It also reflects the fact that as Picasso gets away from the latter his sculptural tendencies moderate; his "models" shift from sculpture to painting, and African carving is replaced by Rousseau and Cézanne.

The pervasive greenness and the peculiar morphologies of the branches and boughs in the landscapes executed at La Rue des

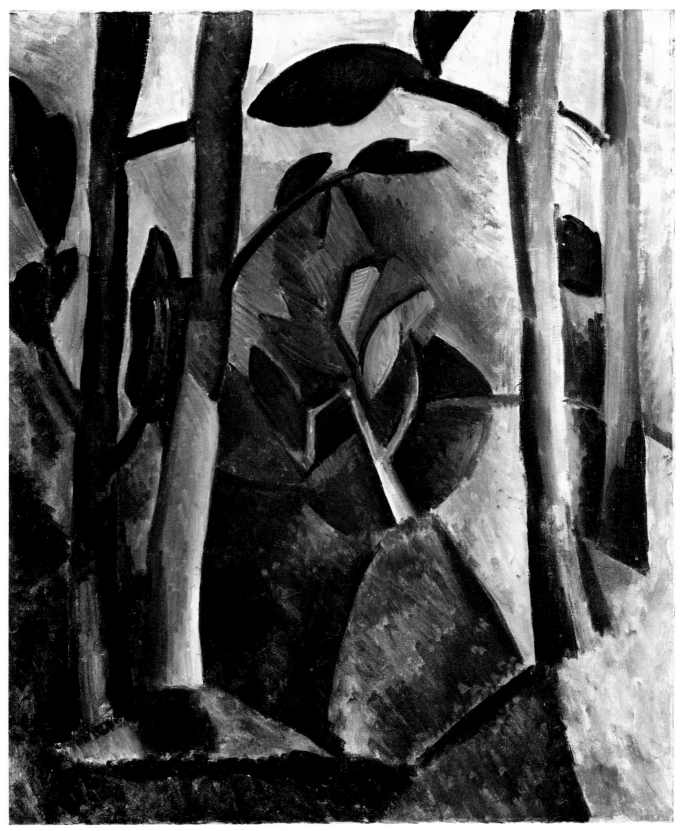

Pablo Picasso. *Landscape.* La Rue des Bois, August–September 1908
Oil on canvas, 28⅞ x 23¾ in (73.4 x 60.3 cm). Collection André Meyer, New York

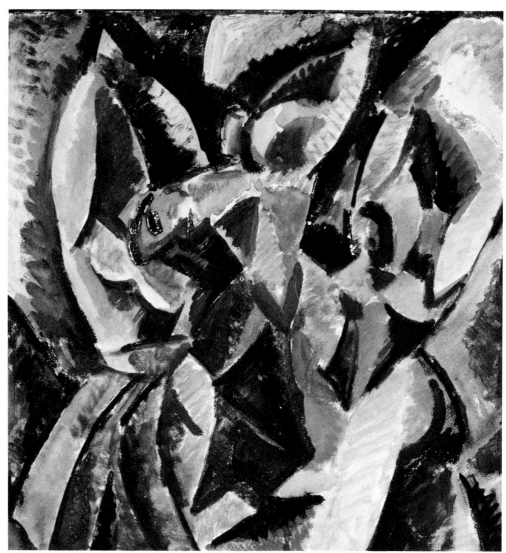

Pablo Picasso. *Three Women.* Spring 1908. Gouache on paper, 20⅛ x 18⅞ in (51 x 48 cm)
Centre National d'Art et de Culture Georges Pompidou, Musée National d'Art Moderne, Paris

During the fall of 1908 Picasso spent much of his time at work on *Three Women,* a monumental canvas that represented his most important statement since the *Demoiselles,* with which "historically," as Fry observes, "it bears a symmetrical relation" and "by comparison with which it is more successful, and unified, though less ambitious."[121] This great picture, Picasso's largest and most important of 1908, is notable for its absence from the literature on Cubism until about a decade ago. The oversight is hardly explained by the fact that the painting has been in Russia since its purchase by Schoukine from Gertrude Stein in 1913. Many other Russian Picassos (and Matisses) were much reproduced and written about in the West, and reproductions of *Three Women* as well as many of its preparatory drawings and gouaches have been readily available since 1942 in Zervos.[122]

The first discussion of the picture in any major book on Picasso or Cubism appeared only in 1966 in Fry's *Cubism.* Its absence from earlier books causes the treatment of the first years of Cubism to be out of balance in the accounts by Barr, Penrose, Golding, and Rosenblum, to say nothing of those of Habasque, Chipp, Descargues, Fosca, and Cabanne.

Zervos, on the basis of Picasso's advice, assigned *Three Women* and its studies to the last months of 1908—i.e., after the artist's late summer sojourn at La Rue des Bois. But as Daix's forthcoming catalogue raisonné will show, the sketches and the Centre Pompidou gouache unquestionably belong with a series of related works that can securely be placed in spring and early summer, when Picasso was still in Paris. As it was entirely contrary to Picasso's practice to develop such drawings and

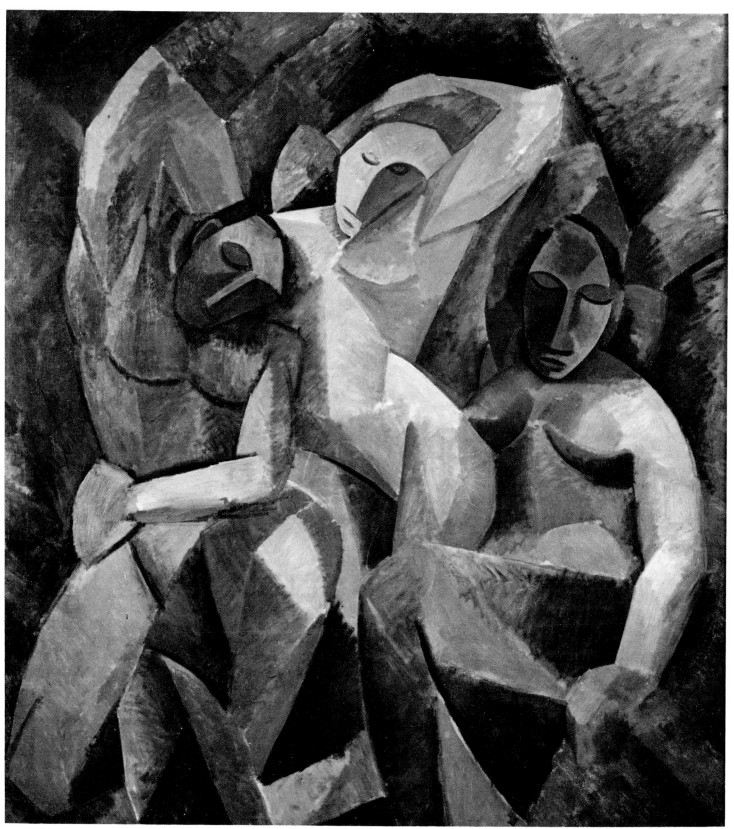

Pablo Picasso. *Three Women*. November 1908–January 1909. Oil on canvas, 78¾ x 70½ in (200 x 179 cm). The Hermitage Museum, Leningrad

Fernande Olivier and Dolly van Dongen in Picasso's studio. Autumn 1908
Courtesy Mlle Dolly van Dongen, Paris

André Salmon in Picasso's studio. Early summer 1908
Photothèque Hachette, courtesy Galerie Louise Leiris, Paris

gouaches for a large oil and then to leave on vacation without executing it, Daix had also originally planned to push the date of the large canvas back to June–July.[123]

Daix's proposal had one major drawback, however. This was the fact that by eliminating a chronological gap between the large oil and its major studies—such as the Centre Pompidou gouache—he was removing the primary explanation for the considerable stylistic difference between them. With few exceptions, these studies are "African" works, characteristic of Picasso's production during the year that followed the *Demoiselles;* the most developed among them present brashly contrasted colors articulated by energetically brushed striations.[124] The large oil, on the other hand, is executed in a very controlled manner, its relatively subtle facture and gradation of tones fostering a smooth linkage of planes. This highly developed *passage,* and the total consistency of the illusory bas-relief space it makes possible, is not to be found in any work of Picasso that can be securely identified with the months prior to or during his vacation at La Rue des Bois.

I believe we can resolve this apparent contradiction by refer-

ence to a document which makes it clear (at least to my satisfaction and that of Daix) that Picasso did, in fact, execute *Three Women* prior to going on vacation at La Rue des Bois—but in the African style of the Paris study. Hence the picture we see today represents a sweeping reworking of the image, which would have been largely carried out, as Picasso indicated to Zervos, late in 1908.[125] The document in question is a photograph that shows André Salmon in Picasso's studio in front of *Three Women.*[126] A close look at this photograph reveals that the large painting behind Salmon does not conform to the present *Three Women* but resembles, on the contrary, the African-style studies. The woman at the left in the Salmon photograph— whose ancestors go back to the second figure from the left in the *Demoiselles*—has bright, striated drapery over her right thigh; striated patterns (probably yellow, if we judge by the Paris study) of a type that recall the postludes to the *Demoiselles* are clearly visible in the background between the figure and the edge of the canvas; above her head is a light area which conforms to the bright green patch at the top of the Paris study and presents, in relation to its neighboring planes, the marked con-

trasts of value that must have characterized this "Salmon version."

In working toward the painting we see now, Picasso retained the masklike faces but gradually eliminated the salient African characteristics, such as the *strappato* striations and the bright color contrasts. The latter gave way to a smoothly graduated surface of muted green and terra-cotta planes whose very close light values permit them to pass easily into one another. Compare, for example, the raised and bent right arm of the figure we have been discussing in the Salmon photo to its reworked version in the final painting. In the former, the right-hand plane of the upper arm, which is in shadow, is much darker than its adjoining planes, and it is totally demarcated from them by a firm edge. In the work as we see it today, that plane is only slightly darker than its neighbors, into which it now blends imperceptibly toward its top. By the same token, the space enclosed by the arm and head, which must have been brightly colored at the time of the Salmon photograph, has become a dull green whose value hardly differs from that of the planes of the terra-cotta arm and shoulder.

What all this spells out is a composition conceived within a consistent system of *passage*—a step-wise linkage and fusion of close-valued planes in a shallow, bas-relief space. As nothing in Picasso's work during the first nine months of 1908 may be similarly described, I cannot escape the conclusion that what intervened here, what influenced the change in style that followed from Picasso's decision to rework *Three Women* in the fall of 1908,[127] was the experience of seeing the Estaque Braques. The nature of Picasso's painting at La Rue des Bois suggests his readiness to appreciate and assimilate Braque's message. But those paintings demonstrate only a primitive and inconsistent grasp of Cubist syntax as compared with that in *Three Women*.

Picasso apparently worked on *Three Women* on and off until at least the end of 1908 and probably a bit longer. An interesting photograph of Dolly van Dongen on Fernande Olivier's lap in front of *Three Women* shows the painting in a state not far from that of the Salmon photo; this was probably taken just after Picasso had begun to rework the canvas,[128] having already washed much of it down with turpentine.[129] As we see it there, the ornamental African elements are gone, but the demarcation of planes and the light-dark contrasts of the chest, head, and raised arm of the figure on the left are much the same as in the Salmon photograph (except that the contour of the chest has been changed from an angular, straight edge to the definitive shallow curve). On the other hand, the planes in the lower center of the picture anticipate their final state, though they are less "analyzed" and less close in value than they were to become.

It is significant that Picasso's elimination of most of the African attributes from *Three Women*—they disappear from other works of late 1908 as well—coincided with a renewed Cézannism and with the adoption of a Cubist syntax related to that of Braque (although in this respect Braque's painting remained more evolved until the summer of 1909).[130] By the time Picasso's art became fully Cubist, in the pictures executed at Horta,

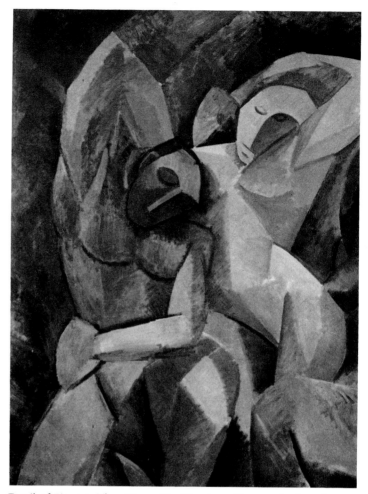

Detail of Picasso's *Three Women*. The Hermitage Museum, Leningrad

the influence of primitive sculpture had disappeared entirely; it would reappear only with the end of Analytic Cubism in 1912, in connection with the early construction sculptures and the transition of Picasso's painting into Synthetic Cubism. Braque's work, on the other hand, had all along been devoid of references to African sculpture. "Unlike Picasso," as Golding wrote, "Braque did not see in African art an answer to some of the problems of contemporary painting. Although many years later Braque recalled how strong an impression Negro art made on him, it is hard to see any direct reflection of this in the paintings executed at the time when Picasso was reacting so positively to African sculpture."[131]

Braque's lone statement about African art was made in 1954 in response to a question by Dora Vallier: "Negro masks," he is quoted as saying, "also opened a new horizon for me. They permitted me to make contact with instinctive things, direct manifestations that ran counter to a false traditionalism which I abhorred."[132] Although this is often quoted in a context that implies a direct influence of African art on Braque's work,[133] what Braque actually said testifies rather to the satisfaction that

he (like most other early twentieth-century artists) took in primitive art as a conceptual endeavor at odds with post-Renaissance Western traditions—in effect, an *art autre.* Braque's remark reflects an attitude toward the primitive which began to flower in the nineteenth century but has roots in French letters that go back to Montaigne, who compared his own culture unfavorably with that of "cannibals." Meyer Schapiro aptly characterized this late nineteenth-century French syndrome (which Gauguin tried mimetically to realize) as the "myth of a primitive"—a belief that there resided a superior spontaneity, energy, and sincerity in the ethos of the indigenous peoples. The fascination with the primitive continued into the early twentieth century, but by then interest (at least among artists) had focused on the plastic quality of "Negro" sculpture (African was not distinguished from Oceanic)[134] apart from its value as cultural symbol or ethnographic index.

Numerous instances of the influence of African and Oceanic art have been cited in the work of the Fauves and German Expressionists. And it has traditionally been assumed that the direct influence of this art on early Cubism was even greater. Only Kahnweiler has consistently argued against this thesis. While he allowed for an affinity in the two arts based on the Cubists' manifest interest in primitive sculpture, he found it necessary to "dispute the validity of the thesis of a direct influence [at that time] of African art on Picasso and Braque." What happened, he continued, was "a phenomenon usual at the beginning of a break with the existing tradition: We try to reassure ourselves by finding elsewhere, in time and space, confirmation of the new trends we adopt." Thus the role of "essentially conceptual" African art for Kahnweiler was to "corroborate the thought of the Cubist painters."[135] He detects a direct influence on Picasso only in 1912, in connection with the latter's first constructions and collages and his transition into Synthetic Cubism; he mentions no influence of primitive art on Braque.

Kahnweiler's position—unquestionably a form of "special pleading" on behalf of Picasso, who denied the influence of African art on the *Demoiselles*[136]—has been almost universally rejected in the literature. Most commentators quite justifiably see an influence of African art in the *Demoiselles* and in Picasso's work of the year following. Where they go wrong, it seems to me, is first in identifying this influence as fundamental to the formation of Cubism, and second in characterizing the African and Cézannist influences in Picasso as simultaneous, when they were, in fact, essentially consecutive. For this reason, it seems to me necessary to modify the widespread belief that African art played a role comparable to that of Cézanne in the formation of Cubism. In the *Demoiselles,* those constituents associated with African art stylistically oppose rather than fuse with any Cézannist proto-Cubism that may be isolated in the work. In the year that followed, Picasso was almost entirely caught up in African influences, but there is virtually nothing Cézannist in the pictures of this period. In the course of translating suggestions taken from African sculpture into his paintings of 1907–08,

Picasso had made a revolutionary break with perception-based, illusionist nineteenth-century art; but the scaffolding of these pictures is still far from Cubist.

When Cézannism reentered Picasso's work in the proto-Cubism of La Rue des Bois, and, even more, in *Three Women* and the other works of late 1908, it effectively *displaced* African art, whose stylizations and morphologies were squeezed out even as the pictorial structure shifted from a context oriented toward sculpture in the round to one implying bas-relief. The "vitalism" that had animated Picasso's typical African paintings gave way to a more controlled and orderly spirit in greater harmony with the Cézannist heritage. Those "barbaric" energies still evident in the Paris sketch and apparent in the Salmon version of *Three Women* are more contained in the final revision—transmuted, as it were, from an aggressive into a pacific state through Picasso's submission to a Cubist discipline.

The influence of Cézanne on Picasso was sporadic up to autumn 1908 and was always coexistent with that of other sources ranging from Iberian sculpture to Rousseau's painting. Cézanne was never, to be sure, to play quite the role in Picasso's evolution that he did in Braque's. Nevertheless, Picasso's work of the winter of 1908–09 shows a marked increase in the absorption of Cézannian elements, and a rather consistent Cézannism emerged during the spring of 1909 just as his painting began to come into alignment with that of Braque and the acquaintanceship between the two ripened into friendship.

Whereas previously Picasso had adopted from Cézanne a figure's posture, the flattened ellipse of a bowl, or a high horizon line—all useful technical discoveries—his deeper, broader Cézannism of 1909 reflected a more integral awareness of Cézanne's work and a sense of affinity with a certain aspect of the man. Braque was committed to Cézanne the modest artisan struggling to find his voice through single-minded dedication; but he also was committed to Cézanne the architectonic "classical" painter of French tradition. Picasso became attached to precisely that "flaw" in Cézanne's classicism which makes his art truly modern, namely, his malaise—the tremor we detect behind even the most outwardly calm and apparently stable of Cézanne's compositions. "It's not what the artist does that counts, but what he *is,*" Picasso told Zervos. "What forces our interest is Cézanne's anxiety"[137]—a statement not surprising from a painter himself described by his friend and biographer Roland Penrose as having "always been assailed by the demons of perpetual doubt."[138]

At the heart of Cézanne's disquiet—or at least that aspect of it which is most readily located in his work—was his anxiety over "realization," his doubt about his ability to complete the individual picture, and more broadly, to realize his aims in his work as a whole. The unfinished state of many of Cézanne's paintings, particularly those of his later years, bears witness to this anxiety. Picasso's exploration of a new definition of "finish"—in part forced upon him by his own problems of realization—became for him an opening into Cézanne's oeuvre and an aspect of a

special bond between the two painters. This syndrome did not come into play for Braque, in whose appreciation of Cézanne integrity—in the literal as well as metaphorical sense—was an important factor.[139] It is therefore not by accident that the nominally unfinished Cézannes should inflect the history of Cubism specifically through Picasso's work—at just the time (1909) when Picasso's interest in Cézanne had deepened.[140]

Art historians are often too prompt in taking painters at their own word. Thus we sometimes tend to read into Cézanne's pictures more of a problem with realization than the work itself necessarily presents.[141] Cézanne felt compelled late in life to theorize about his work, and I suspect his frequent expressions of anxiety over "realization," like certain contradictions in his writings (and between his theory and practice), resulted in part from an inability fully to perceive—and certainly to verbalize— the wide-ranging implications of his own painting. Thus, while Cézanne's complaints were certainly true to the man, we should not necessarily read them into the work. The autonomous planes and unpainted "breathing spaces" in such late pictures as the Zurich *Mont Sainte-Victoire* (pl. 124), for example, are perfectly understandable at our remove in terms of the organic unfolding of Cézanne's late style. Cézanne nevertheless felt compelled to excuse the white intervals among the planes by suggesting that they derived from visual difficulties related to age.[142] The fact was rather that his art had carried him beyond the point where he could verbally rationalize the gap in the conflicting demands of *realisation sur nature* and the consistency of his painting in its own terms. Picasso's explicit acceptance of the non-finito as a systematized component in finished paintings—made possible by dropping any demand for "truth to nature"—can throw some light retroactively on the early state of this innovation as we see it in Cézanne. The logic of the continuity between the two artists is in no way altered by the fact that Cézanne himself, so far as we know,[143] considered pictures containing unpainted canvas or mere underpainting incomplete. While Picasso was the first consciously to emphasize the painting process as an experience for the viewer, it was Cézanne's new way of composing a painting that made the drama of pictorial integration—the mosaic of decisions that determine its *becoming* a work of art—a subject for art itself. Renoir had said that Cézanne "could not put two spots of color on a canvas without its already being very good."[144] Picasso amended this by saying "without its already being a picture."[145]

We must approach the question of finish in Cézanne keeping in mind the fact that few if any artists are entirely conscious of their enterprise, and therefore of the manner in which the changing directions in their art may transcend the frames of reference imposed by their moment in time. There is no question, of course, that many of the works that Cézanne left partially unpainted simply went wrong. But the evidence of my eyes in respect to such paintings as The·Museum of Modern Art's *Still Life with Apples* (pl. 147), to take a convenient example, leads me to the opinion that there are also many

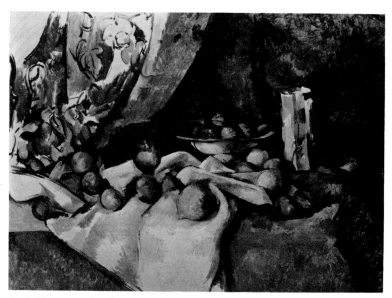

Paul Cézanne. *Still Life with Apples.* (pl. 147). 1895–98. Oil on canvas, 27 x 36½ in (68.6 x 92.7 cm). The Museum of Modern Art, New York, Lillie P. Bliss Collection

nominally unfinished paintings from the last years of Cézanne's life on which the artist simply stopped working when the structure had arrived at the point where a further mark upon the surface might have taken more away than it could add.

While Cézanne himself, consistent with his conservative attitudes in general, appears to have judged these canvases from the point of view of received notions of finish, I would suggest that he had intuited, quite without being able to interpret or define, a new and autonomous concept of finish—one that in its essentially twentieth-century character differed even from the non-finito of Impressionism. The Impressionists had only partially disengaged the question of finish from a standard outside the picture (i.e., nature), locating it primarily in style—the even flicker of light and the allover molecular texture that we demand of an Impressionist picture.[146] Cézanne, it seems to me, proposed in *all* his mature painting—though not in his philosophy—a more self-contained idea of finish, in which the integrity of the composition alone is the determining standard.

In his later years, under the influence of the very particular non-finito that watercolor permits and indeed abets, Cézanne quite evidently began thinking of the unpainted surfaces in his oil paintings somewhat differently than he had previously. As watercolor requires the white surface of the paper to function throughout the field—i.e., behind the transparent color—as part of the composition and not merely as a support, Cézanne was able, as Reff points out in the present volume, to accept unpainted areas in that medium without disturbance to his received views on the unity of style. The question naturally arises as to how much carry-over there was from Cézanne's watercolors—a central medium for him only in the latter part of his life—to his oil paintings. It is, I think, possible to exaggerate

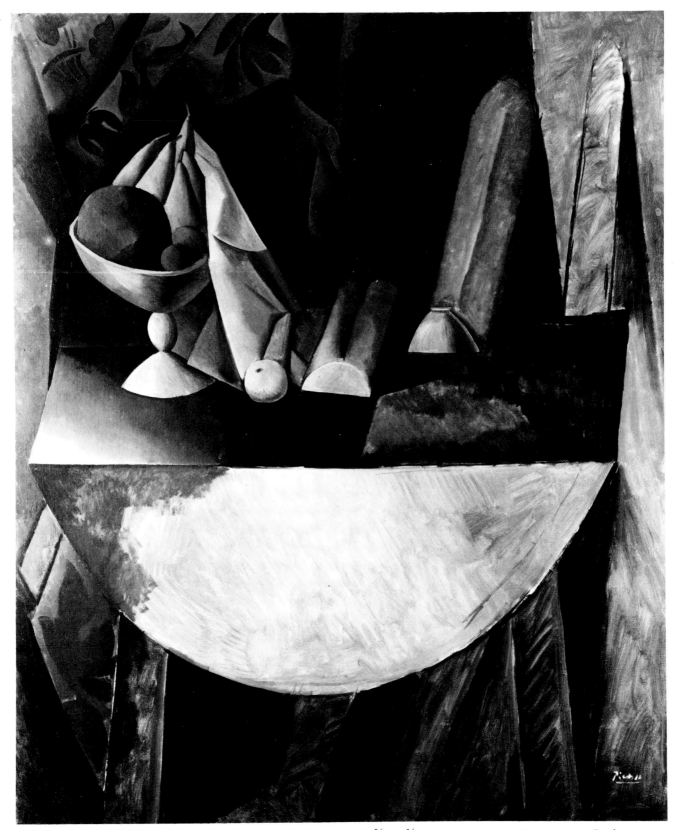

Pablo Picasso. *Bread and Fruit Dish on a Table*. Early 1909. Oil on canvas, 64⅝ x 52¼ in (164 x 132.5 cm). Kunstmuseum, Basel

this carry-over, which Cézanne himself did not acknowledge in any case. Nevertheless, aspects of some of the later oils—among them their transparency and certain patterns in the brushwork—are almost universally considered by scholars as having their origin in watercolor, and I feel that this carry-over included the function of unpainted areas.

In *Still Life with Apples,* Cézanne ceased work at a point when much of the surface was still unfinished as defined by any traditional meaning of the word. The range of handling in this image passes from the highly developed modeling of the most prominent fruit through the rudimentary modeling exemplified by the apple at the apex of the group at the left, to the fragmentary contouring and toning in the curtain, to the underpainting of the background and much of the tablecloth, and finally to the significant areas of surface that are entirely unpainted. The "incompleteness" does not, to my eye, detract from the picture. On the contrary, the gamut of unfinishedness forms a hierarchy of its own that is integral to the structure of the work.

Picasso's magnificent *Bread and Fruit Dish on a Table* of early 1909 provides an instructive comparison. The largest Picasso of 1909 and, in my opinion, the best, *Bread and Fruit Dish* has, despite its reproduction in Zervos, suffered the same mysterious neglect as *Three Women* and is absent from almost all major accounts of Picasso or Cubism from Barr onward. Picasso's conscious and constructive use of the non-finito in this painting, which he released to Kahnweiler from his studio and which he signed,[147] seems to me unquestionably to attest his experience of Cézanne—whose work, at the very least, provided a "sanc-

tion" for it. While *Bread and Fruit Dish* contains no wholly unpainted canvas, Picasso did admit that possibility into his work not long afterward in a few paintings such as *Carafe and Candlestick,* which were influenced by the configurations of Cézanne's watercolors more than by those of his oils.

Though *Bread and Fruit Dish* was probably completed shortly after *Three Women,* its syntax is relatively less evolved and it is willfully eclectic.[148] Its bare Cubist scaffolding is reinforced by a Cézannist high perspective (which tends to align the plane of the tabletop with the frame) and a few Cézannist "displacements" (such as the discontinuous depth of the table's rear contour), while the composition retains the frontality and monumentality of its 1908 origin in *Carnaval au bistrot,* itself somewhat influenced by Cézanne's largest *Cardplayers.*[149] The Cézannist structure of *Bread and Fruit Dish* is nevertheless made to accommodate the tightly modeled, simplified fruit and bowl, whose forms—like the saturated green of the drapery behind them—derive more from Rousseau's painting than from Cézanne's. The resultant duality in no way diminishes the picture, however. Indeed, Picasso embeds his contrast of sources into the work quite consciously by reinforcing it with the polarity he establishes between the finished and seemingly unfinished. Thus the three loaves of bread (beginning left to right) pass from a smooth finish to rough modeling to underpainting. To be sure, the extremes of facture in *Bread and Fruit Dish* go beyond those of the partially finished Cézannes. What Cézanne himself considered proper finish was looser and more Impressionist-derived than the tight modeling Picasso adopts here from Rousseau (who had once said of Cézanne, "I could finish his pictures"—and he didn't mean the unfinished ones).

Georges Braque. *Port in Normandy.* Early 1909. Oil on canvas, 32 x 32 in (81 x 81 cm). The Art Institute of Chicago, Samuel A. Marx Purchase Fund

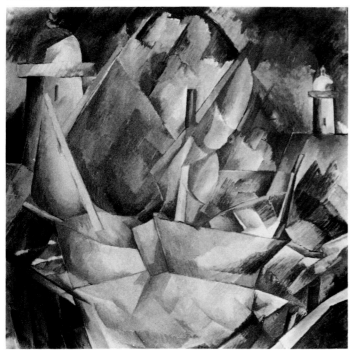

Pablo Picasso. *Landscape at Horta.* Summer 1909. Oil on canvas, 25⅝ x 32 in (65.1 x 81.3 cm). Collection Nelson A. Rockefeller, New York

Georges Braque. *Château of La Roche-Guyon.* Summer 1909. Oil on canvas, 31½ x 23⅜ in (80 x 59.5 cm)
Moderna Museet, Stockholm, gift of Rolf de Maré

Fernand Léger. *The Bridge.* 1909
Oil on canvas, 36½ x 28⅝ in (92.7 x 72.6 cm)
The Museum of Modern Art, New York,
Sidney and Harriet Janis Collection (fractional gift)

Although the still life on the left of *Bread and Fruit Dish* is influenced by Rousseau in its drawing, modeling, and color, it may be linked to Cézanne, insofar as its reductiveness recalls the latter's admonition to "treat nature by means of the cylinder, the sphere, the cone." What Cézanne intended by this statement is not at all the call to abstraction it has been taken out of context to mean.[150] This simplistic and largely erroneous interpretation nevertheless took on a life—indeed, an historical role—of its own, and in the years prior to World War I influenced especially the lesser Cubists, who saw in it a sanction for their restrained and stylized aesthetic.

As this essay is consecrated to only the beginnings of Cubism, the important developments of the summer of 1909 are outside its scope. Suffice it to note that early Cubism reached its apogee then with Picasso's painting at Horta. Braque's work that same summer at La Roche-Guyon remained more consistently Cézannian than Picasso's, and more painterly; some images of the Château consist of little more than what in Cézanne would be considered underpainting. While in the painterliness of these pictures Braque anticipates High Analytic Cubism, he adds only an enhanced verticality to the pictorial syntax that he had previously established with *Houses and Trees* and *Harbor in Normandy.*

As Picasso and Braque were bringing early Cubism to its fulfillment, the third and last of the pioneer Cubists, Fernand Léger, was independently forging his own brand of Cubism in such pictures as *The Bridge.* Despite its tentativeness—especially in regard to color—this picture very successfully combines a geometrical reduction of landscape and architecture (which already reveals Léger's characteristic "peasant" simplicity and bluntness) with a *passage* of planes that shows how well he had been able to absorb and build upon Cézanne. Indeed, the knitting together of planes in *The Bridge* is so sophisticated, so elliptical in its relation to the Cézannian model, that it is hard to believe that Léger had not by this time profited from seeing the 1908–09 paintings of Braque or Picasso. Yet Léger—who was not given to making claims on his own behalf—maintained that his first contacts with these or any other Cubist paintings came only a year later, in 1910, and his assertion has been accepted by most of the close students of his work.[151] With the 1909 Légers, we arrive at the last important abstract pictures that may be said to have come directly out of Cézanne; as I observed at the outset, the Cézanne influence of the subsequent years cannot be disengaged from that of Cubism itself, in the sense that the experience of Cubism has altered the way we see Cézanne.

During the period on which I have focused in this essay—summer 1907 to autumn 1908—Picasso's and Braque's art remained essentially independent of one another despite some influence of Picasso on Braque in late 1907 and what I consider a more significant influence of Braque on Picasso in late 1908. As the friendship between the two matured, the crossover of

Pablo Picasso. *Carafe and Candlestick.* Autumn 1909. Oil on canvas,
20⅞ x 28 in (53 x 71.1 cm). Collection E. V. Thaw & Co., Inc, New York

ideas and influences multiplied, so that by the autumn of 1909
Cubism had indeed become a "joint creation"; as of winter, it is
impossible to separate the roles of the two painters. Although
certain inventions in Cubism after that can be attributed to one
or the other painter (e.g., collage to Picasso, *papier collé* to
Braque), their respective contributions to the organic, day-to-day
evolution of the style will remain forever inseparable. "We saw
each other every day and talked a lot," said Braque of those
years, "and things were said between us that will never be
repeated . . . that no one would understand now." "We were,"
he added, "like two mountain climbers roped together."[152]

I believe that Braque would have created early Cubism had
Picasso never existed, and that his commitment to a Cézannist
syntax kept his painting more stylistically unified and more
advanced in the direction of what proved to be High Analytic
Cubism than Picasso's until at least the summer of 1909. This
said, I return to my judgment that the Picassos of 1907–09, their
frequent eclecticism notwithstanding, are stronger paintings.[153]
The range and robustness of Picasso's plastic imagination, sym-
bolized by that very eclecticism, became a propellant for the
Cubism of 1909. What might have been a narrow enterprise in
the hands of Braque alone was lifted to heroic heights.

Only during the High Analytic period of 1910–12 can
Braque's pictures hold their own next to Picasso's in terms of
pure quality. This follows, I believe, from the fact that in
passing from a sculptural to a painterly phase, the movement
had finally aligned itself with Braque's greatest gifts and, in so
doing, had recapitulated the development that took place in
Cézanne's painting during the last years of his life. Braque
could never have competed with Picasso as a sculptural painter;
place even his early 1909 *Port in Normandy* next to *Bread and
Fruit Dish* of the same period and it gets blown off the wall by

the Picasso—not by virtue of the latter's size, but by its plastic
intensity. This sculptural power reflects Picasso's definition of
Cubism as an art "of *forms*." Braque had, from the beginning,
defined it as "a materialization of a new *space*"—and the trans-
parencies made possible by the dissolution of solid forms in
High Analytic Cubism directly served Braque's interests, so that
pictures such as his *Portuguese* fully hold their own next to the
best 1911–12 Picassos.

Braque's formation of a syntax for Analytic Cubism was the
basis on which, beginning in 1909, he was able to engage
Picasso in a probing four-year dialogue of a kind that Picasso—
to judge by his personality and habits over the rest of his
career—was instinctively inclined to avoid. The reflective, medi-
tative character of the Analytic Cubism of those years, its search-
ing, metaphysical quality, is alien to Picasso's art both before
and afterward, though it is consonant with the spirit of both
Cézanne's and Braque's enterprises. It may therefore be no
exaggeration to say that we owe many of our greatest Picas-
sos—those of High Analytic Cubism—to Braque's ability to get
the Spanish master patiently to explore the depth of the syntax
which was their common heritage from Cézanne. Later Picasso
would show just how broad and elastic this syntax could be by
putting it in the service of morphological and expressive inter-
ests of which neither Cézanne nor Braque had ever dreamt.

Photo by Braque of Picasso in Braque's army uniform. 1909
From Sabartès, *Picasso: documents iconographiques*

Photo of Braque and Picasso. Courtesy Jean Masurel, Paris

NOTES

1. The 1895 exhibition, for which there exists no catalog or inventory, contained, according to Ambroise Vollard (*Paul Cézanne* [Paris: Galerie A. Vollard, 1914], p. 58), some 150 works, presumably shown in rotation (see John Rewald, *Cézanne, Geffroy et Gasquet* [Paris: Quatre Chemins–Editart, 1959], p. 17), and was thus the largest Cézanne exhibition—including the memorial retrospective at the 1907 Salon d'Automne—until 1926.
2. Matisse purchased Cézanne's *Three Bathers* (Venturi 381), which he later gave to the Museum of the Petit Palais, from Vollard, who asked 1,300 francs for the picture—a quite high price for the time and one for which the relatively impecunious Matisse had to make real sacrifices. He offered Vollard 300 francs down payment toward the purchase of the canvas and of an original plaster bust by Rodin, for which the price was only 200 francs. The remaining payments were to be made within a year. The influence of *Three Bathers* may be seen in numerous paintings by Matisse, for example, the *Bathers with a Turtle* (1908) in the St. Louis Art Museum.

Just when Matisse had his first contact with Cézanne's painting is open to some doubt. At one point Matisse said that he had not seen any Impressionist or Post-Impressionist painting until the showing of the Caillebotte bequest at the Luxembourg in 1897. (Reported in Jacques Guenne, "Entretien avec Henri Matisse," *L'Art vivant* 1, no. 18 [September 15, 1925], p. 4.) Later he remembered seeing Impressionist painting somewhat earlier at the Durand-Ruel gallery. (Alfred H. Barr, Jr., *Matisse: His Art and His Public* [New York: Museum of Modern Art, 1951], p. 16, note 4.) Dominique Fourcade ("Autres Propos d'Henri Matisse," *Macula* 1 [1976], p. 95) cites Frank Harris' account (in French trans.) of his interview in 1921 with Matisse—published as "Henri Matisse and Renoir" in *Contemporary Portraits* (New York: Brentano's, 1923)—in which Matisse reported to Harris that what he really enjoyed while he was a student at Gustave Moreau's studio and was copying at the Louvre, "c'était lorsque je quittais le Louvre, et que je courais rue Laffitte, à la boutique de Durand-Ruel, où je pouvais me remplir l'oeil des Cézanne et des autres impressionnistes, et ainsi compléter ma vue de la croissance de l'art jusqu'à notre temps." Alexander Romm (*Henri Matisse*, trans. from the Russian by Chen I-wan [Ogiz-Izogiz, 1937], p. 19) reports that "Lenaret" (the painter Georges Linaret), who was a student of Moreau and an acquaintance of Matisse, bought two oils by Cézanne, which he subsequently brought to Moreau's studio.
3. Robert Delaunay saw Cubism as growing directly out of Cézanne's water-

colors: "Cézanne et Renoir ont été les précurseurs [du cubisme]—mais cependant Cézanne surtout a perçu des horizons nouveaux auxquels sa vie de peintre troublé et inquiet n'a pas suffi pour trouver les moyens de les aborder. Cependant, dans les dernières aquarelles de Cézanne, quelle limpidité tendant à devenir une surnaturelle beauté en dehors du déjà-vu . . . La révolution, c'est la brisure, déjà entrevue dans le compotier de Cézanne et dans ses aquarelles." (*Du cubisme à l'art abstrait*, ed. Pierre Francastel and Guy Habasque [Paris: S.E.V.P.E.N., 1957], pp. 58, 97.) It is not unlikely that Delaunay spoke about this to Apollinaire, with whom he was closely allied in 1912, and who asserted in *Les Peintres cubistes*, published in March 1913—ed. Leroy C. Breunig and J.-Cl. Chevalier (Paris: Hermann, 1965), p. 58—that "the last pictures of Cézanne and his watercolors belong to Cubism." Nevertheless, even Delaunay's Window pictures, which are those that most relate in their transparency to Cézanne's watercolors, depend for their syntax on Braque and Picasso—a dependency more marked in the Eiffel Towers and other works.
4. The characterization used by John Russell, *G. Braque* (London: Phaidon, 1959), p. 9, and repeated by Douglas Cooper, *The Cubist Epoch* (London, Los Angeles, New York: Phaidon, 1971), p. 27.
5. Of the various dates suggested for the cessation of Picasso's work on the *Demoiselles*, that of early summer 1907 has always appeared to me most satisfactory. In view of the research of Pierre Daix, whose catalog of Picasso's Cubist art will appear shortly, this date no longer seems to me disputable. (Pierre Daix, *Le Cubisme de Picasso: catalogue raisonné de l'oeuvre peint, des papiers collés et des assemblages, 1907-1916* [Geneva: Ides et Calendes, to be published Fall 1977].)

By "confirmation of Matisse's personal style" I am referring to the transition from the later Fauve pictures with their still broken brushwork to pictures containing more cloisonné patternings—the difference, roughly speaking, between the two versions of *Le Luxe* and of *The Sailor*.

As we shall see, the crucial phase of Braque's passage into the early Cubism of *Houses and Trees* took place at L'Estaque over a period of about four months, from May to September 1908, and it is impossible to designate a precise moment when the pictures cease to be primarily Cézannist and pass into what we would call Cubism. But it is clear that by the end of July 1908 Braque was painting such pictures as *Trees and Viaduct*, which are generally recognized (see below) as examples of "Cubism proper."
6. *La Jeune Peinture française* (Paris: Société des Trente, 1912), pp. 42, 46. In 1920, Salmon situated "the revelation" of Cubism around 1908, that is to say, the year following the painting of the *Demoiselles*. He added, however, that Picasso had been "preparing it [Cubism] without being aware of it" (*sans y trop songer*). (*L'Art vivant* [Paris: Grès, 1920], p. 112 and footnote.)
7. *L'Art vivant*, p. 112.
8. *The Rise of Cubism*, trans. Henry Aronson (New York: Wittenborn, Schultz, 1949), p. 7. Translated from *Der Weg zum Kubismus* (Munich: Delphin-Verlag, 1920). The first, incomplete version was published as "Der Kubismus" in *Die Weissen Blätter* 3 (Zurich-Leipzig), no. 9 (September 1916), pp. 209-22.
9. "Interview with Picasso" (December 2, 1933), *Le Point* 42 (Souillac), October 1952, p. 24.
10. *Juan Gris: sa vie, son oeuvre, ses écrits* (Paris: Gallimard, 1946), p. 145.
11. *Picasso: 40 Years of His Art* (New York: Museum of Modern Art, 1939), p. 70, and *Picasso: 50 Years of His Art* (New York: Museum of Modern Art, 1946), p. 56.
12. *Masters of Modern Art* (New York: Museum of Modern Art), p. 82.
13. Musée National d'Art Moderne, Paris, November 4, 1960-January 23, 1961, p. 185, cat. no. 552.
14. *Theories of Modern Art* (Berkeley and Los Angeles: University of California Press, 1968), p. 266, note 1.
15. *La Naissance du cubisme, Céret 1910* (Gap: Ophrys), p. 17.
16. *Cubism and 20th Century Art* (New York: Abrams), p. 25 (italics mine).
17. *Cubism: A History and Analysis, 1907-14*, 2nd rev. ed. (London: Faber and Faber, 1968), p. 47. (1st ed., 1959.)

Five years after the publication of Golding's book, Daniel Robbins, in his monograph on Albert Gleizes, called for outright rejection of "our habitual concept of Cubism, controlled by the study of Kahnweiler," with all the

emphasis this put on the *Demoiselles*. His aim in this, however, was not to clarify the relation of that picture to the subsequent work of Picasso and Braque, but rather to move the whole development of these two artists from the center of the Cubist stage, in order to emphasize the role of Gleizes, Metzinger, Delaunay, Villon, and Le Fauconnier. (*Albert Gleizes, 1881–1953* [Paris: Musée National d'Art Moderne, 1965], p. 19.)

18. P. 24.

19. "The Philosophical Brothel," published in two parts in *Art News* 71, no. 5 (September 1972), pp. 22–29, and no. 6 (October 1972), pp. 38–47.

20. "The Demoiselles d'Avignon Revisited," *Art News* 72, no. 4 (April 1973), pp. 45–48.

21. P. 29.

22. P. 66.

23. *G. Braque,* catalog, Royal Scottish Academy, Edinburgh, and The Tate Gallery, London, 1956, p. 29.

24. Nicole Mangin, who has published six volumes of a catalogue raisonné of Braque's painting covering the years 1924 to 1957, has gathered reproductions of a certain number of works of 1907–08 that do not appear in either Kahnweiler's photographic albums (not all photographs of which have been published) or any other sources for work on Braque. Mlle Mangin, who has not specialized in the works of the Cubist period and has not yet ordered those works to her satisfaction, has generously permitted me access to her files. In discussing with me her views on these works, she has indicated Braque's own recollection of the dates of pictures, given to her verbally during the last years of the painter's life.

For the student of art history, the problem with the Braque literature is that the same pictures of 1907 and 1908 tend to be reproduced in almost all publications, while many of the other pictures—even those for which photographic records, provenances, etc., exist—are rarely if ever reproduced. Thus, for example, *Houses and Trees,* in the Rupf Collection of the Bern Museum, has been reproduced hundreds of times and has become a virtual symbol of all the work that Braque did at L'Estaque, while the smaller first version of that picture is hardly known.

In his "Georges Braque" (*Orbes,* no. 3 [Spring 1932], pp. 79–94, 96–97), the journalist George Isarlov published a sketch for a catalogue raisonné of the paintings. He seems, however, to have used little more than the photographs and information as to sizes available in the Kahnweiler albums. Some of his dates are patently wrong, some of the sizes are inaccurate, and the similarity and repetition of Braque's motifs evidently created confusion. Isarlov was totally unaware of *Landscape with Houses* (discussed below) and other works dispersed prior to his work on Braque. Though we must presume he had some access to the artist in establishing his dates, it is impossible to believe, given the inaccuracies and omissions of his list, that Braque granted him much time or thought. Nevertheless, it is the only thing resembling a catalogue raisonné that has ever been published on the work of Braque's Fauve and Cubist years.

25. Daniel-Henry Kahnweiler with Francis Crémieux, *My Galleries and Painters* (New York: Viking, 1971), p. 39. Translated from *Mes Galeries et mes peintres* (Paris: Gallimard, 1961) by Helen Weaver. Earlier reported by Kahnweiler in "Du temps que les cubistes étaient jeunes," *L'Oeil,* January 15, 1955, p. 28. A celebrated variant of this oft-quoted remark of Braque appears in Fernande Olivier's memoirs—written and published at a distance of several decades from the early years of Cubism—(*Picasso et ses amis* [Paris: Stock, 1933], p. 120): "Mais, finit-il [Braque] par répondre, malgré tes explications, ta peinture, c'est comme si tu voulais nous faire manger de l'étoupe ou boire du pétrole." Judith Cousins, Researcher of the Museum Collection, notes that in the form provided by Fernande Olivier, this remark was not specifically associated with the *Demoiselles* except by implication, as was also the case with an earlier version by Salmon (*L'Art vivant,* p. 123, note: "C'est comme si tu buvais du pétrole et mangeais de l'étoupe enflammée!"). Subsequently, however, it has been cited as representing Braque's response to his initial contact with the *Demoiselles,* not only in Kahnweiler (see above), but also in secondary sources such as Douglas Cooper (*G. Braque,* pp. 27–28) and Roland Penrose (*Picasso: His Life and Work* [London: Gollancz, 1958], p. 125), among others. It is the present author's suspicion that the remark was repeated by Picasso and

that he was largely responsible for its dissemination.

26. In the catalog *Georges Braque,* Musée de l'Orangerie, Paris, October 16, 1973–January 14, 1974: ". . . marque la conversion de pôle," p. vi.

27. *Cubist Epoch,* p. 27. Cooper's statement about the effect of the *Demoiselles* on Braque follows immediately upon the reference to Braque's having been "brought to Picasso's studio by Guillaume Apollinaire in the late fall of 1907." It therefore seems to me impossible to interpret this passage otherwise than that Braque made a decision to "renounce Fauvism" immediately upon seeing the *Demoiselles,* that Picasso was in the "lead" in the development of Cubism at the moment, and that from that moment (i.e., autumn 1907) the history of Cubism was a "joint creation."

All these assumptions seem to me either open to serious question or simply wrong. Cooper is aware and, indeed, has made clear elsewhere in his work that Braque had begun to renounce Fauvism before that time, and that pictures such as the *Terrace of the Hotel Mistral,* completed in early fall 1907, already show Braque having almost entirely left Fauvism behind (*G. Braque,* pp. 8, 27).

In this article I shall show that Braque had advanced significantly that fall even beyond the point marked by the *Hotel Mistral,* and that to speak of a renunciation of Fauvism in November or December 1907 following the Picasso visit is entirely misleading. While not questioning that the *Demoiselles* is far more radical than pictures Braque had painted in the fall of 1907, I am persuaded that the *Landscape with Houses,* published here for the first time, if not the *Hotel Mistral* itself, shows that Braque was clearly moving in the direction of Cubism before he met Picasso, and that *Landscape with Houses* reflects greater understanding of its structural principles than anything in the *Demoiselles.*

Finally, the phrase "joint creation" (recollected perhaps from Russell; see note 4, above) seems to me mistaken because Picasso and Braque saw relatively little of each other in the year following the *Demoiselles.* Their developments—with the exception of Braque's *Nude*—suggest little interaction until the autumn of 1908. Nothing resembling a "collaboration" between the two artists is evident until 1909, the period to which Kahnweiler assigns the beginning of their close relationship. Certainly, Picasso had no role in Braque's progression into the first examples of "Cubism proper" at L'Estaque from May until September 1908. Indeed, it should be observed that Cooper himself, in the summer 1908 entry of the chronological outline in *G. Braque* (p. 17), states: "Influence of Cézanne leads to first Cubist pictures."

28. See Golding, p. 21.

29. The works in the Kahnweiler sale, with a few exceptions, are not only undated but were auctioned in blocks that in no way related to their chronology.

Kahnweiler, somewhat contradictorily, has spoken of Braque's having developed his Cubism independently (*Rise of Cubism,* p. 8), while noting elsewhere Braque's having been influenced by the *Demoiselles,* which he describes as "the beginning of Cubism."

30. As, for example, John Richardson, *Georges Braque* (Hammondsworth, Middlesex: Penguin, 1959), p. 6; Pierre Daix, *Picasso* (New York and Washington: Praeger, 1965), p. 73; Golding, p. 64; Edward Mullins, *The Art of Georges Braque* (New York: Abrams, 1968), p. 28; André Dubois, "Cubisme et cubismes," *Travaux IV, Le Cubisme* (Université de Saint-Etienne, C.I.E.R.E.C., 1973), p. 83; Leymarie, p. vi; Judith Wechsler, ed., *Cézanne in Perspective* (Englewood Cliffs, N.J.: Prentice-Hall, 1975), pp. 7–8.

31. "Souvenirs sur Paul Cézanne et lettres inédites," 69, no. 247 (October 1, 1907), p. 400.

32. Although *Still Life with Apples* was identified in the catalog of the Salon d'Automne retrospective as *Le Compotier* (no. 44), there is no question that it was the picture exhibited. We know this because *Le Compotier* is listed as being in the Gangnat Collection. The Museum's picture—which, of course, contains a *compotier*—belonged to Gangnat at the time of the exhibition and was the *only* Cézanne still life owned by him.

33. I say coinciding "roughly" because it may very well be that Derain's large *Still Life* of 1904 was painted after the opening of the Salon d'Automne, to which it may be a response. Nothing in the Derain literature makes it possible to date this work securely either before or after the opening of the exhibition.

34. None of the major Fauve painters knew Cézanne personally. Even Matisse,

who was older than his colleagues and was familiar with Cézanne's work for more than a decade before the latter's death, did not try to meet him, perhaps out of a feeling of shyness and respect: "I have often been in the neighborhood of Aix without it ever occurring to me to visit Cézanne. The artist gives the best of himself in his pictures; so much the worse for those who demand more: an artist's words do not matter essentially." (Georges Duthuit, *The Fauvist Painters,* trans. Ralph Mannheim [New York: Wittenborn, Schultz, 1950], p. 60, note 1.) In analyzing why Matisse chose not to seek out Cézanne when he had many opportunities to do so during 1896–1906, Dominique Fourcade ("Autres Propos de Matisse," pp. 104–6) has suggested that it may have been out of fear of the disruptive effect—and the "elephantine" intrusion—such a meeting would have posited in terms of Matisse's uncertainties about his own creative process and his dependency on the power generated by the older master's work.

35. Camoin was one of the exhibiting artists in the original "Cage of Beasts" in the Salon d'Automne of 1905, and he has been frequently listed among the Fauve painters, as for example in Louis Vauxcelles, *Le Fauvisme* (Geneva: Cailler, 1958); Jean Leymarie, *Fauvism* (Geneva: Skira, 1959); Charles Chassé, *Les Fauves et leur temps* (Lausanne-Paris: Bibliothèque des Arts, 1963); Gaston Diehl, *The Fauves* (New York: Abrams, 1975, trans. from French ed. of 1971).

36. *André Derain* (Leipzig: Klinkhardt & Biermann, 1920), p. 7.

37. See John Elderfield, *The "Wild Beasts": Fauvism and Its Affinities* (New York: Museum of Modern Art, 1976), pp. 118–20.

38. *Chroniques d'art (1902–1918),* ed. L. C. Breunig (Paris: Gallimard, 1960), p. 265 (from "Art et curiosité, les commencements du cubisme," *Le Temps,* October 14, 1912). Douglas Cooper (*Cubist Epoch,* p. 65) has noted the variants in statements concerning Derain's role in the creation of Cubism written by Apollinaire in the course of 1912–13: "Writing in *Le Temps* in October 1912 . . . Apollinaire rather casually noted that as a result of the friendship which grew up between Picasso and Derain in 1906 'that almost immediately Cubism was born.' A few months later, in an article of February 1913 in *Der Sturm,* this first vague statement was changed into: 'The Cubism of Picasso was born of a movement originating with André Derain.' But Apollinaire modified even this claim in his famous booklet *Les Peintres cubistes,* published in March 1913, where he wrote that while 'the new aesthetic first originated in the mind of André Derain, the most important and daring works which it produced forthwith' were created by Picasso and Braque, who should therefore be considered as co-originators of Cubism."

39. See Kahnweiler, *Derain,* p. 5.

40. The picture had been purchased by Kahnweiler sometime after the Indépendants and was sold at auction in the fourth sale (May 7–8, 1923, no. 178) of the sequestrated property of Kahnweiler; it was purchased by a private collector who still owns it. Ellen C. Oppler gives a summary of errors in the recent literature on Derain—in writings by Denys Sutton, Jean Laude, Bernard Dorival, and Michel Hoog—that have contributed to spreading "considerable confusion around this painting." (*Fauvism Reexamined* [New York and London: Garland Publishing, 1976], photo-reprint of Ph.D. thesis, Columbia University, 1969.)

41. In Kahnweiler, *Derain,* pl. 3; Golding, pl. 92 B; Jean Laude, *La Peinture française (1905–1914) et "l'Art Nègre"* (Paris: Klincksieck, 1968), pl. 28.

42. Kahnweiler (*My Galleries and Painters,* p. 43) declares that the close friendship of Picasso and Braque began in 1909. Marked interaction between the two painters—a situation of give-and-take—is visible in the work itself only after Picasso returns from Horta, where he spent the summer of 1909.

43. I take issue here—in matter of degree—with Golding, who seems to regard Cézanne and what he calls "Negro art" as equally influential in Derain's *Bathers*: "But what gives Derain a place as a true forerunner of Cubism is that he was the first painter to combine in a single work the influences of both Cézanne and Negro art. This he did in his large *Baigneuses* . . . which was painted in the winter of 1906 and shown at the Salon des Indépendants of 1907" (p. 139). He also states that "some of the heads in Derain's *Baigneuses* . . . are close to the Negro head reproduced by Carl Einstein in his *Negerplastik,* Munich 1920, pls. 14 and 15. This head was in the collection of Frank Haviland, a friend of Derain's" (p. 140, note 2).

44. John Elderfield notes that it "was the new interest in Cézanne . . . that showed to the Fauves a way of using African sculpture in their work—once their paintings began to show the influence of Cézanne" (p. 110).

45. These large black-and-white photographic reproductions were available through Vollard. The photograph of Derain in his studio, in which the reproduction of the Cézanne may be seen in the background, was taken at the behest of the American architect Gelett Burgess, who published it in "The Wild Men of Paris" (*Architectural Record* 27, no. 5 [May 1910], p. 414). This important article was not totally overlooked in the subsequent literature; it is mentioned by Barr (in *Picasso: 50 Years of His Art,* p. 257, notes to p. 56). However, it is only in Edward Fry's article, "Cubism 1907–1908: An Early Eyewitness Account" (*Art Bulletin* 48, no. 1 [March 1966], pp. 70–73), that the implications of this photograph (not to say much of Burgess' text) were first appreciated.

46. See Golding, pp. 49–51, and Reff, "Themes of Love and Death in Picasso's Early Work," *Picasso in Retrospect,* ed. Roland Penrose and John Golding (New York and Washington: Praeger, 1973), pp. 43–44.

47. The Salon des Indépendants of that year began on March 20 and finished on April 30. Picasso had begun making very tentative sketches for a large figure picture of female nudes (and two male figures) at the end of 1906, but he did not begin work on his large canvas until spring 1907. Work on the first state of the *Demoiselles* is commonly thought to have begun in March, but Pierre Daix (*Le Cubisme de Picasso*), on the basis of as yet unpublished studies, has convincingly established the date as mid-May.

48. Alfred H. Barr, Jr., "Matisse, Picasso, and the Crisis of 1907," *Magazine of Art* 44, no. 1 (January 1951), p. 168.

49. In conversation with this author, 1976.

50. Golding, p. 49. Golding also suggested (p. 48) the possibility that Picasso's "spirit of rivalry" had been aroused.

51. See Oppler, pp. 289–90.

52. In an undated letter, evidently written during the summer of 1907 to Vlaminck, Derain refers to two pictures of this group since destroyed, one of a horse and another of a bull, which he describes as "près de ce que j'ai toujours cherché à réaliser." (André Derain, *Lettres à Vlaminck* [Paris: Flammarion, 1955], p. 164.) Kahnweiler (*Derain,* p. 5) mentions the bull picture (*Stierbild*) as one of those works which he saw for the last time at Chatou, in the fall of 1907 at Derain's parents' home.

53. Derain, *Lettres,* p. 152.

54. Golding, p. 63. The full quote is, "Hitherto, as a minor Fauve, Braque had not been a painter of any great historical importance."

55. Hilton Kramer, "Those Glorious 'Wild Beasts,'" *New York Times,* Sunday, April 4, 1976.

56. See Cooper, *G. Braque,* pp. 26–27.

57. Though Cézanne dismissed Gauguin as a maker of "Chinese images," Gauguin himself was at certain moments able to assimilate aspects of Cézanne's modeling to his more decorative style. By the same token, the Fauve painters, open to the influence of both Post-Impressionists, tended especially during the transitional period of the decline of Fauvism to fuse elements of the two styles.

58. Braque would return to L'Estaque for the third time in 1908. In 1909 he worked at La Roche-Guyon, also a site painted by Cézanne.

59. John Richardson (in conversation with the author) has expressed his belief that all the paintings begun in L'Estaque were worked on subsequently in the Paris studio, including *View of L'Estaque,* of which he feels the strong contouring to be the element added subsequently. There seems to me to be such a marked difference between the contouring of the *Terrace of the Hotel Mistral* and the *Landscape with Houses* that I am inclined to believe the *View of L'Estaque* did not profit from the more abstract, conceptual tendencies of Braque's work in Paris. This picture seems to me closer to *Landscape at La Ciotat* than to any of the works that can with more sureness be identified as having been finished in Paris.

60. Braque told this to Mangin, and his remark will be recorded in the future publication of her catalogue raisonné for this period.

61. Kahnweiler's recollection in conversation with this author in 1976 was

that the color of *Viaduct* was Fauve in character.

62. In February 1977 this particular Cézanne (on loan from the Pearlman Foundation) was hung side by side with the Braque *Hotel Mistral* (on loan from the Josten Collection) at the Princeton University Museum—a juxtaposition striking for the affinities it showed.

63. Dora Vallier, "Braque, la peinture et nous," in *Cahiers d'art* 29, no. 1 [October 1954], p. 14.

64. Golding, p. 64.

65. See his review of the Impressionist exhibition of 1880, reprinted in Joris-Karl Huysmans, *L'Art moderne* (Paris: Charpentier, 1883), pp. 89–90. In the present volume, George Heard Hamilton ("Cézanne and His Critics") cites a letter in which Huysmans writes to Pissarro: ". . . certainly [Cézanne] is an eye case, which I understand he himself realizes" (May 1883).

66. The term "distortion" implies the *a priori* acceptance of the integrity of an object which is then pulled or pushed out of shape. This is essentially an expressionist device, and therefore the term should not be used for Cézanne. Cézanne's selection of "constructive sensations" from the totality of the visual field proceeds from an assumption of the integrity of a picture rather than that of the natural world.

67. Recounted in Emile Bernard, *Souvenirs sur Paul Cézanne et lettres* (Paris: La Rénovation Artistique, 1921), p. 27.

68. Ibid., pp. 29–30.

69. "Impressionist and Modern Drawings, Paintings and Sculpture," Christie, Manson & Woods, Geneva, November 9, 1969. As the picture did not meet the reserve price, it remained with the owner. John Richardson, then with Christie's, brought the picture to the attention of Nicole Mangin, and it will appear in her catalogue raisonné of Braque's work. She, in turn, brought it to my attention, and (but for its appearance in the sales catalog) it is published here for the first time, with her approval and with the consent of the owner, who has permitted me to study the picture and have photographs made.

70. John Richardson is of the opinion that this picture was begun at L'Estaque and represents a scene from the environs of the town. While this is certainly possible, the great stylistic advance Braque has made here over and against the more rudimentary Cézannism of the *Hotel Mistral* suggests to me that this picture was painted entirely in the Paris studio.

71. This date for the beginning of *Nude* has become traditional, although there appears to be no absolutely firm documentation for it. It is listed as the last work of 1907 in Isarlov's catalog (no. 31), and Braque never took issue with any of the many texts that cite him beginning work on this picture in the month of December.

72. If we compare such Picassos as *Landscape at Horta* with the nearest prototypes in both Braque and Cézanne in terms of the treatment of the sky and its relationship to the scene below, the conclusion that Picasso had in mind such Braques as *Port in Normandy* (early 1909) is inescapable. (See reproductions below.)

73. We have no sure date for Derain's *Provençal Landscape,* but for the purposes of my argument here a precise date is not necessary. Pictures resembling this one are to be found in Kahnweiler's photographic album of Derain's work dated anywhere from 1907 through 1909. As dates in Kahnweiler's records are often based on the time of the entry of the work into Kahnweiler's stock rather than the date of execution, considerable confusion can arise. In the case of a painter like Derain, who sent his work to Kahnweiler only irregularly, the practice wreaks havoc with any attempt to organize a secure dating.

74. *Rochers rouges,* no. 195 in the catalog. (This was the sole Braque shown at the Salon d'Automne, the rest of his entries having been refused, according to Apollinaire, *Chroniques d'art,* p. 46 [from *Je dis tout,* October 19, 1907]).

75. According to Cooper (*G. Braque,* p. 16), Kahnweiler signed a contract with Braque for his entire production after purchasing the lot of pictures from the Salon d'Automne. Kahnweiler denies having made any contract with Braque before 1912, but he did informally arrange to purchase his work regularly beginning late in 1907.

76. *My Galleries and Painters,* pp. 38–39, and as recounted in 1976 in conversation with the author.

77. Every major text on Braque indicates that he worked on nothing but this picture for about six months—unlikely as that might appear. Late in his life, however, he told Nicole Mangin that he had, in fact, painted his first few Cubist still lifes in the opening months of 1908 before leaving for L'Estaque. Since a great many of the indications Braque gave Nicole Mangin are doubtful—some can even be proven wrong—it is hard to know what to make of his suggestion for the dating of the first still lifes. One of the pictures Braque placed in the early 1908 category is the well-known *Still Life with Musical Instruments* in the Laurens Collection. In my opinion, this picture may indeed have been painted before Braque's departure for L'Estaque. It is not nearly so developed in Cubist terms as the works he painted in the summer; the forms are stylized and simplified, but Braque has only limited success with the linkage of planes—more difficult to realize here than in a landscape. The most Cubist aspect of the picture is the manner in which the neck of the guitar has been bent backward away from the picture plane so that the viewer sees part of the instrument from a perspective inconsistent with the rest. The painting is, however, more stylized than truly Cubist, though its brown and green coloring conforms with the other work executed from early 1908 through the end of summer.

78. Cited in Russell, p. 9.

79. Maurice Gieure, *G. Braque* (New York: Universe Books, 1956), p. 17. Trans. from French ed. (Paris: Tisné, 1956).

80. Cited in Pierre Cabanne, "Braque se retourne sur son passé," *Arts,* no. 783 (July 1960), p. 10.

81. Quoted in André Verdet, "Avec Georges Braque," *XXe Siècle* 24, no. 18 (February 1962), supplement, n.p.

82. Georges Charbonnier, *Le Monologue de peintre* (Paris: René Juillard, 1959), p. 18. (Based on a radio interview with Braque.)

83. Ibid., p. 8.

84. Jean Leymarie, *Braque,* trans. James Emmons (Geneva: Skira, 1961), p. 11.

85. P. 9.

86. Quoted in Russell, p. 12 (italics mine).

87. Ibid., p. 9.

88. Quoted in Gieure, p. 18. Most painters, Braque complained, "totally ignore that what is *between* the apple and the plate can be painted too . . . This in-between space [*entre-deux*] seems to me just as important as the objects themselves" (Charbonnier, p. 10).

89. P. 81, no. 31. See also Golding, p. 62. Isarlov lists this picture as the last work of 1907, presumably because it was begun in December of that year. The *Nude* was not, however, completed until June 1908. Pierre Daix drew to my attention the "June 1908" inscription on the back of the canvas recorded by Leymarie in his catalog *Georges Braque,* 1974, p. 24, no. 18.

90. The percentage figures are only as exact as permitted within the limitations of Zervos (for the analysis of Picasso's subjects) and of Isarlov in combination with Cooper and Richardson (for Braque's).

91. P. 405.

92. *G. Braque,* p. 17; *Georges Braque: l'oeuvre graphique original,* with catalogue raisonné by Edwin Engelberts (Geneva: Musée d'Art et d'Histoire, 1958), no. 1; Russell, p. 10; Werner Hofmann, *Georges Braque: His Graphic Work* (New York: Abrams, 1961), no. 1; Mullins, p. 33. (The basis for the 1908 date appears to be what is referred to as the "original" drawing for the print, in the collection of Douglas Cooper.)

93. *Braque graveur* (Paris: Berggruen, November–December 1953), no. 1: "1907—Etude de Nu. Cette première eau-forte de Braque, gravée en 1907, ne fut publiée qu'en 1953, par Maeght dans un tirage limité à 30 exemplaires numérotés et signés par l'artiste." Braque told Nicole Mangin on the occasion of the Maeght publication in 1953 that he had executed the etching in late 1907 and made what he remembered as three *épreuves d'essai* at that time.

94. Fry, *Cubism,* pp. 16, 54, 192, note 8; Fry, "Cubism 1907–1908: An Early Eyewitness Account," pp. 70, 71, and note 23; Cooper, *Cubist Epoch,* pp. 27–28; Oppler, p. 293, note 3.

94 a. Since I wrote the above, it has been pointed out to me by Judith Cousins, Researcher of the Museum Collection, that a comparable suggestion has already been made by Michel Hoog ("Les Demoiselles d'Avignon et la

peinture à Paris en 1907-1908," *Gazette des beaux-arts* 82, October 1973, p. 214).

95. "Cubism 1907-1908: An Early Eyewitness Account," pp. 70-71.

96. Since Fry is committed to the idea that *Three Nudes* is related to Braque's immediate response to the *Demoiselles,* he places it prior to the large *Nude,* suggesting that the latter is based upon the former. This is consistent with Burgess' report that Braque had referred to it as "a sketch for the painting entitled *Woman* in the Salon des Indépendants" ("The Wildmen of Paris")—very possibly the *Nude* in an early state. See below, note 109. In view, however, of the confused pose of *Nude* as compared with the logic of the related figure in *Three Nudes,* one is tempted to conclude that the drawing postdates the painting. This would be even more likely if, as was suggested above, the original conception of the large *Nude* was that of a prone figure. In that case, *Three Nudes* might relate not to the *Demoiselles,* but to another Picasso which was being elaborated in the spring of 1908, namely the *Three Women* in Leningrad, the first version of which Picasso probably completed in early summer.

97. Richardson, p. 7; Russell, p. 10; Golding, pp. 62-63; Rosenblum, *Cubism and 20th Century Art,* p. 32; Cassou, p. 31, cat. no. 61; Oppler, p. 294; Leymarie, *Georges Braque* (Orangerie), p. vi.

98. Golding, p. 62.

99. Cooper, *G. Braque,* p. 28.

100. Ibid. p. 28.

101. Ibid.

102. Fry, "Cubism 1907-1908: An Early Eyewitness Acount," p. 71.

103. Cooper, *G. Braque,* pp. 17, 28, *Cubist Epoch,* p. 29; Golding, *Cubism,* p. 66; Fry, *Cubism,* p. 17; Hope, *Georges Braque,* p. 29; Leymarie, *Braque,* p. 6.

104. Golding, p. 67.

105. Leymarie, *Braque,* p. 32.

106. According to the custom of the Salon d'Automne, each member of the jury had the right to retrieve one painting from a rejected group. Albert Marquet and Charles Guérin each voted in one of the rejected Braques, but the artist nevertheless withdrew all of his entries. Accounts vary as to the number of pictures submitted by Braque to the 1908 Salon: Kahnweiler in *Der Weg zum Kubismus* (p. 15) said five; but in *Juan Gris* (1947, p. 69, note 2) and in *The Rise of Cubism* (p. 5) he said six; Hope (p. 33) gave the number as seven, as did Barr (*Matisse,* p. 532, note 10 to p. 87). Leymarie (*Braque,* p. 35) notes that Rouault was also on the jury of 1908.

107. This exhibition, Braque's first one-man show, was held from November 9 to 28 and, according to the catalog, included twenty-seven works. Guillaume Apollinaire wrote the preface to the catalog.

108. The similarity of the motif of *Balustrade, Hotel Mistral* to that of the *Terrace of the Hotel Mistral* was probably what prompted Braque mistakenly to date the former autumn 1907 in his conversations with Nicole Mangin. The confusion is understandable, but there can be no question of situating *Balustrade* in autumn 1907, given the character of the works we have from that period, despite the fact that it is patently less developed than other pictures from the 1908 stay at L'Estaque. Its affinities to the latter works in color, and the relationship of its drawing to the facial features of the *Nude,* speak for a spring 1908 date—a presumption reinforced by the fact that it entered the records of Kahnweiler's gallery with the other 1908 landscapes. Isarlov lists *Balustrade* (under the title *Terrace*) as the fourth work to have been executed in L'Estaque in 1908 (no. 35). The works that precede it on his list are *Road near L'Estaque* (no. 32) in The Museum of Modern Art, the study for *Houses and Trees* (no. 33) in the Masurel Collection, and *Factory Roofs at L'Estaque* (no. 34). None of these makes sense in such a chronological order. Braque presumably reviewed at least briefly Isarlov's catalogue raisonné, and he seemingly took no issue with the assignment of *Balustrade* to 1908 at that time.

109. The *Nude* has traditionally been believed to have been completed before Braque's departure for L'Estaque, and some writers assume that it was finished even before the opening of the 1908 Indépendants on March 20. This view is based on indications that the picture was exhibited there despite its absence from the catalog. Apollinaire's review of Braque's entries at the Indépendants

refers to a "large composition" which "appears to me the most original effort of this Salon." "Certainly," Apollinaire continues, "the evolution of this artist from his tender *The Valley* [a Fauve painting executed at La Ciotat in the summer of 1907] to his latest composition is considerable. And yet, these two canvases were painted at an interval of only six months." (*Chroniques,* p. 51; from *La Revue des lettres et des arts,* May 1, 1908.) Burgess, who visited Braque's studio between nine and twelve months after the Indépendants, quotes Braque as referring to the painting *Woman* as "in the Salon des Indépendants" (p. 405), and at a greater remove Olivier reported that Braque "exhibited at the Indépendants a large canvas of Cubist character" (p. 120).

It is not difficult to imagine, especially in view of the weakness of the final state of *Nude* and the length of time Braque worked on it, that he came close to finishing the picture more than once and then, dissatisfied, took it up again. Thus he might well have added *Nude* to his entries in the Indépendants after the catalog had gone to press. Such indecision sorts well with his having then decided to take it south, where he worked on it at L'Estaque.

110. The type of composition is Cézannian in origin. See, for example, the way in which the "unstable" fruit in the lower part of Cézanne's *Still Life with Peppermint Bottle* (Venturi 625), National Gallery, Washington, is fixed in the composition by its relationship to the tectonic forms of the wall division and molding in the upper part of the painting (as well as the drapery which surrounds it).

111. "Representation of the position of objects in space is done as follows: instead of beginning from a supposed foreground and going on from there to give an illusion of depth by means of perspective, the painter begins from a definite and clearly defined background. Starting from this background the painter now works toward the front by a sort of scheme of forms in which each object's position is clearly indicated, both in relation to the definite background and to other objects." (Kahnweiler, *The Rise of Cubism,* p. 11.)

112. Quoted in Jean Paulhan, *Braque, le patron* (Geneva and Paris: Editions des Trois Collines, 1946), p. 35.

113. Oppler, p. 306.

114. Matisse was a member of the jury that rejected the Cézannesque paintings Braque had submitted to the Salon d'Automne of 1908; he is traditionally credited with having described one of the refused pictures as *fait de petits cubes* and drawing a sketch to illustrate his words for Vauxcelles, who afterward made use of the phrase in his review of Braque's show at Kahnweiler's gallery in November 1908, obviously referring primarily to *Houses and Trees* and its sketch. According to Matisse (in "Testimony against Gertrude Stein," February 1935; Supplement, pamphlet no. 1, to *Transition,* no. 23, 1934-35, p. 6), ". . . it was Braque who made the first Cubist painting. He brought back from the South a Mediterranean landscape that represented a seaside village seen from above. In order to give more importance to the roofs, which were few, as they would be in a village, in order to let them stand out in the ensemble of the landscape, and at the same time to develop the idea of humanity which they stood for, he had continued the signs that represented the roofs in the drawing on into the sky and had painted them throughout the sky. This is really the first picture constituting the origin of Cubism and we considered it as something quite new about which there were many discussions."

See Oppler (pp. 304, 305, 379-80) for a summary of Matisse's involvement in the naming of Cubism.

115. *Braque,* pp. 35, 37.

116. Picasso's blueness from the end of 1901 until late 1904 is essentially Symbolist—i.e., color is conceived as a counterpart of mood, a visual metaphor that describes the spirits of his subjects. Blue enters Cézanne's work in the first instance as a result of the pervasive blueness of Provençal light and therefore as the color for shadows, and it is probable that Cézanne never thought of his color as other than an extension of this natural fact. The overall blueness of many of his later pictures is not, however, explicable as a purely natural phenomenon, and it unquestionably endows these pictures with a distant and meditative mood not totally unrelated to that of the fin-de-siècle Monets. A tendency to use monochromy for poetic ends is common to Monet and certain Symbolists, and some of Cézanne's late pictures share in this tendency, whether intentionally or not.

117. Vollard was in possession of the picture at the time Picasso held his one-man exhibition there (June 1901).

118. See Rubin, *Picasso in the Collection of The Museum of Modern Art* (New York: Museum of Modern Art, 1972), pp. 36–38.

119. Golding, p. 50. Golding nevertheless discusses some specific sources for this influence.

120. See discussion of this passage below and note 150, below.

Some houses in these landscapes almost appear constructed from children's building blocks and are, at first glance, reminiscent of the architecture in pictures executed about the same time by Braque in L'Estaque. What separates the two, however, is the more advanced Cézannism of Braque's work. In Picasso the contours are generally closed and the planes of the houses do not pass into those of the nearby objects. The schematic reductionism of Picasso's houses is reminiscent of the simple geometry of the still lifes he executed earlier in the summer of 1908, which evoke Rousseau rather than Cézanne.

For additional explanation of the greenness of the La Rue des Bois landscapes, see Rubin, p. 51.

121. Fry, *Cubism,* p. 18.

122. Christian Zervos, *Pablo Picasso,* II, Les oeuvres de 1906 à 1912 (Paris: Cahiers d'Art, 1942), nos. 101–8.

123. Communicated to me in conversations with Daix in January 1976.

124. These striations seem to have been suggested by the patterns and scarification marks on African sculpture. They also resemble the ribbed patterns of the copper-covered guardian figures from the Bakota, Gabon. For a possible naturalistic source, see Rubin, pp. 44, 199.

125. Zervos' indication "Winter, 1908" for this picture is often taken to mean the last months of 1908. However, as Pierre Daix observes (letter to this author of November 2, 1976) and as he will observe in *Le Cubisme de Picasso,* what Picasso meant when he said "winter 1908" corresponds neither to the interpretation usually given Zervos nor to the traditional interpretation of "winter 1908–09," but instead "goes from November to mid-February" because, "like most Spaniards, Picasso considered *primavera* to begin with the first nice days in February." This suggests that Picasso probably continued to work on *Three Women* into the beginning of 1909, which corresponds to the 1908–09 dating in the Kahnweiler photographic albums (although, as was previously noted, the dating in these albums often has more to do with the time of the arrival of a painting in the gallery than with the period during which it was actually painted).

126. This picture was first published in Pierre Berger, *André Salmon* (Paris: Seghers, 1956), opp. p. 48, and brought to the attention of the art-historical community by Edward Fry in his *Cubism* (pl. no. 8). Our photograph, from the Photothèque Hachette, was made available through the Louise Leiris Gallery.

Fry had not observed the difference between the *Three Women* in this photograph and the final painting. When I drew Daix's attention to the variance he revised his earlier decision to move the execution of the final work back to early summer.

127. As was observed above, the chronology of events in the last four months of 1908 is very difficult to establish. To begin with, there is some doubt about the date of Picasso's return from La Rue des Bois. In all likelihood, however, he returned to Paris by the end of September, and since Braque certainly returned around that time, it is more than probable that the two saw each other some time in October. Whether or not Picasso saw Braque's L'Estaque pictures in October, he most certainly saw them in the exhibition at Kahnweiler's the following month. Thus the dates given to Zervos by Picasso for the execution of *Three Women* (see note 125, above) correspond roughly to the period following Picasso's first confrontation with Braque's pictures.

128. A variant of the photograph I reproduce here was published in *Cornelius Theodorus Marie van Dongen, Retrospective Exhibition,* University of Arizona Museum of Art, Tucson, February 14–March 14, 1971, and William Rockhill Nelson Gallery of Art, Atkins Museum of Art, Kansas City, Mo., April 25–May 23, 1971, p. 27. When I drew that document to the attention of Pierre Daix, he visited Dolly van Dongen, who gave him another photograph, obviously made on the same occasion, which contains more of *Three Women* in

the background. The latter photograph is the one I publish here.

It is possible, though highly improbable, that the view of *Three Women* as we see it in the van Dongen photo shows the work prior to the state in which we see it in the Salmon photograph, that is, as Picasso was putting in the broader planes of his original composition. The freshness of the planar passages in the lower center of the picture might lead one to this conclusion. But these are easily explained by the fact that Picasso washed out most of his picture before reworking it (see following note).

129. An X-ray photograph of a section in the upper left of the picture made for me by the Hermitage shows that this section at least—and presumably much of the rest of the canvas—was washed down with solvent before Picasso resumed work on it. In order to prevent future crackling, Picasso had to remove as much of the paint film as possible, so as not to apply his pigment over dry paint. Oil paints that are only three or four months old, as the paint of *Three Women* would have been when Picasso returned to it, are removed without great difficulty by scraping off any thick pigment and washing the surface with turpentine. This produces precisely the uneven and streaked effect which the Hermitage X ray shows.

130. By "evolved" I mean, teleologically speaking, further advanced in the direction in which Cubism would subsequently move. Thus Braque's *Port in Normandy,* painted from memory in Paris early in 1909, is as developed in Cubist terms as the work done by Picasso at Horta de San Juan in the late spring and summer of that year.

131. P. 66.

132. Cited in Vallier, p. 14.

133. Cooper, for example, says the following: "The influence of Negro art is less visible than in the work of Picasso. Yet it is innately present, for Braque himself spoke about becoming acquainted with Negro sculpture at this time through Matisse and Picasso, and claimed that it opened up for him a new horizon." (*Cubist Epoch,* p. 27.) The logic escapes me here. What Cooper is actually saying is that because African sculpture opened a new horizon in Braque's thinking, it is "innately present" (whatever that is) in Braque's art.

134. Kahnweiler ("Negro Art and Cubism," *Horizon* 18, no. 108 [December 1948], p. 413) observes: "*Negerplastik* by Carl Einstein, the first book to appear on Negro art as art, makes no distinction between African and Oceanic art. It would be wrong to criticize it for this. It was concerned with the plastic discovery of these arts, not with ethnography. Their classification could wait."

135. Ibid.

136. Picasso's assertion that the *Demoiselles* was not influenced by African art but rather by Iberian art is first reported by Zervos in his introduction to Volume II of the catalogue raisonné. Picasso went so far as to claim that he had not even seen African art at the time he worked on the picture. Why Picasso asserted this, and maintained the position until his death, is something of a mystery. In any case, close students of the problem have found no difficulty in showing that Picasso was, indeed, familiar with African art by March 1907 and certainly by June and July of that year, when the later portions of the *Demoiselles* were executed. I suspect that Picasso simply got tired of having this picture (and his immediately subsequent work) "explained" by reference to African art—as if he had done nothing but transpose its imagery into painting. At the same time, Picasso was quite aware that critics were overlooking the very real influence of Iberian art. The posture Picasso took reminds us in its exaggeration of his observation about art in general—"a lie that helps us understand the truth." Picasso seems, in any case, to have entirely convinced Kahnweiler, who to this day insists that the earliest direct influence of African art has to do with the relationship of Picasso's Wobe mask to the sheet-metal guitar of 1912. Daix also accepted Picasso's view literally ("Il n'y a pas 'd'art nègre' dans 'Les Demoiselles d'Avignon,'" *Gazette des beaux-arts,* ser. 6, vol. 76, October 1970, pp. 247–70), but has since revised his opinion.

137. "Conversation avec Picasso," *Cahiers d'art* 10 (1935), no. 10, pp. 173–78.

138. P. 123.

139. By this I am not implying that Braque failed to appreciate those Cézannes in which the surface is not completely covered. On the contrary, later in his life he acquired a very beautiful still life (pl. 160) which shows a great

deal of unpainted canvas. While it may be that the purchase of this modest unfinished work best suited his financial possibilities at the time, it is certain that Braque would never have acquired such a picture had he not been convinced of its quality.

140. The influence of the unpainted white canvas in many of Cézanne's works is certainly discoverable, prior to Cubism, in a number of Fauvist paintings by Matisse and Derain done in 1905–06. Matisse's decision to leave substantial areas of the primed canvas unpainted in such pictures as the *Girl Reading* (illustrated in Elderfield, p. 27) and to employ interstitial bits of unpainted "breathing spaces" in many others certainly received sanction from the experience of Cézanne. In Picasso, the admission of unpainted white areas is more extreme, as *Carafe and Candlestick* of 1909 illustrates. Moreover, Picasso picked up from Cézanne the idea of mixing in a finished work passages that are left in coarse underpainting with others that are "finished" with careful modeling. This more radical non-finito has no counterpart in Fauvist painting.

141. Cooper, for example ("Two Cézanne Exhibitions—II," *Burlington Magazine* 96, December 1954, p. 383), compares Cézanne unfavorably with a number of artists whose "achievements were more consummate, because they were fully able to achieve their aim. Cézanne was not, and he knew it." Such pre-Crocian confusion of an artist's intentions with the actual visual fact of his work is surprising for a critic of Cooper's sophistication.

142. "Now being old, nearly seventy years," Cézanne wrote Bernard, "the sensations of color, which give light, are the cause of abstractions that do not allow me to cover my canvas entirely or to pursue the delimitation of objects where their points of contact are fine and delicate; from which it results that my image or picture is incomplete." (Emile Bernard, *Souvenirs et lettres* [Paris: Société des Trente, 1912], p. 88.)

143. The relatively few pictures that Cézanne signed and sent to exhibitions before 1895 are fully painted. A few of those which Cézanne sold to Vollard between the middle nineties and his death do, however, contain varying degrees of non-finito. The Museum's *Still Life with Apples* is a case in point. Given the nature of the relations between Vollard and Cézanne, it is certainly possible that the importunate dealer, with the painter's consent, put such a work into one of the lots he purchased, even though Cézanne had reservations about it. Thus we cannot necessarily say that Cézanne considered it finished. Nevertheless, the fact that he let such a picture out of his hands at all raises the possibility of a "gray area" between Cézanne's stated attitude toward finish (in his letters) and his subjective judgment as to whether a given picture "worked."

144. Cited in Maurice Denis, "Cézanne," *Theories, 1890–1910,* rev. ed. (Paris: Rouart et Watelin, 1920), p. 252. Cézanne "ne peut pas mettre deux touches de couleur sur une toile sans que ce soit déjà très bien."

145. Picasso put it this way to me in the course of a conversation held while he was showing me the Cézannes in his collection. I cannot guarantee the accuracy of this since it was written down after leaving Picasso's house and not while I was there. I do remember, however, that Picasso pronounced it as his own idea rather than a variant of a remark of Renoir's. Although I took notes following almost all the fifteen or so meetings I had with Picasso, I have been very reserved about quoting or even paraphrasing him (see *Picasso in the Collection of The Museum of Modern Art,* p. 11) because note-taking or tape recorders were not permitted in Picasso's presence. Hélène Parmelin records— also from memory—a comparable observation made to her by Picasso (*Picasso Dit* [Paris: Cercle d'Art, 1966], p. 85): ". . . si tu prends une toile de Cézanne . . . dès qu'il commence à mettre une touche la toile est déjà là."

146. An unpainted area of canvas in an Impressionist picture would immediately detach itself from the surface of the image by its failure to reflect light in a manner continuous with the painted surface. We presume the articulation of the entire surface in this respect in an Impressionist picture in a manner in which we do not in Cézanne, even in those oils of his in which the surface is entirely covered.

147. It is probable that the signature appearing on the front of *Bread and Fruit Dish* was added by Picasso sometime after the picture was painted. The picture was, however, released to Kahnweiler in the normal way, after which it passed to the Bignou Gallery and then to Françoise Leclerq, who sold it to the

Basel Museum. Some of Picasso's 1908 pictures were signed on the back, often by an employee of Kahnweiler's gallery (see Golding, p. 74). As *Bread and Fruit Dish* was relined before coming to the Basel Museum, there are no records of this one way or another.

148. While it is probable that *Three Women* was completed toward the very end of 1908 or shortly after the beginning of the following year, *Bread and Fruit Dish* has usually been associated with the opening months of the latter year, which would put its completion shortly afterward. Inasmuch, however, as the chronology of this period remains very vague and without documents that allow us to fix the completion of these works precisely, it is possible that *Bread and Fruit Dish* was completed before *Three Women.* Its somewhat less developed style—it is less organized on the basis of *passage,* the structural underpinning of *Three Women*—is perhaps also explained by the fact that the work is, as far as composition is concerned, a metamorphosis of a picture which goes back to the very beginning of 1908, the *Carnaval au bistrot* (see note 149, below).

Pablo Picasso. *Carnaval au bistrot.* 1908. Watercolor on paper, $8\frac{7}{8}$ x $8\frac{1}{4}$ in (22.5 x 21 cm). Private collection, London

149. There seems to me to be an obvious recollection of the largest of Cézanne's *Cardplayers* (Barnes Collection) in the study for what was to be *Carnaval au bistrot,* especially in regard to the placement of the table and the handling of the table legs. The presence of one standing figure next to the seated group also echoes the Cézanne composition but is certainly to be found in many other paintings whose subject calls for a group of figures seated at a table. For a study of the metamorphosis of *Bread and Fruit Dish* from the *Carnaval au bistrot* see Christian Geelhaar, "Pablo Picassos Stilleben 'Pains et compotier aux fruits sur une table': Metamorphosen einer Bildidee," *Pantheon* 28 (1970), no. 2, pp. 127–40.

150. Theodore Reff, "Cézanne and Poussin," *Journal of the Warburg and Courtauld Institutes* 23 (1960), nos. 1–2, demonstrates that this famous passage from a letter to Emile Bernard has been consistently misunderstood by being taken out of context. Cézanne was not advising painters to make geometrical abstractions. He was discussing problems in the representation of three-dimensional forms in the context of techniques of perspective—from the point of view of what amounted to a traditional art-school exercise. In his essay in the

present volume, Reff points out that, far from being a radical pronouncement, Cézanne's statement was "based on a method of linear construction which originated in the Renaissance" and that "the idea of reducing nature's diversity to simple geometric solids is as conventional as that of rendering its depth in perspective." Cézanne's "purely practical advice" was misrepresented, as Reff says, "from the beginning" by Bernard's Neo-Platonic interpretation according to which geometric forms are "contained in everything we see, they are its invisible scaffolding" (see Reff, note 206). "In the Cubist studios where such ideas were common," Reff continues, "Cézanne's statement, divorced from its context and enhanced by his prestige, quickly gained currency . . . and in a later treatise Gleizes maintains that 'he [Cézanne] spoke of the cylinder, cube, and sphere, thinking that their purity could unify everything.'" When . . . the cube is added to other solids, Reff concludes, "the distortion of Cézanne's meaning becomes complete. For he chose them only as forms whose curving surfaces receded from the eye . . ."

It should perhaps be added that the context of Cézanne's remark to Bernard was that of an ongoing discussion of theoretical questions which frequently left Cézanne at a loss as to what to say to his admirer. As a result, Cézanne often fed Bernard art-school bromides. In a letter of July 25, 1904, for example, he tells Bernard, "In an orange, an apple, a ball, a head, there is a culminating point; and this point is always . . . closest to our eye; the edges of the objects flee toward the center on our horizon." The level of the observation about the cylinder, sphere, and cone is not very different from this. Despite Cézanne's dutiful feeling that a painter should have a theory to go along with his practice, his letters show that his self-imposed dialogue with Bernard sometimes exasperated him; "I can scarcely read his letter," Cézanne writes his son on September 13, 1906, speaking of "Emilio Bernardinos, one of the most distinguished aesthetes."

151. See Douglas Cooper, *Fernand Léger et le nouvel espace,* trans. from English by François Lachenal (Geneva: Editions des Trois Collines, 1949), pp. 35–36, and Pierre Descargues, *Fernand Léger* (Paris: Cercle d'Art, 1955), pp. 25, 28. Thus the accepted view has been that Léger, through Robert Delaunay (whom he knew before 1909), was introduced to Max Jacob and Guillaume Apollinaire, who in turn brought him in 1910 to Kahnweiler's gallery, where he was *first* shown the works of Picasso and Braque.

Bradley Jordan Nickels, however, records Kahnweiler's saying to him in a conversation in 1963 ("Fernand Léger: Paintings and Drawings, 1905–1930" [Ph.D. dissertation, Indiana University, 1966], p. 39) "that Léger had probably seen the work of Picasso and Braque before 1910." Christopher Green, (*Léger and the Avant-Garde* [New Haven and London: Yale University Press, 1976], pp. 13–14) concludes that Léger's debt to the Montmartre Cubists was ". . . at least equal to the debt he owed Cézanne and the Douanier. It may well be that Apollinaire and Max Jacob were for Léger the intermediaries between Montparnasse and Kahnweiler, but it is unlikely that before he went to Kahnweiler's he had heard nothing of what was to be seen there . . . he was at this time (1908–1911) in contact with Delaunay, and so his life in 'La Ruche' could not have been altogether out of touch with the advanced developments in the Parisian avant-garde. Delaunay was well informed: in November he had seen Kahnweiler's exhibition of Georges Braque's L'Estaque landscapes, and he was a regular visitor at the home of one of Kahnweiler's first clients, the German connoisseur and dealer Wilhelm Uhde, who in the autumn of 1909 was painted by Picasso and who by this date owned thirteen Braques. Certainly Delaunay was excited by what he saw at that time, and it seems at the least unlikely that he communicated none of his excitement and none of his knowledge to his friend." Green (p. 318, note 27) draws attention to the "particularly telling comparison" between Léger's *Bridge* of 1909 and Braque's L'Estaque landscapes of 1908.

152. Cited in Vallier, p. 14.

153. The exhibition titled "European Master Paintings from Swiss Collections," held at The Museum of Modern Art from December 1976 through February 1977, afforded an unparalleled opportunity to compare key Picassos and Braques of these years. As most of these pictures are divided between the museums of Bern and Basel, it is rare that one has the opportunity to see them side by side. The study made possible by their prolonged juxtaposition during this exhibition has confirmed for me the feeling that the early Cubist Picassos are, in general, superior to the contemporaneous Braques, despite their relative backwardness in terms of syntax. On the other hand, the judgment that the High Analytic Cubist Braques fully hold their own next to major Picassos of that period, a judgment which is easily confirmed by many other experiences, was also sustained by the opportunity to see, side by side, Braque's *Portuguese* and Picasso's *Aficionado,* two pictures which, though they are in the same museum collection, are not normally hung in proximity.

Comparative Chronology

CÉZANNE SIGNED AND DATED fewer than a dozen paintings, and none of these were executed after the middle seventies. Some of his works (the portraits of Geffroy, Vollard, Gasquet, landscapes of Annecy, etc.) can be dated with the help of external evidence, but in general only approximate dates can be established, based on stylistic criteria that are obviously a matter of individual interpretation. It is not surprising, therefore, that the dates suggested by various scholars often differ widely. This comparative chart takes into account only the writings of those authors who have concerned themselves specifically with the chronology of Cézanne's work. They are, in the order of the appearance of their publications:

Ambroise Vollard Vollard's 1915 book on Cézanne, as well as some articles and a volume of recollections,[1] provides dates based mostly on what the artist told him or on what he remembered.

Georges Rivière The father-in-law of Cézanne's son, Rivière inserted a chronological list of the painter's work at the end of his Cézanne biography of 1923. This list, very incomplete and full of errors, is nevertheless the first attempt at a catalog of the oeuvre. The dates given by him, sometimes very unreliable though at other times extremely accurate, were obviously established with the help of the artist's son, whose recollections were usually more reliable for later works the execution of which he had witnessed. A few more dates were provided in a subsequent book by Rivière, published ten years later.[2]

Lionello Venturi The author of the first catalogue raisonné of Cézanne's work, Venturi has the tremendous merit of having tried to establish a succinct chronology of Cézanne's paintings, watercolors, and drawings. But the dates suggested by him have since been widely questioned. In a number of cases more recent research has provided precise information that contradicts Venturi's findings. Yet his catalog (though incomplete) is still indispensable as a reference book.[3]

Lawrence Gowing Gowing established the excellent catalog of a Cézanne exhibition in England (1954) for which he disregarded Venturi's dates and replaced them with new ones, based on his intimate knowledge of the works and his perceptive eye of a painter. Violently attacked by Douglas Cooper, he replied in an article in the *Burlington Magazine*.[4] The dates here quoted refer to these publications as well as to his essay in the present volume.

Douglas Cooper While Cooper, in two articles in the *Burlington Magazine*, took issue with the dates suggested by Gowing, his passion for contradiction led him to use trumped-up references and quibbling arguments that greatly reduce the value of his chronology.[5] Some of the dates quoted here were also culled from his subsequent writings.

Robert Ratcliffe Ratcliffe is the author of an as yet unpublished doctoral dissertation at the University of London with an extremely methodical chronology.[6]

Theodore Reff Since 1959, Reff has written numerous articles on Cézanne which occasionally touch on problems of chronology, problems that are studied more extensively in his essay in the present volume. The dates quoted here were taken from these various sources.[7]

John Rewald Rewald's first article on Cézanne appeared in 1935; he has written a long review of Venturi's catalogue raisonné, discussing problems of dating the artist's works.[8] He is now preparing a new catalogue raisonné of Cézanne's paintings, as well as one, in collaboration with Adrien Chappuis, of Cézanne's watercolors.

The chronology that follows confines its attention to paintings included in the present exhibition.

J.R.

1. A. Vollard, *Paul Cézanne* (Paris: Galerie A. Vollard, 1915, 1919, 1924, 1938; New York: N. L. Brown, 1923). Also, *Recollections of a Picture Dealer* (Boston: Little, Brown, 1936).
2. G. Rivière, *Le Maître Paul Cézanne* (Paris: Floury, 1923) and *Cézanne* (Paris, 1933).
3. L. Venturi, *Cézanne: son art—son oeuvre*, 2 vols. (Paris: Paul Rosenberg, 1936).
4. *Cézanne Paintings*, exhibition catalog, Edinburgh and Tate Gallery, London, 1954. Also, "Notes on the Development of Cézanne," *Burlington Magazine*, June 1956.
5. D. Cooper, "Two Cézanne Exhibitions," *Burlington Magazine*, November and December 1954.
6. R. Ratcliffe, "Cézanne's Working Methods and Their Theoretical Background" [University of London, 1960].
7. Notably T. Reff, "A New Cézanne Exhibition," *Burlington Magazine*, March 1960, and "Cézanne's Constructive Stroke," *Art Quarterly*, Summer 1962.
8. J. Rewald, "A propos du catalogue raisonné de l'oeuvre de Cézanne et de la chronologie de cette oeuvre," *La Renaissance*, March–April 1937. Also, "Some Entries for a New Catalogue Raisonné of Cézanne's Paintings," *Gazette des beaux-arts*, September 1975.

COMPARATIVE CHRONOLOGY

Pl. 1 Vollard: 1890; Rivière: 1895; Venturi: 1895; Ratcliffe: 1895–96; Reff: 1895–96; Rewald: 1895 (April–July)

Pl. 3 Rivière: 1897; Venturi: 1896–97; Rewald: 1896

Pl. 4 Vollard: 1899

Pl. 5 Rivière: c. 1900; Venturi: 1898–1900; Gowing: c. 1901; Cooper: c. 1901; Ratcliffe: not before 1898; Reff: 1898–1901; Rewald: c. 1900

Pl. 9 Vollard: 1896; Rivière: 1896; Venturi: c. 1896; Gowing: c. 1896; Reff: 1896–97; Rewald: c. 1900

Pl. 12 Venturi: 1895–1900; Cooper: c. 1893; Reff: c. 1899; Rewald: c. 1899

Pl. 13 Venturi: 1895–1900; Cooper: c. 1893; Reff: c. 1899; Rewald: c. 1899

Pl. 16 Venturi: 1900–06; Rewald: 1905–06

Pl. 19 Venturi: 1900–04; Reff: probably 1900–02; Rewald: 1902–06

Pl. 20 Rivière: 1888; Venturi: 1900–04; Reff: probably 1900–02; Rewald: 1902–06

Pl. 22 Rivière: 1904; Venturi: 1904–05; Gowing: 1904–05; Cooper: probably 1905–06; Reff: 1902–05; Rewald: 1905–06

Pl. 23 Venturi: 1904–05; Rewald: 1905–06

Pl. 24 Reff: 1902–05; Rewald: 1902–05

Pl. 31 Venturi: 1898–1900; Ratcliffe: between 1895 and 1899; Rewald: c. 1898

Pl. 33 Venturi: c. 1900; Ratcliffe: between 1895 and 1899; Rewald: c. 1895

Pl. 34 Venturi: c. 1900; Ratcliffe: between 1895 and 1899; Rewald: 1898–1902

Pl. 35 Venturi: 1900–04; Reff: c. 1895; Rewald: 1900–04

Pl. 36 Venturi: c. 1900; Ratcliffe: between 1895 and 1899; Rewald: c. 1898

Pl. 37 Venturi: 1898–1900; Ratcliffe: between 1895 and 1899; Reff: 1898–99; Rewald: c. 1898

Pl. 49 Venturi: c. 1900; Rewald: 1898–1900

Pl. 50 Venturi: c. 1900; Rewald: 1900–04

Pl. 51 Venturi: c. 1900; Rewald: 1898–99

Pl. 52 Venturi: c. 1900; Rewald: 1896–99

Pl. 53 Venturi: c. 1900; Rewald: c. 1900

Pl. 55 Venturi: 1904–06; Gowing: c. 1905; Cooper: c. 1905; Reff: c. 1904; Rewald: 1902–05

Pl. 57 Vollard: 1904; Rivière: 1904; Venturi: c. 1904; Rewald: 1900–04

Pl. 59 Venturi: 1904–06; Reff: c. 1904; Rewald: 1904–06

Pl. 60 Venturi: 1904–06; Rewald: 1904–06

Pl. 67 Venturi: 1894–98; Cooper: c. 1898; Reff: 1894; Rewald: 1893–94

Pl. 69 Venturi: 1899; Rewald: 1898

Pl. 71 Venturi: 1900–06; Gowing: Fontainebleau 1905; Rewald: 1904–06

Pl. 72 Venturi: 1895–1900; Rewald: 1895–1900

Pl. 73 Venturi: 1900–06; Rewald: 1900–04

Pl. 75 Venturi: 1900–06; Rewald: 1902–06

Pl. 77 Rivière: 1898; Venturi: c. 1885; Rewald: c. 1898

Pl. 79 Venturi: 1902–06; Rewald: c. 1906

Pl. 80 Venturi: 1900–06; Rewald: 1902–06

Pl. 83 Rivière: 1906; Venturi: 1906; Rewald: 1906

Pl. 85 Venturi: 1900–06; Gowing: 1904 or 05; Rewald: c. 1904

Pl. 114 Venturi: 1894–1900; Reff: end of 1890s; Rewald: c. 1900

Pl. 116 Rivière: 1885; Venturi: 1894–1900; Rewald: 1896–98

Pl. 117 Gowing: c. 1906; Rewald: c. 1902

Pl. 119 Venturi: 1894–1900; Rewald: c. 1904

Pl. 120 Venturi: 1904–06; Rewald: 1902–06

Pl. 121 Venturi: 1904–06; Rewald: 1902–06

Pl. 122 Venturi: 1904–06; Rewald: 1902–06

Pl. 124 Venturi: 1904–06; Rewald: 1902–06

Pl. 128 Venturi: 1904–06; Gowing: c. 1906; Rewald: 1904–06

Pl. 139 Rivière: 1897; Venturi: 1895–1900; [Gowing: 1898–99]; Rewald: 1895–97

Pl. 140 Venturi: c. 1895; Cooper: 1896–97; Rewald: c. 1899

Pl. 144 Reff: c. 1899; Rewald: c. 1905

Pl. 145 Venturi: c. 1895; Gowing: c. 1892; Cooper: c. 1895; Reff: 1892; Rewald: c. 1895

Pl. 146 Venturi: 1895–1900; Reff: c. 1900; Rewald: c. 1900

Pl. 147 Venturi: 1895–1900; Gowing: probably after 1895; Reff: 1895–96; Rewald: 1895–98

Pl. 148 Rivière: 1887; Venturi: 1895–1900; Gowing: c. 1895; Cooper: probably 1894; Rewald: 1896–98

Pl. 157 Venturi: c. 1900; Rewald: 1898–1900

Pl. 160 Venturi: date uncertain (catalogued among pictures of 1895–1900); Rewald: c. 1898

Pl. 166 Venturi: 1900–05; Gowing: c. 1899; Cooper: 1897–98; Ratcliffe: possibly 1898–99; Rewald: 1902–06

Pl. 186 Venturi: 1898–1905; Reff: early 1900s, probably before Venturi 723 (pl. 192); Rewald: 1902–06

Pl. 192 Venturi: 1900–05; Reff: early 1890s, probably before Venturi 722 (pl. 193) and Venturi 725 (pl. 186); Rewald 1900–04

Pl. 193 Venturi: 1900–05; Gowing: c. 1900; Cooper: c. 1902; Reff: early 1900s, probably after Venturi 725 (pl. 186); Rewald: 1899–1904

Pl. 201 Venturi: c. 1895; Reff: early 1900s; Rewald: 1898–1900

Pl. 202 Venturi: 1879–82; Reff: 1896–97 or slightly later; Rewald: c. 1900

Plates

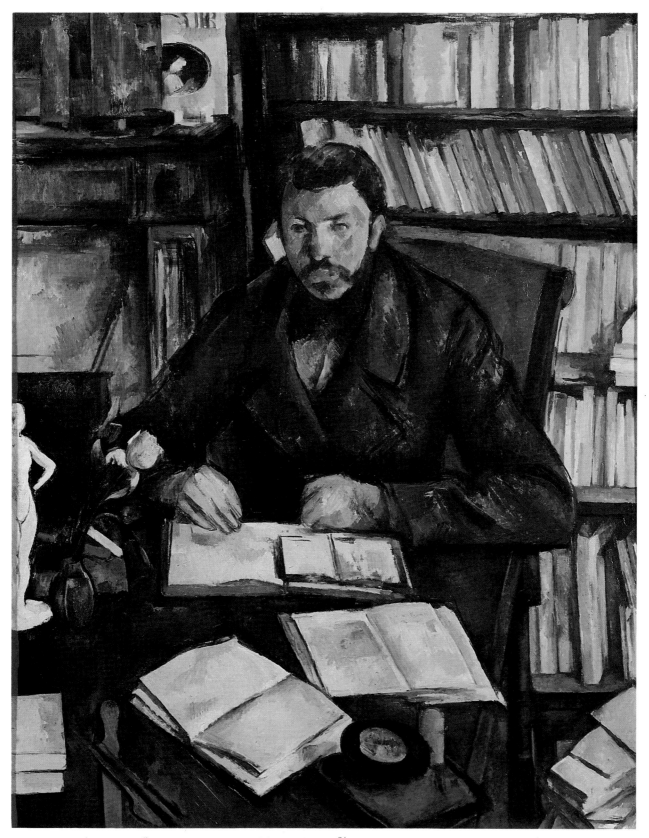

Pl. 1. *Portrait of Gustave Geffroy.* 1895. Venturi 692. Oil on canvas, 45¾ x 35 in (116.2 x 89.9 cm)
Musée du Louvre, Paris, life interest gift

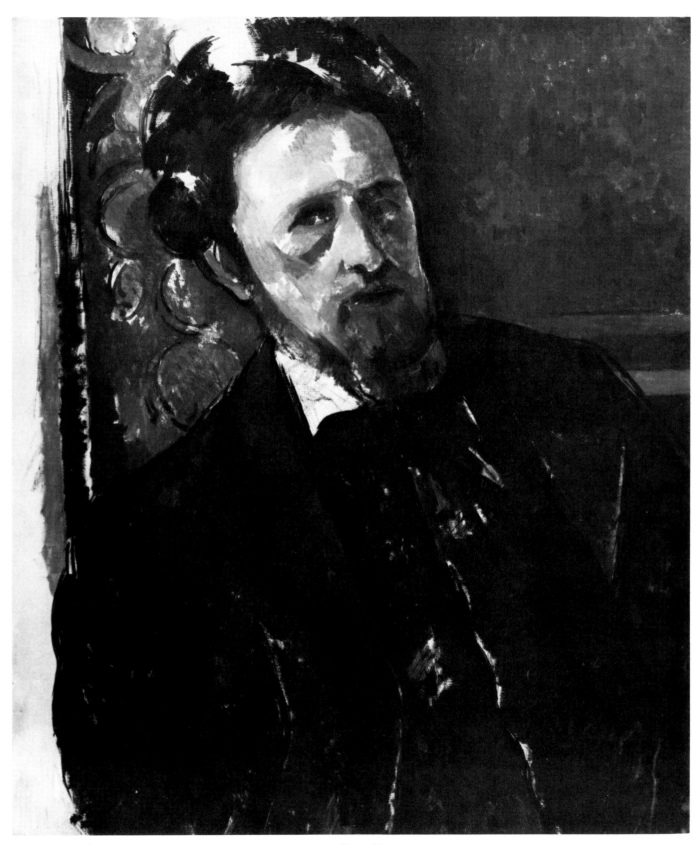

Pl. 2. *Portrait of Joachim Gasquet.* 1896. Venturi 694. Oil on canvas, 25⅝ x 21¼ in (65 x 54 cm). Modern Gallery of Art, Prague

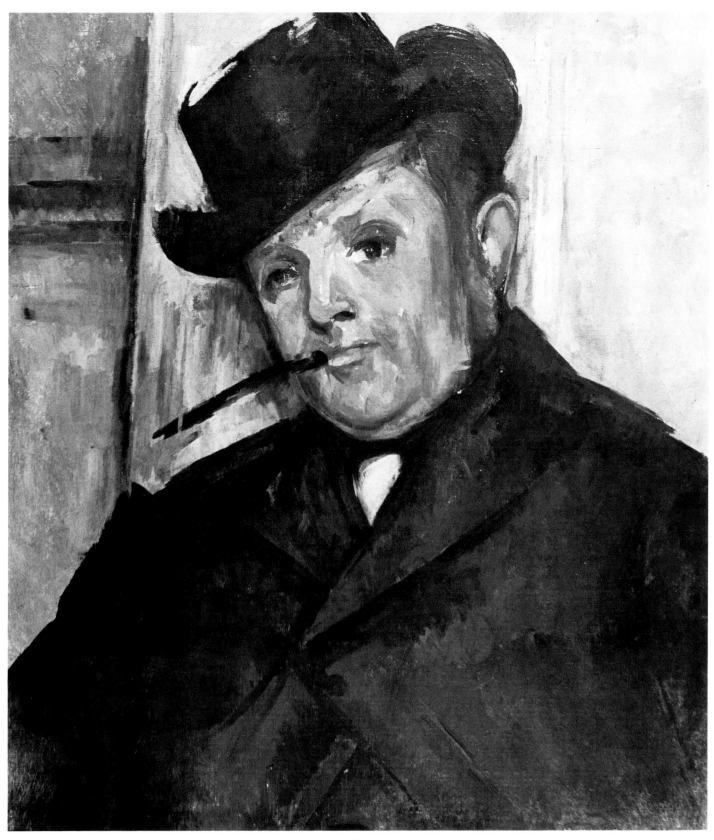

Pl. 3. *Portrait of Henri Gasquet.* 1896. Venturi 695. Oil on canvas, 22 x 18½ in (56 x 47 cm). The McNay Art Institute, San Antonio, Tex.

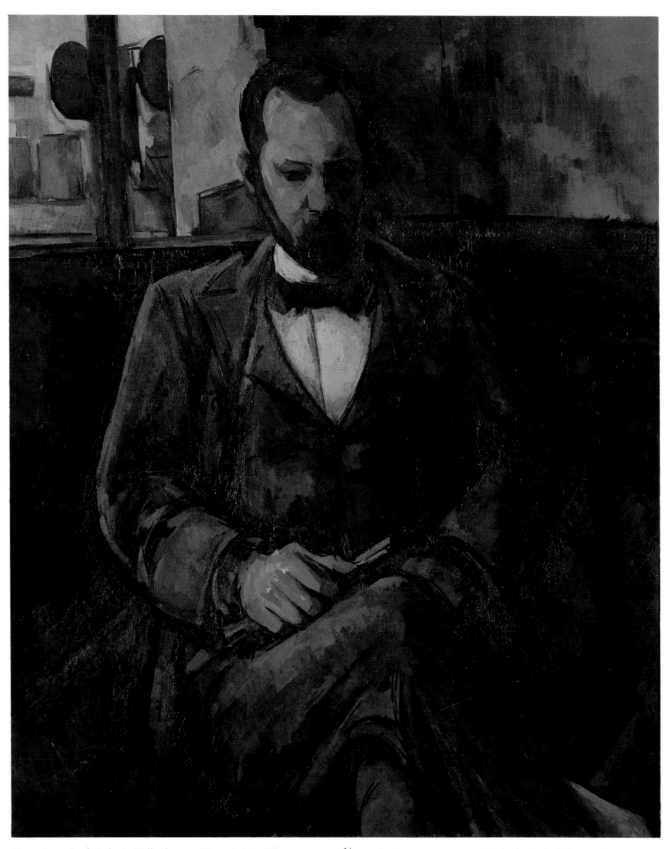

Pl. 4. *Portrait of Ambroise Vollard.* 1899. Venturi 696. Oil on canvas, 39½ x 32 in (100.3 x 81.3 cm). Musée du Petit Palais, Paris

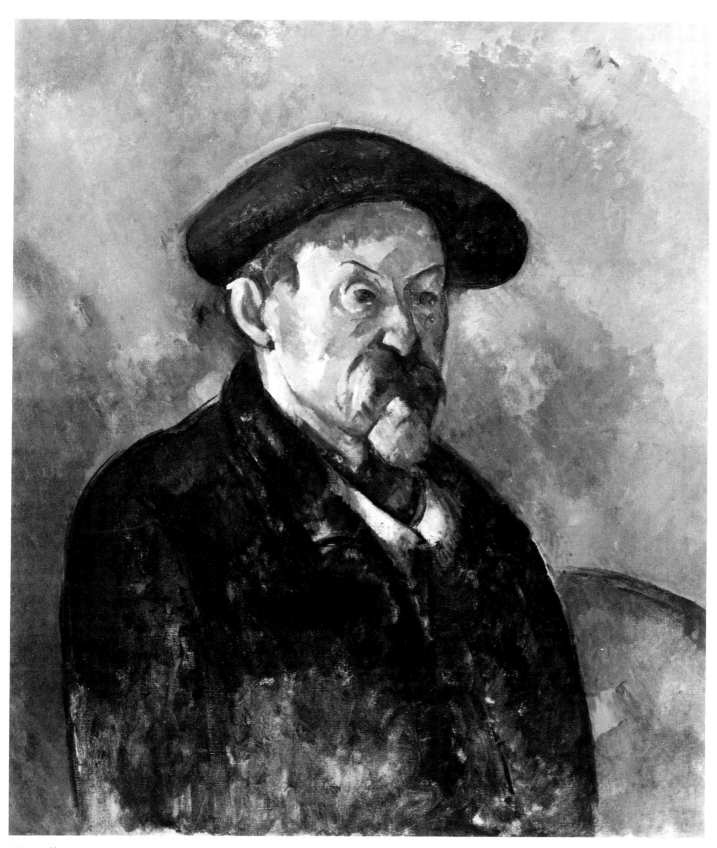

Pl. 5. *Self-Portrait with a Beret*. c. 1900. Venturi 693. Oil on canvas, 25 x 20 in (63.5 x 50.8 cm)
Museum of Fine Arts, Boston, Charles H. Bayley Fund and partial gift of Elizabeth Paine Metcalf

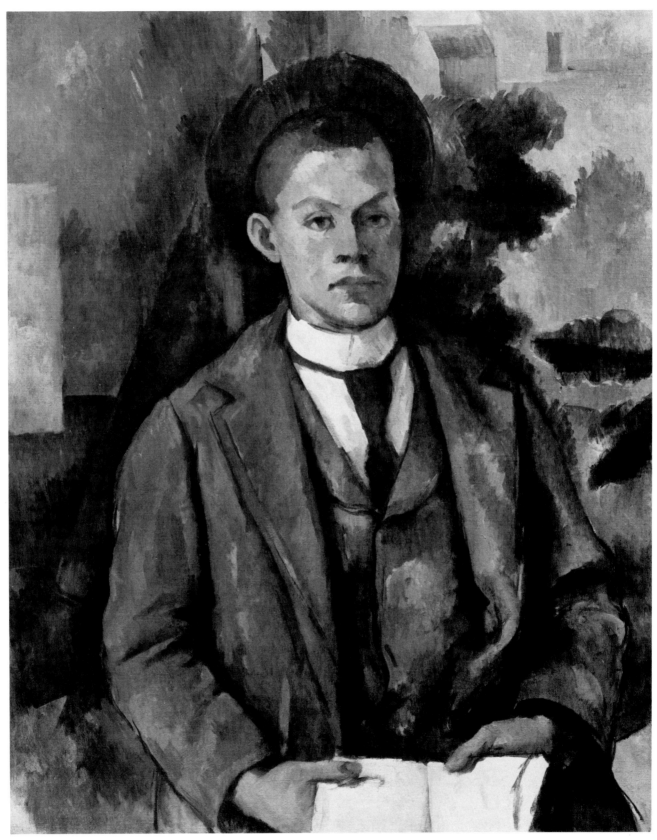

Pl. 6. *The Reader.* c. 1894. Venturi 678. Oil on canvas, $31\frac{7}{8}$ x $25\frac{5}{8}$ in (81 x 65 cm). Private collection

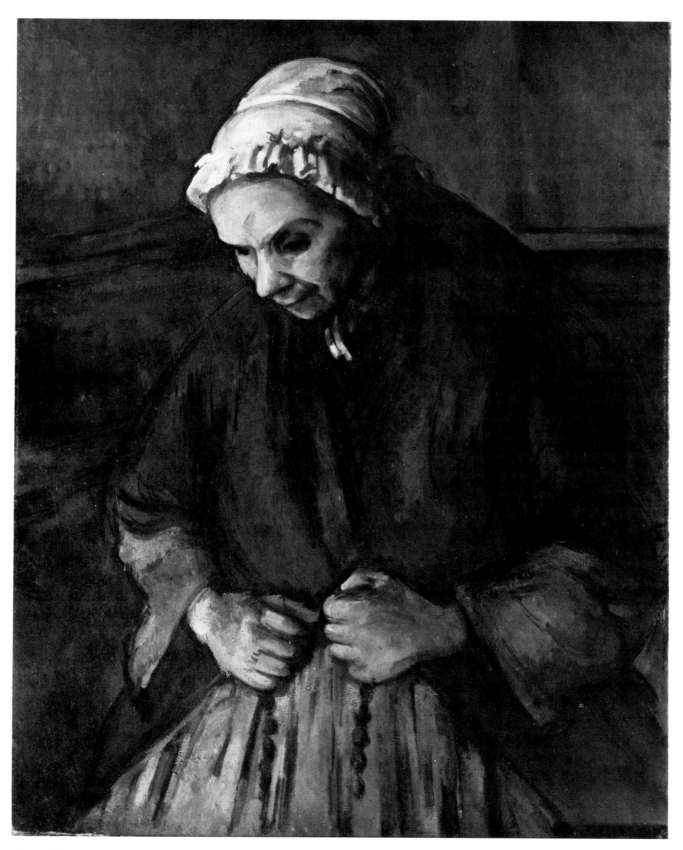

Pl. 7. *Old Woman with a Rosary*. 1895–96. Venturi 702. Oil on canvas, 33½ x 25⅝ in (85 x 65 cm). National Gallery, London

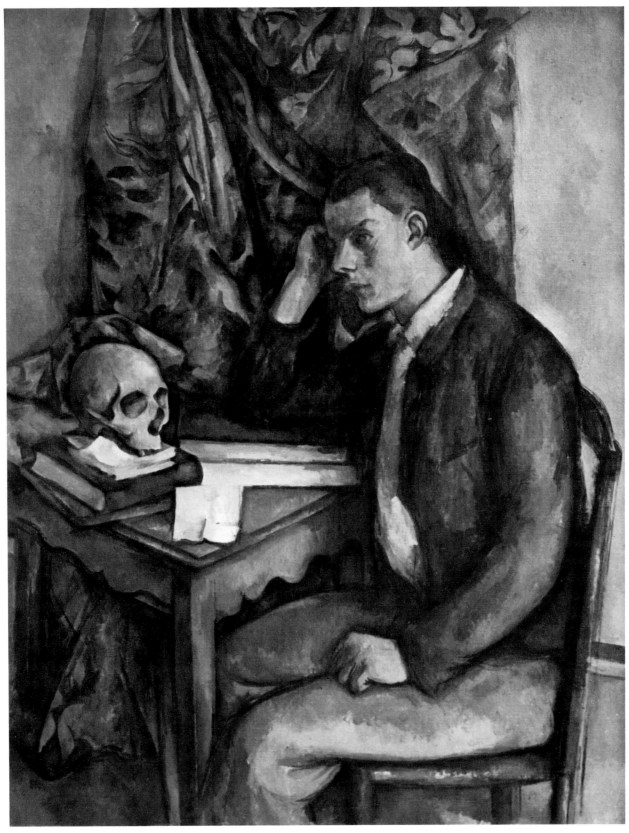

Pl. 8. *Young Man with a Skull.* 1896–98. Venturi 679. Oil on canvas, 51⅛ x 38⅛ in (130 x 97 cm)
© The Barnes Foundation, Merion, Pa.

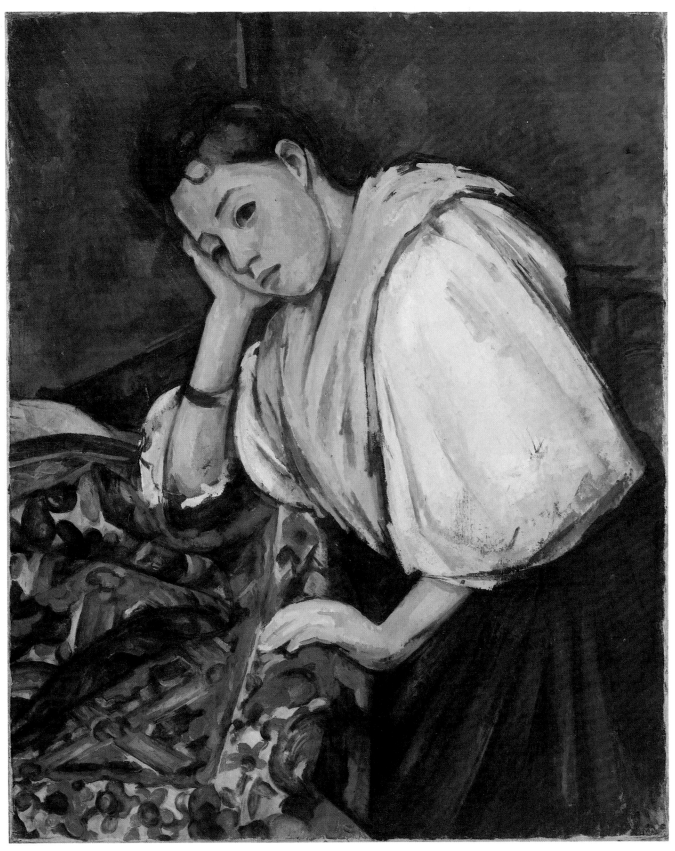

Pl. 9. *Young Italian Girl Resting on Her Elbow.* c. 1900. Venturi 701. Oil on canvas, $36\frac{1}{4}$ x $28\frac{3}{4}$ in (92 x 73 cm)
Collection Dr. and Mrs. William Rosenthal, New York

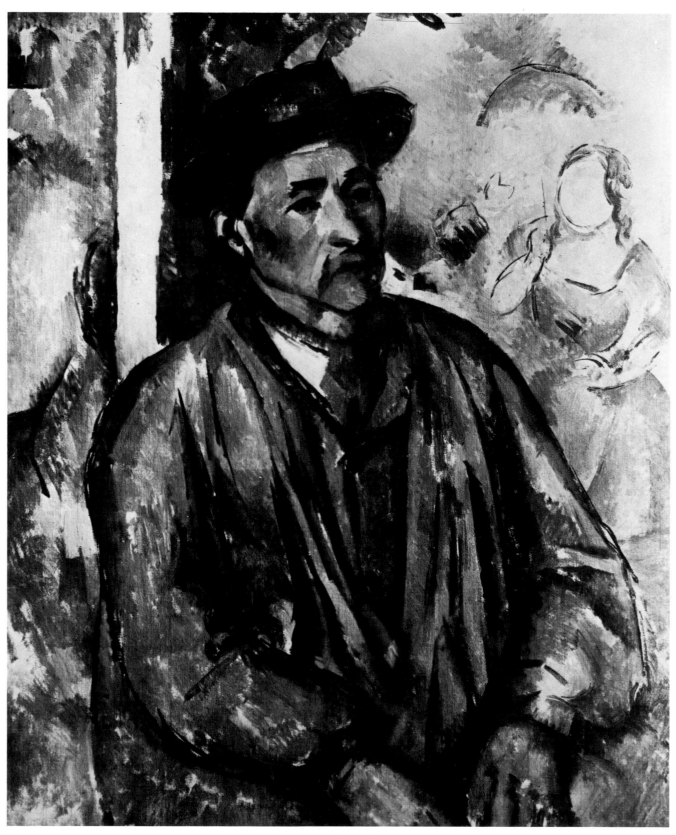

Pl. 10. *Peasant with Blue Blouse.* c. 1897. Venturi 687. Oil on canvas, 31⅞ x 25⅝ in (81 x 65 cm). Private collection, Detroit

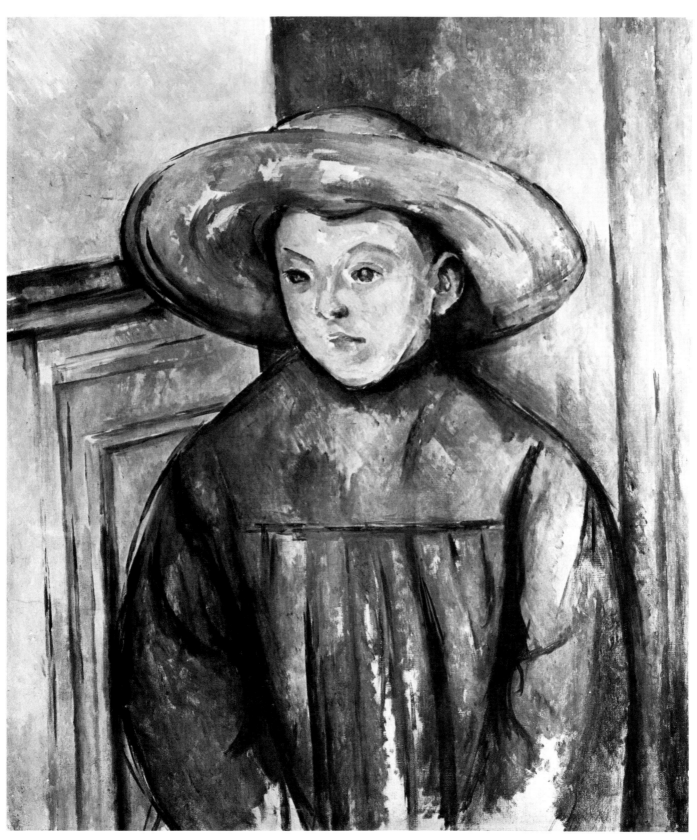

Pl. 11. *Child with Straw Hat*. 1896. Venturi 700. Oil on canvas, 27¼ x 22⅞ in (69 x 58 cm). Los Angeles County Museum of Art

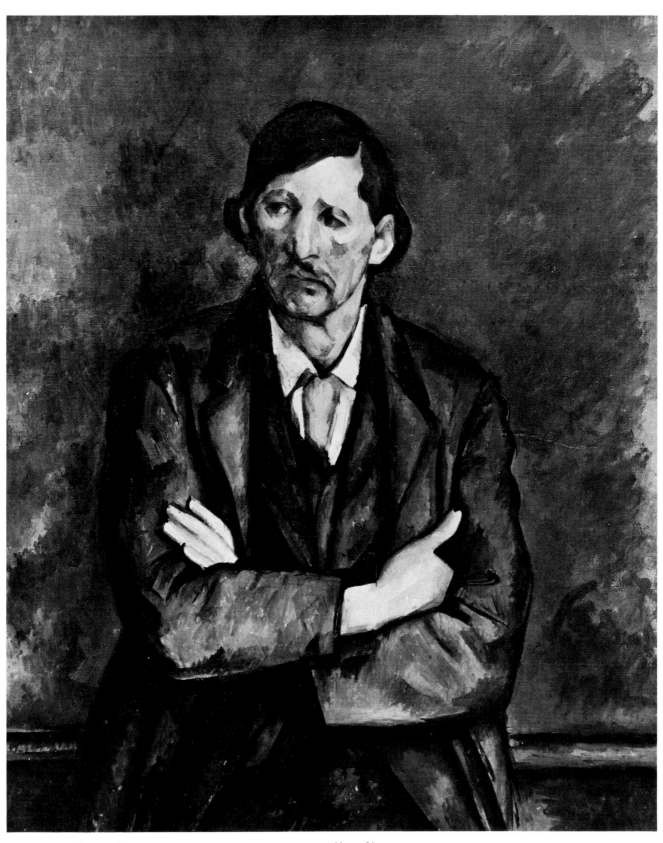

Pl. 12. *Man with Crossed Arms.* c. 1899. Venturi 685. Oil on canvas, $36\frac{1}{4}$ x $28\frac{5}{8}$ in (92.1 x 72.7 cm)
Collection Mrs. Carleton Mitchell, Annapolis

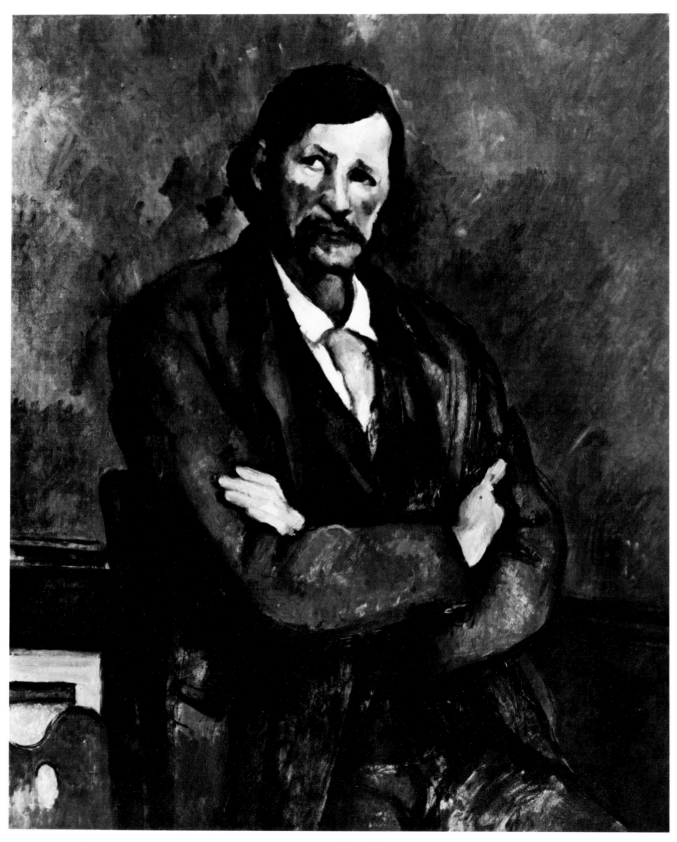

Pl. 13. *Man with Crossed Arms*. c. 1899. Venturi 689. Oil on canvas, 36¼ x 28⅝ in (92.1 x 72.7 cm)
The Solomon R. Guggenheim Museum, New York

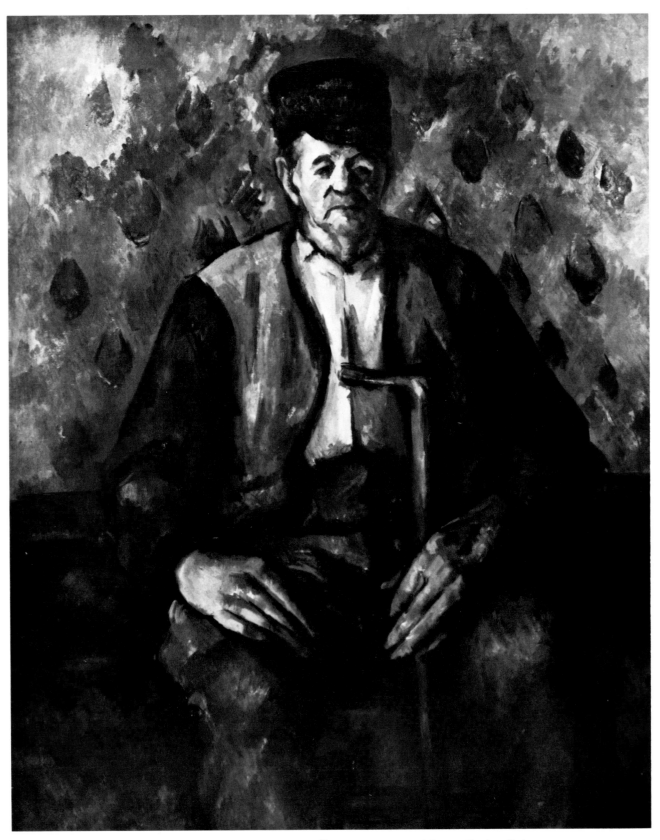

Pl. 14. *Seated Peasant.* c. 1900. Venturi 713. Oil on canvas, 28 x 22¾ in (72 x 58.5 cm). Private collection, Paris

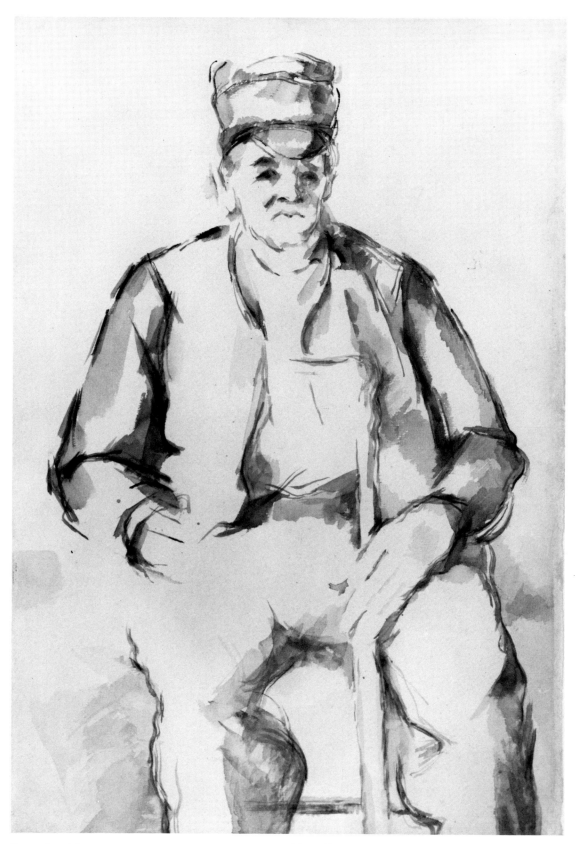

Pl. 15. *Seated Peasant.* 1900–04. Venturi 1089. Watercolor, 18½ x 12⅝ in (47 x 32 cm). Kunsthaus, Zurich

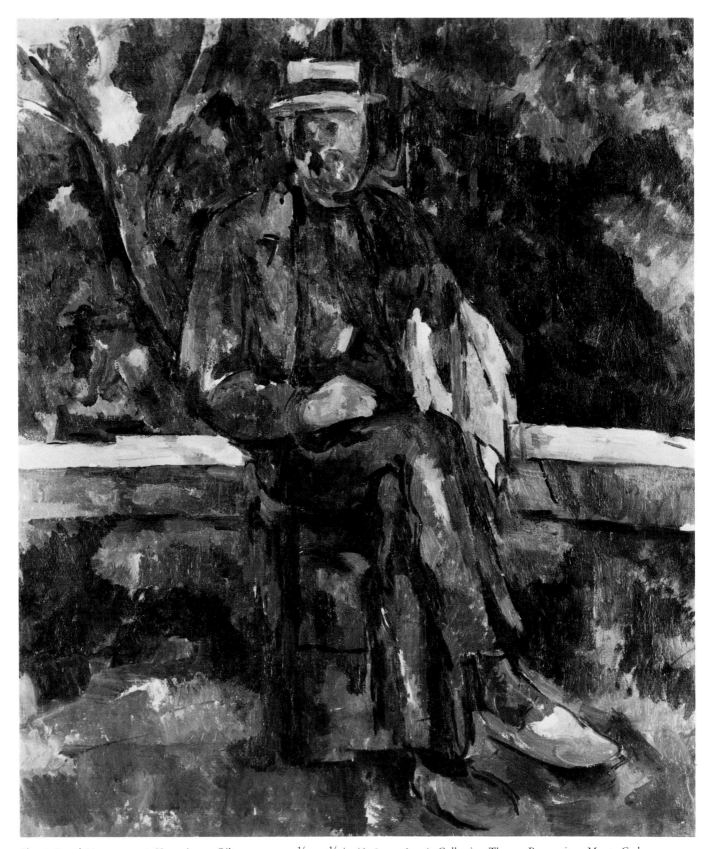

Pl. 16. *Seated Man*. 1905–06. Venturi 714. Oil on canvas, 25½ x 21½ in (64.8 x 54.6 cm). Collection Thyssen-Bornemisza, Monte Carlo

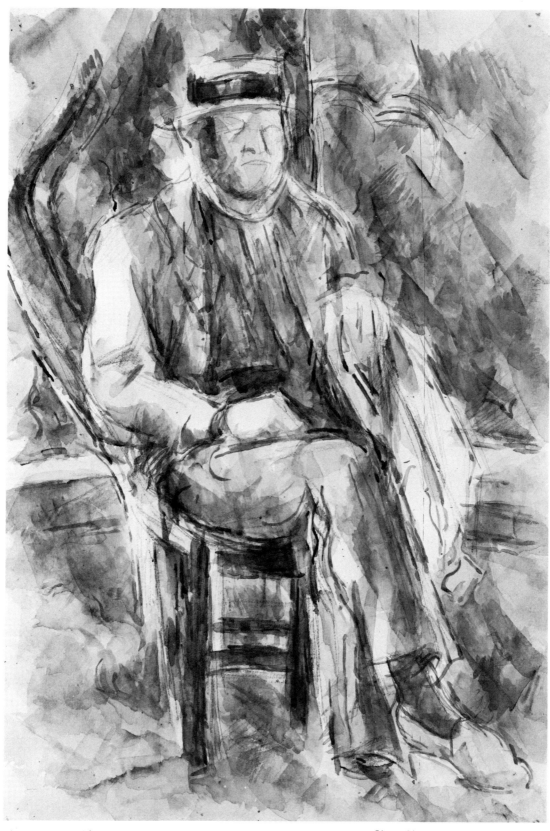

Pl. 17. *Peasant with Straw Hat.* c. 1906. Venturi 1090. Pencil and watercolor, 18⁷⁄₈ x 12³⁄₈ in (48 x 31.5 cm) The Art Institute of Chicago

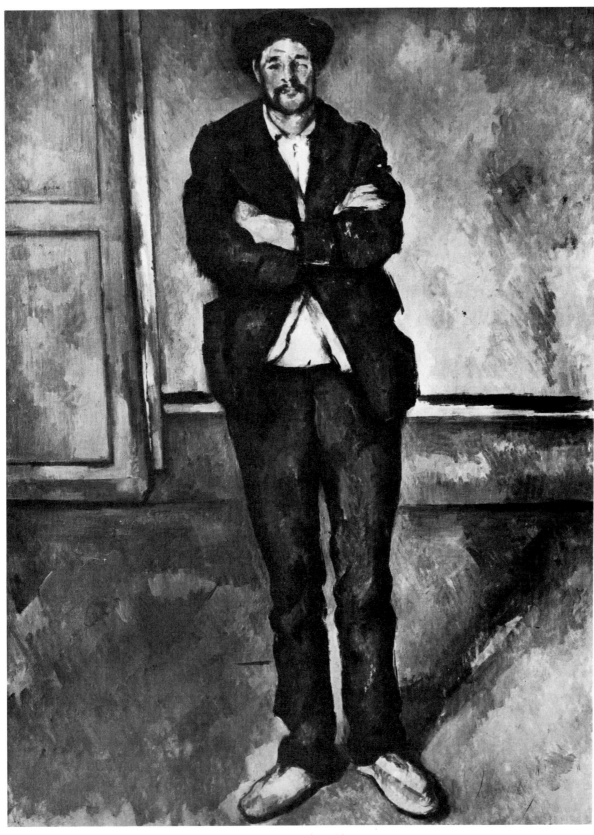

Pl. 18. *Standing Peasant*. c. 1895. Venturi 561. Oil on canvas, 31½ x 22½ in (80 x 57.1 cm)
© The Barnes Foundation, Merion, Pa.

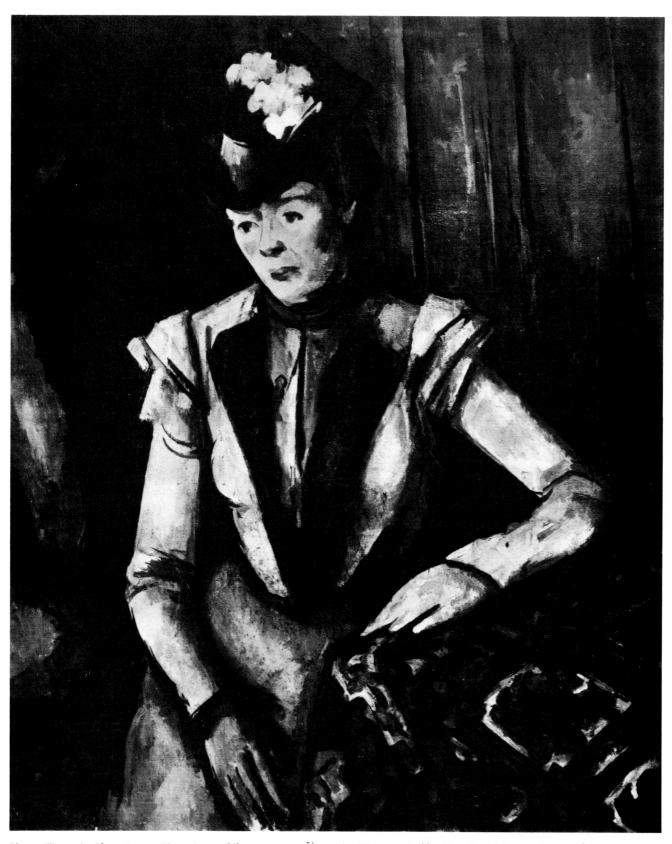

Pl. 19. *Woman in Blue.* 1892–96. Venturi 705. Oil on canvas, 34⅝ x 28 in (88 x 71 cm). The Hermitage Museum, Leningrad

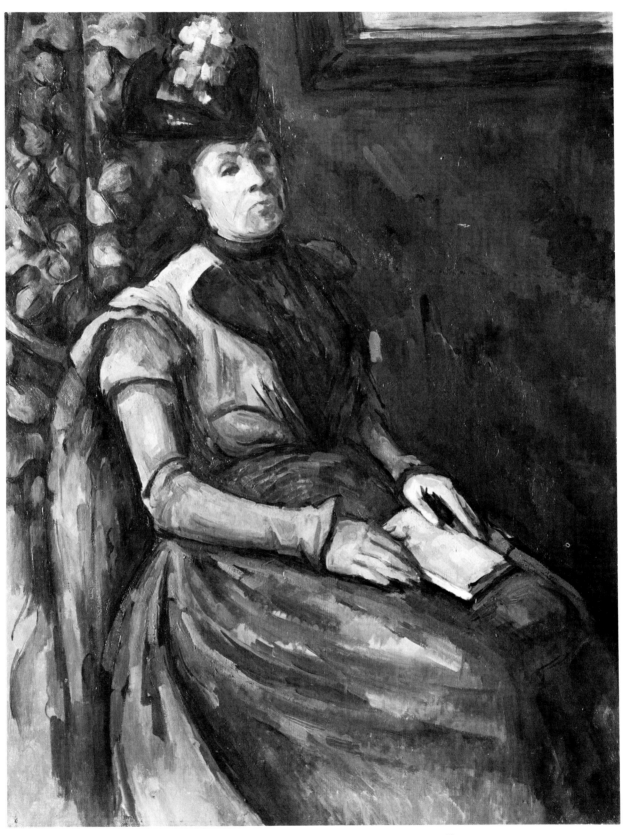

Pl. 20. *La Dame au livre* (*Seated Woman in Blue*). 1902–06. Venturi 703. Oil on canvas, 26 x 19⅝ in (66 x 49.8 cm)
The Philips Collection, Washington

Pl. 21. *Portrait of a Woman.* 1902–04. Venturi 1093. Watercolor, 19½ x 14⅝ in (49.5 x 37 cm). Private collection, Basel

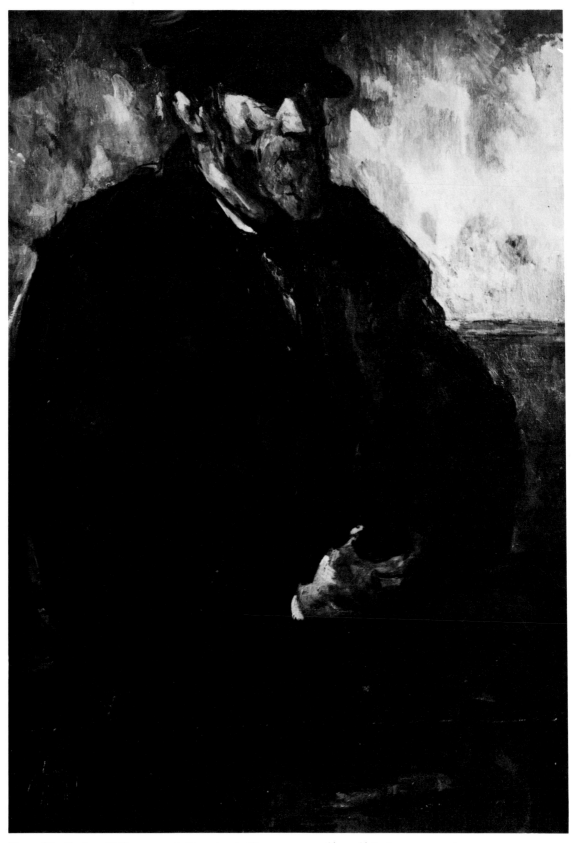

Pl. 22. *The Gardener Vallier*. 1905–06. Venturi 716. Oil on canvas, 42⅛ x 28½ in (107 x 72.4 cm)
Private collection, France

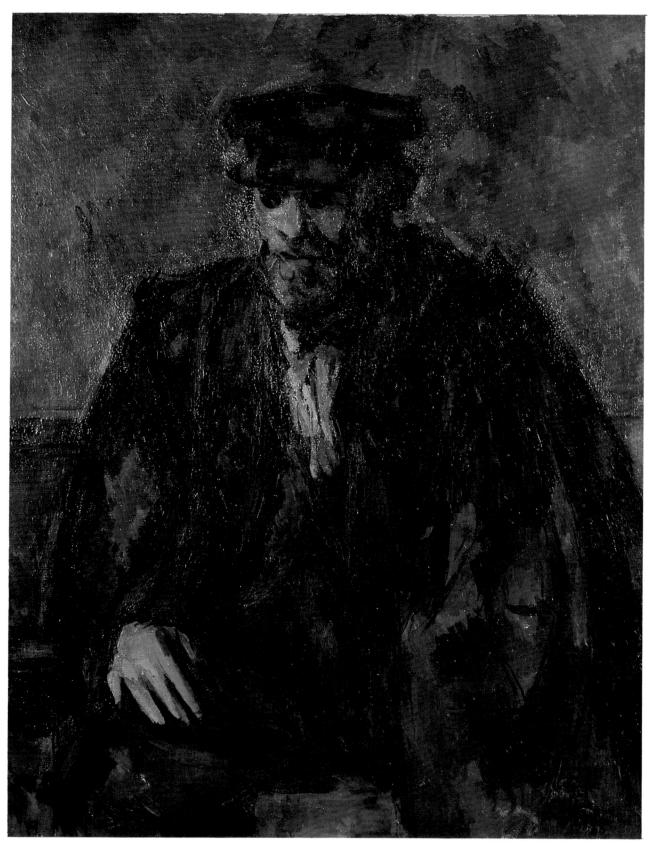

Pl. 23. *The Gardener Vallier* (*Presumed Portrait of Cézanne*). 1905–06. Venturi 717. Oil on canvas, 39½ x 32 in (100.3 x 81.3 cm)
Private collection, Switzerland

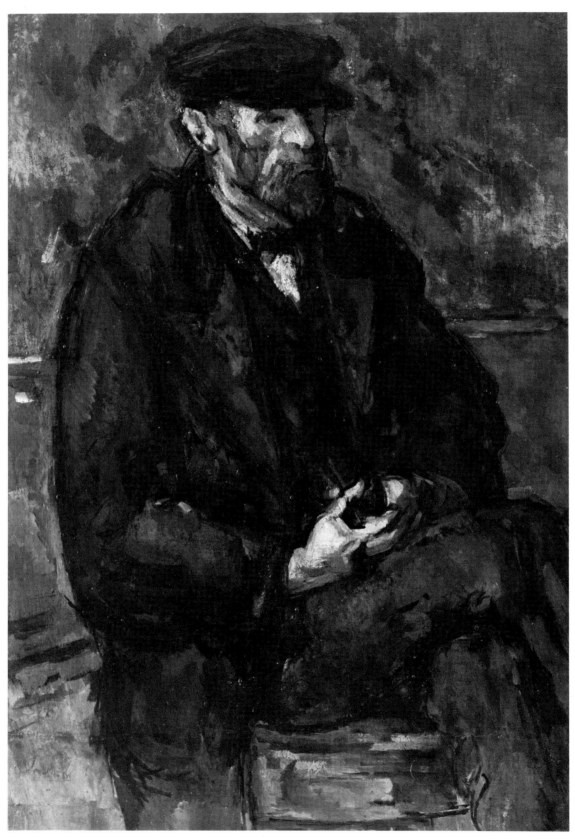

Pl. 24. *The Sailor*. 1905–06. Oil on canvas, 42¼ x 29⅜ in (107.4 x 74.5 cm)
National Gallery of Art, Washington, gift of Eugene and Agnes Meyer

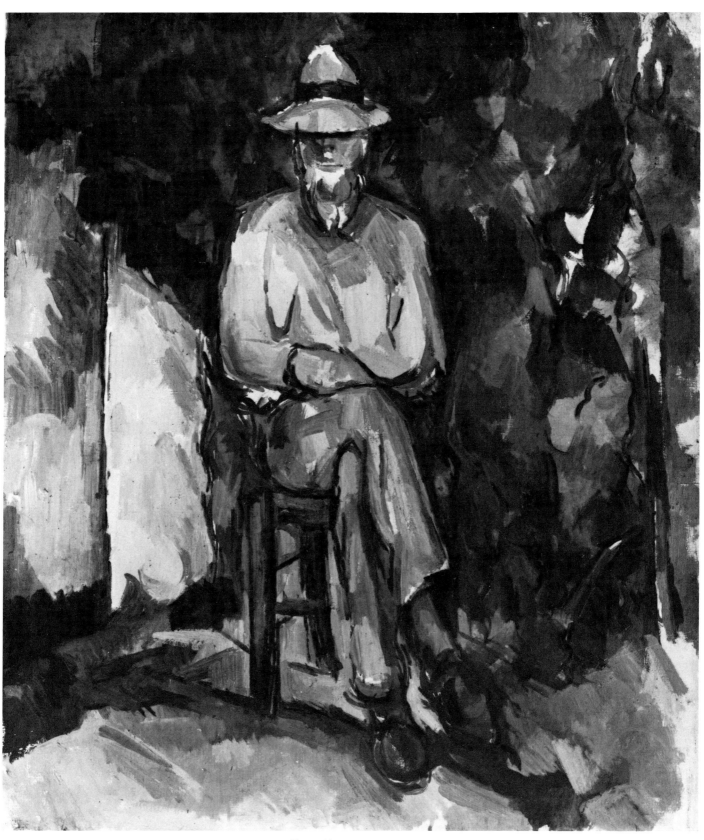

Pl. 25. *Vallier Seated.* 1905–06. Venturi 715. Oil on canvas, 24¾ x 20½ in (63 x 52 cm). The Tate Gallery, London

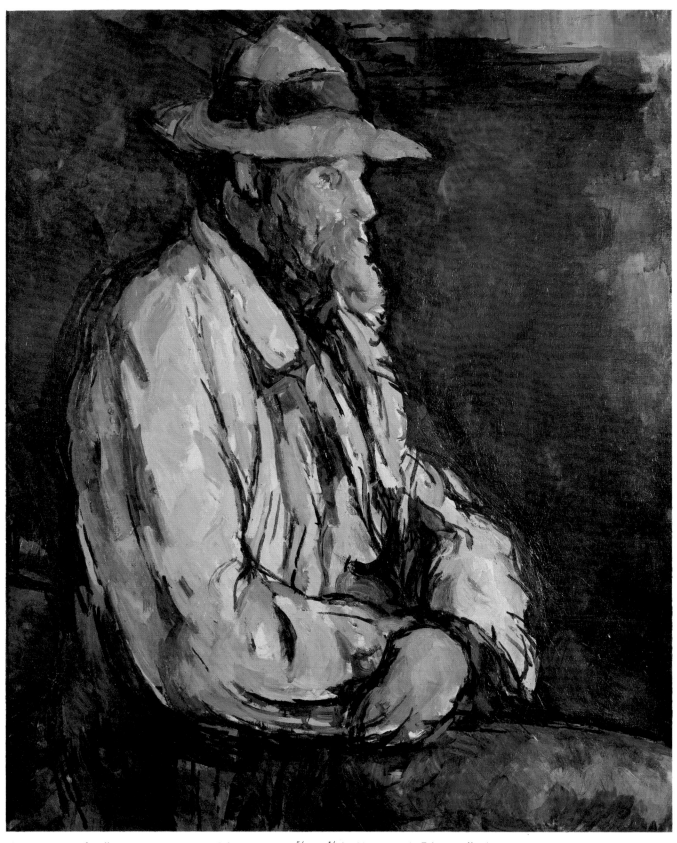

Pl. 26. *Portrait of Vallier.* 1906. Venturi 718. Oil on canvas, $25\frac{5}{8}$ x $21\frac{1}{4}$ in (65 x 54 cm). Private collection

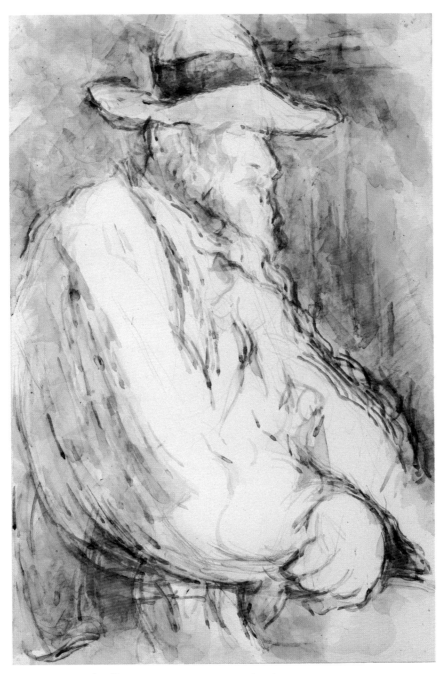

Pl. 27. *Portrait of Vallier.* 1906. Venturi 1102. Pencil and watercolor,
18⅞ x 12⅝ in (48 x 32 cm). Private collection, Chicago

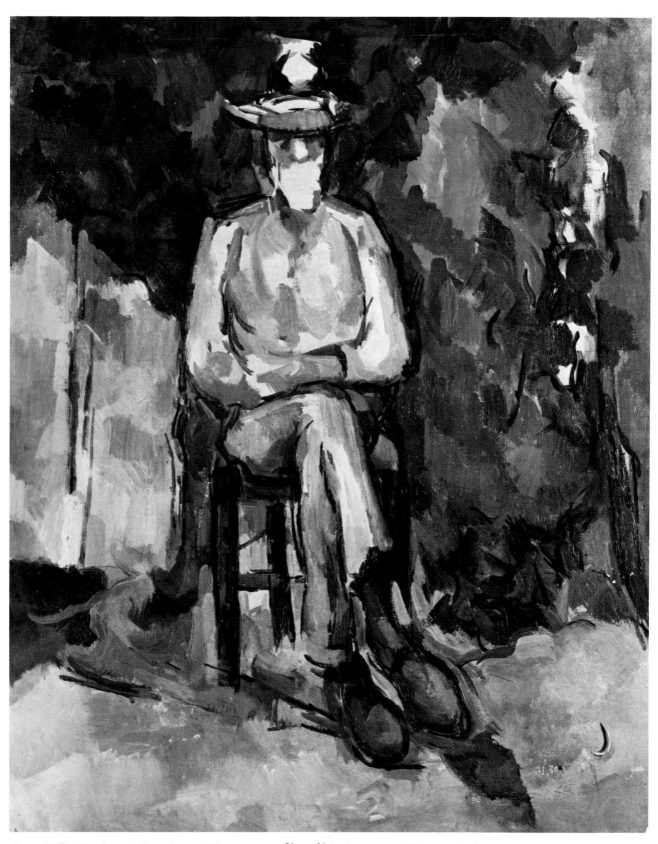

Pl. 28. *Vallier Seated.* 1906. Venturi 1524. Oil on canvas, 25⅝ x 21¼ in (65 x 54 cm). Private collection

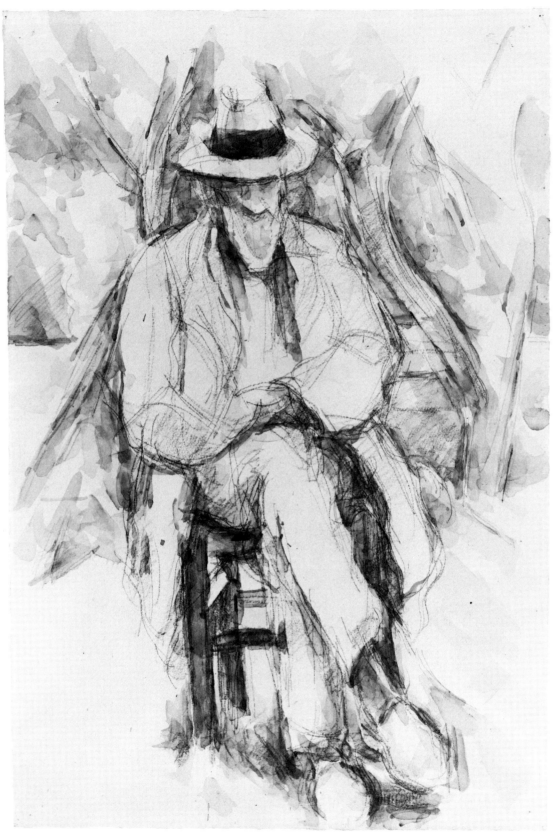

Pl. 29. *Portrait of Vallier.* 1904–06. Venturi 1092. Pencil and watercolor, 18¾ x 12¼ in (47.5 x 31 cm)
Private collection, Los Angeles

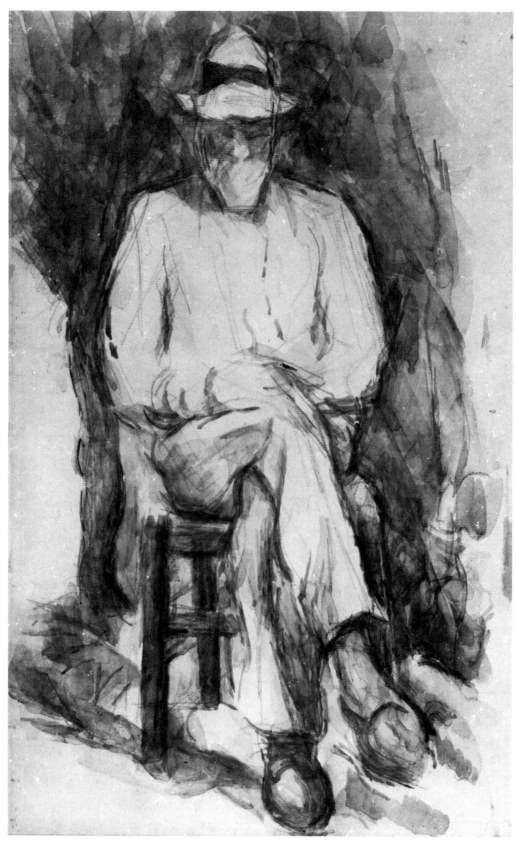

Pl. 30. *Vallier Seated*. 1906. Venturi 1566. Watercolor, 12⅜ x 18⅞ in (31.5 x 48 cm)
Collection Heinz Berggruen, Paris

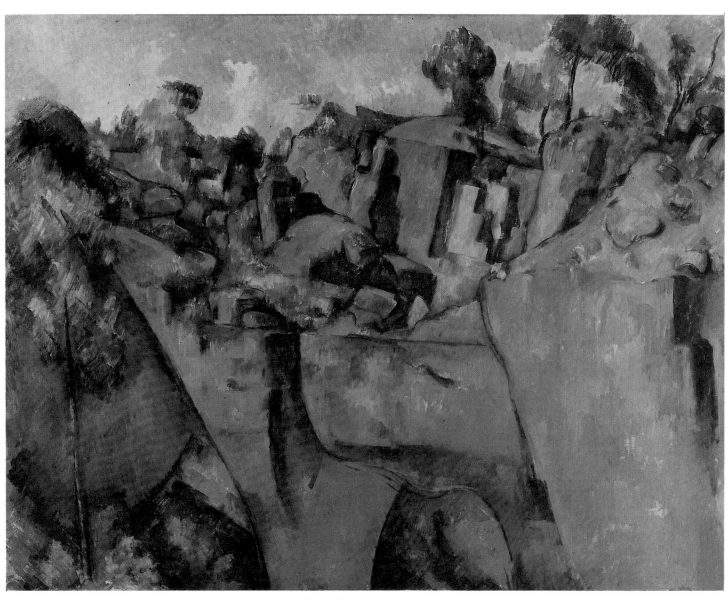

Pl. 31. *Bibémus Quarry*. c. 1895. Venturi 767. Oil on canvas, 25⅝ x 31⅞ in (65.1 x 81 cm). Museum Folkwang, Essen

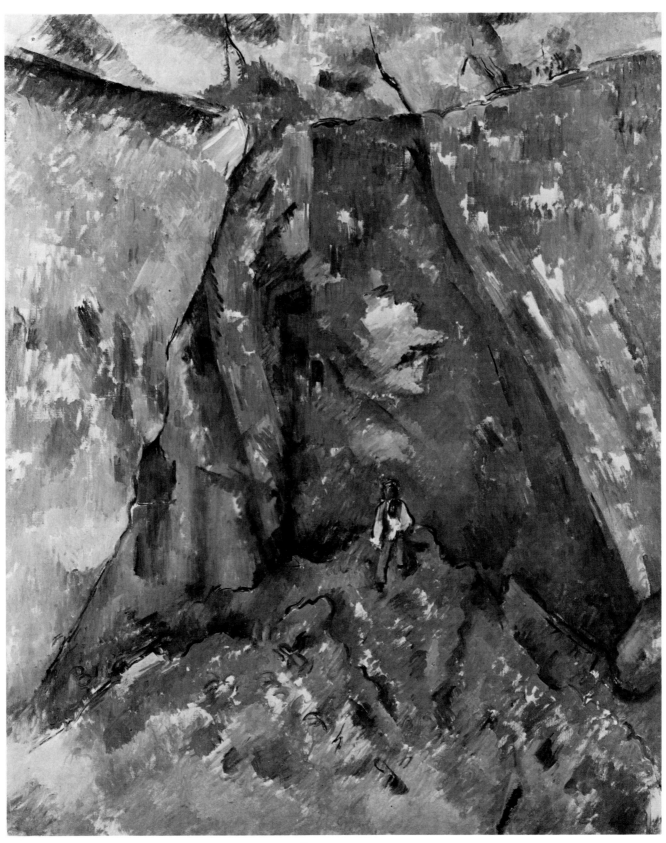

Pl. 32. *Bibémus Quarry.* c. 1895. Venturi 772. Oil on canvas, 31⅛ x 25 in (79 x 63.5 cm). Private collection, Paris

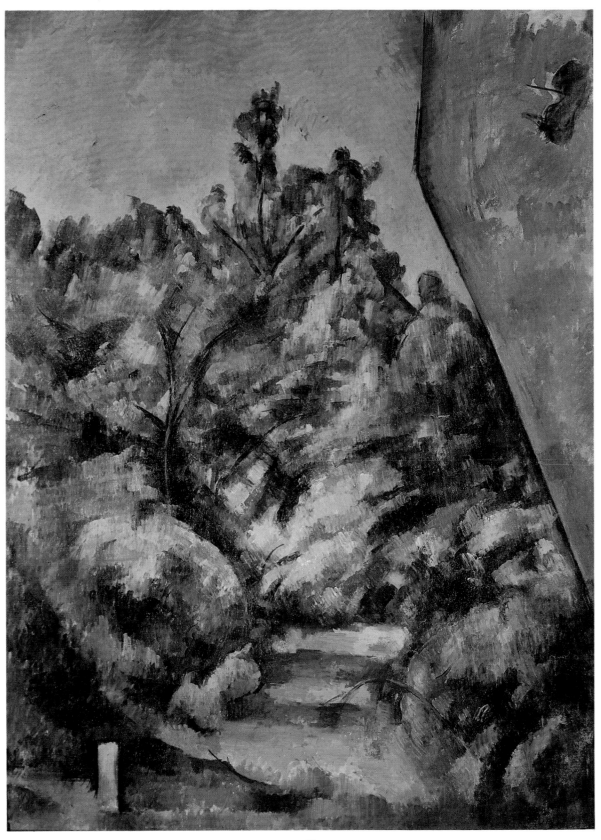

Pl. 33. *The Red Rock.* 1895–1900. Venturi 776. Oil on canvas, 35⅞ x 26 in (91 x 66 cm)
Musée du Louvre, Paris, Walter-Guillaume Collection

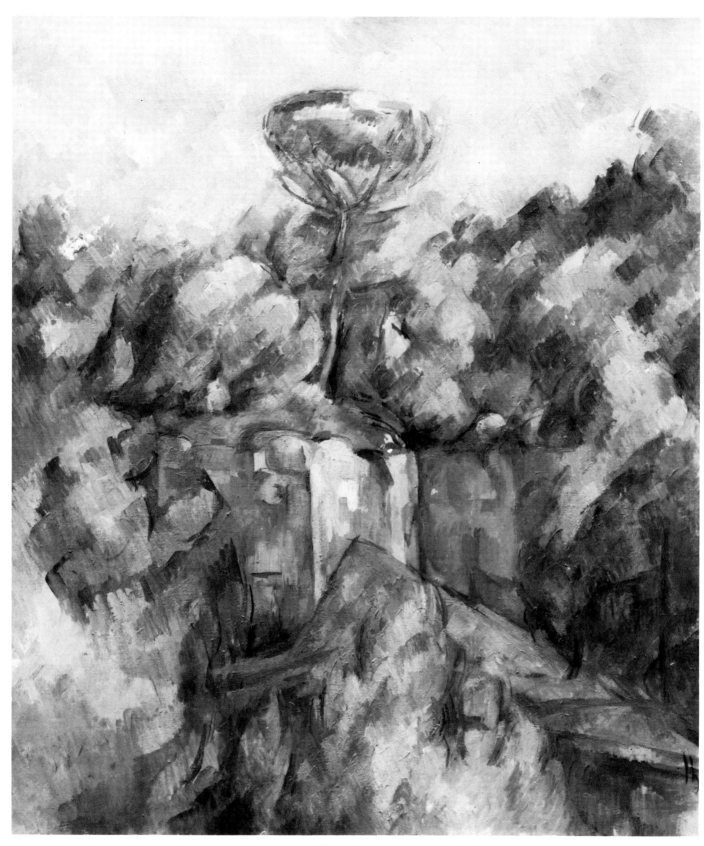

Pl. 34. *Bibémus Quarry*. 1898–1900. Venturi 778. Oil on canvas, 25⅝ x 21¼ in (65 x 54 cm). Collection Sam Spiegel, New York

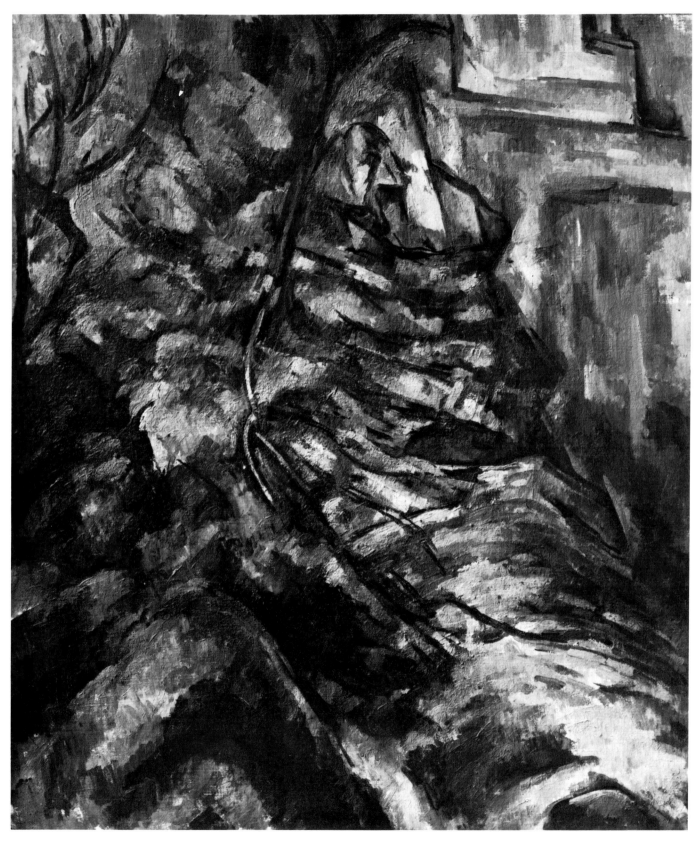

Pl. 35. *Rocks and Branches at Bibémus*. 1900–04. Venturi 785. Oil on canvas, 24 x 19¾ in (61 x 50 cm). Musée du Petit Palais, Paris

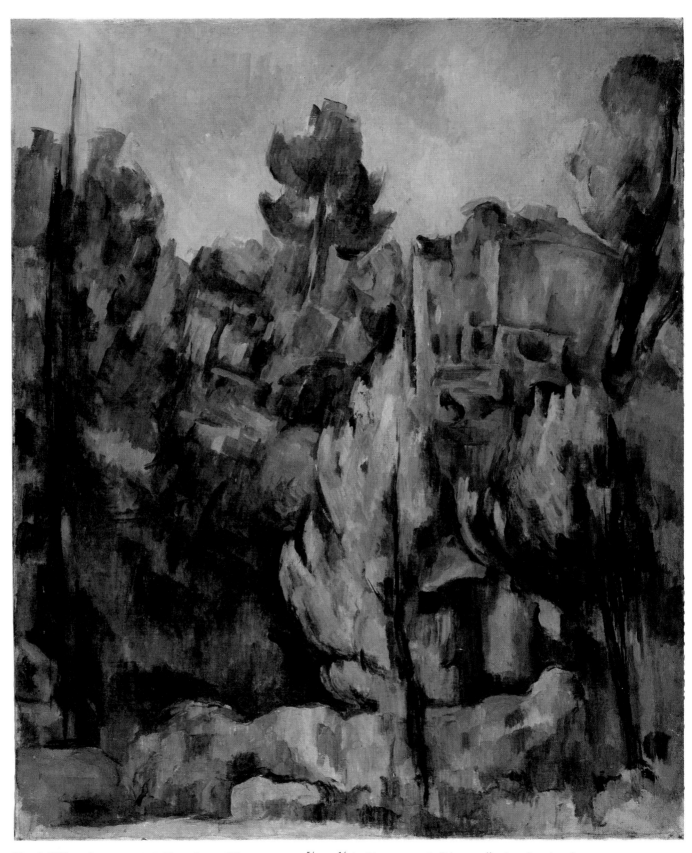

Pl. 36. *Bibémus Quarry*. c. 1898. Venturi 777. Oil on canvas, 25⅝ x 21¼ in (65.1 x 54 cm). Private collection, Los Angeles

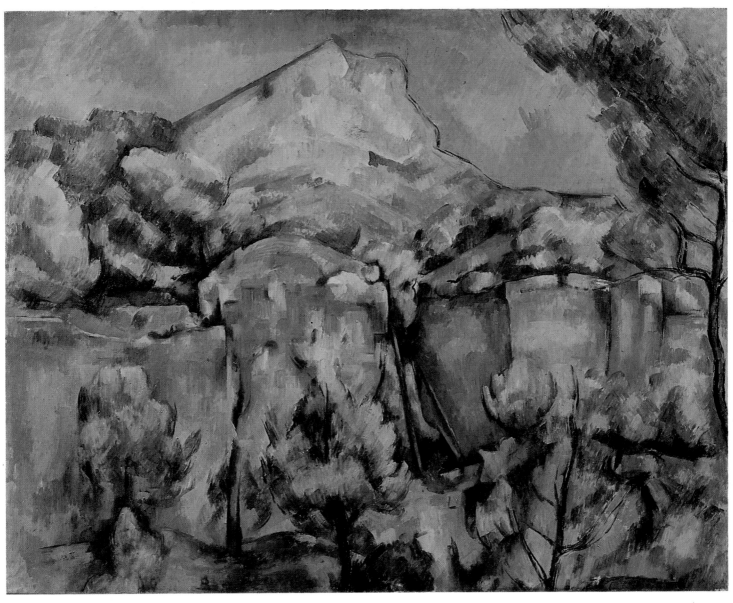

Pl. 37. *Mont Sainte-Victoire Seen from Bibémus.* c. 1898–1900. Venturi 766. Oil on canvas, 25½ x 32 in (64.8 x 81.3 cm)
The Baltimore Museum of Art, bequest of Miss Etta and Dr. Claribel Cone

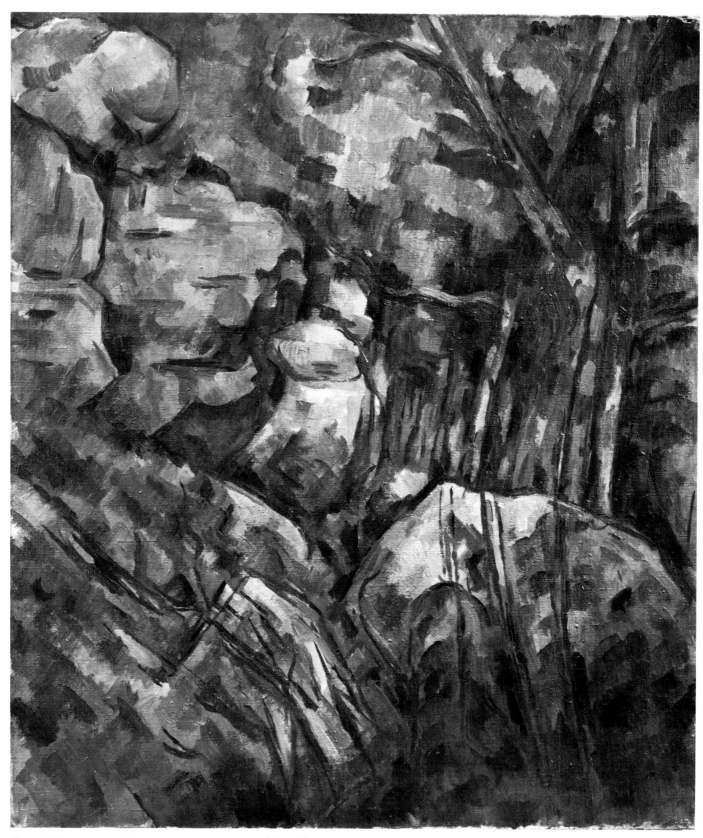

Pl. 38. *Bibémus.* c. 1904. Venturi 786. Oil on canvas, 25⅝ x 21¼ in (65 x 54 cm). Formerly collection Henri Matisse, Nice

Pl. 39. *Rocks near Bibémus*
1895–1900. Watercolor and pencil,
12⅝ x 18⅞ in (32 x 48 cm)
Staatliche Graphische Sammlung,
Munich

Pl. 40. *Rocks near the Caves
above Château Noir.* 1895–1900
Watercolor, 12¼ x 18½ in
(31 x 47 cm). Collection
Gianni Mattioli, Milan

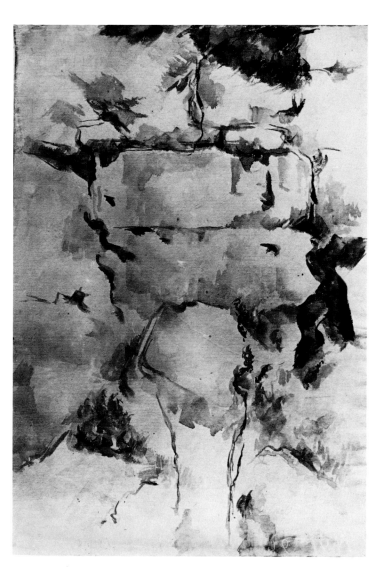

Pl. 41. *Rocks near the Caves above Château Noir.* 1895–1900
Pencil and watercolor, 17½ x 11⅞ in (44.5 x 30 cm)
Private collection, New York

Pl. 42. *Rocks near the Caves above Château Noir.* 1895–1900. Venturi 1042
Watercolor, 19¼ x 11⅜ in (48.9 x 28.9 cm). Private collection, London

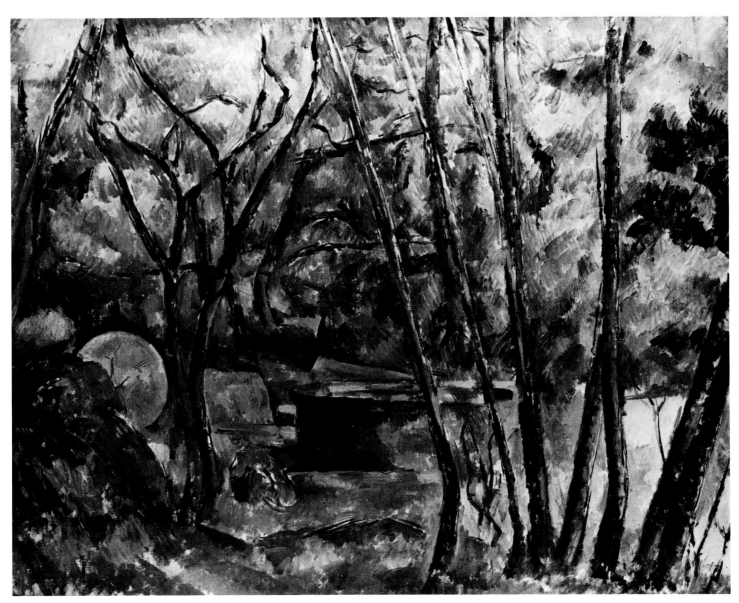

Pl. 48. *Forest of Château Noir.* 1890–92. Venturi 485. Oil on canvas, 31⅞ x 25⅝ in (81 x 65 cm). © The Barnes Foundation, Merion, Pa.

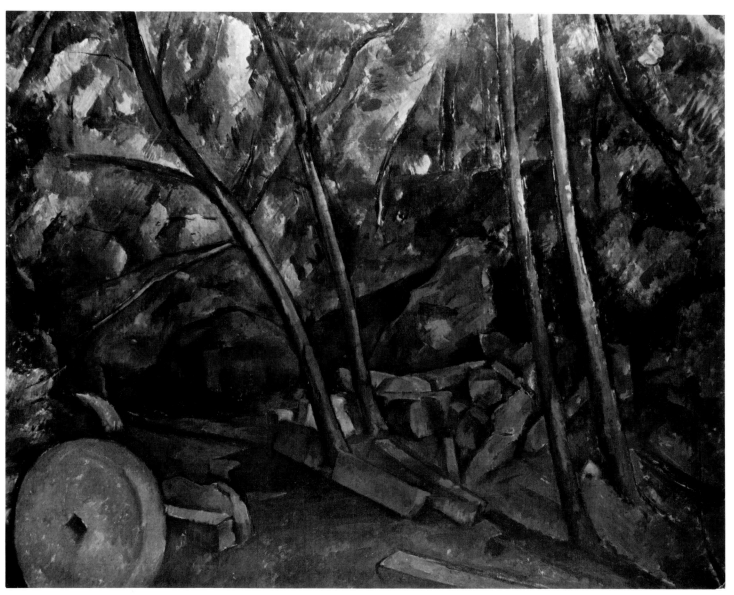

Pl. 47. *Forest of Château Noir.* 1892–94. Venturi 768. Oil on canvas, 28¾ x 36¼ in (73 x 92 cm). Philadelphia Museum of Art, Carroll S. Tyson Collection

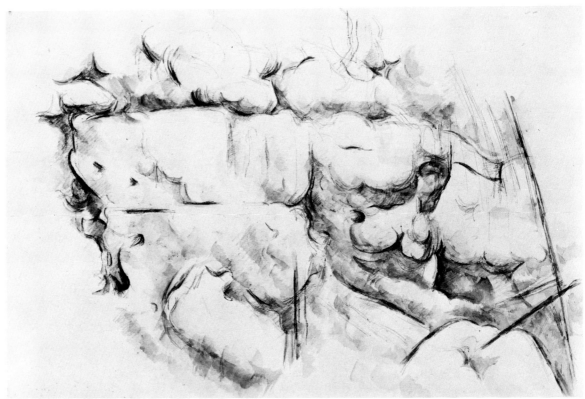

Pl. 45. *Rocks near the Caves above Château Noir.* 1895–1900 Venturi 1043. Pencil and watercolor, 12³⁄₈ x 18³⁄₄ in (31.4 x 47.6 cm) The Museum of Modern Art, New York, Lillie P. Bliss Collection

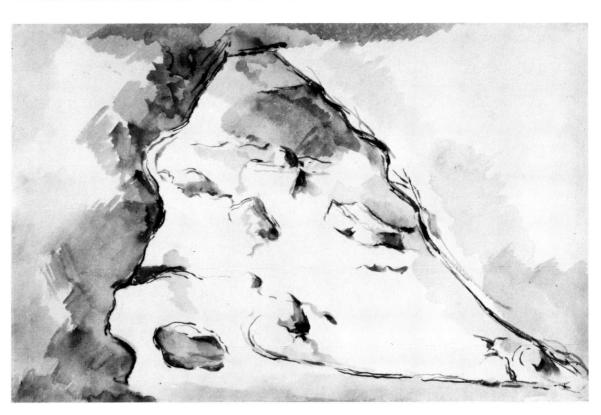

Pl. 46. *Bibémus Quarry* 1895–1900. Watercolor, 12 x 18¹⁄₄ in (30.5 x 46.4 cm) Galerie Beyeler, Basel

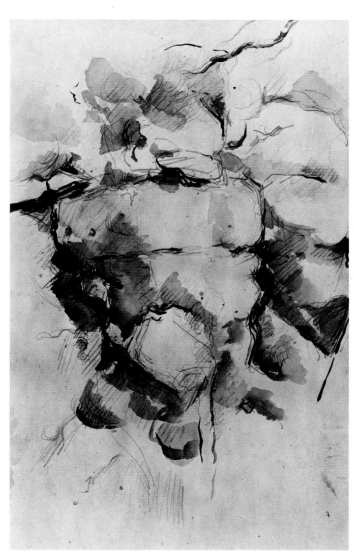

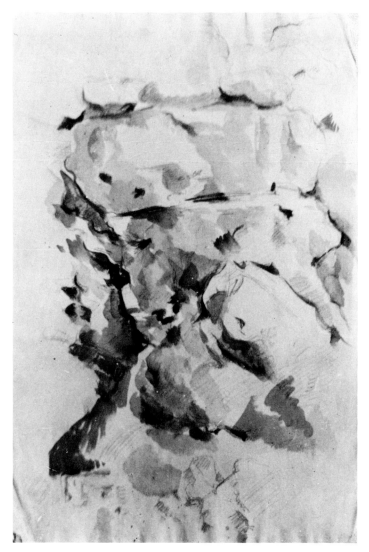

Pl. 43. *Rocks near the Caves above Château Noir.* 1895–1900. Venturi 1044
Pencil and watercolor, 18½ x 12 in (47 x 30.5 cm)
Collection Mr. and Mrs. Joseph Pulitzer, Jr., St. Louis

Pl. 44. *Rocks near the Caves above Château Noir.* 1895–1900
Pencil and watercolor, 18 x 11⅝ in (45.7 x 29.6 cm)
Private collection, New York

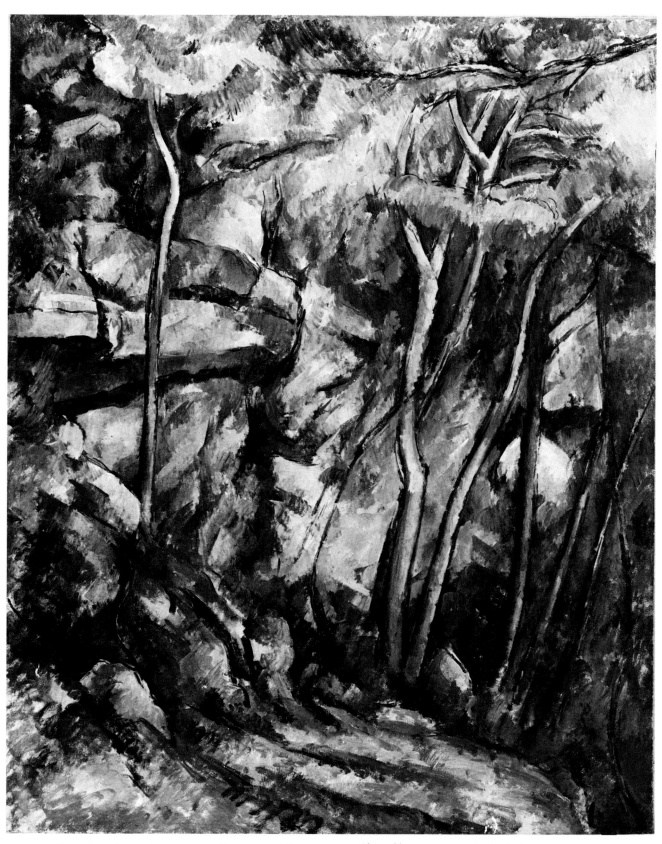

Pl. 49. *In the Park at Château Noir.* c. 1898. Venturi 779. Oil on canvas, 36¼ x 28¾ in (92 x 73 cm). Musée du Louvre, Paris

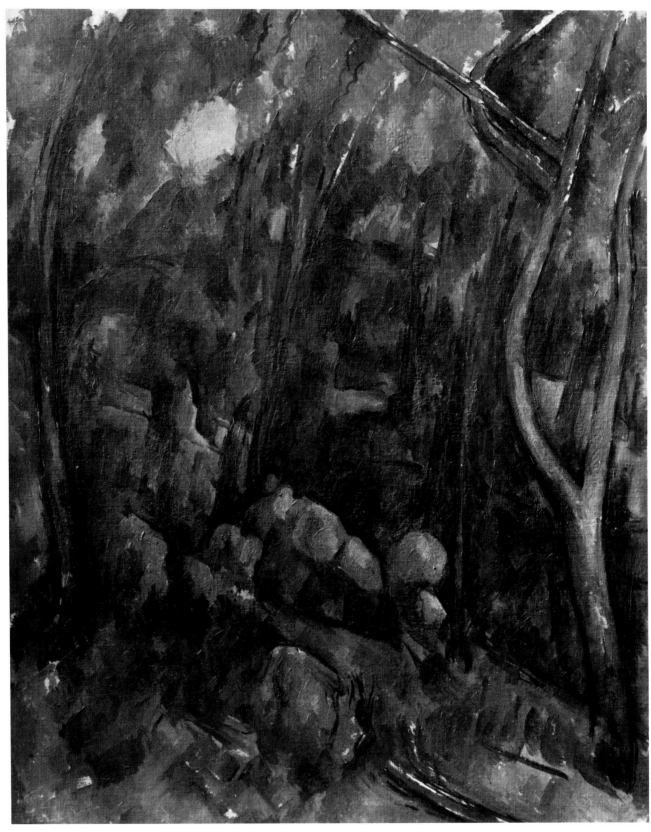

Pl. 50. *Forest near the Caves above Château Noir.* 1900–04. Venturi 787. Oil on canvas, 35¾ x 28⅛ in (90.7 x 71.4 cm)
National Gallery, London

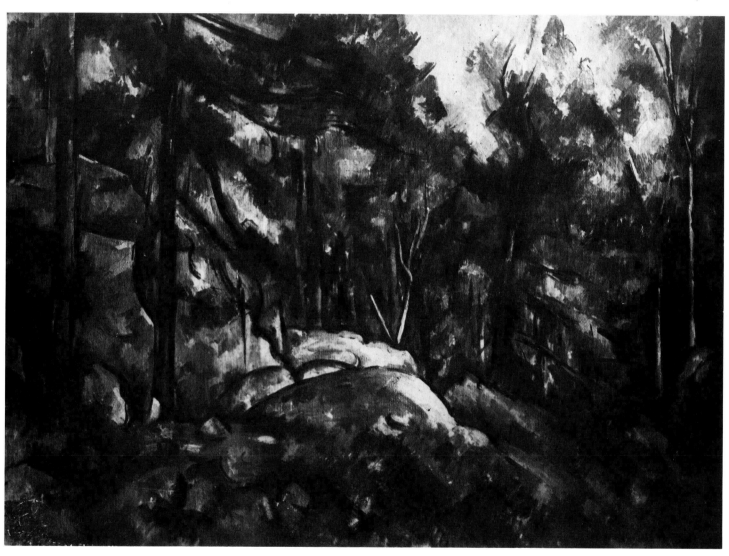

Pl. 51. *Rocks in the Park of Château Noir.* c. 1900. Venturi 784. Oil on canvas, 24 x 32 in (61 x 81 cm)
The Fine Arts Museum of San Francisco, gift of the Mildred Anna Williams Fund

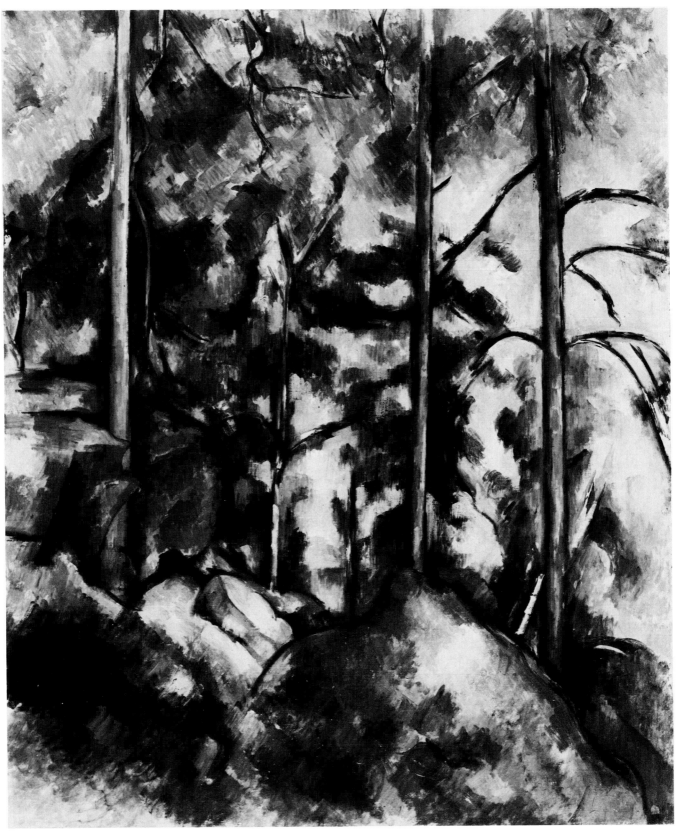

Pl. 52. *Pines and Rocks* (*Fontainebleau?*). 1898–99. Venturi 774. Oil on canvas, 32 x 25¾ in (81.3 x 65.4 cm)
The Museum of Modern Art, Lillie P. Bliss Collection

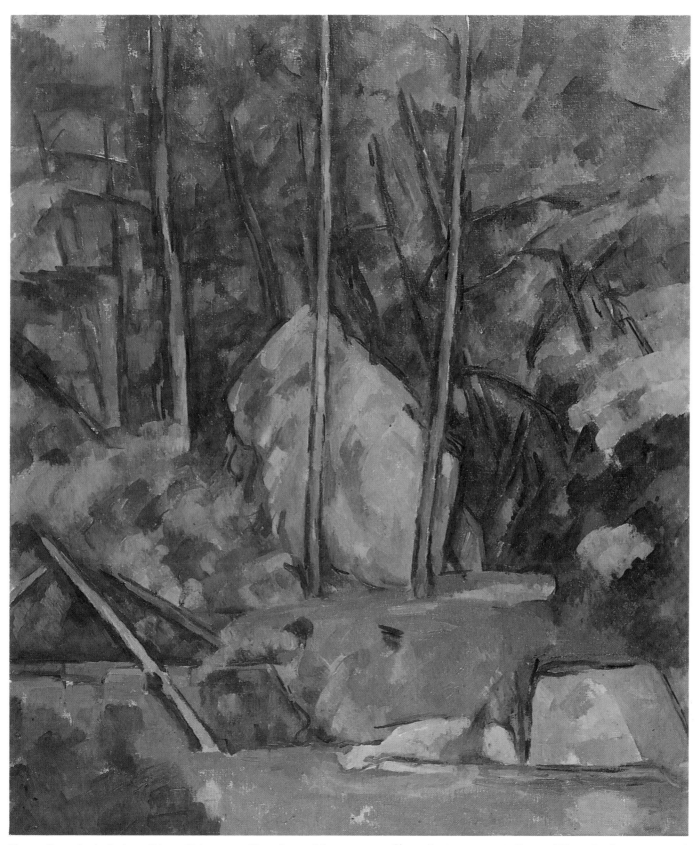

Pl. 53. *Cistern in the Park at Château Noir.* c. 1900. Venturi 780. Oil on canvas, 29¼ x 24 in (74.3 x 61 cm). Estate of Henry Pearlman, New York

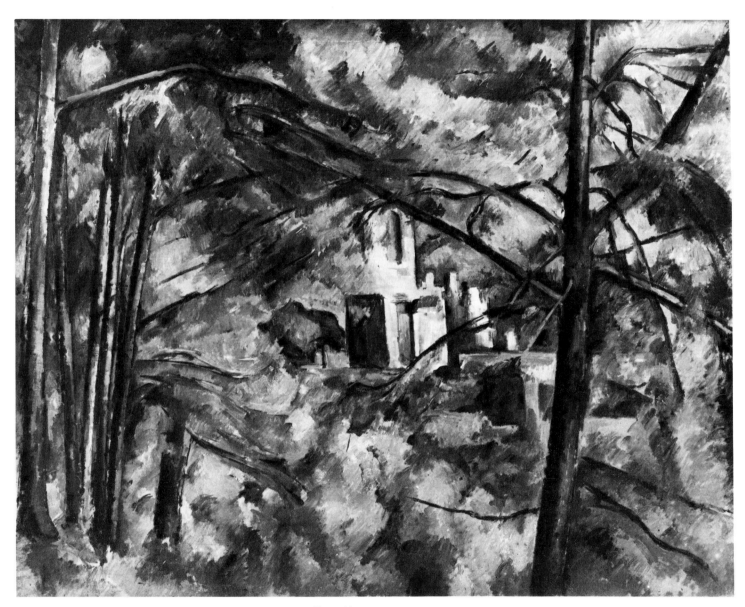

Pl. 54. *Château Noir*. c. 1894–95. Venturi 667. Oil on canvas, 28¾ x 36¼ in (73 x 92 cm). Oskar Reinhart Collection, Am Romerholz, Winterthur

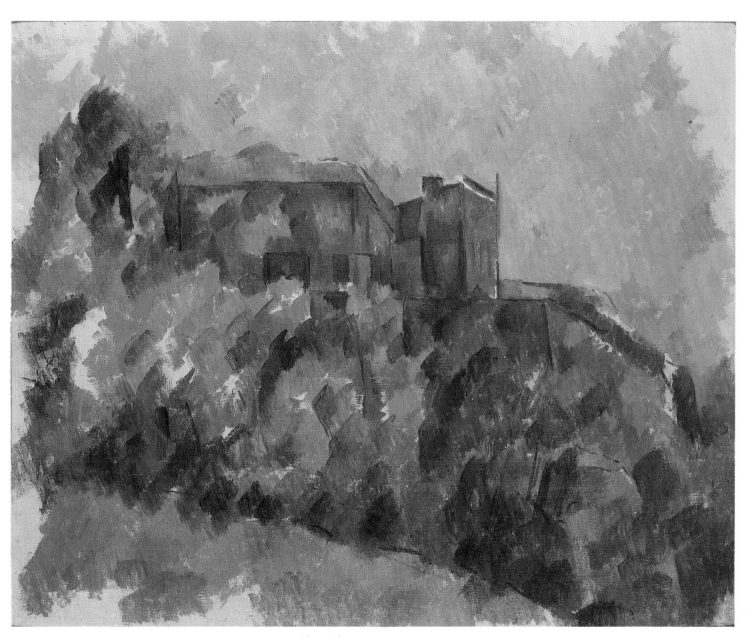

Pl. 55. *Château Noir*. 1902–05. Venturi 797. Oil on canvas, 27½ x 32¼ in (70 x 82 cm). Collection Jacques Koerfer, Bern

Pl. 56. *Entrance to Château Noir.* 1900–04. Oil on canvas, 40 x 32 in (101.6 x 81.3 cm). Estate of Henry Pearlman, New York

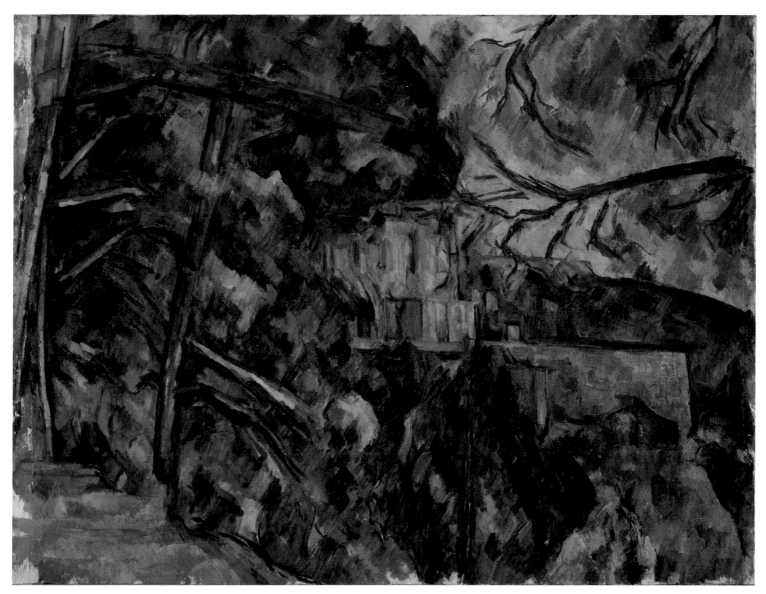

Pl. 57. *Château Noir*. 1900–04. Venturi 796. Oil on canvas, 29 x 38 in (73.7 x 96.6 cm). National Gallery of Art, Washington, gift of Eugene and Agnes Meyer

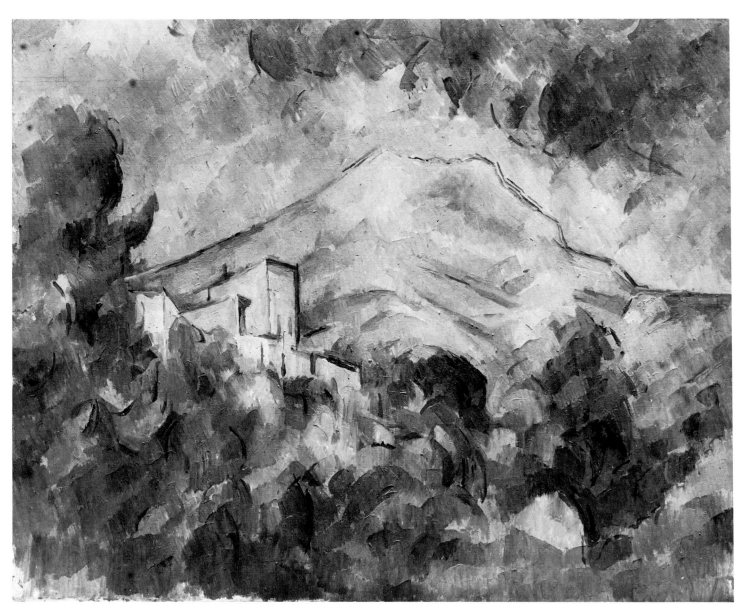

Pl. 58. *Mont Sainte-Victoire and Château Noir.* 1904–06. Venturi 765. Oil on canvas, 25¾ x 31⅜ in (65.6 x 81 cm). Bridgestone Museum of Art, Tokyo

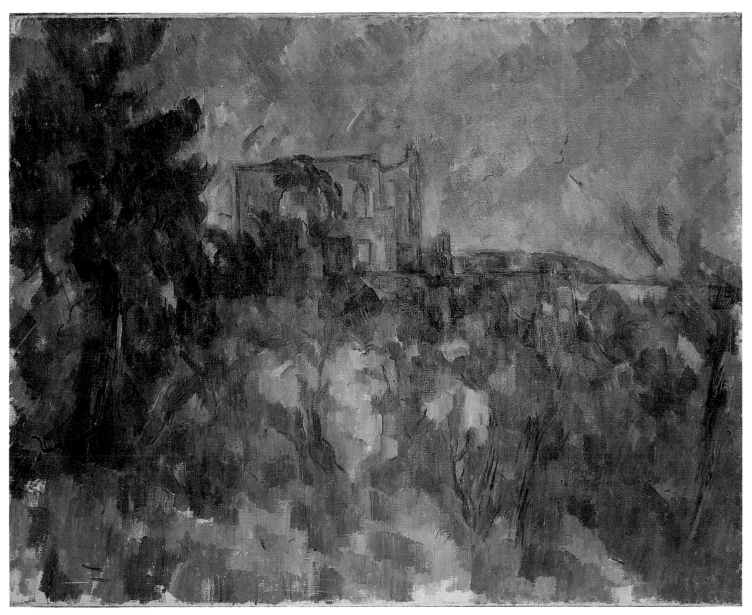

Pl. 59. *Château Noir.* 1904–06. Venturi 795. Oil on canvas, 28¾ x 36¼ in (73 x 92 cm). Musée du Louvre, Paris, gift of Pablo Picasso

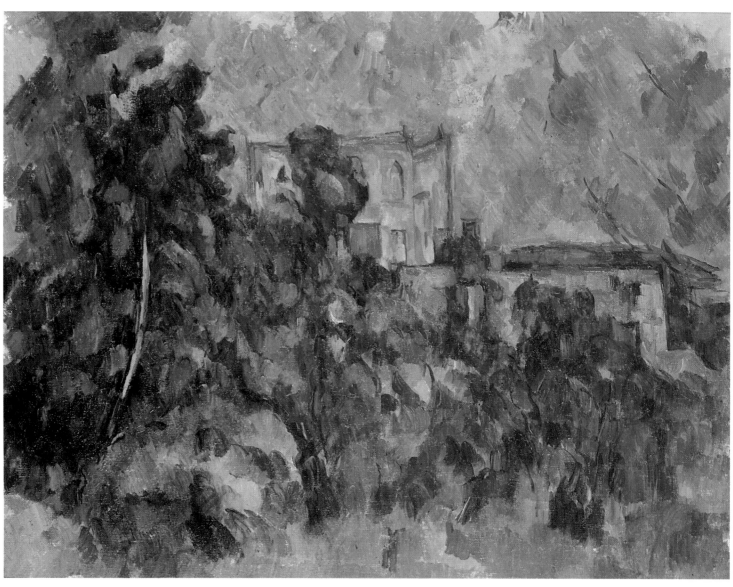

Pl. 60. *Château Noir*. 1904–06. Venturi 794. Oil on canvas, 29 x 36¾ in (73.6 x 93.2 cm)
The Museum of Modern Art, New York, gift of Mrs. David M. Levy

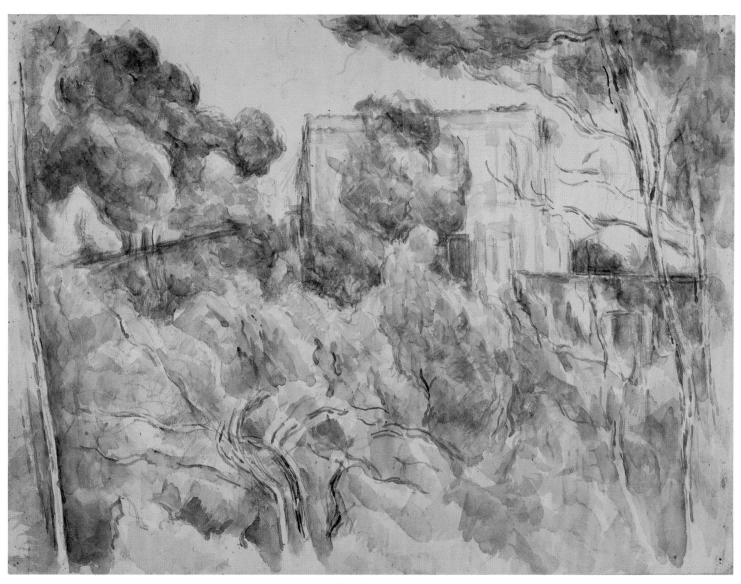

Pl. 61. *Château Noir.* c. 1904. Venturi 1036. Pencil and watercolor, 16½ x 21¾ in (41.9 x 55.2 cm). Collection Mrs. Potter Palmer II

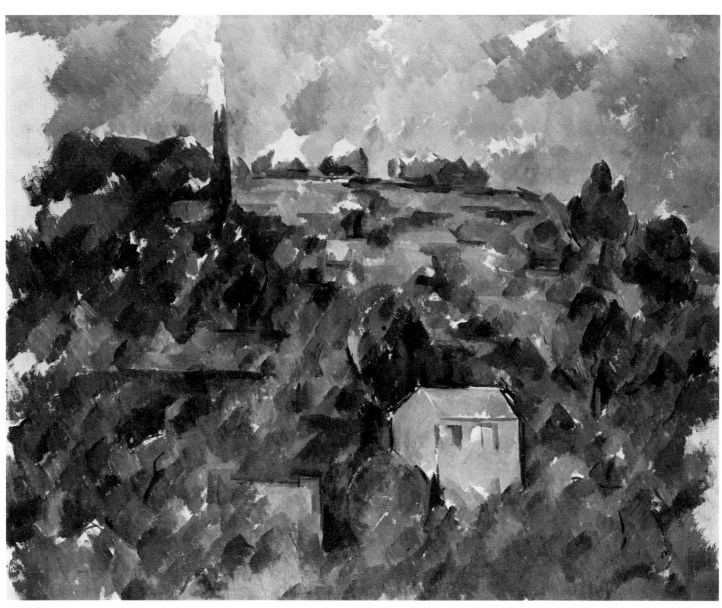

Pl. 62. *House on a Hill.* 1904–06. Oil on canvas, $25\frac{7}{8}$ x $31\frac{7}{8}$ in (65.7 x 81 cm). National Gallery of Art, Washington, presented to the U.S. Government in memory of Charles A. Loeser

Pl. 63. *Well at Château Noir.* 1895–1900. Venturi 998. Watercolor,
18¾ x 11¾ in (48 x 30 cm). Collection Mr. and Mrs. John W. Warrington

Pl. 64. *Pines and Rocks at Château Noir.* 1895–1900. Venturi 1060
Watercolor, 18⅞ x 12¼ in (48 x 31 cm). Private collection, U.S.A.

Pl. 65. *Pines and Rocks near the Caves above Château Noir.* c. 1900. Venturi 1041. Pencil and watercolor, 18⅛ x 14 in (46 x 35.5 cm) The Art Museum, Princeton University, N.J.

Pl. 66. *Pistachio Tree in the Courtyard of Château Noir*. c. 1900. Venturi 1040. Watercolor over pencil sketch, 21¼ x 16⅞ in (54 x 43 cm)
The Art Institute of Chicago

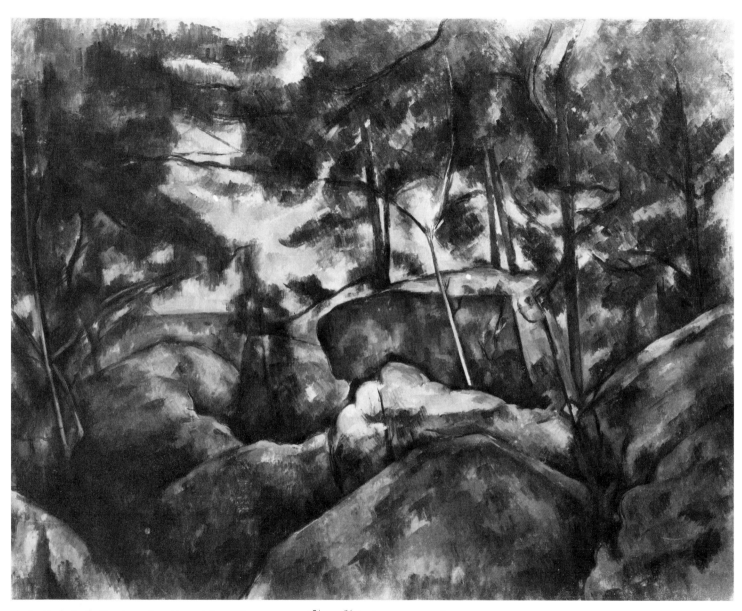

Pl. 67. *Rocks in the Forest*. c. 1893. Venturi 673. Oil on canvas, $28\frac{7}{8}$ x $36\frac{3}{8}$ in (73.3 x 92.4 cm)
The Metropolitan Museum, New York, H. O. Havemeyer Collection, bequest of Mrs. H. O. Havemeyer

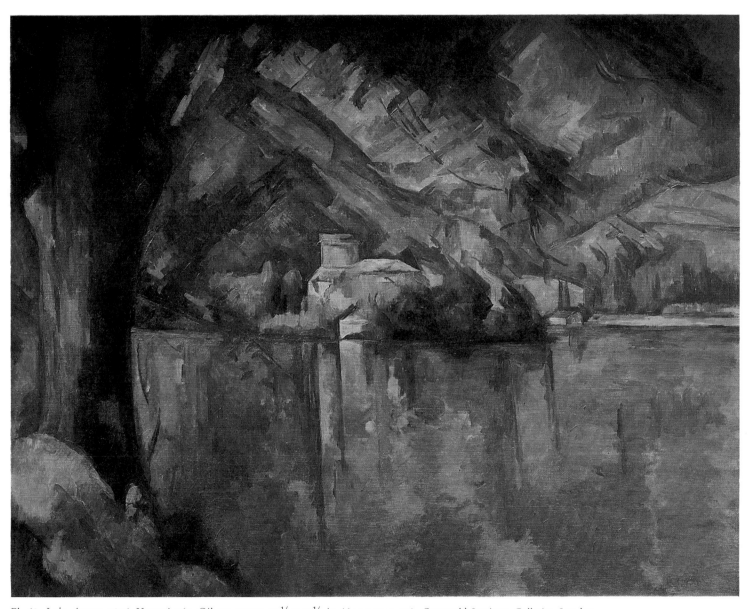

Pl. 68. *Lake Annecy*. 1896. Venturi 762. Oil on canvas, $25\frac{1}{4}$ x $31\frac{1}{8}$ in (64.2 x 79.1 cm). Courtauld Institute Galleries, London

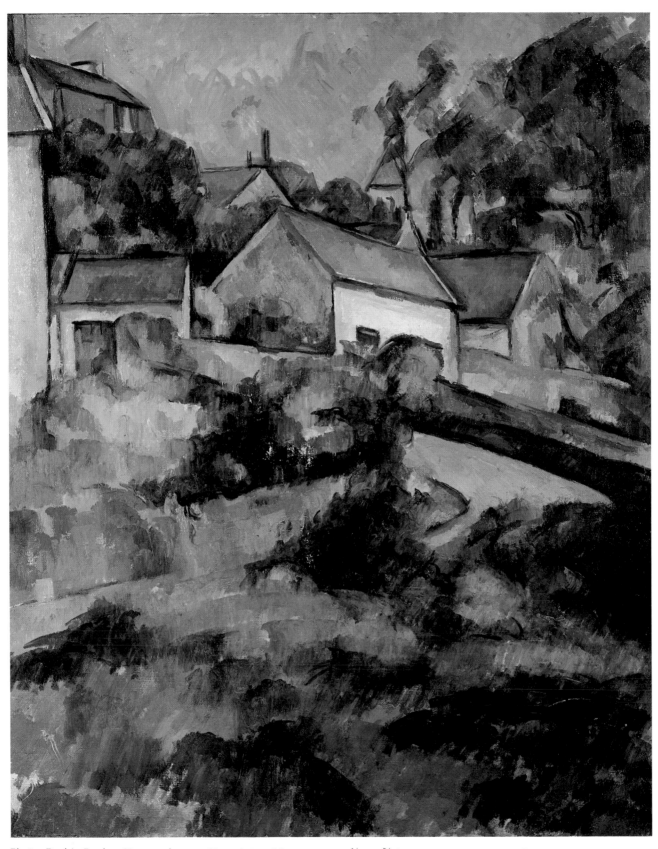

Pl. 69. *Bend in Road at Montgeroult.* 1899. Venturi 668. Oil on canvas, 31½ x 25⅝ in (80 x 65 cm). Private collection

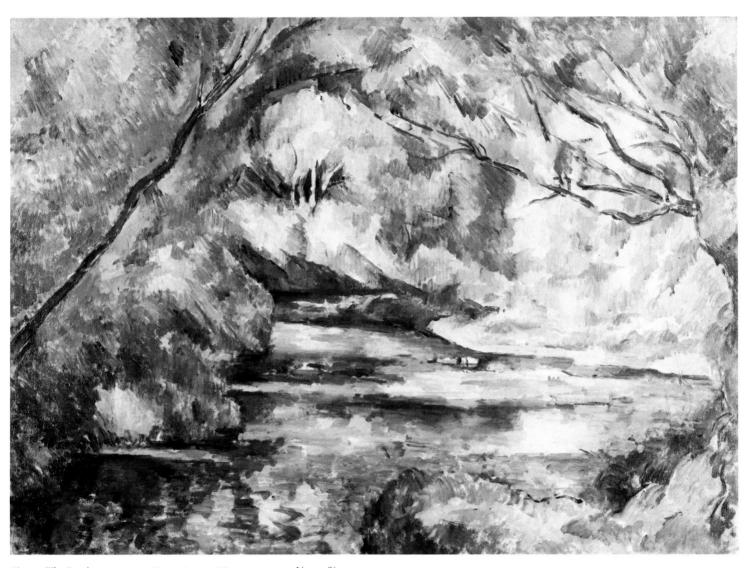

Pl. 70. *The Brook*. 1895-1900. Venturi 783. Oil on canvas, 23⅛ x 31¾ in (58.8 x 80.7 cm)
The Cleveland Museum of Art, Leonard C. Hanna, Jr., Collection

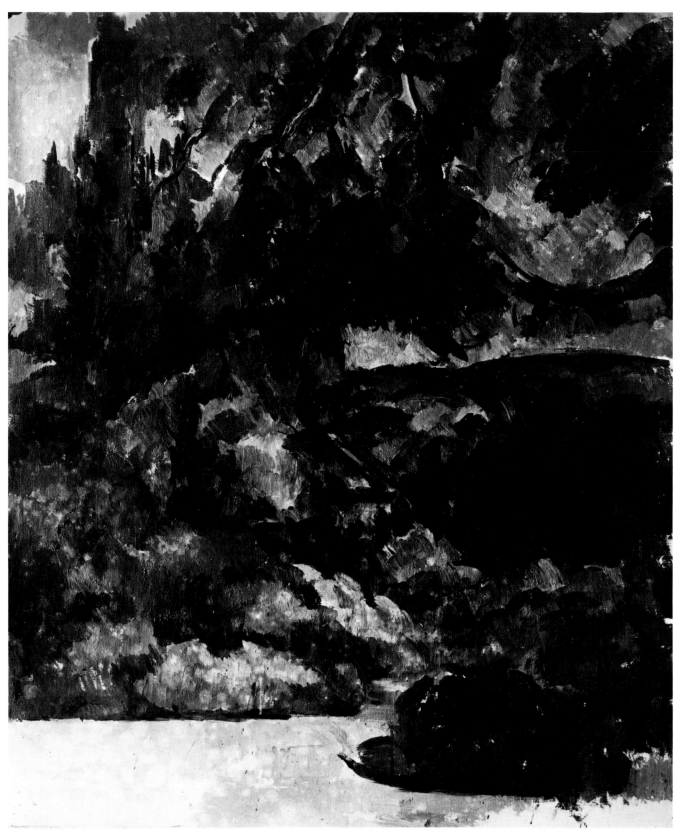

Pl. 71. *Blue Landscape.* 1904–06. Venturi 793. Oil on canvas, 40⅛ x 32⅝ in (102 x 83 cm). The Hermitage Museum, Leningrad

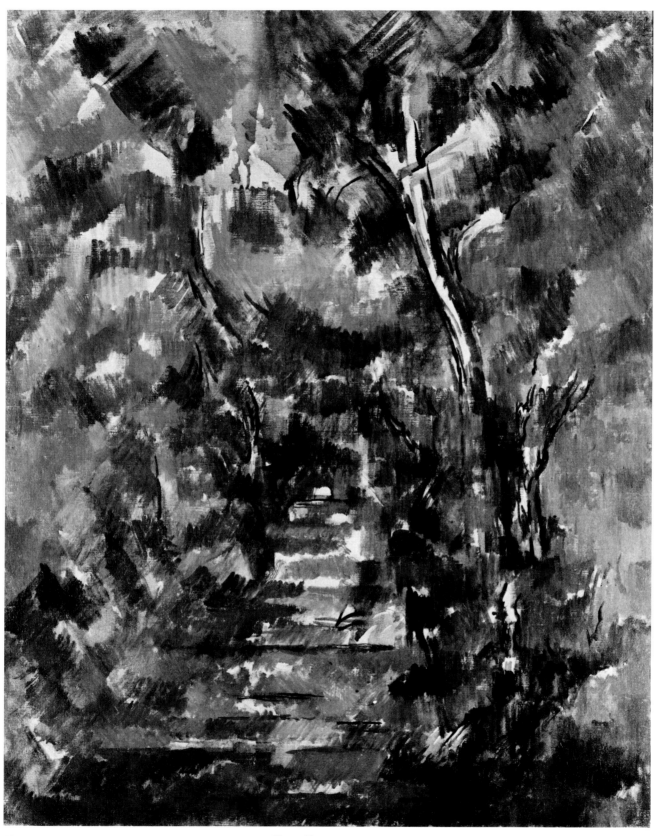

Pl. 72. *Forest*. 1895–1900. Venturi 1527. Oil on canvas, 31¼ x 25⅜ in (79.5 x 64.5 cm). Collection Ernst Beyeler, Basel

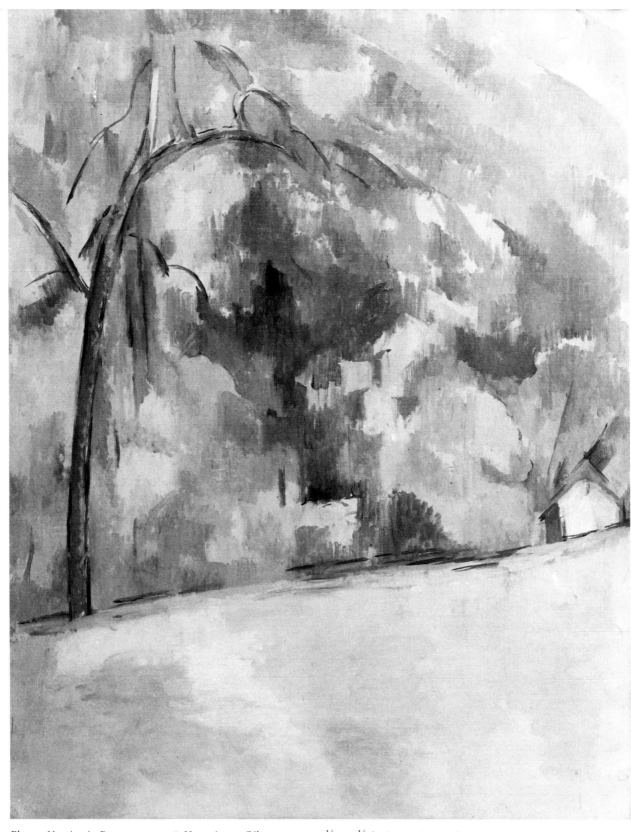

Pl. 73. *Morning in Provence*. 1900–06. Venturi 791. Oil on canvas, 31¼ x 24½ in (79.4 x 62.3 cm)
The Albright-Knox Art Gallery, Buffalo, Room of Contemporary Art Fund

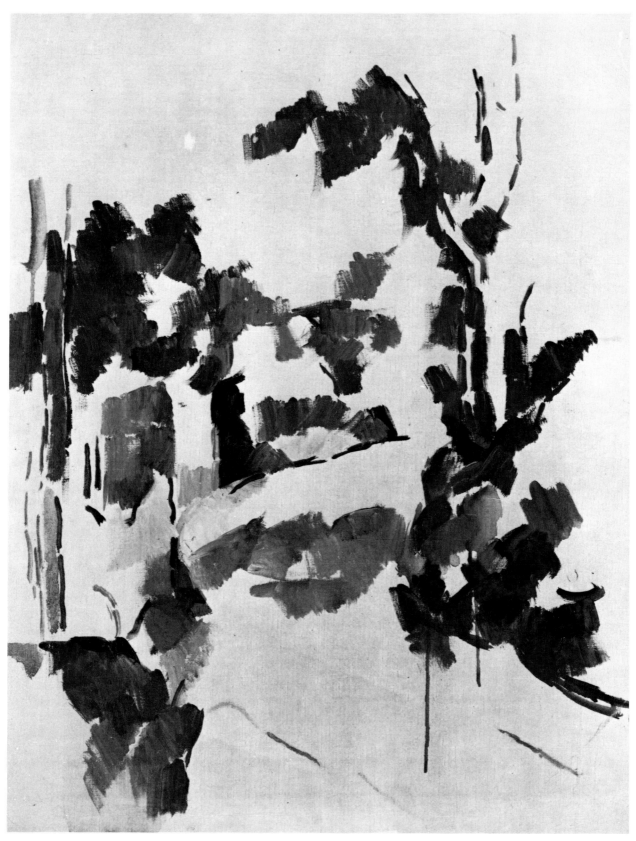

Pl. 74. *Winding Road.* c. 1904. Oil on canvas, $25\frac{1}{4}$ x 19 in (64.1 x 48.3 cm). Private collection

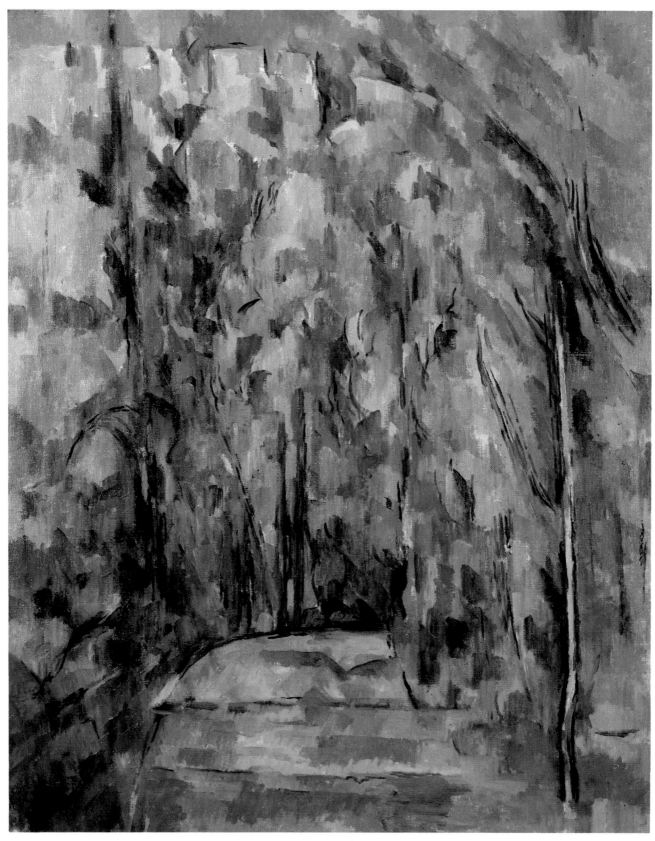

Pl. 75. *Bend in Forest Road.* 1902–06. Venturi 789. Oil on canvas, 32 x 25½ in (81.3 x 64.8 cm). Collection Dr. Ruth Bakwin, New York

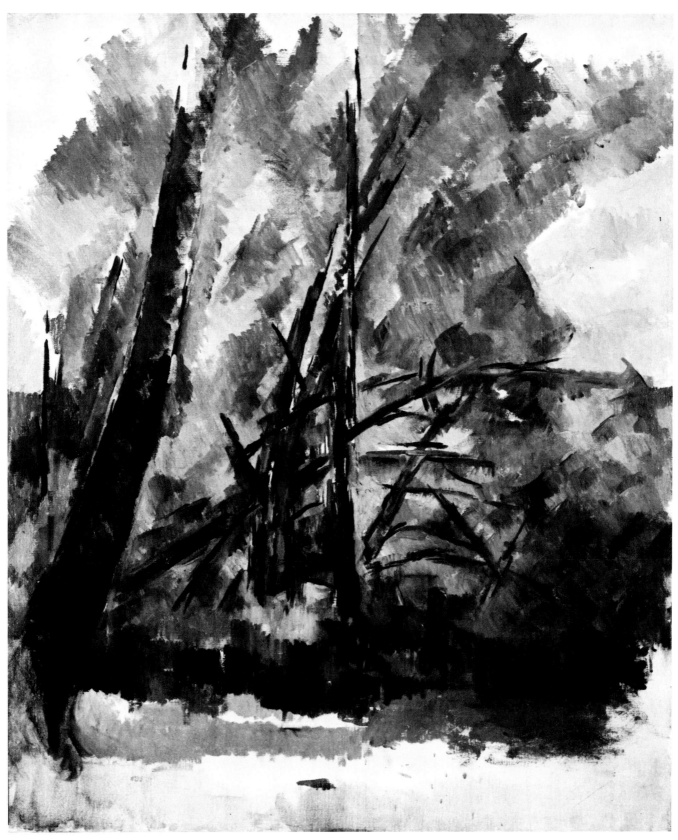

Pl. 76. *Trees at Le Tholonet.* 1900–04. Oil on canvas, 32 x 25⅝ in (81.3 x 65 cm). Private collection, U.S.A.

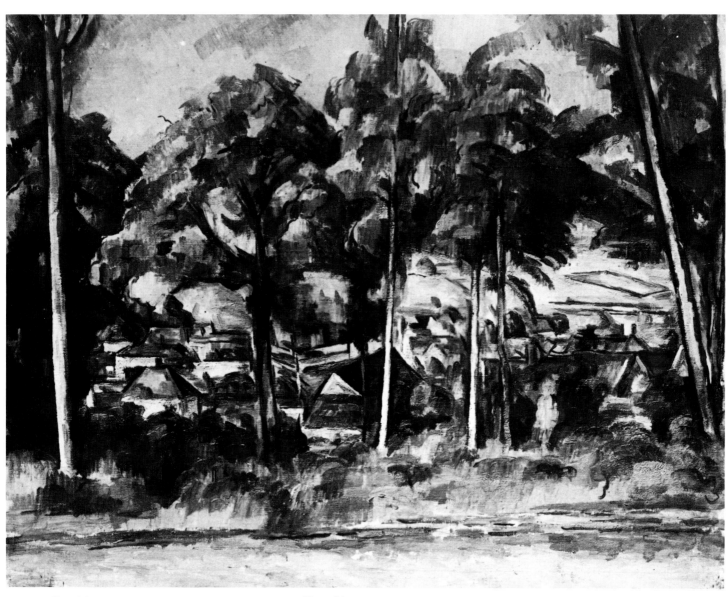

Pl. 77. *Village behind Trees*. 1895. Venturi 438. Oil on canvas, 25⅝ x 31⅞ in (65 x 81 cm). Kunsthalle Bremen

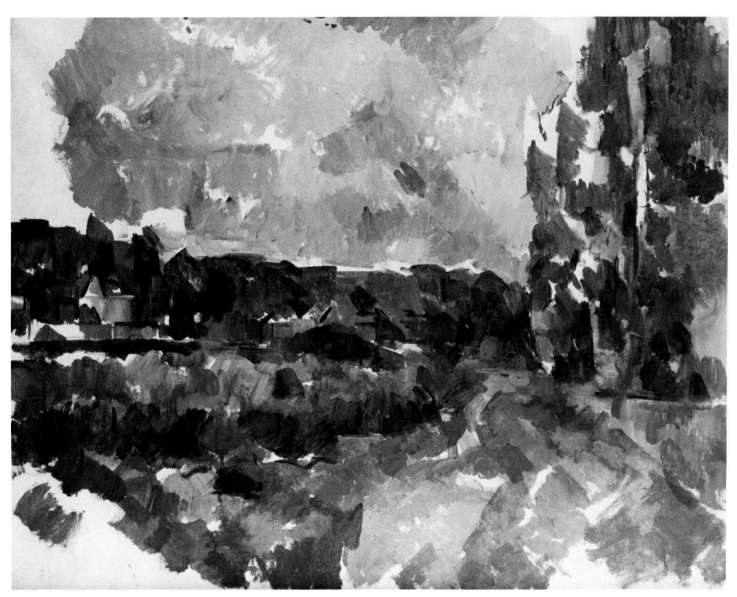

Pl. 78. *Banks of a River.* c. 1904. Venturi 1533. Oil on canvas, 25¼ x 31⅞ in (64 x 81 cm). Whereabouts unknown

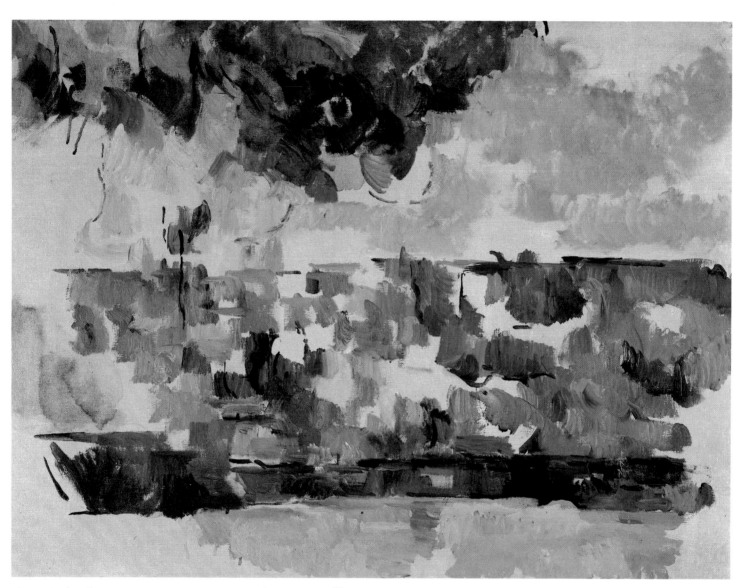

Pl. 79. *Garden of Les Lauves.* c. 1906. Venturi 1610. Oil on canvas, 25¾ x 32 in (65.5 x 81.3 cm). The Phillips Collection, Washington

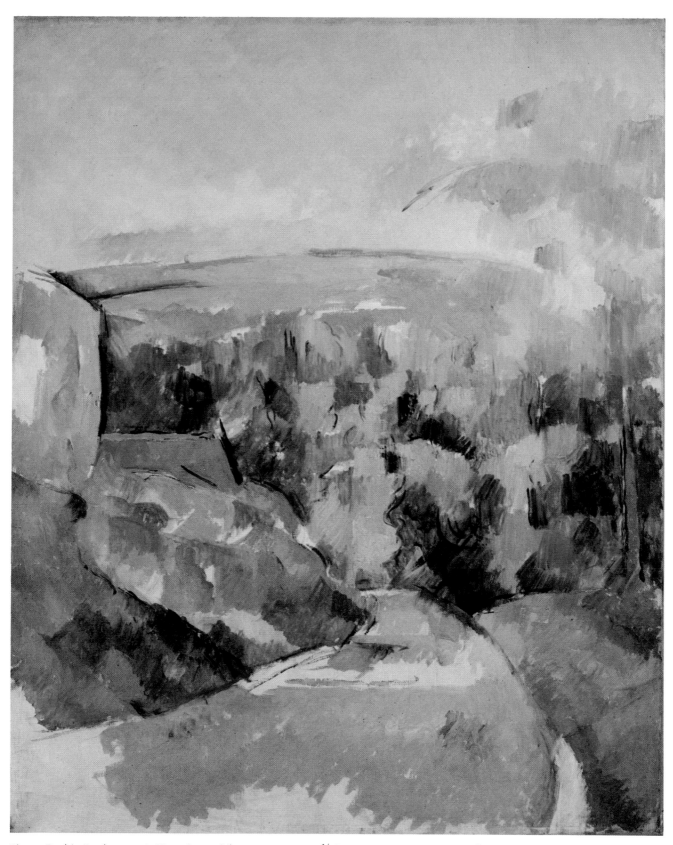

Pl. 80. *Bend in Road.* 1900–06. Venturi 790. Oil on canvas, 32 x 25½ in (81.3 x 64.8 cm). Private collection

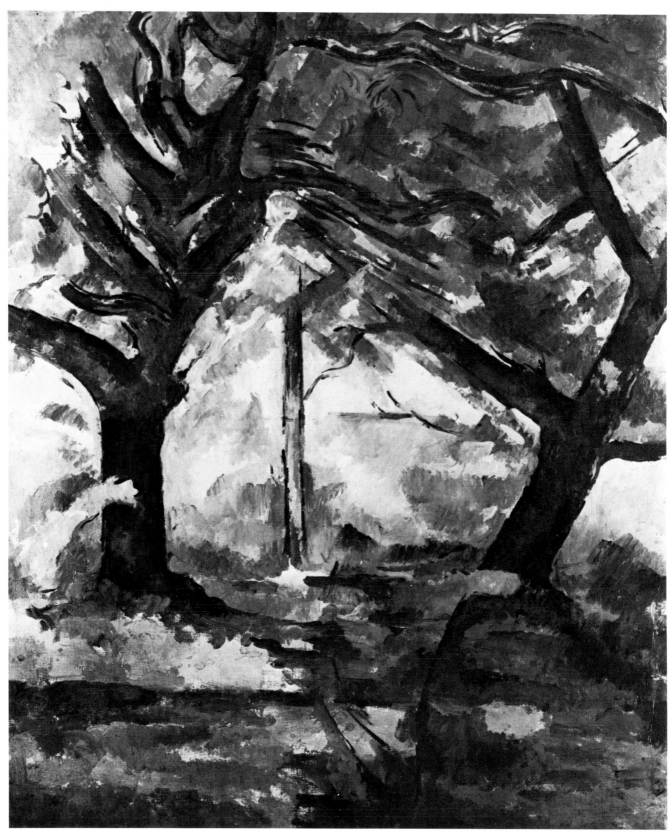

Pl. 81. *Large Trees*. c. 1904. Venturi 760. Oil on canvas, 31⅞ x 25⅝ in (81 x 65 cm). Collection Mrs. A. Kessler, Rutland, England

Pl. 82. *The Tall Trees.* 1902–04. Pencil and watercolor, 18½ x 23 in (47 x 58 cm). Collection Dr. and Mrs. A. W. Pearlman, New York

Pl. 83. *Le Cabanon de Jourdan.* 1906. Venturi 805. Oil on canvas, 25⅝ x 31⅞ in (65 x 81 cm). Collection Riccardo Jucker, Milan

Pl. 84. *Le Cabanon de Jourdan.* 1902–06. Venturi 1078. Pencil and watercolor, 18⅞ x 24¾ in (48 x 62.8 cm). Private collection, Zurich

Pl. 85. *Landscape with River.* c. 1904. Venturi 769. Oil on canvas, 24 x 29 in (61 x 73.7 cm)
Museum of Art, Rhode Island School of Design, Providence, Museum Reserve Fund

Pl. 86. *Village Street*. 1895–1900. Venturi 845. Pencil and watercolor, 14 x 17½ in (35.5 x 44.5 cm). Private collection

Pl. 87. *Trees Reflected in
the Water, Lake Annecy.* 1896
Pencil and watercolor,
12¼ x 17⅞ in (31 x 45.5 cm)
Private collection, Europe

Pl. 88. *Crossed Trees.* c. 1896
Venturi 938. Watercolor,
16 x 21⅞ in (40.5 x 55.5 cm)
Private collection

Pl. 89. *Provençal Landscape*
1895–1900. Pencil and watercolor,
$12\frac{3}{8} \times 18\frac{7}{8}$ in (31.3 x 47.8 cm)
Museum of Fine Arts, Budapest

Pl. 90. *House among Trees*
c. 1900. Venturi 977
Pencil and watercolor,
$11 \times 17\frac{1}{8}$ in (28 x 43.5 cm)
The Museum of Modern Art,
New York,
Lillie P. Bliss Collection

Pl. 91. *Corner of Lake Annecy.* c. 1897. Venturi 936. Watercolor, 18⅛ x 23¼ in (46 x 59.1 cm). The St. Louis Art Museum

Pl. 92. *The Forest*. 1890–1900. Venturi 1056. Pencil and watercolor, 21¾ x 16¾ in (55.3 x 42.6 cm). The Newark Museum

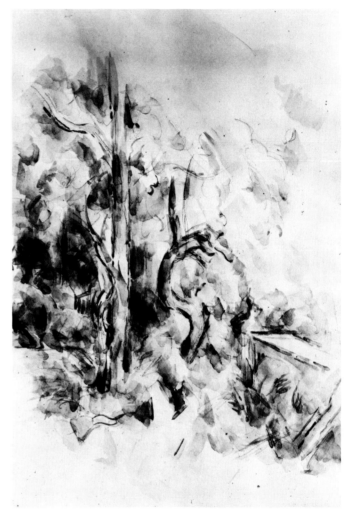

Pl. 93. *Provençal Landscape*. c. 1900. Watercolor,
15¾ x 12½ in (40.2 x 31.7 cm). Collection Mrs. Allan D. Emil

Pl. 94. *Cistern in the Park at Château Noir*. 1900–02. Venturi 1038
Watercolor, 17¾ x 11¾ in (45.1 x 29.8 cm)
Estate of Henry Pearlman, New York

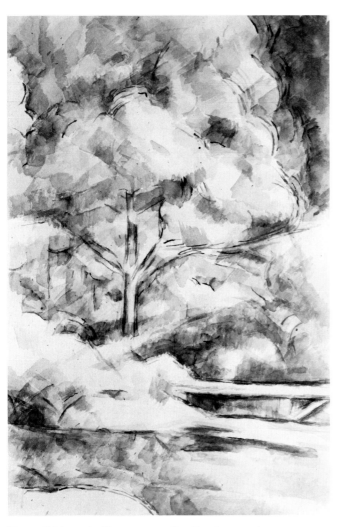

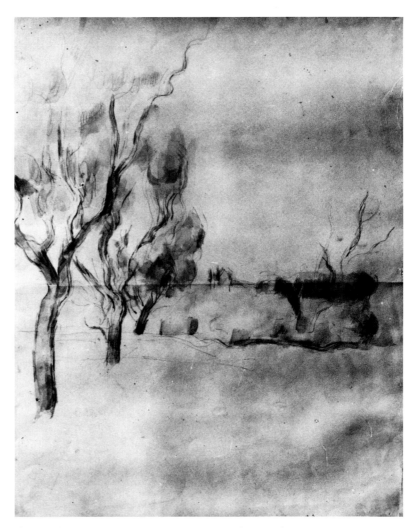

Pl. 95. *Bridge under Trees.* c. 1900. Pencil and watercolor,
18⅛ x 11⅞ in (46 x 30 cm)
Collection Mr. and Mrs. Richard K. Weil, St. Louis

Pl. 96. *Almond Trees, Provence.* c. 1900. Pencil and watercolor,
20½ x 17⅞ in (52 x 45.5 cm)
Collection Mr. and Mrs. Walter Bareiss

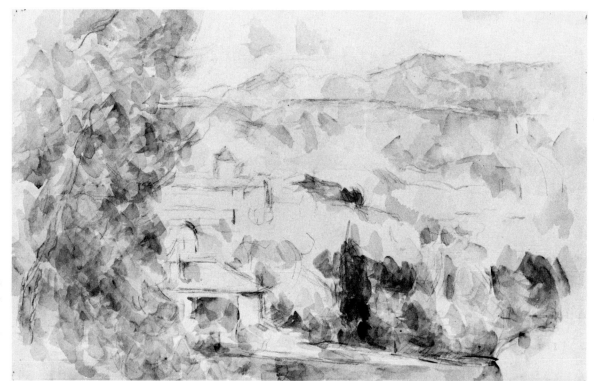

Pl. 97. *Landscape, Aix.* 1900–06
Venturi 1064. Watercolor,
13¾ x 21¼ in (35 x 54 cm)
Collection
Mr. and Mrs. Henry M. Reed,
Montclair, N.J.

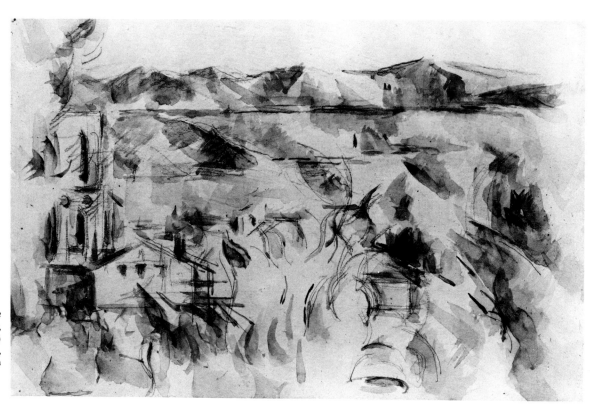

Pl. 98. *Aix Cathedral Seen from
Les Lauves.* 1902–04. Watercolor,
12 x 18½ in (30.5 x 47 cm)
Philadelphia Museum of Art,
Arensberg Collection

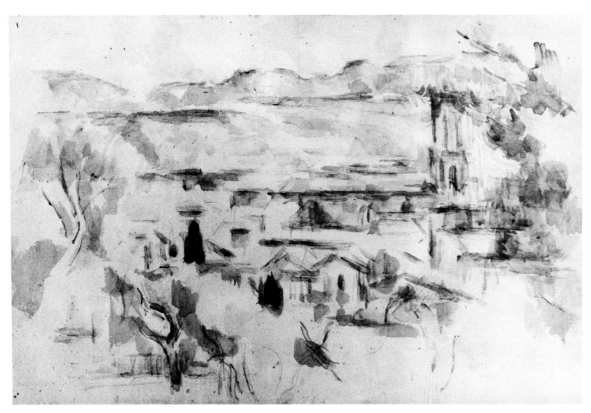

Pl. 99. *Aix Cathedral Seen from
Les Lauves.* 1902–04. Pencil and
watercolor, 12¼ x 18⅝ in
(31.2 x 47.3 cm)
Musée du Louvre, Paris, gift of
the Estate of Pablo Picasso

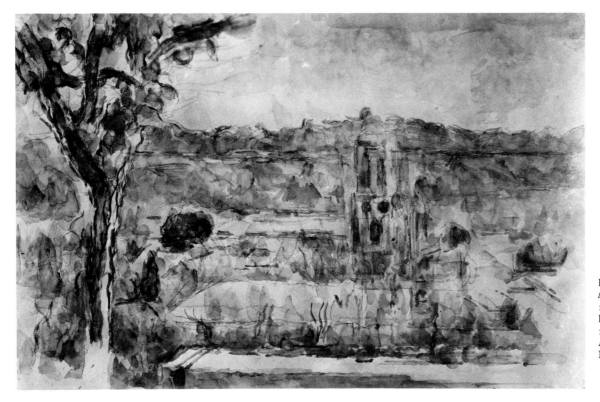

Pl. 100. *Aix Cathedral Seen from
the Garden Terrace of Les Lauves*
1904–06. Venturi 1077
Pencil and watercolor,
12½ x 18½ in (31.8 x 47 cm)
Alex Hillman Family Foundation,
New York

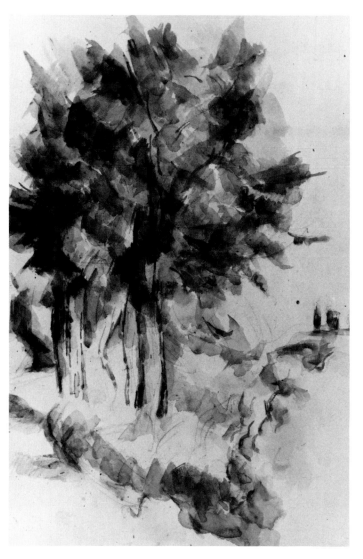

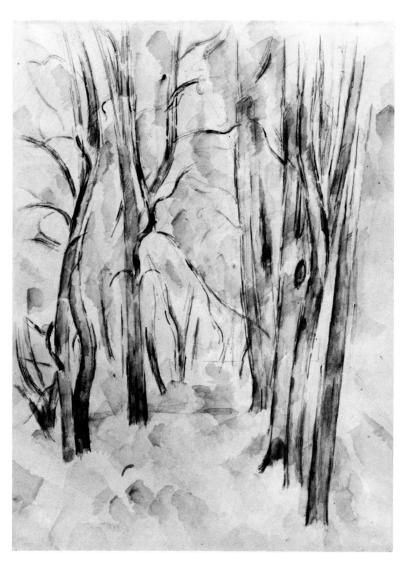

Pl. 101. *Trees.* c. 1900. Pencil and watercolor,
18 x 11¾ in (45.7 x 29.8 cm)
Collection Mr. and Mrs. Eugene Victor Thaw, New York

Pl. 102. *Forest Scene.* 1895–1904. Venturi 1544. Watercolor and pencil,
17¾ x 12¼ in (45 x 31 cm)
Private collection, Lausanne

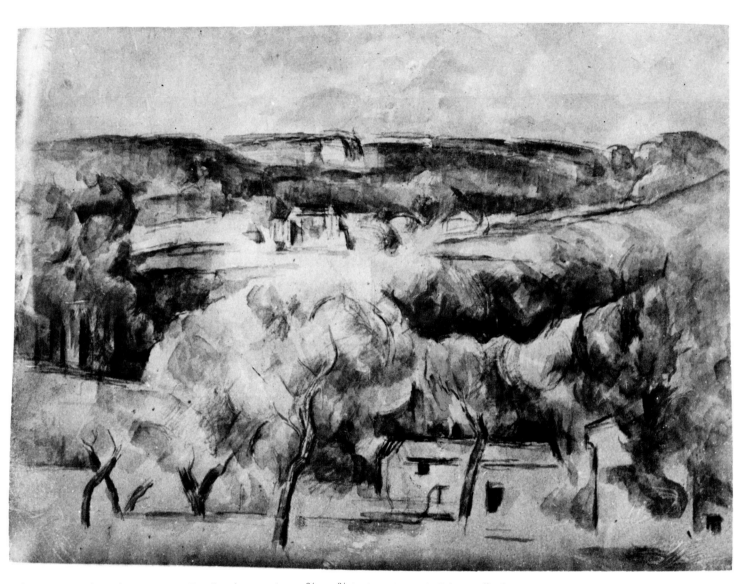

Pl. 103. *Provençal Landscape.* 1900–04. Pencil and watercolor, 17¾ x 23¾ in (45 x 60.3 cm). Private collection

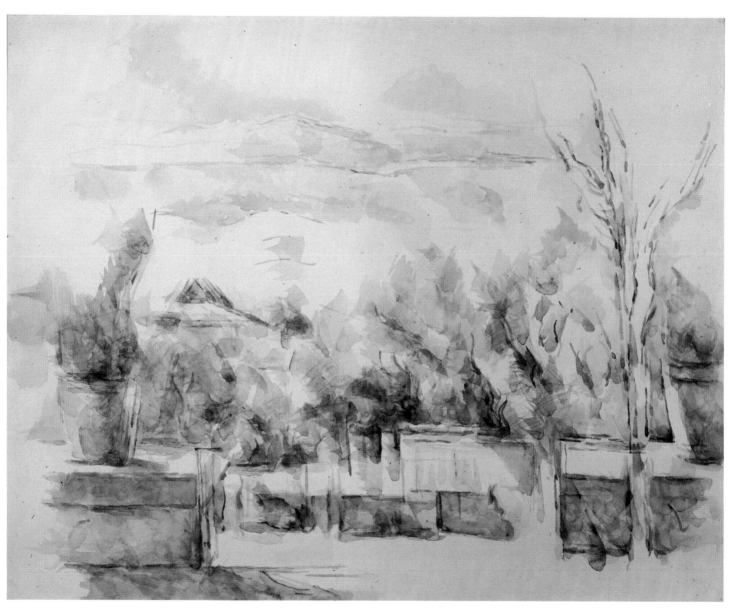

Pl. 104. *The Garden Terrace at Les Lauves*. 1902–06. Venturi 1072. Pencil and watercolor, 17 x 21¼ in (43 x 54 cm)
Collection Mr. and Mrs. Eugene Victor Thaw, New York

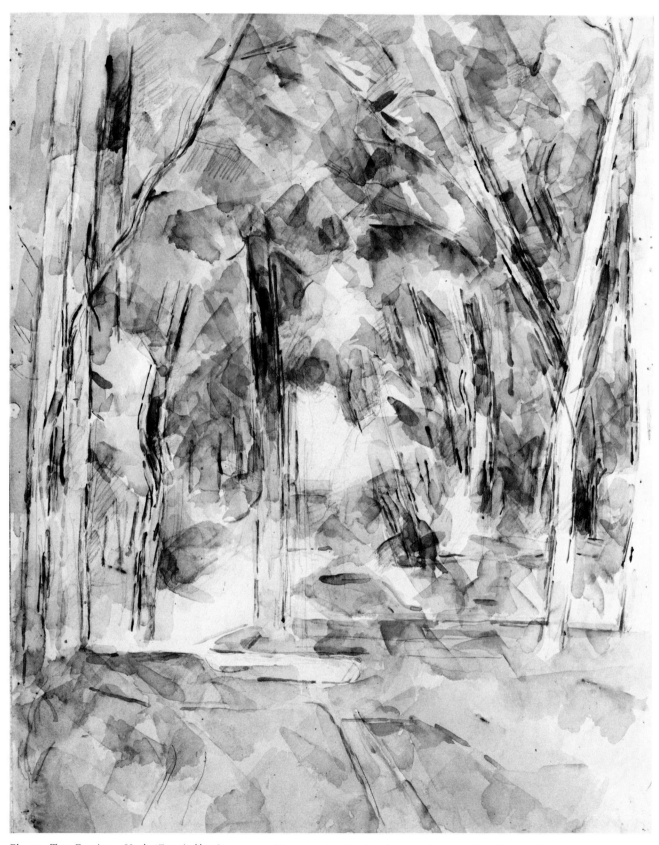

Pl. 105. *Trees Forming a Vault* (*Fontainebleau?*). 1904–05. Venturi 1063. Pencil and watercolor, 24 x 18 in (61 x 45.8 cm) Estate of Henry Pearlman, New York

Pl. 106. *House beside the Water*
1900–04. Venturi 1551. Watercolor,
12½ x 18¾ in (31.5 x 47.5 cm)
Private collection, Basel

Pl. 107. *Château de Fontainebleau*
1904–05. Venturi 925. Pencil and
watercolor, 17⅜ x 21⅝ in
(44 x 55 cm)
Collection Heinz Berggruen, Paris

Pl. 108. *Mill on the River*
c. 1904. Venturi 1554. Watercolor,
12⅛ x 19¼ in (30.75 x 49 cm)
Collection Walter Dudek, Hamburg

Pl. 109. *Trees by the Water.* c. 1904
Venturi 1552. Watercolor,
12⅝ x 19¼ in (32 x 49 cm). Collection
Mr. and Mrs. Eugene Victor Thaw,
New York

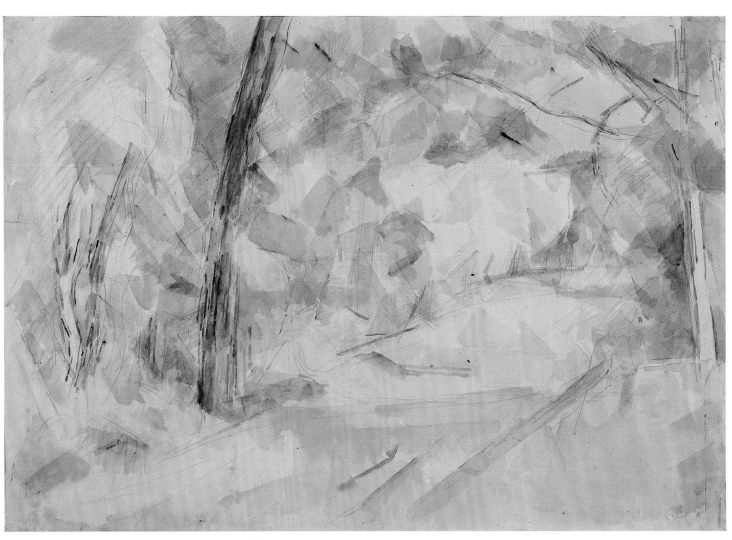

Pl. 110. *Trees Forming a Vault*. Watercolor, 17½ x 24½ in (44.5 x 62.2 cm). Estate of Henry Pearlman, New York

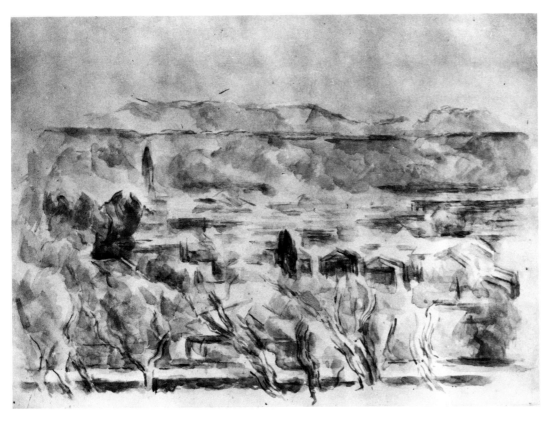

Pl. 111. *View from Les Lauves toward Aix*
1902–06. Venturi 1612. Watercolor,
15¾ x 21¼ in (40 x 53.9 cm)
Collection Emily A. Wingert, Montclair, N.J.

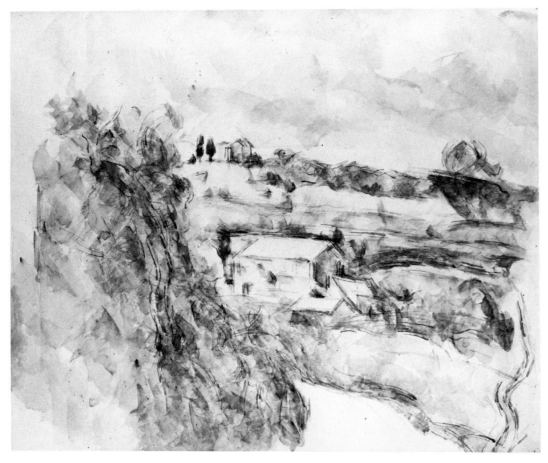

Pl. 112. *House near Bend at Top of
Chemin des Lauves*. 1904–06. Venturi 1037
Pencil and watercolor,
18⅞ x 24⅞ in (48 x 63.2 cm)
Estate of Henry Pearlman, New York

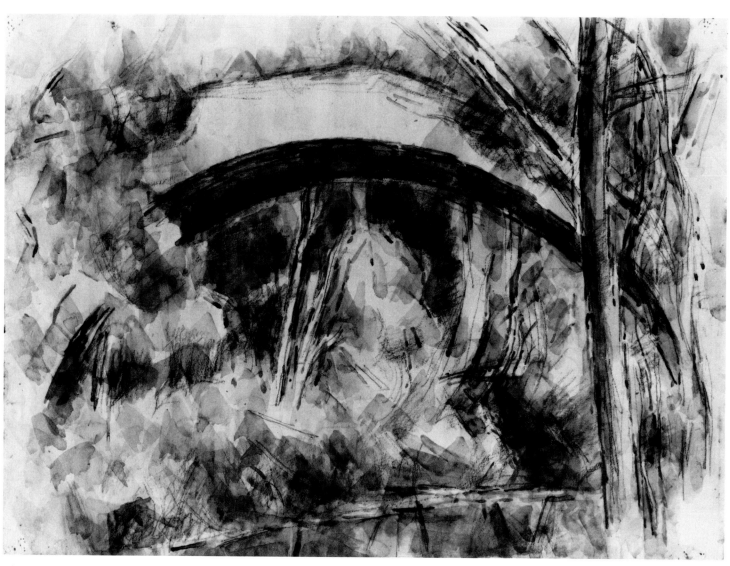

Pl. 113. *Le Pont des Trois Sautets*. c. 1906. Venturi 1076. Pencil and watercolor, 16⅛ x 21⅜ in (40.8 x 54.3 cm), irregular
Cincinnati Art Museum, gift of John J. Emery

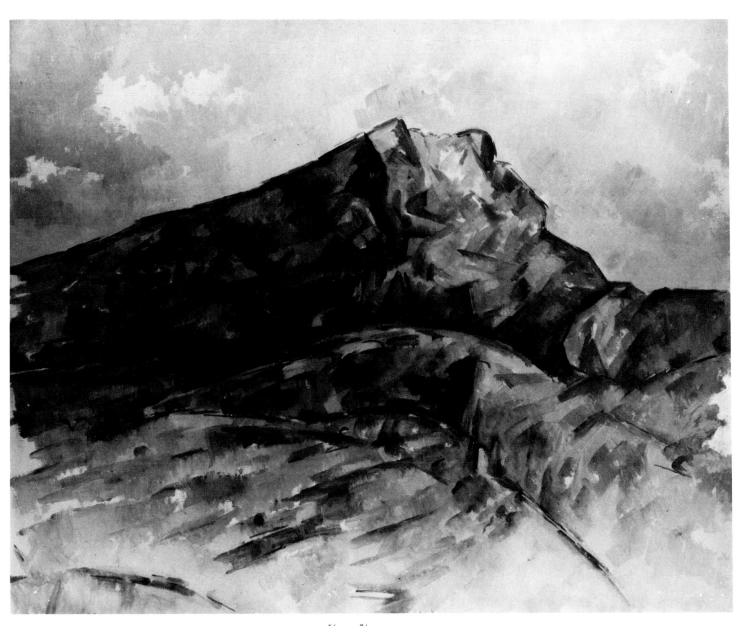

Pl. 114. *Mont Sainte-Victoire.* c. 1904. Venturi 665. Oil on canvas, 25⅝ x 31⅞ in (65 x 81 cm)
Estate of Mrs. Edsel B. Ford, Grosse Pointe Shores, Mich.

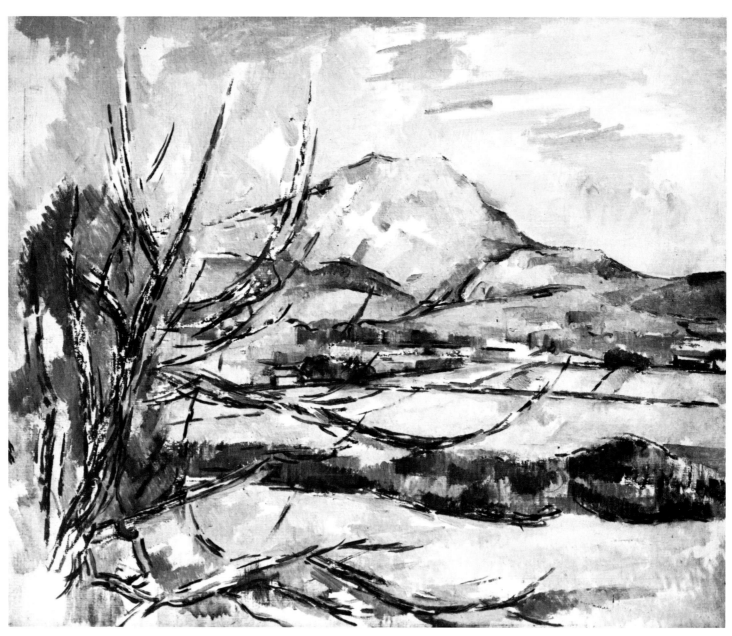

Pl. 115. *Mont Sainte-Victoire.* 1900–02. Venturi 661. Oil on canvas, 21½ x 25½ in (54.6 x 64.8 cm). National Gallery of Scotland, Edinburgh

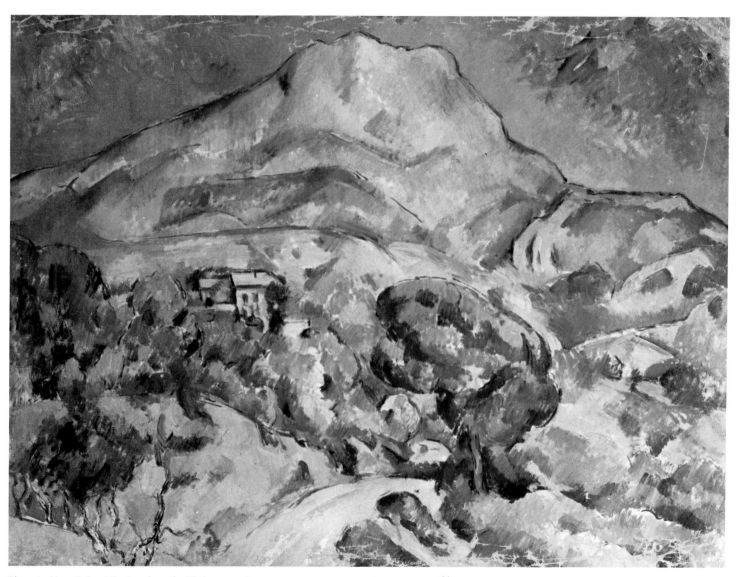

Pl. 116. *Mont Sainte-Victoire above the Tholonet Road.* 1896–98. Venturi 663. Oil on canvas, 30¾ x 39 in (78 x 99 cm). The Hermitage Museum, Leningrad

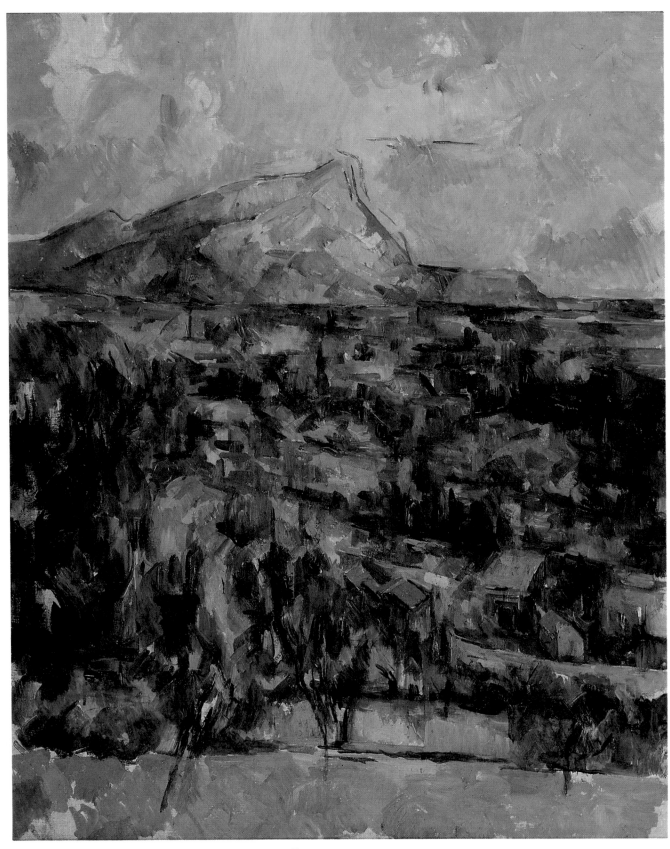

Pl. 117. *Mont Sainte-Victoire.* c. 1902. Oil on canvas, 33 x 25⅝ in (83.8 x 65 cm). Estate of Henry Pearlman, New York

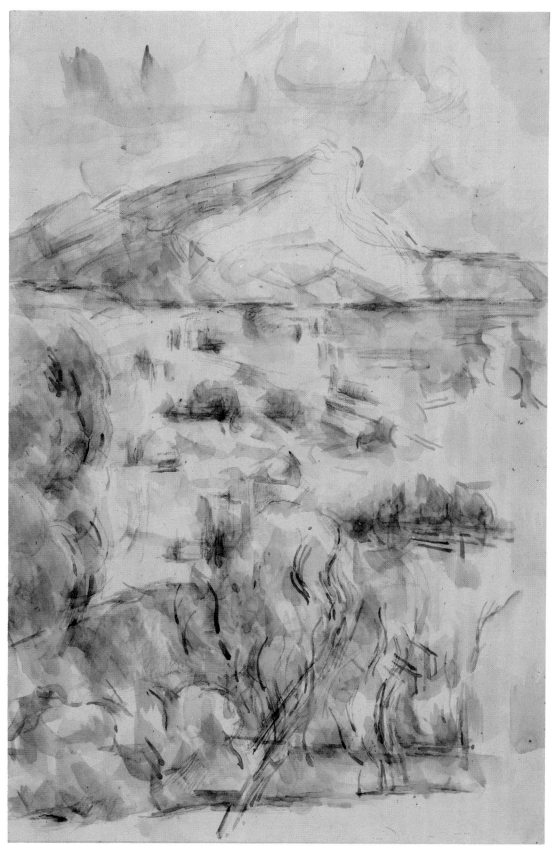

Pl. 118. *Mont Sainte-Victoire Seen from Les Lauves.* 1901–06. Pencil and watercolor, 18⅞ x 12¼ in (48 x 31 cm)
Private collection

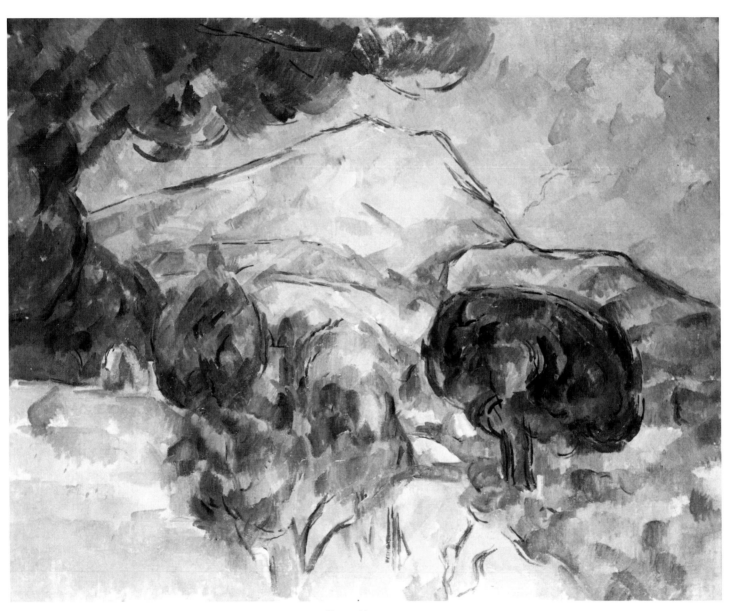

Pl. 119. *Mont Sainte-Victoire.* c. 1904. Venturi 666. Oil on canvas, 28⅞ x 36¼ in (73.2 x 92.1 cm)
The Cleveland Museum of Art, Leonard C. Hanna, Jr., Collection

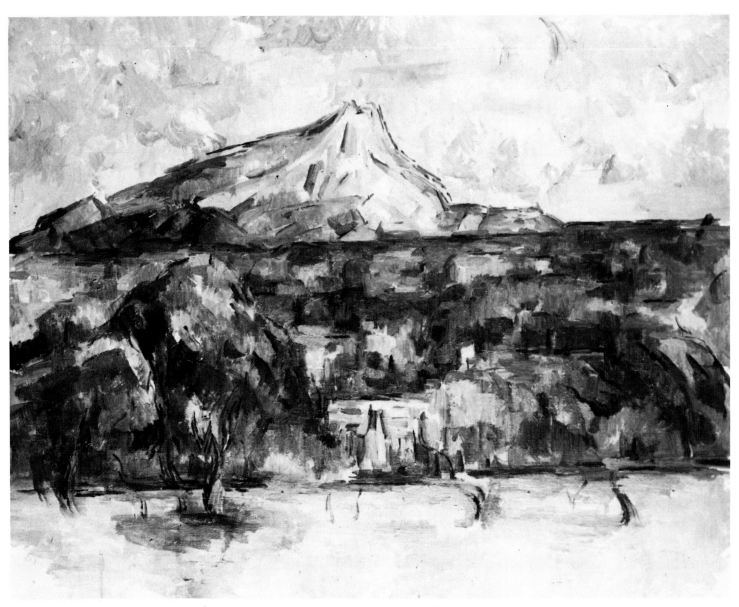

Pl. 120. *Mont Sainte-Victoire Seen from Les Lauves.* 1902–06. Venturi 800. Oil on canvas, 25⅝ x 32 in (65 x 81.3 cm)
Nelson Gallery of Art—Atkins Museum, Kansas City, Mo., Nelson Fund

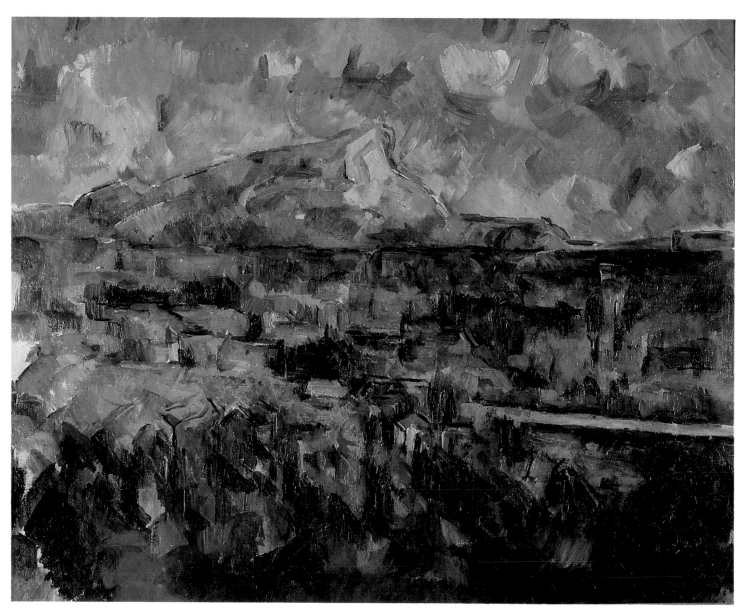

Pl. 121. *Mont Sainte-Victoire Seen from Les Lauves.* 1902–06. Venturi 799. Oil on canvas, 25½ x 32 in (65 x 81 cm). Private collection

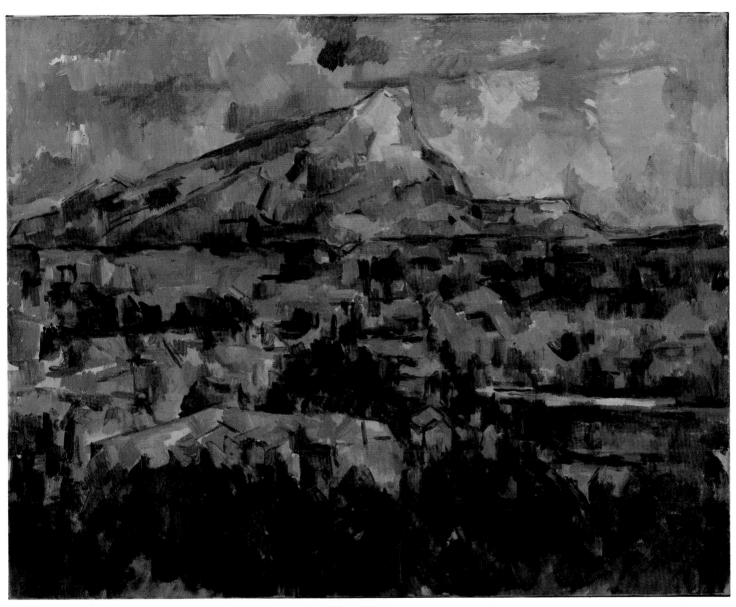

Pl. 122. *Mont Sainte-Victoire*. 1902–06. Venturi 798. Oil on canvas, 27$\frac{1}{2}$ x 35$\frac{1}{4}$ in (69.8 x 89.5 cm) (sight)
Philadelphia Museum of Art, George W. Elkins Collection

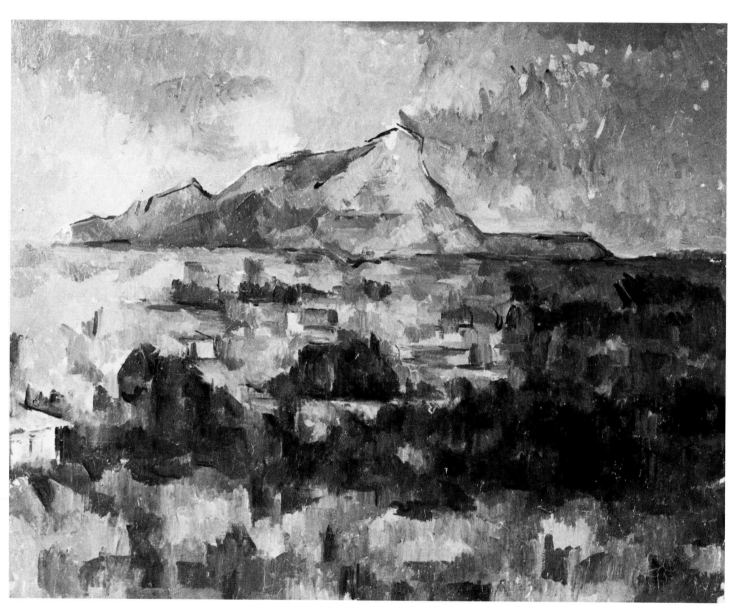

Pl. 123. *Mont Sainte-Victoire.* 1902–06. Venturi 802. Oil on canvas, 25⅝ x 31⅞ in (65 x 81 cm). Private collection, Switzerland

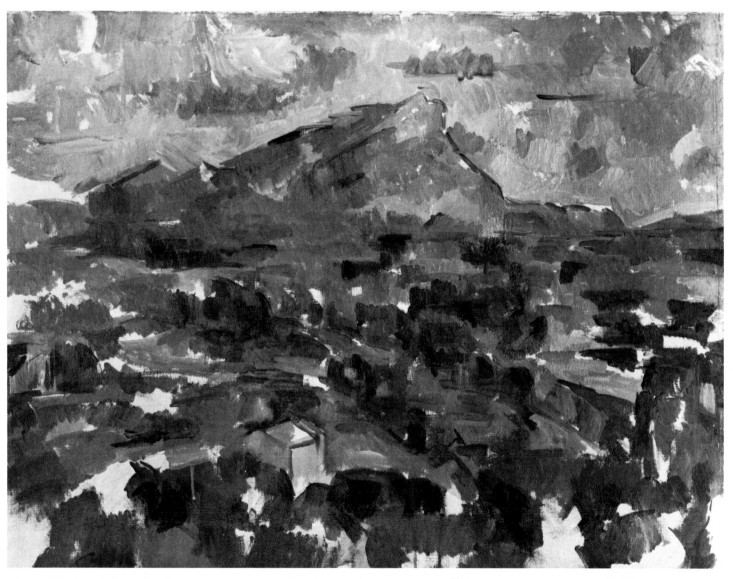

Pl. 124. *Mont Sainte-Victoire Seen from Les Lauves.* 1902–06. Venturi 801. Oil on canvas, 25 x 32¾ in (63.5 x 83 cm). Kunsthaus, Zurich

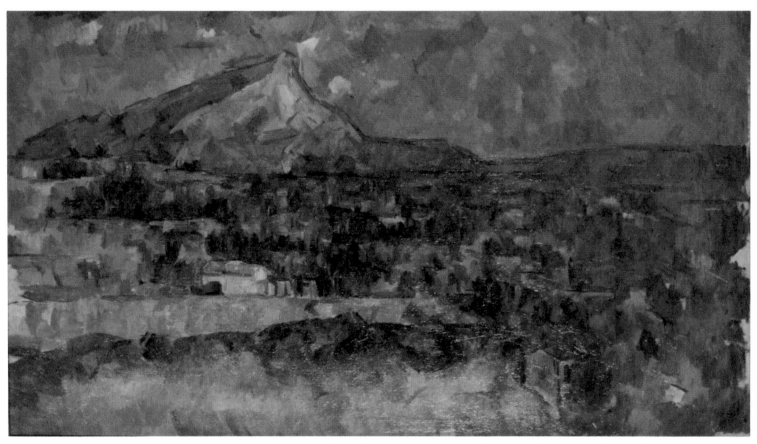

Pl. 125. *Mont Sainte-Victoire*. 1902–06. Venturi 804. Oil on canvas, 22¼ x 38¼ in (56.5 x 97.2 cm). Collection Walter H. Annenberg, Palm Springs

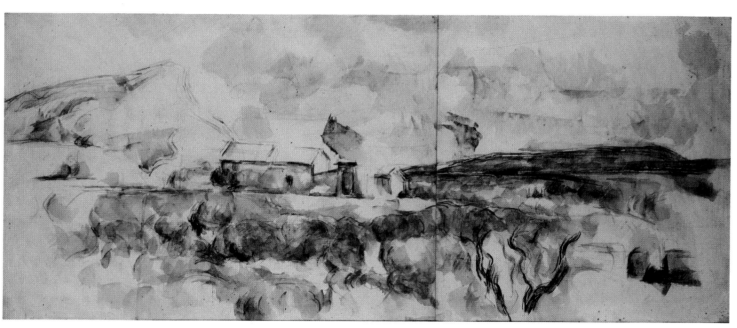

Pl. 126. *Mont Sainte-Victoire Seen from Les Lauves.* 1902–06. Venturi 917. Pencil and watercolor, 13 x 28⅜ in (33 x 72 cm)
Collection Ernest M. von Simson, New York

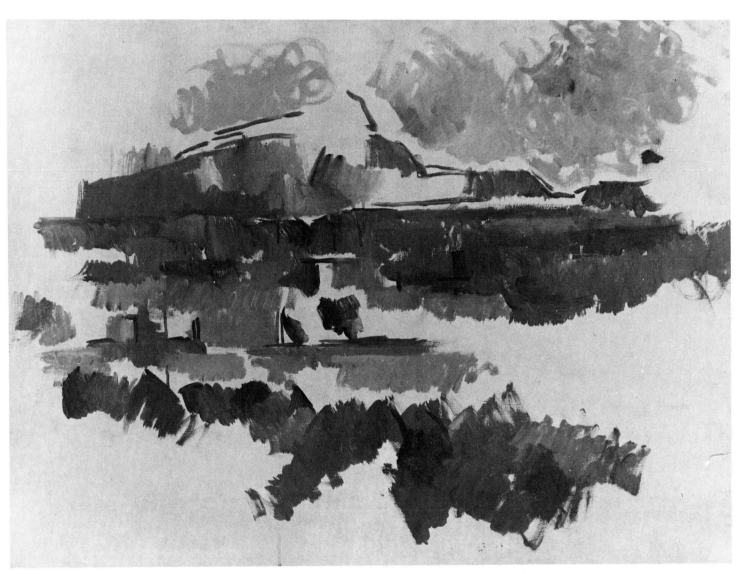

Pl. 127. *Mont Sainte-Victoire.* 1904–06. Oil on canvas, 21¼ x 28¾ in (54 x 73 cm). Galerie Beyeler, Basel

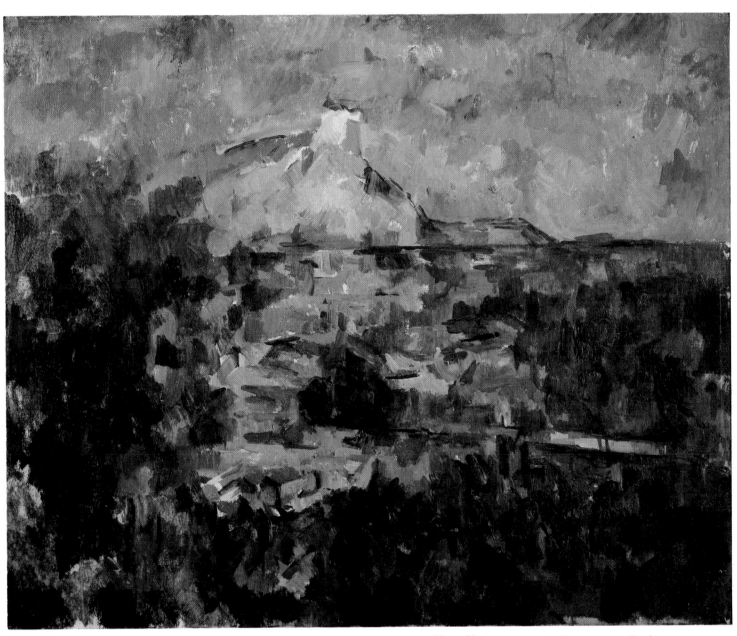

Pl. 128. *Mont Sainte-Victoire Seen from Les Lauves*. 1904–06. Venturi 1529. Oil on canvas, 23⅝ x 28⅜ in (60 x 72 cm). Kunstmuseum Basel

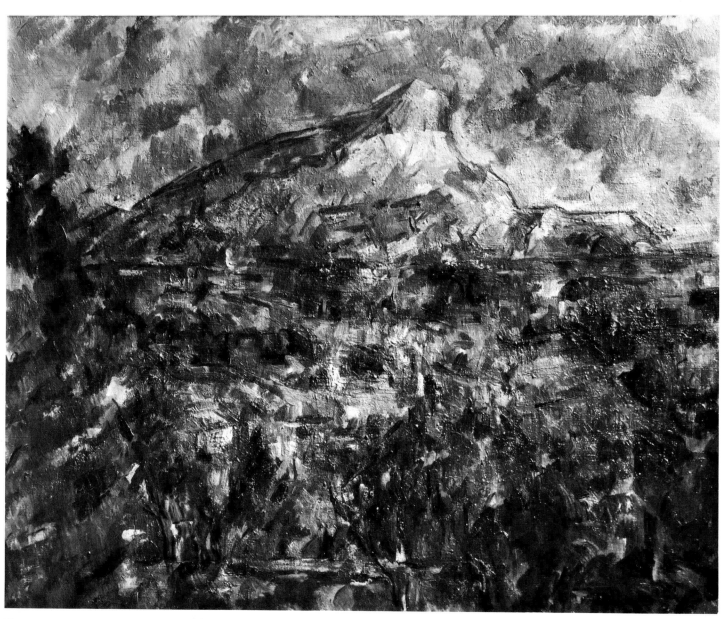

Pl. 129. *Mont Sainte-Victoire Seen from Les Lauves.* c. 1906. Venturi 803. Oil on canvas, 23⅝ x 28¾ in (60 x 73 cm)
Pushkin Museum of Fine Arts, Moscow

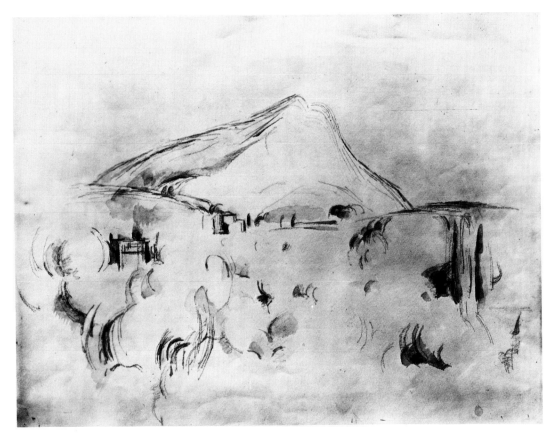

Pl. 130. *Mont Sainte-Victoire Seen from the North of Aix.* 1895–1900. Venturi 1027
Watercolor, 16⅝ x 21½ in
(42.3 x 54.6 cm)
Musée Granet, Aix-en-Provence

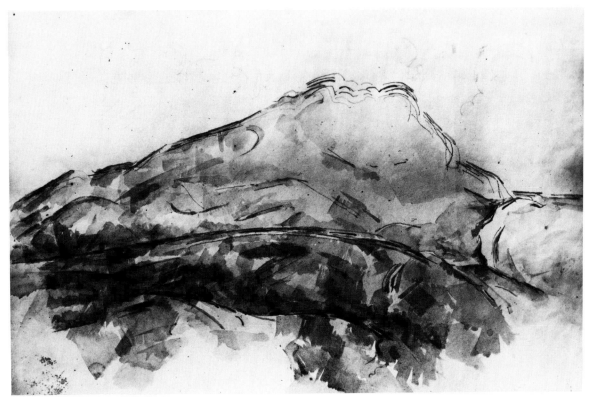

Pl. 131. *Mont Sainte-Victoire*
1902–02. Pencil and watercolor,
12¼ x 19 in (31 x 48 cm)
Private collection

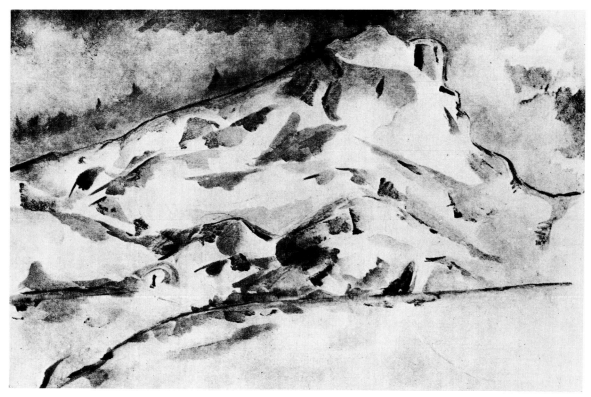

Pl. 132. *Mont Sainte-Victoire*
1900–02. Venturi 1562
Pencil and watercolor,
12¼ x 18⅞ in (31.1 x 47.9 cm)
Cabinet des Dessins,
Musée du Louvre, Paris

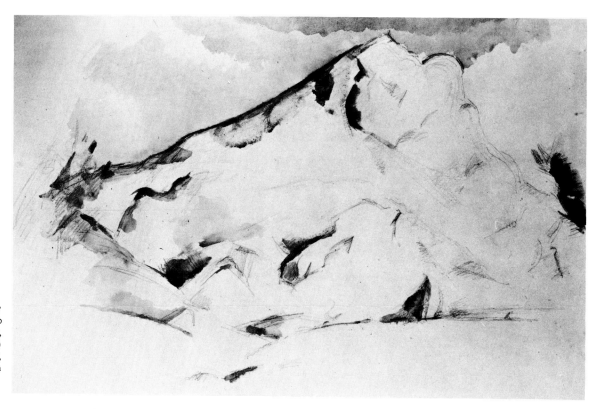

Pl. 133. *Mont Sainte-Victoire*
1900–02. Venturi 1560
Watercolor,
12¼ x 18⅞ in (31 x 48 cm)
Collection John S. Thacher,
Washington

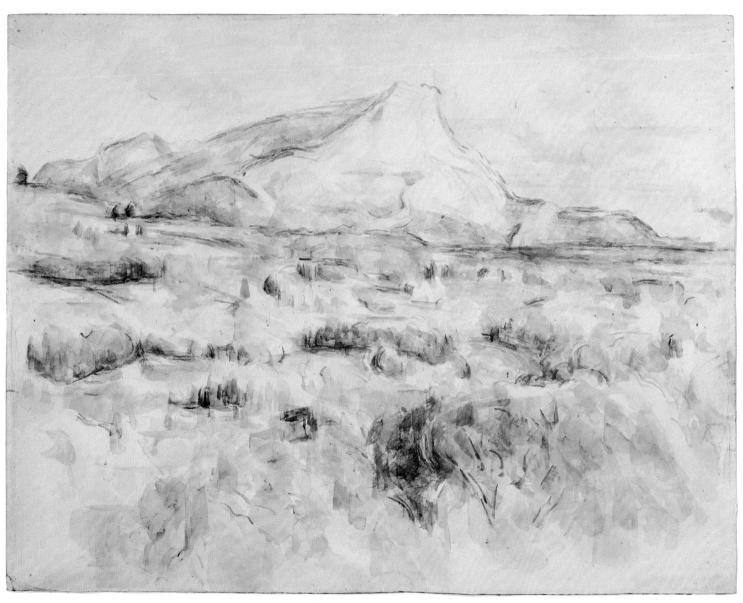

Pl. 134. *Mont Sainte-Victoire.* 1902—06. Pencil and watercolor, 16¾ x 21⅜ in (42.5 x 54.3 cm)
The Museum of Modern Art, New York, anonymous gift, donor retaining life interest

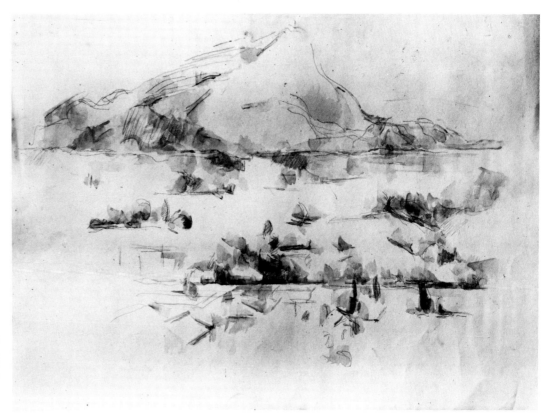

Pl. 135. *Mont Sainte-Victoire Seen from Les Lauves.* 1901–06. Pencil and watercolor, 18⅝ x 24¼ in (47.5 x 61.5 cm) National Gallery of Ireland, Dublin

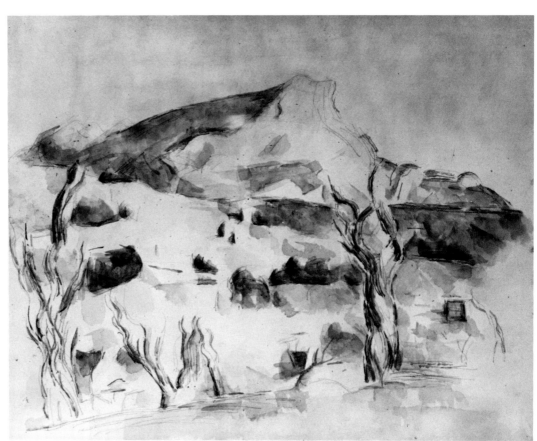

Pl. 136. *Mont Sainte-Victoire Seen from Les Lauves.* 1902–04. Pencil and watercolor, 16½ x 20½ in (41.9 x 52 cm) Private collection, Los Angeles

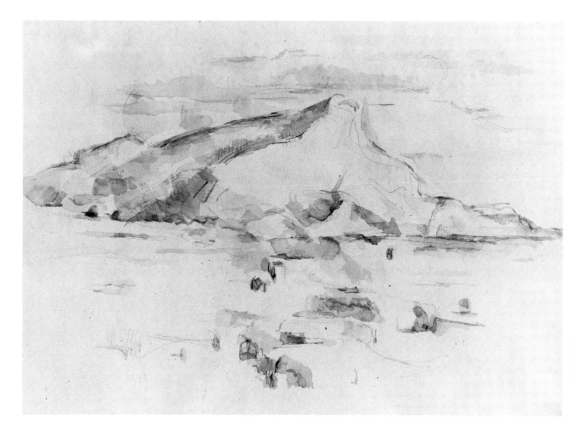

Pl. 137. *Mont Sainte-Victoire Seen from Les Lauves*. 1902–04. Pencil and watercolor, 12¼ x 17¼ in (31 x 43.8 cm) Private collection

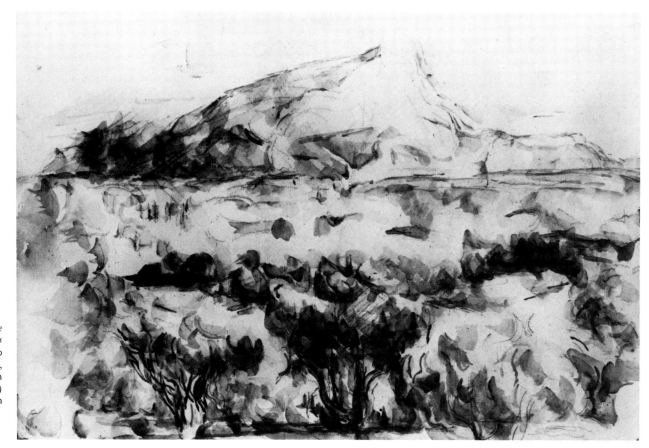

Pl. 138. *Mont Sainte-Victoire Seen from Les Lauves* 1902–06. Venturi 1030 Pencil and watercolor, 14⅛ x 21⅝ in (36 x 55 cm) The Tate Gallery, London

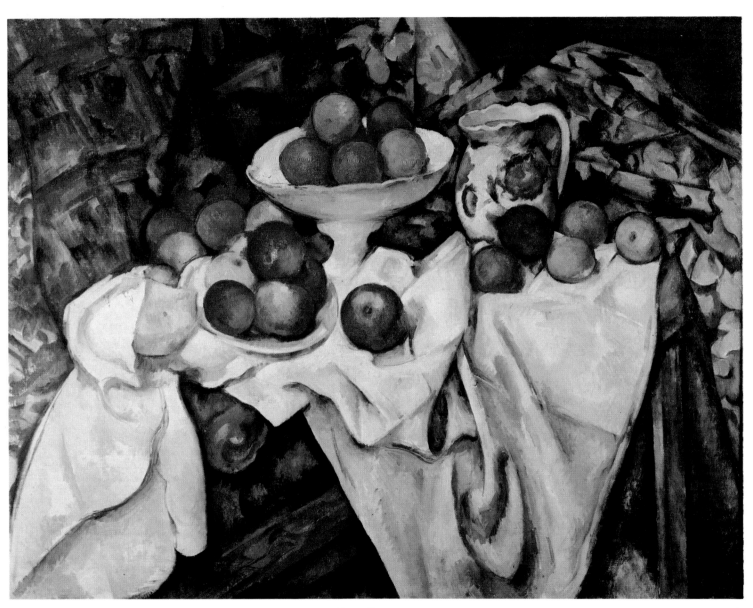

Pl. 139. *Apples and Oranges*. 1895–1900. Venturi 732. Oil on canvas, 29⅛ x 36⅝ in (74 x 93 cm). Galerie du Jeu de Paume, Musée du Louvre, Paris

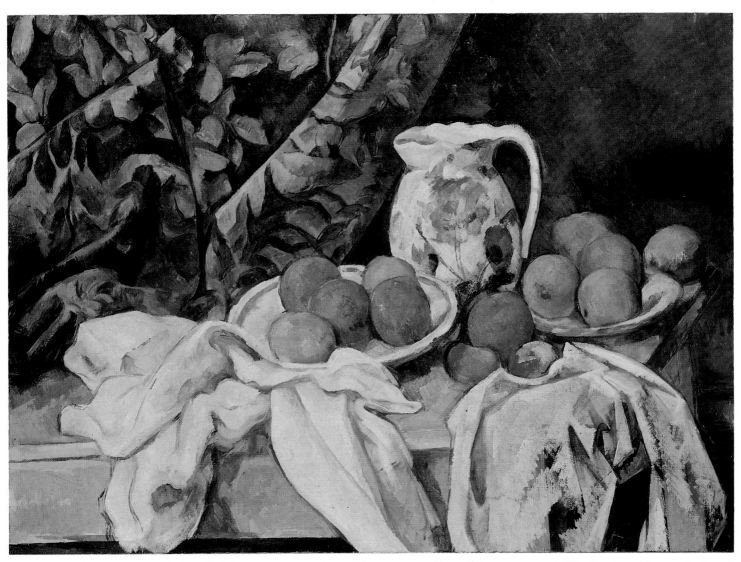

Pl. 140. *Still Life with Curtain and Flowered Pitcher*. c. 1899. Venturi 731. Oil on canvas, 21½ x 29⅛ in (54.7 x 74 cm). The Hermitage Museum, Leningrad

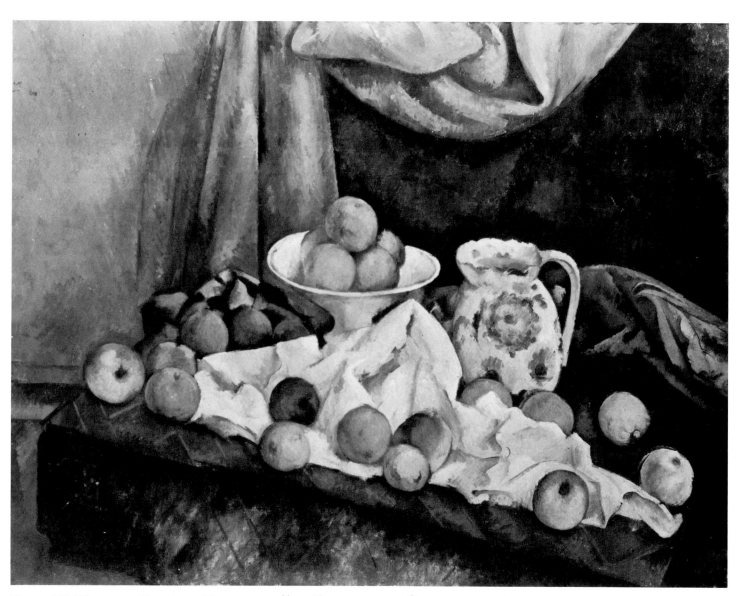

Pl. 141. *Still Life.* 1892–94. Venturi 592. Oil on canvas, 28¾ x 36¼ in (73 x 92 cm). © The Barnes Foundation, Merion, Pa.

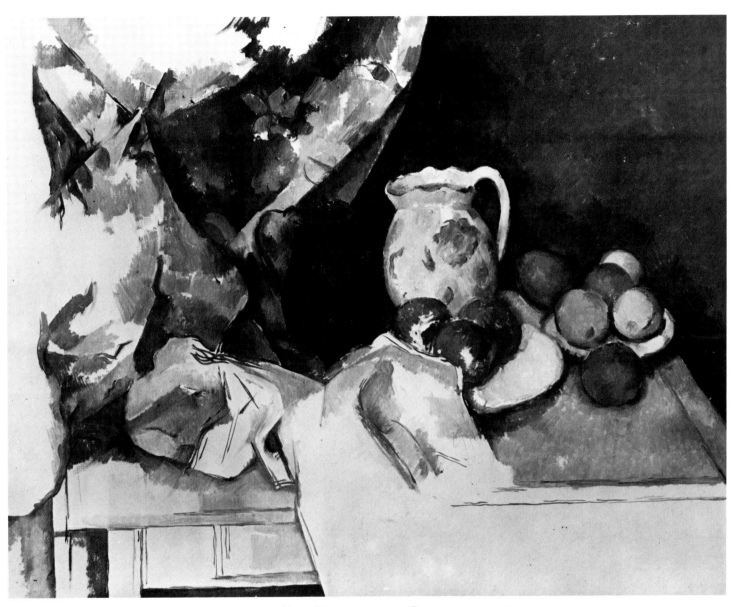

Pl. 142. *Still Life*. 1892–94. Venturi 745. Oil on canvas, 25⅝ x 31⅞ in (65 x 81 cm). © The Barnes Foundation, Merion, Pa.

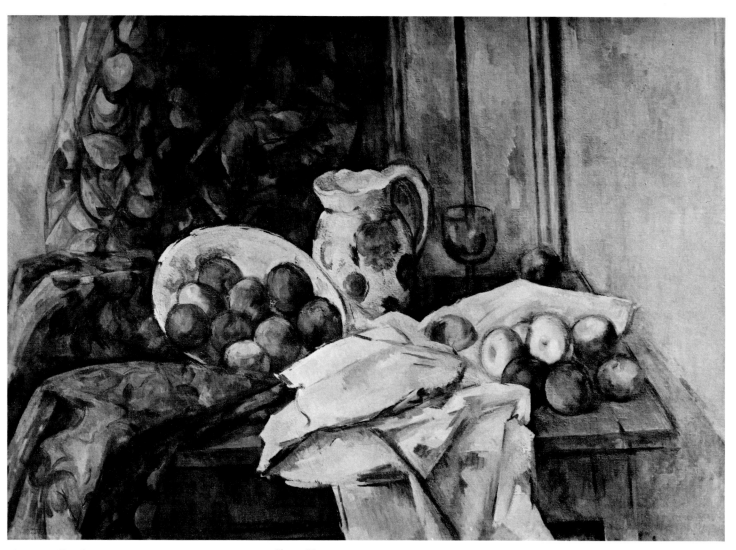

Pl. 143. *Still Life.* c. 1900. Venturi 742. Oil on canvas, 28¾ x 39⅜ in (73 x 100 cm). Oskar Reinhart Collection, Am Römerholz, Winterthur

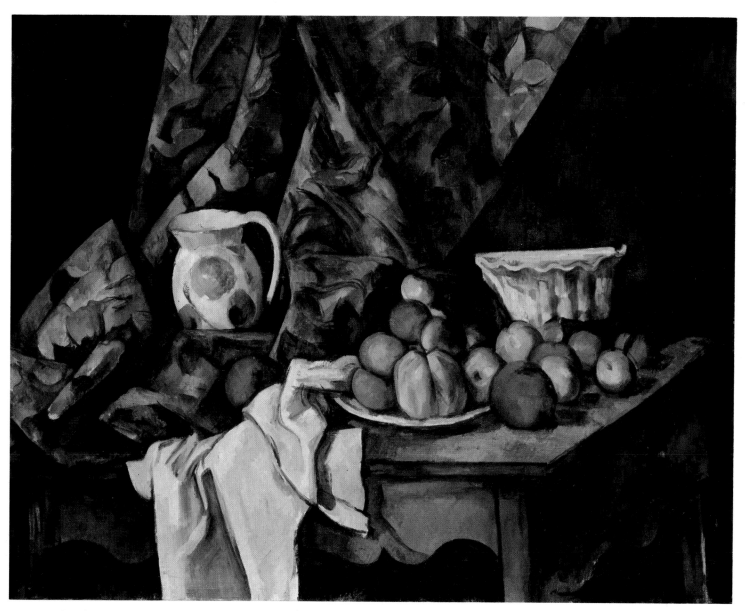

Pl. 144. *Still Life with Apples and Peaches.* 1905. Oil on canvas, 32 x 39⅝ in (81.3 x 100.7 cm). National Gallery of Art, Washington, gift of Eugene and Agnes Meyer

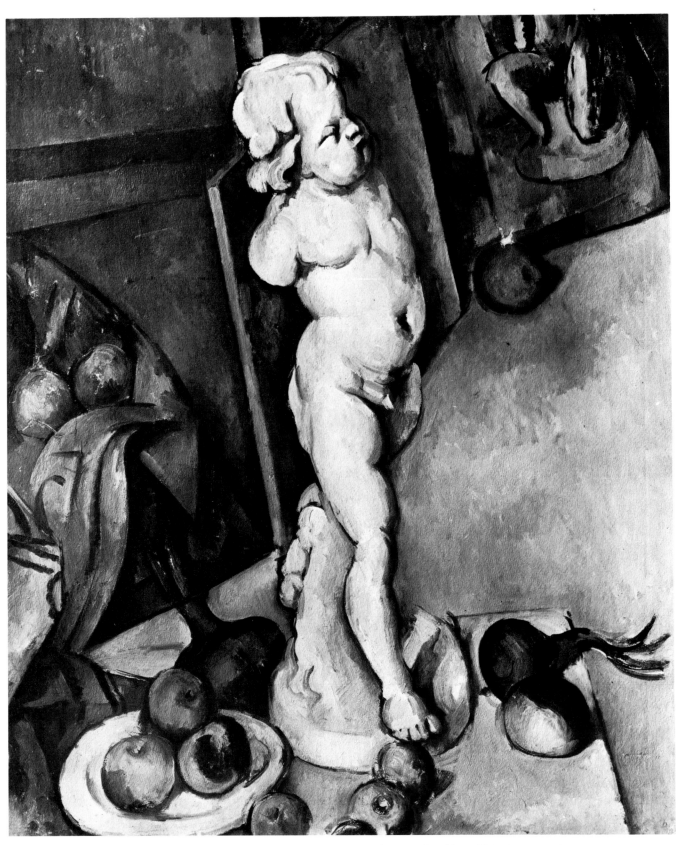

Pl. 145. *Still Life with Plaster Cupid.* c. 1895. Venturi 706. Oil on paper mounted on panel, 27½ x 22½ in (70 x 57 cm) Courtauld Institute Galleries, London

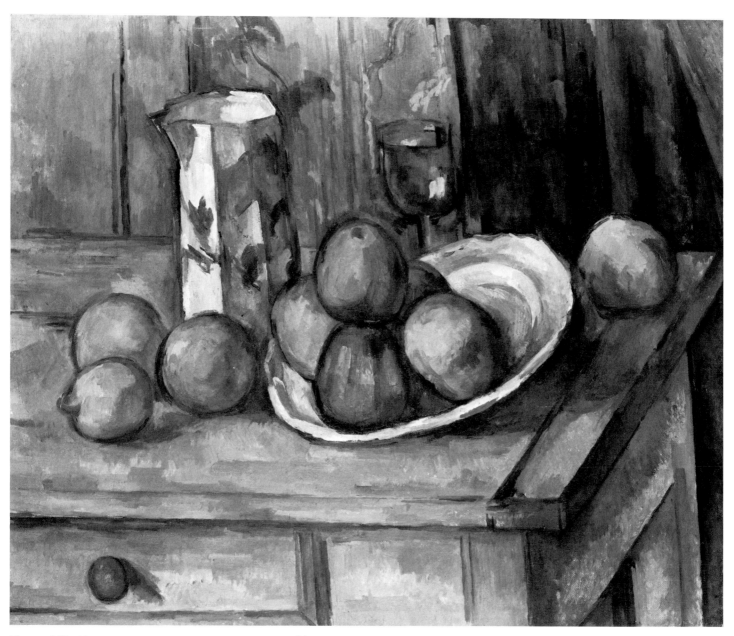

Pl. 146. *Still Life*. c. 1900. Venturi 735. Oil on canvas, 18 x 21⅝ in (45.8 x 54.9 cm). National Gallery of Art, Washington, gift of the W. Averell Harriman Foundation in memory of Marie N. Harriman

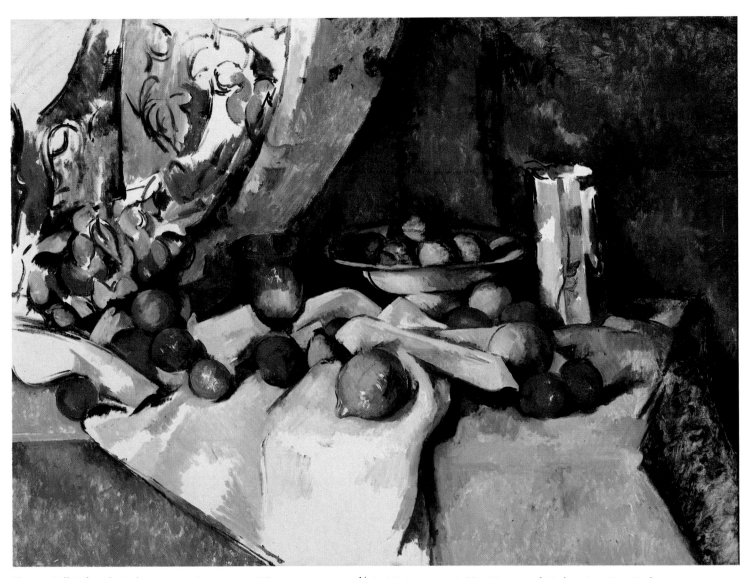

Pl. 147. *Still Life with Apples.* 1895–98. Venturi 736. Oil on canvas, 27 x 36½ in (68.6 x 92.7 cm). The Museum of Modern Art, New York, Lillie P. Bliss Collection

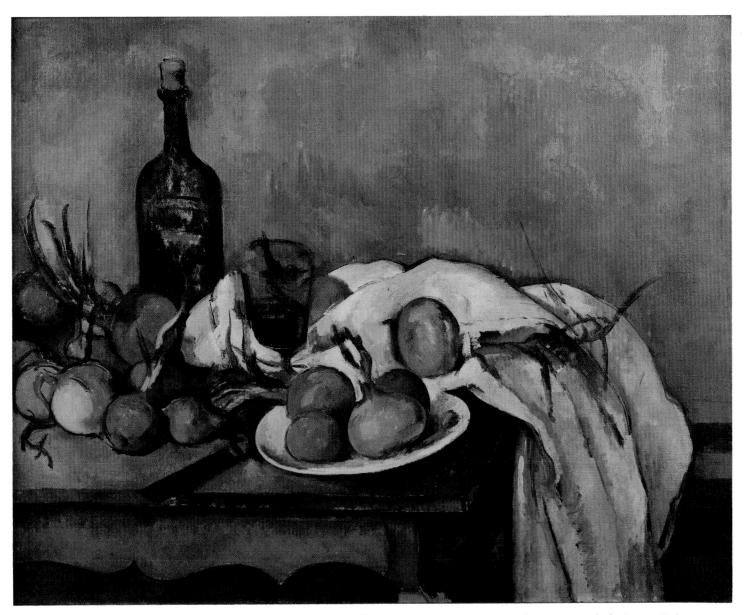

Pl. 148. *Still Life with Onions.* c. 1895. Venturi 730. Oil on canvas, 26 x 32¼ in (66 x 82 cm). Galerie du Jeu de Paume, Musée du Louvre, Paris

Pl. 149. *Still Life*. 1895–1900. Venturi 740. Oil on canvas, 18⅛ x 21⅝ in (46 x 55 cm). © The Barnes Foundation, Merion, Pa.

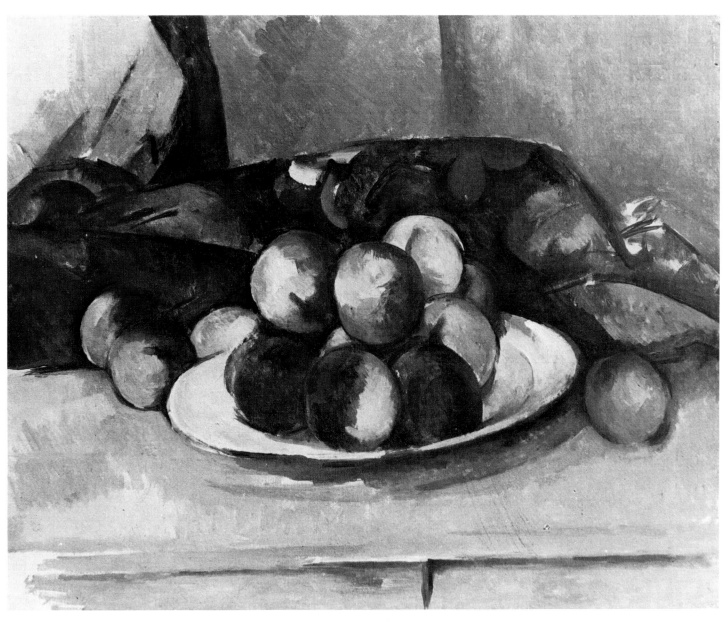

Pl. 150. *Still Life with Peaches.* 1895–1900. Venturi 743. Oil on canvas, 14⅛ x 18⅛ in (36 x 46 cm). Private collection

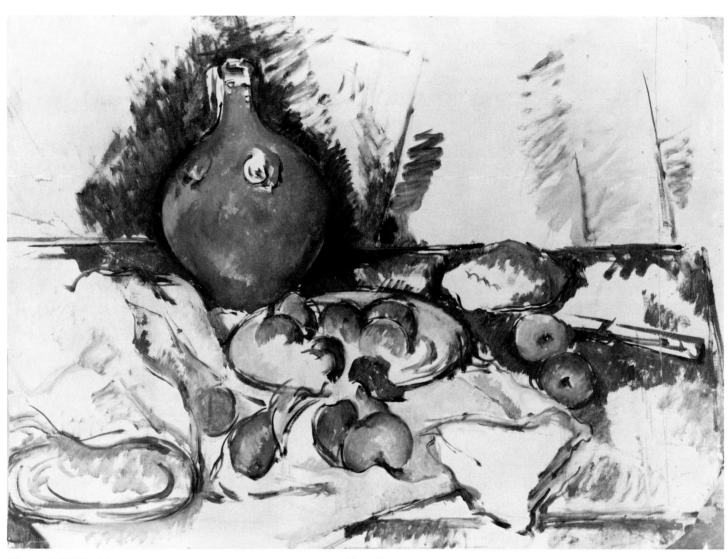

Pl. 151. *Still Life with Water Jug.* c. 1893. Venturi 749. Oil on canvas, 20⅛ x 26¾ in (51 x 68 cm). The Tate Gallery, London

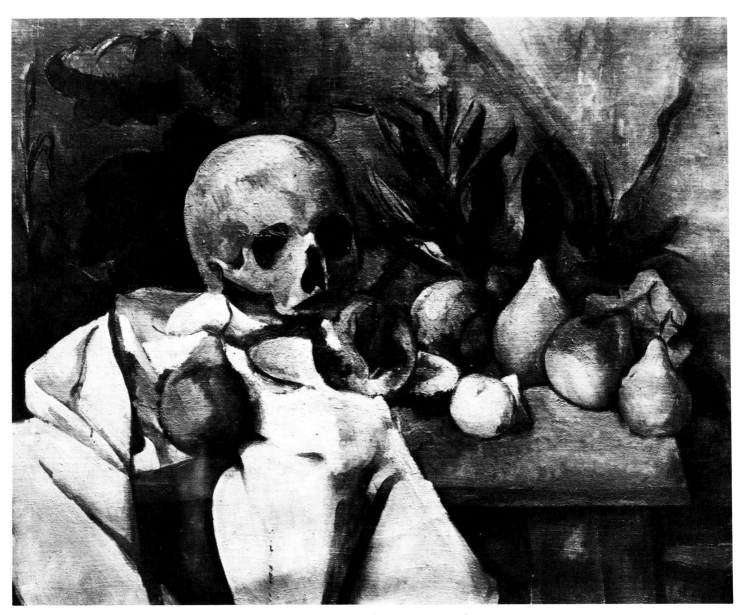

Pl. 152. *Still Life with Skull*. 1896–98. Venturi 758. Oil on canvas, 21¼ x 25⅝ in (54 x 65 cm). © The Barnes Foundation, Merion, Pa.

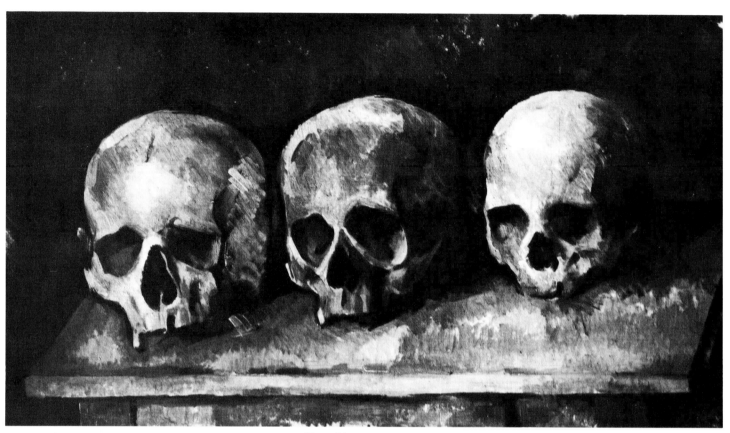

Pl. 153. *Three Skulls*. 1898–1900. Venturi 1567. Oil on canvas, 13⅜ x 23⅝ in (34 x 60 cm). Detroit Institute of Arts, Tannahill Collection

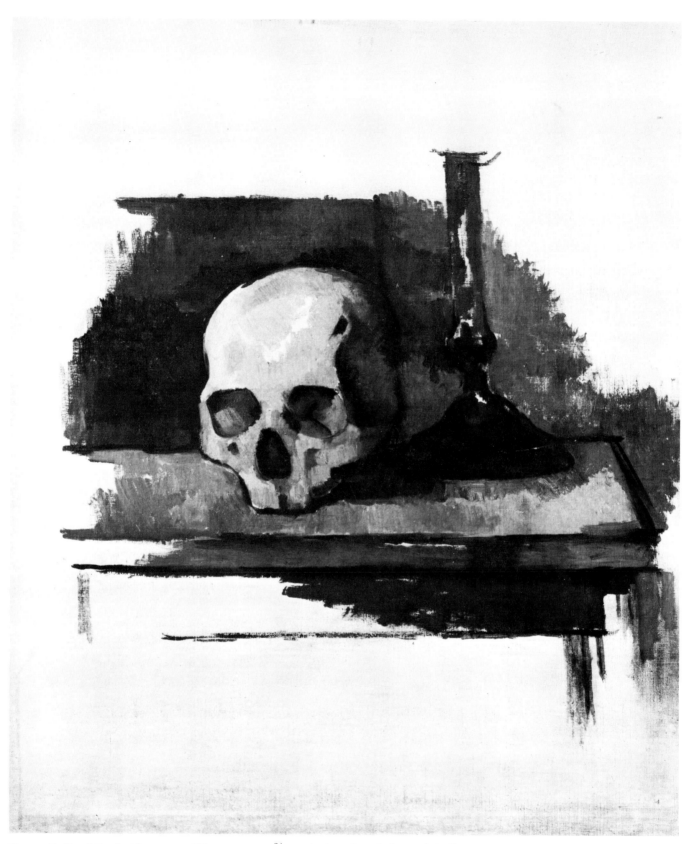

Pl. 154. *Skull and Candlestick*. 1900–94. Oil on canvas, 19¾ x 24 in (50 x 61 cm). Staatsgalerie, Stuttgart

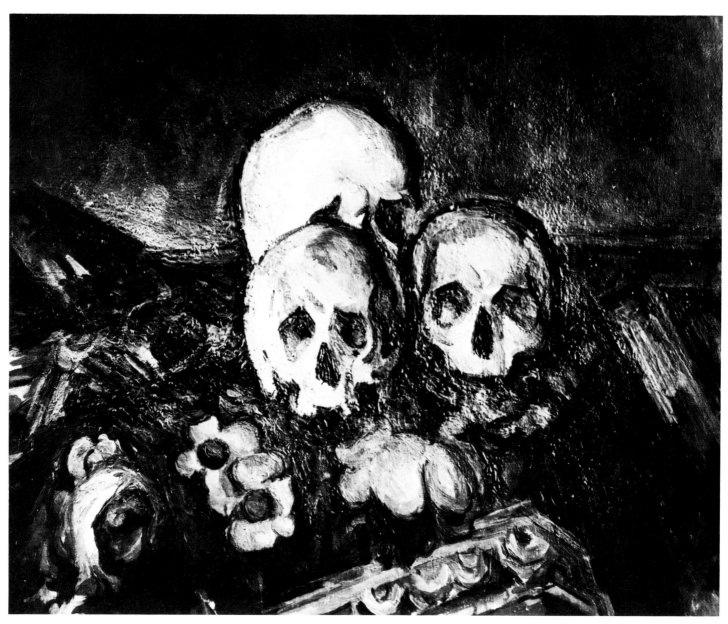

Pl. 155. *Three Skulls on an Oriental Rug.* c. 1904. Venturi 759. Oil on canvas, 21½ x 25⅝ in (54.5 x 65 cm). Private collection, Switzerland

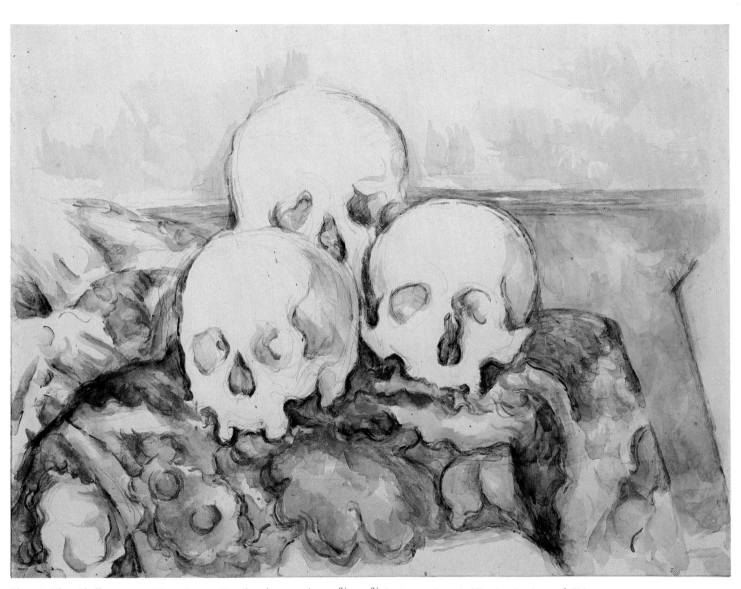

Pl. 156. *Three Skulls*. 1900–04. Venturi 1131. Pencil and watercolor, 18¾ x 24¾ in (47.7 x 63 cm). The Art Institute of Chicago

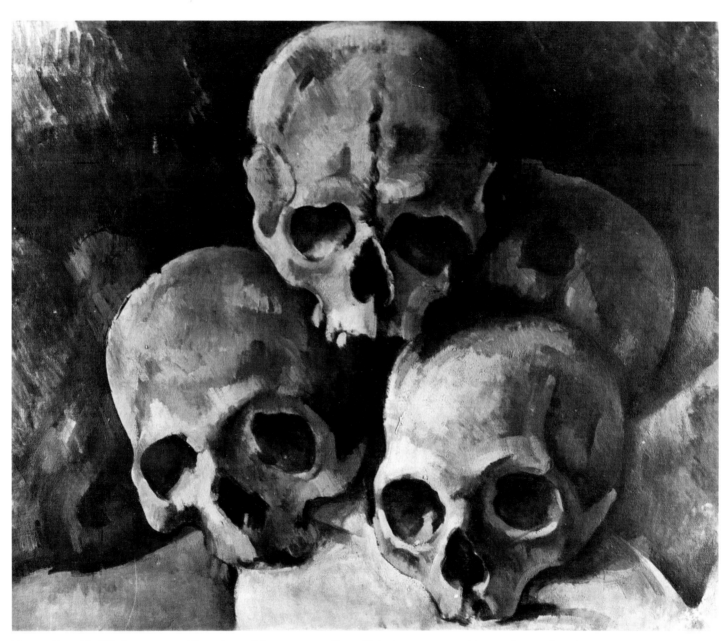

Pl. 157. *Pyramid of Skulls*. 1898–1900. Venturi 753. Oil on canvas, 14⅝ x 17⅞ in (37 x 45.5 cm). Private collection, Zurich

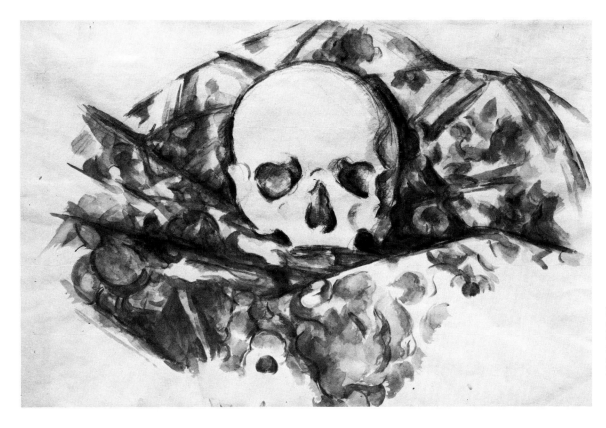

Pl. 158. *Skull on a Drapery*
1902–06. Venturi 1129
Pencil and watercolor,
12½ x 18¾ in
(31.7 x 47.5 cm)
Private collection

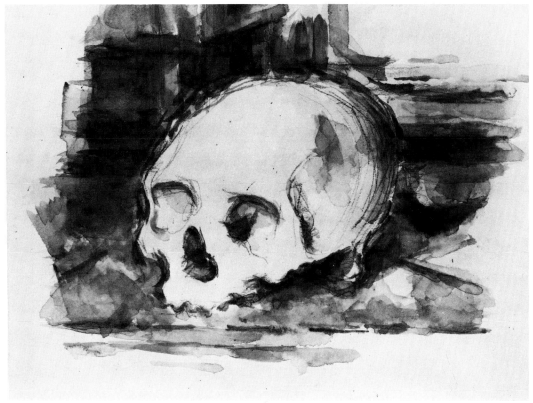

Pl. 159. *Study of a Skull.* 1902–04
Venturi 1130. Pencil and watercolor,
10 x 12½ in (25.4 x 31.8 cm)
Estate of Henry Pearlman, New York

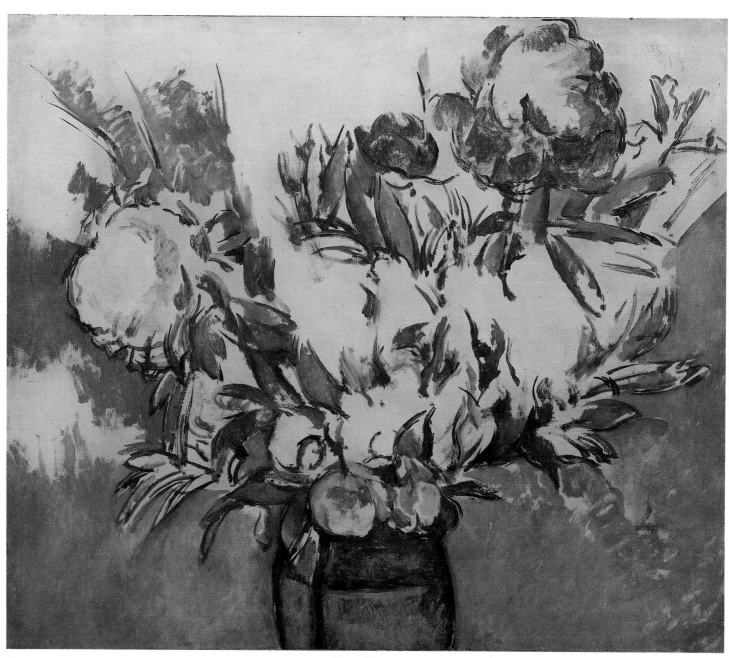

Pl. 160. *Peonies in a Green Jar.* 1895–98. Venturi 748. Oil on canvas, 22⅝ x 25¾ in (57.5 x 65.5 cm). Private collection, Paris

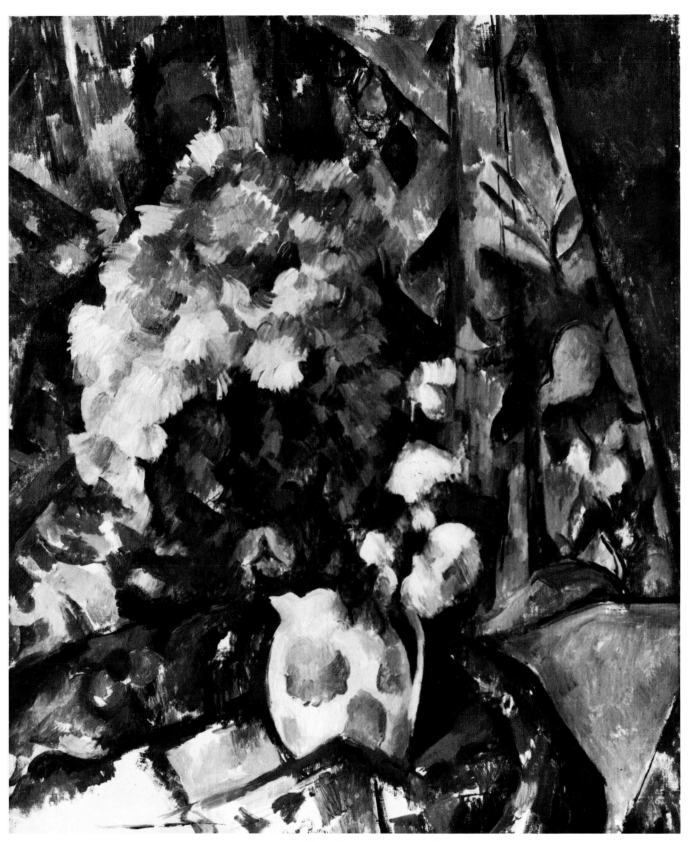

Pl. 161. *Vase of Flowers*. c. 1900. Venturi 755. Oil on canvas, 26⅜ x 21⅝ in (67 x 55 cm). © The Barnes Foundation, Merion, Pa.

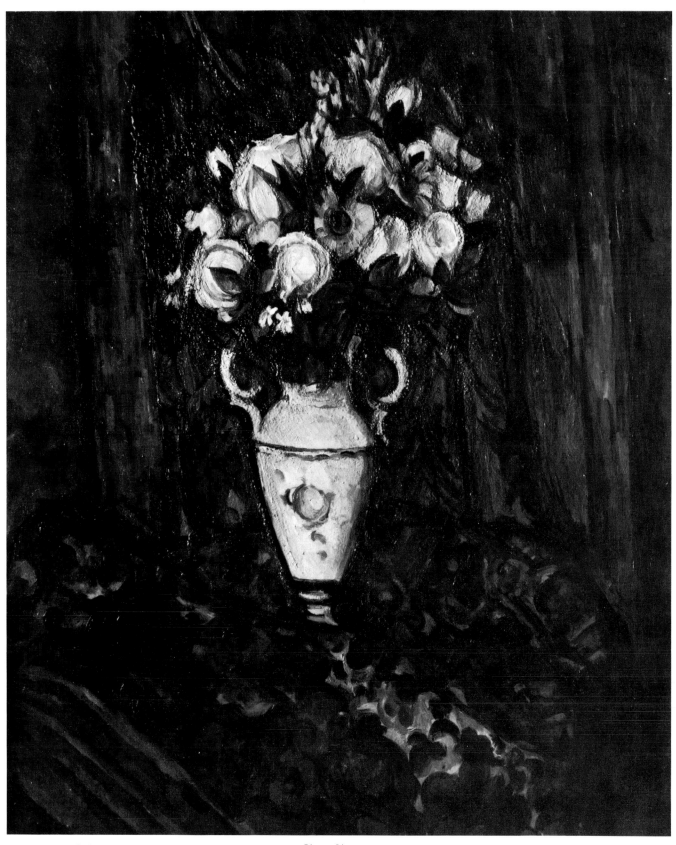

Pl. 162. *Vase of Flowers*. 1900–03. Venturi 757. Oil on canvas, 39⅞ x 32⅜ in (101.2 x 82.2 cm). National Gallery of Art, Washington, gift of Eugene and Agnes Meyer

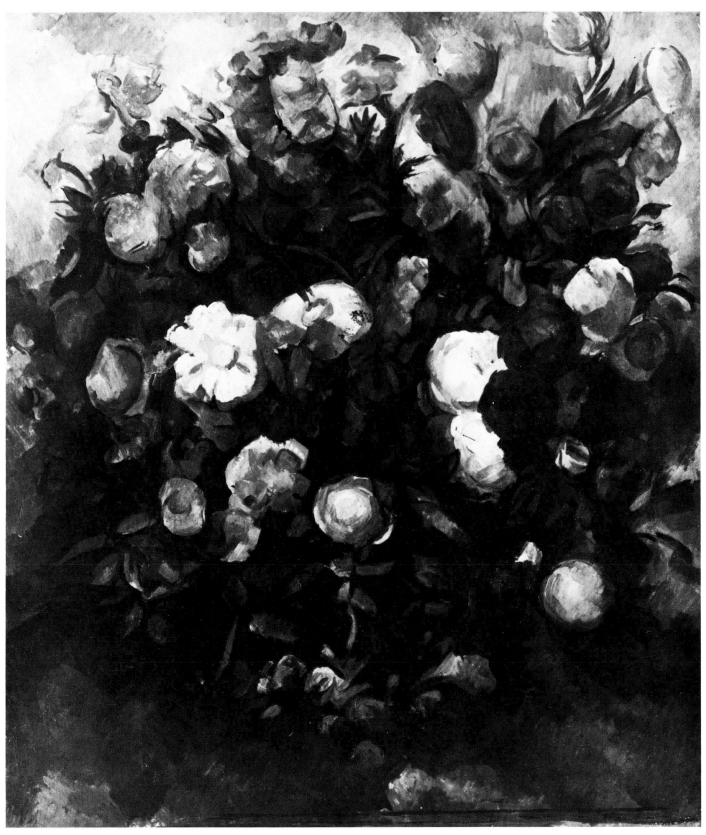

Pl. 163. *Flowers* (*Copy after Delacroix's Roses and Hortensias*). 1902–04. Venturi 754. Oil on canvas, 30¼ x 25¼ in (77 x 64 cm)
Pushkin Museum of Fine Arts, Moscow

Pl. 164. *Flowers.* 1900–04. Venturi 756. Oil on canvas, $25\frac{5}{8}$ x $21\frac{1}{4}$ in (65 x 54 cm). Private collection

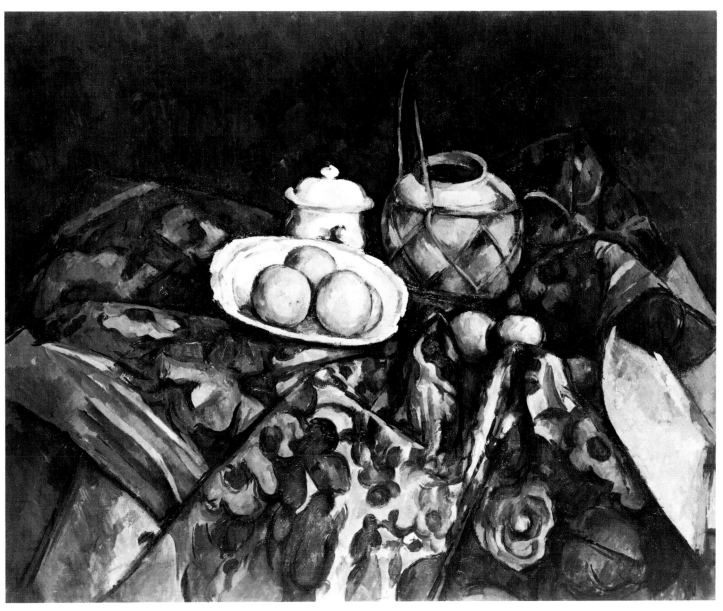

Pl. 165. *Still Life with Ginger Jar, Sugar Bowl, and Oranges.* 1902–06. Venturi 738. Oil on canvas, 23⅞ x 28⅞ in (60.6 x 73.3 cm)
The Museum of Modern Art, New York, Lillie P. Bliss Collection

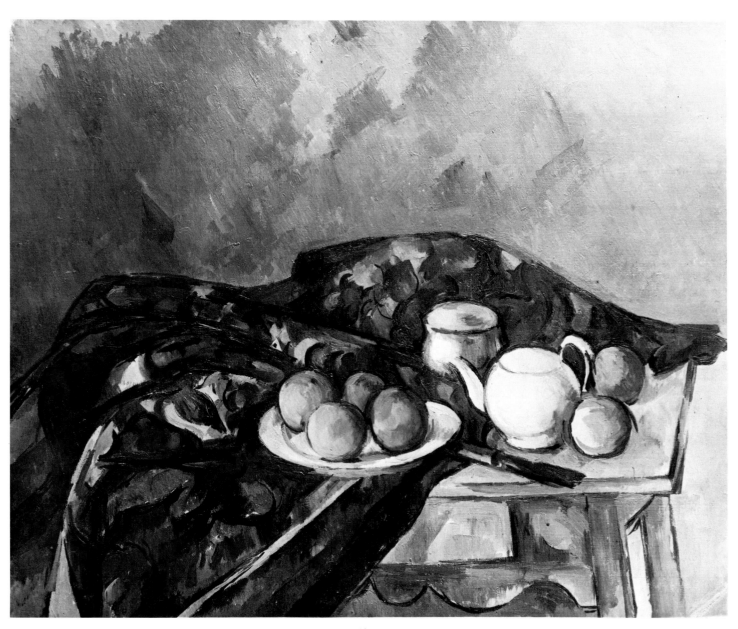

Pl. 166. *Still Life with Teapot*. 1902–06. Venturi 734. Oil on canvas, 23 x 28½ in (58.4 x 72.4 cm). National Museum of Wales, Cardiff

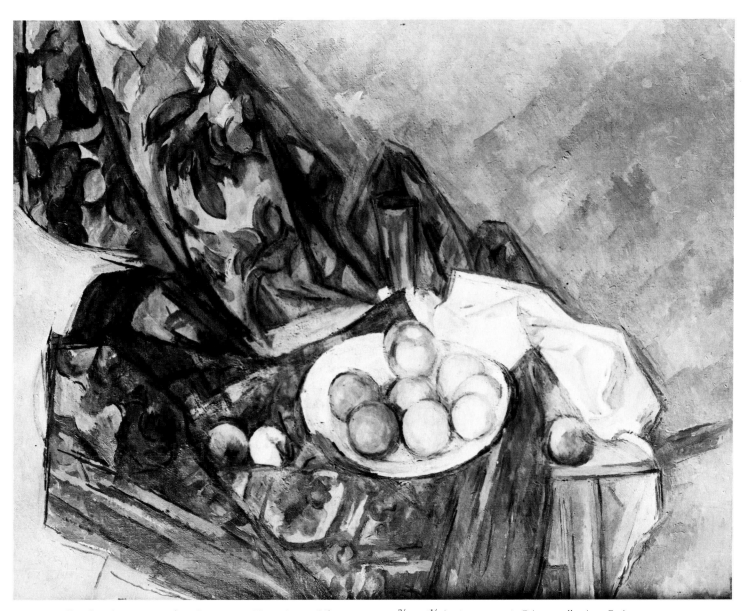

Pl. 167. *Still Life with Drapery and Fruit.* 1904–06. Venturi 741. Oil on canvas, 28³/₄ x 36¹/₄ in (73 x 92 cm). Private collection, Paris

Pl. 168. *Foliage.* 1895–1900. Venturi 1128. Pencil and watercolor, 17⅝ x 22⅜ in (44.8 x 56.8 cm)
The Museum of Modern Art, New York, Lillie P. Bliss Collection

Pl. 169. *Rose amid Foliage.* 1895–1900. Venturi 1127. Watercolor, 18⅞ x 12¼ in (48 x 31 cm). Private collection

Pl. 170. *Roses in a Bottle.* 1900–05. Venturi 1542. Pencil and watercolor, 17⅛ x 12⅛ in (43.5 x 30.8 cm). Private collection

Pl. 171. *Still Life with Teapot
and Fruit.* 1895–1900
Venturi 1150. Watercolor,
17¼ x 23¼ in (43.9 x 59.1 cm)
Private collection, Washington

Pl. 172. *Apples, Bottle, and Glass*
1895–98. Venturi 1617. Pencil and watercolor,
12¼ x 18⅞ in (31 x 48 cm)
Collection Mr. and Mrs. Adrien Chappuis,
Tresserve, France

Pl. 173. *Apple, Carafe, and Sugarbowl*
c. 1900. Venturi 1135. Watercolor,
18⅞ x 24⅞ in (48 x 63 cm)
Kunsthistoriches Museum, Vienna

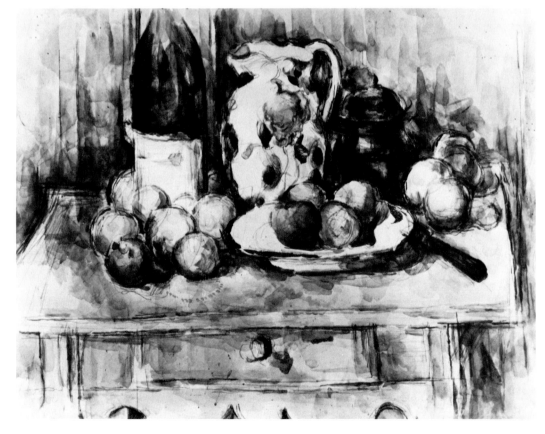

Pl. 174. *Apples on a Sideboard*
c. 1900. Venturi 1142. Watercolor,
18⅞ x 24⅜ in (48 x 61.9 cm)
Private collection

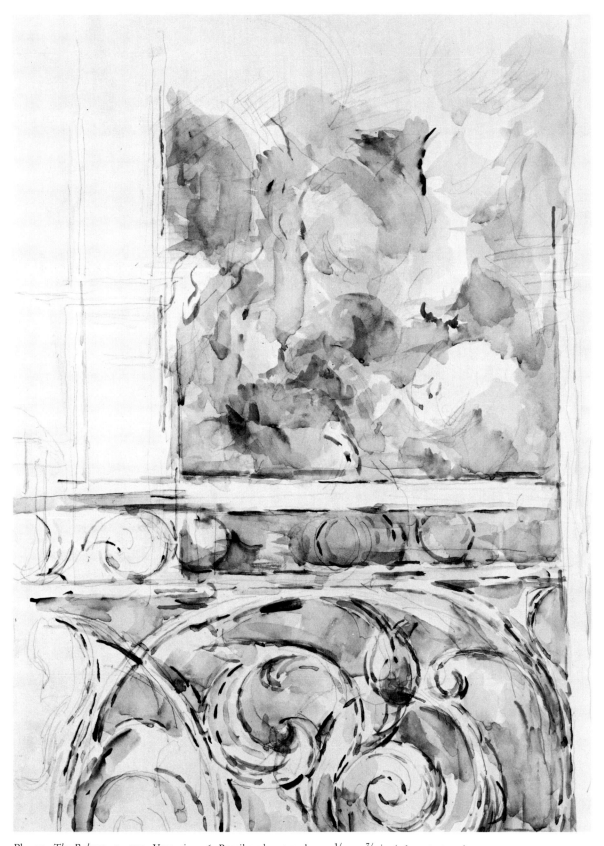

Pl. 175. *The Balcony.* c. 1900. Venturi 1126. Pencil and watercolor, 22¼ x 15⅞ in (56.5 x 40.4 cm)
Philadelphia Museum of Art, A. E. Gallatin Collection

Pl. 176. *The Plaster Cupid*. c. 1900. Venturi 1084. Pencil and watercolor, 19¼ x 24¾ in (49 x 63 cm). Private collection, Switzerland

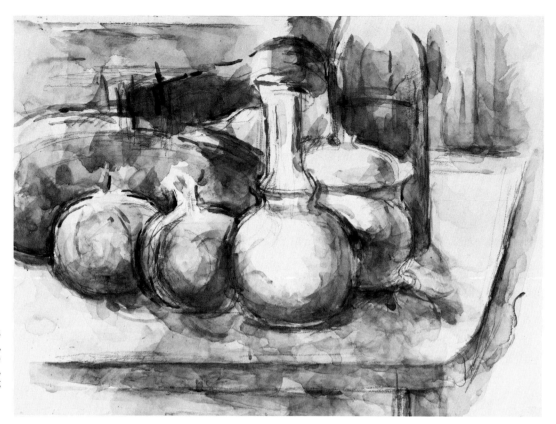

Pl. 177. *Still Life.* 1900–06
Pencil and watercolor,
11¾ x 15¾ in (30 x 40 cm)
Private collection, Switzerland,
provenance Jacques Dubourg

Pl. 178. *Still Life:*
Apples, Pears, and Pot
(*The Kitchen Table*). 1900–04
Venturi 1540
Pencil and watercolor,
11 x 18¾ in (28.1 x 47.8 cm)
Cabinet des Dessins,
Musée du Louvre, Paris

Pl. 179. *Fruit and Glass*
c. 1900. Venturi 1132.
Watercolor,
8$\frac{1}{8}$ x 10$\frac{3}{8}$ in (20.5 x 26.5 cm)
Wildenstein Galleries,
New York

Pl. 180. *Still Life with Melon*
1900–06. Venturi 1146. Watercolor,
18$\frac{1}{8}$ x 23$\frac{5}{8}$ in (46 x 60 cm)
Estate of Mrs. Edsel B. Ford,
Grosse Pointe Shores, Mich.

Pl. 181. *Bottles, Pot, Alcohol Stove, Apples.* 1900–06. Venturi 1541. Pencil and watercolor, 18½ x 22 in (47 x 56 cm)
Collection Mr. and Mrs. Leigh B. Block, Chicago

Pl. 182. *Apples and Inkwell*
1902–06.
Pencil and watercolor,
12½ x 17¾ in (31.7 x 45 cm)
Collection Mr. and Mrs.
Paul Hirschland,
Great Neck, N.Y.

Pl. 183. *Kitchen Table: Jars and Bottles*
1902–06. Venturi 1148. Pencil and
watercolor on paper,
mounted on cardboard,
8⅜ x 10¾ in (21.2 x 27.2 cm)
Cabinet des Dessins,
Musée du Louvre, Paris

Pl. 184. *Still Life with Apples, Bottle, Glass, and Chairs.* 1902–06. Venturi 1155. Watercolor, 17½ x 23¼ in (44.5 x 59 cm)
Courtauld Institute Galleries, London

Pl. 185. *Still Life.* c. 1906. Venturi 1154. Pencil and watercolor, 18½ x 24½ in (47 x 62 cm). Estate of Henry Pearlman, New York

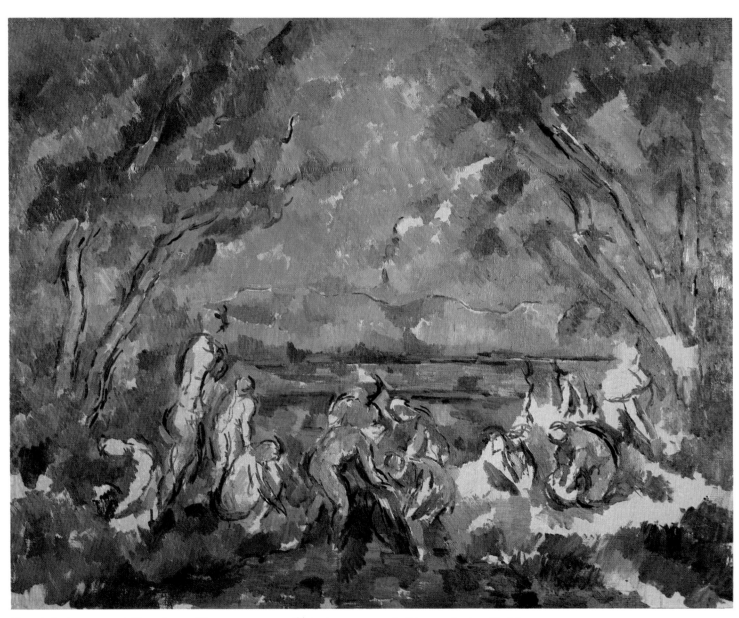

Pl. 186. *Bathers*. 1902–06. Venturi 725. Oil on canvas, 29 x 36⅜ in (73.5 x 92.5 cm). Private collection, Zurich

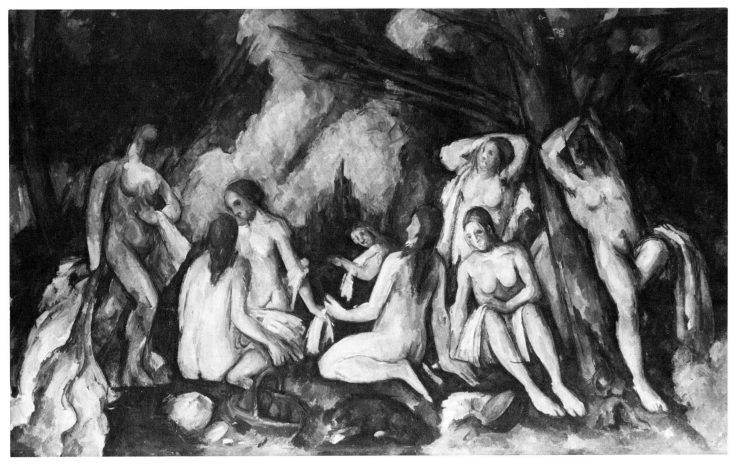

Pl. 187. *Bathers.* 1895–1906. Venturi 720. Oil on canvas, 52⅜ x 81½ in (133 x 207 cm). © The Barnes Foundation, Merion, Pa.

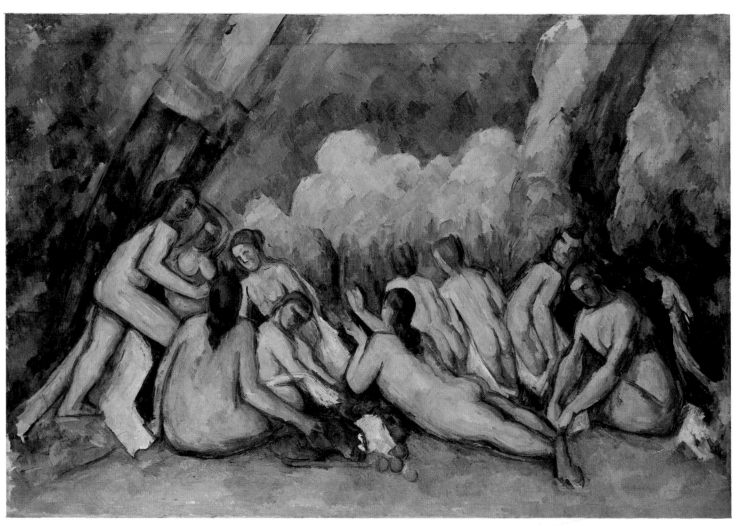

Pl. 188. *Bathers*. 1900–06. Venturi 721. Oil on canvas, 51¼ x 76¾ in (130 x 195 cm). National Gallery, London

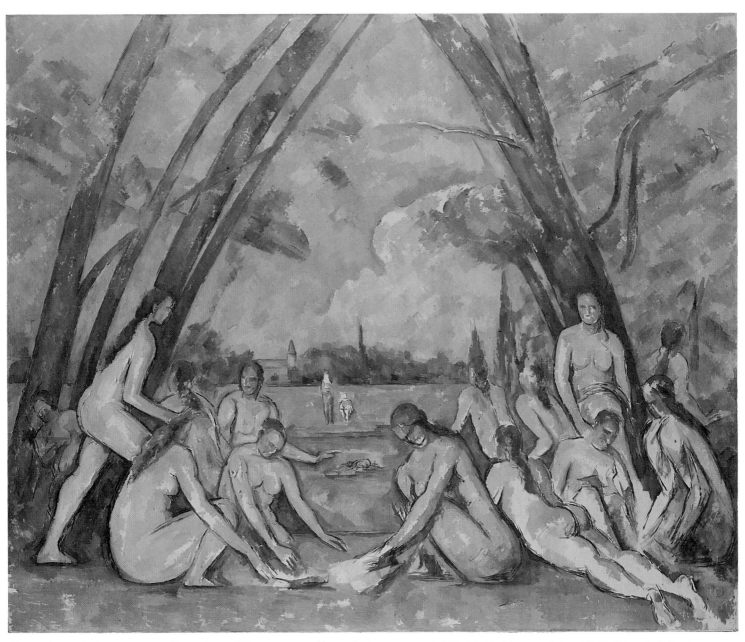

Pl. 189. *Large Bathers.* 1899–1906. Venturi 719. Oil on canvas, 81⅞ x 98 in (208 x 249 cm). Philadelphia Museum of Art, W. P. Wilstach Collection

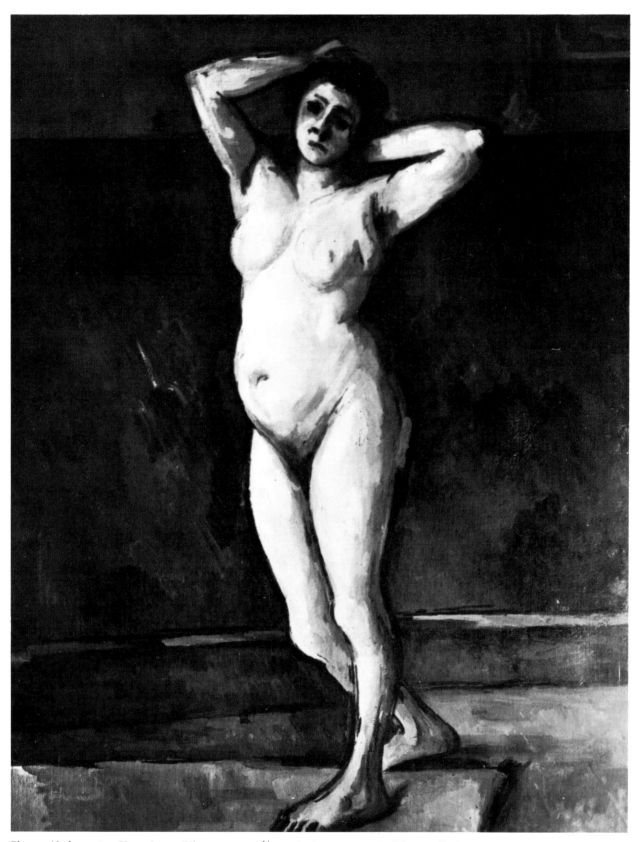

Pl. 190. *Nude.* c. 1895. Venturi 710. Oil on canvas, 36½ x 28 in (92.8 x 71.1 cm). Private collection

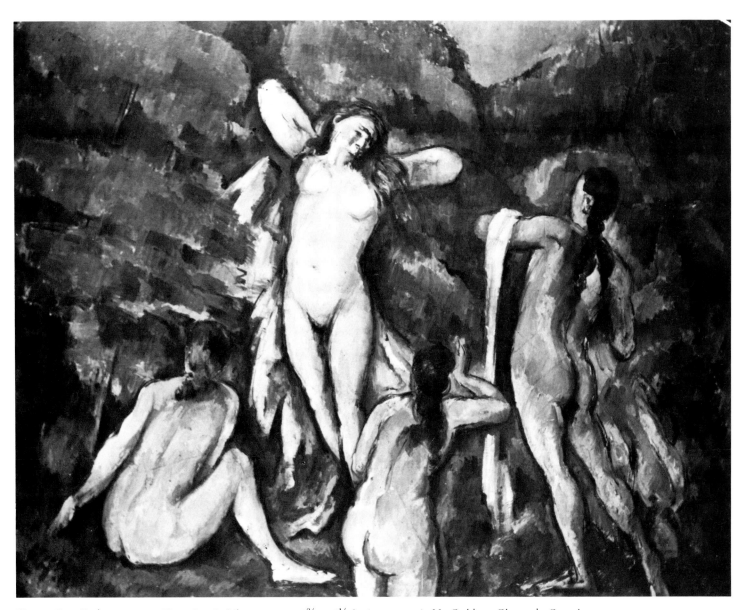

Pl. 191. *Four Bathers*. 1888–89. Venturi 726. Oil on canvas, 28¾ x 36¼ in (73 x 92 cm). Ny Carlsberg Glyptotek, Copenhagen

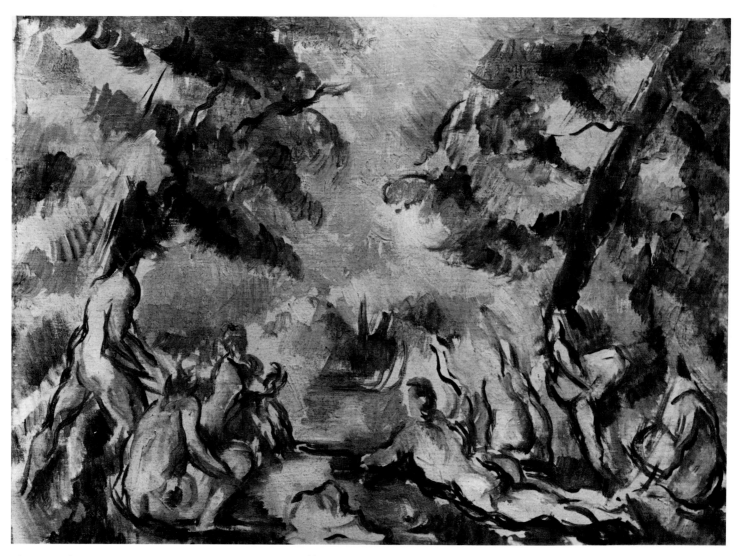

Pl. 192. *Bathers.* 1899–1904. Venturi 723. Oil on canvas, 11 x 14⅛ in (28 x 36 cm). Private collection

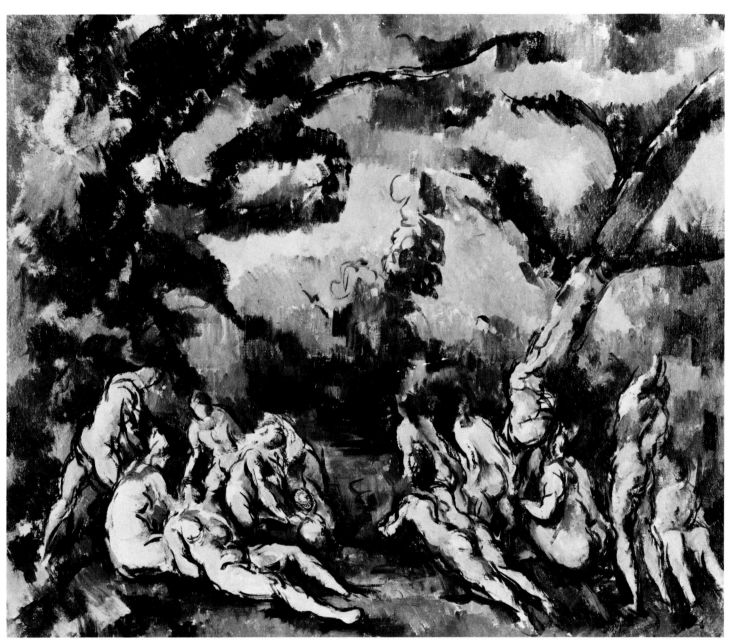

Pl. 193. *Bathers.* 1899–1904. Venturi 722. Oil on canvas, 20¼ x 24¼ in (51.3 x 61.7 cm)
The Art Institute of Chicago, The Amy McCormick Memorial Collection

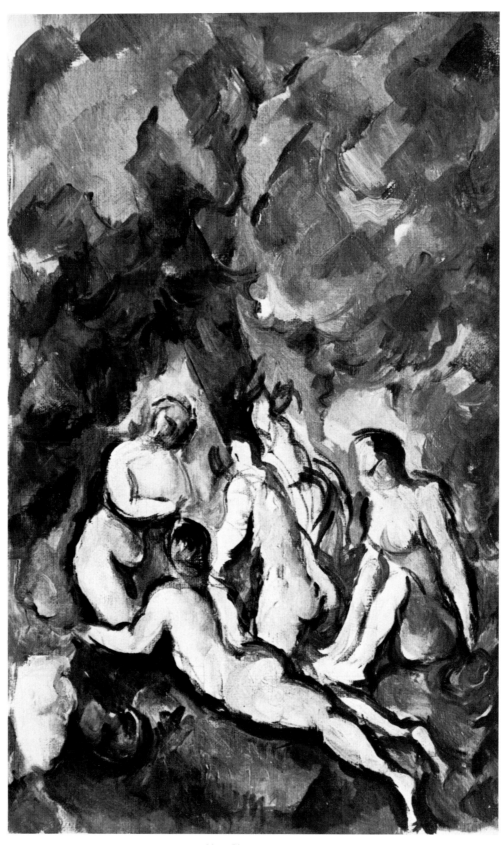

Pl. 194. *Bathers*. c. 1900. Oil on canvas, 13¾ x 8⅞ in (35 x 22.5 cm). Formerly Galerie Beyeler, Basel

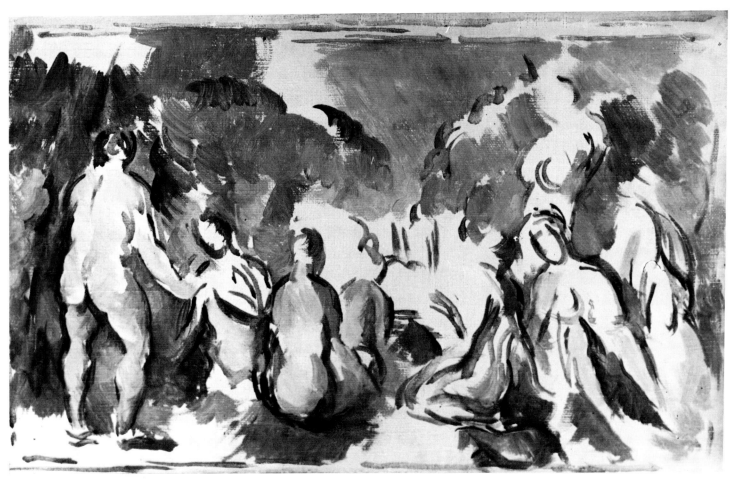

Pl. 195. *Study of Bathers*. 1900–06. Oil on canvas, 8⅜ x 12⅞ in (21.2 x 32.5 cm). Collection S. Rosengart, Lucerne

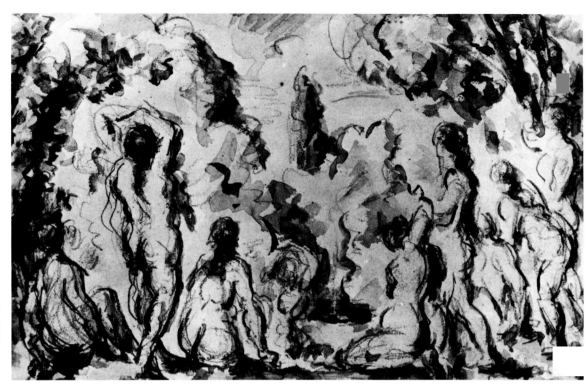

Pl. 196. *Bathers.* c. 1900
Venturi 1109
Pencil and Watercolor,
4¾ x 7⅛ in (12 x 18 cm)
Private collection, Switzerland

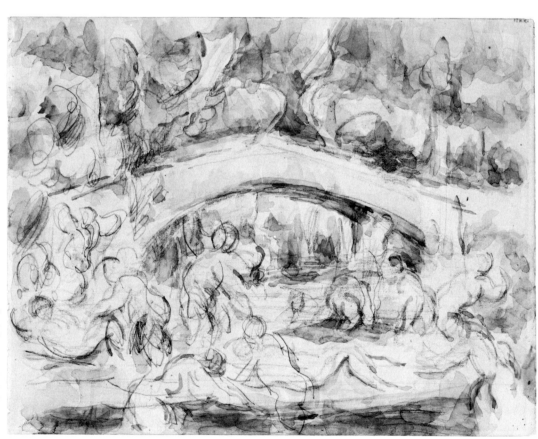

Pl. 197. *Bathers under a Bridge,* c. 1900
Venturi 1115. Pencil and watercolor,
8¼ x 10¾ in (21 x 27.4 cm)
The Metropolitan Museum of Art,
New York,
Maria De Witt Jesup Fund,
from The Museum of Modern Art,
Lillie P. Bliss Collection

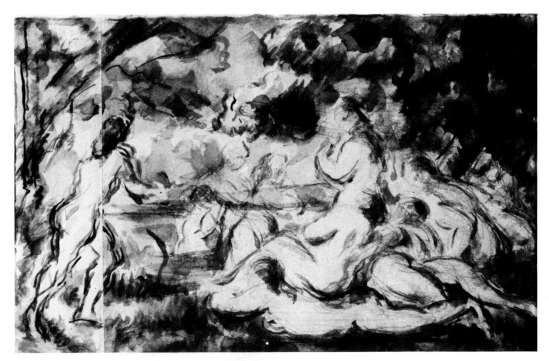

Pl. 198. *Bathers.* 1900–06. Venturi 1104
Watercolor, $6\frac{3}{4}$ x $10\frac{1}{4}$ in (17 x 26 cm)
Private collection, Switzerland

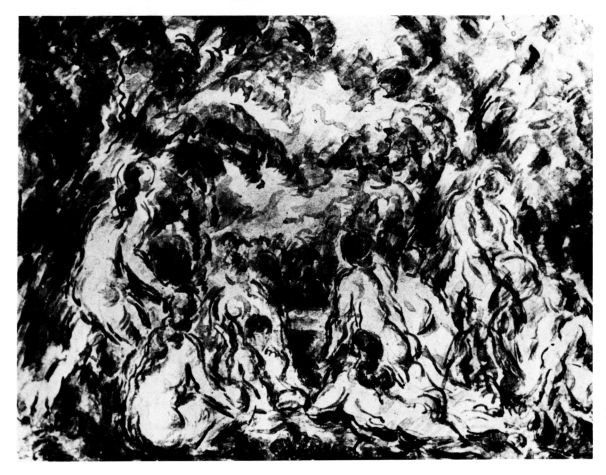

Pl. 199. *Bathers.* 1900–06
Venturi 1103. Watercolor,
$7\frac{1}{8}$ x $19\frac{7}{8}$ in (18 x 25 cm)
Whereabouts unknown

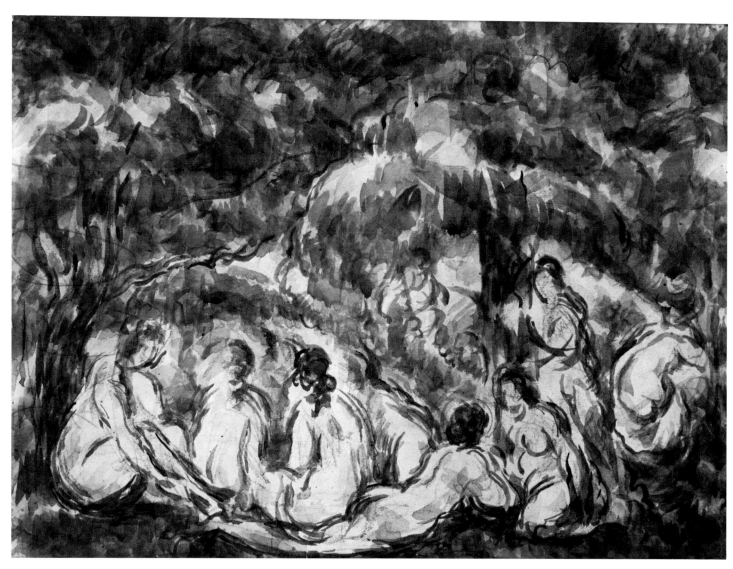

Pl. 200. *Bathers.* 1902–06. Venturi 1105. Pencil and watercolor, $8\frac{1}{4}$ x $10\frac{5}{8}$ in (21 x 27 cm). Private collection

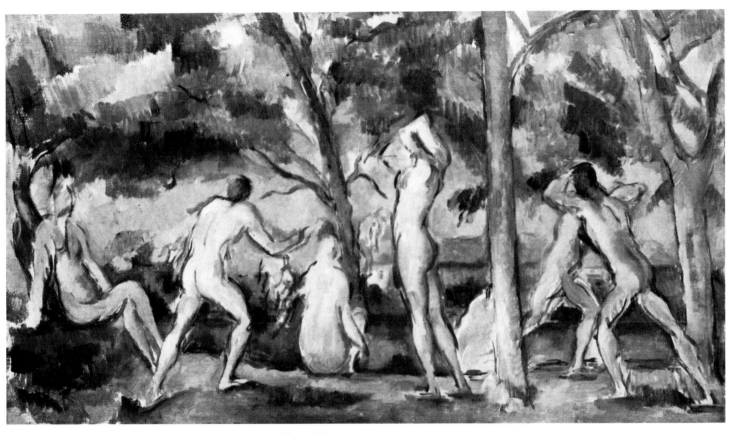

Pl. 201. *Bathers.* 1898–1900. Venturi 724. Oil on canvas, 10⅝ x 18⅛ in (27 x 46.4 cm)
The Baltimore Museum of Art, bequest of Miss Etta and Dr. Claribel Cone

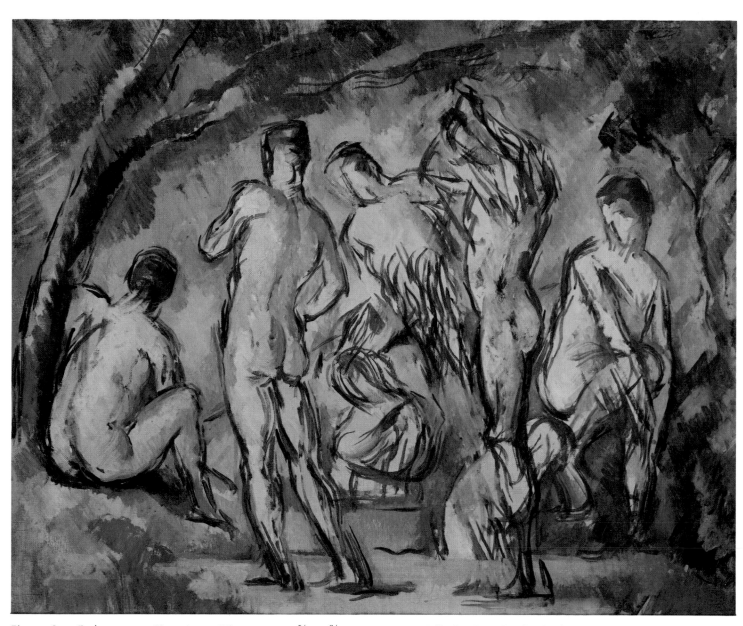

Pl. 202. *Seven Bathers*. c. 1900. Venturi 387. Oil on canvas, 14⅝ x 17¾ in (37 x 45 cm). Collection Ernst Beyeler, Basel

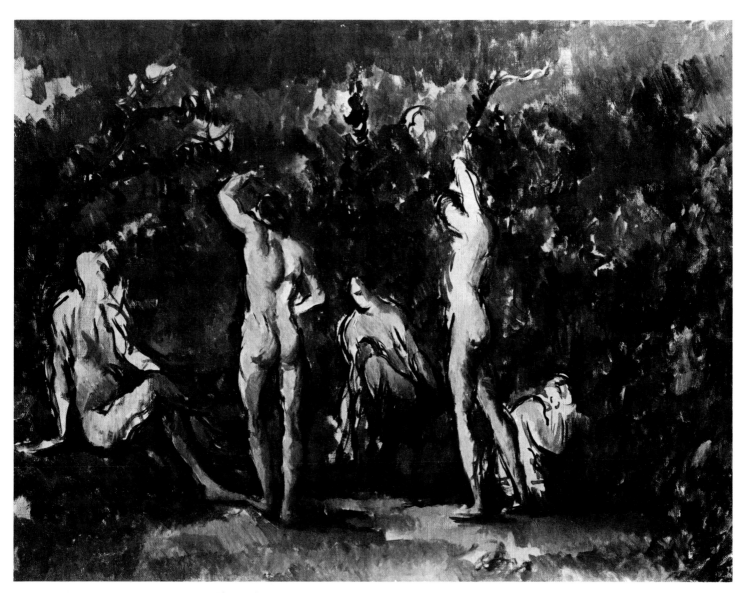

Pl. 203. *Bathers.* 1900–04. Oil on canvas, 16⅝ x 21⅝ in (42.2 x 55 cm). Collection Stephen Hahn, New York

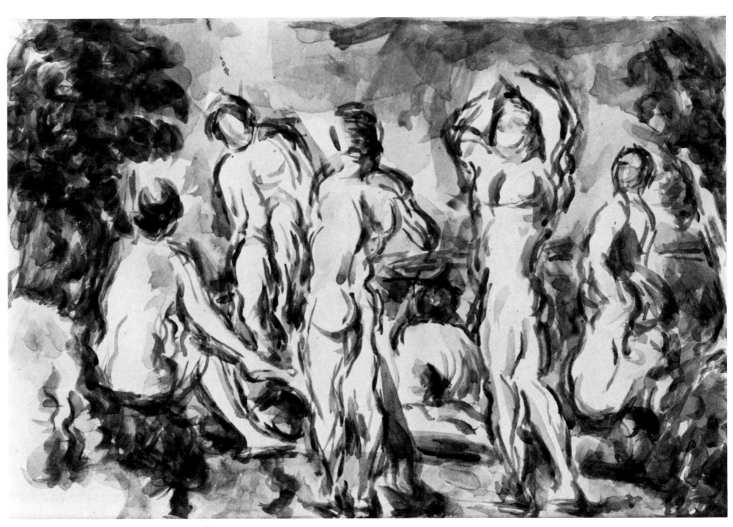

Pl. 204. *Bathers*. c. 1900. Watercolor, 7¼ x 10½ in (19 x 26.5 cm). Estate of Taft B. Schreiber, Beverly Hills

Catalog

John Rewald

PAINTINGS

The painting entries, by John Rewald, are based on his notes for corresponding entries in the catalogue raisonné of Cézanne's works that he is preparing for publication as a New York Graphic Society Book by Little, Brown and Company (Inc.). The present catalog applies to the exhibition "Cézanne: The Late Work" as shown at The Museum of Modern Art, New York. Essentially it is also a catalog of the exhibition as shown at The Museum of Fine Arts, Houston, and the Grand Palais, Paris; but stipulations of lenders have necessitated certain variations in the makeup of the exhibition at its three showings.

1. **Portrait of Gustave Geffroy.** 1895. Venturi 692
Oil on canvas, 45¾ x 35 in (116.2 x 89.9 cm)
Musée du Louvre, Paris, life interest gift
Pl. 1

In March 1894, Gustave Geffroy had published a highly appreciative article on Cézanne, who immediately thanked the author whom he had never met. When, in the fall of that same year, the painter spent some time at Giverny, Monet had the idea of inviting a few friends to a luncheon in Cézanne's honor.

"It's agreed for Wednesday," Monet wrote on November 23 to Geffroy. "I hope that Cézanne will still be here and that he'll join us, but he is so peculiar, so apprehensive of new faces, that I'm afraid he may default in spite of his desire to know you. How unfortunate that this man should not have had more support in his existence! He is a true artist, who has wound up by doubting of himself too much. He needs to be bolstered up and has been very sensitive to your article."

Cézanne did attend the luncheon, where Monet had gathered, besides Geffroy, the novelist and critic Mirbeau as well as Rodin and Clemenceau. The following spring, encouraged obviously by Geffroy's sympathetic attitude, the artist sent a short letter to the writer and art critic:

"The days are lengthening, the temperature is growing milder. I am unoccupied every morning until the hour when civilized man sits down to lunch. I intend coming up to Belleville [a populous suburb of Paris where Geffroy lived] to shake your hand and to submit to you a plan which I have now embraced, now abandoned and to which I sometimes return." This plan was to paint Geffroy's portrait in his study. Work was begun early in April 1895 and continued almost daily until the middle of June. Obviously the various objects on the desk were arranged very carefully, with a small plaster by Rodin almost cut

off by the frame, and a paper flower that Cézanne especially brought along. It is even conceivable that he arranged some of the bright orange books on the shelves so as to get their color accents where he needed them. The effect of the pronounced plunging view may be due in part to the fact that the room did not afford the artist a great distance from his subject, though it does correspond to a general tendency observed in many of his late works.

According to Geffroy, Cézanne worked on everything except the sitter's face, which was "left for the end," as he explained. But on June 12 the painter sent word to Geffroy: "As I am about to depart and cannot bring to a satisfactory conclusion the work which surpasses my strength and which I was wrong to undertake, I would like to ask you to excuse me and to hand over to the messenger whom I shall send to you, the things I have left in your library." The writer succeeded, however, in persuading Cézanne to work on the picture for another week. Before leaving for Aix, the artist promised to finish the canvas after his return.

Indeed, on July 6, Cézanne informed Monet: "I had to leave Paris because the date fixed for my trip to Aix had arrived. I am with my mother, who is far on in years and whom I found frail and alone. I was forced to abandon for the time being the study that I had started at Geffroy's, who had placed himself so generously at my disposal, and I am a little upset at the meager result I obtained, especially after so many sittings and successive bursts of enthusiasm and despair. So here I am then, landed again in the South, from which I should, perhaps, never have separated in order to fling myself into the chimerical pursuit of art. To end, may I tell you how happy I was over the moral support I received from you, which served as a stimulus for my painting. So long then, until my return to Paris, where I must go to continue my task, as I promised Geffroy."

As it turned out, the year 1895 was to provide at long last a good deal of "moral support" for Cézanne. With the death of Gustave Caillebotte in 1894, five of Cézanne's paintings were bequeathed to the government. But the donation as a whole, which included sixty-five works, generated considerable protest, mainly from France's powerful academic painters; yet two of the five Cézannes did eventually enter the Luxembourg museum. During that year, too, a newly established young art dealer, Ambroise Vollard, managed to track down if not Cézanne at least his son and to arrange the artist's first one-man exhibition. It opened in November 1895 in Vollard's small Parisian gallery; Cézanne sent him altogether 150 canvases, which had to be displayed in rotation, the premises being too cramped to show all at once. On this occasion, Geffroy wrote another article to extol Cézanne and predict that his works would some day be hung in the Louvre.

In Aix meanwhile, the painter was working at the Bibémus quarry while staying at the Jas de Bouffan with his eighty-year-old mother. It

may have been her health that kept him in the South longer than expected. In any case, on April 3, 1896—despite his repeated pledges—Cézanne finally dispatched a messenger to Geffroy to collect his paraphernalia, leaving the portrait behind. The artist himself did not return to Paris before the fall.

Cézanne and Geffroy were not to see each other again. In subsequent years the artist was to make strangely derogatory remarks about Geffroy to a new literary friend, Joachim Gasquet. The reasons for this change in attitude have never been fully explained. Geffroy, anyhow, continued to admire Cézanne, to say so in print, and to collect his works (he owned, among others, the still life *Apples and Oranges*, pl. 139). But Geffroy was a liberal, always supporting causes of the "left," such as the fight against the conviction of Captain Dreyfus, while Cézanne gradually espoused the views of the "right," though he did not follow Gasquet's royalist clamors. (While Cézanne did his portrait, Geffroy had been finishing a biography of the famous French socialist and revolutionary, Louis-Auguste Blanqui, who had spent almost half his life behind prison walls.)

Geffroy's likeness distinguishes itself by an unusually rich coloration. The writer, observing Cézanne at work, noticed that he "accumulated thin films of color, always maintaining the fresh and brilliant aspect of the painting." Yet the pigment is applied somewhat more heavily along the model's shoulders—where his blue suit had to be set off against the purple chair—and in the shirt front. The particularly thin layers of paint in the face seem to indicate that each coat was dry before another was put on (Vollard was to comment on this procedure when Cézanne did his portrait a few years later; see the note for that painting below). In spite of the thin appearance of the paint, however, individual strokes are applied with a fairly "nourished" brush; occasionally blue lines on top of these deftly establish contours.

"Of all Cézanne's portraits," Roger Fry has written, "perhaps that of M. Geffroy is the most celebrated. Its success must be partly due to the extraordinary number of sittings to which his admiring and clearsighted sitter submitted. . . . The equilibrium so consummately achieved results from the counterpoise of a great number of directions. One has only to imagine what would happen if the books on the shelf behind the sitter's head were upright, like the others, to realize upon what delicate adjustments the solidity of this amazing structure depends. One cannot think of many designs where so complex a balance is so securely held. The mind of the spectator is held in a kind of thrilled suspense by the unsuspected correspondence of all these related elements. One is filled with wonder at an imagination capable of holding in so firm a grasp all these disparate objects, this criss-cross of plastic movements and directions. Perhaps, however, in order to avoid exaggeration, one ought to admit that since Cézanne's day other constructions have been made as complex and as well poised, but this has I think been accomplished at too great a sacrifice of the dictates of sensibility, with too great a denial of vital quality in the forms. And it is due entirely to Cézanne's influence that any such constructions have been attempted. He it was who first, among moderns at all events, conceived this method of organizing the infinite complexity of appearance by referring it to a geometrical scaffolding. Though it must always be remembered that this is no *a priori* scheme imposed upon the appearances, but rather an interpretation gradually distilled from them by prolonged contemplation. There is no suggestion here of a mechanical process: Cézanne's sensibility was so tensely alert that there is no hint of the dryness which might have resulted from so geometrical a construction. The concordance which we find in Cézanne between an intellect rigorous, abstract and exacting to a degree, and a sensibility of extreme delicacy and quickness of response is seen here in masterly

action. Such a concordance must be something of a miracle. No wonder that so nice a balance of special gifts, each of them comparatively rare, occurs only at long intervals in the history of art.

"Here at all events Cézanne might, one thinks, for once have felt that he had 'realized,' so overwhelming is the expression of living reality. Vasari would certainly have expressed it by saying that this was life itself, and no mere imitation, which may be only another way of expressing Cézanne's idea that the artist is the means by which nature becomes self-conscious."

It appears obvious that Fry, when he commented on the painting, did not know that Cézanne himself regretted having undertaken this portrait which he found beyond his strength, that he was dissatisfied with the "meager result" and abandoned the work—unfinished.

For Geffroy's account of how this picture came into being, see his *Claude Monet* (Paris: Crès, 1922), chapters "De 1892 à 1895 . . . Retour de Cézanne vers Monet" and "Pièces justificatives."
R. Fry, *Cézanne: A Study of His Development* (New York: Macmillan, 1927), pp. 69-71.

2. Portrait of Henri Gasquet. 1896. Venturi 695
Oil on canvas, 22 x 18½ in (56 x 47 cm)
The McNay Art Institute, San Antonio, Texas
Pl. 3

Among Cézanne's portraits of the turn of the century, this likeness occupies a special place both for its lightness of touch (not unrelated to the Geffroy portrait, pl. 1) and its relaxed, almost "jovial" expression. It does not betray the strain of the motionless attitudes that the artist usually imposed on his sitters. And the sweeping curves of the hat, whose diagonal is repeated in the cigar (or pipe?), avoid the rigidity that lingers in so many of Cézanne's portraits.

Henri Gasquet was a boyhood friend of the painter, a prosperous citizen of Aix, owner of an inherited bakery. Although it appears unlikely that they had maintained a close relationship through the years, it is nevertheless certain that Cézanne's cordial acquaintance with the subject and long familiarity with his features helped him to let his guard down. In contrast, Geffroy had been barely known to him, and there was no real rapport with many of his other sitters, such as the peasants he painted in those years, or a few children. In general a deeper congeniality is reflected in Cézanne's pictures of older models, among them the *Woman with a Rosary* (pl. 7) and Vallier (pls. 22-30).

While this is never mentioned, it is very likely that Cézanne and Gasquet occasionally conversed in Provençal—which would automatically establish closer bonds between them. The baker's son, the poet Joachim Gasquet, was active in the movement launched by Frédéric Mistral to revitalize this idiom which—though still widely spoken—had fallen into neglect as a literary vehicle. Cézanne may of course also have spoken Provençal with the laborers at the Jas de Bouffan who sat for his *Cardplayers,* and with his gardener Vallier.

In the fall of 1896, Henri Gasquet's son received the revelation of Cézanne when he saw two of his landscapes in an exhibition of local artists at Aix. This prompted the baker to introduce the young poet to his friend and, eventually, to ask the latter to do his portrait. If we are to believe the unusually beautiful and brilliant young woman whom Joachim Gasquet had married that same year, she and her husband were present when the painter began to work on that likeness (this appears doubtful only because of Cézanne's known aversion to being watched while he painted, and also because he generally did not talk with his models—or, rather, he preferred them to remain silent). According to Marie Gasquet, as the sittings started:

". . . Cézanne, as his old friend had foreseen, became more sociable.

His conversation, of astonishing erudition, kindled by the enthusiasm of the listener, who provided the repartee, was a splendid and enriching enchantment. In order to put us all at ease, my father-in-law, during the short pauses, evoked picturesque recollections with him. Cézanne smiled, a sad and distant smile; in the sunniest corner of my memory I keep the souvenir of the day when for the first time I saw frank laughter brighten his tense face." This happened when the two friends reminisced about the aubade they had organized in their youth for a pretty laundress and her parrot.

It was apparently in this happy mood that the painting progressed. Unfortunately, Marie Gasquet remembered nothing more and concluded her account with the words: "Once the portrait of Henri Gasquet was terminated, it was put into a corner, turned against the wall, Cézanne wishing to do one of my husband."

It is of course idle to debate to what extent this picture is terminated. It is evidently an accomplished likeness, though there are, as in so many other works of Cézanne, still spots of uncovered canvas; but it also seems that the artist neglected to finish the four corners. A report from the restorer Sheldon Keck indicates that these corners were in all probability filled in by a foreign hand. Moreover—as far as is known—Cézanne did not present the work to his friend, who supposedly had "commissioned" it.

As to the portrait of Joachim Gasquet, which Cézanne now undertook (pl. 2), it definitely remained unfinished.

M. Gasquet, in *Le Tombeau de Cézanne* (Paris: Société Paul Cézanne, 1956), pp. 31–32.

3. Self-Portrait with a Beret [Portrait de l'artiste au béret]. 1898–1900. Venturi 693
Oil on canvas, 25 x 20 in (63.5 x 50.8 cm)
The Museum of Fine Arts, Boston, Charles H. Bayley Fund and partial gift of Elizabeth Paine Metcalf
Pl. 5

One of Cézanne's last self-portraits; Gowing believes it to be the very last. As in one-third of all his self-portraits, the artist's head is covered, as if the warmth provided by the beret gave him special comfort.

Cézanne was now turning sixty and had been suffering from diabetes for some ten years, but his face is not lined, though his goatee and moustache are snowy. His meager eyebrows have a strange Oriental slant.

The canvas is covered very thinly, particularly the area of the artist's coat. The brushwork in the face is closely related to that in the likeness of Joachim Gasquet, 1896 (pl. 2). Behind Cézanne appears a red upholstered armchair that seems to have been part of the painter's household effects for many years; it may have been the same that appears in various portraits of Hortense Fiquet executed around 1876–77, and subsequently also in a picture of their son.

It is probable that this portrait was painted in Paris, or its vicinity, where Cézanne stayed in 1898 and '99; the other canvases with the red armchair also seem to have originated in the North. This may partially explain the cool light that emphasizes the peculiar "crispness" of style and shows a somewhat greater detachment than the unfinished Gasquet likeness. Gowing feels here the absence of the "flamboyant energy" of the portraits painted during the preceding years, yet this is in some way compensated for by an almost glowing serenity, which excludes any complacency of the artist for his "model" while he soberly observes himself in a mirror.

Cézanne's detachment lends a nearly abstract aspect to this work, which assembles almost immaterial flat surfaces of perfect equipoise;

the dark coat and beret framing the face are relieved by the vivid red corner, its curve balanced by the artist's left shoulder. Even this red corner lacks bulk. The background is perfectly neutral. Gone are the structural details, the intrusive wallpaper, the appealing granular texture of earlier self-portraits. What remains is an image that is both stark and subtle. As in many of his other self-portraits, Cézanne here appears grave and lonely and, above all, distant.

Portraits and still lifes are obvious subjects for any artist who, accustomed to working outdoors, cannot do so because of the weather. Yet portraits became less numerous in the output of the aging Cézanne, and those that do occur were also painted out of doors whenever possible, as for instance the likenesses of his gardener Vallier. Cézanne's wife and son were now sitting for him much less frequently. To fall back on himself was of course one of the solutions for this dilemma, albeit a solution to which Cézanne did not turn often as his years advanced.

One may presume that most artists do not scrutinize their features in moments of unhappiness or doubt. They are certainly more apt to do so when they feel secure and confident enough to engage in such a mute but lucid monologue. Yet hardly any other painter went as far as Cézanne in excluding every trace of sympathy or warmth from the reflection he was tracing. The feelings he allowed to come through in portraits of friends, and especially of his son, are absent here. The features he studied and built up on this canvas with deft brushstrokes—put down slowly perhaps, but needing no corrections—were those of a man who had learned through bitter years that self-reliance and self-respect were his most secure sources of strength.

4. Portrait of Ambroise Vollard. 1899. Venturi 696
Oil on canvas, 39½ x 32 in (100.3 x 81.3 cm)
Musée du Petit Palais, Paris
Pl. 4

Cézanne's dealer, Vollard, has described with many picturesque details how in 1899 he posed for his portrait, how the painter installed a chair for him on a precariously balanced crate, and how—when forced immobility made him sleepy—he fell from this unstable seat. Not only was he forbidden to move, but he also had to remain silent, and there were but short rest periods. The sittings began at eight in the morning and lasted until eleven thirty. The artist proceeded slowly and with apparent difficulty, simultaneously working on a large composition of bathers (probably pl. 187, to which Cézanne must have devoted himself on days when his model was not available).

"Vollard sits every morning for Cézanne, and this for a very long time," Maurice Denis noted in his diary on October 21, 1899, doubtless after a talk with the dealer. "The minute he moves, Cézanne complains that he makes him lose his *line of concentration*. He also speaks of his own lack of *optical qualities*, of his incapacity of *realizing* like the old masters (Poussin, Veronese, Le Nain, he likes Delacroix and Courbet too); but he does believe that he has *sensations*. To prepare himself to paint in the morning, he goes in the afternoon to the Louvre or [the museum of plaster casts at] the Trocadéro and draws after statues, antiques, or works by Puget, or else he does a watercolor out of doors; this, he claims, improves his disposition to *see* well the next day. When there is sunshine, he complains and does not work much: he needs *gray weather*."

Vollard observed that Cézanne did not work with heavily loaded brushes, "but applied, one on top of the other, films of color that were as thin as watercolor touches; the colors dried immediately."

When, after countless sittings, Vollard drew the painter's attention to two tiny spots on the hand where the canvas was not covered,

Cézanne explained that he had to find the right color to fill these minute white spaces: "If I put something there at random, I should have to redo the entire picture, starting from that very spot."

After 115 sittings (so Vollard reports), the painter had to leave for Aix but told his dealer, "I am not dissatisfied with the shirt front." He intended to continue the portrait and asked Vollard to leave in his studio the suit he was wearing. Yet, as the cloth fell prey to moths, the project had to be abandoned. Unfortunately, Vollard's inordinate penchant for anecdotes and punch lines obscured what sense of veracity he may have possessed. The story about the shirt front, amusing though it is, need not be taken too literally. The sober majesty of this likeness and the incredible "presence" of the sitter are more eloquent than Vollard's chatty report.

This is a dark painting with a somber brown background, though reddish above the dividing line at right, where its color appears to relate to the very prominent hand. The outside wall perceived at the window is pink-gray; there are two dark disks not readily identifiable and two yellow rectangles that may represent chimneys. The hand is brushed freely in pinkish red, constituting the sole lively accent of the painting. Its position breaks the strict vertical formed by the head and shirt front, just as the raised knee breaks the strictly frontal view, and as the red in the upper right corner softens the suddenness of the somewhat brighter hand.

Vollard's suit is of a brown lighter than that of the background, with many black linear indications to set off outlines, folds, creases, etc. The diagonals at the bottom—on different levels at left and right—are unclear; they can hardly correspond to the floor, as they are not aligned with the horizontals of the wall above Vollard's shoulders. The sitter's eyes are empty, as in pl. 9.

Despite Vollard's story of 115 sittings, there is surprisingly little impasto, except on the right side of the face, at the shoulder, the collar, and the lapel—that is, in areas where the artist endeavored to detach voluminous forms from the flat background. Yet even there the successive layers of paint are by no means as heavy and "crusty" as they were to be a few years later in the likenesses of the gardener Vallier. As to the richly nuanced white shirt front, it does not reveal the sustained effort implied in Vollard's reminiscences.

See A. Vollard, *Paul Cézanne* (Paris: Ambroise Vollard, 1914), chap. 6, "Mon Portrait," and M. Denis, *Journal* (Paris: La Colombe, 1957), 1:157.

5. Man with Folded Arms [L'Homme aux bras croisés]. c. 1899. Venturi 685
Oil on canvas, 35½ x 28⅝ in (90.2 x 72.7 cm)
Collection Mrs. Carleton Mitchell, Annapolis
Pl. 12

6. Man with Folded Arms (With Palette) [L'Homme aux bras croisés (Avec palette)]. c. 1899. Venturi 689
Oil on canvas, 36¼ x 28⅝ in (92 x 72.7 cm)
The Solomon R. Guggenheim Museum, New York
Pl. 13

The model of these pictures has not been identified, though he has often been called, for no known reason, the "Clockmaker." It is not possible to establish whether he sat for Cézanne in Paris or in Aix. The execution of these paintings relates them to the likeness of Gasquet of 1896 (pl. 3) and also to the portrait of Vollard of 1899 (pl. 4). This explains why they are assumed to have been painted around 1899, a date that Douglas Cooper considers to be too late.

While Cézanne had occasionally executed several portraits of the same sitter, he had not painted them twice in an identical attitude—

something he was to do more frequently in his very last years in various pictures of his gardener Vallier. The difference between these two canvases is essentially one of the angle under which the model is seen, with a simultaneous shift of the wainscot, though in both cases it intersects the background near the man's elbow. Also, in one of these versions—not necessarily the later of the two—the back of a stretcher and a palette, leaning against the wall, appear in the lower left corner. This shows a tendency, apparent equally in other works, to animate the neutral background; in the Vollard portrait this had been achieved with the window in the upper left and the unexplained disks that are perceived beyond it.

Analyzing the version without the palette, Erle Loran has said that "the distortions in this portrait may be compared with those found in El Greco. The plastic means are similar to El Greco's, and the resulting expressive qualities are certainly comparable. The most obvious distortion is in the features, which are out of normal line with the vertical axis of the head. The general effect is of a rising impetus on the left . . . and a dropping or returning movement at the right. . . . At the left the upper malar bone pushes to the left and upward, while on the right the ear and heavy hair drop downward. Linear rhythms can be felt in the rising eyebrow at the left and the curved, dropping brow on the right. The mouth is distorted and it curves down at the right, affording unusual tension as it adds to the general downward pull on the right, in opposition to the rising movement of the eye and the cheekbone on the left side.

"In terms of space, the front plane of the head . . . rotates dynamically away from the static background wall. . . . Another spatial phenomenon is analyzed here as a shift in eye levels. The subject's right eye and eyebrow are arched as if seen from below. . . . But his left eye is drawn as if seen from above. . . . Accidental or not, this device increases the illusion of space, of 'seeing around' the head. Picasso and Braque carried the idea to its radical conclusion, and they have made a complex system of drawing which incorporates two or three different views of the head in one image, front view with two sides, for example."

E. Loran, *Cézanne's Composition* (Berkeley and Los Angeles: University of California Press, 1943), pp. 90–91.

7. Italian Girl Resting on Her Elbow [Jeune Italienne accoudée]. c. 1900. Venturi 701
Oil on canvas, 36¼ x 28¾ in (92 x 73 cm)
Collection Dr. and Mrs. William Rosenthal, New York
Pl. 9

Tradition has it that this young girl was related to the professional Italian model who—around 1893–95—posed in Paris for the various versions of the *Boy with Red Vest*, and that this picture was also executed in Paris, after Cézanne's return from Lake Annecy in the fall of 1896. Yet stylistically the work is much closer to the 1899 likeness of Vollard and to the *Woman in Blue* (pl. 19) of a few years later, where the same square-patterned, floral-bordered table cover appears. This spread was one of the artist's props in Aix (though he could have brought it there from Paris), while the "close-up" presentation of the girl and the plunging view of the table suggest the narrowness of Cézanne's rue Boulegon studio. Finally, it does seem possible that the girl's outfit is part of the famous Arlesian costume, without the typical large black shawl that usually hides whatever is worn underneath.

The sitter is dressed in a white blouse with extremely full sleeves; a yellow scarf crossed in front is apparently tucked into the intensely blue gathered skirt. She wears no headdress. Her right elbow rests on the table, her hand cupped around her cheek. Her strangely pupilless

eyes seem to betray, if not boredom, at least complete absence of thought and emotion. A dark, neutral background enhances the impressive volume of the motionless figure, which occupies almost the entire picture space.

The brushwork is emphatic, the decisiveness of the strokes being helped by the total absence of detail except for the lively design of the table spread. The walls, the scarf, the blouse, and the skirt offer large, uniform surfaces, modulated occasionally by slight variations of color and by blue shadows. The head is drawn with unusual sharpness: the brows, the eyes, the ear, the nose, the mouth are neatly delineated; a precise outline surrounds the oval face, separating it from the cupped hand and the neck, adding to its masklike appearance. Similar ovals and dark, sightless eyes show up in the heads of Picasso's Negro period as well as in his portrait of Gertrude Stein. Did he see this picture at Vollard's? Many years later Picasso told Brassaï: "Cézanne! He was my one and only master! Don't you think I looked at his pictures? I spent years studying them."

8. Rocks at Fontainebleau [Rochers à Fontainebleau]. 1893–94.
Venturi 673
Oil on canvas, 28⅞ x 36⅜ in (73.3 x 92.4 cm)
The Metropolitan Museum of Art, New York, H. O. Havemeyer Collection, bequest of Mrs. H. O. Havemeyer
Pl. 67

When Vollard sat for his portrait in 1899, he noticed that Cézanne applied his oils very thinly, like watercolor touches; they would dry immediately, permitting him to put one stroke over the other where he was not satisfied with the result. This testimony appears somewhat surprising, because by the turn of the century the artist seems to have worked mostly with brushes fully loaded with pigment, so that even the very first coat was a rather heavy one. It was in *earlier* works, such as this landscape, *L'Amour en plâtre*, pl. 145 (which Gowing actually dates 1892), the *Portrait of Geffroy* of 1895, pl. 1, or the still life with onions, pl. 148, that his execution resembles his watercolor technique; all these paintings date from the middle nineties and are the point of departure for this exhibition.

Though Douglas Cooper prevailed upon the Metropolitan Museum to abandon the traditional title for this picture, which located it in Fontainebleau, because he claimed that it represents the area around Château Noir, this does not seem to be the case. Both the color, which is far removed from the chromatism of canvases painted at Château Noir, and the cold blue light point to a Northern motif, as does the straight line of the horizon that appears in the distance at left. Since Cézanne is known to have worked at Fontainebleau around 1893—a date supported by the execution of this landscape—there appears to be no need for a change of either date or designation.

The paint is applied so thinly that the canvas ground shimmers through in many places. Yet it does not look as though this thinness is merely a preparation for a denser application of pigment; instead, the "watercolor technique" is obviously an intentional device. Indeed, in numerous spots the color almost seems to have been rubbed on lightly. This delicate execution not only alleviates the heaviness of the subject; it also results in a tremendous variety of tints, among which a bluish purple dominates. Tumultuous masses of rocks in dark colors are spread across the width of the picture beneath entangled trees that obstruct the sky but through which filters a ray of yellow and orange light falling on the central boulder.

In a subtle analysis of this painting, in which he senses a "catastrophic mood," Meyer Schapiro aptly quoted a passage from Flaubert's *Sentimental Education:*

"The path zigzags between the stunted pines under the rocks with angular profiles; this whole corner of the [Fontainebleau] forest is somewhat stifling, a little wild and close. . . . The light . . . subdued in the foreground planes as if at sundown, cast in the distance violet vapors, a white luminosity. . . . The rocks filled the entire landscape . . . cubic like houses, flat like slabs of cut stone, supporting each other, overhanging in confusion, like the unrecognizable and monstrous ruins of some vanished city. But the fury of their chaos makes one think rather of volcanos, deluges, and great forgotten cataclysms."

9. Forest Scene [Sous-bois]. 1895–1900. Venturi 1527
Oil on canvas, 32 x 25⅜ in (81 x 64.5 cm)
Collection Ernst Beyeler, Basel
Pl. 72

Clement Greenberg has described Cézanne's late style with these words: "The illusion of depth is constructed with the surface plane more vividly, more obsessively in mind; the facet-planes may jump back and forth between the surface and the images they create, yet they are one with both surface and image. Distinct yet summarily applied, the square pats of paint vibrate and dilate in a rhythm that embraces the illusion as well as the flat pattern. The artist seems to relax his demand of exactness of hue in passing from contour to background, and neither his brushstrokes nor his facet-planes remain as closely bunched as before. More air and light circulate through the imagined space. Monumentality is no longer secured at the price of a dry airlessness. As Cézanne digs deeper behind his broken contours with ultramarine, the whole picture seems to unsheathe and then re-envelop itself. Repeating its rectangular enclosing shape in every part of itself, it seems also to strain to burst the dimensions of that shape."

C. Greenberg, "Cézanne" (1951), reprinted in *Art and Culture* (Boston: Beacon Press, 1961), paperback ed. pp. 55–56.

10. Mont Sainte-Victoire above the Tholonet Road [Le Mont Sainte-Victoire au-dessus de la Route du Tholonet]. 1896–98.
Venturi 663
Oil on canvas, 30¾ x 39 in (78 x 99 cm)
The Hermitage Museum, Leningrad
Pl. 116

The narrow, little-traveled road of Le Tholonet, leisurely winding its way toward Mont Sainte-Victoire, is seen here from a slight elevation near the path that leaves the road and leads through the forest to Château Noir. The latter, on the slope at left and here hidden, is located almost directly opposite the single farmhouse that stands above the road at right. Two umbrella pines, one behind the other, cast their combined shadow on the road. (Their two trunks appear more clearly in pl. 119, painted from almost precisely the same spot.)

The canvas appears covered by a single layer of paint. The colors are bright, the peculiar orange of the earth being complemented by the brilliant green of the vegetation. The mountain is more pink than blue, its delicate shades following the undulations of the rock's surface with great verisimilitude. This subtly modulated block is contrasted against the intense blue of the sky. While the soil is most colorful after rain, the cloudless sky and the pale color of Sainte-Victoire indicate a limpid summer day.

Occasionally, thin blue brush lines detach certain forms. Some, such as those that define the branches of the olive trees in the lower left corner, seem to have been drawn before color was applied; others, notably those that follow the outline of the mountain, were added afterward for greater clarity. It is precisely this clarity of individual

features that distinguishes this landscape from the second one of the same subject, executed a few years later and of a much more summary character.

This canvas must have remained rolled up for many years—hence the numerous traces of cracks and the chipped paint that can be observed along the top as well as the bottom.

The road has been widened and straightened in recent years, and the motif is thus considerably altered; but one of the large pines still stands.

11. Bibémus Quarry [La Carrière Bibémus]. c. 1895. Venturi 767
Oil on canvas, 25⅝ x 31⅞ in (65 x 81 cm)
Museum Folkwang, Essen
Pl. 31

In this, probably one of Cézanne's earliest views of the Bibémus quarry, the ochers of the stones are interrupted by spots of greens; the shadows are blue, the sky is light blue. The entire picture is brushed thinly, but the forms are crisp and the lines are neatly drawn, usually confining planes of different colors. Sharp edges are accentuated, though some blue-gray uncut rocks in the middle distance are less clearly defined.

"The contrast between near and far," as Kurt Badt has observed, "seems in Cézanne's works to be cancelled out by some overriding unity and his landscapes, especially in his old age, are successful when painted according to the methods he used for figure compositions, with the principal subject large and imminent in the middle of the picture while it is at the same time distant in space, at the horizon of real space. . . . And while the central motif which comprises the core of the whole formal structure lies in the distance, the impression not infrequently given in Cézanne's pictures (quite the opposite from that usually given in the works of other artists) is that space is pushing forward into the foreground. Although it is immobile it yet seems to have been projected from the distance, indeed even to have stepped out of it. It is as though the object which is the motif and which is depicted in the distance determined space, as though this motif conveyed its own powers to other nearer objects and by the extension of these things actually created space."

This serene painting, one of Cézanne's masterpieces of the middle nineties, was "deaccessioned" (a word made famous more recently) under Hitler because "such a bad picture does not deserve to hang in a [German] museum." It had originally been bought for the Folkwang Museum by its founder, Karl Ernst Osthaus, after a visit with Cézanne in Aix in 1906 (see the note for no. 61). Stopping in Paris on his return, Osthaus had acquired this and another landscape from Vollard. Since the end of World War II, the Folkwang Museum has been able to repurchase it.

K. Badt, *The Art of Cézanne,* trans. S. A. Ogilvie (Berkeley and Los Angeles: University of California Press, 1965), p. 163.

12. Mont Sainte-Victoire Seen from the Bibémus Quarry [Le Mont Sainte-Victoire vu de la carrière Bibémus]. c. 1897. Venturi 766
Oil on canvas, 25½ x 32 in (64.8 x 81.3 cm)
The Baltimore Museum of Art, bequest of Miss Etta and Dr. Claribel Cone
Pl. 37

Cézanne stood here near a deep excavation beyond which rise large orange rocks with sharp edges where blocks have been extracted. Above them hovers Sainte-Victoire as though quite nearby, yet between the quarry and the mountain extends a valley with the village of Le Tholonet; toward the left the Gorges des Infernets with the Zola dam are hidden. To the right of this spot stood the *cabanon* where the

painter stored his gear. This is his most panoramic representation of the picturesque quarry, whose individual rock formations he usually studied from a nearer position.

Even before Cézanne's mother died in October 1897, he seems to have ceased working at the Jas de Bouffan. In August of that year he invited a friend to join him at eight in the morning at Bibémus or meet him later for lunch at Le Tholonet—a long and steep walk downhill (his carriage probably picked him up there after the meal for the return to Aix). He continued painting at the quarry throughout September; it is likely that this landscape was done at that time, since both in color and execution it shows some similarities with the Geffroy portrait of 1895 (pl. 1).

The rocks and the ground, interspersed with vivid greens, are of a strong orange. Between them and the very blue sky extends the bluish-purple and pink wall of the mountain, traced by a delicate blue outline. Blue-black brush lines also appear elsewhere. There is a greater accumulation of brushstrokes in the center. Although the canvas is completely covered, the upper two corners are thinly painted, especially the one at right.

13. Bibémus: The Red Rock [Bibémus: le rocher rouge]. c. 1897. Venturi 776
Oil on canvas, 35⅞ x 26 in (91 x 66 cm)
Musée du Louvre, Paris, Walter-Guillaume Collection
Pl. 33

As Michel Hoog has observed, "The mass of the trees, treated in small and regular hatchings, is strangely interrupted by the red-orange wall of an overhanging rock, which in its color as well as in its texture forms a contrast with the rest of the canvas." Indeed, the curiously shimmering execution of the shrubs and trees seems to hark back to such works as the *Trees at the Jas de Bouffan* (Venturi 474, 475), painted some ten years earlier, except that the foliage is here treated more freely and less strictly submitted to a rigorous pattern of diagonal planes. Its vividly interwoven brushstrokes and its rich nuances of greens and blues beneath a clear blue sky appear almost in conflict with the orange-red road and its violet shadows, but above all with the flat and smooth surface of the ocher rock. From a compositional point of view the completely asymmetrical and sudden intrusion of this rock upon the sylvan scene is a highly unusual feature in Cézanne's landscapes.

Cézanne dans les Musées Nationaux, Orangerie des Tuileries (Paris: Editions des Musées Nationaux, 1974); comments by M. Hoog, p. 120.

14. Bibémus Quarry. c. 1898. Venturi 777
Oil on canvas, 25⅝ x 21¼ in (65.1 x 54 cm)
Private collection, Los Angeles
Pl. 36

Cézanne here focused his attention on a cubic form rising from among bushes and trees. The stone has been cut away from either side of it, leaving an ocher block almost in the shape of a house, a ghostly building with bland, windowless walls which may have stood there for centuries, merging its glowing, sun-drenched color with the green provided by nature to soften its isolation. It is a typical aspect of the ancient quarry, and the artist—alone in this savage site where few visitors ever ventured—could concentrate on it with the fervor aroused by the beauty of this, his home ground.

15. Bibémus Quarry. 1898–1900. Venturi 778
Oil on canvas, 25⅝ x 21¼ in (65 x 54 cm)
Collection Sam Spiegel, New York
Pl. 34

A green and ocher harmony of entangled forms under a pale sky against which stands out a solitary young umbrella pine. From the center foreground the deep ocher ground rises in a triangle toward a block of yellow stone, its vertical wall dramatically lit by the sun where the dark point of the triangle meets it. (Such "spotlight" effects are rare in Cézanne's paintings.) The greens are lighter at the bottom and in the middle ground, growing considerably bluer as they recede into the background; at right, where they rival the pine in height, they are much darker than the sky behind them (thus creating another strong contrast of light).

The brushstrokes are heavy with paint and are frequently applied diagonally. Linear indications are in evidence only here and there to define shapes within the tangle of vegetation and stones. But the execution throughout carries great assurance and imposes the feeling that the artist here was able to convey the intimate relationship of strange forms and strong color that attracted him to the Bibémus quarry.

16. Thicket in Front of the Caves above Château Noir [Sous-bois devant les grottes au-dessus de Château Noir]. 1900–04. Venturi 787
Oil on canvas, 35¾ x 28⅛ in (90.7 x 71.4 cm)
National Gallery, London
Pl. 50

Among the paintings Cézanne did near the rocky ridge above Château Noir, this one is remarkable for its overall dark coloration that captures the specific mood of this not easily accessible motif, from which the light is banned by dense foliage. Dull blue-violet tones predominate; there is only scant green; the rocks are yellow-brown with some orange. The brushstrokes are large, though many small spots of canvas are left bare.

Whereas solid forms shown in Cézanne's landscapes have remained unaltered and thus can attest to the scruples with which he observed and represented them, the vegetation has frequently changed to such an extent that comparisons between his motif and the actual site remain inconclusive. But here the unusual forked trunk with a twisted branch survived—at least until a recent fire destroyed all the trees along the ridge—bearing witness to the faithfulness with which the artist retained on his canvas all the basic elements of his motif: the slope with its boulders, the curves of the tree, the denseness of the forest, and even the spot near the top through which some light penetrated to this almost mysterious scene.

17. Trees—Le Tholonet [Arbres—Le Tholonet]. 1900–04
Oil on canvas, 32 x 25⅝ in (81.3 x 65 cm)
Private collection, U.S.A.
Pl. 76

The energetic, multidirectional strokes show the confidence with which Cézanne, toward the end of his life, confronted his canvas. The maze of green and purplish-blue splashes that only infrequently overlap—each constituted of a few repetitive applications of the brush—is made "readable" through dark blue lines indicating tree trunks and branches. The rhythms of these emphatic lines and the more agitated brushwork of foliage and sky combine to create a lush image. This image (though technically unfinished) is completely cohesive owing to the fact that the artist did not cover the canvas section by section, but seems to have put down his touches simultaneously all over the surface. Whereas in many much-reworked paintings the pigment forms heavy crusts; here the picture has been left in what might be called its first state, with the color—in contrast to the extremely thin coat of

paint that often appears in earlier works—put down with a fully loaded brush. It is this technique, combined with muted tints, that characterizes the output of Cézanne's last years.

18. Rocks and Branches at Bibémus [Rochers et branches à Bibémus]. 1900–04. Venturi 785
Oil on canvas, 24 x 19¾ in (61 x 50.2 cm)
Musée du Petit Palais, Paris
Pl. 35

This commentator remembers a visit to Vollard during which the old dealer extricated this painting from a closet and—the canvas being unframed—put it on a chair and slowly rotated it to determine where the top was. No conclusion was reached on that occasion, yet (though the landscape is not easy to "read") it seems rather obvious that it should be seen as shown here, with the small gray-blue rectangle in the upper right corner representing the sky.

Probably the most "misguiding" feature of this work is the central tree with branches that appear to be hanging down. Actually, there seem to be *two* trees, or at least a fallen, dead branch whose stem almost touches the slim trunk of a young, perfectly vertical tree, the branches of which extend beyond the top of the picture. As to the undulating ground that recedes into the distance, it is probably not a path but some rocky section of the quarry which the artist may have observed from a spot completely detached from it.

The background and first plane are ocher; at left, behind the branches, this ocher becomes orange-red. To the right there are indications of cubes, with a slightly curved line that could represent an arch; above it sharp edges recall the steplike cuts so clearly observed in pl. 31.

The branches are traced with a blue brush; the vegetation abounds in emerald greens and blues, often applied in small, diagonal strokes. There is a dense interplay between the foreground greens and the background ochers. The stone blocks at right are brushed more largely, often with vertical strokes. Despite this divergence of execution, the canvas is completely covered. While the diagonal brushwork seemingly harks back to earlier periods of Cézanne, the color scheme as well as a certain lushness of texture points to the turn of the century.

19. Bend in Road at Montgeroult [Route tournante à Montgeroult]. 1898. Venturi 668
Oil on canvas, 31½ x 25⅝ in (80 x 65 cm)
Private collection
Pl. 69

This is one of the last important and completely finished landscapes that Cézanne painted in the North before more or less permanently retiring to Aix; its yellow-ocher tones and deep blue-greens, however, show a close relationship to many late works of the South, such as views of the Bibémus quarry and panoramas of Sainte-Victoire seen from Les Lauves.

Montgeroult is a village not far from Pontoise (and even closer to Marines, where Cézanne supposedly painted *Village behind Trees,* pl. 77). The artist stayed there during the summer of 1898, not 1899, as frequently stated. The subject is a turning, uphill road and not—as Venturi wrote—a river. During World War II the place was heavily damaged, so that Cézanne's motif cannot be recognized anymore.

Meyer Schapiro has described the painting as follows: "It is an undistinguished subject, without a dominant or a central point of interest, yet is picturesque for modern eyes. The Romantics found the picturesque in the irregular, the roughly and oddly textured, the ruined, the shadowy and mysterious; the painters of the beginning of this century found picturesque the geometric intricately grouped, the

disorder of regular elements, the decided thrust and counterthrust of close-packed lines and masses in the landscape. A scene like this one was fascinating to the artist as a problem of arrangement—how to extract an order from the maze of bulky forms. It is one aspect of the proto-Cubist in Cézanne.

"Here the severely geometrical is crossed with the shapeless, pulsing organic, its true opposite. The yellow road, cutting through the foreground vegetation, carries the angular thrusts of the buildings into the region of growth. In contrast to the solid, illuminated substance of the thickly painted buildings, rendered with dark outlines, the bushes and trees rise among them in loose masses of thin, cool color. There are similar tones in the roofs and shaded walls, but these are strictly bounded by drawn lines, unlike the edges of the bushes and trees. To the bareness of the bright, hot surfaces of the houses is opposed the polychromy and more impulsive brushwork of the darker foreground."

M. Schapiro, *Cézanne* (New York: Abrams, 1952), p. 112.

20. Village behind Trees [Village derrière des arbres]. c. 1898. Venturi 438
Oil on canvas, 25⅝ x 31⅞ in. (65 x 81 cm)
Kunsthalle, Bremen
Pl. 77

This is a painting of "lush" density, all in rich orange-ochers and blue-greens, pushed to a rare degree of completeness. From what looks like a road parallel to the picture plane, beyond which stand a few trees, the ground seems to descend toward a fairly large, compact group of closely assembled houses. Because of the sloping terrain, only the tops of these buildings are visible, their roofs echoing the darker orange tones of the foreground strip. The cubes and triangles of these buildings are strongly defined amidst the vegetation. In the distance, fields stretch out to a horizon hidden by the foliage of the tall trees. Far away, at the extreme right, a brilliant emerald lozenge repeats the colors of the second tree from the left which stands out powerfully from the very dark blue-green of its neighbor, against which a whitish tree trunk is set for greater contrast.

The execution, vivid but controlled, is carried out mostly with a loaded brush that leaves a substantial coating of pigment. The direction of the strokes often follows the textures of the various components: leafy branches, rooftops, fields. Here and there an accumulation of brushstrokes bears witness to Cézanne's effort to establish clearly the lines where two colors meet (tree trunks, house walls, roofs, etc.). The bluish sky fuses gently with the treetops.

The location of the motif is in doubt, a fact that makes it difficult to date this canvas (yet Venturi's initial suggestion of c. 1885 must be discarded). Though the picture is often considered to represent a Provençal landscape, this seems definitely not to be the case. Despite the fact that Cézanne worked only in a comparatively few places around Paris during the last decade of his life, none can be identified positively with this view. It seems that there is no connection with Fontainebleau and its vicinity—which leaves no choice but to accept Rivière's assertion that the picture represents the village of Marines. Rivière doubtless drew this information from his son-in-law, Paul Cézanne *fils*. It is established that the artist was in Marines and nearby Montgeroult during the summer of 1898 and there met the young painter Louis Le Bail. Unfortunately, that lovely sector north of Pontoise suffered heavily during World War II, so that any hope of finding Cézanne's motif must now be abandoned.

21. Pines and Rocks (Fontainebleau?) [Pins et rochers (Fontainebleau?)]. 1896–99. Venturi 774
Oil on canvas, 32 x 25¾ in (81.3 x 65.4 cm)
The Museum of Modern Art, New York, Lillie P. Bliss Collection
Pl. 52

This painting has traditionally been dated around 1900, but its thin application of paint and its rather small, often diagonally slanted brushstrokes seem to assign it to a somewhat earlier period. The purplish tints of the rocks vaguely relate this picture to pl. 67, though it is not certain whether or not it represents Fontainebleau Forest.

The paint is thinner in the vertical left and right sections, while in the foreground and the center several layers of subtle color variations can be observed. Whatever foliage there is along the slim red tree trunks with their mostly bare branches appears almost transparent against the blue sky whose tonalities pervade the canvas.

"Cézanne is not an Impressionist," Pissarro once explained to the youthful Matisse. "He has never painted sunlight; he always paints gray weather."

"At first glance," wrote Alfred Barr commenting on Matisse's recollections, "the *Pines and Rocks* seems impressionist but upon study it takes on a profound sense of stability and permanence. Yet its stability appears mysteriously weightless, a structure without mass achieved in space; and its air of permanence seems an affair less of the sensual, material world than of the spirit.

"Recently Matisse, looking back fifty years to his talk with Pissarro, remarked that while an impressionist landscape is a moment of nature, 'a Cézanne is a moment of the artist.'"

A. Barr, *Masters of Modern Art* (New York: Museum of Modern Art, 1954), p. 21.

22. Forest Scene [Intérieur de forêt]. 1898–99. Venturi 784
Oil on canvas, 24 x 31⅞ in (61 x 81 cm)
The Fine Arts Museums of San Francisco, gift of the Mildred Anna Williams Fund.
Pl. 51

This painting was probably executed around 1898–99, when Cézanne spent a good deal of time in and near Paris, but whether it was painted in the forest of Fontainebleau or somewhere in the region of Le Tholonet is difficult to decide. The pervasive green tonalities and the relatively thin application of paint relate this landscape rather closely to pl. 67, but the rock-strewn slope could also be the one that ascends toward the ridge behind Château Noir, except that there the rocks and trees are generally not quite as dense nor the tree trunks as red. As in pl. 67 there is a total absence of any opening in the thicket through which even a narrow path leads deeper into the somber woods.

Some of the boulders show ocher tints not unlike the tones of those near the Bibémus quarry; but the foliage of the trees is of a sharp green, in contrast to the dark fir trees around Château Noir, and the pale blue sky is quite unlike that of Provence.

The picture presents a superb unity of color and texture, achieved less through contrasts than through the subtle harmony of muted tones.

23. Still Life with Plaster Cupid [Nature morte avec l'Amour en plâtre]. c. 1895. Venturi 706
Oil on paper mounted on panel, 27½ x 22½ in (70 x 57 cm)
Courtauld Institute Galleries, London
Pl. 145

It is a moot question whether this still life was painted in Paris or in Aix. The plaster putto is still in Cézanne's Lauves studio, but he could have brought it there from Paris. As to the intensely blue drapery with a design of darker blue, it appears in a number of still-life arrangements

that cannot be identified with any particular period or place, except that it does not show up in compositions dating after 1895 and is frequently used with props associated with Aix, some of which are also to be found in the artist's studio. Both the putto and the cast of a flayed man—similarly preserved, though without a head—depicted in the canvas standing in the background, were the subjects of other paintings as well as numerous drawings.

This is both a complicated and fascinating assembly of objects, observed as though seen from an elevated position—a particularity that may in part be associated with works executed in small studios where the artist compensated for the insufficient distance from his subject by a pronounced plunging view. As a matter of fact, the plaster cast is perceived here in a kind of close-up that makes it larger than "life-size" (actually measuring some eighteen inches, it rises to almost twenty-four in the picture). The cupid dominates the elements carefully grouped around it in an elaborate spatial construction. The proportions of the cast seem somewhat overemphasized in relation to the fruit and onions at its feet. (Onions also appear in another still life of approximately the same period, pl. 148, where they play a more important and decorative role; that work was probably painted in Aix.)

Lawrence Gowing was the first to fully "decipher" the intricate composition: "The subject is complex. In the centre, among onions and apples on the table, is a plaster cast after the Cupid by Puget in the Louvre. At the right, standing on the floor beyond it, is seen the lower part of a painting of the so-called Anatomy, attributed to Michelangelo. A second canvas, against whose oblique plane the Cupid is outlined, stands beside it, and at the left of the picture is a third, a still life of apples on a blue cloth which lies on the table immediately in front (and at first sight not easily distinguishable from it). This is the right-hand part of another still life of the period [in the National Gallery of Washington, Chester Dale Collection]. The picture thus contains a cast and a painted cast, apples and painted apples, a cloth and a painted cloth. It is notable that there is here no suggestion of the incongruity which has been inseparable from the device of the picture within a picture, as used by other artists from the fifteenth century to Chirico. We feel an agreement between the Baroque sculpture, the natural material of domestic life and the pictures: the theme is in fact the association, and fusion, on which the mature style of Cézanne is based."

L. Gowing, catalog entry for Cézanne exhibition, Edinburgh and Tate Gallery, London, 1954, no. 50. Gowing and Reff date this work to the early 1890s; Cooper dates it c. 1895, as did Venturi.

24. Still Life with Apples [Nature morte avec pommes]. 1895–98.
Venturi 736
Oil on canvas, 27 x 36½ in (68.6 x 92.7 cm)
The Museum of Modern Art, New York, Lillie P. Bliss Collection
Pl. 147

To contemplate an unfinished picture is almost like looking over the artist's shoulder while he is at work—something Cézanne himself would not have tolerated. The problem of what is "finished" is an extremely complex one in Cézanne's case, since many canvases that appear completed (such as the portrait of Vollard, pl. 4) still required, to his mind, a good deal of work. This question would be easier to answer if Cézanne had signed his paintings and in this way indicated that he had accomplished his aim, but he seldom put his name on his pictures and never did so in his later years. Thus it is not only works with a certain amount of uncovered canvas that should be considered "unfinished." Yet, unfinished works are not necessarily of diminished quality or interest. Indeed, the distinction between Cézanne's finished and unfinished pictures is so tenuous as to be almost meaningless.

Where—in an unfinished painting—the average gallery-goer sees mostly what is actually there and to some extent also what is missing, to an artist such a work suggests much more. It shows what the painter's priorities were when, faced with an empty canvas, he set out to trace on it the lines and colors he regarded as significant; it also indicates how he went about his task, keeping at every stage a perfect balance of tonal harmonies and linear directions.

However, Cézanne does not seem to have adopted just one approach: different paintings bear witness to different processes of execution. There are almost blank canvases that reveal a complete network of pencil lines, put down before he began using his brushes (in this still life a few vague pencil indications appear under the thin coat of paint). There are other pictures where patches of color scattered all over the surface challenged him to find the right tones that would link them together; they lead one to wonder how he could work on everything simultaneously, since each new color spot immediately invited further developments to maintain the precarious equilibrium that he pursued with even the smallest brushstroke. And there are paintings where he seems to have concentrated on one large section while filling the rest with a vibrant web of lines, put there (as in pl. 62) apparently to alleviate the contrast between the densely covered top and the still bare lower part of the composition.

As if this did not present enough questions, there is also the problem of the thickness of paint: at what stage, once the canvas is fully covered, should work be suspended? There are paintings, particularly of Cézanne's last years (such as pl. 155), which show a prodigious crust of pigment, indicating that Cézanne applied coat after coat after coat until the surface began to resemble a relief and the dried pigment, in some parts, seemed to "curdle." It is evident—and Cézanne knew this from Balzac's Frenhofer, the hero of the short novel *Le Chef-d'oeuvre inconnu*—that it is always possible to apply more brushstrokes on top of those that are already there and that the real issue for an artist is to know when to stop. Late in life Cézanne explained to the young painter Maurice Denis: "I cannot convey my sensation immediately; so I put color on again, and I keep putting it on as best I can. But when I begin, I always try to paint sweepingly, like Manet, by giving form with the brush."

This still life was certainly begun "sweepingly." Many large and uniform areas covered by a thin coat of color have not yet been textured or fully treated but have obviously been filled in to provide a foil for the objects on the table and for the patterned curtain in the upper left. Against them the pieces of fruit form lively green, red, and yellow accents; yet it appears by no means certain that their strong colors might not eventually be somewhat subdued once their surroundings take on a more specific character. Meanwhile, however, these colors form the key to the work that remained to be done; it is around them that this painting was built. The other tones are mostly neutral and applied in thin, multidirectional strokes, sometimes accompanied by swirls and serpentines. A hasty brush here seems to have been anxious to eliminate the whiteness of the canvas to better establish the intense colors of the fruit. The pattern of the curtain is occasionally indicated with deep red and some blue brushstrokes, whereas in contrast to this tentative procedure the fruit already benefit from outlines that strongly insist on their forms and curves.

While it is fascinating to study how Cézanne went about his work, there was, for his still lifes, a first creative step which too often goes unnoticed. It consists in carefully assembling the fruit, the crockery, arranging the folds of the napkin, adding the curtain to liven up the background, introducing two verticals in the form of a glass and a

pitcher, but above all placing the apples, the lemons, and the green plums (?) where their colors would be needed. Nothing is accidental here, from the green plums, set off by themselves in a white bowl, to the single green pear half hidden by the napkin, from the large lemon in the center foreground to the small one to the right of the bowl, from the shiny red apples "nonchalantly" scattered over the table to the spots in the lower part of the curtain, which are of the same red. Everything is meticulously willed. And it is not impossible that the execution of Cézanne's pictures varied according to the specific problems that confronted him in each case.

Odilon Redon, in a diary note of 1908, was to say: "The painter who has found his technique does not interest me. He rises every morning without passion and, calmly and peacefully, pursues the work begun the day before. I suspect him of a certain boredom, like that of a virtuous laborer who continues his task without the unforeseen flash of a happy minute. He does not experience the sacred torment whose source is in the unconscious and the unknown; he does not expect anything from what will be. I love what has never been."

For Cézanne quoted by Maurice Denis, see M. Denis, *Théories, 1890–1910,* 4th ed. (Paris: Rouart & Watelin, 1920), p. 248.

O. Redon, *A soi-même: journal* (Paris: Floury, 1922), p. 105, entry of 1908.

25. Still Life with Onions [Nature morte aux oignons]. 1896–98. Venturi 730
Oil on canvas, 26 x 32¼ in (66 x 82 cm)
Musée du Louvre, Galerie du Jeu de Paume, Paris
Pl. 148

Against what is for Cézanne an unusually large expanse of unencumbered wall, many objects are crowded on the table with its scalloped apron. While the composition is deliberately off-center, a perfect equipoise is reached between the "soaring" dark bottle at left and the cascading folds of the white tablecloth at right, both superbly standing forth from the gray-blue-greenish background. In the center foreground the artist put a white dish with two oranges(?) and two onions. The diagonal that leads from the shoot of the lighter onion to the cork of the bottle is carried over by the tall glass standing between dish and bottle. The repeated round forms of fruits and vegetables are everywhere livened by the willowy green arabesques of onion shoots, one of which seems to emerge from the folds of the tablecloth, extending even beyond it; others rise to the left of the bottle. In no other work has Cézanne made such ingenious use of these decorative elements.

The perspective of the table appears somewhat awkward; while its front runs perfectly parallel to the picture plane (with a black knife slightly protruding from it), its side shows a great divergence between the receding top and that of the scalloped board beneath it. At the same time the large folds of the white cloth seem stretched out beyond where they might be supported by the surface of the table (an incident to be observed in many of Cézanne's still-life arrangements).

The paint is applied thinly—except near the bottle, which may originally have been taller and placed a little more to the right. It is there that the only impasto in the picture appears, as though the bottle had at first been almost touching the stemmed glass and then, possibly, put directly over a second glass, whose oval rim can be detected. However, this oval rim does seem to have been traced *on top* of the belly of the bottle.

The colors are light and rich in delicate gradations. The onions vary from almost white to pink and red; there are a few yellow fruit among them, especially one at the extreme left, while the wainscot at the right bottom is slightly darker than the wood of the table. In the folds of the

hanging white cloth appear subtle tonalities of green. The colors seem to relate this work stylistically to the Geffroy portrait of 1895 and the Bibémus landscape of c. 1897 (pl. 37); Gowing's suggestion of c. 1895 is of course also acceptable, yet even earlier dates, such as 1890–94, have been proposed. This graceful, subtle, and indefinably felicitous work seems to stand on the threshold of a new phase in Cézanne's evolution, where his strokes become increasingly heavy with pigment, where his brushwork appears more vibrant though his execution often seems labored, where the surfaces of his pictures are less smooth, where his colors sometimes show a tendency to turn darker, but where his concepts transcend any realistic approach and reach the glorious detachment and freedom, the intense and fierce attitude toward nature, of his last years.

26. Bouquet of Peonies in a Green Jar [Bouquet de pivoines dans un pot vert]. c. 1898. Venturi 748
Oil on canvas, 22⅝ x 25¾ in (57.5 x 65.5 cm)
Private collection, Paris
Pl. 160

Each unfinished canvas of Cézanne's offers a different cue to his method, if indeed one can speak of any "method" at all. For this bouquet of peonies, the problem resided obviously in the dense intermingling of red or pink blossoms and green leaves, a problem to be solved through the soft color variations of the petals and the sharp design of the pointed leaves. Just as Cézanne in his portraits often left the face for the end, so here he devoted himself to the other components before turning to the bouquet itself. Though it is impossible to say where he began, he did establish the pink-mauve-gray background and the emerald green jar, both of which provided him with more or less uniformly colored surfaces, before tackling more explicitly the intricate flowers that actually are the main subject of the picture. The leaves are drawn with a blue brush and their greens filled in in many places. Where there are large empty areas between the leaves, we can imagine the blossoms that were to occupy them, such as those already sketched. Only two small ones appear more carefully painted immediately above the rim of the jar, as though the artist had planned to work his way from there toward the three uppermost flowers whose colors and shapes are already indicated. Thus the extreme poles at the bottom and the top of the bouquet are established, between which the link remained to be found. But there are enough delicate tints, enough lively forms of leaves, enough tender curves of blooms, enough vibrant brushstrokes to arouse a felicitous sensation of sparkle and creativity. At least so thought Georges Braque, who owned and cherished this painting.

"A painter achieves *poésie* only when he transcends his talent and exceeds himself," Braque once explained to a friend. "Rembrandt, for example, in his late works, Corot in the best of his figure paintings, and of course Cézanne. Degas, on the other hand, doesn't have it. Compare a Degas with a Cézanne and you'll see that while one is compounded of talent and artistry, the other has a pictorial life, a pictorial reality of its own."

"Metamorphosis and Mystery," based on Georges Braque's conversations with John Richardson, reprinted from *The Observer* (London), in the exhibition catalog *Georges Braque—An American Tribute,* 1964.

27. Still Life with Curtain and Flowered Pitcher [Nature morte avec rideau et pichet fleuri]. c. 1899. Venturi 731
Oil on canvas, 21½ x 29⅛ in (54.7 x 74 cm)
The Hermitage Museum, Leningrad
Pl. 140

Cézanne painted five still lifes showing the same flower-decorated pitcher and, in the background, the same brownish curtain with leaves; one of these is pl. 139. In view of the fact that the curtain appears also in a much earlier work, *Mardi-Gras,* known to have been executed in Paris, it may be presumed that all five compositions were done there, although pl. 139 shows a second drapery or rug that the artist subsequently used in his Aix studio.

"At first sight," as John Richardson has observed, this painting "seems a relatively straightforward representation of a classic still-life subject, but on closer examination anomalies emerge. The central dish of fruit, for instance, is tilted so precariously that it threatens to slide out at the onlooker. Likewise the tabletop slopes leftwards out of the picture, and the perspective of the side of the table is awry. Sometimes we seem to be looking up, sometimes down at the objects, as if the artist had changed his viewpoint. There is nothing arbitrary in the liberties that Cézanne has taken. On the contrary, by subtly adjusting the way things look and registering tonal relationships with almost scientific precision, he has endowed his still life with an extra measure of tangible reality and heightened our experience of forms in space. In the other two more elaborate variants of this theme [pls. 139 and 143] . . . Cézanne switches his viewpoint even more drastically, in a way that anticipates Cubist still lifes of 1908–09.

"Far from being at odds with the rest of the highly worked picture, the 'unfinished' passage in the right-hand bottom corner plays an important pictorial role. The transparency of the napkin provides a necessary note of spontaneity and emphasizes the solidity of everything else in the still life. It is also important to remember that Cézanne never thought in terms of 'finished' pictures; he had the courage to stop before killing a picture with a last fatal brushstroke."

J. Richardson, *Master Paintings from The Hermitage and the State Russian Museum, Leningrad* (Washington: National Gallery of Art, 1975; exhibition shown also in New York, Detroit, Los Angeles, and Houston), p. 88.

28. Apples and Oranges [Pommes et oranges]. c. 1899. Venturi 732
Oil on canvas, 29⅛ x 36⅝ in (74 x 93 cm)
Musée du Louvre, Galerie du Jeu de Paume, Paris
Pl. 139

This still life is painted on a white canvas whose priming is visible in the tablecloth at lower left. Compared with such a serene composition as pl. 148, set against a large, unadorned wall, this picture presents a cluttered and almost agitated arrangement of opposing elements, colors, and patterns. There are two different draperies in the background: at the left—seemingly hanging from the wall—the rug with rust-brown purplish squares and a red and dark green design that was still in Cézanne's Lauves studio until World War II; next to it is a brown-beige curtain with a pattern of light green leaves and some traces of red that cascades down, met by the multifolded large white tablecloth on which crockery, apples, and oranges are assembled. At left, behind the tilted dish and half-hidden by the tablecloth, appears a small green fruit, echoing the color of the green upholstery. The dark brown background in the upper right seems related to the Vollard portrait, pl. 4. (This would imply that this picture may have been painted in Cézanne's Paris studio on the rue Hégésippe Moreau in 1898–99, although the milkpot is presumed to have been among the artist's paraphernalia in Aix.)

The surface on which the elements of this still life are assembled appears somewhat ambiguous, concealed as it is by the white cloth; only one table leg can be seen at the right, whereas at the left the tabletop may be resting on the sofa whose wooden frame and green upholstery can be perceived below the round dish. The white pitcher with floral design barely detaches itself from the busy surface of the curtain at right, while the stark orange fruit form a sharp contrast to the white of the cloth and the bowl. The draperies on the top and the tablecloth at the bottom practically fill the entire space not occupied by the still-life objects proper.

Though unusually crowded, this composition obviously corresponds to a specific mood of the artist, for, as David Sylvester has said: "An apple or an orange was perhaps the best possible subject he could have: first, because while working from nature, he could still dispose it as he wished; secondly, because it carried no strong emotional overtones to distract him from realizing his sensations; thirdly, because such objects presented, far more readily than landscape, the possibility of finding those clear and regular forms, like orders of architecture, which are needed for the creation of a monumental art."

This painting originally belonged to Gustave Geffroy.

D. Sylvester, " 'Still Life with Teapot,' by Cézanne," *The Listener* (London), January 18, 1962.

29. Still Life—Milk Pitcher and Fruit [Nature morte—Pot à lait et fruits]. c. 1900. Venturi 735
Oil on canvas, 18 x 21⅝ in (45.8 x 54.9 cm)
The National Gallery of Art, Washington, gift of the W. Averell Harriman Foundation in memory of Marie N. Harriman
Pl. 146

This still life appears to be seen from above, as happens frequently in Cézanne's late still lifes and also in some portraits. On the seemingly tilted table a carefully tilted plate with fruit adds to the impression of a plunging view. The octagonally shaped milkpot appears in other, earlier compositions which are viewed also as though the artist were looking down on them. The repeated use of this prop over a number of years may indicate that Cézanne kept this pitcher in Aix, where his studios at the Jas de Bouffan and, later, in the rue Boulegon did not allow for much distance and thus may have strengthened his tendency to observe his subjects from above.

Between the light blue wall at left with shadows of a medium blue and a greenish curtain at right appears a vaguely patterned strip of yellow, orange, and light brown. The table is "badly aligned," its border in the back, behind the objects at right, not meeting the stretch that extends between the milkpot and the edge of the canvas at left. Such irregularities often occur in Cézanne's still-life arrangements, as though his concentration on individual features had prevented him from straightening interrupted lines.

The fruit are orange-colored, except for one deep-red apple in the foreground. Even the peach at right leans toward orange, its tint close to that of the wooden kitchen table; at left appear two oranges and a lemon. The plate is white, as is the pot, whose green ornaments are echoed in the curtain. The fruit, plate, and pot—all strongly accented by blue contours—are heavy with accumulated pigment, which becomes thinner as it moves away from the central part of the composition. The protruding dark knob of the drawer creates an illusion of space between the picture surface and the onlooker, a mission Cézanne usually entrusted to a diagonally placed knife whose handle projects beyond the edge of the table; in other instances this role is played by the folds of a tablecloth or rug that hang down from the support on which the still-life objects are assembled.

The dense brushwork, as well as the carefully established composition and color scheme with the single red note off-center, conveys an impression of solidity where each element is clearly identified while remaining an integral part of a masterfully structured whole.

30. Pyramid of Skulls [Pyramide de crânes]. 1898–1900. Venturi 753

Oil on canvas, 14⅝ x 17⅞ in (37 x 45.5 cm)
Private collection, Zurich
Pl. 157

This still life appears to have been painted from very close up, possibly in Cézanne's small studio on the rue Boulegon at Aix. The artist later took the four skulls (all without jawbones) to his studio at Les Lauves, erected in 1902, where they still are.

The three lower skulls—one of them partly hidden—are brownish, the upper one is white. They are set against a blue-black background with, in the lower left, some crumpled reddish material. The skulls are assembled on a white cloth whose folds can be discerned at right. The sharp line of the cloth meets at left a light brown surface, possibly the top of a table. This line accentuates the vertical repeated in the uppermost skull, whereas the converging diagonals of the cloth and of a blue shadow in the lower right corner, as well as the reddish material at left, contribute to the triangular effect. Here and there thin blue strokes trace with precision the outlines of the skulls and the rims of eye sockets and noses. The blue-black holes of eyes and noses echo the dark background and produce a haunting image in which the interplay of highlighted craniums and deep, hollow recesses creates a fascinating, almost abstract pattern. The plasticity of the rounded volumes literally seems to burst from this fairly small canvas.

Painted rather thinly, in tiny, frequently diagonal brushstrokes, with occasionally two or more superimposed layers of pigment, the picture does not have the heavy crust, the intensely labored and dramatic surface, of pl. 155. Instead there is—despite the gruesome subject—a kind of elegant serenity that seems to counter the threat of death. This is a contemplative work devoid of fear.

31. Candlestick and Skull [Chandelier et crâne]. 1900–04

Oil on canvas, 19¾ x 24 in (50 x 61 cm)
Staatsgalerie, Stuttgart
Pl. 154

This work repeats an arrangement the artist had already painted in his youth (Venturi 61), though here it is stripped of all romantic elements, so that only the stark skull and the yellow candlestick remain. Executed on a grayish-white ground, the picture shows an extremely vigorous attack, with the lines of the table being most energetically brushed (there is no trace of preliminary pencil preparations). But in contrast with his approach to most of his later works, Cézanne seems to have concentrated first—and exclusively—on the two objects and their immediate surroundings, leaving the rest of the canvas completely uncovered. The colors are an indefinable brown inclining toward blue, with a few touches of violet in the background at right. The grayish skull stands out against the dark background, its shadows strongly accented and the highlight on the forehead indicated by bare canvas.

This is obviously an unfinished work. The artist may have felt that his statement, as it stands, needed no more elaboration. Yet, unfinished still lifes are comparatively rare in Cézanne's oeuvre, especially when their unchanging components (unlike flowers or fruit) remained constantly available for further efforts. Indeed, Cézanne is known to have spent months and even years on another composition of skulls, pl. 155. There a prodigious crust of paint surrounds the three skulls, the result of innumerable working sessions in which the artist applied constantly more pigment to the areas where the skulls detach themselves from the background or from the tapestry on which they have been assembled. "Always to the loom return with your work," La Fontaine had advised,

and always to that canvas the old painter returned in a heroic effort to impose his vision and his will on that sinister trinity. As he did so, what may have started as a colorful image with white globes on blue-green, red, and rust-brown ornaments (see the watercolor of the same composition, pl. 156) became slowly darker and darker, the colors thus adding their own note of gloom to the haunting still life.

In a letter discussing Faulkner's *A Fable,* Thomas Mann once said that the author had "sweated over the book—certainly not in vain, but he did sweat, and that should never be noticeable, for art must make the difficult seem easy."

In front of pl. 155 it is not simple to agree with that notion, since the difficult has by no means been made to seem easy there. Instead it has been made grandiose. The intensity of the artist's endeavors is transmitted with an almost overpowering force; the urge that drove him on is sublimated with an incredible and gripping bluntness.

When Emile Bernard visited Cézanne in February 1904, he saw that canvas in his studio. For one month he had been working on it every morning from six to half past ten. "What is still wanting," the master explained in front of those three skulls, "is the realization. Maybe I'll achieve it, but I am old and it is possible that I'll die without having reached that supreme goal: to realize like the Venetians."

Bernard acquired an idea of the slowness of Cézanne's procedure when his host offered to let him work in one of the rooms below the large studio. While he was painting a still life there, he heard him "coming and going overhead . . . frequently he also went out to sit in the garden, then suddenly rushed upstairs. Often I surprised him in the garden with an extremely discouraged air; he would tell me that something had stopped him . . . we then talked about the atmosphere, color, the Impressionists, and the question that tormented him: the relation of tonal values."

"For the entire month I spent in Aix," Bernard later recorded, "I thus saw him labor on this picture of skulls that I consider his testament. Almost every day the painting changed in its color and form, and yet when I first arrived at his studio it might have been removed from the easel as an accomplished work. Truly, his process of study was one of meditation, his brush in hand."

Upon his return to Aix, late in March 1905, Bernard found the canvas nailed to the studio wall . . . abandoned. Yet there is no way of telling whether Cézanne did not take it up once more, persisting in his Sisyphean efforts.

E. Bernard, *Sur Paul Cézanne* (Paris: R. G. Michel, 1926), pp. 20–21, 22, 30–31, 63.

32. Still Life with Teapot [Nature morte à la théière]. 1902–06. Venturi 734

Oil on canvas, 23 x 28½ in (58.4 x 72.4 cm)
National Museum of Wales, Cardiff
Pl. 166

Speaking of this masterful still life, David Sylvester has said:

"As we look at the four spheres embraced by the ellipse of a plate in the centre of *Still Life with Teapot,* we don't really know if they are and which of them are apples, oranges, apricots, and we don't care. What we know as we look at them, know it physically, in our bodies, is the feeling of having the shape of a sphere, a shape that is perfectly compact, a shape that can touch similar shapes at one point only, a shape which has a very precise centre of gravity. Perhaps the thing that makes us so deeply aware of this shape—which is of course no more a geometric sphere than the sides of a Doric column are straight lines—is above all because of the relation between the shapes of the four fruits

on the plate and the two on the edge of the table and that of the teapot—the teapot apart from its handle and spout—is also a sphere, standing out against those of the fruits, about twice as large and white against their luminous yellows and oranges. Its shape rhymes with the shapes of the fruits and acts as rhyme does in verse—both connecting what is dispersed and heightening our awareness of the shapes of the words that rhyme.

"... Among the contradictions which [Cézanne's] art presents there is none, perhaps, more profound than that between the sense of the transience of life and of its permanence. In the *Still Life with Teapot,* even more, even much more, in the great late paintings of Mont Sainte-Victoire, we experience these contradictory feelings separately, and each as poignantly as the other. There is a hopeless sadness that all we see and rejoice in dies for us no sooner than it is seen; there is a serene affirmation that what we are now looking at will be there forever. We are faced with our deepest concerns about life and our place in it, but exalted here by this total acceptance of the intolerable fact that mortality and immortality are only meaningful in relation to each other."

D. Sylvester, "'Still Life with Teapot,' by Cézanne."

33. Still Life with Flower Holder [Nature morte au vase pique-fleurs]. c. 1905
Oil on canvas, 32 x 39⅝ in (81.3 x 100.7 cm)
National Gallery of Art, Washington, gift of Eugene and Agnes Meyer
Pl. 144

A darkish-brown harmony pervades this large composition; it appears also in the *Portrait of Vollard,* known to have been the product of countless sittings. This overall tonality, which contributes to the extraordinary compactness of the work, is brightened by three pinkish-white spots: the pitcher, the napkin, and the scalloped bowl with holes for inserting flowers. (This vase is found in no other of Cézanne's still lifes but was a popular product of old faience factories, such as that of Moustier in the Alps, which produced, among others, white wares to be found all over Provence.) The fruit, probably peaches, are yellow-orange and red; only the closest—which originally was placed even farther forward—and the one half-hidden in the folds at left are completely red; these two could be apples.

The table is of a lighter brown than the uniform background; the drapery or tapestry is the familiar one with a brownish-blue pattern of foliage. Although there is less impasto than in other contemporary canvases, the work process was evidently a long one; in some places the first layer of pigment seems to have dried before a new coat was applied on top of it. Along the outlines of the pitcher and the curves of the fruit is a heavy crust where the paint occasionally seems to have curdled.

34. Château Noir. 1900–04 Venturi 796
Oil on canvas, 29 x 38 in (73.7 x 96.6 cm)
National Gallery of Art, Washington, gift of Eugene and Agnes Meyer
Pl. 57

The contrast of blue and ocher is tempered at left by patches of green foliage. The expanse of the intensely blue sky is livened by the deep blue arabesques of bare branches, originally placed slightly lower. They are reminiscent of the ornamental branches in Cézanne's earlier panoramas of the Arc valley. Beneath sky and branches lies the more uniformly blue stretch of the Mont du Cengle.

The building and its terrace are ocher, as is the ground that extends toward the wall of the terrace. At left appears the path leading to Château Noir from the Maison Maria, in front of which the artist had set up his easel. The distant barn-door is red, while the pseudo-Gothic windows above it reflect the blue of the sky.

Whatever impasto occurs is accumulated mostly—as so often in Cézanne's work—along the lines where two colors meet: tree trunks, branches, the edges of the building.

How meticulously Cézanne observed compositional exigencies is attested not only by his displacing the bare branches (of a dead tree?), but even more by the fact that he had the canvas widened by as much as one inch on either side. Thus he obtained a greater space between the abutment of the terrace and the frame—setting the ocher wall off more strongly—and gained a narrow stretch for the forest. These strips, while similar to each other, are of a different texture from the original canvas, but they were added while the work was in progress, since many brushstrokes continue across the joints; the left strip, however, is less densely covered than the right one.

The traditional date of 1904 for this painting indicates that Cézanne continued to work at Château Noir even after settling in his studio of Les Lauves.

35. Bathers [Baigneurs]. 1898–1900. Venturi 724
Oil on canvas, 10⅝ x 18⅛ in (27 x 46.4 cm)
The Baltimore Museum of Art, Bequest of Miss Etta and Dr. Claribel Cone
Pl. 201

It was in the spring of 1904 that Bernard Berenson advised Leo Stein to take an interest in Cézanne and directed him to Vollard's small gallery on the rue Laffitte. From that time on, Leo and his sister Gertrude acquired works by Cézanne, their collection being eventually oriented to what they considered the "Big Four": Renoir, Cézanne, Matisse, and Picasso.

The exact date at which this work entered the Stein Collection has not been established, but in photographs taken around 1905 it appears on a wall of their famous studio at 27 rue de Fleurus. The painting had been included in the large Cézanne retrospective of the Salon d'Automne of 1904, and it may have been there that the Steins first saw it and decided to purchase it. Known only is that it remained in Gertrude's possession after she and her brother divided their pictures in 1913 and that, in 1926, she sold it to her friend Etta Cone. In the intervening years it was seen by the countless writers and painters who gravitated around the Steins, or at least paid visits to their studio when they came through Paris, equally attracted by them—or by Gertrude alone—and by the collection. Indeed, for a long time more of Cézanne's works were accessible at the rue de Fleurus than at the Luxembourg Museum, which had accepted only two of the artist's five paintings that Caillebotte had bequeathed to the state. And those two were landscapes, whereas the Steins also owned a splendid portrait, a small still life, and this study of bathers, not to mention a number of watercolors. Just as important was the fact that these works were hanging next to canvases by Matisse and Picasso, offering many a young American painter who had come to Paris to immerse himself in the new art movements a unique opportunity to study significant works by the leading pathfinders.

Similar groups of a few male nudes, frequently assembled on fairly small canvases, had preoccupied Cézanne for decades. However, the number of these studies diminished during his final years as the big compositions of female bathers increasingly claimed his attention. Yet it was here, in canvases of more modest dimensions, that he could

improvise more readily and give freer rein to his imagination and his sense of rhythm and movement.

Lively, thin, often repeated brushstrokes fill the upper part of the painting with patches of greens and blues. Beneath their flickering array the outlines of the pink figures and the trees are drawn with a dark blue brush that loosely traces their shapes without imprisoning them in firm contours. The bare, yellowish canvas appears only in a few places. The attitudes of the men are "active" in contrast to the more static poses of the bathers in the three large versions (pls. 187–89); the only element that might conceivably relate this picture to the composition in the Philadelphia Museum (pl. 189) is the sketchy indication of a few figures on the distant shore of the water.

36. Group of Seven Bathers [Groupe de sept baigneurs]. c. 1900. Venturi 387

Oil on canvas, 14⅝ x 17¾ in (37 x 45 cm)
Collection Ernst Beyeler, Basel
Pl. 202

In the fall of 1910, a young (twenty-three-year-old) aspiring painter from Chicago, Manierre Dawson, was encouraged by a chance acquaintance to visit Gertrude Stein during his first, and very brief, stay in Paris. Although he had gone to Europe primarily to see works of the old masters and to study the principal monuments, he was greatly impressed with the paintings by Cézanne that he saw at the Steins' place. He subsequently asked his friend where he could see more of these and was taken to Vollard's small gallery on the rue Laffitte. On November 2, Dawson confided to his diary that the dealer "was very slow to bring them out. My head has been full of the few things I saw. One painting I cannot forget, a late one and apparently unfinished. The arbitrary black lines, the tying of knots, the emphasis these made in showing where the parts were important to the composition, and the great variety of altered forms were very instructive to an understanding of inventive pictures, and gave me a big lift in support of what I was trying to do in my own work. One thing I noticed was the invariable success of Cézanne's color." (Archives of American Art, Smithsonian Institution; this document was brought to my attention by Miss Doreen Bolger.)

So strong was the impact of this visit to Vollard's that less than two weeks later, when Dawson summed up his impressions of Europe in a diary entry dated Dresden, November 14, he mused: "I am beginning to settle on favorites: Tintoretto, Rubens, Poussin, Delacroix, Turner, Constable. I think I have been most affected by Cézanne who, in the few works of his I have seen, doesn't take the scene at face value but digs into the bones and shows them. He isn't afraid of bold lines in landscape or figure and he makes the color what it should be." (Catalog of Manierre Dawson Retrospective, Museum of Contemporary Art, Chicago, November 1976–January 1977, p. 12.)

There can be no doubt that Cézanne would have been delighted to find his name associated with such favorites of his as Tintoretto, Rubens, Poussin, and Delacroix. As to the works to which Dawson referred, it is unfortunately not possible to identify them, but since he speaks especially of unfinished paintings and "inventive" pictures, his observations could certainly be applied to a painting such as this one.

37. Bathers [Baigneurs]. 1900–04

Oil on canvas, 16⅝ x 21⅝ in (42.2 x 55 cm)
Collection Stephen Hahn, New York
Pl. 203

This is probably one of Cézanne's last paintings of this type. That this

and most of the similar works done around the turn of the century are of a sketchy nature may relate to the artist's arduous labor on the much more ambitious large compositions of bathers. There the question of "finish" became essential, while here he seems to have been satisfied with establishing color harmonies and indicating problems that did not necessarily have to be treated extensively.

The brushstrokes are light and scattered all over the canvas, leaving numerous bare spots. Many shades of green are intermingled with mauve tints and with blue; this blue reaches its greatest intensity in the sky. The sand in the foreground is of a yellow tan; behind it appears a slim band of blue, representing water that—to the right—loses itself in the foliage. A broken horizontal line along the bank even runs through the body of the bather standing in the water. The bodies of the figures show a good deal of uncovered canvas (the same is to be observed in many watercolors of bathers) with indications of pink; their outlines are constituted by repeated and often vague blue, purple, and even red brushstrokes.

The branches at left, formed by strokes that run at right angles to their curves, provide an arabesque not unlike that observed in the right corner of pl. 83, where it softens the composition in an opposite direction.

38. Bathers [Baigneuses]. 1899–1904. Venturi 722

Oil on canvas, 20 x 24¼ in (51 x 61.7 cm)
The Art Institute of Chicago, Amy McCormick Memorial Collection
Pl. 193

Cézanne's lifelong preoccupation with compositions of nudes in the open air went through various phases. In the seventies, he began to represent groups of more or less isolated male bathers only loosely linked to each other; in the eighties, he concentrated frequently on a few female nudes closely assembled, often in pyramidal arrangements; from the nineties on he devoted himself to large and intricate compositions of numerous figures. Yet he also executed paintings quite different from these general types, either of single nudes (among them a very large one) or small canvases with half a dozen male bathers near and in the water. Occasionally he did more sketchy pictures—such as this one—which, while related to his more ambitious projects, retain something of the instant inspiration and the verve absent from the huge compositions that represent his ultimate effort to place nude figures in a natural setting. The problems that faced him there have been defined by Herbert Read (though not necessarily with reference to the various paintings of bathers) when he wrote:

"Cézanne found that it is the most difficult thing in the world to give direct expression to visionary conceptions. Unchecked by an objective model, the mind merely flounders over an expanse of canvas. It may achieve a certain force, a certain vitality; but it will lack, not only verisimilitude, which matters little, but that knitting together of form and colour into a coordinated harmony which is the essential of great art. Cézanne came to realize that to achieve such a harmony the artist must rely, not on his vision, but on his sensations. To realise the sensations—that became the watchword of Cézanne. It amounted to a self-imposed conversion: a spiritual renewal. The dynamic vision of the romantic had to be transformed into a static vision of the classical."

There is no denying, however, that in this spontaneous work, where his brush seems to have roamed over the canvas with utmost freedom, Cézanne did achieve an—admittedly casual—"knitting together of form and colour," while recouping some of the dynamic vision of his early, romantic years.

H. Read, *The Meaning of Art* (London: Faber & Faber, 1931), sect. 73.

39. Bathers [Baigneuses]. 1900–04. Venturi 723
Oil on canvas, 11 x 14⅛ in (28 x 36 cm)
Private collection, Zurich
Pl. 192

Among the pictures related to Cézanne's last compositions of *Bathers* (pls. 187, 188, 189), this one occupies a special place insofar as it contains figures and attitudes—even trees—specifically connected with one or another of these three large paintings. But since—as for most other works of his—its date of execution is not known, there is no way of establishing its place in the sequence of these three compositions discussed in Theodore Reff's essay in the present volume. The spontaneity and freedom of brushwork make it likely, however, that this study was started *after* the artist had begun to devote himself to the first of the three big canvases with its particularly labored execution. Despite its sketchy technique, this perfectly balanced composition, its palette reduced mainly to blues and greens, seems an almost lighthearted "aside" in which Cézanne—on a relatively small surface—could express some of the multiple ideas, inspirations, or projects that were to receive more weighty consideration in the monumental paintings.

40. Study of Bathers [Etude de baigneuses]. 1900–06
Oil on canvas, 8⅜ x 12⅞ in (21.2 x 32.5 cm)
Collection S. Rosengart, Lucerne
Pl. 195

Despite the many years and the strenuous efforts that Cézanne devoted to his three large compositions of bathers, there are hardly any small paintings (or drawings or watercolors) that relate directly to them or that can be considered as preparatory studies. This small canvas is no exception. While some of the summarily indicated figures appear in similar attitudes in the large pictures, this composition echoes only vaguely the groups of nudes that were the focus of Cézanne's ultimate representations of bathers.

Blue and green and their intermediaries are the dominant—almost the exclusive—colors. The brushstrokes are loose, with outlines drawn in blue and, at the right, in brownish tonalities. A few flesh colors appear in the standing nude at left and in the central, seated one, both seen from the back. The sketchy character of this work notwithstanding, there is, combined with the spontaneity, a splendid cohesion of shapes and colors. All that is essential seems to have been said.

41. Bathers [Baigneuses]. 1902–06. Venturi 725
Oil on canvas, 29 x 36⅜ in (73.5 x 92.5 cm)
Private collection, Zurich
Pl. 186

Venturi called this painting *Ebauche des grandes baigneuses,* apparently considering it to be a study for pl. 189, with which it does have one thing in common: the bathers occupy only the lower third of the canvas, with trees and sky filling the rest. Yet the attitudes and the grouping of the figures are totally different from those of the other, the largest of Cézanne's bather compositions. Moreover, the artist supposedly began to work on that canvas before the turn of the century (opinions as to the date vary considerably), while the style of this picture clearly points to the last years of the painter's life. Rather than a study *for* pl. 189, this seems to be an independent version in which—incidentally—the figures are no longer the primary focus, at least not as they appear in this unfinished work. But it is "unfinished" merely because there are spots of canvas left uncovered; these occur in places where only colors—not compositional elements—are missing: some of the bodies (where pinkish tones are absent), some of the ground

(where blue-green tints are lacking), and occasionally in the sky (where brushstrokes simply do not meet closely). As Cézanne explained in a letter to Emile Bernard of October 1905, "the sensations of color, which give the light, are for me the reason for the abstractions which do not allow me to cover my canvas entirely nor to pursue the delimitation of the objects where their points of contact are fine and delicate; from which it results that my image or picture is incomplete."

This may explain why so many of Cézanne's late paintings show scattered spots of bare canvas. In earlier years such lacks had occurred sometimes in corners (even in pl. 154 the artist had still concentrated on the central subject), but in his last years he shows a much stronger preoccupation with the total image, apparently working simultaneously on the entire canvas, probably from the center toward the borders and no longer from the bottom up, as he had done in the eighties. Thus the web of brushstrokes is spread over the entire surface, though progress becomes slower as the various elements take shape and the canvas is covered more densely, for then each bare spot presents a challenge, its surroundings tolerating only the one *right* tone that can weld together the multinuanced touches. This is doubtless why Cézanne in his late years spoke so often of *réflection* (meaning deep thought) in front of his work, as the contemplation of nature alone—though still his primary aim—could not help complete a painting that demanded the last, crucial strokes needed for the desired harmony.

This loosely brushed picture is completely dominated by blue-gray tonalities with a few greenish-blue tints in the ground, the trees, and the sky. There is no color difference between sky and foliage, the trees being suggested by almost random blue lines that isolate trunks or branches from the background. The horizontal strip of the distant shore is of a soft pink-purple, the same color also appearing here and there in the foreground, as well as in the four central bathers.

The support is grayish-white; in the bare spots appear a few vague pencil lines. But the paint seems literally "thrown" at the canvas in large, fairly thick splotches, each formed by a series of repeated strokes. There is only one—by all appearances spontaneous—layer of pigment; the resulting rather abstract and flat mosaic owes its distinct features (vegetation and nudes) to superimposed dark blue outlines.

The darkest spot of the composition is a deep blue triangle in the center foreground, around which four nudes are gathered. Their group is separated from those at the left and right in an arrangement not found elsewhere in Cézanne's work, except in a watercolor (Venturi 1108). Most of the bare white areas are concentrated around the groups of bathers on either side of this center. The figures of the central group appear to be bending down, as though their attention were attracted by something on the ground. This has led to the not altogether farfetched assumption that the composition was inspired by the finding of Moses among the bulrushes.

42. Thicket in Provence [Sous-bois provençal]. 1900–04. Venturi 791
Oil on canvas, 31¼ x 24½ in (79.4 x 62.3 cm)
The Albright-Knox Art Gallery, Buffalo, Room of Contemporary Art Fund
Pl. 73

The subject of this picture—or rather the almost complete absence of a subject—is quite unusual for Cézanne, and so is the composition with a flat foreground, limited by a sharp diagonal, occupying one-third of the canvas. At the border of the light green field that constitutes the foreground stands a single, gracefully bent tree that detaches itself from a thicket of foliage which fills the other two-thirds of the surface and forms a strong contrast to the empty green space. To the right a small

ocher house is located. Reduced to these few pictorial elements, the painting is carried solely by its colors; they are so limpid that this picture has also been called *Morning in Provence* (it is known that the artist used to rise at dawn and, in the summer, often stopped painting outdoors well before noon).

Discussing Cézanne's work after the turn of the century, Theodore Reff spoke of "that largely abstract, even musical harmony—intervals of blue, green, orange and lilac . . .—that marks Cézanne's last period." He also noticed in this landscape another characteristic of the painter's late works, the use of repeated broken contours.

T. Reff, "A New Exhibition of Cézanne," *Burlington Magazine,* March 1960, p. 117.

43. Bend in Forest Road [Route tournante en sous-bois]. 1902–06.
Venturi 789
Oil on canvas, 32 x 25½ in (81.3 x 64.8 cm)
Collection Dr. Ruth Bakwin, New York
Pl. 75

The ocher color of the woodland path points to a motif near the Bibémus quarry, possibly in the area of Le Tholonet, though it has not been possible to locate the strangely crenelated crest of the background. (On the slope behind Château Noir there exists no such level path with a view of the rocky ridge.) This ocher path with reddish-blue shadows winds through a forest with blue tree trunks and dense foliage whose color scheme extends from light green to dark blue-green. Near its bend the presence of some ocher boulders can be guessed at on the left. At top right the indentations of the hill are indistinguishable behind the trees; elsewhere they are of a light yellow color, contrasting with the sky, whose blue sometimes veers to pale green. Small, oft-repeated blue lines, set on top of the various greens, impose a vague structure—the forms of branches, profiles—that the first patchwork of tints had ignored, thus providing a semblance of depth for what had started as a completely flat assemblage of colors. (See Clement Greenberg's comments quoted for no. 9.)

There is no impasto, yet work has been carried to the point where bare canvas appears only in small spots here and there. The brushstrokes—always several short ones of the same hue—are almost all applied vertically (though sometimes diagonally in the path), further avoiding any attempt to express through texture the specific character of the subject.

44. Bend in Road [Route tournante]. 1902–06. Venturi 790
Oil on canvas, 32 x 25½ in (81.3 x 64.8 cm)
Private collection
Pl. 80

One of the most startling features of this landscape is the light and delicate color applied on a gray canvas. Many large areas—such as sky, distant hill, and road—are blocked in with single-tint splashes, but within the checkered vegetation in the center blue lines are put on top of these to detach individual sectors. Apparently no previous pencil indications were used (such indications are obviously obliterated in more finished works, but they frequently appear when the canvas is not completely covered).

The lower tree trunk at right is of the same red as the rock at left, where blue lines also appear, though less frequently than in the vegetation. The patchwork of variations of red at left and of greens and blues in the right-hand treetop is a marvel of subtlety.

The hill in the background is crowned by a heavy blue line that spreads across the canvas like a flat rainbow; beyond it, pale pinks meet the soft blue of the sky. In the middle distance an elongated red spot

(stronger than any of the other reds) draws the eye and leads it upward to the orange-yellow hill, accenting the exquisite harmonies of blue and green.

In most places only one coat of fairly solid paint, usually of light tones, has been applied, on top of which are, here and there, darker tones, reminiscent of the artist's watercolor technique. Between the brushstrokes small spots of bare canvas can be observed.

It is noteworthy that Cézanne's more finished paintings, especially those with heavy crusts of pigment, are generally darker than works left in this condition. Did he always begin with such light tones, and was it as a result of prolonged labor and accumulation of coats of paint that his canvases lost the bright colors with which they had started?

45. Mont Sainte-Victoire above the Tholonet Road [Le Mont Sainte-Victoire au-dessus de la Route du Tholonet]. c. 1904.
Venturi 666
Oil on canvas, 28⅞ x 36¼ in (73.2 x 92.1 cm)
The Cleveland Museum of Art, Leonard C. Hanna, Jr., Collection
Pl. 119

Comparing this second version of the subject with the earlier one (No. 10, pl. 116), Erle Loran has observed:

"In version II, Cézanne makes a quite different interpretation of the mountain, although it is seen from almost the same position (about thirty feet to the left). This painting is obviously a much later work . . . and is far more rhythmic and synthesized in form. Looking at the front planes at the bottom of the picture, we notice that Cézanne has flattened out the olive trees, which in version I protrude somewhat at the lower left. They have been fused with the 'passages' and color planes of the earth and road. All the trees are more formalized. . . . Notice how the main tree [actually two trees] at right center, with its trunk here placed to the left of the foliage volume, pushes downward in rounded planes, creating a strong pull or tension in relation to the rounded forms of the trees bordering the frame at the upper left, in the sky. In version I the trunk of this same tree is pushed to the right, with the heavy foliage volumes building up and to the left. These two contrasting interpretations of the same tree motif afford factual evidence of a conscious approach to organization and design on Cézanne's part. The rightness of each interpretation in its own specific composition seems obvious. Here is proof again that plastic organization demands distortion and alteration of factual appearances. It shows also that every new work of art has its own new laws, even though the same subject is used.

"The mountain in version II is austere and formal, being, on the whole, a severe simplification of the motif in nature rather than a deviation from it. But superimposed lines are particularly obvious and they mark out its four main divisions or planes, within which the smaller modulations are developed."

E. Loran, *Cézanne's Composition,* p. 99.

46. Banks of a River [Bords d'une rivière]. c. 1904. Venturi 769
Oil on canvas, 24 x 29 in (60.9 x 73.6 cm)
Museum of Art, Rhode Island School of Design, Providence, Museum Reserve Fund
Pl. 85

The patchwork of broad, overlapping brushstrokes, along with the fact that distances are established through color modulations rather than linear devices or receding volumes, is typical of Cézanne's last works. So is the amplitude of his approach, the sureness and confidence with which his brush proceeded. This landscape is formed by four parallel planes: the wide, empty foreground, the river, the bank beyond it, and

the sky above. On the far side of the water are vague—though well established—indications of a few buildings; only a curved wall at the extreme right beneath a large cluster of trees draws and guides the eye into the picture space.

This painting appears like a striking illustration of a remark Odilon Redon had formulated decades earlier: "Aerial perspective . . . is simply the result of a rigorously exact tone and well-observed values."

The location of this motif is not known, but since Cézanne worked in and around Fontainebleau in 1904, it would appear very likely that this landscape was painted on that occasion.

47. Blue Landscape [Paysage bleu]. 1904–06. Venturi 793
Oil on canvas, 40⅛ x 32⅝ in (102 x 83 cm)
The Hermitage Museum, Leningrad
Pl. 71

According to A. Barskaya, the *Blue Landscape* was evidently painted during the same period as The Museum of Modern Art's *Château Noir* (pl. 60), which bears a close affinity to the Hermitage canvas. "Cézanne obviously left the painting unfinished," writes Barskaya; "there are large [?] areas of white primer which have not been filled in, and on the lower part of the canvas one can see drops of liquid paint. It is also possible that the rent in the centre, now restored, was the result of a blow that the artist gave his picture in a moment of exasperation, as was frequently the case with him. However, by giving up the canvas about halfway through, Cézanne, perhaps unintentionally, has offered us a glimpse into the inner workings of his art. By brushwork alone, without recourse to topographical indications, the artist has created a composition of blending shapes which evoke an impression of deep space."

Whether "half-finished" or not, this landscape is above all an example of the almost turbulent execution encountered in some of Cézanne's last works. It cannot have been by accident that he selected a motif such as this, practically devoid of structural elements—the vague corner of a building appears drowned in the surrounding blues and greens—and of such a reduced scale of colors. This enabled him to put the accent of this picture on the multilayered brushwork, the lively and closely knit splashes of saturated tones; it even permitted him to carry the colors beyond those of nature, to revel in deep blues that seem to translate an emotion rather than a perception.

Lawrence Gowing believes this landscape to have been executed at Fontainebleau and consequently dates it c. 1905. Yet the hill in the background may also have been located in the region of Les Lauves. In paintings such as this, however, the question of the exact place appears to be of scant importance (except for purposes of dating), for as Kandinsky observed of Cézanne's works: "Not a man, nor an apple, nor a tree is represented, but all these are used by Cézanne to form a thing that is called a picture and that is a formation of inner, painterly resonance."

A. Barskaya, *Paul Cézanne* (Leningrad: Aurora Art Publishers, 1975), p. 189.
W. Kandinsky, *Ueber das Geistige in der Kunst* (Munich: Piper, 1912).

48. The Cistern in the Park at Château Noir [La Citerne dans le parc de Château Noir]. c. 1900. Venturi 780
Oil on canvas, 29¼ x 24 in (74.3 x 61 cm)
Estate of Henry Pearlman, New York
Pl. 53

The paint is laid on with a heavily loaded brush, though the individual strokes are fairly small (in subsequent years Cézanne's brushstrokes tended to become larger). The main accent is provided by the brilliant orange-ocher of the middle ground, behind which appears a large rock of lighter, blue-gray tones. Two slender tree trunks in front of this central rock stress the verticality of the composition, counterbalanced by a more squarish block at the extreme right and by the diagonal poles at left, joined above the cistern. A deep, almost purple-blue shadow models the low wall of the cistern, in front of which appears another, large, almost purple-blue spot, as though to break any threat of symmetry.

The vegetation behind the cistern is of a deep green, but as the eye rises—and follows the rise of the grounds—it perceives increasing browns and blues next to greens, a shimmering mixture of tree trunks, foliage, subdued light, and dark earth. Without any specific indications of space, the colors and the direction of the brushstrokes, extending without interruption to the top of the canvas, convey the sensation of an ascending thicket, dense and mysterious.

49. View toward the Tholonet Road near Château Noir [Vue vers la Route du Tholonet près de Château Noir]. 1900–04
Oil on canvas, 40 x 32 in (101.6 x 81.3 cm)
Estate of Henry Pearlman, New York
Pl. 62

Where the path through the woods at Château Noir joins the Route du Tholonet in the direction of Aix, the roof of a farmhouse farther down the slope is perceived between slim tree trunks. In the distance green hills rise above the valley. Cézanne began this painting by focusing on these gently curved hills, to the point of completely neglecting the foreground.

The hills are represented by diagonally slanted broad blue brushstrokes intermingled with spots of green and pink. The brushstrokes almost seem to race one another to fill the grayish canvas with their close weave, from which the trees and their rare branches are sharply set off by several parallel and broken outlines. The bottom is constituted exclusively by a net of nervous blue and nearly black lines, put down emphatically yet repeated—occasionally up to six times—indicating that the painter had not yet decided which of these lines to use. No such lines appear to have preceded the hills in the upper section, but then these do not feature any structural elements. It is a moot question to what extent the multiple lines of the roof and the ground would have been obliterated once Cézanne had established their forms through color.

50. Château Noir. 1902–05. Venturi 797
Oil on canvas, 27½ x 32¼ in (70 x 82 cm)
Collection Jacques Koerfer, Bern
Pl. 55

The immediate foreground presents variations of green behind which appear large diagonal spots of green-blue, the green turning sometimes close to yellow and the blue into muted purple. The sky is executed in the same technique, though with a lighter blue mixed with lighter green. Mont Sainte-Victoire, whose top can barely be perceived, is treated in a darker blue. The building complex, outlined in straight blue lines, takes on a cubic aspect. Its front—a dull yellow—provides the central note of the composition, with shadowed parts in a bluish mauve-pink; the barn door is slightly reddish. This creates a strange contrast between the lively foreground vegetation, the rigid structure, and the flat though richly textured sky. White canvas is visible mostly along three edges of the canvas and in the foliage.

The application of paint, while by no means thin, is considerably less heavy than in other versions of the same subject, where several layers of pigment form an uneven crust. Yet all tonal values are most carefully balanced and interrelated, so that this is not to be considered as a

preparatory study nor as an "unfinished" one, but simply as a work whose execution was *interrupted* at the present stage. It might well illustrate what Cézanne told young Maurice Denis in 1906: "As I cannot convey my perception immediately, I put on more color and keep putting it on as best I can. But when I begin, I always try to paint sweepingly, like Manet, by giving form with the brush."

51. Château Noir. 1904–06. Venturi 794
Oil on canvas, 29 x 36¾ in (73.6 x 93.2 cm)
The Museum of Modern Art, New York, gift of Mrs. David M. Levy
Pl. 60

The features of the "motif" are reduced to pictorial elements, to spots of color in an irregular weave of strokes. "One must have a feeling for the surface," said Matisse, "and know how to respect it. Look at Cézanne. Not a single spot in his pictures sinks in or weakens. Everything has to be brought to the same plane in the mind of the painter."

Because of the strange way in which Cézanne humbly submitted to his perceptions while dominating them, he remained attached to nature's permanence rather than allowing himself to be distracted by the charm of evanescent conditions of light. His concern lay in the complete integration of his observations on the picture plane.

Though Cézanne had previously often set side by side several short strokes of the same tint, he now seemed to pick up a different hue from his palette whenever he reloaded his brush, a brush that was wide and heavy with paint, so that it could deposit large patches on the canvas. These combine into an opaque surface on which they are so densely assembled that they lose their individuality and become blotches of indistinct shape. While they are put down with remarkable authority, these blotches are interlocked so freely that the surface seems to be alive. It is from this cohesion of apparently loose brushwork, from the compactness of its web, from the richness of subtly attuned or opposed nuances that there rises an image of supreme power or, as Cézanne would have put it more modestly, a *harmony parallel to nature.*

This landscape used to hang in Monet's bedroom. Once, when he showed it to a visitor who had come to Giverny in the company of Georges Clemenceau, his only comment was, "Yes, Cézanne, he is the greatest of all of us."

Matisse quoted by G. Diehl, "A la recherche d'un art mural," *Arts et lettres* (Paris), April 19, 1946.
Monet quoted by M. Georges-Michel, *De Renoir à Picasso* (Paris: Fayard, 1954), p. 24.

52. Château Noir. 1904–06. Venturi 795
Oil on canvas, 28¾ x 36¼ in (73 x 92 cm)
Musée du Louvre, Paris, gift of Pablo Picasso
Pl. 59

The colors appear strangely dull and muted. The brushstrokes are large and not too heavily loaded with paint. Trees and sky almost fuse, though the diagonal brushwork of the sky is opposed to vertical strokes elsewhere. The yellow house and the terrace stand out from the maze of green. The main building with its slanting roof can be perceived to the right of the west wing. The foreground has remained vague, its vegetation ascending toward the horizontal terrace wall.

Speaking of the colors of a scroll by Takanobu in Kyoto (12th–13th century), André Malraux said: "In the Occident, mat painting means frescoes. But frescoes remain in the shade. I have found the substance of this scroll only in the *Château Noir* of Picasso's collection. Vollard, faithful to Cézanne, had not varnished it."

A. Malraux, *La Tête d'obsidienne* (Paris: Gallimard, 1974), p. 191.

53. Lady with Book [La Dame au livre]. 1902–06 (or somewhat earlier). Venturi 703
Oil on canvas, 26 x 19⅝ in (66 x 49.8 cm)
The Phillips Collection, Washington
Pl. 20

While less famous than the *Old Woman with a Rosary,* this painting is just as masterly, as rich in nuance, as deep in color, as opulent in texture, as poignant as a human statement. The broad brush here laid the pigment on heavily—in few coats and with little impasto—forming a mosaic of muted tones which the artist applied with apparent spontaneity, though we know from his letters how long he hesitated, how anxiously he made sure that every stroke would add just the right tonality.

Only the sleeves and bodice of the woman's dress are blue or blue-green, the jabot being blue-black, as is the hat adorned with blue flowers; the skirt is blue-purple with traces of green. To the left hangs a curtain with brown foliage on a blue-black ground. The wall at right is a reddish-brown. A blue strip appears in the picture frame at top right. The only vivid accent that brightens this grave harmony is the lively yellow of the book in the sitter's hands.

Though she also posed for another picture (pl. 19), it is not known who the sitter was. It might have been Mme Brémond, Cézanne's housekeeper in Aix, especially since tailored suits were extremely popular in the late nineties, as were triple-puffed sleeves. She could of course have worn an outfit that was already slightly out of fashion. This was less likely to apply to the artist's wife, although Venturi accepted the hypothesis that she is represented here.

54. Lady in Blue [La Dame en bleu]. 1902–06. Venturi 705
Oil on canvas, 34⅝ x 28 in (88.5 x 72 cm)
The Hermitage Museum, Leningrad
Pl. 19

The woman who sat for this painting is obviously identical with the model of pl. 20, wearing the same outfit. However, the general appearance of this picture is brighter; there are fewer shadows in her face, her tailored suit is lighter, partaking more of green, and while at left the brown drapery with leaves has been replaced by a much darker section of wall (which, at right, shows vertical lines absent from the other version), the colorful rug on the table in the lower right, with its red and green floral ornaments set in rust-brown squares, adds an extremely lively note to the composition. The yellow book, on the other hand, has been dispensed with. The verticals of the background might have threatened this arrangement with rigidity were it not for the woman's bent arm that superbly fills the space and stresses the weight of the figure.

Discussing Cézanne's portraits, Douglas Cooper once remarked that the artist "was quite indifferent to his sitter's face or character. . . . His portraits have a great vitality, but because of their plastic organization, not because of the sitter's personality." *Vitality* may not be the right word for the impressive physical *presence* that distinguishes Cézanne's likenesses, yet it is true that his portraits do not betray specific moods and that it is usually impossible to ascertain even the approximate age of his models. But when Cooper tried to explain this by saying that "Cézanne's sensations proceeded from his brain," he certainly both oversimplified and misstated the problem.

Whether Cézanne studied a landscape, a still-life composition, or a human being, his observations were concerned with color relationships, his task being to reconstruct on the flat surface of his canvas what he contemplated while he worked. "For the artist," he told his son, "to

see is to conceive, and to conceive is to compose; for he does not express his emotions as the bird modulates its tune: he composes." And to Gasquet he explained: "One does not paint souls. One paints bodies . . ." At the same time he insisted:

"There is a logic of color. . . . The painter owes obedience to this logic, never to that of the brain; if he abandons himself to the latter, he is lost. Always heed the logic of the eyes. If he feels accurately, he'll think accurately. Painting is above all a question of optics. The material of our art is there, in what our eyes think. Nature, when she is respected, always finds a way of saying what she signifies."

D. Lord [Cooper], "Nineteenth-Century French Portraiture," *Burlington Magazine,* 1938, pp. 253–63.
"Cézanne parle . . . ," in L. Larguier, *Le Dimanche avec Paul Cézanne* (Paris: L'Edition, 1924), p. 133; statements by the artist transcribed by his son.
J. Gasquet, *Cézanne* (Paris: Bernheim-Jeune, 1926), pp. 100, 88.

55. The Garden at Les Lauves [Le Jardin des Lauves]. c. 1906. Venturi 1610

Oil on canvas, 25¾ x 32 in (65.5 x 81.3 cm)
The Phillips Collection, Washington
Pl. 79

Painted on a yellowish, gray-white canvas, this landscape is organized into three distinct horizontal areas, of which an almost bare strip forms the foreground. On it appear a few hastily brushed splashes of light green, above which runs the dark, mostly dull violet wall of the terrace. Beyond this wall are frequently square patches of blue, green, orange, and pink, loosely assembled with a great deal of bare canvas between them. The top section is occupied by the sky, with indications of pink in the middle, which form the central focus around which the other color spots freely evolve. At right the sky is blue; in the upper left is what looks like a somber cloud in gray-blue and blue, responding to the dark wall at the bottom.

In some places—especially at left and in the sky—diluted paint has been rubbed on the canvas, or possibly was wiped off after being brushed on; sometimes the paint was so thin it actually ran. But mostly there is a regular, single coat of pigment with strokes that occasionally overlap. The welter of multicolored spots has not yet reached the stage where the artist usually applied some blue lines with his brush to impose an order on the whole and set off individual features of the subject. Even at this early stage, however, there is no fumbling; what has been put on canvas occupies its rightful place in the work about to be born, which seems to be opening up like a bud ready to bloom before the beholder's eye.

Discussing Cézanne's oft-quoted statement that he wished to replace modeling by *modulation,* Herbert Read has explained that the artist meant "the adjustment of one area of colour to its neighboring areas of colour: a continuous process of reconciling multiplicity with an overall unity. Cézanne discovered that solidity or monumentality in a painting depends just as much on such patient 'masonry' as on the generalized architectural conception. The result, in terms of paint-application, is an apparent breaking up of the flat surface of a colour area into a mosaic of separate colour-facets. This procedure became more and more evident during the course of Cézanne's development, and is very obvious in a painting like *Le Jardin des Lauves. . . .* An isolated detail from almost any painting done after 1880 will show the same mosaic surface-structure. It must be appreciated, however, that what we thus isolate to dissect into its constituent planes is, in the whole picture, completely integrated into the picture as a whole. The justification of such a technique for Cézanne is that it is 'a good method of construc-

tion.' As in a completed architectural monument, we should not be aware of the units that together constitute the unity."

H. Read, *A Concise History of Modern Painting* (New York: Praeger, 1959), pp. 18–19.

56. Le Cabanon de Jourdan. 1906. Venturi 805

Oil on canvas, 25⅝ x 31⅞ in (65 x 81 cm)
Collection Riccardo Jucker, Milan
Pl. 83

In July 1906, Cézanne mentioned in a letter to his son that he was working "at Jourdan's," and in October, after heavy rains and thunderstorms had put an end to the summer's extreme heat, he announced to him that he was climbing up to the Quartier de Beauregard—northeast of Aix—where he was doing watercolors (see pl. 84). Though the exact location of the Cabanon de Jourdan is not known, it is a fact that an Aix merchant named Jourdan owned a great deal of real estate in the Beauregard sector; he was even municipal councillor of the nearby commune of Saint-Marc. Jourdan's *cabanon,* in what is reputedly Cézanne's last landscape painting, is a low building of bright ocher beneath a blue sky with, at left, a door of startling blue, the same blue used for peasant carts in Provence (van Gogh represented such a blue cart in a view of La Crau near Arles). To the right of the house, in the background under the trees, appears a dark form that looks like a typical Provençal well in the shape of a beehive; farther to the right and closer to the foreground stands a wall in the blue shade. Across the ocher foreground run vivid patches of green. The brushwork is lively and superbly emphatic.

It was while the artist was working on this canvas, shortly before his death, that the reactionary and influential critic Camille Mauclair published a book, *Trois Crises de l'art actuel,* with a chapter on "The Crisis of Ugliness in Painting," in which he had this to say:

"As to Monsieur Cézanne, his name will remain attached to the most memorable art joke of these last years. . . . This honest man . . . paints in the provinces for his own pleasure and produces works that are heavy, badly constructed, and conscientiously ordinary: still lifes of rather fine texture and raw colors, leaden landscapes, figures that a journalist has recently called 'Michelangelesque' and which are simply the crude attempts of an eager person who has not been able to replace his good intentions by knowledge. (I insist with the most sincere urbanity on these 'good intentions.' I have no doubt that Monsieur Cézanne, far from the snobs and in no way believing himself to be the great man they are inventing, is mad about painting and does the best he can. But what of it! Let us bow to the intentions; yet the spirit inhabits those it pleases, and they are not always the ones who most ardently call for it. And it has never inhabited Monsieur Cézanne.)"

Leaden landscapes and memorable art jokes, indeed!

57. Mont Sainte-Victoire Seen from Les Lauves [Le Mont Sainte-Victoire vu des Lauves]. c. 1902

Oil on canvas, 33 x 25⅝ in (83.8 x 65 cm)
Estate of Henry Pearlman, New York
Pl. 117

Though Cézanne hardly changed the spot on the crest of the Lauves hill from which he so often painted Sainte-Victoire during his last years, he met the challenge of monotony by slightly varying the angle from which he contemplated it, or altered the format of his canvas. Sometimes he looked more to one side than to another; occasionally he featured trees in the foreground, focused on some buildings, or even added strips of canvas to the standard format of his stretcher so as to convey the immensity of the wide plain from which—in the dis-

tance—the mountain suddenly rises. (In like manner he added strips of paper to his sheet to attain the same effect in a watercolor; see pl. 126.) But only seldom did he attempt the opposite—a vertical view, where the importance of Sainte-Victoire is somewhat reduced as it appears "pushed" toward the top of the composition that presents itself in three horizontal layers: the narrow ocher-pink band of a field in the foreground, set against the richly textured wooded middle ground livened by a few red roofs, and topped by the mountain whose cool blue is almost indistinct from the sky from which dark blue outlines vibrantly detach it. Thus it is the middle ground that fills the greater part of the canvas, its pinkish-ocher tones linking it to the foreground while blue tints interspersed among the many green shades lead the eye toward the sky. Each of these three layers is conceived with strict regard to the function of the other two and forms a total harmony of a dense weave of strokes, each of which, despite the tremendous freedom of execution, corresponds to elements of the motif.

58. Mont Sainte-Victoire Seen from Les Lauves [Le Mont Sainte-Victoire vu des Lauves]. 1902–04. Venturi 798
Oil on canvas, 27½ x 35¼ in (69.8 x 89.5 cm) (sight)
Philadelphia Museum of Art, George W. Elkins Collection
Pl. 122

Discussing the juxtaposition of photographs of motifs with the corresponding paintings (cf. the quotation in the note for no. 59), E. H. Gombrich differs markedly from Erle Loran in the attitude that he adopts:

"Historians of art have explored the regions where Cézanne and van Gogh set up their easels and have photographed their motifs. Such comparisions will always retain their fascination. . . . But however instructive such confrontations may be when handled with care, we must clearly beware of the fallacy of 'stylization.' Should we believe the photograph represents the 'objective truth' while the painting records the artist's subjective vision—the way he transformed 'what he saw'? Can we here compare 'the image of the retina' with the 'image in the mind'? Such speculations easily lead into a morass of unprovables. Take the image on the artist's retina. It sounds scientific enough, but actually there never was *one* such image which we could single out for comparison with either photograph or painting. What there was was an endless succession of innumerable images as the painter scanned the landscape in front of him, and these images sent a complex pattern of impulses through the optic nerves to his brain. Even the artist knew nothing of these events, and we know even less. How far the picture formed in his mind corresponded to or deviated from the photograph it is even less profitable to ask. What we do know is that these artists went out into nature to look for material for a picture and their artistic wisdom led them to organize the elements of the landscape into works of art of marvellous complexity that bear as much relationship to a surveyor's record as a poem bears to a police report."

Max Raphael devoted a long study to this painting, in the course of which he stated: "The complex relationship between art and nature cannot be defined as one of imitation of a model given once and for all. . . . Just as nature alone does not determine the mind, so the mind, conversely, cannot dictate its law to nature. . . . Man's active, creative mind is never identical with itself for any length of time. . . . For the very reason that in art the human mind neither imitates nature nor imposes its own laws on it, the work of art possesses specific reality and is governed by laws of its own. . . . Whatever form art may assume in the course of history, it is always a synthesis between nature (or history) and the mind, and as such it acquires a certain autonomy vis-à-vis both these elements."

Speaking specifically of this landscape, Raphael observed: "Cézanne restricted his palette to four main colors—violet, green, ocher, and blue—which he used in sharply contrasting ways. In the foreground we see a triad whose components—violet, ocher, and green—do not show the slightest inner connection, for although the red in the violet is complementary to the green and the blue in the violet is complementary to the ocher, the two greens he chose are not complementary to *this* red and the ocher is not complementary to *this* blue in the violet. The mutual exclusion of color qualities is not overcome by any external means of connection or mediation; the three colors in the foreground do not form a harmonious chord, but a shrill dissonance of tremendous force. As early as 1884 Cézanne had written to Zola: 'The external appearance of art is undergoing a terrible transformation, taking on too much of a very paltry form. At the same time the ignorance of harmony reveals itself more and more through the discord of colors and, what is even worse, the aphony of tones.'

". . . Cézanne's capacity for differentiation is extraordinary: the abundance of color gradations to be found in his works could be created, recorded, and mastered only by an exceptionally strong artistic temperament, a superior intellect, a stubborn will, and an uncommonly sharp eye. His general principles of differentiation, in addition to light and shadow, involve contrasts between warm and cold, opacity and transparency, brilliance and dullness, thickness and thinness, smoothness and roughness, structure and absence of structure; degrees of intensity and magnitude, and relative position. There are brighter and darker greens, violets, etc., warm and cold ochers, greens, blues; all the main directions—the vertical, the horizontal, and many slanted ones; all tendencies to movement—reclining, standing, and extending; every sort of positioning on the surface and opening up in depth, and every kind of transition from rest to movement. The thicker layers of paint are more opaque, more structural, and rougher, whereas the thinner layers are less opaque and smoother; the result is a play of textures, with transparency in depth and relief in the foreground. . . .

"*Mont Sainte-Victoire* is not painted in consistently clear tones; light and dark colors alternate continually in an austere rhythmic structure. At the bottom plane of the painting a darkness of violets and greens is used throughout. The middle plane can be divided into three bands, each showing three articulations: in the lowest the values are disposed horizontally as light-light-dark; in the middle one the disposition is reversed (dark-dark-light); in the upper reigns symmetry (dark-light-dark), preparing the bipartite division of the sky into a cold and a warm dark. The distribution of light may also be described as follows: the painting is divided by a line which runs from the lower left corner to the center top; to the right of this line a shadow falls dramatically across the path of light; to the left a light and half-light area falls across the shadow, producing a contrast which gives way to symmetry at the top. But this distribution is nevertheless only the external, regulative aspect of the composition of light. It must also be noted that the lower part shows a number of violent contrasts both in depth and horizontally. In the upper part, however, the contrasts penetrate and pass into one another; the middle part is transitional in the sense that many small lights and shadows are concentrated in a small space in the form of external contrasts which begin to interpenetrate in a hovering manner, but are not yet as clearly outlined as in the mountain. But in studying this rich compositional development we must not overlook the presence of conflict—the fact that the light is merely a path which runs horizontally between two different kinds of dark, trying to penetrate them, but without brightening them. . . .

"As for the role of color in the composition, the division of the painting into three horizontal bands is again of crucial significance. At

the bottom the principal colors are violet, green, and ocher; they are strongly concentrated in relatively large masses which together form a kind of oval. The lower section of this oval consists of rising violet tones pressing into depth, rhythmically interrupted by dark greens. The upper section of the oval consists of various greens which check the movement in depth. The warm dark green at the right has a heavy downward movement; the brighter, cooler green at the left, a slightly upward movement. The two parts of the oval are linked by the ocher of the farmstead (with the red roofs), whose linear boundaries extend into depth, while the intense cold color seems to be immobilized "between the two opposed movements, forward and backward."

E. H. Gombrich, *Art and Illusion,* Bollingen Series (Princeton, N.J.: Princeton University Press, paperback ed., 1972), pp. 65–66.

M. Raphael, *The Demands of Art,* trans. N. Guterman, Bollingen Series (Princeton, N.J.: Princeton University Press, 1968), pp. 9, 16–17, 36–37.

59. Mont Sainte-Victoire Seen from Les Lauves [Le Mont Sainte-Victoire vu des Lauves]. 1902–06. Venturi 799
Oil on canvas, 25½ x 32 in (65 x 81 cm)
Private collection
Pl. 121

Comparing this work with a photograph taken from the spot where it was painted, Erle Loran has observed:

"Here is one of the last paintings Cézanne made of the mountain, and without the accompanying photograph of the motif it might be considered highly abstract. Definite transformations have certainly been made and the arbitrariness of the individual color planes is typical of the series of late paintings done from this location.

". . . The motif reveals typical aerial perspective or fading away of the mountain, which is seen here from a distance of eleven miles or more; but although Cézanne has eliminated its details he has given the mountain an intensity almost equal to that of the foreground forms and has emphasized its height. The photograph shows a gradual diminishing and fading away from the immediate foreground toward the distant mountain. . . . Cézanne, on the contrary, has kept this vast space comparatively shallow . . . without losing the effect of planes stepping back into the distance. In fact, Cézanne's painting actually involves more distance than [the] photograph shows. The large . . . area of trees . . . is almost entirely missing in the photograph.

". . . Three-dimensionality is clearly established; yet in this painting, as in the entire series to which it belongs, the allover patchwork of color planes produces a pronounced two-dimensionality. The individual planes are definitely flat and the line drawing is more segmented and ragged than usual, making the larger divisions less clear in space. Strong construction lines that 'carry through' vertically, diagonally, and horizontally afford still more two-dimensionality."

E. Loran, *Cézanne's Composition,* pp. 104–5.

60. Mont Sainte-Victoire Seen from Les Lauves [Le Mont Sainte-Victoire vu des Lauves]. 1902–06. Venturi 801
Oil on canvas, 25 x 32¾ in (63.5 x 83 cm)
Kunsthaus, Zurich
Pl. 124

Painted on a light gray ground (with traces of a preparatory pencil sketch still visible?), the picture is a mosaic of large, seemingly slapdash spots applied vertically, horizontally, and diagonally in dull tones: earthen yellows are neighbors to dark greens; a few isolated, almost muddy pinks contrast with variations of blues which elsewhere turn into grayish purple. The dense though light blue of the sky is relieved by frank greens. From a few feet away the somber blues and greens of the plain in the foreground appear nearly black, while clearly perceptible diagonals lead the eye simultaneously into the distance and upward to the blue mass of the mountain with a daring spot of pink.

It is a miracle to see the multicolored patches gain cohesion as one steps away from their entanglement and becomes aware of directions and receding planes that convey an impression of vast spaces. While this is not the "optical mixture" that Seurat had advocated a little more than a decade earlier, it is nevertheless an execution that opposes contemplation from too close up, since the eye of the beholder must operate the fusion from which the image emerges. But this is characteristic not only of the paintings of Cézanne's last years; it is also to be observed in the late style of many other artists, from Titian and Rembrandt to Degas and Monet. It is as though individual forms and details lose interest for them as they pursue a larger, more general and more "abstract" vision; yet beneath their sweeping statements, their summary execution, and the often heavy crust of pigment lies a profound knowledge of nature and lifelong experience. Their aim is no longer merely depiction of reality but a penetrating concept of the soul.

61. Mont Sainte-Victoire Seen from Les Lauves [Le Mont Sainte-Victoire vu des Lauves]. 1902–06. Venturi 800
Oil on canvas, 25⅝ x 32 in (65 x 81.3 cm)
Nelson Gallery of Art—Atkins Museum, Kansas City, Mo., Nelson Fund
Pl. 120

The German collector Karl Ernst Osthaus visited Cézanne in the rue Boulegon in April 1906. He later recalled that the artist "explained his ideas in front of several canvases and sketches which he fetched from all over the house. They showed masses of brush, rocks, and mountains all intermingled. *The principal thing in a painting,* Cézanne said, *was to find the distance.* It was there that one recognized the talent of a painter. And saying this, his fingers followed the limits of the various planes on his canvases. He showed exactly how far he had succeeded in suggesting the depth and where the solution had not yet been found; here the color had remained color without becoming the expression of distance."

Although the type of subjects mentioned by Osthaus seems to designate works from the Bibémus quarry such as pl. 31, one can imagine even more easily Cézanne providing such interpretations in front of one of his many views of Mont Sainte-Victoire seen from Les Lauves. There more than in any other of his paintings he represented his motif without any recourse to linear perspective, entrusting to color modulations the task of suggesting depth.

On his way back from Aix, Osthaus stopped in Paris and acquired from Vollard two landscapes by the artist, one of them a view of the Bibémus quarry, pl. 31.

62. Mont Sainte-Victoire Seen from Les Lauves [Le Mont Sainte-Victoire vu des Lauves]. 1904–06. Venturi 1529
Oil on canvas, 23⅝ x 28⅜ in (60 x 72 cm)
Kunstmuseum, Basel
Pl. 128

Joachim Gasquet's recollections of Cézanne, put down many years after the painter's death, do not always inspire confidence. The poet's innate verbosity often transformed Cézanne's occasionally quite awkward words into an insufferably literary style. Yet, despite such shortcomings, Gasquet does seem to have caught some of the artist's expressions when he transcribed a conversation with him in front of a motif (which, incidentally, was not this one):

"You see, a motif is this. . . ." (He put his hands together . . . drew

them apart, the ten fingers open, then slowly, very slowly brought them together again, clasped them, squeezed them tightly, meshing them.) "That's what one should try to achieve. . . . If one hand is held too high or too low, it won't work. Not a single link should be too slack, leaving a hole through which the emotion, the light, the truth can escape. You must understand that I work on the whole canvas, on everything at once. With one impulse, with undivided faith, I approach all the scattered bits and pieces. . . . Everything we see falls apart, vanishes, doesn't it? Nature is always the same, but nothing in her that appears to us, lasts. Our art must render the thrill of her permanence along with her elements, the appearance of all her changes. It must give us a taste of her eternity. What is there underneath? Maybe nothing. Maybe everything. Everything, you understand! So I bring together her wandering hands. . . . I take something at right, something at left, here, there, everywhere, her tones, her colors, her nuances, I set them down, I bring them together. . . . They form lines. They become objects, rocks, trees, without my planning. They take on volume, value. If these volumes, these values, correspond on my canvas, in my sensibility, to the planes, to the spots which I have, which are there before our eyes, then my canvas has brought its hands together. It does not waver. The hands have been joined neither too high nor too low. My canvas is true, compact, full. . . . But if there is the slightest distraction, if I fail just a little bit, above all if I interpret too much one day, if today I am carried away by a theory which runs counter to that of yesterday, if I think while I paint, if I meddle, whoosh! everything goes to pieces. . . .

"The artist is no more than a receptacle for sensations, a brain, a recording apparatus. . . . But if it interferes, if it dares, feeble apparatus that it is, to deliberately intervene in what it should be translating, its own pettiness gets into the picture. The work becomes inferior. . . .

"Art is a harmony parallel to nature. What can we say to the fools who tell us: the painter is always inferior to nature? He is parallel to her. Provided, of course, he does not intervene deliberately. His only aspiration must be to silence. He must stifle within himself the voices of prejudice, he must forget, always forget, establish silence, be a perfect echo. Then the landscape will inscribe itself on his sensitive tablet. In order to record it on the canvas, to externalize it, his craft will have to be appealed to, but a respectful craft which also must be ready only to obey, to translate unconsciously—so well does it know its language—the text it is deciphering, the two parallel texts, nature as seen, nature as felt, the one that is there . . . (he pointed to the green and blue plain), the one that is here . . . (he tapped his forehead), both of which must merge in order to endure, to live a life half human, half divine, the life of art, listen to me . . . the life of God."

J. Gasquet, *Cézanne*, pp. 131–33.

63. Mont Sainte-Victoire Seen from Les Lauves [Le Mont Sainte-Victoire vu des Lauves]. 1904–06
Oil on canvas, 21¼ x 28¾ in (54 x 73 cm)
Galerie Beyeler, Basel
Pl. 127

It is in works such as this that Walter Pach found "a conception of painting in which the aspect of nature—recalling that of the great Chinese painters of mountain scenery—is rendered by a succession of almost abstract forms, which give to the younger men their strongest suggestion of the expressiveness of an art built even more directly on such a base."

W. Pach, *The Masters of Modern Art* (New York: Huebsch, 1924), p. 107.

64. Seated Man [Homme assis]. 1905–06. Venturi 714
Oil on canvas, 25½ x 21½ in (64.8 x 54.6 cm)
Collection Thyssen-Bornemisza, Monte Carlo
Pl. 16

An unknown peasant or neighbor of Cézanne's is posing here on the terrace of the artist's Lauves studio. This painting once more illustrates the fact that Cézanne often "drew" lines on top of broadly brushed areas and that he did not follow any preconceived plan of work, so that essential sections, such as the features of the model, could be left vague, or rather could be attended to on a later occasion (which might never arise). Yet the still loose tissue of brushstrokes that spreads over the entire surface is much denser than in other abandoned pictures of the last years. It was precisely at this stage of the execution, where the canvas is essentially covered and only a few white spots remain, that the painter felt the greatest qualms about each new stroke, qualms for which he had given the reasons when Vollard discussed with him the unfinished aspect of the hand in his own portrait (pl. 4).

The yellow horizontal of the low wall is "crowned" by the yellow straw hat; the white towel over the sitter's arm relieves the darkness of the blue figure posing against blue-green foliage. For a watercolor of the same subject see pl. 15.

65. The Gardener Vallier [Le Jardinier Vallier]. 1905–06. Venturi 716
Oil on canvas, 42⅛ x 28½ in (107 x 72.4 cm)
Private collection, France
Pl. 22

All his life Cézanne dreamt of painting nudes out of doors, especially as preparatory studies for the large compositions of female bathers which preoccupied him during his last years. But for various reasons he never found it possible to carry out this project. Once he had moved into his Lauves studio, however, in the fall of 1902, he frequently had fully clothed models pose for him on the terrace, under the linden tree. In these works he could observe the human figure enveloped by natural light, though doubtless sitting in the shade. This was a new departure for him after the many portraits of his wife, his son, or some friends, most of which had been executed indoors. Yet it is worth noting that his earlier figure paintings were generally much brighter than those of his final years, which, despite the natural light, are conceived in a considerably darker vein that is not merely a result of an accumulation of successive layers of pigment; it is also due to the use of more opaque, darker, and earthier colors.

"The portrait of his gardener," Roger Fry wrote of this canvas, "is typical of a good many portraits of these years. Here . . . the aspect chosen is less frontal, there is a free sweeping emphasis in the contours very different from the precision and austerity of the *Geffroy* [pl. 1]. The picture is deep in tone and rich with the sombre glow of indigos, broken with violet and green, and contrasted with rich earth reds and oranges."

R. Fry, *Cézanne: A Study of His Development*, p. 81.

66. The Gardener Vallier [Le Jardinier Vallier]. 1905–06
Oil on canvas, 42¼ x 29⅜ in (107.4 x 74.5 cm)
The National Gallery of Art, Washington, gift of Eugene and Agnes Meyer
Pl. 24

Because Vallier sports a visored cap, this painting has often been called *The Sailor*. It is one of the two largest pictures for which Cézanne's gardener posed. To judge from the dark green modulations in the

background, here he sat on the terrace. His gaunt figure occupies the entire canvas, to which a strip of about five and a half inches was added at the bottom, below the knee, to permit the appearance of the red diagonal of the chair and thus temper the heavy, somber mass of his body.

The canvas is completely covered, the brushstrokes being so broad that the uppermost of several thick layers looks almost as though it had been applied with a palette knife. The coat and cap are deep blue with hints of purple, sometimes approaching black. The weather-beaten face and hand are of the same brick color as the chair. The wall behind the figure is dark brown and the soil a somewhat lighter brown.

Heavy impasto appears over the entire canvas, but particularly in the face, especially at right, where deep shadows sharply set off the nose; it is found also in the beard and at the temple, where the accumulated pigment forms small lumps. Heavy impasto similarly surrounds the right hand and the left shoulder, following the line that sets it off from the background. This impasto attests to hard, strenuous work and many silent sittings.

It is an impressive, compact presentation of a man wrapped in his own concerns, from whom no emotions emanate. Yet there is immense grandeur here—a gripping and haunting image of an old man at the end of a long, hard life being scrutinized by another old man. One is reminded of what Santayana said of Marcel Proust: "Life as it flows is so much time wasted, and . . . nothing can ever be recovered or truly possessed save under the form of eternity, which is also . . . the form of art."

67. The Gardener Vallier, Full-Face (Presumed Portrait of Cézanne) [Le Jardinier Vallier vu de face (Portrait présumé de Cézanne)]. 1905-06. Venturi 717
Oil on canvas, 39½ x 32 in (100.3 x 81.3 cm)
Private collection, Switzerland
Pl. 23

According to Joachim Gasquet, the portraits of the gardener Vallier also represent an old beggar as well as Cézanne himself, who, once his model had left, would dress in the latter's tattered clothes in order to continue working. But this story sounds highly improbable, not only because Gasquet had completely lost touch with the painter by 1905 and is anyhow—as we now know—not always a reliable source, but mainly because it appears rather incongruous to imagine Cézanne working in front of a large mirror on the terrace of his Lauves studio.

Though not as tall as the other versions (since no strip has been added here), this canvas is a few inches wider, providing for the full breadth of the seated, frontal figure, his ample coat thrown over his shoulder for an even heavier effect. The execution is, if anything, still more labored, with more impasto and more lumps of accumulated pigment than in pl. 24. But the large dark mass of the squat peasant is relieved by a light scarf around his neck and the more articulate hand on his knees.

"I proceed very slowly," Cézanne had written to the young painter Emile Bernard, "because nature presents itself to me with great complexity, and there is continual progress to be made. One must observe one's model well and feel very accurately, but also express oneself with distinctiveness and force."

Since the three versions of the Vallier portrait left Vollard's gallery, there has never been an opportunity to see them together. It could be that their study at this exhibition may provide some clues as to their possible sequence.

André Masson has said of Cézanne's last period that "the concentration is such that it explodes. It is a 'phenomenon of the future.' Tired

of proposing to a blind world the richness of his vision, he henceforth dialogues only with the interlocutor that is within him. A sovereign liberty is the result, that of the ultimate quartets of Beethoven, that of the rugged practices of the Zen monks. Offerings to that which has no end."

In one of the most moving passages of her biography of Roger Fry, Virginia Woolf describes one of Fry's lectures: "With pauses and spurts the world of spiritual reality emerged in slide after slide—in Poussin, in Chardin, in Rembrandt, in Cézanne—in its uplands and its lowlands, all connected, all somehow made whole and entire, upon the great screen. . . . And finally the lecturer, after looking long through his spectacles, came to a pause. He was pointing to a late work by Cézanne, and he was baffled. He shook his head; his stick rested on the floor. It went, he said, far beyond any analysis of which he was capable. And so instead of saying, 'Next slide,' he bowed, and the audience emptied itself."

Where Roger Fry remained without words, this commentator must be permitted to do likewise.

A. Masson, in *Le Tombeau de Cézanne*, p. 38.
V. Woolf, *Roger Fry: A Biography* (London and New York: Harcourt Brace, 1940), chap. 11, sect. 7.

WATERCOLORS

The watercolor entries, by Adrien Chappuis and John Rewald, are based on corresponding entries in the catalogue raisonné of Cézanne's work that John Rewald is preparing for publication as a New York Graphic Society Book by Little, Brown and Company (Inc.).

68. Apples, Bottle, and Glass [Pommes, bouteille et verre]. 1895-98. Venturi 1617
Pencil and watercolor on white paper, 12¼ x 18⅞ in (31 x 48 cm)
Collection Mr. and Mrs. A. Chappuis, Tresserve, France
Pl. 172

This is essentially a drawing with color added. Repeated pencil lines insist on the roundness of the fruit and occasionally indicate shadows. But then deft brushstrokes provide brilliant red accents and a few yellow touches, leaving the paper white for the highlights. The flat top of the table is the main agent creating space, animated by the round shapes of fruit. The bottle, the glass, and the window frame convey a sense of depth and height. The result is an image that combines delicate indications with sparkling affirmations.

69. Foliage [Etude de feuillage]. 1895-1900. Venturi 1128
Pencil and watercolor on white paper, 17⅝ x 22⅜ in (44.8 x 56.8 cm)
The Museum of Modern Art, New York, Lillie P. Bliss Collection
Pl. 168

The initial pencil sketch appears to have been rather vague, with many repeated strokes representing dark areas. But despite these preparatory indications, the treatment of the subject is exclusively by color, mostly greens and blues in light, delicate, frequently superimposed washes with a good deal of paper between them remaining bare. They convey the impression of a luxuriant tangle of foliage intermingled with occasional touches of red that usually surround empty spots as though possibly representing whitish-pink roses. A few blue lines emerging from and disappearing into this maze obviously indicate branches.

70. Still Life: Apples, Pears, and Pot (The Kitchen Table) [Nature morte: pommes, poires et casserole (La Table de cuisine)]. 1900–04. Venturi 1540
Pencil and watercolor on white paper, 11 x 18¾ in (28.1 x 47.8 cm)
Cabinet des Dessins, Musée du Louvre, Paris
Pl. 178

According to Geneviève Monnier, "The contours of the objects are still outlined by the means of a brush and blue color . . . but washes of bright colors (reds, blues, yellows) model the volumes with a suppleness and a fluidity never met before."

Cézanne dans les Musées Nationaux, p. 27.

71. Roses in a Bottle [Roses dans une bouteille]. 1900–05. Venturi 1542
Pencil and watercolor on white paper, 17⅛ x 12⅛ in (43.5 x 30.8 cm)
Private collection
Pl. 170

Very faint pencil lines appear only in the roses. These are of a deep red with a few bright-green leaves. The vase is dark blue with some spots of green and purple. Richly nuanced purplish blues, greens, and faded pink are assembled freely on the white sheet without preliminary drawing. Various diagonals create the illusion of a space which, however, is impossible to conceptualize. Their directions and color accents form an unusual contrast to the blossoms that are suggested rather than defined. What astonishes is the firmness with which the delicate medium is used for an exceptionally solid and yet subtle representation.

72. Study of a Skull [Etude de crâne]. 1902–04. Venturi 1130
Pencil and watercolor on white paper, 10 x 12½ in (25.4 x 31.8 cm)
Estate of Henry Pearlman, New York
Pl. 159

An early photograph shows the subject at the top of an otherwise blank sheet which may have been some eighteen inches high. It has since been cropped.

As is frequently the case with Cézanne's watercolors, the preparatory pencil sketch merely established basic shapes; a series of light, repeated curves provided the outlines of the round back of the skull (later to be retraced by short, broken lines applied with a brush). Still more vague were the scrawls that indicated the eye sockets and the nose, subsequently accented with color touches. Except for these shaded parts, the skull is left white, standing out with splendid plasticity from its surroundings, whose colors close in on it from all around. For the background there are fewer pencil indications, since here various layers of transparent, mostly yellowish colors were applied without much concern for precise spatial information, though horizontal and vertical bands help to set off the skull more sharply.

According to the catalog of the 1963 Knoedler exhibition, "Nothing in the stylistic treatment of this study suggests the contemplation of death: it could just as well be a study of fruit. The eye sockets—which in some of Cézanne's contemporary skull paintings [pls. 152, 155] are very dark, hollow and sad—are here mostly devoid of color and almost gay in expression. The usual feeling of boniness, achieved with severe linear outline and contrast of light and shade, is also lacking from this watercolor. Instead, the lines around the skull are broken, soft and sketchy; the background . . . is equally free in execution."

73. Skull on a Drapery [Crâne sur une draperie]. 1902–06. Venturi 1129
Pencil and watercolor on white paper, 12½ x 18¾ in (31.7 x 47.5 cm)
Private collection
Pl. 158

Georges Rivière speaks of a canvas painted in 1903 in the Lauves studio, representing a "skull on a drapery." However, no such picture of a single skull exists, while there is an oil painting of three skulls on a drapery (pl. 155). In all likelihood Rivière was mistaken about the medium and meant this watercolor.

The colors of the carpet are vivid greens and reds; the shades on the skull—which was first established in pencil—are blue-green. But the remarkable thing is that the richly patterned material is draped in sharp folds; here the design is traced freely, without a previous pencil outline. Whereas the pattern is closely knit in some parts, it is loosely strewn with a few deft brushstrokes across the white paper at right. In the midst of the folds that maintain their rigidity despite the vivid design, the skull is enthroned in immutable whiteness—a contrast of soft and hard substance as well as of rich colors and deathly pallor.

G. Rivière, *Paul Cézanne* (Paris: Floury, 1923), p. 224.

74. Three Skulls [Trois Crânes]. 1902–06. Venturi 1131
Pencil and watercolor on white paper, 18¾ x 24¾ in (47.7 x 63 cm)
The Art Institute of Chicago
Pl. 156

The prevalent hues of this work point to Cézanne's Lauves studio, since they are closely related to those of the landscape watercolors he made in the vicinity of that studio between 1902 and his death.

The execution, especially in the rug, consists of successive layers of thin, transparent watercolor whose cumulative effect stresses shapes and patterns. From the heavy lower part, the background lights up toward the top. But it is the complete absence of color in the spheres of the three skulls that provides the most startling feature, since their roundness is obtained not through any attempt at modeling, but through the density of their surroundings, as well as the sharp accents of the sockets of eyes and noses. This is the most pertinent confirmation of Léo Marchutz's observation that in Cézanne's watercolors "all colors stand for shadows; lights are colorless, and the unity of the surface is created by the white of the paper."

75. Kitchen Table: Jars and Bottles [Table de cuisine: pots et bouteilles]. 1902–06. Venturi 1148
Pencil and watercolor on white paper, mounted on cardboard, 8⅜ x 10¾ in (21.2 x 27.2 cm)
Cabinet des Dessins, Musée du Louvre, Paris
Pl. 183

Geneviève Monnier has observed: "The color is applied in swift, superposed brushstrokes; apparently they are disordered, not following the preparatory pencil sketch. 'The shape and the outline of the objects are given to us through the opposition and the contrasts that result from their particular colorations' (Cézanne). Effectively the objects set on this table recompose themselves in the light when seen at a distance."

In this watercolor the strongest volumes are the red box in the middle ground and the large bottle behind it. The orange-colored tube lying not quite horizontally in the foreground stabilizes a certain shifting movement.

Cézanne dans les Musées Nationaux, p. 158.

76. Still Life. 1906. Venturi 1154
Pencil and watercolor on white paper, 18½ x 24½ in (47 x 62 cm)
Estate of Henry Pearlman, New York
Pl. 185

According to Georges Rivière this "unfinished" watercolor is one of the last three executed by Cézanne, the others being pls. 27 and 84. It has often been noticed how fluid and vibrant the touches and the colors are in the works after 1900. This is also true for this still life, in which moreover the architectural structure with three horizontal levels and at least three vertical accents is very firm. The carafe with its many reflections has an almost feminine opulence; the rectangular white label suggests the volume of the bottle and brings forth the feeling of space between the wall and the objects on the table.

77. Apples, Bottle, Chair Back [Pommes, bouteille, dossier de chaise]. 1902–06. Venturi 1155
Pencil and watercolor on white paper, 17½ x 23¼ in (44.5 x 59 cm)
Courtauld Institute Galleries, London
Pl. 184

In the catalog of the exhibition of Cézanne drawings and watercolors at Newcastle and London (1973), Lawrence Gowing wrote: "The brush stroke that is a distinct, deliberate shape only exists in relation to the paper. The paper is part of it. Together they constitute a new unit, an entity of figure and field. The residue of white itself asserts it; the paper sparkles with its new status as a partner in the analogue of nature. In [this] still-life from the Courtauld Institute the arcs of colour, convex and concave in turn, interlocking with the whiteness of the paper, echo backwards up the pile of fruit to reach their summit in the chair-back. There is a ceremonious elaboration about them, yet innumerable hours in the Louvre spent on the study of how the spring and recoil of rhythm made volume manifest must have contributed to such an image."

In the same catalog Robert Ratcliffe points out that "there is a close affinity between this boldly brushed-in chair back and [the drawing of] the *Rococo clock* [A. Chappuis, *The Drawings of Paul Cézanne* (New York Graphic Society, Boston, 1973), no. 1223]."

Watercolour and Pencil Drawings by Cézanne, Laing Art Gallery, Newcastle upon
 Tyne, and Hayward Gallery, London, 1973, pp. 21 and 170.

78. Trees Reflected in the Water (Lake Annecy?) [Arbres se reflétant dans l'eau (Lac d'Annecy?)]. 1896
Pencil and watercolor on white paper, 12¼ x 17⅞ in (31 x 45.5 cm)
Private collection, Europe
Pl. 87

Slight and vague pencil indications are enhanced with large, superbly orchestrated washes of yellow-green, green, and blues. The identification of the subject is by no means certain. Lawrence Gowing takes this to be a Marne view of 1888 because he detected adumbrations of the reflection of a bridge in the river but no bridge above the water. According to him, the palette, which is largely lacking in violet blue, is quite close to the Courtauld *Mont Sainte-Victoire* (Venturi 1023). Despite Gowing's extreme perceptiveness, it would seem that the great freedom of execution to be observed in this work precludes such a comparison.

79. Village Street [Rue de village]. 1895–1900. Venturi 845
Pencil and watercolor on white paper, 14 x 17½ in (35.5 x 44.5 cm)
Private collection
Pl. 86

Views such as this, of a strangely deserted street with the emphasis on blocklike forms of houses with slanted roofs, are rare among Cézanne's late watercolors. The location is unknown, but from the shape of the buildings it can be presumed that this is a village of the North, possibly the one represented in the painting *Village behind Trees* (pl. 77), supposed to have been done at Marines, where the artist is known to have worked in 1898.

The preparatory pencil drawing established the essential, mostly rigid lines, to which the brush subsequently added—as so often in Cézanne's works—the blue tints for shadows, leaving the paper white in the zones bathed by light. The bright red of the roofs is tempered in part by a transparent layer of blue, applied on top of it. Because of the geometric character of the motif, even the shadows occupy clearly defined, straight-lined areas. Only a tree at right introduces some curves into this masterful interplay of horizontals, verticals, and diagonals.

80. The Well in the Park at Château Noir [Le Puits dans le parc de Château Noir]. 1895–98. Venturi 998
Watercolor on white paper, 18¾ x 12 in (47.6 x 30.5 cm)
Collection Mr. and Mrs. John W. Warrington
Pl. 63

Not unlike the works Cézanne painted near the caves above Château Noir, this watercolor is extremely representational only to one who knows the motif. The narrow, shaded path that leads from the terrace in front of Château Noir to the bend where the abandoned millstone stands by the cistern is seen here as it passes a small well. At its left protrudes a square block on which pails or jugs were placed while the water, hoisted from the well with a rope dangling from wooden poles, was poured into them. Every detail has been observed; the few straight lines of the well, the low block, and the poles are surrounded by luxuriant vegetation. At the bottom of the sheet appears a curve in the path; near the top some naked branches undulate.

This well was still being used throughout the 1930s.

81. Rocks near the Caves above Château Noir [Rochers près des grottes au-dessus de Château Noir]. 1895–1900
Watercolor on white paper, 12¼ x 18½ in (31 x 47 cm)
Collection Gianni Mattioli, Milan
Pl. 40

The maze of rocks is highlighted by ocher tones such as prevail in the nearby Bibémus quarry. Only familiarity with the entangled masses of these rocks emerging from shrubs and sometimes half-hidden by trees (now gone) allows a clear "reading" of the subject. Despite its apparently abstract character, this is an astonishingly faithful representation of an unusual—almost secretive—motif.

82. Rocks near the Caves above Château Noir [Rochers près des grottes au-dessus de Château Noir]. 1895–1900
Pencil and watercolor on white paper, 17½ x 11⅞ in (44.5 x 30.2 cm)
Private collection, New York
Pl. 41

Not often did Cézanne use this peculiar technique of "hatching" in his watercolors: short brushstrokes rhythmically assembled. They proved here to be an excellent means for contrasting the large, solid surface of the rock in the background with the quivering foliage in front of it. In addition, they suggest the vibration of flickering light and thus provide a sensation of movement in this essentially stable setting.

83. Rocks near the Caves above Château Noir [Rochers près des grottes au-dessus de Château Noir]. 1895–1900. Venturi 1044
Pencil and watercolor on white paper, 18½ x 12 in (47 x 30.5 cm)
Collection Mr. and Mrs. Joseph Pulitzer, Jr., St. Louis
Pl. 43

Cézanne treated this subject several times; in each study the light is different and the concern about the rocks, the bushes, or the slope beneath varies. Since the artist here has detached the rocks more resolutely from their helter-skelter surroundings, their specific forms appear more clearly than in the other studies. Chappuis dates this sheet as c. 1895.

84. Rocks near the Caves above Château Noir [Rochers près des grottes au-dessus de Château Noir]. 1895–1900
Pencil and watercolor on white paper, 18 x 11⅝ in (45.7 x 29.6 cm)
Private collection, New York
Pl. 44

The concept of this study differs from the more tranquil or more fluid one of most of the other watercolors representing the same motif; in the fashion of a weighty musical rhythm, three accents seem to rise from below, directed toward the right. The two heavy blocks above suggest an upward movement to the left, as if they were being pushed in that direction.

Not all the light pencil hatchings have been covered by color, their texture being integrated with that of the washes to produce a cohesive pattern that appears abstract until one compares this delicate image with a photograph of the actual spot.

85. Rocks near the Caves above Château Noir [Rochers près des grottes au-dessus de Château Noir]. 1895–1900. Venturi 1043
Pencil and watercolor on white paper, 12⅜ x 18¾ in (31.4 x 47.6 cm)
The Museum of Modern Art, New York, Lillie P. Bliss Collection
Pl. 45

The still clearly visible pencil drawing was very detailed and even shows some rather strong, dark accents later barely touched by color; near the top no color was applied at all. In some places the pencil lines were subsequently redrawn with a pointed blue brush. In general, brush-strokes carefully follow the preparatory study, though concentrating on the areas in the shade, the paper being left mostly bare for the large surfaces struck by sunlight. Here there are only some hints at ocher, which in the recesses appears accompanied by blue and more reddish-brown tints. There are comparatively few indications of green, as though the rocks were to be isolated from their sylvan surroundings.

86. Rocks and Cave [Rochers et caverne]. 1895–1900
Pencil and watercolor on white paper, 12 x 18¼ in (30.5 x 46.4 cm)
Galerie Beyeler, Basel
Pl. 46

This motif is almost certainly located in the Bibémus quarry. The artist has achieved here a monumentality beyond that of the natural aspect.

87. Pine and Rocks near the Caves above Château Noir [Pin et rochers près des grottes au-dessus de Château Noir]. c. 1900. Venturi 1041
Pencil and watercolor on white paper, 18⅛ x 14 in (46 x 35.5 cm)
The Art Museum, Princeton University, New Jersey
Pl. 65

A recent fire has destroyed all the vegetation along the rocky ridge that leads from Château Noir to the Bibémus quarry. For a photograph of the motif see Erle Loran, who observes, "This watercolor might be used to demonstrate that form and space cannot be created with tonal values and color planes when the linear structure is largely decorative and two-dimensional."

E. Loran, *Cézanne's Composition,* p. 117 and pl. 33, with photograph of the motif.

88. Pistachio Tree in the Courtyard of Château Noir [Pistachier dans la cour de Château Noir]. c. 1900. Venturi 1040
Pencil and watercolor on white paper, 21¼ x 16⅞ in (54 x 43 cm)
The Art Institute of Chicago
Pl. 66

In the middle of the small court of Château Noir stood, and still stands, a gnarled pistachio tree. In the rear extends the slanting roof of a wing of the structure beyond which one perceives the tops of pine trees and the faint outline of the rising "back" of Mont Sainte-Victoire. This outline is today completely covered by the trees, which have grown considerably since Cézanne worked there some seventy-five years ago. With his usual care, the artist faithfully reproduced the partly hollowed and twisted trunk as well as the four blocks that set it off against the level of the court itself, with—in the right corner—a stone that seems to have been cut to cover a well and which, even today, occupies the very spot where Cézanne observed it.

As in most watercolors of Cézanne's later years, a few penciled lines were first thrown on paper as mere indications of general forms, while the essential image is achieved through color. His brush sometimes follows the outlines of a branch, so that color and line are one; where less linear forms are concerned, strokes of usually very dilute color are woven together and superimposed to achieve a dense and yet luminous tissue. The great miracle of Cézanne's ultimate watercolor technique is that those strokes, applied one on top of the other or at least overlapping, remain transparent and light despite their accumulation, attesting to an incredibly delicate and controlled procedure, unique of its kind.

89. Forest Scene [Sous-bois]. c. 1900. Venturi 1544
Pencil and watercolor on white paper, 17¾ x 12¼ in (45 x 31.1 cm)
Private collection, Lausanne
Pl. 102

If ever any of Cézanne's watercolors can be called "elegant," it is works such as this one with its delicate colors and exquisite rhythms. The slender tree trunks, the absence of boulders, and the quality of the light seem to point to some woods of the North rather than to the region around Château Noir.

90. House among Trees [Arbres et maisons]. c. 1900. Venturi 977
Pencil and watercolor on white paper, 11 x 17⅛ in (28 x 43.5 cm)
The Museum of Modern Art, New York, Lillie P. Bliss Collection
Pl. 90

On the right an alley of high trees, open toward the background; on the left the sloping area of a courtyard and the walls of a rural building. According to the catalog of the 1963 Knoedler exhibition, "Cézanne's interest in a subject such as this reflects his fascination with pictorial interrelationships between solid, clearly defined architectural planes and the . . . insubstantial effects of foliage. It was not representational completeness but a satisfying pictorial structure that he sought, yet the firm reality of architectural and foliate forms is still conveyed."

91. Bridge under Trees [Arbres et pont]. c. 1900
Pencil and watercolor on white paper, 18⅛ x 11⅞ in (46 x 30 cm)
Collection Mr. and Mrs. Richard K. Weil, St. Louis
Pl. 95

In this work a free, constructive technique is firmly enforced through color; the lights are produced by the white paper. The color scale is limited to blues and greens, put down in large, transparent patches, on top of which occasional lines are drawn with the brush, bounding the solid forms in the midst of lush foliage. However, some repetitive curves are also superimposed on these masses of green so as to supply them with vague shapes. Since the color patches are spread over the entire sheet—including the four corners—one may consider this a "finished" watercolor, one in which the artist has "realized" his purpose.

Lawrence Gowing dates this work somewhat before 1900: c. 1897, a year which Cézanne spent near Corbeil on the Seine, not far from Paris, as well as at Aix.

92. Almond Trees in Provence [Amandiers en Provence]. c. 1900
Pencil and watercolor on white paper, 20½ x 17⅞ in (52 x 45.5 cm)
Collection Mr. and Mrs. Walter Bareiss
Pl. 96

There is an almost Oriental flavor to this work with its few, deft "signs" floating freely on the large white sheet. The receding row of almond trees provides a sensation of space which is enhanced rather than diminished by the sparse touches in the distance that leave the rest of the paper unencumbered.

93. Sheet of Water at Edge of Woods [Plan d'eau à l'orée d'un bois]. c. 1900. Venturi 936
Pencil and watercolor on white paper, 18⅛ x 23¼ in (46 x 59.1 cm)
The St. Louis Art Museum
Pl. 91

Venturi thought that this watercolor represented a corner of Lake Annecy; it was also listed in the catalog of the 1963 exhibition at the Knoedler Galleries as *Coin du lac d'Annecy.* But in view of the general style of this work, the date of c. 1900 seems more appropriate than that of 1896 (when Cézanne worked at Annecy).

Some features of this landscape are admittedly slightly ambiguous, such as the distance of the opposite shore, the branches of the tree, or certain patches of color in the sky. One has to follow and interpret carefully the network of pencil lines to perceive that some strokes which might be taken for profiles of distant hills are in fact details of unfinished trees. The location of the site thus remains undetermined.

94. The Balcony [Le Balcon]. c. 1900. Venturi 1126
Pencil and watercolor on white paper, 22¼ x 15⅞ in (56.5 x 40.4 cm)
Philadelphia Museum of Art, A. E. Gallatin Collection
Pl. 175

As Alfred Neumeyer has observed, "The forms of the grill of the balcony loom big and nearly threatening. They are conceived by the painter as a wheel-like motion which stirs the colors of the background into vibrancy." The frame protruding at left is not easy to interpret. The catalog of the 1963 Knoedler exhibition describes it as a French door; it might also be the half-opened shutter of a window placed at some distance in a wall, set at right angle. The grill is conceivably not that of a balcony, but of a French window.

A. Neumeyer, *Cézanne Drawings* (London and New York: Thomas Yoseloff, 1958), p. 60.

95. Provençal Landscape [Paysage provençal]. 1900–04
Watercolor on white paper, 15¾ x 12½ in (40.2 x 31.7 cm)
Collection Mrs. Allan D. Emil, New York
Pl. 93

A single house at the foot of a hill is conjured up through large, isolated spots of color. Though the execution of many of Cézanne's late oils appears related to his watercolor technique, here the opposite seems to apply: the process of assembling large, almost blocklike splashes of color of no "descriptive" quality seems linked to the brushstrokes of his last landscapes.

96. Mont Sainte-Victoire. 1900–02. Venturi 1562
Pencil and watercolor on white paper, 12¼ x 18⅞ in (31.1 x 47.9 cm)
Cabinet des Dessins du Musée du Louvre, Paris
Pl. 132

Commenting on this watercolor, Roger Fry wrote: "Every particle is set moving to the same all-pervading rhythm. And the colour, sometimes exasperatedly intense, sometimes almost uniform in its mysterious greyness, upholds the theme by the unity of its general idea, the astonishing complexity and subtlety of its modulations. One feels that at the end Cézanne reposed a complete confidence in the instinctive movements of his sensibility, broken as it was by the practice of a lifetime to the dictates of a few fundamental principles."

R. Fry, *Cézanne: A Study of His Development*, pp. 79–80.

97. Mont Sainte-Victoire. 1900–02. Venturi 1560
Pencil and watercolor on white paper, 12¼ x 18⅞ in (31 x 48 cm)
Collection John S. Thacher, Washington
Pl. 133

This motif is seen from a spot close to that where the somewhat similar watercolor of the Louvre, pl. 132, was executed. The shape of the mountain is related to what Cézanne observed from the hill of Les Lauves, though here he was not separated from it by the vast valley; he seems to have stood closer to the foot of the rock, possibly in the vicinity of Saint-Marc.

98. The Forest—The Park at Château Noir [La Forêt—Le Parc de Château Noir]. 1900–04. Venturi 1056
Pencil and watercolor on white paper, 21¾ x 16¾ in (55.3 x 42.6 cm)
The Newark Museum
Pl. 92

The short road leading from the Maison Maria (which Cézanne had painted around 1895, Venturi 761) to Château Noir here appears in the foreground. It winds its way through a thick forest that on one side climbs the rock-strewn hill toward the caves, and on the other side—invisible here—descends to the Route du Tholonet. An irregular succession of heavy oaks wedged among the pine trees probably signals the presence of a subterranean watercourse. Where the road bends sharply in direction of Château Noir, an old cistern is located. From three poles a chain with a pail used to be suspended; one of these poles appears at the extreme right. It is this road, cleared long ago through the tangle of trees—some of them dead but held in place by their neighbors—that provides light for the scene, since the dense vegetation spreads deep shadow and coolness over the site. Darkness and light, solid rocks and sinuous trees, blues and greens, nature's forms and man-made shapes often attracted Cézanne to this spot, where he also painted the oil shown in pl. 53.

99. House beside the Water [Maison au bord de l'eau]. 1900–04.
Venturi 1551
Pencil and watercolor on white paper, 12½ x 18¾ in (31.5 x 47.5 cm)
Private collection, Basel
Pl. 106

There exists another version of the same subject, Venturi 935, probably done earlier (c. 1888), though it does not appear absolutely certain that these two watercolors are really separated by ten years or more. The multiple reflections on the water are observed with a true painter's relish. The distant range of trees is placed on a dam that holds back the water. On the left, behind the inclined and sketchily marked trunk, one may discern a round-shaped building with an arched opening in the front.

100. The Tall Trees [Les Grands Arbres]. 1902–04
Pencil and watercolor on white paper, 18½ x 23 in (47 x 58 cm)
Collection Dr. and Mrs. Alexander Pearlman, New York
Pl. 82

According to the catalog of the 1963 exhibition at the Knoedler Galleries, "This dynamic composition, in which the tension of the twisting trees at the sides is contained by the calm vertical of a thin sapling, is repeated with some narrowing of the spatial intervals in *Les Grands Arbres,* a painting of 1895–98 (Venturi 760 [pl. 81]). Venturi calls our drawing *Bare Trees in the Fury of the Wind.* . . . But an actual storm is not required to account for these twisting shapes; Cézanne's own dramatic feeling leads him often to seize upon the active, reaching quality of the limbs of trees."

101. Outskirts of Aix [Environs d'Aix]. 1900–06. Venturi 1064
Pencil and watercolor on white paper, 14 x 21¼ in (35.5 x 54 cm)
Collection Mr. and Mrs. Henry M. Reed, Caldwell, N.J.
Pl. 97

Light washes of purples, blues, greens, and rusts are freely distributed over a slight pencil sketch, with very few brush lines to delineate forms. The mountain range in the distance is probably the Chaîne de l'Etoile, which Cézanne also perceived from his studio.

102. Mont Sainte-Victoire Seen from Les Lauves [Le Mont Sainte-Victoire vu des Lauves]. 1902–04
Pencil and watercolor on white paper, 12¼ x 17¼ in (31 x 43.8 cm) (sight)
Private collection
Pl. 137

Delicate washes seem almost to "float" on the paper atop some vague pencil indications. Their complete lack of corporeality notwithstanding, these spots of color are distributed so judiciously and are so perfectly in harmony—with an attenuated vertical balanced by a pronounced horizontal—that they convey an impression of vast space as well as of soaring height.

103. Mont Sainte-Victoire Seen from Les Lauves [Le Mont Sainte-Victoire vu des Lauves]. 1902–04
Pencil and watercolor on white paper, 16½ x 20½ in (41.9 x 52 cm)
Private collection, Los Angeles
Pl. 136

It is amazing how Cézanne, never tiring of the panorama dominated by Sainte-Victoire that he perceived from Les Lauves, always found compositional variations to avoid repetitions of this view. He might focus on a farm complex in the middle distance or animate the foreground

with gnarled olive trees (as he did here), but he could also step farther down the slope, beyond these trees, so that the plain would unfold before him unencumbered. In addition, he could vary the light effects; in this instance they completely divide the monolithic mass of the mountain into two zones: the front—lit by the sun—where the paper remained bare, and the back, covered by deep shadow.

Emile Bernard, who in 1904 accompanied Cézanne up the slopes of Les Lauves, later recorded how the master had executed a watercolor there: "His method was remarkable, absolutely different from the usual process, and extremely complicated. He began on the shadow with a single patch, which he then overlapped with a second, then a third, until all those tints, hinging one to another like screens, not only colored the object but modeled its form."

Unfortunately, Bernard did not elaborate on two other, interrelated and unconventional features of Cézanne's watercolor technique: one was that he put down brushstrokes all over the paper instead of concentrating on a specific section (a process that can also be found in many of his unfinished oil paintings); the other was that each color patch was thus permitted to dry before the next overlapping one was applied. This prevented the watery patches from running into one another and thus assured the unbelievable transparency of the multiple layers that distinguishes Cézanne's watercolor.

However, Bernard may not actually have *seen* the master working on a watercolor, since Cézanne is known to have intensely disliked being observed while he painted. Moreover, Bernard was more interested in Cézanne's mental process than in his technique and eventually even accused him of having "interpreted rather than copied" his motif, at the same time reproaching him for his alleged lack of creative imagination, as though the endless series of representations of Sainte-Victoire in oil paintings and watercolors did not attest precisely to the artist's constantly renewed imaginative approach nursed at the sources of observation.

E. Bernard, *Sur Paul Cézanne,* pp. 23–24.

104. Mont Sainte-Victoire Seen from Les Lauves [Le Mont Sainte-Victoire vu des Lauves]. 1901–06
Pencil and watercolor on white paper, 18⅝ x 24¼ in (47.5 x 61.5 cm)
National Gallery of Ireland, Dublin
Pl. 135

A grand view of Mont Sainte-Victoire conveying an airy feeling of space, enhanced by the balanced rhythm of the surface pattern. See the related views nos. 102, 103, and 105–7.

105. Mont Sainte-Victoire Seen from Les Lauves [Le Mont Sainte-Victoire vu des Lauves]. 1902–06. Venturi 917
Pencil and watercolor on two joined sheets of white paper, 13 x 28⅜ in (33 x 72 cm)
Collection Ernest M. von Simson, New York
Pl. 126

Only in one oil painting (pl. 125) and in this watercolor did Cézanne endeavor to represent the full width of the panorama dominated by Sainte-Victoire that unfolded before him as he stood on the height of Les Lauves. In each case he had to add strips to the standard size of his canvas or paper in order to stretch his work to the demands of the extended, breathtaking view. But the elongated group of farmhouses nestled in the fields before the mountain also appears in another watercolor (Venturi 1033). For all three the artist occupied different spots, though in the second watercolor and the painting the buildings are seen more or less in the axis of the mountaintop. In this watercolor, however, Cézanne stepped more to the left and also farther down

the slope of Les Lauves, so that the farmhouses are pushed up in the composition and are located on a higher level; they also seem nearer the mountain and more to its right.

Before a wide strip was added to this sheet, the yellow mass of the farm complex competed for attention with the pale triangle of the rock. Its emphasis was by no means lost when Cézanne glued a second sheet of paper to the first one, but the inclusion of the blue and distant stretch of the Mont de Cengle more successfully integrated it into the landscape.

A light pencil sketch indicated the essential features of the motif. On top of it overlapping brushstrokes accumulated transparent greens and reds in the lower horizontal plane (the actual foreground, extending between the artist and the bottom of this landscape, has been suppressed); the gnarled branches of an olive tree—acting as a *repoussoir*—are traced in blue, the same blue that establishes the long plateau of the Mont du Cengle. The sky is animated by scattered touches of light blue and pink, which latter appear somewhat faded.

106. Mont Sainte-Victoire Seen from Les Lauves [Le Mont Sainte-Victoire vu des Lauves]. 1902–06
Pencil and watercolor on white paper, 16¾ x 21⅜ in (42.5 x 54.3 cm)
The Museum of Modern Art, New York, anonymous gift, the donor retaining a life interest
Pl. 134

This watercolor is extremely accomplished; it is executed in vivid, most carefully contrasted colors. Though its composition may be related to several other views of Mont Sainte-Victoire, this one has a beauty all its own, radiant with a spiritual force.

107. Mont Sainte-Victoire Seen from Les Lauves [Le Mont Sainte-Victoire vu des Lauves]. 1902–06
Pencil and watercolor on white paper, 18⅞ x 12¼ in (48 x 31 cm)
Private collection
Pl. 118

This watercolor corresponds closely to the oil painting pl. 117, which represents the same view in a similarly vertical composition. But here the verticality has been further stressed by dispensing with the horizontal stretch to the right of Mont Sainte-Victoire (the mountain has been "cropped," so to speak, to the utmost) and by reducing the flat planes at the bottom. Simultaneously, the almond trees of the foreground have been accentuated; their curling branches seem to reach like flames toward the tip of Sainte-Victoire that hovers above them. Yet, despite the unusual format, there remain enough horizontal elements, especially the straight line beyond which the rock rises, to convey the exhilarating sensation of tremendous space that the artist experienced on this elevated site.

108. The Garden Terrace at Les Lauves [La Terrasse du jardin des Lauves]. 1902–06. Venturi 1072
Pencil and watercolor on white paper, 17 x 21¼ in (43 x 54 cm)
Collection Mr. and Mrs. Eugene Victor Thaw, New York
Pl. 104

Though the catalog of the exhibition at the Knoedler Galleries of 1963 says that Cézanne, from this spot, could see the "characteristic profile" of Mont Sainte-Victoire, such was by no means the case. From this terrace in front of his studio, the artist perceived to the south the distant mountain range of the Chaîne de l'Etoile with the Pilon du Roi; and when he went up to the studio itself, he had a view of the

rooftops of Aix and the tower of the cathedral, as in pl. 100, with the Pilon du Roi directly above that tower. In order to see Sainte-Victoire, the painter had to climb farther up the heights of Les Lauves (the road was at the left of his garden, as seen here) and had to look west over the undulating landscape that stretched out toward the mountain, as represented in pl. 134 and many similar works.

The colors of this sheet are fresh; there are light greens and soft blues with strong accents of yellow-orange in the horizontal lines of the wall, through the opening of which a path runs downhill through the bushes and trees toward a narrow canal that borders the property to the south. The execution is in large spots of color with few linear indications; these appear mostly in the tree at right.

109. Bare Trees by the Water [Arbres dépouillés au bord de l'eau]. c. 1904. Venturi 1552
Watercolor on white paper, 12⅝ x 19¼ in (32 x 49 cm)
Collection Mr. and Mrs. Eugene Victor Thaw, New York
Pl. 109

As stated in the catalog of the collection of Mr. and Mrs. Eugene V. Thaw (Pierpont Morgan Library, 1975), "In this beautiful example of Cézanne's late watercolor manner, light, transparent strokes bathe the scene in lavender, green, and yellow, complementing the outlines but also independent of them. The diagonal strokes of the upper part of the sheet and the main tree flow into the principally horizontal strokes of the lower section in the central area. The difference in the substances of solids and of water and air is shown by the frequency of the brushstrokes, culminating in this same central area, where land, wood, and water come together."

And A. Neumeyer observed: "The magic of this watercolor rests on its supreme balance between the tangible line work of the leafless trees and the ethereal vapor of violet and green color touches not related to any defined form. In the lower section, these touches indicate the horizontal-vertical orientation of the painting ground (= potential space); in the upper section, they turn diagonally and create the atmospheric-coloristic echo of the diagonals of the trees. Besides, by the gradation of the color intensity, they indicate distance from the spectator and weight of matter. Line and color are not isolated, but each is the carrier of a multiplicity of aesthetic functions. The result is an ordered universe, deprived of its material particularizations."

A. Neumeyer, *Cézanne Drawings*, p. 62.

110. Trees Forming a Vault (Fontainebleau?) [Arbres formant une voûte (Fontainebleau?)]. 1904–05. Venturi 1063
Pencil and watercolor on white paper, 24 x 18 in (61 x 45.8 cm)
Estate of Henry Pearlman, New York
Pl. 105

This appears to be a large wood tended by foresters, unlike the woods around Aix. The alley resembles those prepared for riding or hunting; hence it seems probable that Cézanne did this watercolor near Fontainebleau.

The thin washes are applied in broad strokes over a preparatory pencil sketch that merely seems to have blocked in some lines and indicated a few shadows. The impression of depth is created by the large and pale foreground area beyond which the green tints turn gently toward blue. The sheet is completely covered with a dense yet transparent weave of spots, splashes, and precise outlines for the trees that stand out superbly—yet without sharp contrasts—from the maze of foliage.

111. Château Noir. c. 1904. Venturi 1036
Pencil and watercolor on white paper, 16½ x 21¾ in (41.9 x 55.2 cm)
Collection Mrs. Potter Palmer II
Pl. 61

Though this appears to be a frontal view, the facade of Château Noir actually looks south into the valley that stretches toward Mont Sainte-Victoire. The mountain lies behind this wing of the "château," seen here from the west from a spot near the Maison Maria; the artist stood on the path leading from that house to the main building. (This path advances to the left of this view, then bends sharply near the cistern, pl. 53, and continues in an almost straight line to the terrace of Château Noir, whose horizontal wall appears clearly at right.) The main feature of this wing, which faces in the direction of Aix, was a large red barn-door beneath a row of pseudo-Gothic windows. Cézanne has represented it on various occasions, attracted obviously by this red note beyond the waves of green vegetation that extended in front of it. The red has faded since, the trees have grown or died, yet the place has kept its strangely haunted aspect, though the yellowish masonry of the isolated building-complex no longer dominates the scene. But sun and sky still endow the grotesque architecture of Château Noir with an impressive grandeur as it emerges amidst unruly vegetation that almost seems to engulf it, while the walls threaten to crumble under long years of exposure and neglect.

112. House near Bend at Top of the Chemin des Lauves [Maison près d'un tournant en haut du Chemin des Lauves]. 1904–06. Venturi 1037
Pencil and watercolor on white paper, 18⅞ x 24⅞ in (48 x 63.2 cm)
Estate of Henry Pearlman, New York
Pl. 112

There exists a painting of the same subject, not catalogued by Venturi. A photograph of the motif, possibly taken by Emile Bernard, who visited Cézanne in Aix in 1904, was found in Cézanne's studio.

Over a minimal pencil sketch are applied large, sweeping brushstrokes on top of which short blue lines occasionally define a tree trunk or the limits of a field. The colors are blues, greens, yellow-orange, and pinkish red. By superimposing these in his very peculiar transparent fashion, the artist also obtained a host of intermediate tints.

The catalog of the 1963 exhibition at the Knoedler Galleries commented, "Characteristic of his late work, painted near Cézanne's studio on the Chemin des Lauves, is the restless excitement of the brushwork, the atmospheric unity of the scene and the rather ambiguous handling of space." Yet the consistent spatial structure of the work does not appear ambiguous; the diagonal slope of the purplish hill at left—skirted by the road (left blank)—serves to set off the horizontal plane at right, lighter in color and obviously more fully exposed to the sun.

113. Forest Road [Chemin sous bois]. 1904–06
Pencil and watercolor on white paper, 17½ x 24½ in (44.5 x 62.2 cm)
Estate of Henry Pearlman, New York
Pl. 110

Since Cézanne abandoned this watercolor in a less advanced state than many other works of the same period, its subject matter is less well defined, except for the diagonal of a road and the indications of a few trees. On the other hand it provides a better illustration as to the artist's method: the grid of vague and hasty pencil lines which—had it been left alone—might not even have resembled the painter's drawings as we know them, and over it the large touches of thin color, applied

not with the tip of the brush but apparently with its whole length (unless he used exceptionally broad brushes of the kind that generally serves only for oils). This watercolor also shows clearly how Cézanne would distribute washes of the same tint over the surface of the white sheet, and then apply touches of another color in different areas, thus giving the earlier spots time to dry before superimposing the next coat. Making sure in this way that the washes would not run together, he obtained these transparent nuances that characterize his late works in this medium. It is because there are as yet few successive coats tying together the scattered spots and achieving fullness of color, and simultaneously eliminating the white areas, that we can speak here of an "unfinished" work. Just the same, even in its intermediate condition, this watercolor is magnificent.

114. The Cathedral of Aix Seen from the Studio at Les Lauves [La Cathédrale d'Aix vue de l'atelier des Lauves]. 1904–06. Venturi 1077
Pencil and watercolor on white paper, 12½ x 18½ in (31.8 x 47 cm)
The Alex Hillman Family Foundation, New York
Pl. 100

On this watercolor oxidated whites in the sky have been removed. The view is taken from the central window on the first floor of Cézanne's studio. In the catalog of the Newcastle and London exhibition of 1973, Gowing observed: "Painting a watercolour from the window of his studio, he found that the tower of the cathedral in the town held palpitating shadow; among the tangled ultramarine and viridian contours, there was fruit on the tree. There had been nothing like this in his work for thirty years and the only similar design was in one of the etchings that he had made at Auvers. Yet the fullness of the colour, woven like garlands across the paper, had never been possible before."

115. Le Pont des Trois Sautets. c. 1906. Venturi 1076
Pencil and watercolor on white paper, 16 x 21 in (40.6 x 53.3 cm)
Cincinnati Art Museum, gift of John J. Emery
Pl. 113

During the intense heat of August 1906, Cézanne would have a coachman drive him to the Pont des Trois Sautets near Palette (see his letter of August 14 to his son). There, on the shaded banks of the Arc River, he found respite. As Erle Loran explains:

"The foliage forms have been rendered in terms of bold areas of flat color; plane is superimposed over plane in a rather abstract manner. Form and space are defined to some degree by the strong light-and-dark pattern; but without the arbitrary line drawing over the color planes, the space would be vague. . . . The heavy vertical tree at the right, which intersects the bridge and a part of the deepest space, provides a means of 'return' from depth to foreground, as well as a clarification of the spatial location of the bridge. In design, the tree provides the necessary opposition of a static straight line to the overpowering curve of the bridge."

E. Loran, *Cézanne's Composition,* p. 112.

116. Le Cabanon de Jourdan. 1906. Venturi 1078
Pencil and watercolor on white paper, 18⅞ x 24¾ in (48 x 62.8 cm)
Private collection, Zurich
Pl. 84

This exceptionally large watercolor, closely related to the painting pl. 83, may have been Cézanne's last landscape, the one on which he had been working when, on the way home from the motif, he fell

during a violent thunderstorm and lost consciousness. The exact location of this *cabanon* is not known.

A preliminary pencil drawing first established all the essential features; some of the pencil lines were subsequently retraced with a blue brush. The blue-green watercolor touches—with a few pink spots in the foreground and in the vegetation—are larger than any of the other brushstrokes. The building itself is left almost completely white, except for a few pale-yellow indications. The tree at right forms an arch that establishes an equipoise with the pointed chimney of the *cabanon* (which S. Geist has mistaken for a tower).

117. Bathers under a Bridge [Baigneuses sous un pont]. c. 1900. Venturi 1115
Watercolor and pencil on white paper, 8¼ x 10¾ in (21 x 27.4 cm)
The Metropolitan Museum of Art, New York, Maria De Witt Jesup Fund, from The Museum of Modern Art, Lillie P. Bliss Collection
Pl. 197

The shape of the bridge recalls that of the Pont des Trois Sautets outside Aix, near the village of Palette, where Cézanne is known to have worked when searching isolation and coolness during the summer of 1906. On either side of the bridge a poplar tree is slightly indicated, as if the artist had merely tested the too symmetrical effect obtained by them. The composition has often been compared to that of the *Grandes Baigneuses* (pl. 189), though the movement of this watercolor appears different, more Baroque. Its animated groups of figures may be related to those of some classical scenes of battles with bridges, perhaps even to Rubens' *Battle of Amazons* in the Alte Pinakothek in Munich.

The colors of this work seem somewhat faded, probably because of overexposure to light.

118. Bathers [Baigneuses]. 1902–06. Venturi 1105
Pencil and watercolor on buff paper, 8¼ x 10⅝ in (21 x 27 cm)
Private collection
Pl. 200

This watercolor on buff paper is lighter than it appears in the reproduction. There is almost no trace of pencil. The eye is led to dwell upon the bathers in the foreground, grouped as if confined by the mass of exuberant vegetation. The curve of the stretched-out nude seems to link two practically separate groups of bathers and is repeated in the trees, thus producing a kind of ellipsis dominated by the intricate blue and green foliage above. These two colors prevail in all Cézanne's late scenes of bathers, occasionally mitigated by diluted yellow washes. As usual the bodies are not tinted (the paper ground remaining untouched); they are "formed" by a series of repeated outlines. Near the right margin one may discern, set apart, the back of a figure half-covered with a cloth.

119. Seated Peasant [Paysan assis]. c. 1900. Venturi 1089
Watercolor on white paper, 18½ x 12⅝ in (47 x 32 cm)
Kunsthaus, Zurich
Pl. 15

Preparatory study for the painting Venturi 713. Alfred Neumeyer observed that "the closeness of the image and a symmetrical position lend the scene its nearly hieratic monumentality. . . . The colors in this as in the other late figure studies are expressively heightened. The model is entirely drawn with the brush, the silhouette and the definition of local color being one."

A. Neumeyer, *Cézanne Drawings*, p. 49.

120. Peasant with Straw Hat [Paysan au canotier]. c. 1906. Venturi 1090
Pencil and watercolor on white paper, 18⅞ x 12⅜ in (48 x 31.5 cm)
The Art Institute of Chicago
Pl. 17

Though Cézanne's activity spans almost fifty years, he had practically never painted portraits out of doors until he moved into his Lauves studio. The exceptions are astonishingly few: some figure studies undertaken in 1866, abandoned or destroyed, and a portrait of Victor Chocquet in his garden, of around 1889. But never does the artist seem to have had a model sit for him at the Jas de Bouffan, under the chestnut trees or near the pool; it is possible that the comings and goings of the farm laborers (whom he painted inside, playing cards) prevented him from working in the open, so that he preferred the isolation of his studio there or of the greenhouse.

No sooner had he moved into his Lauves studio, however, in the fall of 1902, than Cézanne began to avail himself of the terrace in front of the building and of the shade of its single linden tree. While his favorite model was his old gardener, Vallier (see pls. 22–30), he also had other willing acquaintances pose, though only men. Among them was this peasant in a straw hat, sitting here on a chair before the low parapet against the foliage of the garden. One hand lies in his lap, the other—not yet fully defined—rests on a cane; a dark blue ribbon circles the light-colored hat. Many nervous and thin strokes block in the forms without defining them too sharply, volumes being provided by modulations of tints rather than by outlines. As frequently happens in Cézanne's work, certain "details" have been left unattended to—for instance, the face of the sitter, where a few pencil lines show that the preliminary sketch was really nothing but a kind of scaffolding to be amplified by color.

121. Portrait of Vallier. 1904–06. Venturi 1092
Pencil and watercolor on white paper, 18¾ x 12¼ in (47.5 x 31 cm)
Private collection, Los Angeles
Pl. 29

Vallier, who took care of the garden surrounding the Lauves studio during the last years of Cézanne's life, posed repeatedly for the artist. See the paintings pls. 22–26 and 28 and watercolors pls. 27, 29, and 30. The gardener is represented out of doors, posing patiently. It is likely that he sat on the small terrace in front of the study, since the garden itself slopes down the Lauves hill toward Aix. The horizontal line in the background doubtless represents the low wall separating the terrace from the vegetation beyond which the roofs of the town were then still visible. The loose pencil lines and the curves of the trees form a contrast to the sitter's immobility. "Flowing around the old man is sunlight, taking away something of the weight of age and of matter," observed Neumeyer.

A. Neumeyer, *Cézanne Drawings*, p. 49.

122. Portrait of Vallier. 1906. Venturi 1102
Pencil and watercolor on white paper, 18⅞ x 12⅝ in (48 x 32 cm)
Private collection, Chicago
Pl. 27

According to Georges Rivière, this is one of Cézanne's last three watercolors, the others being pls. 84 and 185. See also the painting

pl. 26, which was probably the final one on which Cézanne worked. According to the catalog of the 1963 Knoedler exhibition, "Here Vallier is seen from a much nearer view than in any other version; emerging as in relief against a darker background, his large mass with its sweeping contours is poised against a torrent of line and color. In the background the overlapping translucent glazes of color do not blend, but each retains its prismatic autonomy."

PHOTOGRAPHY CREDITS

Photographs of the works of art reproduced in this volume have been provided, in the majority of cases, by the owners or custodians of the works, indicated in the captions. In many instances the photographs are drawn from the files of John Rewald and have been made available through the courtesy of New York Graphic Society, publishers of his forthcoming catalogue raisonné of the Cézanne oeuvre. The documentary photographs in Professor Rewald's "The Last Motifs at Aix" derive from the author's collection. The following list, keyed to page numbers, applies to photographs for which a separate acknowledgment is due:

David Allison, The Museum of Modern Art, New York: 356; Etablissements J. E. Bulloz, Paris: 61, 212; Walter Drayer, Zurich: 231, 368; Colorphoto Hans Hinz, Basel: 321; Vincent Miraglia, New York: 248 left; Arts Graphiques de la Cité, Paris: 298 left; Service de Documentation Photographique de la Réunion des Musées Nationaux, Paris: 15, 16, 17 bottom, 25 bottom, 28 top, 32 left, 34 top, 35 left, 40, 43 bottom right, 44 right, 58, 65 bottom, 108, 114 top, 209, 241, 243, 253, 324 top, 328, 337, 362 bottom, 365 bottom; Piaget, St. Louis: 295 left; Nathan Rabin, New York: 319; Sandak, New York: 356; Chuck Scardina, Palm Springs: 318; Malcolm Varon, New York: 217; Liselotte Wetzel, Essen: 239